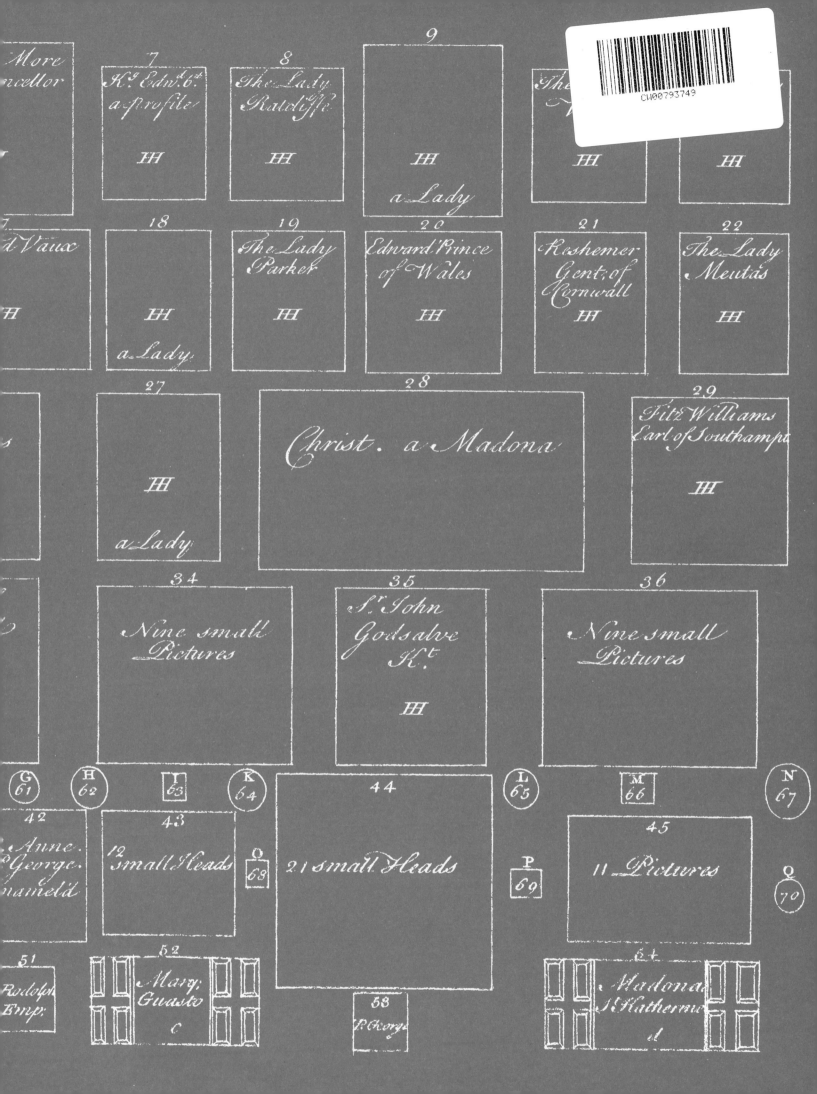

The British as Art Collectors

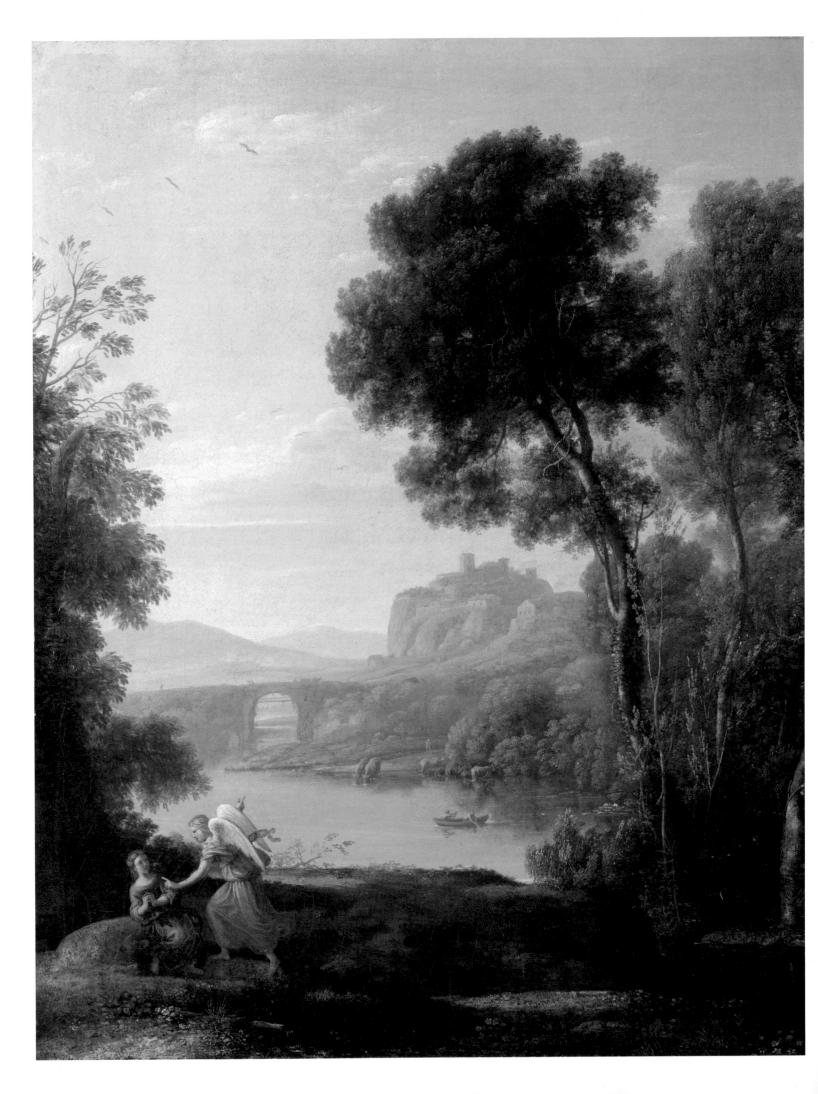

James Stourton
and Charles Sebag-Montefiore

THE BRITISH AS ART COLLECTORS

From the Tudors to the Present

Scala Publishers · London

SCALA

For Pam
IN AMITICIA ET AMORE

This edition © Scala Publishers Ltd 2012
Text © by James Stourton and Charles Sebag-Montefiore 2012

First published in 2012 by Scala Publishers Ltd
Northburgh House · 10 Northburgh Street
London EC IV OAT · UK

www.scalapublishers.com

ISBN 978 1 85759 749 3

Edited by Oliver Craske
Designed and typeset in Fleischman by Dalrymple
Picture clearances: Nicole Harley
Proofreader: Julie Pickard
Index: Joan Dearnley

Printed in China

10 9 8 7 6 5 4 3 2 1

Frontispiece: Claude Lorrain, *Landscape with Hagar
and the Angel* (acquired by Sir George Beaumont, who
presented it to the National Gallery, London in 1828).

Endpapers: from *A Catalogue of the Collection of Pictures
&c. belonging to King James the Second; to which is added
a Catalogue of the Pictures and Drawings in the Closet of
the late Queen Caroline* by George Vertue and William
Chiffinch, London, 1758.

Contents

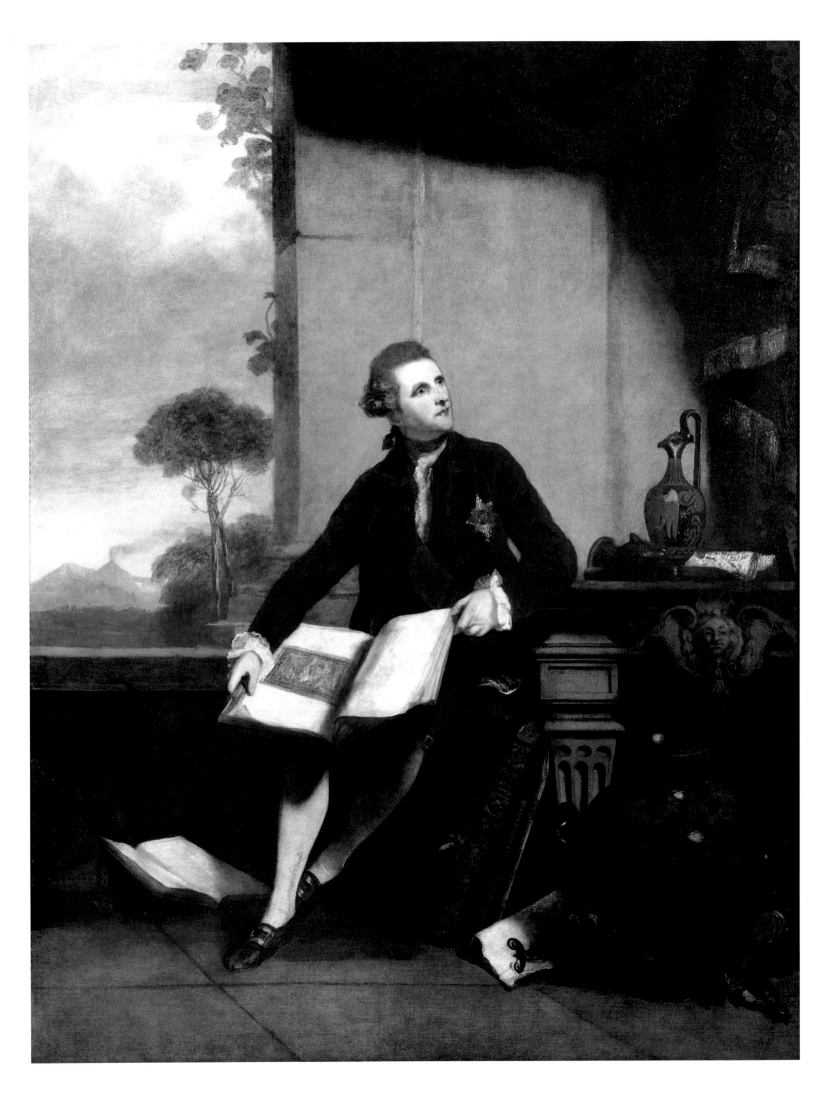

INTRODUCTION

This book is about people, but it is driven by the objects they collected. Although it is not a history of taste – that would be a far more ambitious undertaking – the book describes the fashions that absorbed collectors during the long period it covers. While this story is about private art collectors from the Tudors onwards, the trajectory moves towards a public purpose with the formation of major public institutions: the British Museum, the National Gallery and the Tate Gallery. To see the great art galleries, stately homes and museums up and down Britain is to witness the rich story of the British as collectors. The unfolding narrative inevitably mirrors the history of the country, the chronology of reigns and the punctuation of great events.

The book is divided into four sections:

Royalty: Collecting at Court
Aristocracy: The Country House Boom
Plutocracy: Metropolitan Apogée
Democracy: Collecting in the Museum Age

While these divisions are far from exact and have a whiff of the Whig interpretation of history about them, they conveniently express two of the underlying subtexts of the history of collecting: where the power lay and the movement of art from the private domain to the public. Until the Civil War, British monarchs projected their image and identity through art and patronage. As this function declined, the aristocracy embarked on the building of great country houses which have left such an indelible imprint across Britain. With the Industrial Revolution, new wealth brought forth new people into the collecting arena. Whether their money derived from canals in the north of England

British Collectors and Europe

British Collectors in Italy

The Preferences of British Collectors

Ambassadors, Dealers and Agents

Patronage versus Collecting

The Setting

Regional Tendencies

Politics and Faith

Accessibility of Collections

Collectors and Museums

The 19th and 20th Centuries

Literature

1 Sir Joshua Reynolds, detail from *Sir William Hamilton*
National Portrait Gallery, London (presented to the British Museum by the sitter in 1782)

or banking in the City, this new class of wealth manifested itself in great art collections that were more often than not in London. With the Reform Act of 1832, the powerful oligarchy of aristocrats that ruled Britain in the 18th century entered a slow decline. The 19th century was the age of the museum and its educative and civilising mission. The museum age did not dampen collecting but focused it, and collectors identified with the desirability of making art available to the public.

BRITISH COLLECTORS AND EUROPE

Rather than begin – say – in the 14th century with an account of church patronage, we start with the Tudors who harnessed the arts to the service of the crown. It was the period of the Italian Renaissance when England was waking up to new developments in the arts. This introduces a dominant theme of our story, England's (followed by Britain's) relationship to Europe. The majority of the chapters of this book before 1939 deal with European art, describing an intimate relationship between British collectors and Italy and France, and to a lesser extent Spain and the Netherlands. The British, insular in so many respects, were at their most Europhile through art collecting.

When in 1895 Camille Pissarro pondered why the Impressionists were taking so long to be 'understood in a country that had such fine painters', he concluded that 'England is always late and moves in leaps.'[1] How absolutely right he was. We observe the first leap with Henry VIII, through his tapestries and his patronage of Holbein. England then falls into a beautiful artistic coma until the great leap forward wrought by Charles I and his brilliant 17th-century contemporary collectors, the so-called Whitehall Circle. The Commonwealth winter that followed took decades to thaw. The Restoration spring was hardly a leap and it was only with the establishment of the Grand Tour in the early 18th century that Britain fully re-engaged once more with continental culture. By the mid-century Britain was calling the shots in Italy, and a major force in patronage of contemporary art, excavating the ancient Roman sites, and at home perfecting the country house environment that would be one of the country's most distinctive contributions to European culture. Sculpture and drawings apart, surprisingly little of the art that came to Britain during the earlier

18th century was of first importance. The Papal export laws saw to that. Even in the second half of the century several of the great works of art that did arrive, for example the Jenkins Venus and Poussin's *Seven Sacraments* (Rutland version), were exported by subterfuge.

British collectors remained at the forefront of European collecting despite the conflicts of the second half of the 18th century. In fact wars created opportunities for collectors and, as the dealer William Buchanan put it, 'in troubled waters we catch the most fish'.[2] It was thanks to Napoleon and the wars with Revolutionary France that British collectors enjoyed the great bonanza at the end of the century. Thus the perfect conditions for collecting in Britain appear to be peace at home and war abroad. The background of Charles I's reign was the Thirty Years' War, which made England seem like a haven of peace to Rubens but not sufficient to tempt many Italian artists to London. The Marlborough wars stimulated a second period of art collecting, and the close of the Seven Years' War and the Treaty of Paris (1763) were the catalyst for a period of country house rebuilding and collecting. Without question the most electrifying moment of all came with the French Revolution, which brought the Orléans, Calonne and other Continental collections to Britain. If turbulence abroad was a benefit, then at home the growth, continuity and survival of art collections in Britain were the consequence of political stability. The country has had no civil war since the 17th century.

With the collectors of the British school of painters in the 19th century a note of jingoism creeps in. When Elhanan Bicknell said he didn't 'give a damn' for Old Masters, he was expressing a nationalist attitude to Europe and a determined belief in the primacy of the home model. The rise of industrial wealth and the Empire accorded many Britons a feeling of superiority that insulated them from continental cultural influences. With the advent of Impressionism, the complacent British – along with most other Europeans – failed to understand the new art. As so often in British collecting, a small but brilliant minority pioneered the way. Hugh Lane, the Davies sisters, Samuel Courtauld and a group of Scottish collectors, supplied by the Glasgow dealer Alex Reid, collected Impressionist paintings against the grain of public opinion.

Although museums were by then well established, it was the collectors, often in spite of the museums, who changed attitudes, so that by the 1930s Britain could boast of three figures at the cutting edge of European collecting: Douglas Cooper, Roland Penrose and Edward James. Britain had leapt again. World War II broke Britain's collecting focus on Europe and it took a generation of collectors to refocus partially on America.

BRITISH COLLECTORS AND ITALY

If France offered British collectors a model of what was generally an advanced cultural programme, Italy was more consistently the object of fascination and emulation. Lord Lumley in Elizabethan

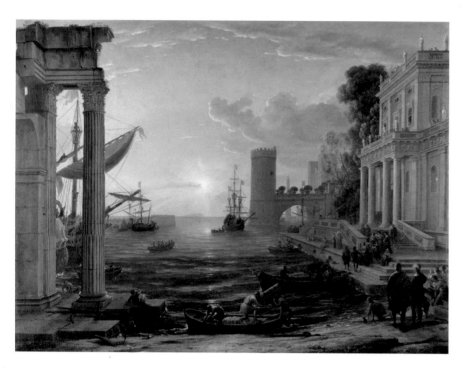

2 Claude Lorrain,
Seaport with the Embarkation of the Queen of Sheba
National Gallery, London (purchased with the Angerstein collection, 1824)

times loved Italy without ever going there. The Earl of Arundel made Italy central to his life. The British love affair with Italy was broadly based. The various states that occupied the Peninsula were of little political importance and would never be rivals to Great Britain. Rome, despite being the centre of Catholicism, exerted a strong fascination on Protestant Britons. The Italians were different in ways that the young Grand Tourists appreciated, their way of life presenting an invigorating contrast to home. Italy became a playground where the British elite could indulge in riotous living or serious study unencumbered by parental supervision. The collectors of the generation of the 17th-century Whitehall Circle were in thrall

to Venice and Venetian art, but it is doubtful if they identified with the Venetian Oligarchy. In the 18th-century Augustan age, Britons turned to ancient Rome. The Hanoverian kings formed an uninspiring model of statecraft compared to Cicero and what began as a literary cult turned to archaeology in the second half of the 18th century. The story of 'digging and dealing' in Rome can be regarded as a pragmatic solution to the want of collecting material. It brings sculpture – albeit ancient – into a story dominated by paintings. The aspirational aspects of collecting Roman – and later, Greek – marbles are underlined by their replacement in the Italianate pantheon of British collectors in the 19th century with early Florentine art. The intellectuals of the Victorian period, a more devout age, saw in the works of Botticelli and Fra Angelico not only the reflection of their religious piety but also a parallel between the heroic mercantile age of the Medici and their own. The spell of Italy continued to transfix Britons in the 20th century with scholar-collectors such as Sir Denis Mahon and Sir Brinsley Ford.

THE PREFERENCES OF BRITISH COLLECTORS

Reviewing the contents of this book, the reader might well ask which artists the British preferred to collect. Titian was the favourite of the Whitehall Circle in the first half of the 17th century and then again of the Orléans generation at the end of the 18th century, but that was partly a matter of supply. Collecting to a great extent depends upon availability and this has generally been underestimated in determining what the British have bought. This is especially true of one of the most enduring of all British tastes, the works of Claude Lorrain (fig. 2). His large output was exportable from Italy, while the works of Raphael were unavailable to the early generations of Grand Tourists. There is a pleasing circularity about the relationship between Claude and his English admirers (this applies less to Scotland) because his first works to arrive in England at the end of the 17th century influenced the development of English informal landscape gardens which in turn stimulated the appetite for more of his paintings. The taste for Nicolas Poussin, although never as popular as Claude, was nonetheless consistent and sustained as is witnessed by the very fine collection of his work in the National Gallery.

Two other artists whom, like Claude, the English have adopted as their own are Holbein and Van Dyck. Holbein was present at the birth of Elizabethan art collecting with Lord Lumley and he became the favourite of Lord Arundel. The artist has always retained his attraction for British collectors. Van Dyck, likewise, who portrayed the Whitehall Circle with such glamorous results (fig. 3), remained much sought after. Sir Robert Walpole owned some of his finest portraits and Sir Joshua Reynolds owned a considerable number of his paintings. On his deathbed Gainsborough famously remarked to Reynolds, 'we are all going to heaven and Van Dyck is of the company'. More improbably, amid the Japanese prints of the aesthetic movement, one of Ricketts and Shannon's most treasured acquisitions was the artist's *Portrait of Archbishop Laud*.

If collectors were consistent in their fondness for Holbein and Claude, then Titian and Rembrandt weave in and out of the story. With Italian art, tastes changed from generation to generation. From the Venetians favoured by Charles I, we turn to the late 17th and early 18th centuries. The generation of Sir Thomas Isham and Lord Exeter bought the works of Baroque Roman, Bolognese and Neapolitan artists, particularly favouring Maratta, Dolci and Giordano, Lord Exeter commissioning work from many living artists. The next generation of collectors, the Earls of Leicester and Burlington, acquired Domenichino and Annibale Carracci. These artists (and mention should be made of Sir Robert Walpole's great Guido Reni), however popular and expensive, were but a substitute for the unobtainable Raphael. To understand what collectors of this period most admired we must look at the copies they commissioned. In Isham's case it was Raphael, Reni, Domenichino and Guercino, while for Francis Dashwood it was Raphael and Reni. Maratta and Giordano declined in popularity as the century wore on but Reni, Domenichino and Annibale Carracci continued to be sought after until the time of Ruskin. During the 19th century as the *Seicento*[3] fashion faded, the star of Botticelli and the early Florentines grew ever brighter (see chapter 17).

Through the ages we discover individual collectors buying particular artists in quantity. Sir Robert Walpole had a room of Marattas at Houghton and later Lord Hertford had something of a fetish

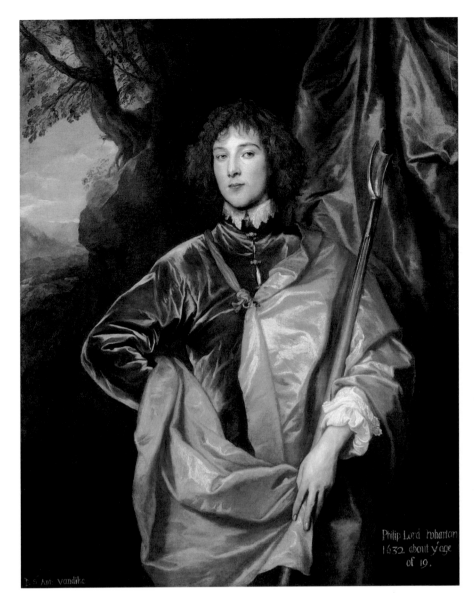

for the child portraits of Greuze, but there was one artist who consistently attracted collectors to commission or buy his work in large numbers – Canaletto. The vogue for view paintings, and his in particular, became as pervasive and enduring as that for Claude. Lord Carlisle and the Duke of Bedford bought them by the dozen, as did George III. The Canaletto Room at Woburn (fig. 5) and the Windsor Corridor lined with Consul Smith's collection both survive. There were several Canaletto Rooms created in England, not just at Woburn but also at Castle Howard and Langley Park. Claude too was given this accolade with a Landscape Room at Holkham (fig. 4).

Landscapes and portraits dominated British collections well into the 19th century. Those who bought works by Claude were also attracted to the works of Gaspard Dughet and Dutch Italianate painters. If France versus Italy has provided one

3 Sir Anthony van Dyck, *Philip, Lord Wharton*

Lords Wharton; Sir Robert Walpole; Catherine II, Empress of Russia; Andrew Mellon; now National Gallery of Art, Washington

of the binary divisions of British collecting, to most 18th- and 19th-century collectors it would have been a choice between Italian and Dutch paintings. Netherlandish artists had been coming to England since the 16th century to paint portraits and during the Restoration they provided court painters, including Sir Peter Lely. Dutch paintings, particularly landscapes, were never out of vogue and provided the mainstay of the art market. We observe their resurgence in the second half of the 18th century with collectors like Charles Jennens, Sir Lawrence Dundas and Lord Bute. The taste for Cuyp (fig. 6) has been attributed to Bute and the artist became a favourite of 19th-century connoisseurs despite the dislike of the artist voiced by John Ruskin in *Modern Painters*. But the Dutch painter

who dominates the story is Rembrandt, who forms a long and consistent, if slow-burning, theme of British collecting since the days of Charles I. The attitude of Victorian collectors to Rembrandt is referred to in chapter 20.

Was there anything that the British did not collect before the end of the 19th century? German painting with the exception of Holbein, Cranach and Elsheimer would be a candidate but perhaps the most surprising omission (bronzes apart) was Italian sculpture of the medieval and Renaissance periods, something that Sir John Charles Robinson of the Victoria and Albert Museum brilliantly rectified on behalf of the state. Perhaps the most complete omission was Spanish sculpture of the same period which not even Robinson bothered with much.

By the end of the 19th century the old canons of art were no longer applicable and the fragmentation of culture offered a far wider range of art for collectors, much of it non-European, African, Japanese, Chinese and Pacific. With the coming of Impressionism and modernism, it is harder to identify consistent preferences. Degas is a candidate; among the post-Impressionists, thanks to the influence of Roger Fry, Cézanne and Gauguin were favourites, but such tastes were confined to a very narrow cultural elite until the 1930s when they began to gain wider acceptance.

This book is heavily weighted towards paintings but this is inevitable given the interest and copious literature that they attract. The collector Robert Benson described them as 'the big game of collecting' and they have always commanded the economic high ground. Ideally we would have given space to a greater number of specialist collectors. For instance in the field of drawings while we mention Lord Arundel, Sir Peter Lely, Lord Burlington, William Talman, the 2nd Duke of Devonshire, William Young Ottley, Richard Payne Knight, Sir Thomas Lawrence, Henry Oppenheimer and Paul Oppé, there is no space for Henry Reveley,[4] John Malcolm of Poltalloch (whose collection is in the British Museum) or John Postle Heseltine.

The drawings collectors remind us of one of the richest seams of British collecting, that of artist-collectors. Van Dyck had important paintings including major works by Titian, but it is with Sir Peter Lely's collection of drawings that the

4 The Landscape Room at Holkham Hall, Norfolk

5 The Canaletto Room at Woburn Abbey, Bedfordshire

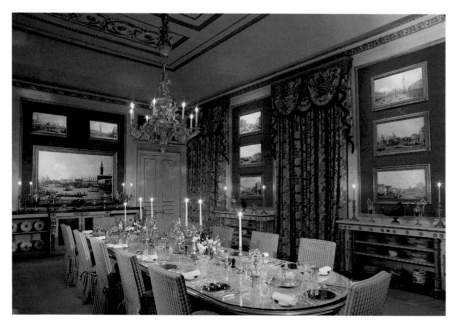

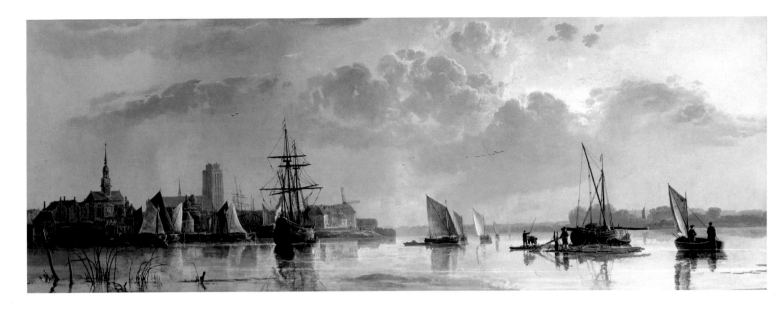

seam fully opens. It was a natural field for artists and had perhaps been invented by them, for Vasari was already a great collector of drawings in 16th-century Italy. Prosper Henry Lankrink, the Jonathan Richardsons, Thomas Hudson, Reynolds and above all Lawrence were to assemble pre-eminent drawing collections. Other artists who formed important collections included Arthur Pond, Sir James Thornhill, Ricketts and Shannon, Fairfax Murray, Jacob Epstein and Henry Moore. Reynolds also had a vast paintings collection and was not above acting as a dealer. This was common practice in the 18th century when the majority of the agents in Italy selling marbles and paintings to Grand Tourists were artists. Some were lapsed painters, while others practised successfully alongside their dealing career. Lord Spencer found it expedient to commission a painting from Gavin Hamilton in order to gain access to his clients' Old Master pictures.

AMBASSADORS, DEALERS AND AGENTS

The role of the ambassador, dealer-adviser and agent is one of the most enduring themes of art collecting in all times and in all places. In the 16th century, ambassadors played a major role in securing diplomatic gifts or notifying King Charles I and his circle about possible or forthcoming sales of pictures or collections. The degree to which the artist, Sir Thomas Lawrence, formed the Angerstein collection or the dealer Agnew influenced the Iveagh collection will always be debated but their main role was to supply. When somebody asked Paul Mellon why his father relied

so much on Joseph Duveen, he answered, 'He had the goods'. In the 17th century it was the agents like William Petty and Daniel Nys who supplied the goods. They were a mixture of scholar-antiquarians, wheeler-dealers and unsuccessful artists. With the Restoration and the coming of auctions to London a more regular source was established but it relied on a very rudimentary connoisseurship. The Grand Tour era (fig. 8) was the great age of the agent – usually acting between clients rather than as a principal – notably Thomas Jenkins and Gavin Hamilton whose activities are covered in chapters 9 and 11 (fig. 7). In the second half of the 18th century, the auctioneers, above all James Christie, dominated the London art market, particularly for deceased estate sales. The dealers' era commenced at the end of the century with the dispersals precipitated by the Napoleonic Wars when tourists were no longer on site in Italy and cash was needed to remove treasures. The story of the activities of the dealer William Buchanan and his cohorts is one of the most compelling in the history of British art dealing.

If the collections of Antiquity in chapter 11 were largely formed through dealers and agents, for the champions of the British school in chapter 14 the supply came from the new showcases of British art, the Royal Academy and the British Institution. If you failed to buy a Turner at the Royal Academy you had to wait until the Gillott or Munro sales and pay a huge price. Agnew's were supplying modern British paintings from 1817 in their Manchester showroom to the new industrial collectors and from 1860 in London. Notwithstanding

6 Aelbert Cuyp, *Dordrecht on the Maas*
Robert Stayner Holford; Anthony de Rothschild; now Ascott (National Trust)

7 Anton von Maron, *Portrait of Thomas Jenkins*
Accademia Nazionale di San Luca, Rome

8 English School (formerly attributed to Nathaniel Dance and James Russel), *British Gentlemen in Rome*
Paul Mellon collection; now Yale Center for British Art, New Haven

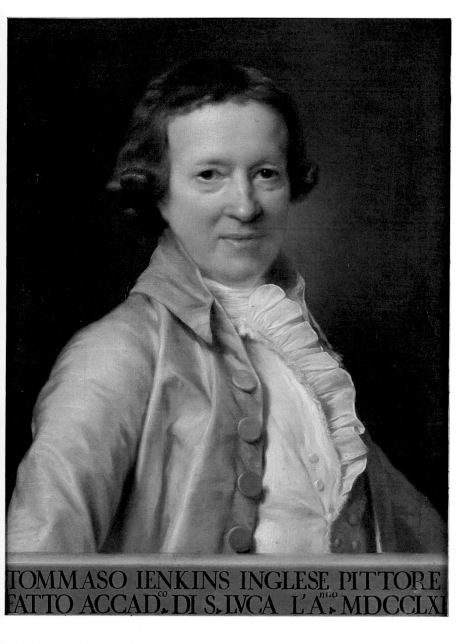

TOMMASO IENKINS INGLESE PITTORE
FATTO ACCAD.co DI S. LVCA L'Anno MDCCLXI

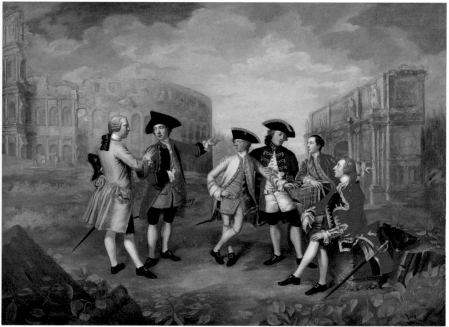

the great auction sales in the 1880s of the Hamilton Palace collection and the Blenheim Palace paintings (which signalled the beginning of the end of the British domination of the art market), the end of the century was a period of great *avant-garde* dealers, the Grosvenor Gallery and the Leicester Galleries, both of which had a profound influence on taste. They heralded the arrival of modernism in London.

The distinction between dealer and collector has rarely been exact. When George III remarked that all his noblemen were now picture dealers he was expressing a truth that in the 18th century art was a speculative venture. In the 19th century even a collector as rich as Sir Thomas Baring was unable to resist selling his Raphael for a handsome profit shortly after he bought it. At the end of the century Herbert Horne stands as an interesting example of the fluidity between collecting, dealing and scholarship. Horne's finances were limited and he traded paintings to help form his remarkable collection of early Italian art at the Palazzo Horne in Florence. Most ethnographical collectors in the 20th century, like James Hooper, traded to supplement their day job income. The post-war era saw the rise of the dealer-collector and several are described in chapters 24 and 25. More ambiguous is the position of Charles Saatchi who sells each exhibition in order to pay for the next.

PATRONAGE VERSUS COLLECTING

Patronage and collecting form a symbiotic relationship. The distinction between what is available on the market and what is created specially for a client applies to all levels of collectors from plutocrats with highly specific demands to the simple squire persuaded by an itinerant artist to have his house or dogs painted. In Tudor times the distinction between patronage and collecting was seldom important. With the advent of informed art collecting in the 17th century the matter comes into focus. Charles I collected Titian but patronised Rubens and Van Dyck, for which we give him perhaps greater credit. We measure the Caroline court by the artists it attracted or failed to attract to London. English patronage of the 17th and 18th centuries tended towards portraits and decorative schemes. With the Restoration, veritable armies of versatile Dutch artists undertook the lesser jobs, for instance the overdoors and overmantels at Ham

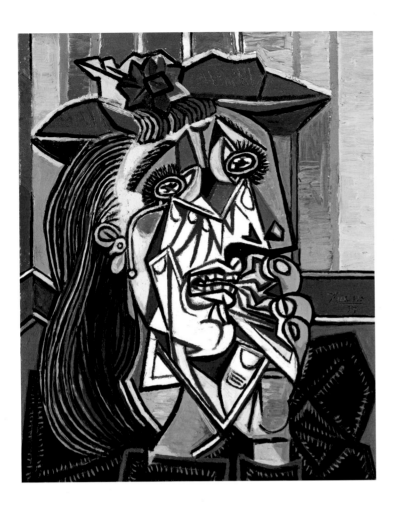

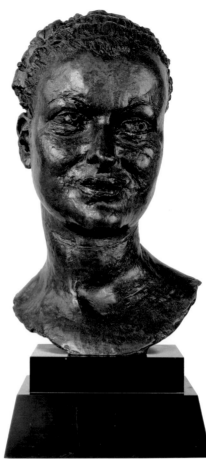

House, while the big staircase mural jobs went to the grander French and Italian artists: Cheron, Laguerre, Pellegrini and Verrio. Commissions to Thornhill meant that Continental artists did not exercise a complete monopoly.

With the coming of the Grand Tour, there was an initial mismatch in Italy between the patrons and the artists. The English travellers wanted portraits, which the painters such as Carlo Maratta executed with reluctance. It is worth remembering that at the turn of the 18th century in Italy the Germans were an equally attractive prospect to the local artists, and, although Sebastiano Ricci came to London, in the following generation Tiepolo went to Würzburg, not Windsor. Solimena found more German patrons than English. The next generation of visitors had no such difficulty and a perfectly adapted Grand Tour art was available in the form of commemorative portraits by Batoni, *vedute* by Canaletto, or by copying what was unavailable such as the compositions of Raphael or versions of antique marbles.

Since the days of Holbein, portraits provided the bedrock of British collecting and they form the most continuous story of patronage: Van Dyck,

Lely, Kneller, Gainsborough, Reynolds, Lawrence, Watts down to Sargent. One of the most pluto-cratic of all tastes was the collecting passion for the grand 18th-century portraits of Reynolds (fig. 1) and Gainsborough that swept Britain and then America at the end of the 19th century and lasted until the 1920s. The patronage and commissioning of portraits continued into the 20th century but the results increasingly lacked aesthetic conviction. The most successful portraits of the last century were chosen by the artist to paint. Whether in Britain or abroad, great portraiture had become a private medium of artists. Roland Penrose was fortunate to acquire one of Picasso's best portrayals of Dora Maar in *The Weeping Woman* (fig. 9). The point is well made by the salutary story of Bob Sainsbury and Jacob Epstein. The sculptor made a portrait of Lisa Sainsbury (fig. 10), and when Bob remarked that it was a good likeness Epstein snorted, 'Posterity won't be interested in whether it is a good or bad likeness: the question will be, is it a good Epstein?'.

Interior décor forms another important aspect of patronage. The decorative schemes of Robert Adam and the rooms furnished by

Thomas Chippendale or Ince and Mayhew have survived long after the sale of the Rembrandts which hung there. It is arguable that the products of patronage have fared far better than those of collecting in English country houses. Family connections ensured that portraits, furniture and other objects designed for the house were kept, while the Old Masters were often the first to be sold. Browsholme Hall in Lancashire still contains its commissioned portraits by Northcote and furniture by Gillow, but its Old Masters went in 1808 (fig. 11).

Patronage came into its own with the champions of the British School (chapter 14). The grievance of William Hogarth over the neglect of native artists was eventually answered in 1768 by the foundation of the Royal Academy and the British Institution in 1805. They precipitated a century of sustained patronage of British painters and sculptors which encompassed some of the finest works of Turner, and later the painters of the Pre-Raphaelite Brotherhood. Apart from native art, the record of patronage of first-rate European art, although inconsistent, has some notable achievements: the Rubens Banqueting House ceiling, the portraits of Van Dyck, Sebastiano Ricci's work at Burlington House, David's *Portrait of Napoleon* and important works by Canova including *The Three Graces*.

THE SETTING

It was Mark Girouard who pointed out that the main theme in British patronage was architecture.[5] Collectors may have paid for excavations in Italy, commissioned cabinets and portraits and winkled treasures out of Egypt, but their primary concern was the setting. From the great Elizabethan prodigy houses, through the baroque palaces of Vanbrugh and the Neo-classical suites of Adam to the baronial halls of Salvin – not forgetting the London palazzos by Barry and Vulliamy – the house has been the main expenditure. It often also provided the main motivation for collecting. It is impossible to overemphasise the connection between architecture and collecting particularly in the 18th century with its belief in the 'genius of the place'.

From the days of Cardinal Wolsey the long gallery became central to grand houses and within a century the gallery had become the principal viewing place of art. Charles I placed his Titian *Emperors* in the gallery of St James's Palace and ordered his own equestrian portrait from Van Dyck to form a *trompe l'oeil* at one end. It is with the building of Holkham Hall that we have the purest example of a house created for an art collection and an art collection formed to fill a house. The two are indivisible. This unitary approach is exemplified

11 The Dining Room at Browsholme Hall, Lancashire, showing the collection of works by British artists

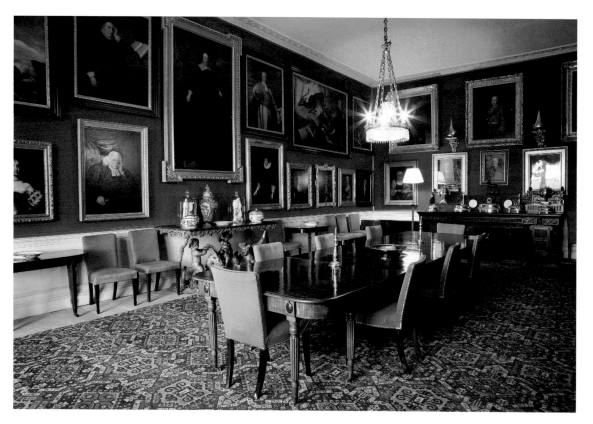

by the Holkham sculpture gallery for which Lord Leicester in his second campaign of buying was concerned to fill specific niches. The Gallery continued to develop and Robert Adam created one of the most attractive at Newby Hall. The final manifestation was the 19th-century picture gallery, of which there are so many instances both in London and the country. Buckingham Palace, Bridgewater House and Hertford House are famous London galleries, while in the country Petworth and Tabley provide good examples (figs 12–14).

The importance of place brings into focus the question of town versus country, a constant tension of British collecting. It was with the dissolution of the monasteries in the 16th century that estates enlarged and rural kingdoms were created but it was not until the reign of Queen Elizabeth that the first country house boom occurred. The great new prodigy houses needed to be filled and Hardwick Hall survives to show us how. The Elizabethan courtier, Lord Leicester, kept his best paintings in London and only a group of portraits at Kenilworth. During James I's reign, Lord Lumley's inventory informs us that he kept the majority of his art at Lumley Castle; however, as a Catholic, unwelcome at court, he was not typical. With the reign of Charles I, the pendulum swings firmly in favour of London and the stretch of the Thames between Whitehall and the City, where the palaces of the King, the Duke of Buckingham and the Earl of Arundel were located. During the Restoration, London still harboured the lion's share of art with Montagu House and Clarendon House, although Ham, on the city's fringes, as well as Dyrham and Althorp, suggest a movement towards the country.

In the first half of the 18th century the subject becomes more complex. It was the time of the second country house boom, the era of Vanbrugh and Kent when great show houses arose on the Yorkshire hills and over the Norfolk flats. This created a dilemma for collectors. The distinction that emerges is that most Grand Tour collections went to fill the newly created country houses. London collections, on the other hand, like those of Richard Mead and Charles Jennens, were more often sourced from the metropolitan art market. The Duke of Marlborough and Sir Robert Walpole were both active collectors from the local market who kept their art in London until their great country houses were ready to receive it, in both

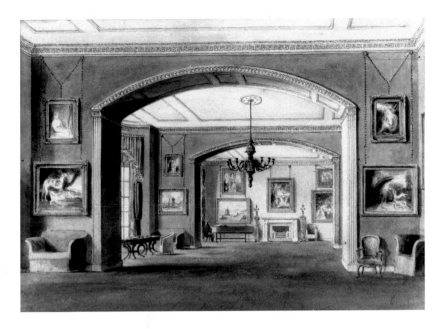

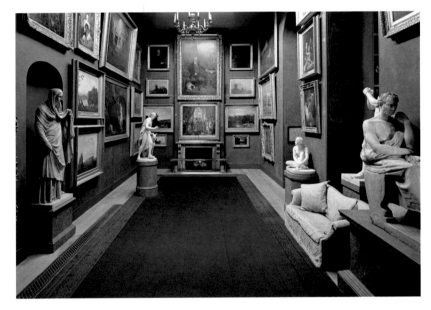

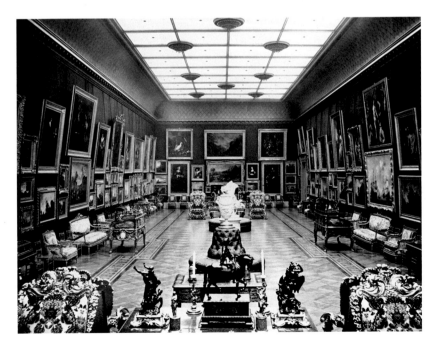

cases towards the end of their lives.

Three parliamentary terms each year brought aristocrats to London and released them to the country during the long recesses. During the second half of the 18th century numerous country houses were built or rebuilt, so that quantitatively more art went to the country, but the most spectacular art collections were in London at Devonshire House, Spencer House, Lansdowne House and Charles Townley's house in Westminster. The Devonshires were one family with a princely seat, Chatsworth in Derbyshire, who preferred to keep their main treasures in or near London at Devonshire House, Piccadilly or at Chiswick. As late as 1816, Dr Spiker could pass Chatsworth, praise its position and architecture but add, 'We did not view the interior

of huge London houses ceased to be financially viable, which accelerated the gradual flight of art collections from London to the country. This never happened in France where a metropolitan culture preferred to keep state in Paris. The difference was partly cultural but also economic. The country house was a self-sufficient unit with plenty of space where art collections could remain undisturbed for centuries until the effects of the death duties introduced in 1894 were felt. Before the advent of public museums such houses provided the perfect vehicle for the survival of art collections. Some like Hatfield and Chatsworth, supported by impregnable wealth, have survived with their collections virtually intact. This also reflects a strict application of primogeniture.

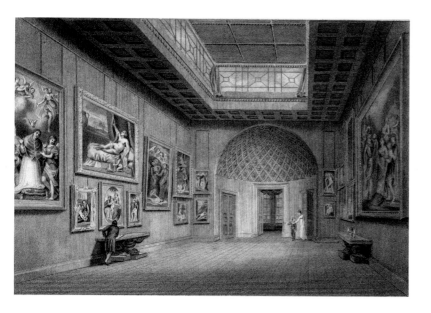

of the house which is said to contain nothing remarkable.'6 He was misinformed, for while the best paintings were at Devonshire House and Chiswick House, the great drawings collection of the 2nd Duke and Lord Burlington had already been transferred along with much of the library.

The arrival of the Orléans collection in London during the 1790s tipped the balance decisively in favour of the capital. The creation of the Cleveland House Gallery (fig. 15), which later mutated into Bridgewater House, together with the collections of de Tabley, Angerstein, Peel and Holford, provided London with a dazzling clutch of great collections. These shone serenely through the 19th century, but social and economic changes after the First World War meant that the upkeep

The gradual abandonment of the great London houses precipitated a consolidation of family collections in the country. Several more would be created in London after the 1880s, notably those of Lord Iveagh and the South African Randlords, but the aristocracy was already in slow decline. The demolition of Devonshire House in 1924 and the transfer of its contents to Chatsworth proved a watershed (fig. 16). The destruction of huge numbers of country houses in the 20th century brought to the market many overlooked pictures and works of art: new country house collections continued to be formed throughout the 20th century but, save for the Old Masters at Harewood, they do not compare with those of previous centuries. The collections of historical portraits at Parham, sporting

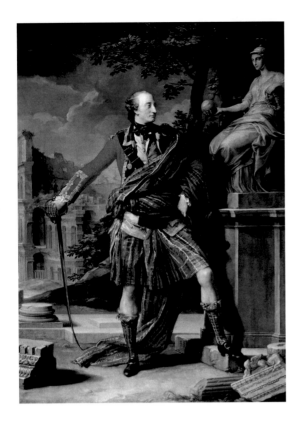

art at Lavington Park and baroque paintings at Basildon Park are examples.

REGIONAL TENDENCIES

Were there regional tendencies in British art collecting? We have not given separate chapters to Scots and Irish collecting because by and large these also followed metropolitan tastes until the late 19th century. The Scots first appear in this story with the arrival of James I and the Stuart dynasty in London in 1603. There were several Scots collectors in the Whitehall Circle of Charles I, notably Lord Ancram who brought the first Rembrandt to London, and the 1st Duke of Hamilton. During the 18th century, Scotsmen played an important role as agents, as described in chapters 9 and 11. We lack the space to describe the patronage and collecting of Sir John Clerk of Penicuik and Lord Annandale. Colonel William Gordon sat for Batoni's most memorable portrait (fig. 17) and the 10th Duke of Hamilton assembled a mighty Francophile collection north of the border, but it is with the coming of the Impressionists to Britain that Scots collectors left their English contemporaries standing with such brilliant figures as Alexander Reid, James Duncan, William McInnes, William Boyd and Sir Alexander Maitland.

Irish collecting came of age with the Grand Tour. The Earls of Charlemont and Milltown were among Batoni's earliest British patrons and Lords Bessborough and Farnham and the Cobbes at Newbridge were intelligent and interesting collectors.[7] The Irish mounted their own national art exhibition in 1853 (four years before the Manchester Exhibition), which took place on Leinster Lawn and included 328 Old Masters out of a total of 1,023 paintings. By the time Irish collectors formed a distinct identity their country was on the road to independence and no longer a part of this story, except for the towering figure of Hugh Lane, whose interests straddle the divide (fig. 18).

Welsh collecting comes into its own in the 18th century with Sir Watkin Williams Wynn, 4th Bt. (1749–1789). He went on an extravagant Grand Tour, commissioning portraits from both Mengs and Batoni, but his greatest act of patronage came on his return home. His London house at 20 St James's Square was designed by Adam

17 Pompeo Batoni,
Portrait of Col. William Gordon
Fyvie Castle, Aberdeenshire
(National Trust for Scotland)

18 Antonio Mancini,
Portrait of Sir Hugh Lane
Dublin City Gallery,
The Hugh Lane

19 Thomas Heming,
Silver gilt punch bowl
designed by Robert Adam
Sir Watkin Williams Wynn; now
National Museum of Wales, Cardiff

20 Anglo-Dutch school view
of Burton Constable
Burton Constable Foundation

21 Andrea Soldi,
The Duncombe Family
Duncombe Park, North Yorkshire

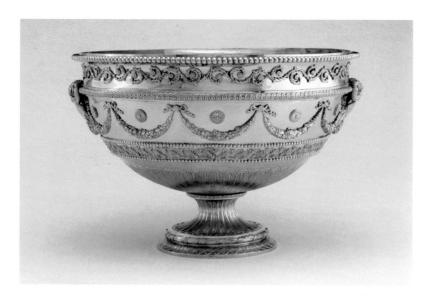

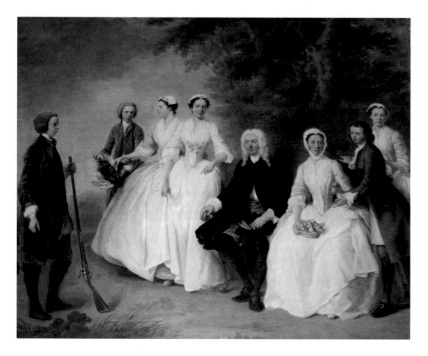

who was also responsible for the carpets, grates, furniture and a lavish suite of silver (fig. 19). He also commissioned landscapes by Richard Wilson. Nineteenth-century Wales produced two distinguished collectors, Thomas Mansel Talbot of Margam Castle and Lord Penrhyn, but the crowning achievement of Welsh collecting came in the 20th century with the Davies sisters.

It is worth briefly examining two counties of England to see how their regional identity illuminates this subject. Yorkshire, England's largest county, has a distinct history of patronage rather than collecting.[8] It has furnished its share of illustrious national collectors, including Lord Rockingham, the Earls of Carlisle, William Weddell, Walter Fawkes, Herbert Read and Michael Sadler, but it is only on descending into manorial houses that one becomes aware of the works of the Dutch artists who poured into Hull to provide portraits of houses, sporting art and all the preoccupations of a local gentry (fig. 20). Grander foreign artists like Andrea Soldi (fig. 21) and Philippe Mercier could sustain practices in Yorkshire and their portraits still decorate many Yorkshire houses. For every peer who went on the Grand Tour there were twenty members of the gentry who had themselves painted with a gun and dog by whomever they could afford.

In Norfolk collecting attained its zenith in the early 18th century when many neighbours went on the Grand Tour including members of the Windham family of Felbrigg, the Walpoles of Wolterton, the Cokes of Holkham and Sir Andrew Fountaine of Narford. There is no question of the influence and stimulation that they exercised upon one another. In the next generation Norfolk produced an extraordinary group of merchant collectors in Great Yarmouth. It is doubtful if any other British town of its size produced such a group of distinguished collectors as the Rev. John Homfray, Thomas Penrice and Dawson Turner. They all collected Dutch paintings, but Dawson Turner's sitting room was dominated by Giovanni Bellini's *Madonna and Child Enthroned with Two Saints and a Donor* (Birmingham; fig. 22). They also influenced and patronised the local 19th-century Norwich school of painters. Dawson Turner engaged both John Sell Cotman and John Crome as drawing masters for his family and owned many of the latter's works. Much of the richness of

British collecting comes from the flavour of local patronage which lies mostly outside the scope of this book.[9]

POLITICS AND FAITH

Given the political divisions of British life between Whigs and Tories, Catholics and Protestants, did these divisions have any bearing on the way people collected? During the 18th century the Whigs had more money but the Tories had more time. A Tory such as Lord Exeter could make three extended tours of Italy without the cares of office. The Whig peers, typically Lords Rockingham and Shelburne, were vastly richer than most Tories. The distinction is obscured by the revelation that Lord Burlington, previously regarded as a staunch Whig, may have been a closet Jacobite and Tory. In Derbyshire, the Tory Curzon family tried to emulate the Whig Cavendish family. They built what could be taken as a Whig house, Kedleston Hall, and filled it with Adam furnishings and Italian and Dutch paintings, but the expense almost ruined them. Wealth apart, political divisions in collecting are barely discernible and while many in office like Sir Robert Walpole and Sir Robert Peel assembled great collections, others, like William Beckford, opted out of politics in order to devote a lifetime to its pursuit.

Divisions of faith are equally hard to discern. A Catholic like Lord Lumley owned portraits of two Jesuit saints, and Lady Arundel shared a liking for devotional paintings, as did her husband, whose religious beliefs were more ambiguous. The Grand Tour commissions of the 5th Earl of Exeter for religious paintings from Carlo Dolci seem to belie his Protestant faith. English Catholic families were largely educated abroad and had a natural sympathy for Continental culture but most were not financially in a position to collect art until the relaxation of the penal fines in the mid-18th century. At this point we find two major Catholic collectors, Charles Townley and Henry Blundell, collecting Roman antiquities. Since most British Catholics before Emancipation in 1829 adopted a 'Cisalpine'[10] attitude of discretion and non-confrontation, they were unlikely to have a specific collecting agenda beyond the furnishing of their chapels which provide an important and separate area of study.

While it is generally believed that collecting

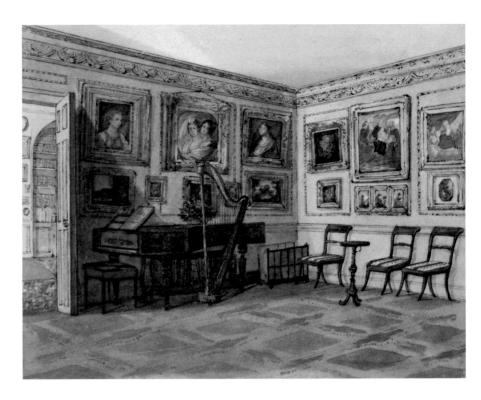

among the Jewish community began in the 19th century, there were exceptions. In London we have the example of Sampson Gideon (1699–1762), known as 'the great oracle'. Gideon advised Walpole on the National Debt and was a successful stockbroker. His collection consisted of a not unusual mixture of Rubens, Murillo and Rembrandt. The series of *Jacob and his Twelve Sons* by Zurbarán and his studio were owned by James Mendez in 1726 and acquired in his posthumous sale in 1756 by the Bishop of Durham. But it is with Ralph Bernal (1786–1854), a Jewish convert to Christianity, that we see a new level of specialist and discerning collecting that anticipated the Rothschilds. If Bernal showed a scholarly discernment, the Rothschilds combined this to an extraordinary degree with the epicurean. The Rothschilds, the most brilliant international collecting family of the 19th century, showed that art collecting could be a passport to assimilation and could also provide a metaphor for spiritual improvement, the traditional aims of Torah and Talmud studies. In the early 20th century the two most compelling collectors of chapter 23, Percival David and Jacob Epstein, demonstrate that thirst for knowledge, questioning and refusal to accept received opinion which is such a feature of Jewish theological debate.

Kenneth Clark made an interesting observation about Jewish collectors in his autobiography:

22 The Drawing Room of Dawson Turner's house in Great Yarmouth; Giovanni Bellini's *Madonna and Child Enthroned with Two Saints and a Donor* hangs at the centre of the wall on the right. Subsequently Lord Ashburnham; Vernon Watney collection; now Birmingham Museum and Art Gallery

'The great collections were not formed by bargain-hunters. In our youth, it was customary for Christian collectors to boast of how little they had paid for their prizes. "Picked it up for a few coppers" was the usual phrase. Jewish collectors on the other hand, were proud to tell one what sacrifices they had made to obtain their treasures... There can be no doubt which of these two standpoints denotes the greater love of art.'[11]

One of the striking features of British collecting is its clubbability. A strong influence was exercised by the Society of Dilettanti from the 1730s, the British Institution from 1805 to 1867 (less a club than an exhibition facility, which gave prizes to young artists), the Burlington Fine Arts Club in the 19th century, and the Oriental Ceramic Society, the Contemporary Arts Society, and the Institute of Contemporary Arts in the 20th century. These groups further stimulated collectors through the books they published, the exhibitions they mounted and the competitive pressure they generated towards the improvement of quality.

If we were writing a history of American collecting, a major ingredient would be formed by a series of remarkable women. In the history of British collecting, they are – as Lord Essex described the Earl of Arundel – like winter pears. The ones that do come into view are formidable: Bess of Hardwick, the Countess of Arundel, the Duchess of Portland, Lady Charlotte Schreiber, Baroness Burdett-Coutts, the Davies sisters, Queen Mary, Lady Ottoline Morrell, Elizabeth Workman, Gabrielle Keiller and Janet de Botton. Before the 20th century female collectors in Britain were extremely rare.

The influence of collectors on the creative process (before and after the age of museums) is difficult to assess but occasionally a letter or direct borrowing highlights how important private collections could be to artists. Van Dyck followed Sebastiano del Piombo's *Portrait of Ferry Carondolet* (then owned by Lord Arundel) when he painted Lord Strafford and his secretary, and it resonates later in Reynolds's unfinished portrait of *Lord Rockingham and Burke* and again in Lawrence's *Portrait of Thomas Baring and his business associates*. The influence of Claude on the British landscape school is well documented and collectors often sought to influence young artists to paint like their favourite Old Master. Beaumont's attempts to make Turner imitate Claude and Payne Knight's desire to make Mortimer emulate Salvator Rosa come to mind. The influence of Norfolk collections of Dutch paintings on the Norwich School has already been mentioned.

The Pre-Raphaelite Movement embodied the revival of early Italian art initiated by collectors; similarly the 19th-century artistic interest in Spain followed a generation behind collectors. Later, the Scots collectors of Whistler and Manet influenced Cadell, Peploe and Fergusson. Many Scots, such as the Cargills, collected the native moderns alongside the Impressionists. A similar circularity is evident with Charles Saatchi whose Boundary Road shows of American artists influenced the Brit Pack generation which he later acquired.

ACCESSIBILITY OF COLLECTIONS

The influence of art collections depends upon their availability to the public. Most collections in Britain were accessible to gentlemen and connoisseurs from the 17th century. Collectors, despite an undeserved recent reputation for solitary hoarding (the 4th Marquess of Hertford was a notorious example) generally enjoy showing their treasures. As early as 1637 Lord Arundel (fig. 23) gave a party for artists and *cognoscenti* to celebrate the opening of his drawings cabinet at Arundel House. *The Journeys of Celia Fiennes 1682–1712* reveals how normal it was for the aristocracy and gentry to open their houses to strangers whether they were at home or not. Perhaps the clearest clue to the popularity of visiting country houses is the growth of the guide book: Wilton in 1731, Stowe in 1744 (gardens only), Houghton in 1747 and Strawberry Hill in 1774. John Harris estimates that from 1740 to 1800 an average of 15 guidebooks a decade were published, rising to 30 in the early decades of the 19th century and sharply tailing off from the 1840s with the increasing popularity of travel and the growth of public museums. As the coming of the railways multiplied the travelling public, owners became more reluctant to open their houses on a regular basis, but this was balanced by lending to the ever more frequent public exhibitions.

Foreigners were dismayed by the exodus of art to country houses. In 1796 Quatremère de Quincy wrote in his *Lettres*, 'I can think of nothing less useful for Europe, or even for the arts of England

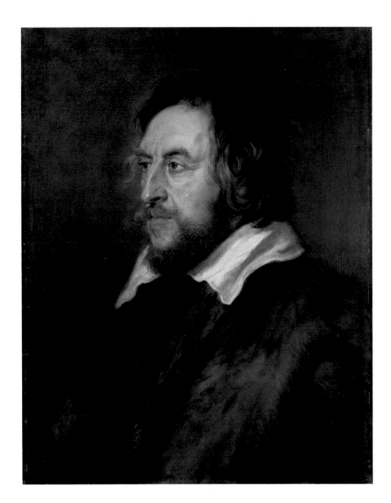

itself".[12] Théophile Thoré-Bürger went even further in 1860 when he remarked that when a work of art went to the country 'it never leaves; it is condemned to perpetual incarceration; one never sees it again in circulation, and one finishes by not knowing if it exists'.[13] However, in most cases a tip to the housekeeper would have secured these gentlemen entry.

London presented different problems of space and circulation. The Italian and French portion of the Orléans collection was exhibited to the public at Michael Bryan's gallery and the Lyceum in 1798/99, with a great effect on visitors. Thomas Hope opened the gallery at his house in Duchess Street in 1804, and Lord Stafford opened the Stafford House gallery in 1806 on Wednesday afternoons in the summer. The importance attached to sharing art with the public was demonstrated by the Manchester Art Treasures Exhibition of 1857, an encyclopaedic display of over 2,000 paintings, not to mention sculpture and decorative arts. It attracted 1.5 million visitors. The Manchester *Guardian* praised the generosity of the lenders but criticised (among others) the Earl of Radnor for the absence of loans from Longford

Castle.[14] By now art was increasingly recognised as an arm of education, not just for the benefit of artists but also for the general public.

COLLECTORS AND MUSEUMS

From the days of the establishment of the British Institution in 1805, collectors had recognised the need to share their collections with the public and many of the supporters of those exhibitions were also advocates of the foundation of the National Gallery in 1824. The relationship between private collectors and public museums was expressed through gifts, bequests, serving as trustees, and the stimulating friendships between collectors and keepers. The slow transition from art as a purely private pleasure to a public resource emerges across several chapters of this book. By the turn of the 19th and 20th centuries, public benefaction was a major motivation of George Salting, Ludwig Mond, Lord Leverhulme, William Burrell, Hugh Lane, the Davies sisters and Samuel Courtauld. In America the attitude would later be described as 'repentant capitalism', but its roots go back to the 17th century.

When Elias Ashmole (fig. 24) died in 1692 his

tomb was inscribed in Latin: 'While the Ashmolean Museum at Oxford endures, he will never die.'[15] Today the longevity of Ashmole's name reflects his shrewdness in linking the immortality of art with the longevity of an institution like Oxford University but also his far-sighted statutes and rules defining the museum's didactic purpose. The opening of the Ashmolean was a transformative event for English intellectual life and represents the extension of learning beyond libraries and books. Ashmole had turned John Tradescant's museum of curiosities in Lambeth into a public institution with a high-minded pedagogical purpose. It did not contain art in the modern sense, but its foundation surely influenced Sir Hans Sloane when he drew up his will a generation later. The three collections that formed the foundation of the British Museum – Sloane's collection of natural history and man-made curiosities, the library of Sir Robert Bruce Cotton and the library and manuscripts of the Earl of Oxford – defined the trajectory of the museum. Its natural history collections would be siphoned off in 1881 and those of the British Library in 1998. The collecting of art and antiquities from beyond Europe would be largely dominated by collectors with a close connection to the British Museum.

Ashmole had no children, and in a dynastically minded age a museum offered an alternative route to immortality. Their childlessness may have influenced the founders of Dulwich Picture Gallery and

the Fitzwilliam Museum (fig. 25), but not that of the Soane Museum. Sir John Soane's house-cum-museum was founded by Act of Parliament in 1833, independently of an educational institution. Soane (who had fallen out with his children) had little dynastic sentiment and his museum is an early case of public purpose overriding family interests. As the century wore on connoisseurs were increasingly motivated by the public role of their collections. On 24 July 1907 Sir Carl Meyer wrote to his wife that Ludwig Mond had offered his collection to the National Gallery if they built a room for it and added 'it seems curious when he has two sons. Does he want a peerage?'[16]

The 19th century saw the heyday for the creation of museums. Through them collectors found a new purpose and a source of knowledge. The beneficial effect of this close relationship is particularly striking in the case of Sir Augustus Wollaston Franks of the British Museum and the likes of Lady Charlotte Schreiber and George Salting. Franks encouraged a generation of specialist collectors many of whom left their treasures to the museum. The same was true of R.L. Hobson and other collectors of Chinese porcelain. The museums may have also unconsciously encouraged the move towards the 'masterpiece' collection and those great 'blockbusters' at the end of the century, the Cook, Mond and Iveagh collections. This was the approach that would be adopted by the American millionaires. Bernard Berenson assured Isabella Stewart Gardner that if she made him her main adviser it would 'not be many years before you possess a collection, almost unrivalled, of masterpieces and masterpieces only'.[17] The impact of museums, the development of art history and the rise of the specialist adviser were all factors in this development.

THE 19TH AND 20TH CENTURIES

Collecting in the 19th century spans several chapters of this book. The subject cannot be easily encapsulated. The Grand Tour came to an abrupt end with the Napoleonic Wars and the world was rapidly changing. New collectors with an industrial background favoured the British school, intellectuals were enamoured with *Quattrocento* Florentine art, explorers and missionaries brought back tribal artefacts, and 'China mania' possessed devotees of the Aesthetic movement, while others

were discovering the Barbizon school. However, the wealth and confidence of Victorian collectors is best expressed by their formidable collections of Old Master paintings.

During the course of the century, auction sales of individual pictures or of entire collections took place which offered rich opportunities to new or younger collectors. To name but three, William Beckford's Fonthill was sold up in 1823, George Watson Taylor's Erlestoke Park in 1832 and the Duke of Buckingham's bankruptcy led to the sale of the contents of Stowe in 1848. This last sale brought high prices. Henry Farrer (dealer) paid 1,000 guineas for Salvator Rosa's *Finding of* Moses (Detroit); T.B. Brown (dealer), 1,470 guineas for Cuyp's *St Philip Baptising the Eunuch* (Anglesey); whereas the exceedingly rich 4th Lord Hertford won *The Unmerciful Servant*, then thought to be by Rembrandt, for a mighty £2,300 (Wallace). The buyers at these sales were still British collectors but the world was changing.

By the end of the century, British collectors began to lose their pre-eminence. This was due to an increase in disposable wealth abroad, particularly in Germany and America, and a decrease in wealth in Britain. The agricultural depression of the 19th century, which tipped the balance decisively in favour of industry, had left many landowners owning large estates constrained by unbreakable family trusts and producing an inadequate income. The Settled Land Act of 1882 enabled families to break long-established entails and precipitated the sale of the Blenheim paintings four years later. In 1894 death duties

were established and in 1910 reinforced to bite harder into deceased estates. The abolition of the American tariff in 1910 provided the impetus for J.P. Morgan to move his collection to America, which may be taken as the symbolic moment when the baton passed across the Atlantic.

General collecting on the scale of Lord Leverhulme and William Burrell moved across the Atlantic and new fields were colonised, notably specialist and modernist (fig. 27). Percival David and George Eumorfopoulos showed how private collectors could exceed public museums in scholarly acquisitiveness. The uncertain response to modernism and the pioneering brilliance of the small band of Impressionist collectors are

26 Peter Blake,
E. J. Power
Collection Clodagh and Leslie Waddington

27 Edward James
with Salvador Dalí's *Sleep*

28 The opening of Institute of Contemporary Arts at Dover Street, London, 1950 with the Earl and Countess of Harewood, the actress Margaret Rawlings and Herbert Read, ICA President

29 Tracey Emin, *My Bed*
Charles Saatchi

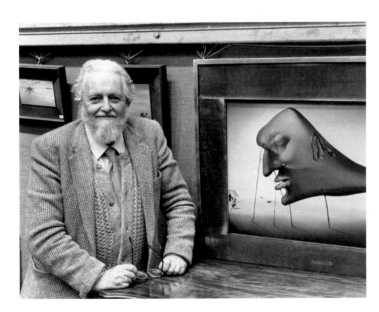

described in chapter 22. From the outset of the 20th century, collecting in Britain bifurcated between devotees of new art (modernists) and old art (classicists). While there was an occasional crossover and not all new art was modernist or old art classicist, this gap has remained until the present time. The London art establishment was essentially classicist until the Second World War and turned modernist thereafter.

The post-war era saw the rise of the role of the State in patronage and collecting to a level not seen since the 17th century, leading Sir Nicholas Serota to suggest that between 1945 and 1985 art collecting was effectively nationalised.[18] The last chapter deals with the years from 1979 to the present, a period of rapid change. Perhaps the most surprising development was the manner in which London changed from being the world centre of the Old Master trade into being a metropolis of contemporary art. This had its origins in the groundbreaking exhibitions at the Whitechapel Gallery and the ICA during the 1960s and '70s (fig. 28). The era is defined by the opening of Charles Saatchi's Boundary Road Gallery in 1983, a series of innovative exhibitions at the Royal Academy and the triumphant inauguration of Tate Modern.

Charles Saatchi's gallery, or more accurately his *Kunsthalle*, which has twice moved location, is the most famous of its kind in Britain but it mirrors similar exhibition spaces in America and Europe. Contemporary art with its penchant for gigantism has outgrown the home. The overriding motivation is no longer to live with art, or even to possess it, but to display it to the public. In the past collectors sought to create Gothic castles or Palladian Elysiums; today they are more likely to be curating an exhibition. The very permanence of museums has given the exhibition a cult-like status. Collectors have moved into this territory at the expense of possession. It is the collector as art impresario.

The Saatchi exhibitions of the 1990s launched the reputations of Damien Hirst and Tracey Emin and gave the public the 'Shark' and *My Bed* (fig. 29), works which saw the label 'masterpiece' redefined as 'iconic'. Before the 20th century the masterpiece was usually a single work of art of acknowledged quality. In the post-war era when an artist's individual brand was at a premium, the term 'iconic' became synonymous with the widely recognisable. Charles Saatchi and other collectors began assembling groups of work by an individual

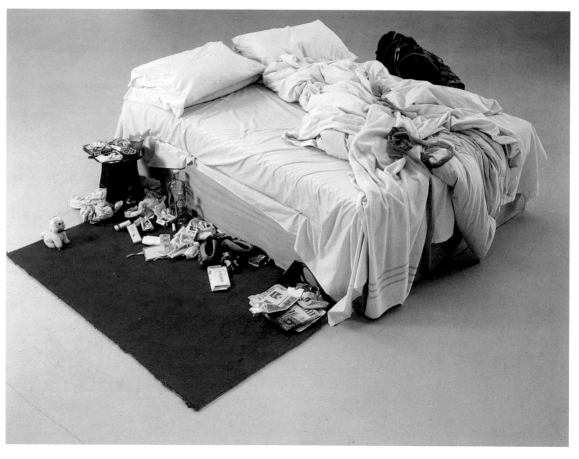

artist, beginning with Julian Schnabel and later moving to young British artists. During the 1960s Ted Power (fig. 26), emulating continental collectors such as Count Panza, had pioneered this approach in Britain. Frank Cohen, a collector with a *Kunsthalle* in Wolverhampton, has adopted a similar approach and he and Saatchi would probably agree that their activities incorporated an element of speculation. Collecting, speculating, curating and exhibiting art comprise the armoury with which these modern Medici project their power and reveal themselves.

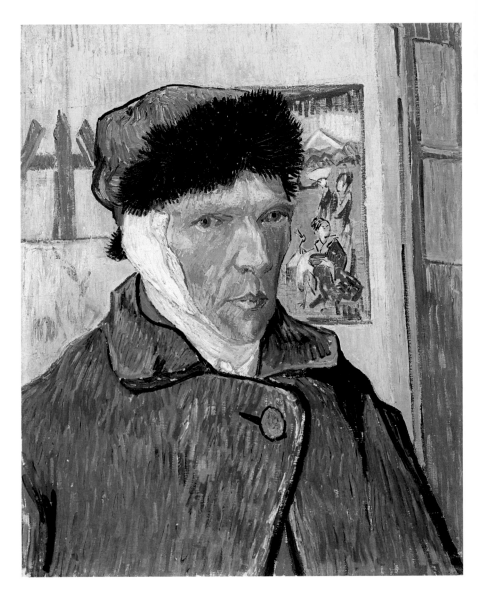

LITERATURE

The literature on British art collecting falls into three phases. First, in the 17th and 18th centuries, Peacham, Richardson, Shaftesbury and Reynolds all wrote essentially about education, explaining what an artist, gentleman or virtuoso should aspire to and what qualities they should admire. Secondly, in the early 19th century, a number of books were published which contained engraved views of country houses: the most notable series was J.P. Neale's *Views of The Seats of Noblemen and Gentlemen in England, Wales, Scotland and Ireland*, published in 11 volumes between 1818 and 1829. Frequently its text contained detailed lists of the picture collections in the houses described.

Later in the 19th century, a number of visitors – usually German – began to inspect British collections and publish their contents. J.D. Passavant toured Britain in 1831 and two years later his *Tour of a German Artist in England with Notices of Private Galleries, etc.* appeared in German with an English edition in 1836. His principal objective was to survey the works of Raphael for his monograph on the artist. Passavant was impressed by English collections and it was probably his book that inspired Dr Gustav Waagen to come to Britain (fig. 31). Like Pevsner in the 20th century, Waagen with his German passion for listing, provided the British with an invaluable guide to the artistic riches of their own country. Waagen's encyclopaedic survey came at exactly the right moment when British collections were at their most brilliant and before dispersals had begun. His *Treasures of Art in Great Britain* appeared in three volumes in 1854 with a supplement in 1857, amplifying a briefer earlier edition of 1838.[19] Waagen's meticulous lists have proven very useful to later

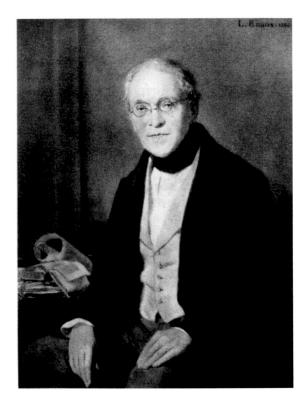

30 Vincent Van Gogh, *Self Portrait with a Bandaged Ear*
Courtauld Gallery, London

31 Dr Gustav Waagen, author of *Treasures of Art in Great Britain*

generations of art historians. It is noteworthy that Waagen's work, written in German, was translated into English by Lady Eastlake, signifying that Waagen was taken to the centre of the British art establishment. Waagen's compatriot, Adolf Michaelis, Professor of Archaeology at Strassburg University, compiled a comprehensive survey of classical antiquities in public and private collections in London and in country houses: his *Ancient Marbles in Great Britain* was published in 1882.

Passavant and Waagen were both art historians, a new profession. The fondness of German art history for lists and classifications was matched in Britain by a more poetic appreciation. Art history in Britain was formed by scholarly curators and collectors such as Eastlake, J.C. Robinson and C.D.E. Fortnum, and literary figures such as Hazlitt, Pater, Swinburne and Ruskin. Mrs Anna Jameson was a popular writer, who wrote on public and private collections and whose *Sacred and Legendary Art*, first published in 1848, ran to a ninth edition, published in 1883.

By the 20th century, art history had come of age and was supplemented by the historiography of art collecting. This had surprisingly deep roots in England, from the years when George Vertue (1684–1756) was jotting down everything he saw. These invaluable but formless observations were brought together by Horace Walpole who, with the catalogue of his father's picture collection and visits to country seats, may be hailed as the father of British collecting studies.

The rise of collection catalogues, in particular, during the second half of the 19th century evidenced a growing interest in art collecting, and reflected the scholarship of some and the vanity of others. Frank Herrmann suggested – tongue in cheek – that their value and interest were in inverse proportion to their size.[20] From the 1960s onwards two art historians began to make something rigorous and substantial of the history of art collecting in Britain: Ellis Waterhouse, and above all Francis Haskell. Haskell applied his brilliant mind to this undeveloped subject and his views and remarks are often quoted in this book. In 1972, Frank Herrmann, a publisher by trade, produced *The English as Collectors*, a pioneering attempt to chart the subject in a single volume. Herrmann produced an excellent anthology (or 'chrestomathy' as he called it) culled from the rich literature,

particularly on 19th-century collecting. It remains a standard work.

A recent fashion of art history is to chart the history of a work of art since its creation, casting a spotlight on collectors; the television series *The Private Life of a Masterpiece* was particularly interesting in this respect. Equally fascinating to the modern mind is the psychology of art collecting. There is a considerable literature on the subject which offers Freudian theories on remaking an imperfect world through art collecting. This literature is good at describing the lonely compulsion of obsessives, of which British art collecting provides several notable examples – Lord Arundel, William Beckford and Lord Hertford, to name only three. But in describing collecting, like creativity itself, as an essentially neurotic activity (which clearly it *can* be), these theories rule out such well adjusted operators as the 18th-century Whigs for whom collecting came as naturally as eating and drinking.[21] The idea that collecting always involves psychological maladjustment would have appalled Sir Robert Walpole, Prince Albert and Samuel Courtauld (fig. 30). Anybody interested in exploring this aspect of collecting may turn to the works of Jean Baudrillard, Werner Muensterberger and Susan Pearce, all of whom have interesting things to say.

The reasons why men and women collect are – as Kenneth Clark pointed out – as obscure as why they fall in love. It is much easier to explain why they collect certain things and how they do it. Collectors come in all sorts: greedy, fastidious, collectors of sets, magpies, aesthetes and historians. Horace Walpole, for instance, meets all these descriptions. It is discrimination that counts. Great collectors like Horace Walpole and William Beckford had exceptional discrimination and expressed an artist's sense of the totality of their collections and the manner in which they unfolded from room to room. Collections usually begin with an immediate aesthetic or emotional response to certain objects before the ordering or intellectual process takes over and the loose assemblage takes on a character of its own. Visitors to Fonthill were left in no doubt that the works of art came to life under the guiding intelligence that selected their companions and created their setting. Collecting is about art and the projection of identity. This book seeks to chart the way in which the British have revealed themselves through their collecting.

Part On[e]

ROYA[L]

Collec[tion]
Court

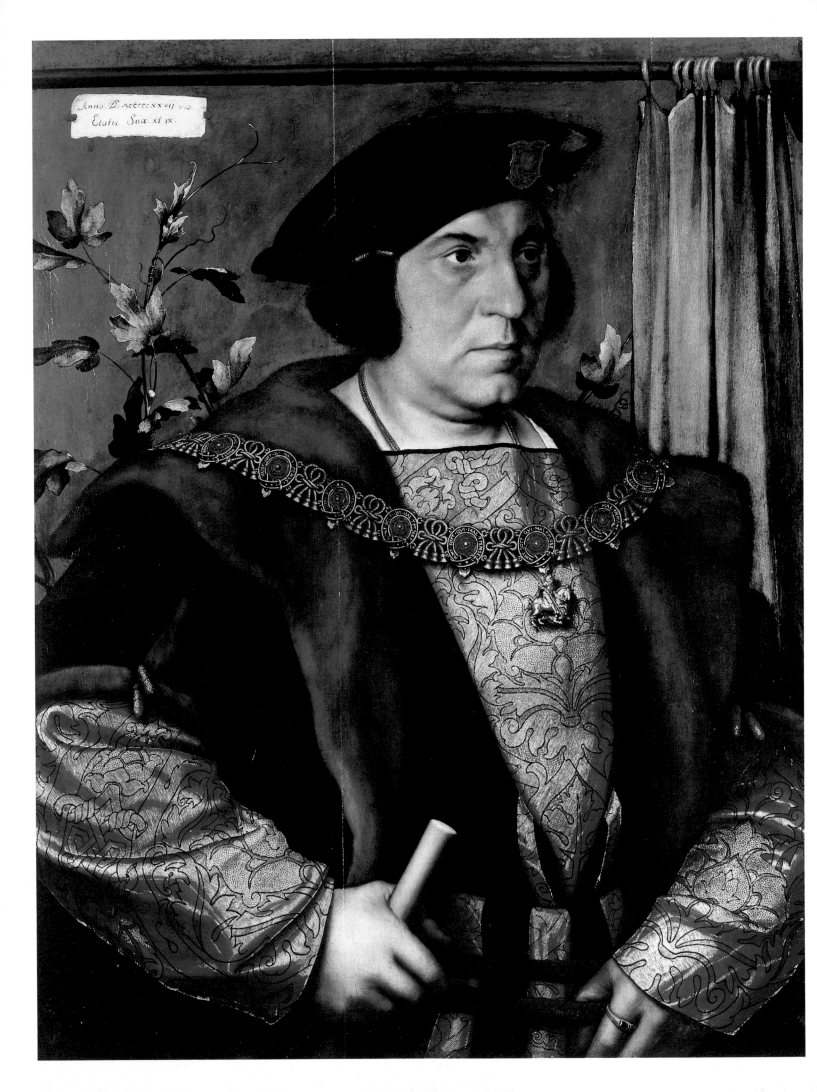

PRECURSORS: COLLECTING AND PATRONAGE IN THE TUDOR AGE

Tudor patronage saw the increasing rise of the arts in the service of the crown. A long period of civil war and instability ended with the arrival of the new dynasty. The visual arts were pressed into proclaiming the power of the Tudors and the cult of the King. The court supplanted the Church as the leading patron but art collecting in the modern sense had hardly begun. The progress, quality and acceptance of the arts is intimately linked to England's relationship with the European continent, by turn embracing and coy. The model was the Burgundian court where medieval notions of chivalry were combined with Renaissance pageantry, allegory and skilled artistry. It is symptomatic that the earliest surviving English portrait commission from a major European artist is of Edward Grimston, painted in 1446 when he was ambassador to the Burgundian court, by Petrus Christus (fig. 33). A few years later came Memling's votive triptych depicting the Welsh knight, Sir John Donne, and his wife. Until ambassadors and other travellers to the continent began regularly to commission and buy paintings towards the end of the 16th century, the art of the Renaissance arrived in England mostly in the form of illuminated manuscripts, tapestries and a small number of tomb commissions to important Italian sculptors.

Henry VII (1457–1509), the first Tudor monarch, had spent most of his life before winning the throne in 1485 in exile at the court of Francis II, Duke of Brittany, but despite a reputation for frugality he recognised the need for splendour at court. He appointed a court painter, a librarian, and a Master of Revels who supervised the festivities which celebrated the marriage in 1501 of his eldest

Henry VII

Cardinal Wolsey

Henry VIII

Holbein in England

The Elizabethan Age

The Earl of Leicester

Bess of Hardwick

Archbishop Matthew Parker

32 Hans Holbein the Younger, *Sir Henry Guildford*
Royal Collection

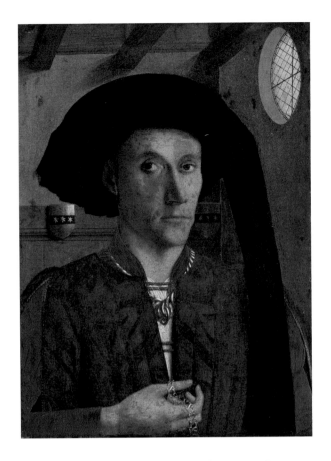

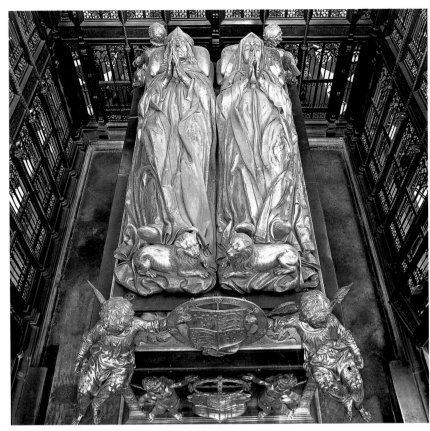

son, Arthur, to Catherine of Aragon. But it is for his architectural patronage that the King is best remembered today, especially through his dynastic chapel at Westminster, the lost palace of Richmond and the surviving Great Hall at Eltham. These were furnished with tapestries and gold plate and a small group of paintings, perhaps including Raphael's *St George and the Dragon* painted *c*.1505 (NG Washington). The Duke of Urbino sent Baldassare Castiglione, later famous as the author of *The Courtier*, to England as his proxy when he was admitted to the Order of the Garter in 1504, and the Raphael may have been brought as a gift. Thus the first significant work of Italian painting reached England. In the same year the King commissioned the sculptor Guido Mazzoni of Modena to create a tomb for himself and his Queen. In the event the commission was carried out by Pietro Torrigiano, who provided more traditional recumbent figures after the King's death, but the tomb remains the most important surviving Renaissance work executed in England (fig. 34). It was completed by the King's son, Henry VIII, but before we come to him, we must deal with the only English Renaissance prince of the church, Cardinal Wolsey.

Although unique in England, Thomas Wolsey (1473–1530) was one of several powerful

cardinal-ministers in Renaissance Europe. Tradition has it that he was the son of a butcher, and Wolsey established the concept of *nouveau riche* showiness. Prodigiously able and hard working, he rose to a position of pre-eminent power, domestically and internationally, during the long and optimistic morning of the new reign. Processions of richly attired retinues, chapels adorned with gold plate, antechambers lined with tapestries that were changed each week and, above all, impressive new buildings were the vehicles by which the Cardinal displayed his wealth. He kept an army of workmen busy at York Place in London and – to mention only two of his country seats – the manor of The More and Hampton Court Palace. He pioneered the Long Gallery in England that came to play such a role in the story of English collecting. Galleries originated merely as links between rooms and we find an example built by Edward IV at Eltham Palace as early as the 1470s, but Wolsey's galleries – and he created at least six – were all some 250ft long and overlooked gardens, although there is little evidence that they were intended primarily for display.

Wolsey's greatest surviving legacy is Cardinal College, later renamed Christ Church, Oxford, perhaps built in emulation of the 14th-century

patron, Bishop William of Wykeham. Vestments, stained glass and manuscripts were purchased in quantity, but to the Venetian ambassador it was the glittering gold and silver plate at Hampton Court that impressed the most, with a staggering contemporary value of £150,000. After the plate, it was his 650 costly tapestries which most clearly signalled his wealth and power to his contemporaries. The tapestries depicted Old Testament and mythological subjects and were of the highest quality, produced in the finest Netherlandish workshops. Wolsey also owned numerous Flemish paintings, but his most important artistic commission was his tomb from Benedetto da Rovezzano, a major Renaissance monument that was only partially completed. After Wolsey's disgrace and death, his possessions were appropriated by the King whom he had so assiduously served.

Henry VIII (1491–1547) was the most magnificent of all English kings (fig. 36). Certainly the richest of them, with an astounding 55 palaces and nearly two and a half thousand tapestries, he represents the zenith of the crown as the fountainhead of patronage, with an emphasis on luxury goods and showy bombast. When he died, the list of his possessions filled four folio volumes and amounted to a hundred thousand items, including 150 paintings and 2000 pieces of plate. Foreign craftsmen poured into England to provide Henry with the semblance of an Italian court filtered through the lenses of France and the Burgundian Netherlands. If Italy was the home of the new humanist learning and the finest but rarely obtainable artists, France and its equally showy King, Francis I, provided a more proximate model for emulation and, at Fontainebleau and Chambord, Italianate models for a modern palace.

Of all the English kings, Henry VIII was also the most aggressive builder. Three projects stand out in particular: his rebuilding of Hampton Court (fig. 35) and Whitehall (the largest palace in Europe by the time he had finished) and his creation of the fantastic hunting lodge of Nonsuch. These palaces were furnished and decorated for the arrival of the King and it was tapestries that formed the main decorative element. Jan Mostinck, the King's procurer, believed he owned as many as any Christian king. Wolsey's foreign policy had placed Henry VIII as the balancing power – or so he

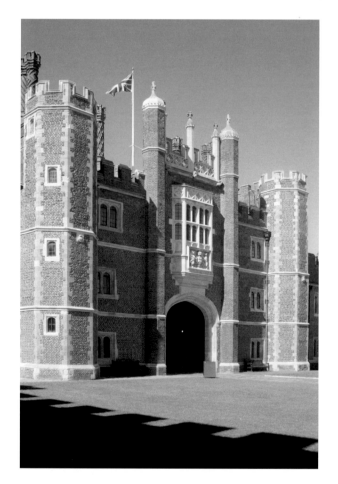

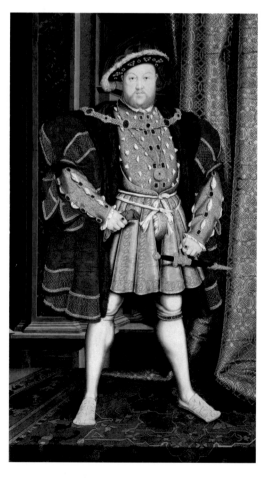

hoped – between the King of France and Charles V, King of Spain and the Holy Roman Emperor. It was these two monarchs that Henry wished to rival in visual magnificence.

A quarter of the King's tapestries had come from Wolsey. Their functions were many: aesthetic, political and practical (excluding draughts and providing good acoustics). The two most valuable sets of tapestries in the King's collection were the *Story of Caesar* with a value of £5,022 in the 1547 inventory; and the *Story of Abraham* which was valued at the Commonwealth Sales in 1649–53 at £8,260, far more than any painting (fig. 37). It is difficult

great painter the King attracted to court was Hans Holbein (*c*.1498–1543). He arrived from Basel in the autumn of 1526 with a letter from Erasmus to Thomas More which explained: 'Here the arts are freezing, he is coming to England to scrape some angels [gold coins] together.' More wrote back: 'Your painter is a wonderful artist, but I fear he will not find England such fruitful and fertile ground as he hoped.' More was probably right in the short term but Holbein was eventually to settle in England and become the King's painter in 1536. Members of the humanist circle around More were to be the patrons of his first visit, and by far

today to recover the importance and expense of tapestries to the 16th century. The rise of paintings eclipsed their predominance and today only 30 items remain in the Royal Collection at Hampton Court. Interestingly tapestries survived as the main moveable decoration at Windsor until well into Charles II's time, as a 1676 inventory reveals. There were many paintings in Henry's collection but for the most part they remain obscure. Sheer quantity necessitated the use of galleries for displaying art; 56 paintings are listed in the Gallery at St James's, and seventeen at Hampton Court – mostly Flemish devotional and portrait paintings including some of real quality, such as Jan Gossaert's *Portrait of the Children of Christian II of Denmark*. The one

the most important commission was *The Family of Sir Thomas More* (1526–27) in which he pioneered the conversation piece in England. Erasmus had compared More's family to the academy of Plato and Holbein's image (the original painting was lost in a fire) presents them to us in a real domestic interior (fig. 38). Holbein painted poets, courtiers, landowners and officials in a manner which is surprisingly uniform and unheroic (fig. 32). It has been estimated that Holbein was patronised by nearly a third of the peerage and one of the main legacies of his time in England was the firm establishment of portraiture as the bedrock of English patronage and taste.

It took a decade for the King to commission

Holbein and the credit is usually given to Thomas Cromwell. Henry's most important commissions to Holbein were the large decorative paintings that have perished: *The Battle of the Spurs*, *The Battle of Thérouanne*, and most famously, the Whitehall Tudor full-length portrait group. What we are left with are the easel paintings, drawings and woodcuts of the King, his queens and ministers. They constitute a set of images as recognisable and powerful as any court record in history. It may have been what Sir Joshua Reynolds called Holbein's 'inlaid' quality that appealed to Henry VIII who appreciated the verisimilitude of his portraits and the level of detail. Holbein's work for the King included paintings of the King's triumphs, engraved frontispieces to books, portraits, heraldry, designs for goldsmiths' work (especially new year gifts) and even a cradle for his daughter Elizabeth.

All accounts of Henry VIII refer to the splendour of his jewels, his apparel and his armour. The King's taste seems to have been for a combination of a *Schatzkammer* of bright and elaborate objects of gold, silver and precious stones (fig. 40) and for narrative art that showed him in a heroic role by allusion. This love of enamelled, woven, carved and painted detail was a constant obsession with Henry VIII and it has echoes with the artists patronised by his royal successors down the centuries, from Zoffany to Fabergé. Changes of taste and civil war have obliterated many of the traces of Henry VIII's patronage, much of which was dedicated to ephemeral jousts and pageants – the greatest of which was the Field of the Cloth of Gold of 1520, the most magnificent festival staged by an English monarch until the Delhi Durbars. The dissolution of the monasteries begun in 1536 made Henry VIII the richest of all English kings. Never before or since was a monarch the fountainhead of so much patronage. He stands like a swollen colossus between the centuries of church patronage and the era of aristocratic collecting, the consequence of this massive transfer of wealth from the monasteries to the crown and its supporters.

'Under a minor prince and amidst a struggle of religions, we are not likely to meet with much account of the arts' begins Horace Walpole's famous description of painting under Edward VI and Mary I.[1] With the death of Henry VIII in 1547 came the iconoclasm of the reign of the child king Edward VI followed by the religious tug-of-war

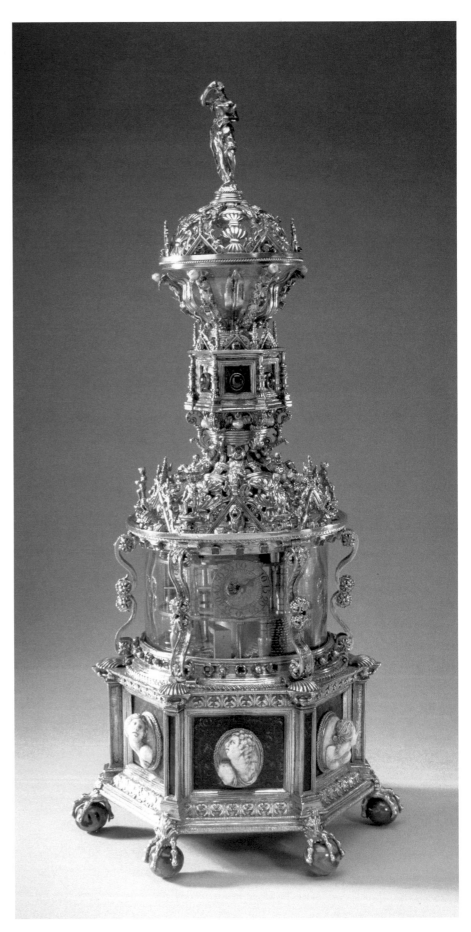

40 The Royal Clock Salt
King Henry VIII; now Goldsmiths' Company, London

of the reigns of the two half-sisters, Mary and Elizabeth. When the latter came to the throne, the spectre of civil war and the threat of Catholic Spain were not propitious for collecting and patronage. The deepest impulses of the age were literary and the word proved more potent than the image in Protestant England. Images were inherently suspect and it is not for nothing that the greatest visual legacies of the age are the abstract arts of architecture and the private, intimate medium of the miniature. The Queen, although herself erudite, was not disposed to commission works of art and architecture but she allowed her courtiers to build great palaces to provide a setting for her as the focus of a pictorial cult as exotic and allegorical as anything in the Orient. The cult of Elizabeth created an industry of portraits commissioned by adoring courtiers. The Queen is portrayed as the provider of peace, the model of chastity and the symbol of defiance. Whatever the allusion, all were created as pledges of loyalty. In this visually controlled world, images of the Queen were approved by the state.

When the French art dealer Nicolas Houel attempted to sell Elizabeth a group of paintings including works attributed to Albrecht Dürer, she was not interested. She did however appreciate the talent of Nicholas Hilliard (1547–1619) who became the Queen's limner and goldsmith. His miniatures look back to the lost world of chivalry depicted in illuminated manuscripts (fig. 41). They represent an Italianate microcosm of the poetic spirit of the day and provide the visual background to the early plays of Shakespeare. Spenser's *The Faerie Queen* finds its intellectual counterpart in the Italian art theory of Lomazzo and Castiglione's *The Courtier* and the ever more popular emblem books that provided tantalising visual clues for the educated to decode in parallel with the allegorical portraiture of the time.

As in the time of Holbein, the most popular genre of collecting in the Elizabethan age was portraiture, its motivation now historical, dynastic, heroic and social. Typical was Lord Howard of Bindon who wrote to thank Robert Cecil for the gift of his portrait 'to be placed in the gallery I lately made for the pictures of sundry of my honourable friends, whose presentation thereby to behold will greatly delight me to walk often in that place'.[2] As long galleries became common so did the commissioning of historical series such as the 'imaginary' portraits of the Kings and Queens going back to Edward II at Hardwick Hall in Derbyshire.

By far the most important development for collecting during Elizabeth's reign was the first country house boom, a growth as extraordinary as it was ambitious. Its exuberance puts one in mind of the châteaux of the Loire. The Queen encouraged her courtiers to build palaces for her reception, and these housed the new dynastic families for whom the English country house and its surrounding estate became a perfect vehicle for an art collection, allowing its survival for many centuries. Among the greatest builders was the Queen's minister, Sir William Cecil, Lord Burghley, who created Theobalds and Burghley House. As a classicist and a power broker, his choice of art was predictable. Roger Wilbraham visited Theobalds in 1598 and described the long

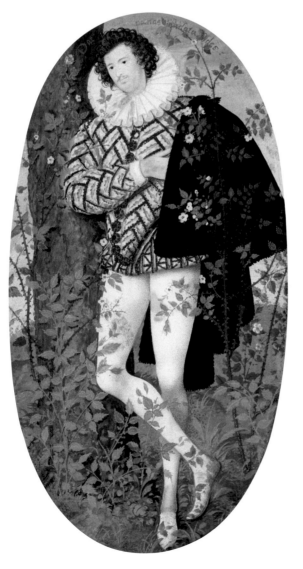

41 Nicholas Hilliard,
Miniature: Young Man among Roses
Victoria & Albert Museum, London. George Salting Bequest, 1910.

gallery 'one side all the emperors beginning with Caesar, t'other the pictures of the chief in Europe'.[3]

Lord Burghley's rival, Robert Dudley, 1st Earl of Leicester, was the most spectacular courtier-collector of the Elizabethan reign (fig. 42). Federico Zuccaro came to England in 1575 at Leicester's behest and the Earl's full-length portrait (now lost) was one of only two pictures the artist certainly painted in England, despite the desire of 19th-century connoisseurs to attribute so many Elizabethan portraits to his hand.[4] At his death in 1588, Leicester owned approximately 200 paintings which were divided between Leicester House, London and his country houses of Wanstead and Kenilworth Castle, but with the lion's share of 91 works at Leicester House, one of the Strand palaces that ran down to the Thames. These – notwithstanding the development of the country house – provided the greatest repositories of art in England for the next half century. Catherine de' Medici sent Leicester paintings and the French ambassador whom he used as an agent secured him at least one picture by Clouet.[5]

The Earl acquired numerous paintings on diplomatic and military expeditions to the Netherlands, possibly including a handful by Joachim Beuckelaer's younger brother, Hubert (the 'Hubbard' encountered in Leicester's inventories and other Elizabethan accounts).[6] He displayed them in the gallery at Leicester House whose inventories list religious and erotic paintings,

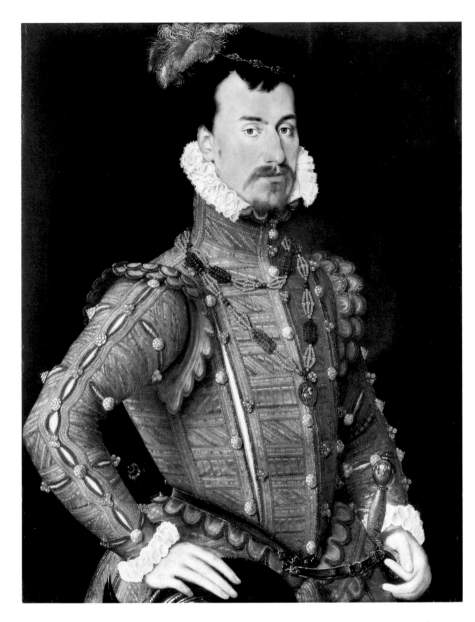

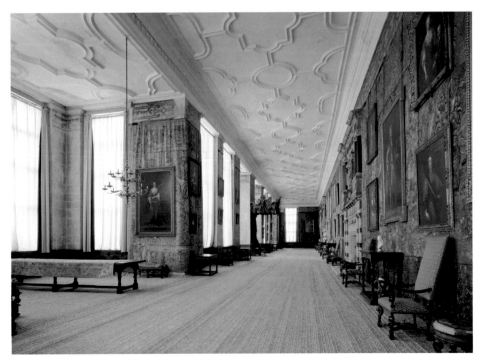

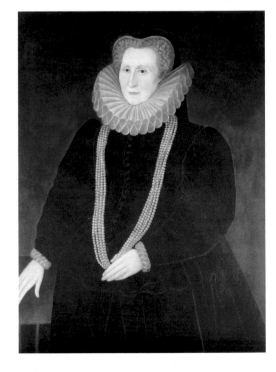

tapestries, busts and maps. At Kenilworth and Wanstead he kept mainly portraits. His nephew and heir, Philip Sidney, poet, soldier, and *beau idéal* of the Elizabethan courtier, travelled to Venice and pondered whether to sit to Tintoretto or Veronese. He chose the latter and this now lost portrait may have hung at Leicester House.[7]

The best information about the contents of Elizabethan collections comes from the surviving inventories of the Royal Collection and those of Archbishop Parker, Lord Leicester, the 1st Earl of Pembroke, and Bess of Hardwick.[8] These assiduously list the plate, textiles, linen, furniture and series of portraits of kings and queens but rarely mention artists' names. An exception in this respect was that of Lord Lumley who bridges the Tudor and Stuart worlds. The most complete example of a house, collection and inventory surviving more or less intact is Hardwick Hall, which reveals what an Elizabethan collection looked like. It was built during the 1590s for the Countess of Shrewsbury, better known as Bess of Hardwick (fig. 44). Although the 6th Duke of Devonshire later supplemented the collection and romanticised it, the essence remains 16th century and a study of its inventories gives us a vivid picture of that time. Bess's will records 37 portraits, mostly of royalty, which hung in the Long Gallery (fig. 43), probably on the window walls facing the tapestries. However, by 1630, perhaps symbolising the rise of the former and demise of the latter, paintings are shown in an engraving by Abraham Bosse hung against the tapestries. During her lifetime, however, the tapestries were by far the most important items. Bess paid £326 for the thirteen tapestries bought second-hand from Sir Christopher Hatton's heirs while it has been estimated that she probably paid less than £50 for the 37 pictures.[9] Her son, William, 1st Earl of Devonshire, commissioned Rowland Lockey to provide 30 portraits, mostly copies of family portraits but including one of Mary Queen of Scots, whose son, James I, was by then King of England.

When Horace Walpole visited Hardwick in the mid-18th century, he described the gallery with 'bad tapestry and worse pictures' and its creator as 'this costly Countess'. Bess of Hardwick, however, commands our attention for her rapacious and successful use of the marriage market to accumulate four fortunes, for building the most advanced house of the time, and through her position as the matriarch of English collecting. Her granddaughter, Alethea, married Thomas Howard, 14th Earl of Arundel and she herself spawned three great collecting ducal families: the Devonshires, Portlands and Newcastles. The 6th Duke of Devonshire summed her up as 'a prudent, amassing, calculating, buildress and progenitrix'.[10]

One of the most assiduous collectors of the Elizabethan age was the book-collector and antiquarian, Matthew Parker (1504–1575), Archbishop of Canterbury, who bequeathed the greater part of his library to Corpus Christi College, Cambridge. The dissolution of the monasteries had provided unique opportunities for the acquisition of manuscripts but Parker also looked to Italy and bought Aldine editions. He was passionately concerned about authentic texts and much of his collecting was motivated by a Protestant desire to find ancient roots for the English church. In 1568, he obtained a licence from the Privy Council to take into his possession many of the most venerable manuscripts in England, from both former monastic and cathedral libraries, to show a tangible precedent for a separate English-speaking church, independent of Rome even before the Norman Conquest. The exacting rules he left to ensure the survival of his bequest mark him as a modern collector and forerunner of Elias Ashmole.

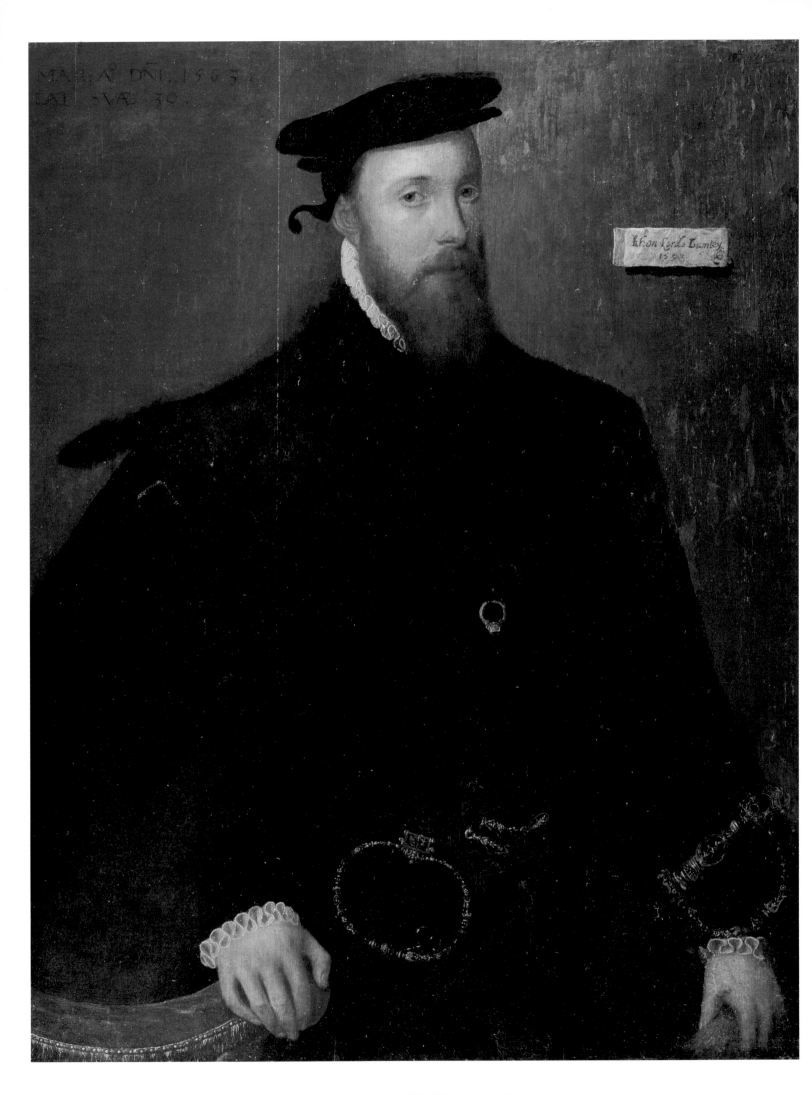

MAR A° DÑI 1563
CAT SVÆ 30

Rhon Lord Bunley
1563

Chapter 2

JACOBEAN ANTIQUARIANS

Although James I was not himself much interested in the arts, he was surrounded by family and courtiers who were. His reign forms the overture to the great collecting movements of the following generation. The King loved erudition and hunting, a combination which typified his contradictory character. The literary bias of the King – which mirrored that of his courtiers – was married with the visual culture of Italy in the form of the Inigo Jones court masques. The first, performed in 1605, was *The Masque of Blackness*, about twelve beautiful Ethiopian ladies in search of paradise which they found in 'this blest isle', Britannia. Apart from the few who had travelled there, the Jacobeans perceived Italy through masques and books. Sidney's *Defence of Poesie* (1595)[1] and Richard Haydocke's translation of Lomazzo's *Trattato dell'arte della Pittura* (1598) – 'to increase the knowledge of the arts which never attained to any great perfection amongst us' – were stepping stones in this understanding. They foreshadowed the creation of 'the virtuoso', the gentleman who devoted himself to literary, artistic and scientific pursuits. The most celebrated of these was John, 1st Viscount Lumley (*c.*1533–1609), a pivotal figure between the Elizabethans and the Jacobeans who combines all the enthusiasms of the time, architecture, genealogy, artists and books (fig. 45).

Lord Lumley unites the two intellectual streams of the Elizabethan and Jacobean periods – a growing fascination with early English history and archaeology, stimulated by the dissolution of the monasteries as both justification and nostalgia, and an equal fascination with the learning and culture of Italy. Lumley embraced both of these, but rejected Protestantism. As an intellectual,

Lord Lumley

Queen Anne of Denmark

Henry, Prince of Wales

Sir Robert Cotton

John Tradescant Senior

45 Steven van der Meulen,
detail from *John Lumley, 1st Baron Lumley*
The Earl of Scarbrough, on loan to the
Victoria & Albert Museum, London

recusant Catholic, his tastes were conditioned by his father-in-law, Henry, 12th Earl of Arundel, who had toured Italy in 1566–67 in the company of the antiquarian Humphrey Llwyd. Lumley spent time in the Tower of London for his part in the Ridolfi plot. His loyalty to the old religion and obsession with ancestry may make him seem old-fashioned, but his intellectual curiosity, acquisitiveness and aesthetic concerns mark him out as a singular collector. The family seat was Lumley Castle near Chester-le-Street in County Durham, where ancestor worship in the form of genealogies and portraits elicited King James's famous quip, 'I didna ken Adam's other name was Lumley'. The other interests of Lumley were expressed through his possession of Henry VIII's palace of Nonsuch at Cheam. Here he created an innovative garden and housed his library of 3,600 books and manuscripts, the largest in the country after that of John Dee.

As a young man Lumley had translated Erasmus's *Education of a Christian Prince* and he had wide interests, particularly in science and history. Italy came to him through books and it is principally on paper that we know Lumley today; his inventory of 1590 goes far beyond the

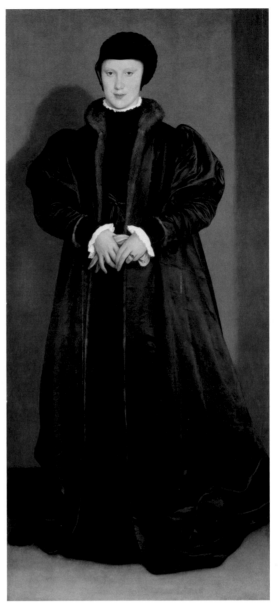

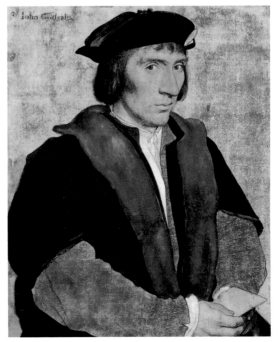

46 Hans Holbein the Younger, *Christina of Denmark, Duchess of Milan*
Lord Lumley; the Howard family, Dukes of Norfolk; now National Gallery, London

47 Fountain with two basins, from *The Lumley Inventory*, *f.37*
The Earl of Scarbrough

48 Hans Holbein the Younger, *Sir John Godsalve*
Royal Collection

perfunctory listing of furniture and silverware. There are the customary portraits but in huge quantity (196 contemporary sitters, 16 mythological and historical figures) and – almost uniquely – artists are often named, including Raphael (a self portrait?), Dürer (a watercolour portrait of Lord Morley now in the British Museum) and Holbein, the hero of the collection. It was natural that an English antiquarian with aesthetic interests would be attracted to Holbein and his most important identifiable works of art were paintings by the artist, including the *Portrait of Christina, Duchess of Milan* (fig. 46), the *Cartoon of King Henry VII and VIII*, and portraits of *Sir Henry and Lady Guildford* (a pair), *Erasmus, Sir Thomas More* and *Sir Nicholas Carew*. Lumley's most remarkable possession was Holbein's sketchbook (fig. 48), containing 85 preparatory drawings (now in the Royal Collection), which had formerly belonged to Edward VI and was probably acquired by Lumley's father-in-law, the 12th Lord Arundel.

The Lumley Inventory (fig. 47) – the incunable of British collecting studies – also provides important information on paintings by Hans Eworth, Gerlach Flicke, Jacques de Poinde, Antonis Mor, Steven van der Meulen (probable but not proven) and Hilliard. A curiosity of this collection is that Lord Lumley had a *cartellino* or *trompe l'oeil* scrap of paper with sitters' names painted on to his portraits. Religious and genre works were more numerous than in most English

collections and, rather provocatively, Lumley had portraits of the two Jesuits, Ignatius Loyola and Francis Xavier. Apart from paintings, fascinating pieces of sculpture are listed, as well as garden ornaments and furniture. Even more curious are the watercolour paintings illustrating architectural garden features, furniture and tombs which give us an extraordinary window into the aesthetic life of this singular collector, whose life was detached from the London Court where the great developments for collecting were to take place.

The Wardour Castle inventory of 1605 describes 192 pictures (also 154 pieces of 'porcelain' in the 'porcelain house'). The pictures are not individually listed, unfortunately, apart from 40 portraits of popes, emperors and senators.[2] When the pictures then in the castle were destroyed or looted in the Civil War they were described as 'rare pictures, the work of the most curious pencils that were known to these latter times of the world'.[3]

King James I's most important artistic legacy was the rebuilding of the Banqueting House by Inigo Jones after the fire of 1619. He also bequeathed a conception of monarchy to his son, Charles I, encapsulated in his book *Basilikon Doron* (1599), which conditioned the royal outlook for the next generation.

Perhaps the King's most important act affecting art collecting in England was his marriage to Anne of Denmark, the sister of Christian IV, who presided over an artistically inclined court in Copenhagen. Her two sons shared her aesthetic and acquisitive genes. Unloved by her husband, Queen Anne took refuge in Catholicism and paintings; Lord Salisbury thought she loved the latter more than people. In her galleries at Somerset House, Oatlands and Greenwich she kept portraits and contemporary Flemish devotional paintings, whose identity is now largely conjectural, but may have been typified by Hans Vredeman de Vries's *Christ in the House of Mary and Martha* (fig. 49), which was actually acquired by her son, Prince Henry (Royal Collection). She patronised Isaac Oliver, the most talented miniaturist of the day, who probably recommended the better Flemish painters to her. At Oatlands she kept two celebrated early paintings; the Trinity panels (1478–79) by Hugo van der Goes depicting *Sir Edward Bonkil in adoration* from the Scottish royal collection (possibly brought south by

49 Hans Vredeman de Vries, *Christ in the House of Mary and Martha*
Royal Collection

James I in 1617) and presumably purloined by the Queen. It was at Oatlands that she kept her portrait *à la chasse* (1617; fig. 50) by Van Somer, the forerunner not only of Van Dyck's full-length, outdoor images of the next generation, but also the precursor of the sporting portrait that was to have such a long run in British patronage down to the 20th century. The Queen introduced England to the Mannerist garden which her eldest son, Prince Henry (1594–1612), was to develop.

Physically and mentally precocious, nobody responded more readily to the world around him than Prince Henry. He was a man of action who loved the tilts – neglecting books to the concern of his scholarly father – and he had energy and curiosity in abundance. An intellectual by osmosis rather than study, he was staunchly Protestant; his heroes were the French King, Henry IV, and the Protestant Stadholder, Prince Maurice of Nassau, who together defined his European political leanings. These he combined with a nostalgic regard for past Tudor chivalric traditions. The Prince was brought up surrounded by well-educated and forward-looking young men like William Cecil, John Harrington and Thomas Howard, 14th Earl of Arundel who were to enjoy the foreign travel that was denied to him by his early death.

With Prince Henry we can observe the flickering light of an English Mannerist court in all its manifestations: a menagerie of exotic animals at St James's, ingenious gardens, a fascination with the occult, illusionist scenery, and an obsession with imported artistic novelties. The Florentine, Costantino de' Servi (1554–1622), was chosen by the Medici Grand Duke, Cosimo II, as an all-round artist to provide Henry with everything from paintings to buildings and gardens. He worked in England between 1611 and 1615 with the Huguenot hydraulic engineer, Salomon de Caus, on the gardens at Greenwich and Richmond. De' Servi constantly complained about the money, an ever more familiar theme of Stuart patronage. Today little remains of de' Servi's work, but he brought a touch of Mannerist Florence and Prague to London.

No doubt encouraged by his mother, around 1610 the young Prince Henry turned to art collecting and solicited gifts of paintings. The States General in Holland immediately obliged with a group of paintings including seascapes by

Hendrick Vroom, such as *The Battle of Gibraltar fought against the Spaniards* (lost). In the same year Sir Thomas Chaloner showed the Grand Duke of Tuscany's representative the fledgling picture collection in the Tudor Long Gallery at St James's and revealed that the Prince wanted what was, erroneously, referred to as the Michelangelo ceiling from the Medici Palace in Siena. He probably meant the scenes by Domenico Beccafumi and a painting by this artist arrived the following year to the delight of the prince. Purchases supplemented gifts – such as the £480 spent with Philip Burlamachi for a shipment of pictures from Venice – frequently facilitated by agents, typically Philip Jacob and the miniaturist Isaac Oliver.

From contemporary descriptions and van der Doort's later notes, we can identify a mixed group of works belonging to Prince Henry: *The Sacrifice of Isaac* by Leonardo Corona, a probable copy of Bronzino's *Story of Holofernes*, portraits of *Henry*

50 Paul van Somer,
Anne of Denmark
Private Collection

IV of France and of *Maurice of Nassau*, the latter probably by Miereveldt, still-life paintings, battle scenes, perspective paintings of palaces by Hans Vredeman de Vries and Hendrick van Steenwijk (father and son), *Prometheus* by Palma Giovane and, probably, works by Tintoretto and Bassano. More certain are Holbein's *Triumph of Riches* and *Triumph of Poverty* (*c*.1533), given by the merchants of the German Steelyard. Prince Henry's gallery was an aesthetic milestone for London, further enriched in 1612 by shipments of bronzes from Florence, mostly by the celebrated Medici court sculptor Giambologna. On their arrival, the Prince picked up the first bronze and kissed it. He handled each one lovingly in turn. Edward Cecil, who was present, suggested a little bronze horse might be a good present for the Duke of York (the future Charles I, then aged twelve) to which the Prince replied, 'No, no, I want everything myself!'

John Evelyn, later in the century, tantalisingly refers to 'a Cabinet of ten thousand Medals' that belonged to the Prince. This may have been the most expensive part of the collection because in 1611 Henry paid £2,200 to Abraham van Hutton for a group of antiquities, medals and coins. He also bought the cabinet of Abraham Gorlaeus of Delft. The only thing he lacked was a library and this was provided by Lord Lumley, thus completing the intellectual circle of artistic and scientific knowledge available to the young Prince. When Henry died in 1612 at age 18 of what we now recognise as typhoid, England was grief-stricken. 'Our rising sun is set ere scarce he had shone,' wrote Lord Dorset. But that sun had illuminated his tongue-tied younger brother, who was to take art collecting to a much greater height (albeit without a broader intellectual framework and with far-reaching and tragic consequences).

If Prince Henry typified a Jacobean infatuation with foreign art, there was also a growing antiquarian interest in the English past. Lord Lumley was not alone in these interests. From Francis Bacon onwards, antiquarians recognised that written texts were not enough; history had to be learned from all the evidence: coins, inscriptions and what we would now call archaeology. John Stow, author of *Survey of London*, Henry Spelman and above all Sir Robert Bruce Cotton were major figures in this respect. In 1600 William Camden and Cotton made a tour to Hadrian's Wall and collected items which they took to Cotton's country house for further study. Camden was a herald and genealogy was an important feature of the period and a major ingredient of Jacobean topographical books. The heraldic motivation wasn't purely antiquarian and often concerned legal disputes about rights to title and land.

The central antiquarian figure was Sir Robert Bruce Cotton (1571–1631), whose library in Westminster became the powerhouse of Jacobean intellectual life, where authors met and sources were consulted. Ben Jonson, for example, went there to find classical references for the court masques. Cotton's library provided a semi-public service from the outset and indeed became the foundation library of the British Museum a century and a half later. At first, James I approved of and even knighted Cotton but he gradually sensed that researches into Magna Carta and

51 *The Utrecht Psalter*
Sir Robert Bruce Cotton; Lord Arundel; now Utrecht University Library

52 Robert Peake,
Henry, Prince of Wales in the
Hunting-Field with Robert
Devereux, 3rd Earl of Essex
Royal Collection

parliamentary privilege were incompatible with his own prerogatives as expressed in *Basilikon Doron*. If James I sensed an ambiguity, his son Charles I smelled sedition, as the library became the meeting place of Parliamentarians in search of precedents and rights. In 1629 the library was closed and Cotton died two years later of a broken heart, or so it was said.

Manuscripts predominated over printed books in Cotton's library. He followed Archbishop Parker in his passion to preserve the earliest written remains in Saxon and 'English', particularly those that gave legitimacy to the Anglican Church.

Cotton lent books generously and many were not returned, especially by the Earl of Arundel. Cotton owned two of the surviving texts of *Magna Carta* and the manuscript of *Beowulf*, less prized then than now. The library was primarily a utilitarian facility, providing historical proof in support of scholarship, although it included many great works of beauty, such as the Utrecht Psalter (fig. 51; purloined by Arundel and now in Utrecht University Library).

Cotton not only collected books; he assembled antiquities, particularly Roman remains, at his country house, Connington Castle in

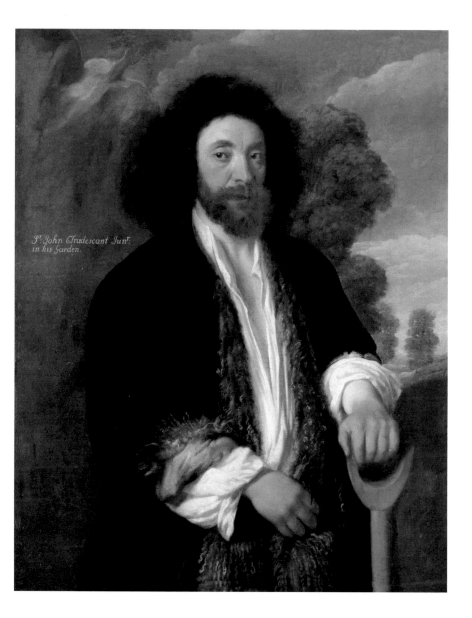

St John Tradescant Junr. in his Garden.

Cambridgeshire, where he constructed a special pavilion to house them. The remains of this collection survive in the Museum of Archaeology and Anthropology at Cambridge. The London house had Roman artefacts, fossils, bronzes and numerous portraits – notably the Robert Peake portrait of Prince Henry à la chasse (fig. 52). After many vicissitudes, in 1700 Cotton's grandson gave the library to the nation and half a century later it would form one of the cornerstones of the British Museum. Today Cotton is perhaps best known as the owner of the early illuminated *Genesis* in the British Library, dating from the 5th or 6th century. The pursuit of learning was a vital ingredient in a tradition of art collecting that the Jacobeans pioneered. It was not for nothing that for 200 years the British Museum and what is now the British Library were one and the same institution.

Although what there was of art was certainly secondary for the Jacobeans to what was deemed curious, this conjunction of art and curiosities is well demonstrated by one of the most seminal collections of the Jacobean era, which was ostensibly the humblest. It was formed by John Tradescant Senior (1570–1638), at his home in Lambeth. In 1609 he became gardener to Robert Cecil, 1st Earl of Salisbury at Hatfield House (fig. 54) and later to the Duke of Buckingham. His passion for plants led him to the Netherlands, Paris, Muscovy and North Africa, but his acquisitive urge was not confined to botanical specimens. He formed a cabinet of curiosities in his house at Lambeth known as 'The Ark', containing coins, shells, stuffed animals and arms and armour. After his death his son, John Junior (fig. 53), a visitor to Virginia on several occasions, continued to augment the collection and encouraged visitors and thus, in an informal way, a museum was born, a source both of revenue and knowledge which eventually blossomed into the Ashmolean Museum in Oxford.

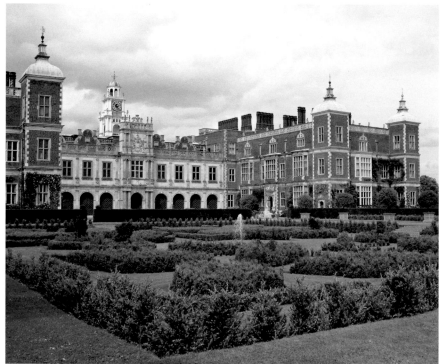

53 Thomas de Critz (?),
Portrait of John Tradescant the Younger in his Garden
Ashmolean Museum, Oxford

54 Hatfield House,
Hertfordshire

Chapter 3

THE EARL AND COUNTESS OF ARUNDEL

Thomas Howard, 14th Earl of Arundel (1585–1646) is the first heroic figure in the history of British collecting. He stands out in his time as a nobleman who studied and absorbed Italy and shared the hardships of the road with scholars and artists. In his desire to acquire great works of art he set the compass of British collecting, not only by the range of what he acquired, from marbles to manuscripts and drawings to gems, but by the standards he brought to bear in their pursuit. More often than not this was done through the assiduity of agents but the compulsion was that of the Earl alone. The Countess of Arundel (1582–1654) was equally remarkable, a great personage in her own right, a partner in many of his activities, and the all-important provider of funds.

The Earl's origins and upbringing mirror the way in which his life was lived, both at the centre of events and apart from them. His family, the Howards, Dukes of Norfolk were the first family of England, ancient and powerful but recently in disgrace as Catholic rebels. The Earl's father, Philip Howard – eventually canonised by the Catholic Church – was attainted in 1589 on a charge of high treason by Queen Elizabeth I. He was imprisoned in the Tower of London at the time of the birth of his son, Thomas. They never met. The boy was brought up by his learned if morbidly devout mother, Anne, in a small house in Essex since the family properties had been forfeited. In 1604 he was restored as Earl of Arundel but not as Duke of Norfolk and he regained some family properties. His marriage two years later to the heiress, Lady Aletheia Talbot, was to prove the most important event in his life. Her father, the Earl of Shrewsbury, owned mineral-rich lands in the North and was a

The Earl and Countess of Arundel

Inigo Jones

Wencelaus Hollar

William Petty

55 The Arundel Head ('The Arundel Homer')
British Museum

patron of Italianate architecture. Shrewsbury and Lord Lumley, Arundel's great uncle, were to be the formative influences on this unusual boy whom the Earl of Essex described as 'the winter pear'.

Arundel conformed to the Anglican faith – something his wife vehemently never did – and began the task of restoring his family's position and fortune which was the motivating force of his life. He became a companion and friend of Prince Henry, who was nine years younger, and was consulted by Lord Salisbury about a group of paintings arriving from Sir Henry Wotton in Venice. It was his meeting with Inigo Jones, however, that was to lead to one of the seminal relationships in English patronage, perhaps only rivalled by that of Lord Burlington and William Kent. In 1612 the Earl applied for a licence to travel to the Low Countries, ostensibly for health reasons. He first went to Antwerp and Brussels where he met the painter Van Balen who introduced him to Rubens. Arundel then crossed the Alps heading for Padua when he heard the news of the death of Prince Henry which brought him hurrying home. He arrived too late for the obsequies and the Prince's death eclipsed his influence at court. He was to have an awkward relationship with Prince Charles, the future King, despite and occasionally because of shared artistic interests.

As soon as possible Arundel set out again for the continent. This time he took the Countess with him and it proved to be a momentous trip. In 1613 they visited Milan, Venice and Vicenza. In Milan the Spanish Governor snubbed them, but Venice proved another matter. Arundel arrived with 35 attendants including Inigo Jones (freed from court by the Prince's death). In Venice, between banquets, the Earl explored every corner of the city and gained a vision of the High Renaissance from great palaces, like that of the Grimani. The resident ambassador, Sir Dudley Carleton, confessed he never knew Venice until the Earl's visit. Together, they went to Bologna and Florence followed by a sojourn at the Delle Grazie monastery in Siena to learn Italian, which they had doubtless realised was essential to get the most out of the country. Around Christmas 1613 the Earl set off for Rome with Jones, staying at 'vile hostarias', followed later by the Countess with the great train of servants. Rome was an architectural revelation and, as Arundel wrote to his wife, 'there are no more

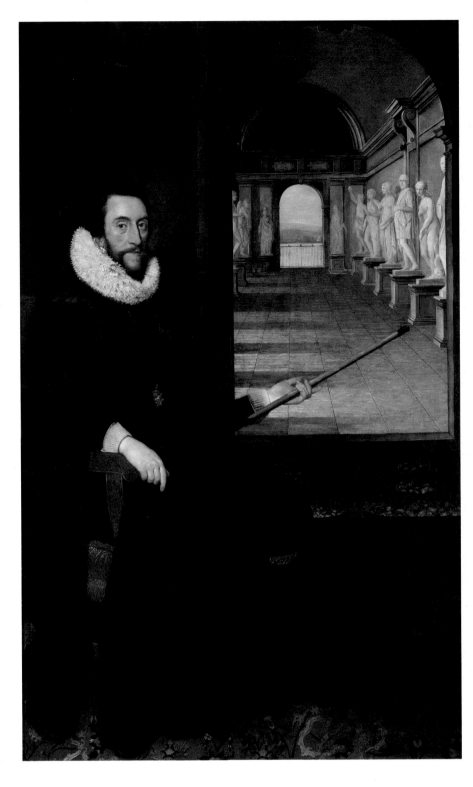

such places'. Finding that the best Roman artists were on contract to the Cardinals and the great families, he had to make do with commissioning sculpture *all'antica* from Egidio Moretti. Arundel also bought books, manuscripts and prints before continuing to Naples and then returning north to Florence.

Their return to England after the Italian journey raised suspicions of Catholic sympathies but for the most part it was an extraordinary rite

56 Daniel Mytens,
Thomas Howard, 14th Earl of Arundel
National Portrait Gallery, London;
on display at Arundel Castle

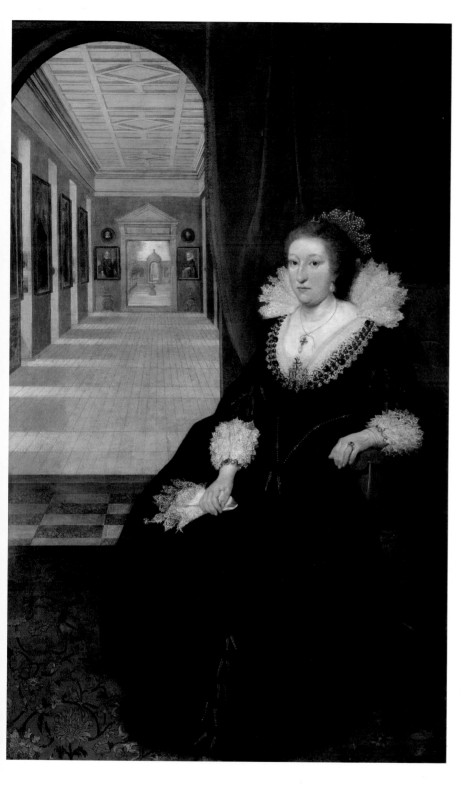

57 Daniel Mytens,
Alathea, Countess of Arundel and Surrey

National Portrait Gallery, London; on display at Arundel Castle

Greenwich, promptly burnt down, so they decided to make alterations to the venerable medieval pile on the Strand which formed Arundel House and whose perimeter can still be discerned on a street map today.

Inigo Jones created a two-storey extension that appears, with some significant artistic licence, in the earliest major portraits, *c*.1618, of the Earl and Countess by Daniel Mytens (figs 56–57).[2] Among the most celebrated of all collector portraits, they show Lord and Lady Arundel sitting at the end of two galleries, she on the ground floor leading to the garden and he on the first floor leading to a fanciful Italian loggia with a view over the river. With money and space in ready supply, the Earl's collecting was accelerating fast. He turned down Sir Dudley Carleton's collection of statues – excepting a *Head of Jupiter* – but bought from the same source a group of Venetian paintings that had been earmarked for the King's fallen favourite, Robert Carr, Earl of Somerset. These included works by Tintoretto, Veronese, Bassano and Titian. Tragically, most were burnt in the Greenwich fire, except for a *Benediction* by Tintoretto.

It was in 1617 that Arundel secured from Antwerp one of his greatest paintings. In that year he wrote to William Trumbull about Sebastiano del Piombo's *Portrait of Ferry Carondolet with his Secretaries* (1512–13; fig. 58), which was misattributed to Raphael until the end of the 19th century. The letter reveals Arundel's tactical but quasi-obsessive approach, his belief in bargaining and sheer persistence. The painting, now in the Thyssen collection in Madrid, was secured by Arundel and had an influence on English portraiture as a forerunner to a series of double portraits of grandees and their secretaries, starting with that of the Earl's friend *Lord Strafford and Sir Philip Mainwaring* by Van Dyck and later Reynolds's unfinished *Portrait of Rockingham and Burke*.

In 1627 Joachim Sandrart visited Arundel House and wrote, 'From the garden one passed into the long gallery of the house; where the superlative excellence of the works of Hans Holbein of Basel, held the master's place. Of these the most important was the Triumph of Riches... in the same gallery were some of Holbein's best portraits: to wit those of Erasmus of Rotterdam, Thomas More...'[3] He goes on to mention works by Raphael, Leonardo, Titian, Tintoretto and Veronese.

of passage for the Earl and Countess. Although we know virtually nothing of what they brought back, contemporaries were impressed. Sir Francis Bacon, observing all the ancient statues, exclaimed, 'My Lord, I see the Resurrection is upon us!'[1] The immediate concern of the Earl and Countess was to create an appropriate setting for their new treasures. The death in 1616 of Lady Arundel's father, Lord Shrewsbury, provided a timely financial injection. Their first project, a house at

Sandrart also refers to gold and silver by Holbein, as well as sketches and books illuminated by him. Holbein was a natural for Arundel to collect. The artist had painted the Howards at the height of their power and his work was available in England. The Earl indirectly inherited *Christina of Denmark* and *Erasmus* (fig. 59) from the Lumley collection and created the Holbein room at Arundel House, which contained over 30 paintings to satisfy what he called his 'foolish curiosity' for that particular artist. So famous was this part of the collection that Cosimo III of Florence asked Arundel for a Holbein and received *Sir Richard Southwell* (1536). The Earl may have received Elsheimer's *The Finding of the True Cross* (c.1603–05) in return.

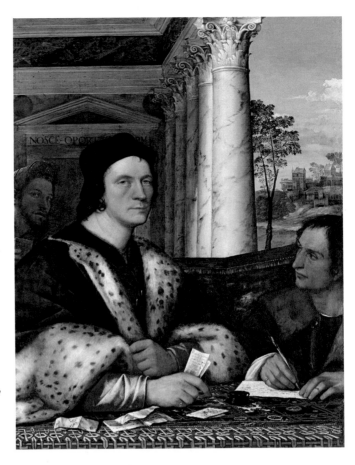

Lord Arundel had realised that buying good antique sculpture on the Italian art market was always going to be difficult for a foreigner, so he encouraged agents to venture further afield and develop an archaeological approach. John Markham, working in Asia Minor, was the first of these. After his death the Earl sent William Petty, who 'was prepared to undertake the labours of Hercules for Arundel'.[4] Petty and the Duke of Buckingham's representative in Constantinople, Sir Thomas Roe, almost succeeded in extracting the six reliefs from the Golden Gate of the city. Petty travelled all over Asia Minor, enduring terrible privations in his pursuit of marbles. He had one spectacular coup. He managed to lay his hands on a distinguished group of classical inscriptions assembled for the French scholar Nicolas Peiresc at Smyrna when the latter's unfortunate agent was temporarily incarcerated. Petty had what others lacked: a knowledge of antiquities, an iron stamina and total dedication to the task irrespective of the risks.

In 1628 John Selden published *Marmora Arundelliana*, the first printed book devoted solely to an English collection of antiquities, which included Petty's haul, although some thought he wasn't given enough credit. Arundel's treasure-seeking continued with Thomas Roe, who unsuccessfully, and perhaps naively, attempted to satisfy both the Earl and the Duke of Buckingham, a problem later resolved by the Duke's assassination. At first Arundel had tried to cultivate court favourites. He had corresponded with Somerset and even reached an accommodation with Buckingham. This had been severely shaken when Buckingham was created a Duke and therefore took precedence over

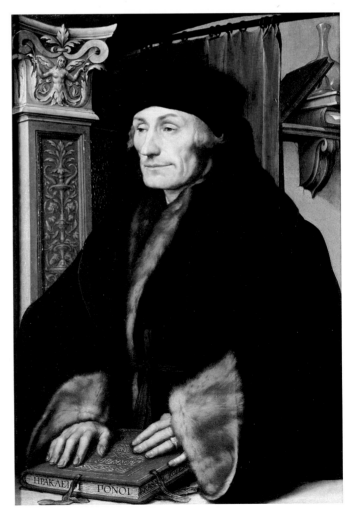

Arundel (see chapter 4 for more on Buckingham). His pride was wounded and when his remonstrations with the King failed, the Earl became, in the words of one courtier, 'a great stranger at the court'. King James had generally protected the Earl where Charles I, initially at least, treated him with feline insensitivity. It was Buckingham's death in 1628 which allowed a rapprochement with King Charles I and it also removed a rival collector. Arundel was to become an increasingly important figure at court as Earl Marshal, ambassador extraordinary and, most improbably, commander of the army against the Scots in 1638.

Although the Earl's friendship with Inigo Jones and even Rubens may have been closer, it is with Van Dyck that he is most often associated. He is sometimes wrongly given the credit for bringing the artist to England in 1620–21, but in any event Van Dyck painted Arundel many times: notably with his grandson in 1635; and with the Countess pointing to Madagascar on the globe in 1639; both compositions are still at Arundel Castle. The artist also planned a great family group for the

Earl, which is today known only from a Fruytiers watercolour at Arundel, to rival the Pembroke family portrait at Wilton. When Rubens came to England in 1629 he painted a portrait of Arundel in armour that has more animation than those by Van Dyck (fig. 61).

As Arundel's confidence grew so did his discrimination and his ambition, which reached their zenith with his attempt to bring back the Obelisk that today forms the centrepiece of Bernini's *Fountain of the Four Rivers* in the Piazza Navona. The Papal authorities refused an export licence. While most of Arundel's antiquities – which exceeded four hundred in number – were Roman (both originals and copies of Greek originals), he was able to acquire the spectacular Greek 4th-century bronze known as the *Arundel 'Homer'*, now in the British Museum (fig. 55). The Earl displayed much of his sculpture in the garden where it became the main aesthetic feature. When Henry Peacham produced the 2nd edition of *The Compleat Gentleman* in 1634, he added a chapter 'On Antiquities' and wrote 'Arundel House is the

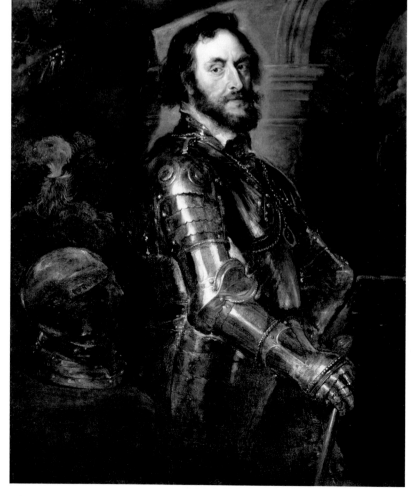

chief English scene of ancient inscriptions... you shall find all the walls of the house inlaid with them and speaking Greek and Latin to you. The garden especially will afford you the pleasure of a world of learned lectures in this kind.'[5] We know from his letters that Arundel was passionate about gardening, particularly at his sylvan retreat, 'that darling villa', at Highgate.

By the 1630s Arundel's attention appears to have shifted from stone to canvas. It is not always easy to establish exactly which paintings he owned, but he secured Raphael and Giulio Romano's *St Margaret* (*c.*1520) from the Priuli Collection in Venice in the teeth of competition from the Whitehall circle of collectors. The 1655 inventory drawn up for litigious purposes purports to represent what the Earl and Countess took to the Netherlands in 1642 but it is certainly incomplete and without enough information for accuracy. It must be seen as a document that indicates directional taste.[6] Out of 799 items it records: Dürer (15), Holbein (43), Parmigianino (25), Raphael (twelve), Rubens (two), Titian (37) and Veronese (eighteen). Of the 37 putative Titians in the collection, several can be securely identified, notably *The Flaying of Marsyas* (Kromeriz), and *The Three Ages of Man* (*c.*1512–15; fig. 62) in the Sutherland collection. Perhaps the most striking entry is that relating to Albrecht Dürer, which underlines Arundel's special interest in northern art. He particularly valued a *Madonna* given to him by the Bishop of Würzburg, 'and for such I esteem it, having ever carried it in my own coach since I had it. And how then do you think I should value things of Leonardo, Raphael, Corregio and such like!'[7]

Arundel was almost unique among the collectors of the Whitehall circle in his fascination with

drawings and prints. Printmakers provided both a library of art-historical images and also a record of the Earl's environment and his travels. It was while searching for Dürer prints in Nuremberg during the Earl's embassy up the Rhine in 1636 that Arundel found Wenceslaus Hollar, who became the Earl's recorder-in-chief. Hollar etched the various German towns they visited, the environs of Arundel House (fig. 63), objects from the collection, as well as views of London and the remains of medieval England. With his great skill in rendering accurate detail Hollar was the antiquarian's perfect artist.

The Earl was arguably most original as a collector of drawings. By the mid-1630s drawings were a virtual obsession and in 1637 he celebrated the creation of a special room at Arundel House with a party for *cognoscenti*, who admired works by Michelangelo, Raphael and Leonardo. He owned a considerable group of the last, many of which are

62 Titian,
The Three Ages of Man
Lord Arundel; Queen Christina of Sweden; Ducs d'Orléans; Duke of Bridgewater; now Duke of Sutherland, on loan to the Scottish National Gallery, Edinburgh

63 Wenceslaus Hollar,
Arundel House

now at Windsor Castle, but how he acquired them remains a mystery. Apart from the three Italian titans, the emphasis was on architectural drawings, Holbein and Parmigianino. Many of the drawings were inherited by the Earl's second son, Lord Stafford, whose sale is full of works tantalisingly attributed to Mantegna, Giulio Romano and Scamozzi. Around 1639 Arundel paid £10,000 to acquire the celebrated cabinet of drawings and medals belonging to Daniel Nys, the Dutch art dealer who had arranged the purchase of the Mantuan collection by Charles I.

What of Lady Arundel? Not only had she, in the words of her husband's will, brought 'to our poor family, the best means of substinence'[8] but she was a significant collector in her own right. From 1614 to 1620 she acted as clerk of works for her husband's building projects but in the 1620s her fiercely independent character emerged. She was not alone among the ladies of the court in her collecting and intellectual interests, the Countesses of Bedford and Pembroke being often-cited examples, but Lady Arundel is more vivid and was a more intrepid traveller. In 1620 she took off to Antwerp where Rubens painted her in a tremendous portrait with Sir Dudley Carleton and her attendants

(Munich; fig. 64). Fluent in Italian, she shared her husband's pleasure in that country and faced down false rumours of an amorous scandal in Venice.

Tart Hall was the chosen backdrop for Lady Arundel's activities as a collector. It stood just south of the present site of Buckingham Palace. There she had her own retreat where she could entertain her Catholic circle. She concentrated on paintings, and an inventory of 1641 gives some clues to the layout and contents. The third floor contained two picture galleries, hung with works by Titian and other Venetians, four landscapes by Joos de Momper and a *Jupiter and Semele* by Giulio Romano. The favoured subject matter was religious, mostly New Testament. There was a Holy Family Room set around an unidentified painting of this subject and next to it a Diana Room with a probable copy of Titian's *Diana and Actaeon*. The Countess had rich painted ceilings representing allegorical and mythological subjects which brought an Italian richness to the house that would have been unusual in London at the time. These may have been painted by Artemisia Gentileschi.[9]

The last years of the Earl's life were difficult. The debts rose (he thought of colonising Madagascar to escape creditors) and the Civil War was on the horizon. In 1642 Lord Arundel left England, and stayed a while in Antwerp before returning to his beloved Italy where he died at Padua in 1646. Within 50 years his collections were effectively dispersed, excepting for some marbles that have remained together at the Ashmolean Museum at Oxford (fig. 60) and the family portraits at Arundel Castle. Large parts of the library survive at the British Library, the College of Arms and the Royal Society. The gems survived together at Blenheim until the Marlborough sales in the late 19th century. The Earl was generally regarded as a difficult, proud man, except to scholars and artists like Inigo Jones, with whom he unburdened himself. 'Here comes the Earl of Arundel in his plain stuff and trunk Hose and Beard in his Teeth, that looks more like a Noble Man than any of us,' said the Earl of Carlisle. Above all Arundel is remembered for his love affair with Italy; an affinity which would become the leitmotif of British collecting for the next 200 years and caused Horace Walpole to crown him 'father of vertue in England'.

64 Peter Paul Rubens,
Portrait of Lady Arundel with her Train
Alte Pinakothek, Munich

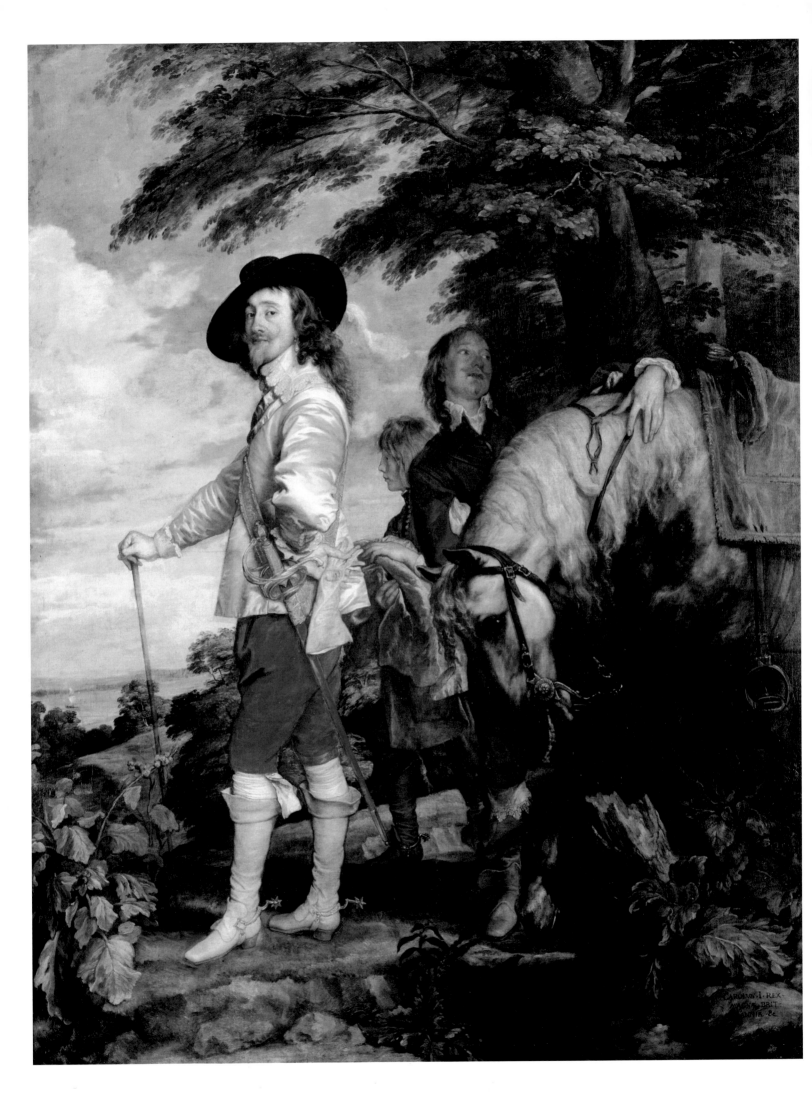

CHARLES I AND THE WHITEHALL CIRCLE

When Prince Henry died in 1612 aged eighteen, his embryonic but significant collection of pictures, bronzes, coins and medals passed to his younger brother, the future King Charles I. There followed an unprecedented importation and accumulation of great works of art under the auspices of Charles I and a group of his courtiers. The rapid formation and subsequent dispersal of the collections of the King and the members of the Whitehall Circle represented a seismic shift in European taste. Seldom had pictures travelled so extensively or changed hands in such rapid succession. For all his many failures as monarch, Charles I was the most discerning and successful English royal collector of all time. Shy as a man and opinionated as a ruler, his passion for classical and Renaissance works of art, his discriminating taste, his awareness of leading contemporary painters and sculptors and the works he commissioned from them enriched the Royal Collection, in a way never equalled.

The King was not alone in his interests. He had been encouraged by his mother, Anne of Denmark, as well as his elder brother Henry, and also by the two greatest courtier collectors of the age, the Earl of Arundel and the Duke of Buckingham. Arundel was fifteen years older than the King and Buckingham only eight years older, and it was the latter who had the closer association. The King's enthusiasm encouraged others, and important collections were formed by the 1st Duke of Hamilton, the 4th Lord Wharton and the 4th Earl of Pembroke, to name only a few. A significant feature of Stuart collecting was the role of agents, mostly artists and diplomats, who were employed on the ground in foreign countries to do the

King Charles I

Duke of Buckingham

Visit to Spain

Rubens in England

The Gonzaga Collection

Daniel Nys

Van Dyck in England

4th Earl of Pembroke

3rd Marquess and 1st Duke of Hamilton

4th Lord Wharton

65 Sir Anthony van Dyck, *Charles I à la chasse*
Musée du Louvre, Paris

scouting and negotiating on behalf of their royal or aristocratic patrons. These included William Petty, Tobie Matthew, George Gage, Endymion Porter, Nicholas Lanier, Daniel Nys, François Langlois, Balthazar Gerbier and diplomats like Sir Dudley Carleton. Such agents provided the sinews of Stuart art collecting.

Throughout the Jacobean reign an expanding literature made England more familiar with Italy. Henry Peacham's *The Complete Gentleman*, first published in 1622, had provided the first detailed account in English of Italian painters, taken largely from Vasari's *Lives of the Artists*. The influence of Peacham was considerable although the early Florentine artists he listed held less appeal to the Whitehall collectors than the 16th-century Venetians. England had diplomatic and trading links with the Venetian Republic, and their colouristic painters held an especial attraction for the Caroline court.

George Villiers (1592–1628), who became 1st Duke of Buckingham in 1623, was the Prince Charming of the age. His dazzling good looks had captivated James I and his glamour lives on in the novels of Dumas. Villiers – as he then was – started collecting in 1619 and enlisted the support of a well informed but unsuccessful Dutch painter who was to become the fixer *par excellence* in the

story for the Whitehall circle, Balthazar Gerbier. He joined Villiers's household and was in Rome in 1621 searching for 'the pearls of Italian art' for his master. In Venice he bought a Titian masterpiece, *Ecce Homo* (Vienna), for the enormous sum of £7,000 and was forced to borrow money from another art dealer who was to be of importance in the future, Daniel Nys. When the Titian and other Venetian paintings acquired by Gerbier, including Tintoretto's *Woman Taken in Adultery* (Dresden), arrived in London it was clear to the court that Lord Arundel had a spectacular rival. Many have doubted Buckingham's commitment to art, but although he lacked Arundel's scholarly motivation, the future Duke was a talented collector. Art provided an outlet for his flamboyant and aesthetic character.

As the reign of James I drew to a close, Buckingham successfully befriended the diffident young Prince Charles and this friendship was cemented during their extraordinary visit to Spain in 1623 to seek the hand of the Infanta. This impulsive bid to break down the serious religious barriers between both Protestant England and Catholic Spain was doomed to failure but the trip was a rite of passage for the Prince as a collector. He was accompanied by Buckingham, Gerbier, Endymion Porter, Lord Denbigh and William Murray, a

66 Titian,
Nude Girl in a Fur Wrap
Kunsthistorisches Museum, Vienna

67 Raphael and workshop,
The Miraculous Draft of Fishes
(cartoon)
Royal Collection; on loan to Victoria
& Albert Museum, London

68 Peter Paul Rubens,
*Equestrian Portrait of the
Duke of Buckingham*

Kimbell Art Museum, Fort Worth,
Texas (the full-size original was
destroyed by fire in 1949, but this
sketch survives)

group whose interest in art exceeded their political experience. The King of Spain's painting collection was the best in Europe and provided a model of princely patronage and acquisition. It was the Titians that made the most impact – they were the best anywhere – and perhaps consolidated the Venetian preference as the defining taste of the Whitehall circle. The marriage negotiations predictably broke down but the young Spanish King, Philip IV, gave Charles Titian's *Venus del Pardo* (Louvre), and *The Emperor Charles V with a Hound* (Prado) to take home. In addition the Prince bought Titian's *Nude Girl in a Fur Wrap* (Vienna; fig. 66) and ordered some copies of Titian's works for the Royal Collection.

Just before his departure for Spain, Charles confirmed his purchase of the seven large tapestry cartoons by Raphael (fig. 67). These were bought in Genoa as designs for the fledgling Mortlake tapestry workshop and were not then considered as autonomous works of art, but they are – along with the Mantegna *Triumphs of Caesar* cycle – Charles's most important remaining legacy to the Royal Collection, and arguably the greatest High Renaissance works outside Italy. A most intriguing commission made during the trip to Spain was a portrait of Charles by Velázquez, the fate of which remains a mystery. The same year the Prince commissioned Rubens to paint a *Self-Portrait* (Royal Collection) and, as the late Sir Oliver Millar noted, 'it was no mean achievement on the part of a seemingly diffident, but deeply sensitive, young connoisseur to have made contact in his early twenties with two such artists as Velasquez and Rubens'.[1] Rubens himself praised Prince Charles as 'the greatest amateur of paintings among the princes of the world'.

Rubens had a special affinity with the Duke of Buckingham, who avidly collected his paintings and commissioned from him the most elaborate of all English baroque equestrian portraits (fig. 68). In 1624, the Duke acquired York House, a palace

on the Thames for which he purchased the whole of Rubens's impressive collection of antique sculpture and Italian paintings as well as many of his own works, a transaction concluded in 1627 for a reported price of £10,000. Two years earlier, Gerbier had written to Buckingham that 'out of all the amateurs, and princes and Kings, there is not one who has collected in forty years as many pictures as your Excellency has collected in five'. Buckingham differed from Arundel, being, as Gerbier put it, 'not so fond of antiquity to court it in a deformed or misshapen stone'.[2] His passion was also for Venetian 16th-century painting. From Madrid Buckingham brought home Giambologna's *Samson Slaying a Philistine* (V&A; fig. 69), commissioned by the Medici for the King of Spain. Buckingham used many agents, not only Gerbier, but also Sir Dudley Carleton, Endymion Porter, Nicholas Lanier, Tobie Matthew and George Gage. The Duke's assassination on 23 August 1628 abruptly terminated this burst of collecting.

Two inventories of Buckingham's collection were made, in 1635[3] (listing 330 pictures) and 1648[4] (200 pictures). Out of those on the earlier list, there were (either originals or copies) 22 Titians, 21 Bassanos (father and son), seventeen Tintorettos, sixteen Veroneses, ten Palmas, three Bonifazios, two Correggios, and a single Giorgione. Eleven pictures by Andrea del Sarto made him the best-represented Florentine. There were three Leonardos, two Raphaels and one Michelangelo. Of contemporary painters, Domenico Feti was represented by sixteen pictures. The influence of Caravaggio was a major theme at York House with pictures by Baglione, Manfredi, Honthorst and Gentileschi as well as several by Caravaggio himself. A surprising appearance is an early version of *Christ Driving the Traders from the Temple* by El Greco (Minneapolis), an artist generally overlooked by British collectors until the late 19th century. Northern artists included Mor and Pourbus the Younger, Mabuse, Elshcimer and of course Rubens.

By the time Charles came to the throne in 1625 he already possessed impressive paintings by Van der Goes, Rubens, Holbein, Titian and Tintoretto. What the new King wanted, above all, was to entice a major Italian painter, preferably Roman, to London. He was unlucky in his timing since Rome in the 1620s – still the cultural capital

69 Giambologna,
Samson Slaying a Philistine
Duke of Buckingham; Worsley family of Hovingham; now Victoria & Albert Museum, London

70 Peter Paul Rubens, Ceiling of Banqueting House, London

71 Banqueting House: the Whitehall façade

of Europe – abounded with wealthy patrons. Guercino turned the King down on the grounds of religion and climate but Nicholas Lanier arranged for two of his paintings, a *Prophet* and a *Landscape* to join the Royal Collection. Francesco Albani also turned down an invitation to London but Orazio Gentileschi was lured from the French court by the new English Queen, Henrietta Maria, and painted a decorative scheme for her house at Greenwich. The King was later to persuade Cardinal Barberini to allow Bernini to make his portrait bust from Van Dyck's triple *Portrait of Charles I*.

By far the most notable artistic patronage by Charles I was of the Flemings, master and pupil, Rubens and Van Dyck. As early as 1621, Rubens had agreed to paint the ceiling of the new Inigo Jones Banqueting House (fig. 71) for the King's father. The commission remained in abeyance until 1629 when Rubens arrived in London as a Habsburg emissary to facilitate a peace treaty. Rubens was enchanted with England, which at that time basked in peace while much of Europe was immersed in the horrors of the Thirty Years' War. 'This island,' he wrote, 'seems to me to be a spectacle worthy of the interest of every gentleman, not only for the beauty of the countryside and the charm of the nation; not only for the splendour of

the outward culture, which seems to be extreme, as of a people rich and happy in the lap of peace, but also for the incredible quantity of excellent pictures, statues and ancient inscriptions which are to be found in this Court.'[5]

The King's commission to paint the Banqueting House ceiling is, curiously, the only decorative scheme by Rubens to remain in its original setting (fig. 70). The theme is the glorification of the Stuarts and the benefits of peace and plenty that the dynasty brought to the kingdom. Painted between 1635 and 1638 to celebrate the reign of James I, the three central panels depict *The Union of the Crowns*, *The Apotheosis of James I* and *The Peaceful Reign of James I*. A series of sketches for this ceiling reveal Rubens at the height of his powers, allegorising the Stuarts as he had the Medici, Gonzagas, Bourbons and Habsburgs. A similar visual programme, of Stuart propaganda, was embedded in the royal portraits by Van Dyck.

The great collecting opportunity of Charles's reign came early. Informed and emboldened, thanks no doubt by his Spanish visit, he was ready to grasp it. The Gonzagas, Dukes of Mantua, had patronised Mantegna and Giulio Romano, and their art collection had long been famous. By the 1620s Mantua was in a state of financial crisis and the Dukes found themselves in difficulties. They showed more interest in dwarfs and parrots than art at this time. The Countess of Arundel on her travels was the first to be alerted, and in 1626 Daniel Nys appeared in the city. Nys was a strange, shadowy, Flemish dealer who knew Italy well. He had bought Venetian paintings for Prince Henry and statues for the Earl of Somerset via the English ambassador, Sir Dudley Carleton, so he was experienced at the game. However, his biggest deal was to prove his most difficult. It started auspiciously and Nys wrote to the King that the collection was 'so wonderful and glorious that the like will never again be met with'. The most famous treasures were *La Perla* (Prado), then attributed to Raphael but now usually given to Giulio Romano, the Mantegna cycle, *The Triumphs of Caesar* (Royal Collection; fig. 73), and Titian's *Twelve Emperors* (destroyed).

The Gonzaga collection also contained Titian's *Entombment* (Louvre), Correggio's *Venus with Mercury and Cupid* (NG London; fig. 72), Andrea del Sarto's *Madonna Della Scala* (Prado), and

a spectacular group of recent Italian paintings by the Carracci, Domenico Feti, and above all, Guido Reni's four *Labours of Hercules* (Louvre) and Caravaggio's *Death of the Virgin*. 'I myself am astounded by my success,' wrote Nys, but in reality his troubles were only beginning. Obtaining payment from Charles I proved difficult and Nys's dishonesty complicated matters further. He had laid out £10,000 and sought a much larger sum from the King, but when this was not forthcoming the dealer declared himself bankrupt. Charles eventually paid for the collection by the expedient of diverting the money earmarked for the Duke of Buckingham's military expedition to La Rochelle, which consequently proved a disaster.

The arrival of the Gonzaga paintings in London made Charles's collection at a stroke rival that of the Spanish royal family. His Italian painting collection was rounded off with some important individual acquisitions. He always wanted a Leonardo and exchanged with Louis XIII of France *St John the Baptist* (Louvre) for Holbein's *Portrait of Erasmus* (Louvre) plus a Titian. Charles could afford to spare one of his Titians, which included *Pope Alexander VI presenting Jacopo Pesaro to St Peter* (Antwerp) and the *Portrait of the Doge Andrea Gritti* (NG Washington). There is no evidence that the King, or for that matter, Arundel or Buckingham, owned any Italian paintings earlier in date than Mantegna. Almost two centuries would elapse before English taste accommodated Italian work of the *Trecento* or early *Quattrocento*.

The artist who crystallised forever the Cavalier image of the Caroline court was Anthony Van Dyck. He briefly visited London in 1620–21, in a bid for patronage from King James I as well as from Arundel and Buckingham, whose collections he studied. In April 1632, the artist returned to London, where he spent the rest of his life. Van Dyck soon produced his first portraits of the King and Queen, and by late 1633 payments had been made for at least 11 more royal portraits. These images are as theatrical and allegorical as any court masque. They present an elegiac, powerful message of order and idyll. Van Dyck emulated Titian in a series of royal images destined for the various long galleries of the royal palaces at Whitehall, St James's, Denmark House, Hampton Court, Richmond, Greenwich and Oatlands. Typical was the St James's gallery lined with the

72 Correggio,
Venus with Mercury and Cupid
Charles I; Dukes of Alba, Spain; Lord Londonderry; now National Gallery, London

73 Andrea Mantegna,
The Triumphs of Caesar, III: The Bearers of Trophies and Bullion
Royal Collection

74 Lucas Cranach the Elder,
Portrait of Johann Cuspinian
Charles I; now Oskar Reinhart Collection, Winterthur, Switzerland

75 Rembrandt van Rijn,
An Old Woman
1st Earl of Ancram; now Royal Collection

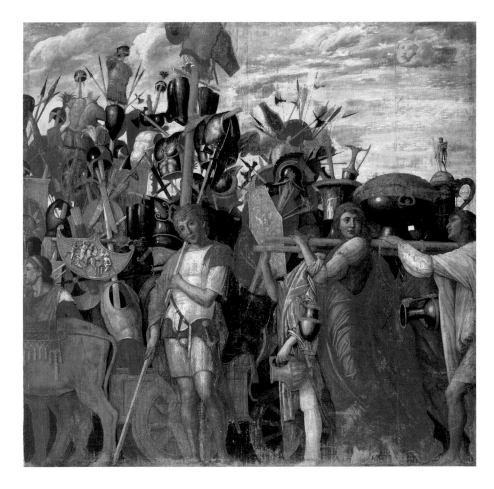

Titian *Emperors* and, as a glorious *trompe l'oeil* climax, the *Charles I on Horseback with M. de St. Antoine* (Royal Collection). Perhaps the most appealing royal portrait is the *Charles I à la chasse* (Louvre; fig. 65) in which the King appears as a country gentleman. Not everybody was seduced by these baroque images of power. Van Dyck's royal portraits were made during the period of the King's personal rule following the dissolution of Parliament. The royal images created by Van Dyck, like the King's art collection, were more in tune with continental absolutism than the murmuring shires at home.

In addition to Rubens and Van Dyck, the Caroline court attracted several other artists from the Low Countries. Hendrick van Steenwyck had arrived in the previous reign but delighted Charles with his interior perspectives for which Van Dyck archly declined to paint the figures. Cornelius van Poelenburgh started the fashion for Italianate landscape which proved an abiding passion with English connoisseurs for two centuries. A most distinguished arrival was Gerrit van Honthorst, who brought the Caravaggesque style to London. The King's collection of northern artists could not rival his Italian works but nevertheless has great interest. Lord Arundel's collection of works by Holbein was superior but the King did acquire his *Portrait of Derich Born* (Royal Collection) and it was through Arundel, travelling by way of Nuremberg in 1636, that the city gave him a rarer prize: the enigmatic *Self-Portrait* by Dürer (Prado). The King's two most celebrated Cranachs, the early *Portraits of Johann Cuspinian and his Wife* (Reinhart; fig. 74) may have been secured through the Duke of Hamilton. In 1632 Hamilton brought from Munich pictures by Calvaert, Frans Franken II, Pencz and Cranach. Other contemporary northern artists admired by the King were the Flemings Jan Brueghel and Hercules Seghers.

Most interesting of all was the King's acquisition of two paintings by the young Rembrandt, the first to arrive in England. Robert Kerr, first Earl of Ancram, one of James I's coteries of Scottish nobles in London, was a friend of John Donne and Constantine Huygens in the Netherlands. It was the latter who directed Ancram to the young lions of the Leiden school, Rembrandt and Lievens. The Earl gave the King three paintings, one by Lievens and two by Rembrandt, a *Self-Portrait* (Liverpool)

and an *Old Woman* (Royal Collection; fig. 75) which were among the very first paintings by Rembrandt to leave the Netherlands, although it is questionable whether their merits were immediately recognised in London.

While the King often received gifts from ambitious courtiers, he also frequently made exchanges. The most famous swap was with the 4th Earl of Pembroke whose Raphael, *St George and the Dragon* (NG Washington; fig. 76) the King gratefully received in exchange for the celebrated book of Holbein drawings which Pembroke passed on to the Arundel collection. Lord Pembroke (1584–1650) is best remembered today as a patron of Van Dyck. John Aubrey said of him that he 'exceedingly loved painting and building, in which he had singular judgement and had the best collection of any peer in England, and was the great patron to Sir Anthony Van Dyck: and had most of his painting'. Pembroke commissioned the artist to paint the great Herbert family group portrait, containing ten life-sized figures and measuring eleven feet high and seventeen feet wide, which took two years to complete between 1634 and 1636 and initially hung in the Earl's London home, Durham House, before its transfer to Wilton.

When the Civil War came the Earl sided with Parliament. He rebuilt his country house, Wilton, after the fire in 1647, to designs by Inigo Jones and John Webb which included the Double Cube Room (fig. 77), the *locus classicus* of Van Dyck galleries. The Earl also owned three paintings by Titian, two by Andrea del Sarto, and one each by Bassano, Correggio and Tintoretto. Only one courtier owned more Van Dycks than Pembroke, Philip 4th Lord Wharton (1613–1696), who similarly opted for the parliamentary side. He owned no fewer than eighteen works, varying greatly in quality, which he kept – unusually for the time – in his country house at Winchendon in Buckinghamshire. His profligate grandson Philip, 1st Duke of Wharton, sold many to Sir Robert Walpole, whose grandson in turn sold seven to Catherine the Great; the best of them all, the *Portrait of Philip, 4th Lord Wharton* was sold by the Soviets in 1932 to Andrew Mellon, and is today in Washington.

One courtier who was shamelessly political in his motivation to collect art was James Hamilton, 3rd Marquess and later 1st Duke of Hamilton

(1606–1649), who modelled himself on the Duke of Buckingham, whose niece he married. In two years between 1636 and 1638 he amassed 600 paintings including Saraceni's *Judith with the Head of Holofernes* and Veronese's *Adoration of the Magi*. Hamilton's collecting was aided by the fact that his brother in law, the 2nd Earl of Denbigh, was ambassador in Venice and used his position energetically to increase his influence and that of Hamilton through art purchases. Arundel was put out by this arrangement, which the King used to his advantage. This is demonstrated by the ongoing negotiations from 1637 over the sale of the della Nave collection in Venice, which included two major Giorgiones, *Laura* and *Three Philosophers* and Antonello da Messina's *San Cassiano Altarpiece* (all three now in Vienna). Through Denbigh, Hamilton bought the collection

76 Raphael,
St George and the Dragon
Henry VII; Earls of Pembroke; Charles I; eventually Catherine II, Empress of Russia; Andrew Mellon; now National Gallery of Art, Washington

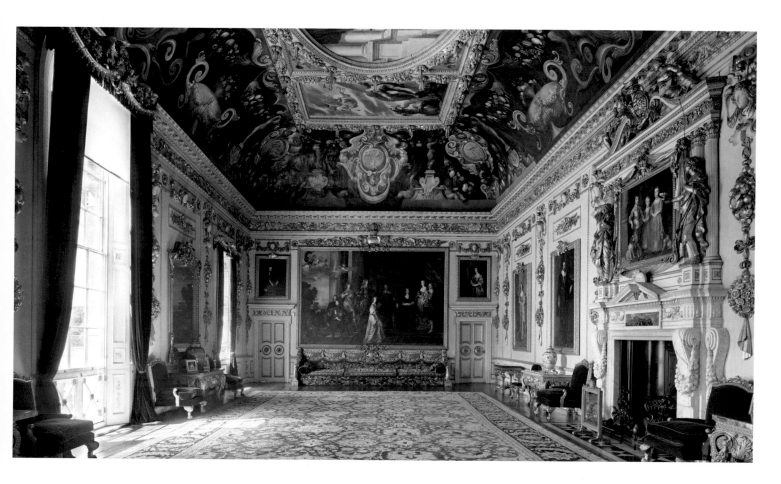

77 The Double Cube room at Wilton House

for Charles I, who then proposed to divide it up so that 'everyone interested in the shares, or some of them, shall throw dice severally; and whosoever throws most, shall choose his share first'.[6] This never happened because by the time the crates arrived, the political situation had deteriorated and they remained with Hamilton. After the Duke's death, the best paintings found their way to Antwerp where several appear in the background of Teniers's *View of the Archduke's Picture Gallery* including all of the paintings mentioned above.

As a result of this brilliant burst of collecting, a visitor to London on the eve of the Civil War could have seen some of the finest pictures in the world all within a mile of the present National Gallery in Trafalgar Square, now the home to several of these pictures. The mansions on the Strand included Suffolk House (shortly to be bought by Lord Northumberland and modernised as Northumberland House); York House (which still contained the Duke of Buckingham's collections fifteen years after his assassination); Durham House (leased by the Bishop of Durham to the 4th Earl of Pembroke), Somerset House (which Charles I had given to Henrietta Maria); and Arundel House. Moving towards St James's Park,

St James's Palace contained some of the King's most magnificent pictures. On the other side of the park was Wallingford House (near the present Admiralty in Whitehall), home to the 1st Duke of Hamilton. Whitehall Palace, filled with great and famous pictures, stood opposite. Downstream at Blackfriars, Van Dyck's collection of important pictures by Titian remained untouched after his death in 1641. Outside London, the royal palaces of Greenwich, Richmond, Hampton Court, Nonsuch and Windsor Castle contained further treasures. However, the consequence of the Civil War and the Commonwealth period was that these extraordinary collections were to be dispersed and the pictures distributed to new collections, mostly on the continent.

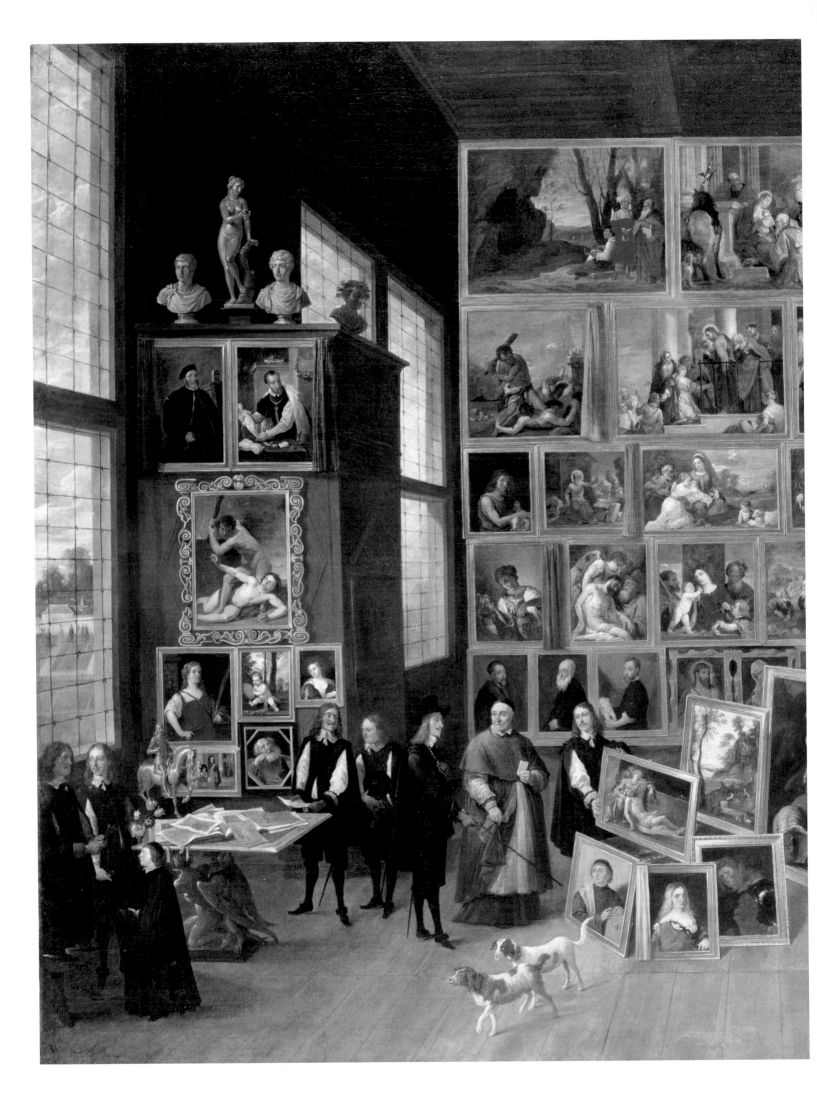

Chapter 5

DISPERSAL
AND COMMONWEALTH

Just as the Arundel, Buckingham, Hamilton and Royal collections were formed out of a spirit of rivalry, so competition attended their dispersal. During the mid-1640s, proposals were made to confiscate and sell the paintings which by then had passed to the sixteen-year-old 2nd Duke of Buckingham. News of a possible sale was reported to Madrid by the Spanish ambassador where it caused considerable excitement. Lord Northumberland, Buckingham's guardian and tenant, somewhat questionably appropriated some pictures for himself, but the young Duke planned to remove his collection to the Low Countries, and in February 1648 received permission to export sixteen chests of pictures. The most famous of Buckingham's Titians, *Ecce Homo*, is believed to have been sold to a canon of Antwerp Cathedral, but many more were purchased by dealers. However, the principal beneficiary of the arrival of the Buckingham pictures in Antwerp was Archduke Leopold-Wilhelm (1614–1662), from 1647 Governor of the Spanish Netherlands (fig. 78). Over the next ten years he built up one of the greatest art collections in Europe, and among his first acquisitions were the pick of the Buckingham pictures, including Titian's *Ecce Homo* (quickly ceded by the canon who bought it) and Gentileschi's *Mary Magdalene*. They now form the nucleus of the Kunsthistorishes Museum in Vienna.

Franz Gerhard and Bernhard Albert von Imstenraedt bought about twenty of Lord Arundel's Holbeins, all alas now destroyed, including the *Family of Sir Thomas More*, the *Triumph of Riches* and the *Triumph of Poverty*. They bought Dürer's *Girl from the Furleger Family*

The Dispersal

Formation of Syndicates

Foreign Buyers

Cromwell's Retentions

Viscount Lisle

10th Earl of Northumberland

78 David Teniers, detail from *Archduke Leopold's Gallery*, showing pictures from the Duke of Buckingham's collection
Petworth House, West Sussex (National Trust)

and their Venetian pictures included Antonello da Messina's *St Sebastian* (Dresden) and four Titians, of which three have disappeared, but the fourth is a supreme late masterpiece, *The Flaying of Marsyas* (Kromeriz). In 1667, the Imstenraedt brothers sold their collection to Karl von Liechtenstein, Bishop of Olmucz and Kremsier, who divided his pictures between his two residences.

Lady Arundel died in 1654, leaving her collection to her younger son Lord Stafford, who began to sell his inheritance quite quickly. One of the first to go was Veronese's *Christ and the Centurion* (Prado), bought by Alonso de Cárdenas, the Spanish ambassador. Family portraits and at least one Holbein (a portrait of Erasmus) returned to competing branches of the family. John Evelyn persuaded Arundel's grandson, later 6th Duke of Norfolk, to give the marble inscriptions which littered the grounds of Arundel House to Oxford University and many of Arundel's learned

manuscripts to the Royal Society. In 1674, the Government of the United Provinces bought Sebastiano del Piombo's *Ferry Carondelet and his Secretary* (fig. 58) as a suitable gift for Lord Arlington, Charles II's Minister. In 1684 the remainder of the Arundel pictures were dispersed by auction.

After the execution of King Charles I, his goods were dispersed in a different way. Commissioners were appointed with extensive powers to draw up inventories and put valuations on individual items: these included not just paintings and statues but tapestries – typically the most valuable, moveable art works – and furniture of all kinds, including chairs, cushions and stools. Usually after a revolution, the new government repudiates the debts of its predecessor, as the Soviet Union did those of the Czar after the Russian Revolution. It now seems remarkable that Parliament authorised the Commissioners to sell the King's possessions

79 Titian,
The Entombment of Christ
Musée du Louvre, Paris (bought by Everard Jabach, a French banker, at the Commonwealth Sale)

to pay off his debts, reserving only what was judged necessary for the State, up to a value of £10,000 (later increased to £20,000), and to plough any surplus into the Navy.

Much of the £20,000 allowance was spent on furnishings for the royal palaces which had been taken over as government offices. Tapestries were especially prized and it was as designs for them that the two most famous sets of paintings were selected for retention in England: the *Acts of the Apostles* by Raphael (valued at £300) and, at £1,000, the much more expensive *Triumphs of Caesar* by Mantegna. Paintings, furnishings and other goods were transported to Somerset House for sale: in May 1650, some 250 paintings and 150 tapestries were available there for prospective purchasers to see. All goods had to be paid for in cash but the initial response to the sale was sluggish.

The King's debts were settled by a combination of payments in cash and the transfer of pictures: a royal plumber or linen-draper owed £900 might find himself receiving £400 in cash and then the choice of up to £500 worth of pictures. The better informed Balthasar Gerbier accepted in settlement of his debt Titian's splendid *Portrait of Charles V* (Prado) and Van Dyck's *Equestrian Portrait of Charles I* (NG London).

Most of the creditors organised themselves into syndicates (which were called Dividends) under the leadership of a named individual with some experience of the art market. The syndicate led by Edward Bass, a minor official under the Great Seal of the Realm, was allocated Raphael's *La Perla* (Prado), at £2,000 the most expensive single item which had belonged to Charles I, as well as Raphael's famous *St George* (NG Washington). The 11th Dividend, led by Edmund Harrison who had been Embroiderer to James I and Charles I, was awarded Titian's *Pesaro Altarpiece* (Antwerp) and Rubens's *Peace and War* (NG London), as well as other highly desirable items. The 2nd Dividend, presided over by David Murray, the King's tailor, acquired many furnishings but also Correggio's *Satyr Unveiling Venus* (Louvre) and Dürer's *Self-Portrait* (Prado). It was the task of each syndicate leader to convert the works of art into cash.

Alonso de Cardenas, the Spanish ambassador in London, acted swiftly and secured for Philip IV a rich harvest including Raphael's *La Perla*, since re-attributed to Giulio Romano, Titian's *Allocution*

of Alfonso d'Avalos and Tintoretto's *Christ Washing the Apostles' Feet*. Everard Jabach, a French banker, who knew the English collections well and was to buy some Holbeins from the Arundel collection, managed to secure Titian's *Entombment* (fig. 79) as well as some outstanding recent paintings such as Caravaggio's *Death of the Virgin* and Guido Reni's *Nessus and Dejaneira*, all of which passed to the Louvre. Belatedly, in December 1652 Cardinal Mazarin, himself a passionate collector, officially recognised the Commonwealth. His ambassador Antoine de Bordeaux secured from the Murray syndicate Correggio's *Satyr Unveiling Venus* (Louvre) and from other sources the same artist's *Allegory of Vice*, the much more attractive pendant to the *Allegory of Virtue* which had been bought by Jabach (both Louvre). However, on 16 December 1653 Cromwell was made Lord Protector and the royal palaces were vested in him. A fortnight later, M. de Bordeaux wrote to Mazarin that the sale was at an end.

It remains to consider two British collections created from the artistic turmoil of the times and to explain why this burst of collecting activity between c.1610 and the 1640s was reversed so swiftly and thoroughly. Algernon Percy, 10th Earl of Northumberland (1602–1668) became the tenant of York House after the assassination of Buckingham. He was a patron of Van Dyck in the 1630s (fig. 82) and bought pictures by other artists, tapestries and silver, but not on the scale of Charles's courtiers. Northumberland found himself increasingly alienated from the King and became one of the most important peers to side with Parliament. Northumberland's career as a collector flourished at precisely the time when the Civil War was at its most intense.

In 1645, Northumberland reminded Parliament that it owed him £360 and suggested that this should be settled in pictures formerly owned by Buckingham. How exactly he reconciled his proposal with his obligations to his landlady is far from clear, but Parliament agreed. Thus Northumberland became the owner of Titian's double portrait of *Georges d'Armagnac, French ambassador to Venice, and his Secretary* (Alnwick), eight pictures by Elsheimer, Andrea del Sarto's *Madonna and Child* (Petworth) and Palma Vecchio's *Portrait of a Venetian Woman* (NG London; fig. 81). In the same year, he bought two

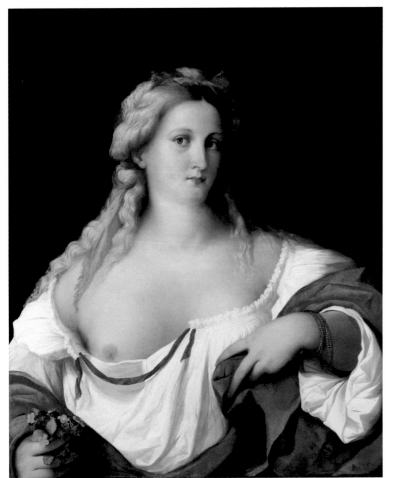

80 Titian,
The Vendramin Family

Sir Anthony van Dyck; 10th Earl
of Northumberland; by descent in
the Northumberland family; now
National Gallery, London

81 Palma Vecchio,
Portrait of a Venetian Woman

10th Earl of Northumberland; now
National Gallery, London

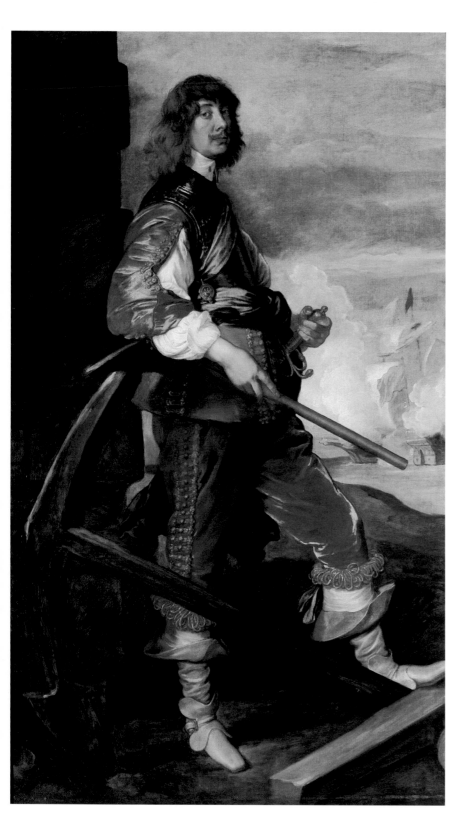

and a *St John* then believed to be by Correggio. Northumberland did not enjoy these for long as he was compelled to return them to the Royal Collection after the Restoration three years later. By the late 1650s, Northumberland's collection was perhaps the finest in England. His genuine aesthetic appreciation of Venetian pictures, especially by Titian, and portraits by Van Dyck, made it similar in character to those of Charles I and his courtiers, but it never compared to them in scale.

Northumberland's nephew Philip Sidney, Viscount Lisle (1619–1698), who succeeded his father as 3rd Earl of Leicester in 1677, also supported Parliament. He was perhaps the only man in England at that time who was trying to create a new collection. He bought between 50 and 60 paintings and nearly 60 pieces of sculpture which had belonged to the King, usually at second or third hand from the Syndicates. These included Holbein's *Portrait of William Reskimer*, Jacopo Bassano's *Good Samaritan*, Polidoro's *Psyche discovers Cupid* and *his Putti with Goats*. Lisle was following in the footsteps of his uncle and in doing so was trying to reverse the situation of the previous few years. But the Restoration in 1660 brought him bad luck. He was instructed to return all his pictures to the restored monarchy. He did so reluctantly, as did his uncle Northumberland, but his loss was the gain of the Royal Collection.

It is pertinent to ask why Stuart collecting proved so short lived. Great connoisseurship and taste combined with ample money ignited this burst of collecting, but was not sufficient to sustain it. It is not difficult to regard this brilliant period of English collecting in the first half of the 17th century as an anomaly.[1] It was concentrated too closely in the King and his courtiers. It lacked the necessary depth, obtained where a wide distribution exists among collectors from different circles, and more importantly where the fashion and taste are broadly accepted. Public opinion was not yet familiar with the arts and was suspicious of both overtly Catholic pictures, referred to as 'superstitious', and of buxom Venetian nudes, labeled 'lascivious'. England was not yet ready to embrace such paintings. After the Restoration, the demand for art widened beyond the small circle of the King and his courtiers: this change enabled more collections to be formed with deeper and longer-lasting roots than the Stuart generations.

82 Sir Anthony van Dyck, *Algernon, 10th Duke of Northumberland*

Earls of Essex; now Duke of Northumberland, Alnwick Castle (bought in 1900)

outstanding pictures by Titian from the estate of Van Dyck, who had died in 1641: these were *The Vendramin Family* (NG London; fig. 80) and *Perseus and Andromeda* (Wallace), which cost £200. By 1657 he bought from one of the King's creditors three pictures from Whitehall Palace: Polidoro's *Psyche Abandoned on a Rock*, Giulio Romano's *Sacrifice of a Goat to Jupiter*

Chapter 6

THE RESTORATION 1660–88

The Restoration of the monarchy in 1660 is sandwiched between two heroic periods of British collecting and as Horace Walpole wrote, 'it brought back the arts, not taste'.[1] The quality of art commissioned and collected was not always high, but it represents the last era of the Court as the fountainhead of patronage. The terms under which the new King, Charles II, accepted the throne provided a precarious balance of power with Parliament which was finally tilted in favour of the latter with the departure of his brother, James II, and the arrival of William of Orange in 1688. Power inexorably shifted in favour of the Whig party and its adherents. The reign of Charles II was a period of great scientific and cultural progress, the era of Sir Christopher Wren, Sir Isaac Newton and the foundation of the Royal Society. The defining event of the period was the Fire of London in 1666 and the subsequent rebuilding absorbed much of the energy of the court. The fundamental achievement of Charles II was to promote the genius of Wren but the tragedy is that the King was never powerful enough to re-cast the plan of the city. Wren's churches and St Paul's Cathedral nevertheless remain the great artistic legacy of the period just as the comedies of the Restoration stage transformed England's theatrical heritage.

The first instinct of the newly restored King Charles II was not so much to collect art as to recover what had been lost during the interregnum. He returned to England in 1660 and on 9th May appointed a Committee to facilitate the process of recovering his father's art collection. Many important works of art including Bernini's *Bust of Charles I* and Tintoretto's *Esther* were returned. Some had never left, including the Raphael

King Charles II

The Duke of York, later King James II

Sir Peter Lely

Taste for Landscapes

1st Earl of Clarendon

1st Duke and Duchess of Lauderdale

Samuel Pepys

2nd Earl of Sunderland

1st Duke of Montagu

83 *Jan Siberechts, Wollaton Park and Hall*
Thomas Willoughby, 1st Lord Middleton; now Yale Center for British Art, New Haven

Cartoons and Mantegna's *Triumphs of Caesar* cycle, which had been earmarked for the Protector. The Royal Collection soon numbered 1000 paintings, although, as the King pointed out to a visitor, it was only half of what his father had owned. The style of the new court aspired – on more modest means – towards the court of Louis XIV, but oscillated between French and Dutch taste; beyond the capital, the latter prevailed.

In anticipation of his return Charles made a bulk purchase in Breda of 71 mostly Dutch and Flemish paintings in April 1660, which included Pieter Bruegel the Elder's wintry *Massacre of the Innocents* (fig. 84). The states of Holland supplemented this for diplomatic reasons with the celebrated 'Dutch Gift' in the same year which brought a group of Venetian Old Master paintings – including works by Titian, Veronese and Giulio Romano, and most strikingly Lorenzo Lotto's *Portrait of Andrea Odoni* (fig. 85) – and Dutch works by contemporary artists such as Dou. When it came to commissions, Charles II preferred landscapes and marine paintings that recorded places and events with which he was associated, typically views by Danckerts, the leading topographical artist of the period, and naval battle scenes by Willem van de Velde the Elder and the Younger. The King had many unaffordable architectural plans but his rebuilding of Windsor Castle was a major artistic achievement (fig. 87). He commissioned Antonio Verrio, the leading available Italian decorative painter of the period, to paint the walls and ceilings. Sadly most of Charles II's work at Windsor was later swept away by George IV.

The King's brother, The Duke of York, who succeeded him in 1685 as King James II, was a Roman Catholic whose religious zealotry became unacceptable to his subjects. He hung Domenichino's *St Agnes* in his bedchamber and received paintings which had belonged to Cardinal Barberini. His most important commission was the Baroque chapel at Whitehall, with large paintings by Benedetto Gennari (who was to follow him into exile at St Germain), and which was itself destroyed in the Whitehall fire of 1698. James II was succeeded by his daughter Mary and her Dutch husband, the Prince of Orange, who became William III. With the exception of a quantity of blue and white porcelain (see chapter 18), they added little to the Royal Collection

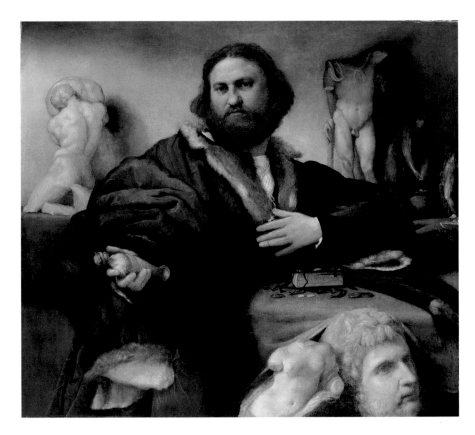

but they bought Kensington Palace and rebuilt Hampton Court.

No painter is more associated with the silk and russet of the Restoration court than the painter of Dutch origins, Sir Peter Lely (1618–1680). He arrived in England around 1641, the year of Van Dyck's death, and accommodated both royalists and parliamentarians with such success that in 1661 he became Principal Painter to the King. But Charles II's patronage was outdone by his brother

84 Peter Brueghel the Elder, *Massacre of the Innocents*
Charles II; now Royal Collection

85 Lorenzo Lotto, *Portrait of Andrea Odoni*
Charles II (part of the 'Dutch Gift'); now Royal Collection

86 Sir Peter Lely,
King James II
National Portrait Gallery

87 The King's Dining Room at Windsor Castle

88 Raphael,
The Three Graces
Sir Peter Lely; now Chatsworth House, Derbyshire

James II (fig. 86), who commissioned Lely to paint not only the court *Beauties* but also thirteen admirals. The artist was a considerable collector in his own right and had bought from the sale of Charles I's collection works by Veronese, Tintoretto, Caroselli and Feti, and Van Dyck's *Cupid and Psyche*. All of these he was obliged to hand over to the new King.

More unusually, Lely had bought large quantities of drawings from the collections of Lord Arundel and Nicholas Lanier. He formed the first important drawing collection in England put together by an artist, including works on paper chiefly by Italian artists, among them Leonardo, Veronese, Raphael (fig. 88), Correggio, Parmigianino and Primaticcio. Sound draughtsmanship was the basis of Lely's own art, and Charles Beale, a contemporary painter, thought his collection the best in Europe.[2] Although earlier collectors used symbols to identify their ownership, stamped discreetly on the sheet, it is with Lely's collection that we see the first use of initials as a collector's mark. Roger North, one of Lely's three executors, described how 'with a letter stamp marked P.L. and some printing ink, I stampt every individual paper… the particulars of all wch were near 10,000'.[3] Lely's drawings were sold by auction in 1688. Another artist-collector was Prosper Henry Lankrink, who arrived from Antwerp in the mid-1660s, bringing with him his drawings, some of which he had bought at the sales of the collections of Rubens and Rembrandt. Lankrink's drawings were mostly 16th- and 17th-century Dutch and Flemish landscape, still-life and flower pieces, and sixteen works attributed to Lely, five to Rembrandt and thirteen to Rubens.

Lely's painting collection contained a mixture of Venetian, Flemish and Dutch works. The largest number was by Van Dyck (whom he had emulated so much as a painter) including his *modello* for the Garter Procession and 37 of the sketches of the

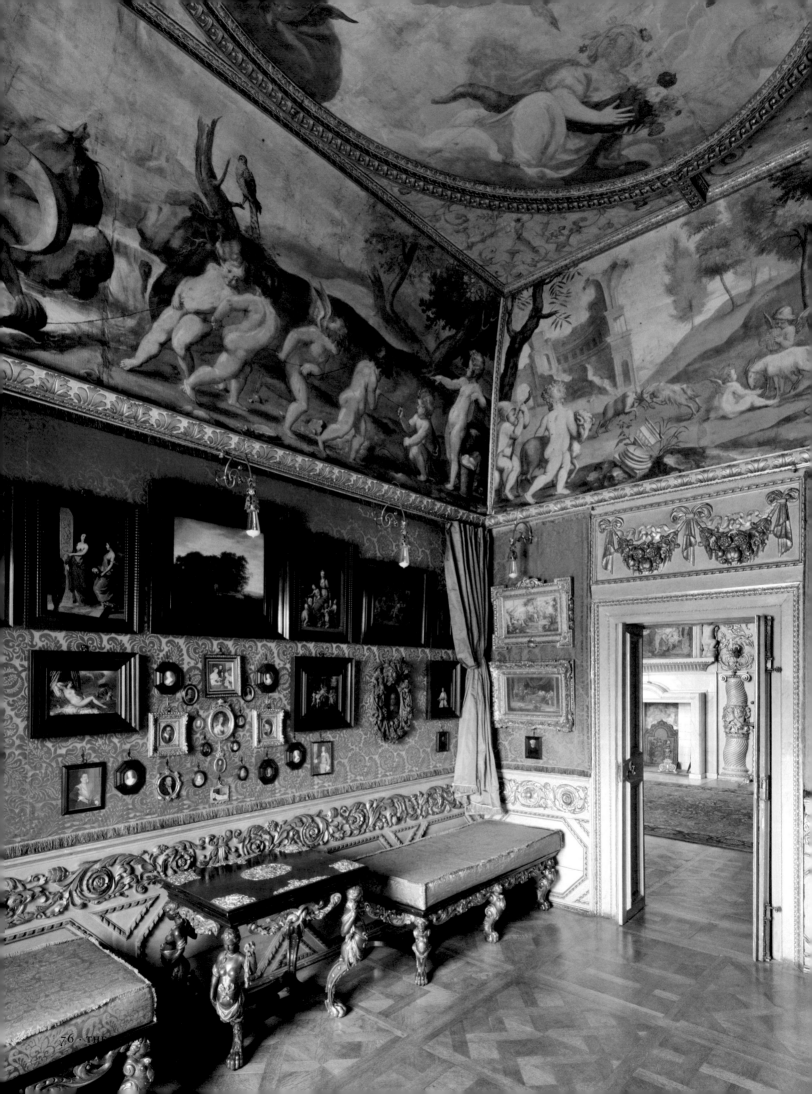

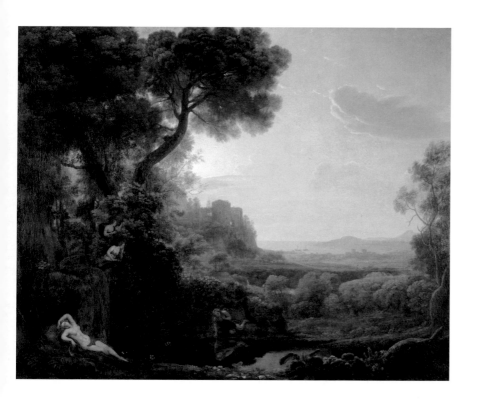

89 The Green Closet
at Ham House

90 Claude Lorrain,
*Landscape with Narcissus
and Echo*

Commissioned by an unidentified
Englishman; probably in Sir Peter
Lely's collection; now National
Gallery, London

Iconography (today mostly at Boughton House). The collection was auctioned in 1682, realising £6,000. The Lely sale was not the first in London, but it started the fashion for high-profile single-owner auctions in England which has never abated. The popularity of art auctions, which had been earlier established in the Netherlands, steadily rose in the capital from the one recorded in 1684 to a peak of 92 in 1691, indicating the vigorous growth of the London market.[4]

Another interesting component of Lely's collection was his landscape paintings by Claude Lorrain (*c*.1602–1682), which puts him among the pioneer collectors in Britain of this artist, who was to become one of the most pervasive of national tastes. An unidentified Englishman had commissioned two Claude landscapes in 1644, *Landscape with Narcissus and Echo* (NG London; fig. 90) and *A Temple of Bacchus* (NG Ottawa), and these may have entered Lely's collection. The Earls of Northumberland and Melfort were early owners of Claude, and his growing popularity may be gauged by the fact that his auction prices had risen to £200 in the 1680s. The taste for imaginary landscapes dated from the reign of Charles I and was exemplified by the work of Cornelis van Poelenbergh, Jan Brueghel and Adam Elsheimer, which contrasted with the topographical exactitude of Hollar. The prevailing taste at the Restoration was for ideal landscapes, usually by Dutch Italianate artists such

as Nicolas Berchem and Adam Pynacker, although Charles II preferred topographical views. We see the emergence of an English landscape school and the birth of the country house portrait in the work of Jan Siberechts, a Flemish artist working in England from the 1670s, who was patronised by Thomas Willoughby, 1st Baron Middleton, at Wollaton (fig. 83). The Dutch wars did not stem the steady flow of artists from the Low Countries who supplied not only landscape but the ubiquitous paintings of fowl and marine subjects. Even a patron as vehemently averse to the Dutch politically as Lord Clifford avidly collected such works and commissioned Gerrit van Roestraten to paint genre scenes.

Apart from landscapes, the dominant feature of restoration collections remained portraits. The most famous was formed by the Earl of Clarendon, whose interests as the historian of the Civil War were primarily iconographic rather than artistic. He housed it in the most splendid London palace of the time, Clarendon House on Piccadilly, built for the Earl by Roger Pratt. John Evelyn visited it in 1668: 'I dined with my Lord Cornbury [Clarendon's son] at Clarendon House, now bravely furnish'd; especialy with the Pictures of most of our Antient & Modern Witts, Poets, Philosophers famous & learned English-men'.[5] Many readers of his *History of the Rebellion* created their own portrait gallery by extra-illustrating it with their own prints of the people described.

The first recorded paintings by Nicolas Poussin in England also date from the second quarter of the 17th century. In 1639 the Marquess of Hamilton acquired a '*quadro d'amorini di monsù Poussino*', probably the copy now at Wilton. Writers such as Sir William Sanderson and John Evelyn attest to his reputation in the mid-century but early references to 'Poussin' are as likely to refer to Gaspard Dughet as to Nicolas. Evelyn's *Diary* on 24th January 1685 refers to a Poussin of *Christ*, belonging to Lord Newport, which may be the earliest known reference to an autograph work. But it was not until the 18th century that the appetite for Poussin's paintings spread.

The variety of Restoration patronage and collecting may still be seen at Ham House, Surrey, a rare survivor on the fringes of London (fig. 89). The Duke of Lauderdale (1616–1682) and his wife, the Countess of Dysart (1626–1698), redecorated

the house in the 1670s plastering it with paintings, employing mostly Dutch artists, although Antonio Verrio provided the decorative scheme for the White Closet. Lauderdale was Scottish Secretary, an ambitious man married to a rapacious wife, whose passion for redecorating their many seats was 'considered to be fundamental to the Duke's projection of power'.[6] An array of versatile and obscure Dutch artists were available to the couple and two of them, Dirck van der Bergen and Abraham Begeyn, painted more than 40 inset paintings over doors and chimneys depicting animals and pastoral and harbour scenes. These were complemented by marine paintings by Willem van de Velde the Younger and battle scenes by Thomas Wijck. The Ham House inventory around 1680 already records 182 paintings. The main internal feature is the long gallery with its 22 portraits, mostly by Lely, in their distinctive auricular frames. The interiors show a leaning towards the new *Chinoiserie* fashion with japanned stools and 'oriental' furniture. The cabinets, chairs and objects demonstrate the very high quality of the decorative arts during the Restoration period.

An excellent example of a grand bourgeois collection is provided by the diarist Samuel Pepys (fig. 91). He started collecting prints in the 1660s – affordable and available in great quantity in the capital – as well as furniture and tapestries for his new house. Pepys was soon commissioning portraits of himself and his family, followed by portraits of his superiors at the Admiralty, the Duke of York and Lord Sandwich. Given his position as a naval administrator, marine paintings were a natural choice, but Pepys's most ambitious commission was a set of views of royal palaces by Hendrick Danckerts for his dining room. The inventory taken at his death records 61 paintings; over half of them were portraits. Pepys's fame as a collector today rests on his book and print

91 John Hayls,
Samuel Pepys
National Portrait Gallery

92 Samuel van Hoogstraten,
A View Down a Corridor
Dyrham Park, Blathwayt Collection
(National Trust)

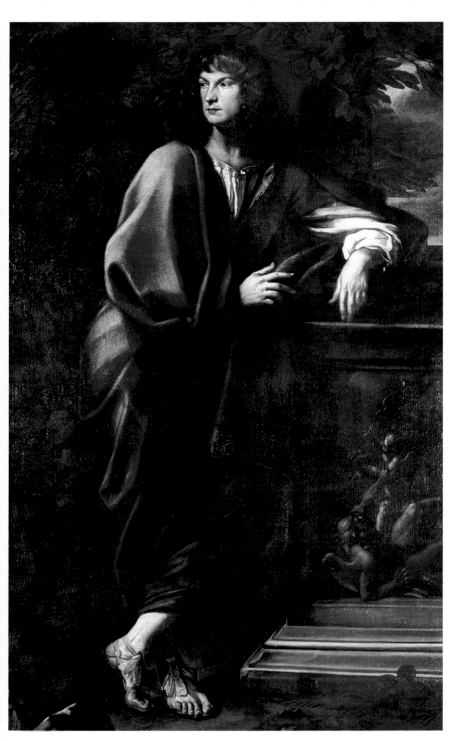

93 Carlo Maratta,
Portrait of Robert, 2nd Earl of Sunderland
Spencer collection, Althorp, Northamptonshire

collection, which happily survive at Magdalene College, Cambridge. He accumulated about 10,000 prints, an encyclopaedic collection of portraits, marine, topographical and landscape views, and humorous themes.

Pepys's tastes were typical of this age and not especially advanced. He admired portraits that were 'very like' and took particular pleasure in the illusionist *trompe l'oeil* painting by Samuel van Hoogstraten belonging to his friend Thomas Povey (fig. 92). 'Above all things,' Pepys wrote, 'I do admire his piece of perspective especially, he opening me the closet door and there I saw that there is nothing but only a plain picture hung upon the wall.'[7] The painting is now at Dyrham Park, which with its Delftware, dark furniture and large paintings by Hondecoeter provides an atmospheric example of Restoration taste. The great antiquarian collection of the age belonged to Pepys's friend, John Evelyn, who preferred prints and medals to paintings for their accuracy. Evelyn represents a new type, 'the virtuoso', a gentleman who studied the historical past and engaged with the scientific present. Evelyn visited many art collections both in England and on the Continent, but his descriptions are tantalisingly brief. He remains a central cultural figure by virtue of his writings, his broad antiquarian interests and his benign influence in persuading the 6th Duke of Norfolk to give the Arundel marbles to the Ashmolean Museum.

If the prosperous bourgeoisie like Pepys were Dutch in their tastes, the higher nobility preferred France and the court workshops of Louis XIV. Several French painters, such as Henri Gascars and Largillière, came to London from Versailles providing a dazzling image of a court which could only remain a dream or dangerous mirage to English kings. Robert, 2nd Earl of Sunderland, was an ambassador who sat for his portrait to Carlo Maratta in Florence in 1664 (fig. 93), and in Paris bought Sébastien Bourdon's *Deposition* and Charles Le Brun's *Martydom of St Andrew*, which he also placed in his remodelled home at Althorp in Northamptonshire. Today he is best remembered for purchasing Holbein's *Henry VIII* (Thyssen) and for the frame pattern named after him which was utilised for the portraits in his gallery at Althorp.

The greatest exponent of French taste was Ralph, 1st Duke of Montagu (1638–1709), who served as an ambassador to France four times between 1666 and 1682. The Duke started conventionally enough by employing as his architect Robert Hooke, a collaborator of Wren, to build his great house in Bloomsbury, which was enriched with the inevitable Verrio decorations. John Evelyn thought that for the contents 'there was nothing more glorious in England'. After a fire in 1685, the Duke decided to rely completely on French taste. He brought over from France a large team of architects and craftsmen, including the court painter fresh from Versailles, Charles

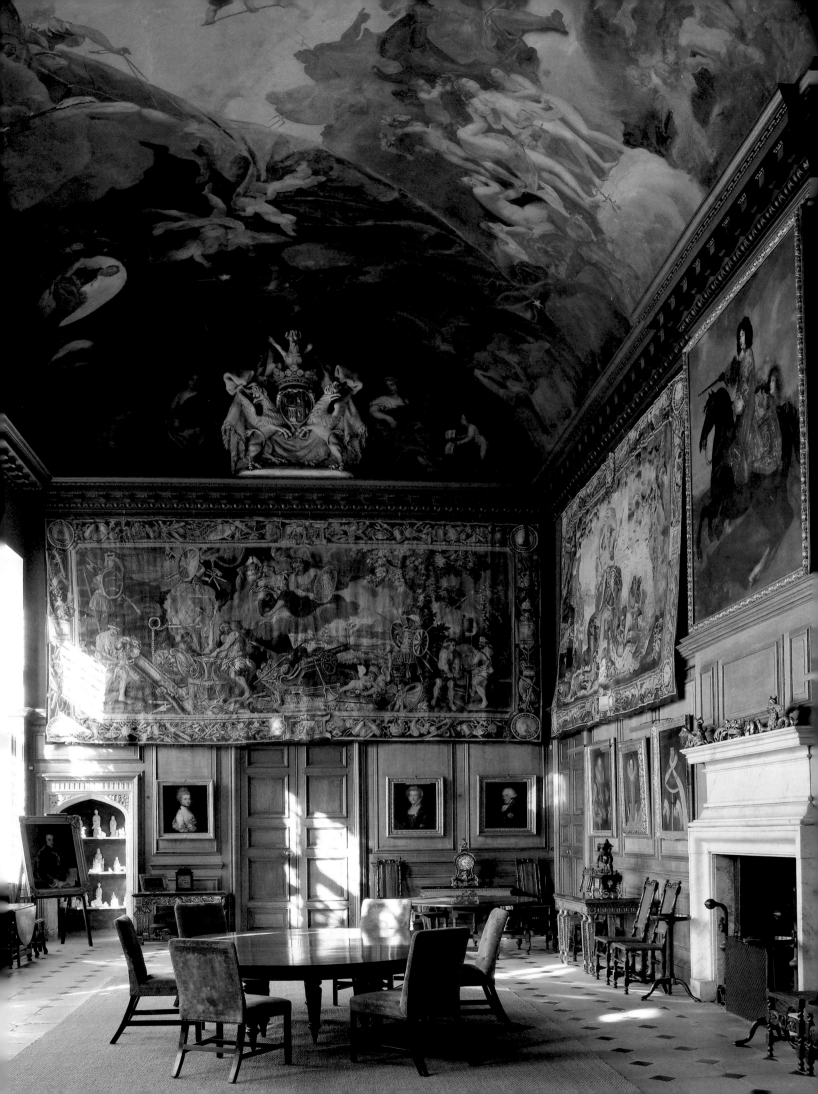

de La Fosse, who painted the staircase (fig. 95). Many wondered whether the Duke was actually in the pay of Louis XIV, which is ironic given that he was a great patron of the Huguenot craftsmen who poured into London after the revocation of the Edict of Nantes in 1685. Among those whom Montagu brought over was the Huguenot flower painter, Jean-Baptiste Monnoyer, to paint decorations for Montagu House. Monnoyer's flower compositions became a great favourite with English patrons and there are many of his works at Boughton and Burghley today (fig. 96). The Duke had a large painting collection and bought the lion's share of the Van Dyck *grisaille* portraits from Lely's sale. Montagu House contained what is now the British Museum from the 1750s, and the building was pulled down in the 19th century to make way for Robert Smirke's classical temple, but paintings by La Fosse commissioned by Montagu may be found today at Basildon Park.

The Duke's own country house, Boughton, has survived in extraordinary purity. Louis Chéron painted the hall (fig. 94), and there is circumstantial evidence that some of the early Boulle furniture was bought by Montagu. Louis XIV presented Charles II with several important pieces and may have given Montagu a bureau by Pierre Gole. Montagu House and Boughton well demonstrate the shift at the end of the century from the Dutch style of the Duke of Lauderdale to French taste which, paradoxically, William of Orange encouraged by his constant patronage of the architect and designer, Daniel Marot. It was French Baroque taste which informed the next generation of country house builders who patronised Vanbrugh, Hawksmoor and Talman.

94 The Great Hall at Boughton House, Northamptonshire, with ceiling painted by Louis Chéron

95 The staircase at Montagu House, painted by Charles de La Fosse for the 1st Duke of Montagu

96 Jean-Baptiste Monnoyer, *Flowers with a Parrot*
1st Duke of Montagu; today still at Boughton House, Northamptonshire

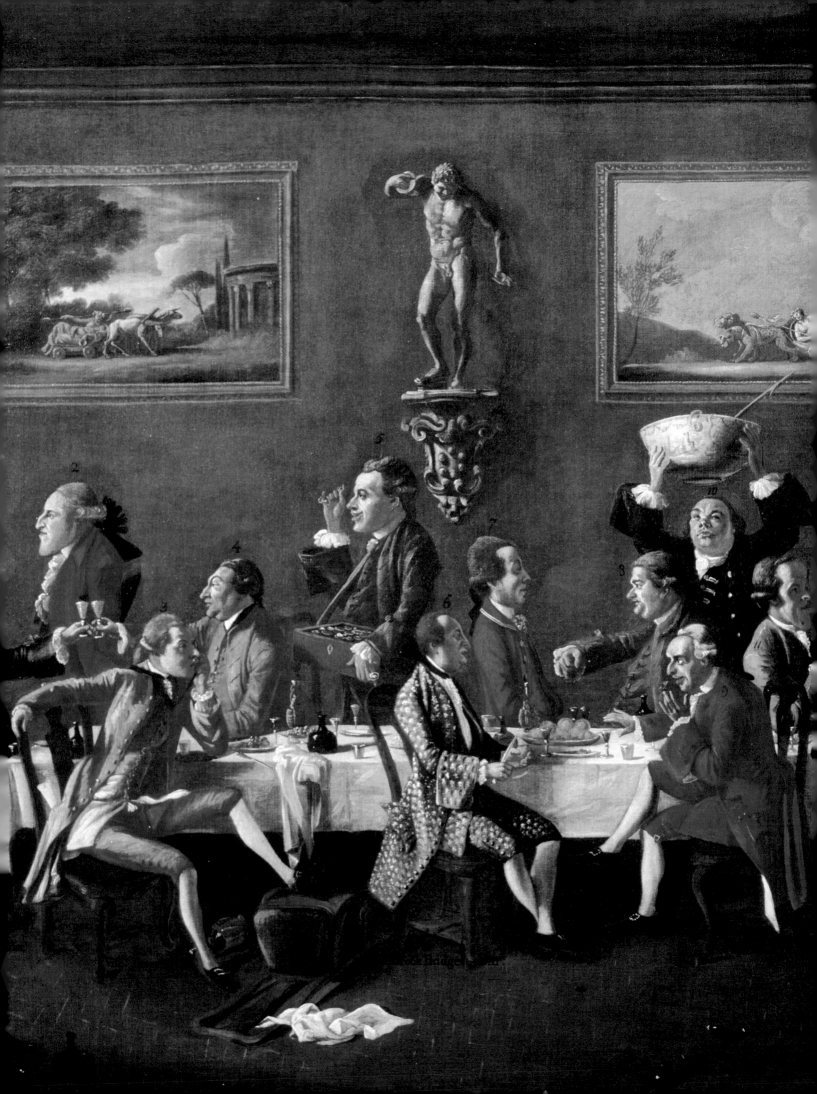

Part Two

ARISTOCRACY

The Country House Boom

Chapter 7

THE GRAND TOUR: THE FIRST PHASE

One of the most striking and attractive episodes of British collecting is the Grand Tour. The habit of travelling to Italy, usually via the Low Countries and France, developed in the 17th century but only became established in the following century. The ferocity of religious conflict had abated, passports were issued with greater ease and the Grand Tour became the principal means by which young Englishmen acquired culture, taste and experience. As Dr Johnson said, 'All our religion, all our arts, almost all that sets us above savages, has come from the shores of the Mediterranean'.[1] The love affair with Italy developed into a systematic and revelatory process whereby young Englishmen discovered art, architecture, manners and sex, freed from parental control – albeit under a tutor – and mingled not only with their peers but also artists and men of learning.

The early 18th century was the age of the consummate *amateur*, when a playwright, Sir John Vanbrugh, could turn to architecture to please a friend, and a noble Earl, Lord Burlington, could design his own villa. It is their confidence that strikes us as much as the amounts of money that the Grand Tourists were prepared to spend. Britain emerged from the wars of Louis XIV as the richest country in the world but with an uninspiring constitutional monarchy. The aristocracy, increasingly fed a diet of the classics in their formative years, chose to identify with Ancient Rome and the reign of the Emperor Augustus who gave his name to the Augustan age. This period of the early 18th century combined exuberant art collecting with stoic self-control. The young men read Cicero and occasionally had themselves portrayed wearing a toga. During the first phase the Grand Tour was

3rd Earl of Shaftesbury

Sir Thomas Isham

5th Earl of Exeter

Andrew Fountaine

Thomas Coke, 1st Earl of Leicester

3rd Earl of Burlington

4th Earl of Carlisle

Canaletto and View Paintings

Batoni Portraits

Sir Francis Dashwood

Henry Hoare the Younger of Stourhead

97 Pompeo Batoni, *James Caulfield, 4th Viscount Charlemont (later 1st Earl of Charlemont)* Yale Center for British Art, New Haven

motivated by an enthusiasm for Roman history and literature rather than archaeological discovery.

Feelings in the Augustan age were restrained but spending was prodigal. The greatest collections were assembled by travellers like Lord Burlington whose fathers had died and who could therefore draw on greater resources. A striking aspect of Grand Tour collecting is that it nearly always had a country house as its focal point; sometimes art was bought to fill a newly built house like Castle Howard in Yorkshire, or provided the motivation for creating one, as in the case of Holkham Hall in Norfolk (fig. 98). The great country houses reflected the political primacy of an educated oligarchy who saw themselves as the successors to the Roman Senate, building and creating for posterity. The obsession of the early 18th-century connoisseurs with architecture was complemented by an enthusiasm for poetry and music. The case that it was a purely Whig oligarchy is harder to make. By virtue of office the Whigs were richer, but Tories like Lord Exeter also went abroad for years on end. It was clear from the outset that the succession of the House of Hanover in 1714 to the throne of Great Britain would initially have little impact on the arts and that the aristocracy, rather than the crown, would be the mainstay of patronage.

Since the Reformation the word had assumed precedence over the image in England. This changed largely due to one book, *Characteristics of Man, Manners, Opinions, Times*, published between 1711 and 1714 by Anthony Ashley Cooper, 3rd Earl of Shaftesbury, a pupil of John Locke. This influential work argued in three volumes that 'the Science of *Virtuoso's*, and that of Virtue itself, became, in a manner, one and the same'. In future, art and virtue came to be regarded as inseparable, an idea followed up by manuals of taste such as that by the painter and collector Jonathan Richardson whose *Account of the Statues, Bas-reliefs, Drawings and Pictures in Italy* (1722) was the most popular guide of its kind. If Venice had been the focus of collecting for the earlier Whitehall Circle, by the end of the 17th century Rome was the main attraction. Richardson – and the earlier authors of Italian guides, William Aglionby and Richard Graham – praised the Bolognese school, especially Annibale Carracci and Guido Reni, whom they saw as the lineal heirs of Raphael. Richardson thought less of the great 16th-century Venetian artists and this was to be reflected in patterns of collecting in England. Contemporary Venetian art was a quite different matter and many Venetian artists, notably Pellegrini, Amigoni, Sebastiano and Marco Ricci, and later Canaletto, were attracted to England.

There has seldom been such a willing transfusion from one culture to another and its visual remains are everywhere to be seen in Britain. The collectors of the Caroline Whitehall Circle relied heavily on a network of well-informed agents. The Grand Tourists found agents and guides waiting in Rome for their arrival, usually in the English coffee house on the Piazza di Spagna. They were often British artists or architects whose judgement and cunning enabled the young travellers to ship home collections of variable quality. These *Ciceroni* worked closely with Italian artists and workshops;

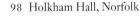

98 Holkham Hall, Norfolk

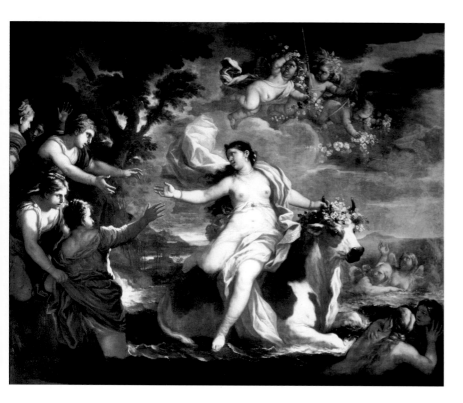

99 Luca Giordano,
Rape of Europa
Burghley House, Lincolnshire
(bought by the 5th Earl of Exeter)

an enormously popular genre with English Grand Tourists, who commissioned portraits by Rosalba Carriera in Venice and Pompeo Batoni and Anton Raphael Mengs in Rome.

A grander and more important figure was John Cecil, 5th Earl of Exeter (1648–1700) whose collection remains *in situ* at Burghley House. His taste in Italian contemporary art was similar – and he even used the same Roman agent as Isham, a Signor Talbot. Exeter's passion was shared by his wife Anne Cavendish, daughter of the 3rd Earl of Devonshire. Although her family were staunchly Whig, Exeter was a Tory who opted out of public affairs and took to travelling and collecting instead. In 1679 he sailed by private yacht with 22 servants and visited Lucca, Padua, Florence and Rome. He commissioned Carlo Dolci's *Adoration of the Magi*, and on his second Italian journey commissioned a further eight works by the artist including *The Flight into Egypt*. Dolci had already painted portraits of two Englishmen, Sir John Finch and Sir Thomas Baines (Fitzwilliam). In Florence the Earl attended the court of the Anglophile Grand Duke Cosimo III of Tuscany, and such was the rarity of noble English visitors at that time that Cosimo presented him with the magnificent ebony pietra dura Roman cabinet (*c.*1680) made in the Ducal workshops. While he was in Florence, Exeter bought two enormous works by Luca Giordano, *The Rape of Europa* (fig. 99) and *The Death of Seneca*, and commissioned a further thirteen. In Naples he bought still lifes from Giuseppe Recco and in Rome several Marattas (fig. 100). Horace Walpole later summarised the Earl's collection as mostly Giordano 'and the scholars of Maratta'. The buying continued through Bologna, Padua, Venice (paintings by Pietro Liberi) and Genoa. Back in England, Lord Exeter commissioned Antonio Verrio to decorate a suite of rooms at Burghley, where he produced his masterpiece, the Heaven Room. The Earl returned to Italy between 1683 and 1684 and gave commissions to Trevisani and Chiari. It was on his final journey of 1699–1700 that he commissioned the French sculptor Pierre-Etienne Monnot for a group of marbles, including a funerary monument depicting the Earl and Countess in Roman dress. Exeter's collection, the most important surviving from this time, illustrates well the early 'Maratta' phase of Grand Tour collecting, before the focus

they knew the local collections well, and generally oiled the wheels for acquiring works of art. Some became rich and famous in their own right.

One of the most interesting late 17th-century travellers to Italy whose collection survives is Sir Thomas Isham, 3rd Baronet (1656–1681), a Northamptonshire squire who inherited the family seat, Lamport Hall, rebuilt from 1655 in an early Jonesian-Palladian style by John Webb. Isham was away for three years, arriving in Rome in 1677 where he spent twelve months. The city had witnessed a reduction in the wealth of the Papacy and the families who depended on Papal patronage. In consequence, Italian artists sought new markets, particularly the newly rich German princelings who were the most voracious buyers of the time. Isham, without huge resources, bought twenty paintings in Rome. Roughly half were originals by Rosa, Lauri and Brandi, and the rest were copies after Raphael, Reni, Domenichino, Guercino, Poussin, Lanfranco and Cortona. The taste for copies – so alien to modern aesthetics – reveals a preference for images, often by Raphael, that were otherwise unavailable. Isham persuaded Carlo Maratta to paint his portrait but he was not the first Englishman to do so. There are two portraits by him from 1664 at Althorp, *The Earl of Roscommon* and *Lord Sunderland*. Although resented by the leading Roman painters, these portrait commissions presaged what would become

shifted to the pursuit of landscapes, view paintings, and, somewhat in the manner of Arundel, swagger portraits and antiquities.

Sir Thomas Isham and Lord Exeter were pioneers, but by the next generation there is the sense of an established custom. The neighbourly nature of the Grand Tour is demonstrated by the proximity of so many Norfolk travellers including members of the Windham family of Felbrigg Hall, the Walpoles of Wolterton, and the Cokes of Holkham. At the centre of this group was one of the most attractive of the early 18th-century Grand Tourists, Sir Andrew Fountaine (1676–1753) of Narford Hall, the scion of an old Norfolk family who was a friend of Lord Burlington, mentor to Thomas Coke, and the very model of the gentleman antiquarian and virtuoso. Fountaine's first Grand Tour took place between 1701 and 1703, when he befriended the philosopher Leibniz in Berlin and was drawn by Maratta in Rome. Fountaine's main interest was in coins and medals, that microcosmic confluence of archaeology, antiquarianism and art.

Andrew Fountaine returned to Florence in 1714 where he commissioned a classic Grand Tour portrait, *Sir Andrew Fountaine and Friends in the Tribuna of the Uffizi* by Giulio Pignatta (fig. 102),

which anticipates Zoffany. He developed a passion for maiolica, of which – with the exception of Lord Arundel – he was the first British collector (fig. 101). To these, Fountaine added bronzes, paintings by Maratta and, rather surprisingly for such a cerebral collector, a series of eleven canvases by Giovanni Antonio Pellegrini, whose easy fluid style brought Venetian sunlight into a Norfolk country house. The artist had been brought to England by the 4th Earl (later 1st Duke) of Manchester in 1708 to paint the walls of his London house in Arlington Street and the staircase at Kimbolton Castle. The large canvases for the saloon at Narford show a mixture of Old Testament subjects and mythology (Ovid and Ariosto) and were almost certainly a gift from Lord Burlington. Towards the end of his life Fountaine wrote, 'As I am no sportsman, I pass my life time in building and improving the ground about my house, which emptys my Pockets, but at the same time gives me the satisfaction of employing a great many poor people.'[2] A perfect Augustan sentiment.

The giant of the Norfolk collectors was Thomas Coke (1697–1759), who was just ten when he inherited great wealth but no seat or title. His story is a seminal case of the creation of a great house and collection through the Grand Tour. It begins

100 Carlo Maratta,
Christ and the Woman of Samaria at a Well
Burghley House, Lincolnshire
(bought by the 5th Earl of Exeter)

101 Part of Andrew Fountaine's collection of maiolica as displayed in the China Room, Narford Hall, Norfolk, photographed before its sale in 1884

102 Giulio Pignatta,
Sir Andrew Fountaine and Friends in the Tribuna of the Uffizi
Sir Andrew Fountaine;
now Narford Hall, Norfolk

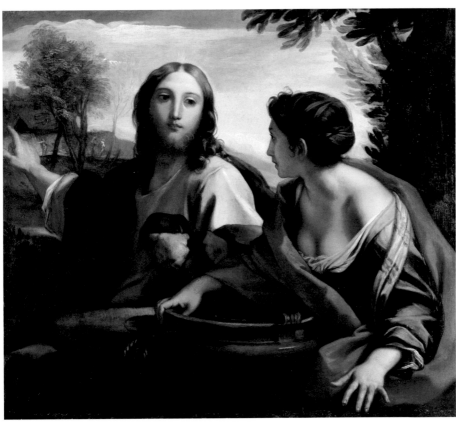

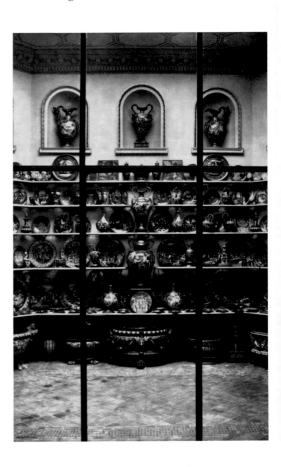

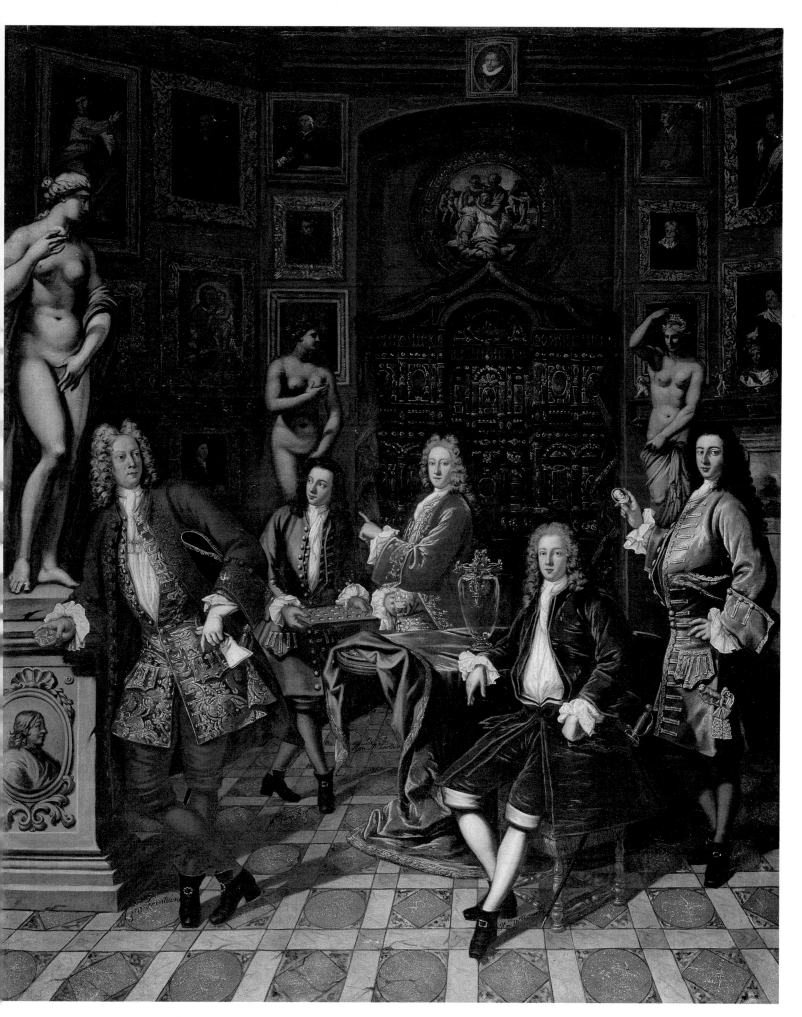

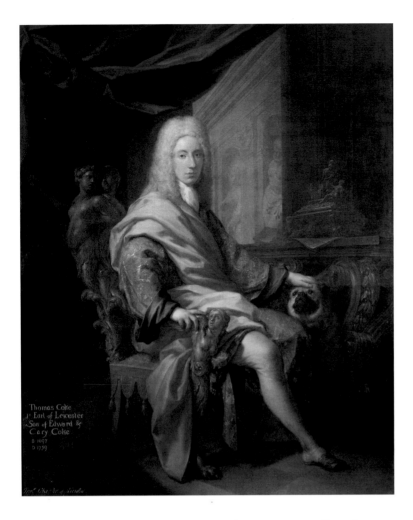

in an exemplary manner and ends in sadness, dominated by the one great task that Coke gave himself: to build and furnish Holkham Hall. Even after the death of his son, when he was without an heir, Coke never wavered in his devotion to this task. He was a staunch Whig who was created Lord Lovell in 1728 by George II, and Earl of Leicester in 1744. He was equally at home at court or in a tavern and enjoyed aesthetes and philistines with the same relish. Lord Leicester was a heavy drinker who fell out with his son and was cold to his wife, but he was also a connoisseur of great discrimination in architecture, art and books whose choices resonate with us today.

Never was a grand tour better planned or more effective than Coke's first visit to Italy aged 15, which lasted six years between 1712 and 1718. Accompanied by a model companion and tutor, Dr Thomas Hobart, Coke purchased works of art in two campaigns, firstly between 1714 and 1717 when the idea of Holkham was forming in his mind, and 30 years later when he spent large sums in Rome on paintings and sculpture to decorate the house. In Rome in 1714 he commissioned Sebastiano

Conca's enormous *The Vision of Aeneas in the Elysian Fields*, in which Coke himself appeared. At about this time he met William Kent with whom he was later to plan Holkham. Coke visited the Roman palaces and bought views of them as well as paintings by Procaccini, Garzi, Conca and Luti. By the end of his visit he wrote, 'I have become, since my stay in Rome, a perfect virtuoso, and a great lover of pictures...' but he also indulged in his two other passions: music and book collecting.[3] Thomas Coke was an outstanding collector of manuscripts, buying a group of 40 from the convent of the Discalced Augustinians at Lyon in 1715 and, in 1719, the manuscript which became known as the Codex Leicester by Leonardo Da Vinci. He was to own 800 manuscripts and 10,000 printed books, with a focus on grand humanist manuscripts and early Italian printed books by Jenson and Aldus.

Thomas Coke was portrayed by Trevisani in 1717 with the head of a marble *Niobe* which indicated a new departure in his collecting, antique sculpture (fig. 103). He bought several pieces in Rome, including one major work, a full-length *Diana*

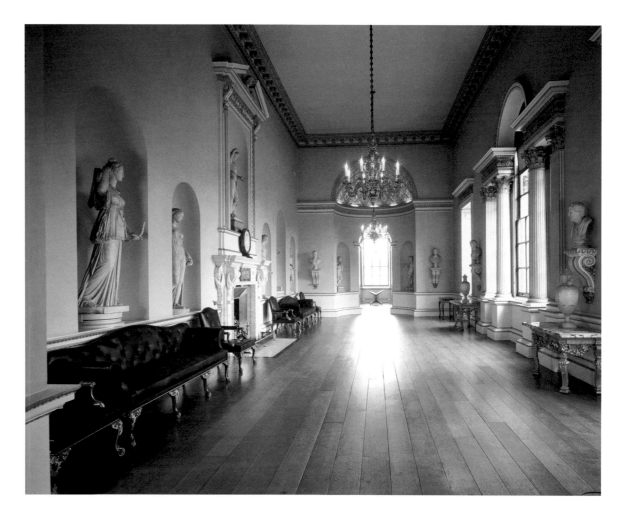

(fig. 104), which gave rise to the legend of Coke's arrest when his agent tried illegally to export it. This unlikely tale demonstrates the increasing difficulty of acquiring good antiquities. In 1686 Pope Innocent XI issued an edict restricting their export, which was strengthened by Clement XII in 1701 and again in 1704, although this did not prevent deals and bribery. Under the circumstances it is remarkable how much ancient sculpture arrived in England in the early 18th century. In Naples, Coke commissioned further paintings from Garzi, Chiari and Solimena and bought views by the precursor of Canaletto, Gaspar van Wittel, known as Vanvitelli. On the way home in Paris he purchased Van Dyck's great equestrian *Portrait of the Duc d' Arenberg* which remains the centrepiece of the saloon at Holkham facing one of Coke's later purchases, the *Flight Into Egypt* by Rubens.

Returning home in 1718, Coke married Lady Margaret Tufton, daughter of the 6th Earl of Thanet and in 1729 fenced and planted the park at Holkham. He delayed the building of the house until 1734, owing to his loss of £70,000 in the South Sea Bubble of 1720. Holkham Hall has four

parents – Lord Burlington, William Kent and Matthew Brettingham (who was clerk of works), but above all Lord Leicester himself, who inspired it and approved every detail. It was built around the art collection, and the two are inseparable. Architecture was a serious aspect of his study in Italy and the house has many novelties. The chaste sculpture gallery with its niches (fig. 105) represents a milestone in the display of sculpture in England, a grander version of Kent's gallery at Chiswick. To fill it, Lord Leicester bought such important pieces as the bust of *Thucydides* and the statues of *Neptune* and *Marsyas*. It may have been the memory of the Salone di Poussin at the Palazzo Doria in Rome that inspired the landscape room filled with works by Gaspar Dughet, Rosa, Domenichino, Locatelli, Vernet and six paintings by Claude Lorrain, including *Apollo and Marsyas*. The conception of Holkham resembles that of a great work of art: Roman hall, sculpture gallery, library, picture gallery and the surrounding landscape. It is Lord Leicester's totality of vision which commands our respect, but it brought him little joy and his life ended on a sad note. Living on a huge

building site, his son dead and his wife estranged, he wrote, 'It is melancholy living to stand alone in one's own Country. I look around, not a house to be seen but my own. I am Giant of Giant Castle and have ate up all my neighbours, my nearest neighbour is the King of Denmark.'[4]

Slightly older than Lord Leicester was his collaborator Richard Boyle, 3rd Earl of Burlington (1694–1753), who inherited at the same tender age of ten, but his life and achievements are much more complex (fig. 106). The latter was the model of Augustan reserve, yet led a revolution in taste both in architecture and gardening, and raised the status of artists in England, as well as being a practitioner himself. Didactic by nature, he operated a 'dictatorship of taste' by establishing the Palladian movement in architecture and decoration as a reaction against the swagger Baroque buildings of Vanbrugh and Hawksmoor. He holds a central position in English 18th-century culture – George Vertue called him 'the noble Maecenas of Arts' – and embodied Lord Shaftesbury's aristocratic virtuoso, laying down principles of neo-classical taste to the extent that Hogarth was moved to lampoon him.

The family wealth came from extensive estates in Yorkshire, Ireland, Chiswick and – most importantly – a parcel of leasehold land around his London home, Burlington House. There he gave house room to the composer Handel and in around 1711 commissioned Sebastiano Ricci to decorate the staircase. The Earl's first visit to Italy was between 1714 and 1715 in the company of two painters, Charles Jervas and Louis Goupy. It lasted only a year and resulted in a rather conventional haul of paintings by Pasqualino, Pietro Da Cortona, Viviani, Maratta and Chiari, as well as Annibale Carracci's *Temptation of St Anthony*, Domenichino's *Madonna della Rosa*, views by Vanvitelli and pastels by Carriera. To this group Burlington added porphyry vases, a harpsichord, a set of bronzes by Massimiliano Soldani-Benzi, a marble table and numerous other items. According to his account books he returned to Dover with over 800 trunks and crates.

Back in England, Burlington became preoccupied with architecture and the rebuilding of Burlington House, initially using the architect Colen Campbell and later William Kent for the interiors. Burlington also took to patronising the

poets John Gay and Alexander Pope. A second Italian visit of six months followed in 1719 specifically to study Palladio. Burlington bought all the architectural drawings he could find by Palladio and his followers and commissioned measured drawings of the architect's buildings (fig. 107). In 1720 the Earl also acquired John Talman's collection of architectural drawings by Palladio and Scamozzi and a book of Inigo Jones designs. These remained his prized possessions and it is largely on account of his architectural drawings that Lord Burlington is remembered as a collector.

The Earl met William Kent on his first Grand Tour and travelled with him on the second. The bluff Yorkshireman's ebullient character appealed to the cerebral Earl, and their friendship went beyond even that of Lord Arundel and Inigo Jones. It reveals Burlington in a more human light. The Earl secured his services, gave Kent

106 Jonathan Richardson, *Richard Boyle, 3rd Earl of Burlington and 4th Earl of Cork*
National Portrait Gallery

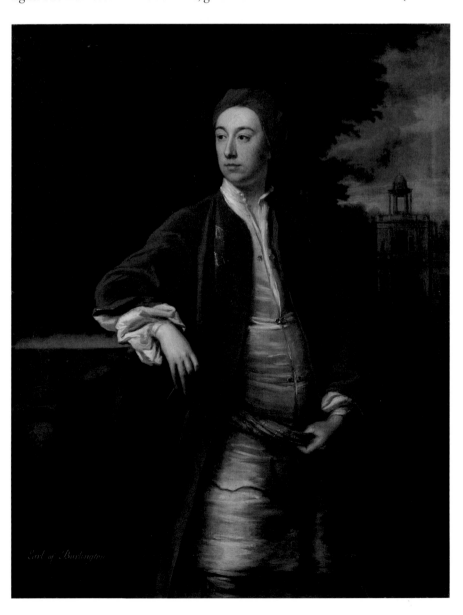

rooms at Burlington House and affectionately referred to him as 'the Signor' or 'poor Kentino'. Surprisingly, it was Kent's slender talent as a painter that Burlington initially championed. His merits as an architect, gardener and decorator seem to have only slowly dawned on Burlington, but their partnership – which is effectively what it became – produced Chiswick House, an English recreation of the Palladian villas in the Veneto (fig. 108). 'Too small to inhabit and too large to hang as one's watch' was Lord Hervey's verdict on Chiswick, where Burlington hung many of his favourite Italian *Seicento* paintings. Chiswick and Burlington House heralded the Palladian style that had such a long run in English architecture. The Earl patronised many London artists including the

sculptor Rysbrack and owned important Dutch and Flemish paintings by Rembrandt, Frans Hals and Cornelis de Vos. Much of his collection survives at Chatsworth since his daughter, Charlotte, married the 4th Duke of Devonshire. Burlington remains an enigmatic figure – he hardly ever wrote a letter – and although outwardly a Whig, he has recently been identified as possibly a closet Jacobite sympathiser.[5]

If Burlington and Leicester built their own palaces, one collector who inherited a house that needed to be filled was Henry Howard, 4th Earl of Carlisle (1694–1758). His father had built Castle Howard in Yorkshire and employed the Venetians Pellegrini and Marco Ricci to make wall decorations. The 4th Earl was to continue in the Venetian

mode but he was also interested in antiquities and his passion for Roman marbles was unleashed on his second visit to Italy from 1738, with further acquisitions coming through an extensive correspondence with agents. These he distributed around the hall at Castle Howard, but he was particularly fond of cameos and intaglios, one of which he clutches in his portrait painted by Hans Hysing.[6] In the grounds of Castle Howard, he built the Temple of the Four Winds, a Pyramid and the Mausoleum to echo the Roman landscape. Thus the family were not content only to buy works of art and sculpture in Italy; they went further and created the flavour of ancient Rome in the grounds. Perhaps his most striking purchase was Bernini's *Bust of Antonio dal Pozzo* (NG Edinburgh). Like other English collectors Carlisle was hampered by the lack of available antiquities and his collecting activities provide an excellent example of how the Italians tried to solve the problem of providing English travellers with goods to take home. If Sir Thomas Isham and Exeter were happy to buy available works by Maratta and Dolci which – portraits apart – took little account of English taste, the next

generation was treated to a specially developed Grand Tour blend of contemporary art, typically represented by the view paintings of Antonio Canaletto and the portraits of Pompeo Batoni.

Lord Carlisle never sat to Batoni but he was a voracious collector of Canaletto. In 1740 the Venetian antiquarian, Zanetti, dispatched no fewer than 17 of the artist's paintings to Yorkshire. Eventually the Venetian room at Castle Howard boasted almost 50 paintings attributed to Canaletto (fig. 110). Carlisle was rivalled in this taste by John Russell, 4th Duke of Bedford (1710–1771) who may have used the British Consul of Venice, Joseph Smith (1682–1770), as his intermediary. In around 1733 he commissioned a set of Venetian views for the dining room at Bedford House, which were removed to Woburn around 1800. While these 'Canaletto rooms' were primarily decorative, modern scholars have sometimes seen in them a Whig validation of the Venetian oligarchic republic and its constitution. The mutually advantageous connection between Canaletto and Consul Smith began in 1728. Unkindly dubbed the 'Merchant of Venice', Smith was not only to become the artist's

109 Canaletto,
The Bacino di San Marco on Ascension Day
Consul Joseph Smith; George III; today Royal Collection

110 The Canaletto Room at Castle Howard, showing the pictures by this artist bought probably by the 4th Earl of Carlisle

111 Giovanni Battista Piranesi, 'View of the interior of the Coliseum', engraving from *Le Antichita Romane de G.B. Piranesi*

112 Thomas Patch, *A Punch Party*, depicting an evening at Mr Hadfield's Inn in Florence, near the Piazza Santo Spirito and much frequented by the English.
Dunham Massey (National Trust)

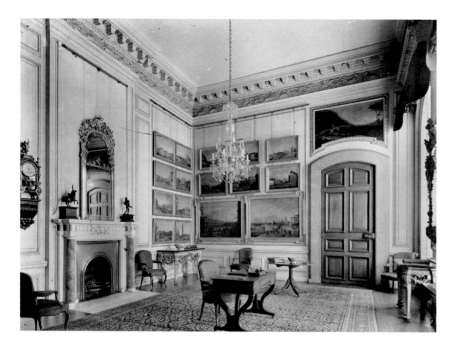

principal agent, selling mostly Grand Canal views to Englishmen, but also the main collector of his work. In 1762 Smith eventually sold his wide-ranging art collection, including 50 pictures and 100 drawings by Canaletto (fig. 109), to George III. Hidden among this consignment was an unrecognised masterpiece: Vermeer's *A Lady at the Virginals*.

If Canaletto was the most famous Italian view painter, he was by no means the only one. Carlisle commissioned a set of six *Capricci* by Panini, and his contemporaries bought views by Canaletto's nephew, Bellotto, and the Dutchman in Rome, Vanvitelli. Views of Venice by Luca Carlevaris appealed to several collectors: four were bought by Christopher Crowe of Kiplin Hall, who served as British Consul in Leghorn (modern Livorno) between 1705 and 1716. The most enigmatic view painter, and the only one touched by genius, was Giambattista Piranesi, who chose a different medium, etching. Although his magisterial prints in their bound book form were the most popular souvenirs of Rome, they have largely disappeared from English country houses. From the late 1740s, Piranesi published his *Vedute di Roma* which represented an imaginative leap in the way the 18th century viewed the ruins of ancient Rome, which seemed to bridge the past and the present. He emphasised the *sic transit gloria mundi* aspect of ancient Rome, which struck a chord. His proto-Romantic vision of the vastness of Roman ruins challenged the more chaste decorative views of Panini and Vanvitelli that were collected by Burlington, Carlisle and others (fig. 111).

Piranesi's prints had an enormous influence on the next generation of British architects, particularly the Adam brothers. He successfully collaborated with the leading English dealers in Rome, Thomas Jenkins and Gavin Hamilton, but he is particularly associated with an Irish collector and patron, James Caulfield, 4th Earl of Charlemont (1728–1799). The Earl initially agreed to finance the artist's book, *Le Antichità Romane*, but then changed his mind. Piranesi took his revenge by writing an acid pamphlet. More happily Charlemont commissioned views from Thomas Patch, now better known for his caricatures of English Grand Tourists (fig. 112), a genre in which the young Joshua Reynolds also briefly indulged. These humorous group portraits form one of the

most unexpected and informal legacies of the Grand Tour. Lord Charlemont also bought ancient marbles and later employed the architect William Chambers to build an octagonal sculpture gallery (since destroyed) as well as a house and the exquisite Casino at Marino in Dublin. The Earl was an intrepid traveller who extended his Grand Tour to Greece and Asia Minor; like Piranesi, he was to play a key role in the Graeco-Roman controversy (see chapter 11).

After the views of Canaletto and Piranesi, the most memorable Grand Tour images are the portraits of Pompeo Batoni. He was a painter of classical Roman histories who transformed the Grand Tour portrait by investing it with a defining polish and panache. He garnished his portraits with easily recognisable allusions: the Colosseum, the Temple of the Sibyl at Tivoli, pieces of antique sculpture, or even pet dogs, and his images of Grand Tourists have become emblematic of the British collector in Italy. Many of Batoni's early British patrons were Anglo-Irish landowners, including Joseph Leeson, 1st Earl of Milltown (1701–1783), who sat for him in 1744 and later built Russborough in County Wicklow. Lord Charlemont was painted by him in 1754 in a characteristic early three-quarter length portrait in which we can observe the development of Batoni's swagger style, with the ruins of the Colosseum in the background (fig. 97). The grander, full-blown style of the *Portrait of Thomas Dundas* and *Colonel William Gordon* was not to emerge until the 1760s, by which time he had a virtual monopoly of the genre, rivalled only by Anton Raphael Mengs. Louis-Gabriel Blanchet (born in Paris in 1705 and died in Rome in 1772) also painted portraits of British sitters and was a particular favourite of Jacobite sitters.

To British visitors, the most important Italian figure in the Roman art world was the worldly prelate, Cardinal Alessandro Albani (1692–1779), an anglophile nephew of Clement XI. His assistance to artists such as Richard Wilson, Joseph Wilton and Robert Adam was invaluable and his villa on the Via Salaria, containing one of the most important collections of antiquities in Rome, was always open to British visitors. The Cardinal's role was deliciously ambiguous in that he was the principal official protector of Roman artefacts but also a *marchand amateur*, much of whose collection ended up in British hands. His Old Master drawings were sold *en bloc* in 1761 to George III with the help of Robert and James Adam.

One of the beneficiaries of Albani's collection was the openly Jacobite but short-lived Henry, 3rd Duke of Beaufort (1707–1745), who was described as 'the man of all Great Britain who had most ascended the staircase to the Pretender's rooms'.[7] He inherited the Dukedom at the age of seven and travelled to Italy between 1726 and 1727. From the Cardinal he bought paintings attributed to Claude, Leonardo and Palma Vecchio, to which he added paintings by Poussin, Guercino, Salvator Rosa's *Fortuna* (Getty) and the Roman marble Badminton Sarcophagus, but showed his originality by commissioning the great pietra dura cabinet (fig. 113) from the Grand Ducal workshops in Florence, probably the grandest piece of Italian furniture in existence, today in the Liechtenstein Collection.

Not every Grand Tourist wanted masterpieces. Some sought an Italianate effect. A rumbustuous figure who typifies the clubbable, hard-drinking aspect of the Grand Tour was Sir Francis Dashwood (1708–1781), sometime Chancellor of the Exchequer and a founder member of the Society of Dilettanti and the Hell-Fire Club. He went to Italy between 1729 and 1732 where he spent much of his time drunk, but nevertheless the country had a profound effect on him. Quite apart from being painted in the guise of a Pope and imitating the rites of the Catholic Church for the amusement of his friends, Sir Francis transformed his home, West Wycombe, into an Italianate villa. He employed Giuseppe Borgnis and his son to decorate it with frescoes after Raphael, Pietro da Cortona and Annibale Carracci (fig. 115). In Italy Dashwood bought many paintings of uneven quality and showed a preference for copies after Raphael and Reni. He was one of the first generation who extended their Grand Tour beyond Italy to Asia Minor with consequences which will be examined in chapter 11.

If Dashwood made his home a temple to Italy, Henry Hoare (1705–1785) created his own Claudian landscape at Stourhead. What William Kent had pioneered in the gardens at Chiswick and Rousham, Hoare perfected at Stourhead. Over the next century, the English informal landscape garden, often designed by Lancelot 'Capability' Brown, not only changed the face of the country

but also nourished the taste for the paintings of Claude Lorrain. At the centre of the Stourhead gardens was a domed temple, the Pantheon in Rome reduced to a rustic garden ornament (fig. 114). Hoare was not an aristocrat but a London banker who started collecting art in 1729 by commissioning a hunting scene from one of Claude's earliest English imitators, John Wootton. He went to Italy between 1738 and 1741, spending a prodigious £3,750, and his grandson later said of this visit 'the study of fine art occupied that attention... which the pursuit of the fox had done in England'. While in Italy, Hoare bought the so-called cabinet of Pope Sixtus – an extravaganza of pietre dure which Beckford coveted – from a convent in Rome. His major painting purchases came later, Poussin's *The Choice of Hercules* from the Chandos

sale (Stourhead) and his *Rape of the Sabines* (Metropolitan). When Horace Walpole visited Stourhead in 1762 he cited paintings by Canaletto, Claude and, interestingly, Rembrandt. Hoare never owned an original Claude but acquired several works in his style by Gaspar Dughet and others. His grandson, Richard Colt Hoare, rounded off the collection from his own extended Grand Tour between 1785 and 1791 with Roman views by the Swiss watercolour painter, Louis Ducros, and Stourhead remains a Grand Tour monument.

Not all Grand Tour collectors were aristocrats or bankers. Many artists financed their visits to Italy by acting as dealers and agents. William Kent travelled in 1709 with John Talman, son of the architect, William. Talman could not afford paintings and statues but he was able to secure the important collection of Italian drawings belonging to Padre Sebastiano Resta which he sold to Lord Somers around 1716. Collectors on the scale of Leicester and Burlington were exceptional and, as Francis Haskell pointed out, 'despite beliefs which were already current in the eighteenth century (and which are still echoed today) the number of major "Old Masters" which left for England before the French Revolution and Napoleonic invasions were insignificant'.[8] Of Italian Renaissance paintings, virtually nothing of any importance came to Britain in the first half of the 18th century. The focus was on exportable works by Claude, Poussin, Dughet, Rosa and Canaletto. Although they would remain among the most popular artists, by the 1750s the scene was changing with sculpture and archaeology beginning to play an increasing role. The easygoing amateurs of the first half of the century gave way to more professional visitors; in 1755 Robert Adam met William Chambers in Rome and found him 'a Prodigy for Genius, for sense and good taste'. Their sketches of antique remains seeded the next great movement in British architecture, Neoclassicism. The first phase of the Grand Tour was over, terminated by the Seven Years' War (1756–63) when the routes to Italy were temporarily closed. The defeat of France would lead to the final flowering of the Grand Tour, described in chapters 9 and 11.

Chapter 8

TOWN AND COUNTRY IN THE EARLY 18TH CENTURY

The early 18th century opened auspiciously with Marlborough's spectacular victories over Louis XIV which signalled the inexorable rise of British power and influence in the world. The Grand Tour confirmed the cultural pre-eminence of Italy and France, but a vigorous native culture was flowering in architecture and literature. The best musicians and painters still came from abroad and English artists languished in comparison with the brilliant writers – Pope, Addison, Steele, Gay, Swift and Defoe. They found only a faint echo in such painters as Hudson and Thornhill before Hogarth began to roar with rage at the connoisseurs' neglect of English art in favour of second-rate foreigners.

London was expanding fast, and becoming more prosperous than any other city in Europe. Rich, energetic, brutal, noisy and with a robust elegance, the city flowed westwards with the establishment of the great estates: Mayfair, for the Grosvenor Estate, started in 1720, and Marylebone, begun for the Portland Estate, at about the same time. Great aristocratic houses fringed Green Park and St James's: Devonshire, Spencer and Marlborough Houses. This nexus supplanted the old Caroline palaces on the Thames as the best addresses in the capital. The major cultural indicators of the age – with one exception – were focused on London: the foundation of the British Museum, the operas of Handel, the rise of the coffee houses and clubs, and Grub Street. Everything was underpinned by wealth, and the City of London replaced Amsterdam as the leading financial centre as the Bank of England and Royal Exchange rose in prominence and standing. A tense but healthy balance existed between mercantile and landed interests. In 1707 the Act of Union with Scotland

Jonathan Richardson Senior

Sir Hans Sloane

The Harleian Library

8th Earl of Pembroke

1st Duke of Marlborough

Sir Robert Walpole

Dr Richard Mead

Paul Methuen

Charles Jennens

2nd Duke of Devonshire

Italian Artists in England

1st Duke of Chandos

Frederick, Prince of Wales

116 Stephen Slaughter, *Portrait of Hans Sloane, Bt.*
National Portrait Gallery

confirmed the increasing prominence of that country. The accession of the House of Hanover in 1714 precipitated the long parliamentary reign of Sir Robert Walpole and the Whig party. For the next 30 years Tories grumbled and Jacobites plotted but the fundamental stability and prosperity, combined with freedom of speech and movement, formed the background to a golden age of collecting in Britain.

The early 18th century also saw the second country house boom. If London was the nexus of the political world, it was territorial power in the provinces that provided the necessary votes and money to gain position in London. The social calendar was divided into parliamentary terms, outside which aristocrats returned to their newly built or refurbished country houses. This was the age of Chatsworth, Castle Howard, Blenheim, Houghton and Holkham. Building, gardening and collecting art were as natural and necessary to the Augustan age as eating and drinking. Collecting had been facilitated by the rise of the London auction rooms as a major means of acquiring and selling books and works of art. The leading auctioneer from the 1720s onwards was Christopher Cock of the Great Piazza in Covent Garden whose partner and later successor in the 1750s was Abraham Langford.

Lord Shaftesbury's influence on collectors has been described in chapter 7. The role of Jonathan Richardson Senior (1665–1745), artist, collector and author, was perhaps as significant in shaping contemporary taste. He was the first English author to write authoritatively about questions of attribution and authenticity and his book, *An Essay on the Theory of Painting* (1715), was followed in 1719 by *Two Discourses, I: An Essay on the Whole Art of Criticism as it Relates to Painting* and *II: An Argument in Behalf of the Science of the Connoisseur*. Richardson expounded the principles on which Old Master paintings and drawings were to be judged and provided specific discussions of a painting by Van Dyck in his own collection as well as works by Poussin and Annibale Carracci recently imported into England by Sir James Thornhill.

Thornhill was one of a number of artist-collectors of the period and the patriotic choice for public commissions such as the decoration of the cupola of St Paul's Cathedral. Thornhill was so proud of his Poussin, *Tancred and Erminia*, that he had himself painted showing it to his

friends (fig. 117). Richardson's discussion of the painting helped promote the taste for Poussin, but he gave still higher praise to Annibale Carracci. Arthur Pond, another artist-collector, favoured Rembrandt's etchings and, under Richardson's influence, formed the Roman Club for English artists to share their experience of Italy. Such talk appalled the great anti-hero of the Augustan age, William Hogarth, who pugnaciously promoted British art with a group of his own that met at Old Slaughter's Coffee House in St Martin's Lane. These groups, with their respective love or hate relationships with Italy, sowed seeds that later blossomed into the foundation of the Royal Academy in 1768. But it is Hogarth who gives us the most accurate picture of the age (fig. 118). He brought the English conversation piece to perfection but found his widest audience through his numerous and polemical prints which adorned many middle-class houses in London, capturing the earthiness, bestiality, elegance and sheer energy of the age.

For a serene and intellectual view of collecting in early 18th-century London we must turn to Sir Hans Sloane (1660–1753), the spiritual successor to Tradescant (fig. 116). A successful and fashionable physician, with a house in Bloomsbury Square, whose patients included Samuel Pepys and Queen Anne, his collections, willed to the nation, became the catalyst for the British Museum. In 1687, he sailed to Jamaica as physician to the

117 Gawen Hamilton, *Portrait of Sir James Thornhill with his Poussin painting 'Tancred and Erminia'*
Beaverbrook Art Gallery, Fredericton, New Brunswick

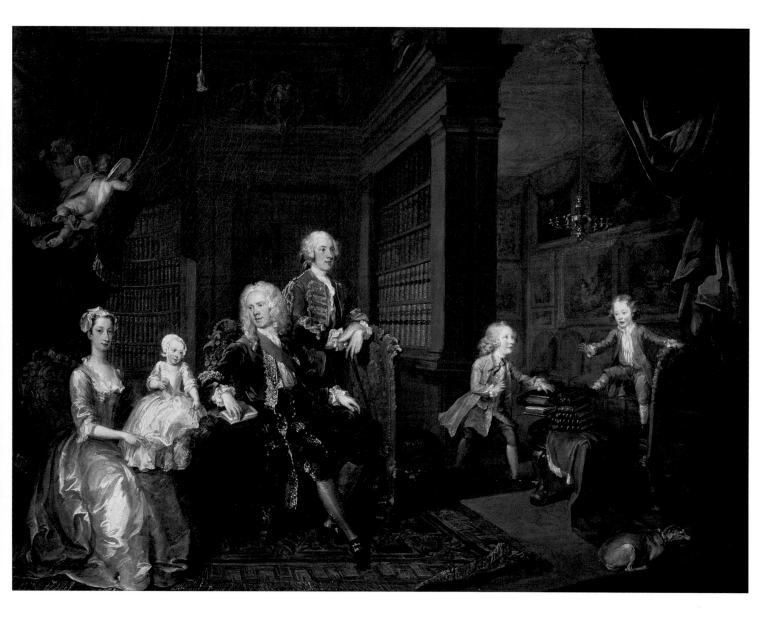

118 William Hogarth,
The Cholmondeley Family
Private Collection

island's Governor, the 2nd Duke of Albemarle. Abroad for nearly two years, he began to collect natural curiosities, described by Evelyn as 'Plants, fruits, Corralls, Minerals, stones, Earth, shells, animals, Insects, &c.'[1] The vast collection, which contained over 200,000 specimens, was highly eclectic and included 521 'serpents'.

Sloane personifies the intellectual curiosity of the 18th century, with its thirst for exploration, discovery, knowledge, classification and measurement, recorded in notebooks or published volumes, sometimes with magnificent folio illustrations. In 1727 he succeeded Sir Isaac Newton as president of the Royal Society. His art collection included antiquities from the ancient Middle East; Roman lamps, urns, gems and inscriptions; Chinese and Japanese paintings and works of art; Eskimo ivory carvings; coins and medals; Old Master drawings including drawings by Holbein and Dürer (of

portraits, landscapes and studies of animals); a fine late 13th-century English Astrolabe; pieces of maiolica, Sèvres and Meissen porcelain; and a vast library of printed books and manuscripts, mostly in the fields of medicine and natural history. Sloane achieved faster results by buying existing collections such as that of his friend William Courten, which brought him outstanding prints, drawings, paintings and medals as well as natural specimens.[2]

In 1714 Sloane bought the old Manor House at Chelsea, although he did not move in with his collection until 1737. Here he would lay out specimens, objects, jewels, coins and medals (23,000 to choose from) on enormous tables for visitors to inspect. Sloane wished his collections to remain intact and although he had two daughters his will directed that the collections be offered to the King for the nation for the sum of £20,000. Sloane's novel plan named 70 trustees,

who pressured Parliament into creating the first museum formed by a democracy for its citizens. Within six months of Sloane's death in January 1753, Parliament passed the bill to establish the British Museum and purchase his collections. In April 1754, acting with a clarity of purpose seldom shown by subsequent governments in museum matters, Parliament purchased a home for the infant museum with money raised by lottery: Montagu House in Bloomsbury. The lottery itself was a fiasco. The tickets were all bought by a single impresario who sold them on at a greatly inflated price, and it was to be almost another 250 years before a national lottery was tried again. But the far-sighted legacy of Sloane had created what has since become the British Museum, the British Library and the Natural History Museum. The British Museum was the first national museum in Britain. It belonged to neither church nor king, and was freely open to the public. It was from the outset a universal museum of everything known to the European Enlightenment and its foundation was the single most important cultural event of the 18th century in England.

Three foundation collections formed the British Museum: Sloane's, the library of Sir Robert Bruce Cotton (presented to the nation in 1700) and the Harleian manuscripts. In addition, George III presented the remains of the old Royal Library in 1757. Robert Harley, 1st Earl of Oxford (1661–1724) and his son Edward, 2nd Earl (1689–1741) had created a vast library in London and at Wimpole Hall, Cambridgeshire. The printed books were estimated at over 50,000 volumes, 400,000 pamphlets and 41,000 prints, and were dispersed by auction after the 2nd Earl's death in 1741. Their manuscript collection, which remains a glory of the British Library, amounted to 7,000 items in European, Hebrew and Oriental languages, 14,000 charters and 700 rolls including the *Harley Golden Gospels* and some fine Anglo-Saxon manuscripts. The library was partly intended to provide the source material for a history of the English people. They also collected portraits of literary and historical figures as well as eminent contemporaries. Edward Harley kept a menagerie – often the adjunct to a collection – at Wimpole and bequeathed his collecting genes to his vivacious daughter, Margaret, 2nd Duchess of Portland. She and her mother sold the manuscripts to Parliament

in 1753 as the second foundation purchase of the British Museum. It realised a derisory £10,000, half the asking price, but the Earl's widow proudly declared, 'I will not bargain.' Christopher Cock had been engaged in 1742 to auction the pictures, antiquities, busts, bronzes, coins and medals in a sale which lasted twelve days.

One of the first great country house collections that combined paintings and antiquities was Wilton House, Wiltshire. The 4th Earl of Pembroke had rebuilt the house to the designs of John Webb and moved the Van Dycks into the Double Cube Room during the interregnum but it was the 8th Earl (*c.*1656–1733) whose 50-year

tenure was to fill the house with statues and paintings. When he started collecting antiquities in the 1680s he was alone in the field in England. His ambitions were immense, his knowledge patchy, his judgement uncertain, but his industry prodigious. He was a pedant obsessed with categorising statues by chronology, origins and iconography – often wrongly – but he takes the credit for commissioning a series of catalogues of the statues, coins and paintings. The volume on the pictures published by Carlo Gambarini in 1731 was the first printed catalogue of a collection of paintings in England.[3] In all, 347 artists were represented, of whom 273 were Italian.

The Earl's approach to collecting pictures was recently described as akin to his systematic and methodical pursuit of coins and medals, with one

119 *The Wilton Diptych*
8th Earl of Pembroke; now National Gallery, London

120 Peter Paul Rubens, *Self-Portrait with Helen Fourment*
1st Duke of Marlborough now Metropolitan Museum of Art, New York

121 Blenheim Palace, created for the 1st Duke of Marlborough

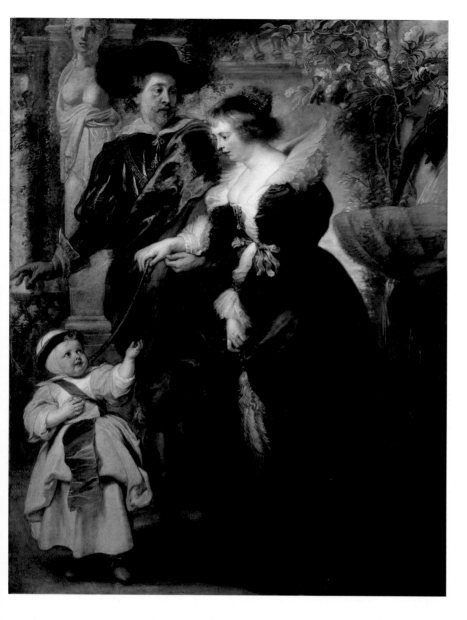

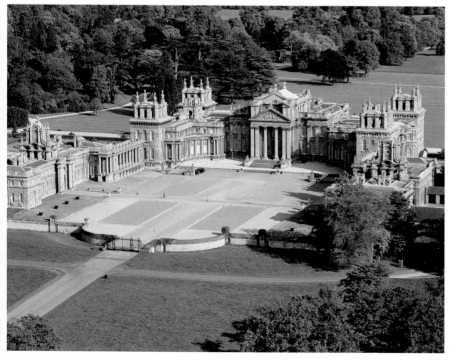

example from every painter, suggesting that he owned a copy of Padre Orlandi's *Abecedario pittorico*, first published in 1704.[4] Although the names of some 15th-century and earlier artists appear in his catalogue, including Masaccio, Fra Angelico, Signorelli and Bellini, Pembroke's purchases of works by Cambiaso, Giordano and Panini show that more contemporary artists also appealed to him. Pembroke foreshadows the Earl-Bishop of Bristol, who later in the 18th century began a collection intended to illustrate Italian painting from the time of Cimabue onwards and northern artists from van Eyck, doubtless inspired by Vasari's *Lives*.

Pembroke's best known purchase was the *Wilton Diptych* (NG London), showing the Virgin adored by Richard II and saints (fig. 119). His collection of antiquities was boosted by the purchase in 1724 of over 80 busts and 23 statues from Cardinal Mazarin's collection. He was always wildly optimistic about the quality and importance of his antiquities and Isaac Newton said, 'Let him have but a stone doll and he's satisfied.' Pembroke was advised by Sir Andrew Fountaine and persuaded the great antiquarian, William Stukeley, to catalogue the marbles, a task he abandoned in the face of constant interference. The sculpture collection was eventually catalogued by Cary Creed in four editions between 1729 and 1731. The task of cataloguing the Greek, Roman and British coins and medals was entrusted to Nicola Francesco Haym, himself a collector, and the volume was published in about 1729.

Although most great country house collections of the age were formed through the Grand Tour, two of the most spectacular were not. They were created by England's most powerful men, John Churchill, 1st Duke of Marlborough (1650–1722) and Sir Robert Walpole (1676–1745). A grateful Parliament rewarded the Duke of Marlborough's victory at Blenheim in 1704 with Blenheim Palace (fig. 121). Marlborough was a heroic figure on a scale not encountered in England since Elizabethan times, and John Vanbrugh created his palace to match his stature. Though designed by Wren, his London home, Marlborough House, was plain, but it was the main repository of the Duke's art collection until (after many vicissitudes) Blenheim was finally completed. Handsome and brilliantly gifted, Marlborough was sensitive to art and assembled the finest group of

paintings by Rubens in England since the Duke of Buckingham. It included *Venus and Adonis* (Metropolitan), *Helena Fourment* (Louvre), *Self-Portrait with Helena Fourment* (Metropolitan; fig. 120), *Lot and his Daughters* (Ringling) and *Anne of Austria* (Metropolitan). These masterpieces were mostly gifts from grateful monarchs and cities the Duke had liberated from the French. But surprisingly, sometimes it was the other way around: the defeated Elector of Bavaria gave him Van Dyck's *Equestrian Portrait of Charles I* (NG London).

Flemish artists dominated the Marlborough collection, including 120 copies by Teniers of paintings in the Archduke's collection. Other artists included Sebastiano del Piombo, Carlo Marratta, Carlo Dolci, Agostino and Ludovico Carracci, Johann Rottenhammer and Jacob Jordaens. He commissioned portraits of himself, his Duchess Sarah and their children by Closterman, the forerunner of later family groups from Zoffany

and Reynolds to Sargent. The Duke also commissioned four bronze casts from Massimiliano Soldani-Benzi after marble statues in the Tribuna of the Uffizi in Florence, which were installed in the Marble Hall at Blenheim in 1711.[5] The Duke's paintings remained at Blenheim until the great Christie's auction of 1884 which triggered – notwithstanding the sale of the Houghton pictures – the first heritage crisis of the modern era.

No man better personifies the first half of the 18th century than Sir Robert Walpole, the most successful politician of the time and *de facto* Prime Minister from 1721. Squat and red-faced, Walpole possessed a hearty appetite for art. A shrewd and munificent collector and patron and a brilliant and ruthless operator who understood men's weaknesses, he controlled jobs and positions and amassed a huge fortune which he spent on the creation of Houghton Hall, Norfolk, and its art collection. Houghton, along with its neighbour, Holkham Hall, contained the most ambitious

122 Guido Reni,
Fathers of the Church Disputing the Dogma of the Immaculate Conception
Sir Robert Walpole; now Hermitage, St Petersburg

123 Interior view of the Red Saloon at Houghton Hall, Norfolk, created for Sir Robert Walpole

124 Jean-Antoine Watteau,
Italian Comedians
Dr Richard Mead; 1st Earl of Iveagh now National Gallery of Art, Washington

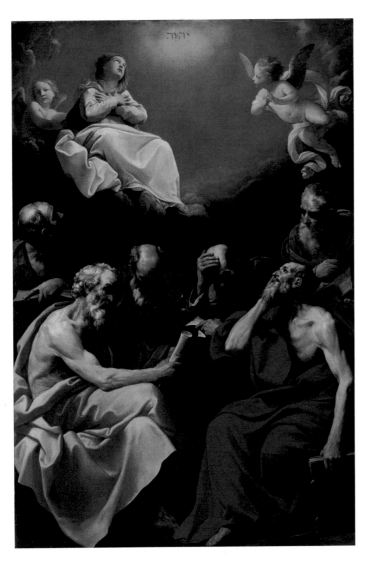

and dedicated a room to his work at Houghton, owning six paintings by him, including a large *Judgement of Paris* and an *Acis and Galatea* as well as the *Portrait of Pope Clement IX Rospigliosi*. Other artists represented included Salvator Rosa, Jan van Huysum, Rubens, Rembrandt and Frans Hals. Walpole owned a much admired Guido Reni, *Fathers of the Church Disputing the Dogma of the Immaculate Conception*, which the Pope had hoped to retain in Italy (fig. 122). The Prime Minister's youngest son, Horace Walpole, catalogued his father's collection in the *Aedes Walpolianae*, privately printed in a first edition of 1747 and a corrected second edition of 1752.

Notwithstanding the movement of art to Blenheim, Wilton and Houghton, it is plain that, with the possible exception of Rome, London had by the middle of the 18th century become the epicentre in Europe for collectors of works of art. Most were aristocratic, but many of the most interesting were not, including Dr Richard Mead, Sir Paul Methuen and Charles Jennens. Mead (1673–1754) was a physician best remembered because in 1720 the French painter Antoine Watteau came to London to consult him and gave him two small pictures, *L'Amour paisible* (now lost) and *Italian Comedians* (NG Washington; fig. 124). Mead was portrayed by the Frenchified Scottish painter, Allan Ramsay (Foundling Museum), and his collection was unusually scholarly, containing antique sculpture, Greek, Roman and British coins, gems, bronzes, miniatures, engravings and drawings by Dürer, Holbein, Michelangelo and Raphael, as well as Hogarth and Vertue. Mead voraciously bought Old Master paintings but more idiosyncratically he collected portraits of doctors and scientists: Sir Theodore Turquet de Mayerne (by Rubens) and Vesalius (by Titian), Boyle and Halley. He also owned Rubens's *Portrait of Lord Arundel* (NG London). Mead's possessions were sold after his death in 1754 and 1755 by Abraham Langford, the partner and successor to the auctioneer Christopher Cock. The two finest pictures in his collection were Holbein's *Portrait of Erasmus* and its long-time companion the *Portrait of Petrus Aegidius* (the scholar and town clerk of Antwerp), then attributed also to Holbein but actually by Quentin Matsys. Both were bought for enormous sums by Lord Folkestone, the *Erasmus* for £110 5s., and the *Aegidius* for £95 11s.

country house collection formed at this time. Walpole was consumed by a passion for paintings, acquiring over 400 in all, as his magnificent house by Colen Campbell rose out of the Norfolk flats. An army of craftsmen and artists decorated it, from William Kent who designed the furniture, to Rysbrack who carved the chimney piece in the Marble Parlour. The Mortlake factory wove the tapestries, the saloon was hung with Utrecht velvet, and Kent's furniture was upholstered with Genoese cut velvet (fig. 123). Walpole's taste in paintings was conventional but superlative: twenty Van Dycks, nineteen Rubenses, eight Titians, five Murillos, two Velázquez and a Raphael. Gifts were welcome: Lord Waldegrave gave him a fine Poussin, and Lord Pembroke obliged with Le Sueur's bronze copy of the Borghese *Gladiator*, still in the stairwell at Houghton.

Walpole, who started buying pictures in 1718, had agents all over Europe, but he was usually represented at auctions by Robert Bragge and Andrew Hay, two *marchands-amateurs*, or by John Howard, a frame-maker. In 1725 Walpole purchased the collection of Van Dyck portraits formed by Philip 4th Lord Wharton, which according to Horace Walpole consisted of 'twelve whole lengths, the two girls, six half lengths and two more by Sir Peter Lely'. Sir Robert admired Carlo Maratta

Sir Paul Methuen (1672–1757) of Grosvenor Street, London, son of the John Methuen who had negotiated the 'Methuen Treaty' with Portugal in 1703, was a much travelled diplomat and politician who acquired pictures both at home and abroad. Consistent with the taste of his generation, his collection comprised Italian 16th- and 17th-century pictures and works by French, Flemish and Dutch 17th-century painters. He bought heavily from the 1st Duke of Portland's sale in 1722, including a large *Madonna and Child with Saints and the Three Cardinal Virtues* by Bonifazio dei Pitati, which he thought was by Titian, a *Tobias and the Angel* attributed to Caravaggio and a *Landscape with a Temple of Bacchus* by Claude (National Gallery of Canada). Perhaps recalling his diplomatic posting in Madrid, he owned pictures attributed to Murillo and Ribera. He owned two great Van Dycks – *The Betrayal of Christ* (fig. 125), which was purchased for £100 from a Mr George Bagna (the receipt survives at Corsham Court) and the *Portrait of the Duke of Richmond and Lennox* (Metropolitan) – and other works by Jan Brueghel the Elder, Rembrandt, Rubens, Snyders and Teniers as well as the Carracci, Dolci, Rosa and Strozzi. Methuen died unmarried in 1757 and bequeathed his collection to his cousin and godson Paul Cobb Methuen who bought Corsham Court, Wiltshire in order to house it.

Probably the largest collection in London belonged to Charles Jennens (1700–1773), the friend and librettist of Handel, who was known as Suleyman the Magnificent. Jennens commissioned Thomas Hudson's *Portrait of Handel*, depicted with the score of the *Messiah* (National Portrait Gallery). *The English Connoisseur* in 1766 listed over 480 pictures in his house in Ormond Street.[6] Among his Dutch pictures were two landscapes by Rembrandt (National Gallery, Oslo and formerly Montreal Museum of Fine Arts) and *The Lute Player* by Frans Hals (Beit Collection, National Gallery, Dublin). By 1761 Jennens owned over 100 Dutch paintings including a Cuyp. He also owned classical Italian works by Domenichino and Annibale Carracci but he signals the growing preference of middle-class collectors for Dutch paintings. This taste, encouraged by sales from Dutch houses, was shared by some aristocrats, such as the Duke of Bedford, who in 1742 acquired a Ruisdael. James Burgess's edition of De Piles's *Lives of the Painters* (1754) included a biography of Ruisdael, who – like Cuyp – was rare in English collections before the mid-18th century, but was destined to become a favourite.

Some aristocrats chose to keep their art collections in their London houses. William, 2nd Duke of Devonshire (1673–1729), the greatest of all the Cavendish collectors, collected primarily for Devonshire House. As *The English Connoisseur*[7] noted, Chatsworth then had 'very little that can attract the eye of the Connoisseur... the pictures are few in number and indifferent'. The glory of the collection, generally hidden from view in London, was the Duke's great drawings collection. He was an avid collector of paintings, antique gems and coins, but drawings were his passion. His major coups were the purchase of drawings from the large collection formed by John, Lord Somers, in 1717, and from Carlo Maratta's studio, in 1720. This was followed in 1723–24 by the fabulous collection of 225 drawings, mostly Dutch and Italian, belonging to Nicholaes Anthoni Flinck, the son of Rembrandt's pupil Govaert Flinck. The Duke owned Van Dyck's Italian sketchbook (from Lely's collection) and he also bought spectacular individual sheets by the same artists. Finally in 1728 he bought Claude's *Liber Veritatis* (an inventory of autograph drawings of his own paintings). As a result, the Chatsworth collection became, along with the Royal Collection, one of the finest and most extensive private collections of Old Master

125 Sir Anthony van Dyck, *The Betrayal of Christ*
Sir Paul Methuen; today still at Corsham Court, Wiltshire

opposite, clockwise from top left

126 Rembrandt van Rijn, *An Actor in his Dressing Room*
2nd Duke of Devonshire; today still at Chatsworth House, Derbyshire

127 Albrecht Dürer, *An Old Man Gesticulating*
2nd Duke of Devonshire; today still at Chatsworth House, Derbyshire

128 Sir Anthony van Dyck, *Pieter Brueghel the Younger*
2nd Duke of Devonshire; today still at Chatsworth House, Derbyshire

129 Leonardo da Vinci, *The Head of a Woman and the Head of a Baby*
2nd Duke of Devonshire; today still at Chatsworth House, Derbyshire

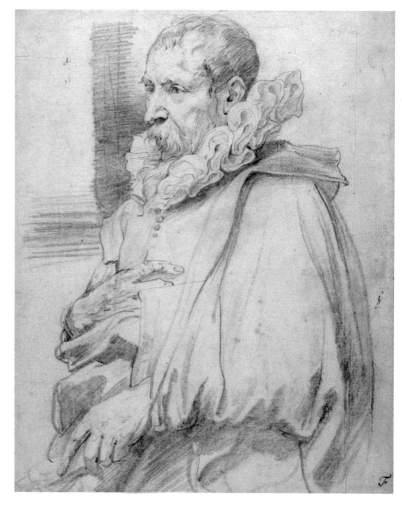

drawings in Europe, its riches (figs 126–129) including sheets by Leonardo, Raphael, Parmigianino, Barocci, Dürer, Rubens, Van Dyck and Rembrandt.

The paintings at Devonshire House in Piccadilly were 'surpassed by very few either at home or abroad.'[8] They included a *Susannah and the Elders* by Sebastiano Ricci, a *Landscape with Mercury and Battus* by Claude and two fine Rembrandts, *The Old Man* and *The Turk's Head*. *Et in Arcadia Ego* by Nicolas Poussin and *The Holy Family* by Murillo were acquired either by the 2nd Duke or his son, the 3rd Duke, but it was the 2nd Duke who persuaded the French collector, Pierre Crozat, to sell him one of the pearls of his collection, Domenichino's *Expulsion of Adam and Eve* (fig. 130). The lion's share of the Old Master paintings and drawings remaining at Chatsworth are his legacy.

The enthusiasm of Grand Tourists for contemporary pictures led a number of Italian artists – mostly Venetian – to visit England in search of patronage. All things Venetian were in fashion; the ever popular opera, as well as singers, painters, velvets, Palladian architecture and it all even gave rise to the form of Anglo-Venetian rococo decoration visible at Moor Park. Giovanni Antonio Pellegrini painted murals mainly at Castle Howard and Kimbolton between 1708 and 1713. Marco Ricci (in England 1708–16) and his uncle Sebastiano Ricci (in England 1712–16) worked for Lord Burlington and the Dukes of Chandos and Portland. Antonio Bellucci also received several commissions from Chandos. Jacopo Amigoni worked in England from 1729 to 1739 and painted the murals at Moor Park and the old Covent Garden Theatre, and Antonio Joli established himself in London briefly as a scene painter between 1744 and 1748.

The most celebrated Venetian painter to visit London was Canaletto, who may have become bored with painting Venetian views and simultaneously short of patrons owing to the War of the Austrian Succession (1740–48). In May 1746 he arrived in England where he remained, with one break, until 1753. He immediately secured the patronage of the Dukes of Norfolk and Richmond. For the latter Canaletto painted in 1747 two delicious views of London from Richmond House, Whitehall: *The Thames and the City of London* (fig. 131) and *Whitehall and the Privy Garden*. At this time, as Ellis Waterhouse put it, 'the enchantment of the Venetian sunshine was still upon him'.[9] Canaletto received his most important commissions for English views from the Dukes of Beaufort and Northumberland, Lord Warwick and Thomas Hollis. Equally important, his visit was of considerable significance for English topographical painting: Samuel Scott was his major follower, but Joseph Nickolls, William James, Thomas Patch and William Marlow owed much to Canaletto's example.

If the country house was not yet the customary treasure house for works of art many, like Lord Burlington at Chiswick, kept their collections on the fringes of London. One of the most dazzling was at Cannons in north London. James Brydges, 1st Duke of Chandos (1694–1744), appears like a brief and brilliant firework – his orchestra and patronage of Handel, his country house, his art

130 Domenichino, *Expulsion of Adam and Eve*
2nd Duke of Devonshire; today still at Chatsworth House, Derbyshire

131 Canaletto,
The Thames and the City of London from Richmond House
2nd Duke of Richmond; today still at Goodwood House, Sussex

collection and his legendary entertainments – before being extinguished by the threat of bankruptcy. He made his fortune as Paymaster-General to the army between 1705 and 1713, with responsibility for equipping the army in the War of the Spanish Succession. His office handled about £24 million of public money, of which Brydges is estimated to have taken a commission of three per cent.[10] In 1713, he decided to rebuild the existing Jacobean house at Cannons, a project which lasted ten years under a succession of architects, including William Talman, John James,

Sir John Vanbrugh, James Gibbs and John Price. The interiors reflected the shift in taste from the Baroque painted ceilings of Burghley House and Chatsworth to the Palladian architectural interiors of the 1720s. Chandos commissioned painted ceilings both from the old-fashioned Baroque artists Godfrey Kneller and James Thornhill, and from the fashionable Venetians, Francesco Sleter, Antonio Bellucci and the Italianate William Kent.[11]

The Duke avidly collected pictures for Cannons and his houses at St James's Square and later Cavendish Square, and we know much about his

132 Grinling Gibbons,
The Tomb of James Brydges,
1st Duke of Chandos, at the
church of St Lawrence, Little
Stanmore, Middlesex

activities owing to the preservation of his papers.
He was influenced by Jonathan Richardson's views
on the importance of connoisseurship, which
at that time had more to do with a full critical
appreciation than with identifying the hand of a
particular artist, and argued that 'a copy of a very
good picture is preferable to an Indifferent orig-
inal'.[12] For example, Chandos wanted a Raphael,
but not an early work when his style was 'so still
and dry'. His picture collection coincided with the
taste of his contemporaries, including Italian works
by Titian, Veronese, Raphael, Pietro da Cortona,
Guercino and Reni, as well as Dutch and Flemish
works by Rembrandt, Dou, Rubens and Teniers.
Recent research has identified the present location
of several of Chandos's pictures.[13] These include
Caravaggio's *Boy Bitten by a Lizard* (NG London);
Dou's *The Schoolmaster* and Willem van Mieris's
The Market Stall (Fitzwilliam); Nicolas Poussin's
The Choice of Hercules (Stourhead); and Salvator
Rosa's *Jason and The Dragon* (Montreal).

Chandos's profligate expenditure, compounded
by losses suffered in the South Sea Bubble, made
his financial position precarious. By the time of his
death in 1744, the family was facing bankruptcy.
The pictures, books, furniture and other contents
of Cannons and his house in Cavendish Square

were sold at auction in a series of sales in 1747.
All that remains near Cannons is his exuberant
tomb monument by Grinling Gibbons in Little
Stanmore church (fig. 132), while at Great Witley
church in Worcestershire the organ, stained
glass windows and ceiling paintings by Antonio
Bellucci from the chapel at Cannons all survive,
having been bought by the 2nd Lord Foley from
the Cannons demolition sale. The Duke is mainly
remembered today as a patron of Handel, who
lived at Cannons in 1717–19, where he composed
his *Chandos Anthems*, and who himself became a
collector of some renown.

The early Hanoverian kings showed no interest
in the arts, but George II's eldest son Frederick
(1707–1751), known to history as 'Poor Fred', was
a considerable patron of painting and gardening.
Philippe Mercier was his painter and librarian
and the Prince was attracted to the arts of France
and the Rococo style. He had sound collecting
mentors in General Guise, later the benefactor
of Christ Church, Oxford, and Sir Luke Schaub,
whose collection he coveted. Realising that pay-
ment would not be forthcoming, Schaub artfully
excused himself.

The Prince bought many of the finest Italian
pictures now in the Royal Collection including

Guido Reni's *Cleopatra* and a set of four pictures by Luca Giordano, but his purchases of French classical landscapes were more important. These included Claude's *Harbour Scene* and Gaspard Poussin's *Landscape with Figures by a Pool* and a very fine Eustache Le Sueur, *Caligula depositing the Ashes of his Mother and Brother in the Tomb of his Ancestors*. He bought good Flemish pictures including two Jan Brueghels, *The Flemish Fair* and *Adam and Eve in the Garden of Eden*, Rubens's large landscapes of *Summer* and *Winter*, companions to the other seasons now in the Wallace Collection and the National Gallery, London, and a group of Van Dycks, including the early *St Martin Dividing his Cloak* and the *Portrait of Thomas Killigrew with Lord Crofts (?)*. The Prince commissioned handsome frames for his pictures, none finer than the splendid rococo frame

with the Prince of Wales's feathers on Wootton's *The Shooting Party: Frederick Prince of Wales with John Spencer and Charles 3rd Duke of Queensberry* (fig. 133). His magnificent state barge was designed by William Kent. George Vertue paid the final tribute to this gifted collector: 'No prince since King Charles the First took so much pleasure nor observations on works of art or artists.'[14] He paved the way for his son, George III, and even more for George IV, to revive Court patronage and collecting.

The early 18th century was a seminal period for the development of British collecting. Maratta, Claude, Salvator Rosa, Van Dyck and the Venetians represented the norm but now we see the birth of new enthusiasms: early Italian paintings (Pembroke), Spanish art (Walpole and Methuen), the growing interest in Rembrandt, Cuyp and Ruisdael and the stirrings of a national school of painting. Italian contemporary art dominated the foreground, followed by French and Dutch artists, but antiquities were also prized. The first half of the 18th century saw the Grand Tour established and the London art market, assuming the mantle of Amsterdam, became the most vigorous in Europe. Dealers and agents were everywhere and Alexander Pope would describe their activities:

He buys for Topham, drawings and design,
For Pembroke, statues, dirty gods and coins,
Rare monkish manuscripts for Hearne alone,
And books for Mead and butterflies for Sloane.

Sloane may have been principally a specimen collector of natural history but his artefacts gave the British Museum a foundation in the works of man which elicited numerous further deposits and encouraged the collecting of items from the wider world beyond Europe. It remains the greatest legacy of the age.

133 John Wootton,
The Shooting Party:
Frederick, Prince of Wales,
with John Spencer and
Charles Douglas, 3rd
Duke of Queensberry
Frederick, Prince of Wales;
today in Royal Collection

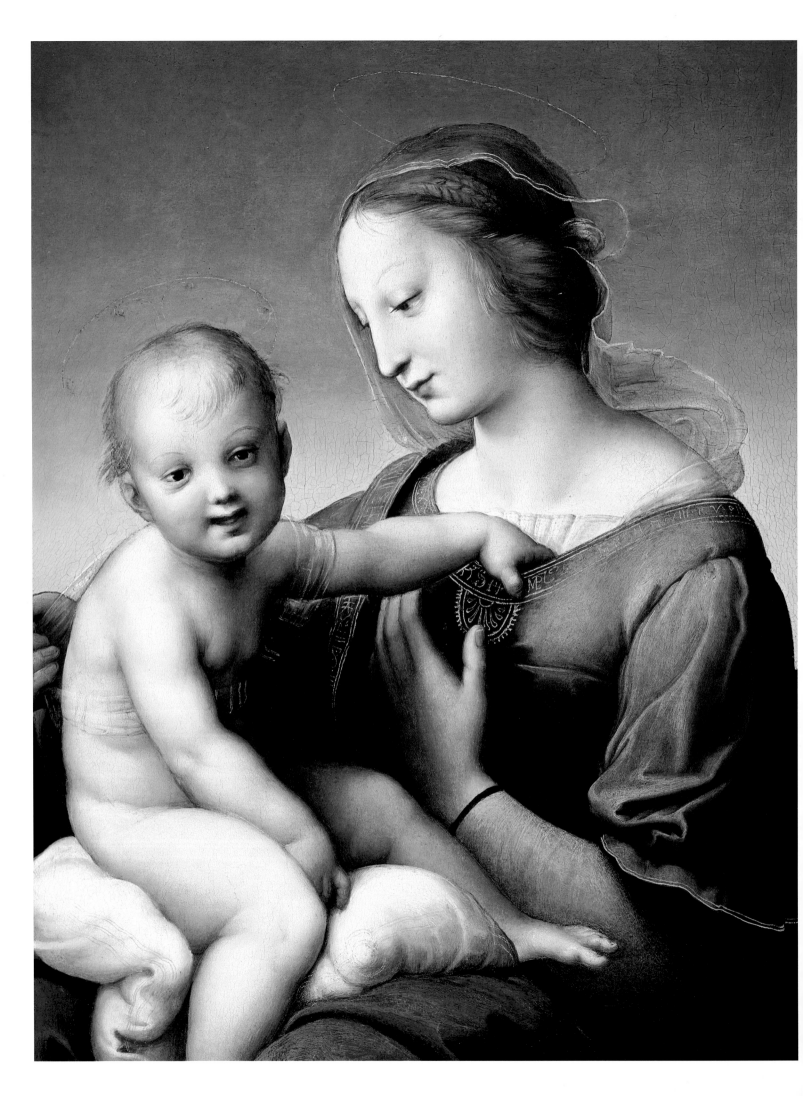

THE GRAND TOUR: HIGH SUMMER

'Our eloquence and the glory of our arms have been carried to the highest pitch,' wrote Horace Walpole in 1762. 'If there are any talents among us, this seems the crisis for their appearance.'[1] The victories of 1759 in the Seven Years' War and the accession to the throne of George III the following year opened a decade of expansion and prosperity. The signing of the Treaty of Paris in 1763 meant that British subjects could resume the Grand Tour – temporarily halted by the war – and it precipitated not only an influx of visitors to Italy (fig. 135), but also encouraged a rash of country house rebuilding at home. It was Robert Adam who would provide the palaces for the next generation. He returned from Italy in 1758 and embarked on the creation of an astonishing series of country house interiors both inspired by the Grand Tour and displaying all the assembled treasures. The Palladian model was supplanted by an enthusiasm for the great classical buildings of ancient Rome. The treasures collected to fill these newly created interiors were to broaden and encompass sculpture (see chapter 11).

While Thomas Jenkins put most of his energies into antiquities, Gavin Hamilton combined this with selling paintings. In 1773 he published the *Schola Italica Picturae*, a combined catalogue of paintings in Roman collections and those available or recently sold to British Grand Tourists. It contains a list of 16th- and 17th-century artists and reveals a shift in taste from the previous generation of collectors. Reni, Guercino, Domenichino, Albani and Caravaggio are joined by Leonardo, Raphael, Andrea del Sarto, Giulio Romano, Veronese, Bassano and Titian. However much British connoisseurs since the age of Charles I had

9th Earl of Exeter

3rd Earl Cowper

Earl-Bishop of Bristol

Robert Adam and his Patrons

6th Earl of Coventry

1st Duke and Duchess of Northumberland

1st Earl Spencer

Sir Joshua Reynolds

4th Duke of Rutland

Welbore Ellis Agar

3rd Earl of Bute

Sir Lawrence Dundas

134 Raphael, detail from
The Niccolini-Cowper Madonna
3rd Earl Cowper; Andrew Mellon; now
National Gallery of Art, Washington

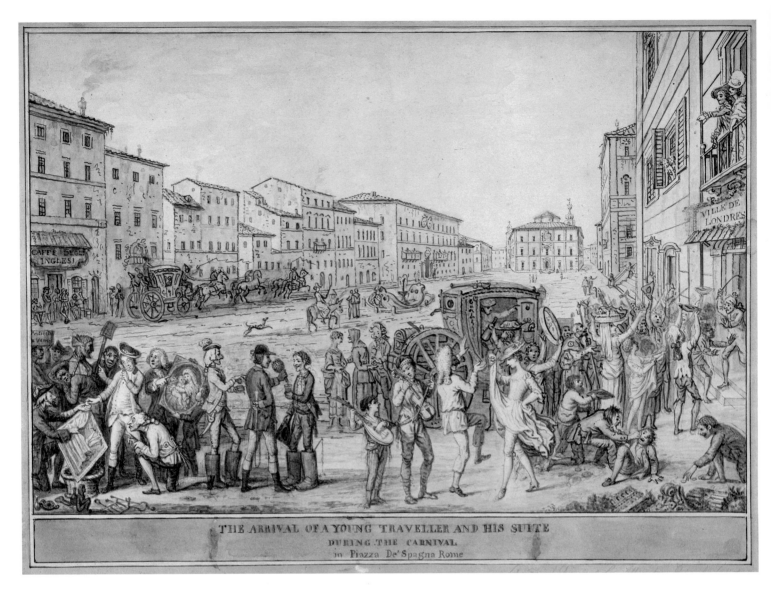

THE ARRIVAL OF A YOUNG TRAVELLER AND HIS SUITE
DURING THE CARNIVAL
in Piazza De' Spagna Rome

desired High Renaissance paintings, it was very hard for them to acquire authentic examples. The vastly increased wealth and prestige of the Britons relative to the declining fortunes of the Italians eased this problem. The two artists missing from Hamilton's list were the French artists already resident in Rome, Claude and Poussin, whose popularity increased during the second half of the century. There were many paintings by both already in Britain, but some of their greatest masterpieces, from the Altieri Claudes to Poussin's *Seven Sacraments* (Rutland), reached Britain in the second half of the 18th century (fig. 136). Living Italian artists had by now largely adapted to the needs and tastes of Grand Tourists. Gavin Hamilton was himself a painter at the vanguard of Neo-classicism, as well as the broker of many important deals such as Lord Lansdowne's purchase of Leonardo's *Virgin of the Rocks* (NG London). Another influential dealer was James

Byres of Tonley (1734–1817) who served as a guide or *cicerone*, most famously to Edward Gibbon. The role of bear-leader was seldom lucrative and could be ludicrous, but it offered opportunities for art dealing and Byres was a tireless networker who frequently organised important exports to Britain.

Tastes broadened with the widening range of the Grand Tour. The discovery of Pompeii and Herculaneum had underlined the importance of a visit to Naples where the British envoy, Sir William Hamilton, maintained a hospitable and scholarly embassy. The favourite Neapolitan Old Master with British collectors was Salvator Rosa (fig. 137), whose wild landscapes anticipated the taste for the sublime: 'precipices, mountains, torrents, wolves, rumblings – Salvator Rosa' exclaimed Walpole in 1739,[2] and Boydell later published 35 engravings after his paintings in British collections. Another popular Neapolitan artist was Pietro Fabris, who satisfied the insatiable demand for views of his city

135 David Allan,
The Arrival of a Young Traveller in the Piazza di Spagna
Royal Collection

136 Claude Lorrain,
Landscape with Aeneas at Delos
Wynn Ellis; now National Gallery, London

137 Salvator Rosa, *Landscape with the Baptism in the Jordan*
National Gallery of Ireland, Dublin

138 Pietro Fabris,
A Neapolitan Scene with Peasants Dancing and Eating
Burghley House, Lincolnshire (bought by the 9th Earl of Exeter)

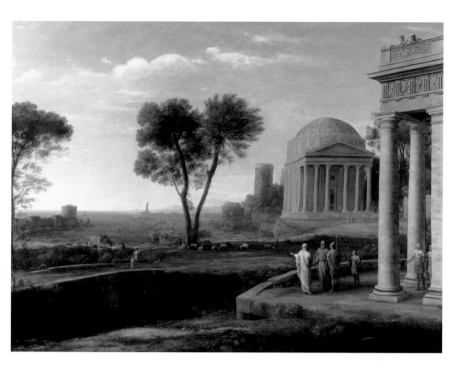

and its exotic surroundings (fig. 138). If an earlier generation had been in thrall to the Venetian views of Canaletto, in the later 18th century the *vedute* market continued unabated for the paintings of Francesco Guardi, Francesco Zuccarelli, Jakob Philip Hackert, Claude-Joseph Vernet and the watercolours of Louis Ducros. The portraitist Pompeo Batoni reached his zenith in the 1760s with works such as *The Portrait of William Weddell* (1766) but he now faced competition from Hugh Douglas Hamilton, Anton Raphael Mengs and Angelica Kauffmann.

The distinction in Grand Tour taste between the first and second halves of the 18th century can be seen at Burghley House, where we can still compare the taste of the 5th Earl of Exeter, whose early Tour was described in chapter 7, with that of his great-grandson Brownlow Cecil, 9th Earl of Exeter (1725–1793). Whereas the 5th Earl mostly bought contemporary pictures by 17th-century artists such as Carlo Dolci, Luca Giordano and Carlo Maratta, the 9th Earl commissioned portraits and view paintings and acquired Old Master paintings with a 16th-century and Venetian bias (fig. 139). Typical of many Englishmen who took advantage of the signing of the Treaty of Paris, the 9th Earl set off in late 1763 and remained abroad for a year. By December he was in Naples, where in January Garrick dined with him 'almost every day and night' in the company of Lord Spencer, Lady Orford, Lord Palmerston, the British Consul and the Minister.[3] Through Sir William Hamilton, Exeter met Angelica Kauffmann who became his infatuation – as she did for so many English gentlemen – and who painted his portrait with Vesuvius and the Bay of Naples behind. In addition Exeter commissioned landscapes and Neapolitan views from Philipp Hackert and Pietro Fabris.

Lord Exeter's two most distinguished purchases were Venetian and Roman respectively: Jacopo Bassano's *Adoration of the Kings*, probably painted in 1537 (Burghley House) and Poussin's architectural *Assumption of the Virgin* (NG Washington), painted *c.*1630–32, which he acquired in Rome in 1764 through James Byres from the Count Soderini for 500 crowns. Whereas the Poussin was a masterpiece, the 'Raphael' Byres sold him (with long protestations of how difficult it had been to get the Vatican authorities to allow its export) was merely a copy of the *Madonna del Passeggio*. The 9th Earl

139 View of the Fourth
George Room at Burghley
House with paintings bought
by the 5th and 9th Earls of
Exeter

occasionally acquired pictures that recalled the
5th Earl's taste including works by Orazio and
Artemisia Gentileschi (the ravishing Orazio of
the *Madonna and Child* was given to him by Pope
Clement XIV), Guercino, Pier Francesco Mola and
Sassoferrato. Lord Exeter went on a second Grand
Tour between 1768 and 1769, returning northwards
through Venice where his outstanding purchases
were three works by Veronese from the Church
of San Giacomo, Murano: *The Wife of Zebedee
Petitioning our Lord* and two shutters of an organ
depicting *St James* and *St Augustine*. The 9th Earl
added Piranesi prints to the library and completed
the sequence of rooms at Burghley in order to
house the collection.

Florence played a more prominent role in
the Grand Tour thanks to two celebrated British
residents, Sir Horace Mann and Lord Cowper,
and through the increasing interest in earlier
Renaissance art. Mann (1706–1786), whose house
was the centre of the Florentine *beau-monde*, lived
in the city from 1738, finally becoming Envoy
and Plenipotentiary in 1782. He was a fussy,
agreeable bachelor who only dabbled in collecting

and dealing himself but assisted visitors like
Richard Colt Hoare with their purchasing. George
Cowper, 3rd Earl Cowper (1738–1789), settled
in Florence in 1760 for largely amorous reasons
and spent the rest of his life in the city 'living in
a very grand way' at the Villa Palmieri. He was as
keenly interested in music and science as art and
formed an enormous art collection which passed
after his death to the family estate at Panshanger in
Hertfordshire. This was a very mixed achievement
with several famous masterpieces by Raphael
and a great deal of dross. Cowper commissioned
fine landscapes from Zuccarelli and Hackert and
assisted visiting English artists such as Romney
and Ozias Humphry.

It was the German artist Johann Zoffany,
however, who was to be his principal protégé.
Cowper commissioned spirited portraits of himself
and his wife (Firle Place) during the artist's stay
in Florence between 1772 and 1778. While in the
city Zoffany pulled off an extraordinary coup
by acquiring and then selling him Raphael's
Niccolini-Cowper Madonna (NG Washington;
fig. 134). Cowper had hoped to sell it on to

George III. Englishmen had sought to acquire genuine Raphaels since the time of Charles I with little success. Around a year earlier, in 1764, Gavin Hamilton had managed to sell to Lord Robert Spencer Raphael's *Ansidei Madonna* (NG London) from the chapel of the Servite Church in Perugia. Spencer was seventeen at the time and gave the painting to his elder brother, the Duke of Marlborough, and it remained at Blenheim until 1885.[4]

Not content with one Raphael Madonna, Cowper acquired a second around 1780, still known as the *Small Cowper Madonna* (NG Washington) and the following year presented George III with a Raphael *Self Portrait* which turned out to be neither by nor of him. But Cowper was fortunate to live in Florence, where he successfully acquired several rare works of the Florentine High Renaissance, such as Fra Bartolommeo's *Rest on the Flight into Egypt with St John the Baptist* (Getty) and three Pontormo panels from the Borgherini Palace (all NG London). Apart from lending his name to the two Raphael *Madonnas*, Cowper is remembered for his appearance in the most famous of all British collector portraits: Zoffany's *Tribuna of the Uffizi*, an apotheosis of the Grand Tour (fig. 140). Zoffany was commissioned by George III and Queen Charlotte to paint the Grand Duke's collection in Florence and the artist had the inspired idea of adding 22 portraits of British visitors to Florence at the time (which did not please his royal patrons). Horace Mann and the artist are prominent, as are the Earls of Plymouth, Dartmouth and Milltown. Lord Cowper is painted

140 Johann Zoffany, *The Tribuna of the Uffizi*
George III and Queen Charlotte; today still Royal Collection

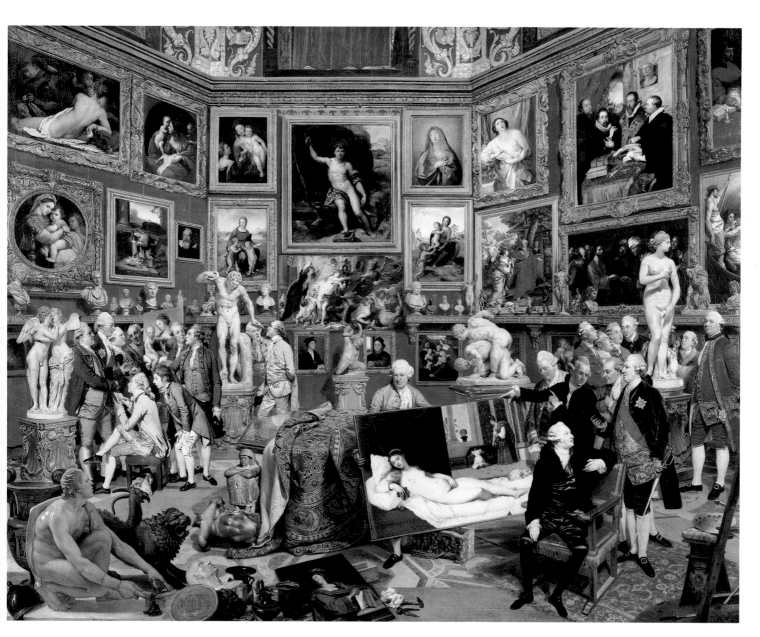

beside his first Raphael with all the laconic hauteur
of a St James's Street clubman. The paintings in
the *Tribuna* provide an anthology of contemporary
taste, dominated by the 'divine' Raphael and
showing works by Guido Reni, Annibale Carracci,
Titian and Rubens.

Thomas Patch, a painter popular for his views of
Florence and caricatures of British Grand Tourists,
and the demi-Englishman Ignazio Hugford were
dealer-collectors active in Florence and both
pioneered the enthusiasm for early Italian art.
Almost the only serious collector to follow them
was the 'Earl-Bishop', Frederick Hervey, 4th Earl
of Bristol (1730–1803) who was Bishop of Derry
between 1768 and 1803. A dazzling figure who
both puzzled and surprised his contemporaries,
Bristol followed his own eccentric and capricious
course in collecting and travel: it is due to him that
so many cities in Continental Europe can boast
a Hotel Bristol. Not constrained by ecclesiastical
duties, he visited Italy in 1765 and spent some
eighteen years there during at least five separate
visits, dying in Rome in 1803. An active patron,
his earliest commission may have been to Joseph

Wright of Derby for a large picture of Vesuvius
erupting, a painting he rejected acerbically. He was
no saint, and in Rome in 1777 he treated Thomas
Banks equally badly over a commission for a
marble sculpture of Cupid. He also commissioned
Pompeo Batoni for his portrait but, in a revealing
gesture, ordered the 'companion' portrait of his
wife from the less expensive Anton von Maron.
The Earl-Bishop was drawn to the ideal landscapes
of Jacob More, owning no fewer than fourteen
of them. Other commissions, mostly for his own
portrait, went to Christopher Hewetson, John
Flaxman, John Deare, Henry Tresham, Philipp
Hackert, Angelica Kauffmann, Madame Vigée-
Lebrun, Hugh Douglas-Hamilton (fig. 141) and
François Xavier Fabre.

In the late 1780s, Bristol turned his attention to
Old Master paintings and was particularly keen to
acquire a Raphael for the gallery at Downhill, his
house built on a cliff-top overlooking the Atlantic,
or Ballyscullion, his eccentric, rotunda-shaped
house, both in County Londonderry. Bristol's
significance as a collector lay in his intention to
create a didactic overall scheme with (as he wrote

to his daughter, Lady Elizabeth Foster, from Naples) a 'gallery of German painters contrasted with a gallery of Italian painters, from Albert Durer to Angelica Kauffmann, and from Cimabue to Pompeo Batoni, each divided by pilasters into their respective schools – Venetian for colouring, Bologna for composition &c'.[5] The Earl-Bishop formed a sizeable collection in Rome but was concerned about its fate with the advance of the French armies. He wrote to Sir William Hamilton in Naples that the 'pictures are chiefly Cimabue, Giotto, Guido da Siena, Marco da Siena, & all that pedantry of painting, which seemed to show the progress of art at its resurrection, & so, had they been left to the mercy of the French, might have been redeemed for a trifle, being like many other trifles, of no use to any but the owner'.[6]

The Earl-Bishop's concern was justified. In 1798 the French army confiscated his property in Rome. Worse was to follow; he was arrested by the French and detained until February 1799. Some of the collection was lost in Rome, and another portion, sent to Naples for shipment to England, was destroyed by salt water. A further group of primitives, as early Renaissance paintings were known, was sold at Christie's in 1802 and a smaller portion, which survived to reach Downhill, was lost when the house was gutted by fire in 1851. The Earl-Bishop's greatest remaining legacy is his other rotunda house, Ickworth in Suffolk, begun towards the end of his life and completed by his successor.

It is easy to think of the impact of the Grand Tour purely in terms of works brought back from the Continent, but it also had a lively influence on architecture and the decorative arts at home. This can be clearly seen in the work of Robert Adam in his most creative decade, from 1760 to 1770, when he worked on remodelling or completing a series of houses: Harewood, Croome, Compton Verney, Kedleston, Bowood, Osterley, Syon and Lansdowne House. One of the reasons for Adam's success was the close attention he gave to the integration of moveable objects within their setting. The overall synthesis of furniture, carpets and fittings required the control of an army of craftsmen, including painters like Cipriani, Kauffmann, Zucchi and Rebecca, as well as furniture-makers like Ince and Mayhew. Typical was Croome Court in Worcestershire, belonging to George, 6th Earl of Coventry (1722–1809), who in 1759 commissioned Adam to remodel its interiors. For Croome, he designed everything from bookcases to clothes presses, the furniture made by William Vile and John Cobb, the leading makers of the day, with the finer details executed by Sefferin Alken, the principal precision carver of the time.

Lord Coventry was frequently in Paris in the early 1760s, and acquired ormolu wall-lights by Simon-Philippe Poirier and Sèvres porcelain, but the most unexpected purchase was his commission of a Tapestry Room from the Gobelins tapestry manufactory. With a crimson ground, the set, known as the *Teintures de Boucher*, was the first of its kind to be ordered by an Englishman. Five similar commissions followed from British patrons, including those for Moor Park, Newby Hall and Osterley Park. In each case Robert Adam meticulously designed the rooms for their setting. Tapestry rooms were much admired in the 18th century and, with their matching covered armchairs and settees, made and still make a sumptuous effect. (The Croome tapestry room is today housed at the Metropolitan Museum, New York; see fig. 142). The Adam synthesis of architecture, fittings, furniture and paintings was never more successful than at Kedleston in Derbyshire, the home of Sir Nathaniel Curzon, 1st Lord Scarsdale. William Linnell and his son John supplied the furniture to complement the Adam decoration (fig. 143). Yet this great Italianate palace with its Grand Tour-style assemblage of paintings by Luca

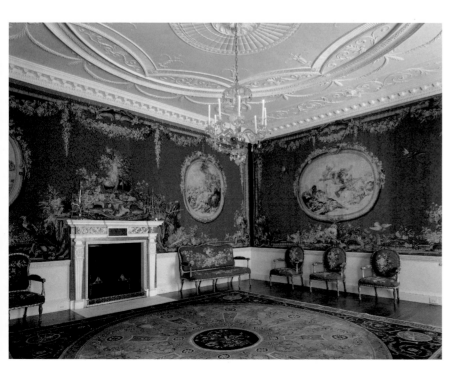

142 Tapestry Room from Croome Court

Commissioned by the 6th Earl of Coventry; now Metropolitan Museum of Art, New York

Giordano, Ludovico Carracci and Bernardo Strozzi was put together for a man who almost certainly never visited Italy. Scarsdale's dealer was William Kent (no relation of the architect) whom he sent to Italy in 1758–59 to find paintings.

Among the most consistent patrons of Robert Adam were Hugh Smithson Percy (1712–1786) and his wife Elizabeth (1716–1776), 1st Duke and Duchess of Northumberland. The couple employed Adam to work on all the family's estates: Alnwick Castle, the original seat of the Percys, was decorated so that it reinterpreted its original Gothic style, in celebration of the ancient lineage of the family; Syon House, the suburban retreat in Middlesex, was transformed into a neo-classical palace devoted to the cult of antiquity; and finally, the refurbishment of Northumberland House, the fashionable mansion on London's Strand, was adapted by Adam and various other architects to pay homage to the latest European and English decorative trends. Northumberland House displayed the bulk of the collections of the couple, which included various Canalettos – of whom the Duke was one of the most faithful patrons during the painter's long London residence – and Italian, Dutch and Flemish Old Masters, among which was Titian's *Vendramin family* (NG London), originally acquired by the 10th Earl of Northumberland.[7]

Although Robert Adam generally hogs the limelight, the first neo-classical interiors in Europe were actually created by James 'Athenian' Stuart at Spencer House, London, for John, 1st Earl Spencer (1734–1783). Prodigiously rich, Spencer had inherited a collection of paintings from his great-grandmother, Sarah, Duchess of Marlborough, but had no suitable London house. He originally commissioned the Palladian architect, John Vardy, in 1755 to build a house overlooking Green Park, but as a member of the Society of Dilettanti he sought something more up to date. Stuart was brought in to create the brilliant series of rooms, with furniture to match, that still exists at Spencer House. Lord Spencer, of whom the 2nd Lord Palmerston said, 'The bright side of his character appears in private and the dark side in public',[8] began buying pictures at the sale of Henry Furnese in London in 1758, acquiring two large canvases, Guido Reni's *Liberality and Modesty* (LACMA) and Andrea Sacchi's *Marc Antonio Pasqualini Crowned by Apollo* (Metropolitan). Between 1763 and 1764 Spencer and his wife, Georgiana, visited Italy where they acquired two large paintings by Salvator Rosa, *Diogenes* and *Cincinnatus* (Althorp). While there, Spencer secured the services of the Rome-based, Scottish painter Gavin Hamilton as his agent, repaying him by commissioning his grandiose *Agrippina with the Ashes of Germanicus* (Tate). Spencer rejected most of what was offered on grounds of size or cost but in 1768 he bought two paintings by Guercino, the *Samian Sibyl* (Althorp) and *King David* (Rothschild Family Trust at Spencer House, London) from the collection of Marchese Locatelli in Cesena. Spencer undoubtedly had a penchant for large 17th-century 'wall-fillers' but there was also a more personal side

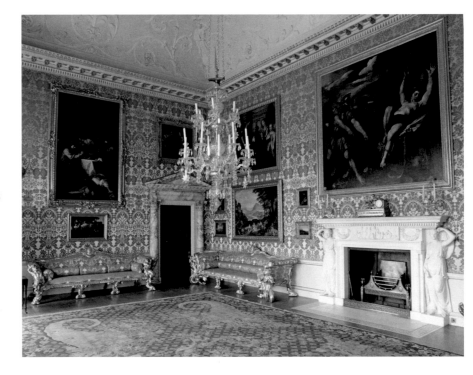

to his patronage which emerges in the enchanting series of family portraits he commissioned from his friend, Sir Joshua Reynolds. The series begins with the portrait of Georgiana Countess Spencer and her daughter and covers three generations (fig. 144).

Joshua Reynolds (1723–1792) was not only a painter but also a major collector and an occasional dealer. His motives as a collector were unusual. Few pictures were put properly on display. He purchased some because of his interest in technique and others for ideas (which he more commonly took from prints). However, he had one of the largest collections of paintings, drawings, sculpture and prints assembled in 18th-century

143 View of Drawing Room at Kedleston, Derbyshire

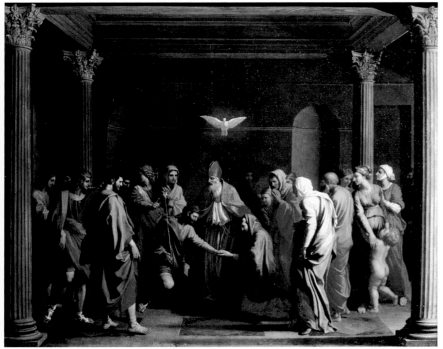

Britain. He attended sales in London and Paris and owned eight Rembrandts still regarded as authentic, including the *Susanna and the Elders* (Berlin). More unusually he acquired Giovanni Bellini's *Agony in the Garden* (NG London). In his 1769 *Discourse*, delivered at the newly founded Royal Academy, of which he was the first President, he differentiated between the curious and the admirable, with a dividing line bisecting the career of Raphael. Reynolds was a voracious collector of drawings, mostly Italian 16th- and 17th-century specimens, and he appreciated sculpture, in which he also dealt. In 1786 he acquired Bernini's *Neptune and Triton* (V&A) of which as he wrote to the Duke of Rutland, 'I buy it upon speculation and hope to be able to sell it for a thousand.' The Duke passed up this opportunity but he bought much else from Reynolds, transactions that illustrate the artist's activity as a dealer. Charles, 4th Duke of Rutland (1754–1787) was a close friend of Reynolds and bought or commissioned over 25 of his pictures. In 1784 the Duke paid an astonishing £1,000 for the artist's *Nativity* (lost with eighteen other paintings by Reynolds in the 1816 Belvoir fire) so it is not surprising that in the following year Reynolds approached Rutland when he had a great prize available.

In 1785 Reynolds, in cahoots with James Byres, was instrumental in Rutland's purchase of Poussin's *Seven Sacraments* from the Boccapaduli family in Rome for the large sum of £2,000 (fig. 145). Poussin's first series of seven pictures of this subject were commissioned by Cassiano dal Pozzo in the second half of the 1630s and these were distinct from the second series, painted for Paul Fréart de Chantelou between 1644 and 1648 (Sutherland Collection). Since an export permit would never have been granted, Byres deviously arranged for copies to be made to cover the walls of the palazzo to fool the authorities. The new acquisitions arrived in London in September 1786 together with another Boccapaduli Poussin, the *St John Baptising the People* (Getty), which Rutland also acquired. Their arrival created a certain *éclat*, and in October Reynolds wrote to the Duke that a rival collector, Welbore Ellis Agar, was 'very much what the vulgar call *down in the mouth*' at having missed the opportunity of buying them and that Lord Spencer 'stood next and was to have them if your Grace had declined the purchase'.[9]

144 Sir Joshua Reynolds, *Georgiana, Countess Spencer with Lady Georgiana Spencer*
Collection of Earl Spencer, Althorp, Northamptonshire

145 Nicolas Poussin, *The Marriage of the Virgin* from *Seven Sacraments*
4th Duke of Rutland; thence by descent

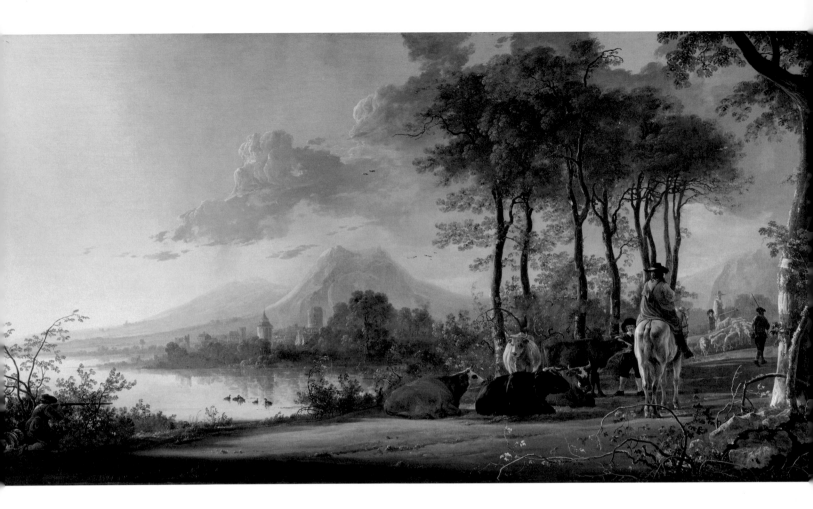

Although Welbore Ellis Agar (1735–1805), to whom Reynolds refers, bitterly regretted having turned down the Poussins, apparently on the advice of Gavin Hamilton, he had plenty to console himself with. Boswell called his collection 'exquisite' and Ellis Agar owned both Claude's *Pastoral Landscape with the Arch of Titus* (Westminster) and the *Hagar and the Angel* (Reinhart), as well as Velázquez's *Prince Balthasar Carlos in the Riding School* (Westminster) and Poussin's *Achilles among the Daughters of Lycomedes* (Boston). A large part of the collection survives intact because at Ellis Agar's death, when it was about to be consigned to Christie's, Robert, 2nd Earl Grosvenor stepped in and bought the entire large collection for the huge sum of £30,000.

Alongside the ever popular Poussin and Claude, there was the growing taste among British connoisseurs for Dutch 17th-century masters. John Stuart, 3rd Earl of Bute (1713–1792) particularly favoured them and by 1764 he had acquired the *River Landscape with a Horseman* (NG London; fig. 146) by Aelbert Cuyp, thereby establishing the artist's popularity in England. Bute, as George III's first minister, exercised enormous influence

over the King and is said to have persuaded him to buy Consul Smith's collection. He had several homes – Bute House in London, Mount Stuart in Scotland, Highcliffe in Hampshire and Luton Park in Bedfordshire – but it was the last that contained his main picture collection. Here Bute needed to fill big rooms, for which Dutch cabinet paintings would have been inadequate. He therefore bought Italian 16th- and 17th-century paintings to cover the walls, but his heart lay with the Dutch school. His agent was an Irishman, a Captain Bailey, who represented him at sales and went to Holland in 1762 in search of paintings for his collection.[10]

We know an unusual amount about the hanging arrangements at Luton Park. The Drawing Room contained a group of Venetian pictures which, interestingly, included not only Titian and Tintoretto but also Tiepolo's *Finding of Moses* (NG Edinburgh). The Library was a 'landscape room' with both Italian and Dutch works, among them Cuyp's *River Landscape with a Horseman*, previously mentioned. Unusually, many of Bute's best paintings lay on the bedroom floor, including Claude's *Morning* and *Evening*. The Picture Cabinet held many of the finest small Dutch works

146 Aelbert Cuyp,
River Landscape with a Horse a Horseman
3rd Earl of Bute; now National Gallery, London

by Pijnacker, Brill, Poelenburgh, Berchem and Ruisdael, but Bute's name will always be associated with his four very fine Cuyps at Luton.

Another Scotsman with a passion for Dutch paintings was the newly wealthy, Sir Lawrence Dundas (1733–1810), who as Commissary-General of the Army in the Seven Years' War accumulated a fortune of £600,000. His famous portrait by Zoffany, seated in the Pillar Room of his Arlington Street London house, shows Jan van de Cappelle's *A Calm* (Cardiff) over the chimneypiece and works by Cuyp, Van de Velde, Pijnacker and Teniers around the side (fig. 147). Dundas, whom Boswell called the 'Nabob of the North', brought together Robert Adam and Thomas Chippendale on the only recorded instance of a direct collaboration, with the latter working to Adam's designs on a set of four sofas and eight chairs for the Arlington Street house.

The development of the 18th-century London art trade gradually obviated the need to visit Italy to acquire Grand Tour art. Most collectors still did make the journey or, like Lord Scarsdale, sent an agent instead. The rise in the status of the London trade is personified by James Christie who set up his auction house at Pall Mall in 1766. The most successful auctioneer of his time, the friend of aristocrats, writers and artists, he once remarked that the presence of Gainsborough and Garrick at an auction added fifteen per cent to his commission. Christie was to dominate the London auction market for paintings but he had competition from Langford, Skinner and Dyke, Harry Phillips, John Greenwood and Peter Coxe. Sotheby's, although already founded in 1744, was devoted to book auctions. Auctioneers dominated the art market until the turn of the century when booty arriving from the Napoleonic Wars gave unprecedented opportunities to dealers, and in particular to William Buchanan. By the 1790s the Grand Tour in its traditional form was halted by the Revolutionary and Napoleonic Wars. In the short term this would make art collecting on the Continent more difficult, and the perils encountered by the Earl-Bishop demonstrate the hazards of collecting in times of war. However the opportunities the wars created for professional dealers in Spain, France and Italy were to give rise to the most important period of British collecting since the time of Charles I.

147 Johann Zoffany,
Sir Lawrence Dundas and his Grandson
The Zetland Collection, Yorkshire

Chapter 10

HORACE WALPOLE
AND ANTIQUARIAN TASTE

The chief motivation of antiquarian collecting
was to assemble knowledge. Two principal strains
can be distinguished, one primarily historical
and sometimes patriotic in its interests, the other
by nature broadly scientific. The first emerged
with the dispersal of the monastic treasures in
the Reformation and we can follow its course
through Archbishop Parker, Lord Lumley, Sir
Robert Bruce Cotton and Dr Mead. The second
was exemplified by the collectors of the natural
world and its 'curiosities', notably Tradescant and
Sloane. The two branches met with the founda-
tion of the British Museum in 1753. Although
the museum, as a product of the Enlightenment,
embraced an international mission from the outset,
the antiquarianism considered in this chapter was
essentially concerned with Britain. It was said that
while the Grand Tourist travelled, the antiquary
stayed at home.

As early as 1707 the Society of Antiquaries was
founded with the objective of studying 'such *things*
as may Illustrate and Relate to the History of Great
Britain' including 'Ancient Coins, books, sepul-
chres, or other Remains of Ancient Workmanship'.
The Society was not concerned with the natural
world and had an archaeological outlook. The
first secretary of the Society was William Stukeley
(1687–1765), an early collector of medieval objects
who owned the celebrated Becket enamel *chasse*
(V&A; fig. 222). The year of the Society's founda-
tion, 1707, was also that of the formal political
union of England and Scotland, and over the
next century the question of British identity and
history fuelled a publishing boom in topographical
works and the emergence of a pantheon of national
culture exemplified by Shakespeare, Handel and

Strawberry Hill

Margaret, 2nd Duchess of Portland

William Constable

Sir Walter Scott

Baronial Taste

George Lucy

148 The Tribune from Horace Walpole's
Description of Strawberry Hill

the novels of Sir Walter Scott. As far as collecting was concerned, few spectacularly valuable items were involved. Matters of context, provenance or the associations of the object commanded as much attention as its craftsmanship, and during the 18th century antiquarians produced one half-genius in the person of Horace Walpole (1717–1797).

In 1746, the year before Walpole took a lease on Strawberry Hill, he wrote, 'The notion I have of a *Museum* is an hospital for everything that is singular.'[1] No British collector has ever more effectively created his own novel world or did more to ensure that posterity would know about it. Walpole was an aristocrat, historian, antiquarian and aesthete all rolled into one. Strawberry Hill and its collections were the vehicle for his imaginative reawakening of the past, 'a small capricious house... built to please my own taste, and in some degree to realise my own visions'.[2] Walpole's visions were original, and while others created Palladian Elysiums Walpole dreamt of the Gothic past and collected the relics of English history in a proto-Romantic spirit. He was not interested in barrows, Roman camps, or what he called 'bumps in the ground', but in the age of Charles I and Lord Arundel, the 'first era of real taste in England', and the Tudor and Jacobean courts beyond.

Horace was the youngest son of Sir Robert Walpole, Prime Minister and creator of Houghton Hall in Norfolk (see chapter 8). At Eton he formed a romantic friendship with the poet Thomas Gray who was to be his companion on the Grand Tour between 1739 and 1741, when they quarrelled and parted company. In Florence, Walpole befriended the British resident, Horace Mann, with whom he corresponded for 46 years. Letters became Walpole's principal means of communicating with posterity. He chose his recipients with care and the *Collected Yale Edition* of them in 48 volumes remains, with Boswell's *Diaries*, the most sparkling window onto the 18th century. Walpole began as a collector of Roman antiquities and he acquired a bust of Vespasian that would be an ornament of the Gallery at Strawberry Hill. In 1743 he purchased the antiquities of his Cambridge mentor, Conyers Middleton, but the acquisition signalled an end to his interest. He then started to collect miniatures (fig. 149) and painted enamels, but the great change in his life occurred in 1749 when he bought the cottage at Twickenham with the fanciful name

Strawberry Hill. A sylvan situation on the Thames with agreeable neighbours, Strawberry Hill became the theatre of Walpole's existence.

No collection was so bound to place as that at Strawberry Hill. For style Walpole flirted with Chinese, Turkish, 'Venetian, Mosque, and Gothic', but settled on a transformation to a late medieval English castle with monastic and cathedral touches. He also formed a 'committee' that encouraged his Gothicism, which over time moved from an elegiac Rococo phase to a more accurate imitation of surviving elements such as in the tombs in Westminster Abbey. The result was a rich and cluttered pile, later dubbed by Sir Walter Scott as 'Gothic toys through Gothic glass'.

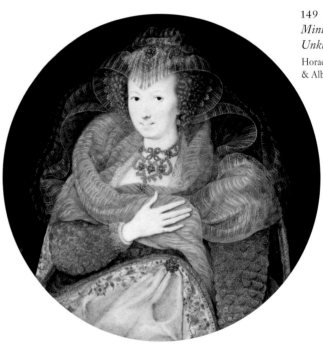

149 Isaac Oliver, *Miniature: Portrait of an Unknown Woman*
Horace Walpole; now Victoria & Albert Museum, London

Designing Strawberry Hill was a pleasant but far from full-time diversion and Walpole spent most of the day writing books and letters. He catalogued his father's art collection in *Aedes Walpolianae* (first edition in 1747) and in 1758 he acquired the 40 manuscript notebooks of George Vertue, which provided the raw material for the first major work of English art history, *Anecdotes of Painting in England* (1762). Walpole poured out *Memoirs* of the various reigns he lived through but by far his most potent literary brew was his Gothic novel, *The Castle of Otranto* (1764–65). Printed anonymously, it has never since been out of print. It was the first book to contain all the iconography of the Gothic novel: castles, ghosts emerging from portraits, dreams and terror (the main

150 Grinling Gibbons,
Woodcarving of a Cravat
Horace Walpole, Strawberry Hill;
now Victoria & Albert Museum,
London

151 Sir Joshua Reynolds,
Portrait of Horace Walpole
National Portrait Gallery

152 The Gallery at Strawberry
Hill from Horace Walpole's
Description of Strawberry Hill

element missing from Walpole's toy castle at Twickenham).

One of the most unexpected and original elements of Strawberry Hill life was Walpole's private press, the first of its kind in England to be used as a personal vehicle of expression. Its productions veered from whimsical pieces to amuse lady visitors to the *Poems of Thomas Gray*.

Inside Strawberry Hill, the historian Lord Macaulay wrote, 'every apartment is a museum; every piece of furniture is a curiosity'.[3] Walpole collected everything except natural history and scientific objects. Portraits dominated the collection: paintings, drawings, miniatures and prints, followed by ceramics, of which 200 pieces were Oriental porcelain, 160 pieces French (mostly Sèvres) and some English and German. But the main talking point of the collection was the 'curiosities' or objects of historical associations: a glove of James I, Cardinal Wolsey's hat and a cravat carved in limewood by Grinling Gibbons (fig. 150). Walpole's sources for such material were metropolitan and country sales where provenance was the guarantee of authenticity. He was assiduous in attending obscure provincial auctions, which as he pointed out, it was rare for a gentleman to attend. Dealers of this kind of material were sometimes referred to as 'nicknackitarians'.[4]

Leaving nothing for posterity to chance, in 1774 Walpole published his *Description of Strawberry Hill*, which is a detailed house tour.[5] The Great Parlour or The Refectory, where Walpole dined, contained portraits of friends and family by Reynolds and others (fig. 151). The Library contained all the usual English and Latin classics, two 16th-century illuminated missals attributed to Raphael and Giulio Clovio, and several of the curiosities. The Holbein Chamber and The Gallery followed (fig. 152). The latter, which Gray characterised as 'all Gothicism, gold and looking glass', was where Walpole placed many of his finest objects: his Langlois lacquer Commodes, and portraits by Lely, Van Dyck, Reynolds, and with pastels by Rosalba Carriera and Liotard. For many, The Chapel, sometimes referred to as The Cabinet or The Tribune, was the climax of the tour (fig. 148). This was a shrine to all that Walpole held sacred, in particular the miniatures by Holbein, Hilliard and Oliver with their associations of Tudor sitters and Stuart collectors. Of all the areas in which Walpole collected, his miniatures were the most outstanding, third only in importance to the

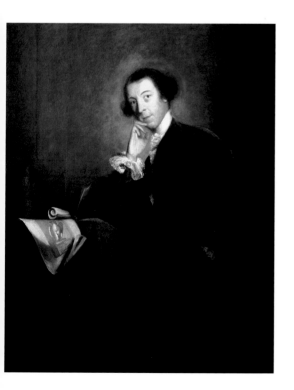

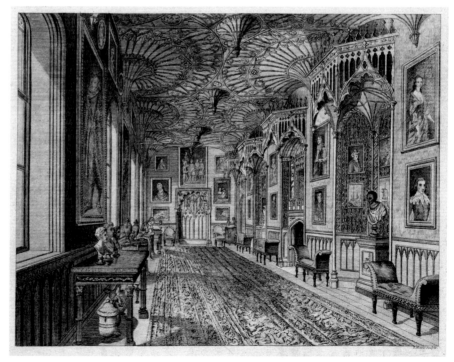

cabinets of the King and the Duke of Portland. The Armoury of Strawberry Hill was created to evoke 'the true rust of the Barons' Wars' and was surmounted with the quarterings of the Walpole family. It was the first romantic assemblage of arms and armour and spawned numerous imitators during the next century.

Walpole once had a dream that he was visiting Whitehall Palace at the time of Charles II and gazed at the remains of the King's father's collection. Strawberry Hill was a palace of memories dedicated to Walpole's private imaginative world. Steeped in history, though often inaccurate, the house demonstrated how the past could be brought to life, and its historical eclecticism obviated the need for furnishings in a uniform style, whether baroque or Palladian. Strawberry Hill was a sensation for Walpole's contemporaries, who poured in to view its wonders, but like so many art collections, its zenith came with its sale. The dispersal of the collection took place long after Walpole's death, taking 32 days in 1842. He had carefully and consciously laid the foundations of his fame through art and letters and he continues to receive the attentions of a sometimes puzzled posterity to this day.

In 1785, when Walpole's interest in collecting was waning, it was temporarily revived by the death of his friend, Margaret, 2nd Duchess of Portland (1715–1785; fig. 153). She was the daughter of Edward Harley, 2nd Earl of Oxford and, as Walpole wrote, 'inherited the Passion of her family for Collecting'. She was a voracious collector and the auction sale took 38 days. Walpole, unlike the Duchess, never strayed into the natural world, and lamented that 'there are but eight [days] that exhibit anything but shells, ores, fossils, birds' eggs and natural history'. The Duchess was a popular bluestocking who surrounded herself with men and women of learning. She admired the Sloane and Mead collections and created a monster collection of her own at Bulstrode Hall in Buckinghamshire, including the Portland Museum of Curiosities. The Duchess was a pioneering collector of china, 'contenting herself with one specimen of every pattern She could get' (Walpole). She bought or owned prints, miniatures, relics and Old Master paintings (without discrimination) and patronised the flower painter, Mrs Mary Delany. She also had a menagerie, and the Rev. John Lightfoot curated

her vast collections of fossils, shells, botany and insects. But she is most celebrated for acquiring, from William Hamilton, the exceptional Roman first-century cameo glass vase still known after her as the Portland Vase (British Museum).

A number of collectors crossed the boundaries between art and science. One, whose cabinet of curiosities survives at his old home, was William Constable (1721–1791), a Roman Catholic gentleman of Burton Constable in Yorkshire (fig. 154). An antiquarian collector of scientific instruments, shells, fossils, minerals, stuffed reptiles and guns, he devoted his life to improving his Yorkshire mansion. He expanded his library and employed Thomas Chippendale to make the furniture. In 1769 Constable acquired the collection of manuscripts and curiosities from Dr John Burton of York, who in turn had acquired many items from the important antiquarian, Ralph Thoresby of Leeds. Constable embarked on a late Grand Tour at the age of 48. In 1770 at Lyon he met Jean-Jacques

153 Michael Dahl, *Portrait of Margaret Cavendish Bentinck, 2nd Duchess of Portland*
Private Collection

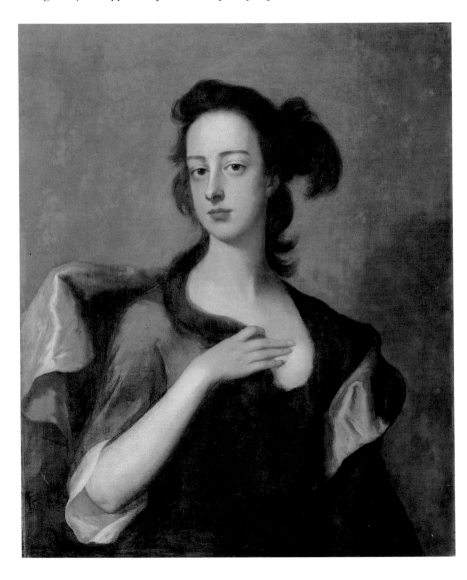

Rousseau, and in the same year was painted as a figure of the Enlightenment by Liotard.

William Cunnington (1754–1810) and Sir Richard Colt Hoare of Stourhead (1758–1838) represent the archaeological tendency. Their collections were a research tool for their pioneering *Ancient History of Wiltshire* (1812–21). The aristocracy caught the vogue: the 3rd and 4th Dukes of Northumberland created a museum of local curiosities and archaeological material at Alnwick and Lord Londesborough built up a collection of 'ancient, medieval, and Renaissance remains', which were published in 1854 with an historical introduction by Thomas Wright. These collectors

anticipate General Pitt-Rivers (see chapter 18) and the growth of local archaeological museums. It was however the 'imaginative' branch of historical and patriotic antiquarian collecting, pioneered by Walpole, that continued to influence taste and later attracted the attentions of a first rank novelist, Sir Walter Scott (1771–1832).

With Scott we encounter a historical colossus who reinvented the idea of Scotland. Through his novels he wove a rich tapestry of tales of Highlanders and Lowlanders, imbuing them with nobility and romance where they had previously been considered merely barbaric. At Abbotsford, his Borders home, he created a setting for his

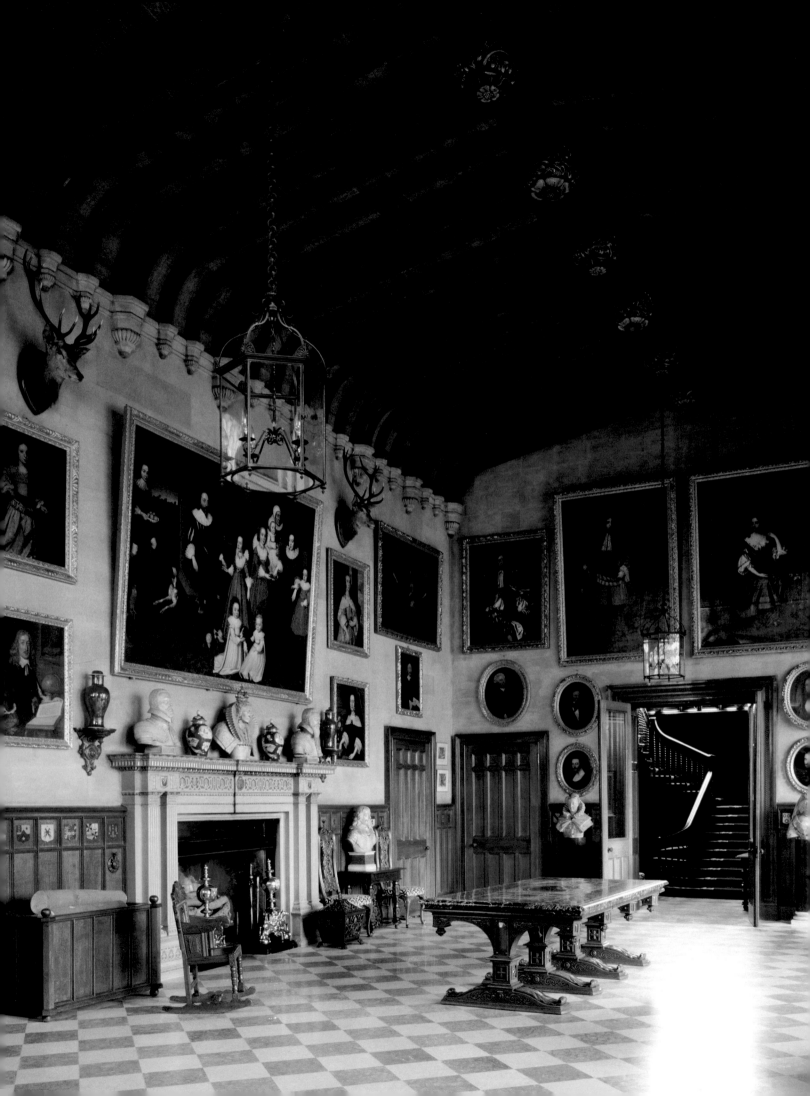

155 The Great Hall at
Charlecote Park, with the
pietra dura table at the centre
(see also page 167)

156 The armoury at
Abbotsford

historical relics, Jacobite material, arms and
armour (fig. 156). The author of a novel entitled
The Antiquary (1816), Scott was a great frequenter
of 'broker's' shops and wrote cynically about
their contents: 'no shop is so easily set up as an
antiquary's… a commodity of rusty iron, a bag or
two of hobnails, a few odd shoebuckles etc.'[6] The
collection had none of the whimsy of Strawberry
Hill and sat comfortably within the late Regency
Gothic of William Atkinson's architecture at
Abbotsford. It anticipates dozens of Baronial
mansions over the next half century with their
armouries, heavy furniture and historical portraits.
Scott was advised on his armour by the greatest
authority of the day, Sir Samuel Rush Meyrick
(1786–1848) of Goodrich Court, Herefordshire.
Meyrick was a pioneering collector of arms and
armour and rendered it a proper field of academic
study. He commissioned the architect Edward
Blore to construct 'a dwelling in the style of
Edward II', with a Grand Armoury, a Hastilude
Chamber fitted up to represent a jousting match,
and an Asiatic Armoury. Eugène Delacroix visited
the collection with Richard Parkes Bonnington
in 1825 and made drawings of the armour. The
Meyrick Collection was eventually bought by Sir
Richard Wallace in 1871 and may still be seen at the
Wallace Collection in London.

William Beckford (see chapter 13), the pioneer

of historicist interiors and matching furniture at
Fonthill and later Lansdown Tower, was propelled
by an aesthetic rather than an antiquarian impulse.
One of the many collectors he influenced was
George Lucy of Charlecote Park in Warwickshire,
whose family had owned the land since the 12th
century. In 1823 Lucy inherited the house, which
has thrilling Shakespearian associations, and initi-
ated an antiquarian refurbishment. The house was
emptied of old furniture and in September 1823
Lucy attended the Fonthill Abbey sale (instructed
by John Farquhar rather than Beckford). Lucy
spent £3,431, over half of which was lavished on
a 16th-century pietra dura tabletop, with an oak
frame made for Beckford (fig. 155). George Lucy
invited a heraldic artist, Thomas Willement, to
redecorate the main rooms of Charlecote and
find suitable furniture and stained glass. In the
footsteps of Horace Walpole and Walter Scott who
created their houses and filled them with objects of
association, by the mid-19th century almost every
old family in Britain was busy reinventing itself,
not only by rebuilding their homes to look more
romantic but restocking them with 'the true rust of
the Baron's Wars'.

Chapter II

ARCHAEOLOGY AND ANTIQUITY

Robert Adam, in the dedication to King George III of his *Ruins of the Palace of Emperor Diocletian at Spalatro* (1764), predicted 'an Age of Perfection' in the arts which would be comparable to 'that of Pericles, Augustus or the Medicis'. When seeking models of perfection Englishmen looked to the architectural and sculptural remains of classical antiquity. While Robert Adam could reproduce the former, the latter had to be acquired, usually from Rome but later also in Greece. The Grand Tourists of the early 18th century avidly read Cicero and other classical authors but – apart from Lords Leicester and Pembroke – had limited success in acquiring important examples of classical sculpture. This situation altered in the second half of the century due to the increased ardour, wealth and political influence of British collectors, but above all through the direct excavation of sites around Rome and the existence of a network of agents and dealers.

The tradition of collecting classical antiquities had been established in England during the 17th century by collectors such as the Earl of Arundel and the Duke of Buckingham, and it was extended in the 18th century by Sir Andrew Fountaine, Sir Robert Walpole and Thomas Coke, the future Lord Leicester. But it was not until the end of the Wars of the Austrian Succession in 1748 and the restoration of peace in Italy that opportunities improved. British collectors had frequently been portrayed with classical sculpture in the background of their portraits to indicate their interests, but their deeper ambition was to build sculpture galleries of ancient art. These were to some extent the successors to the Elizabethan long galleries, with sculpture replacing ancestral portraits. Some were located in London

Society of Dilettanti

Thomas Jenkins

2nd Marquess of Rockingham

1st Marquess of Lansdowne

Charles Townley

Henry Blundell of Ince

William Weddell

Sir William Hamilton

Sir Richard Worsley

7th Earl of Elgin

Richard Payne Knight

6th Duke of Bedford

6th Duke of Devonshire

157 The Strangford Kouros
6th Viscount Strangford; now British Museum

but more often they were purpose-built additions to country houses, such as Holkham, Newby, Ince Blundell and Woburn. These galleries contained a mixture of major and minor pieces with a strong emphasis on Roman copies of Greek originals, supplemented by small bronzes, casts, cameos and gems. The problem was supply. Although Roman export laws could occasionally be breached by a well-connected collector such as Lord Leicester, the best pieces were unobtainable, and new sources were needed.

The increasing passion for antiquity is epitomised by the Society of Dilettanti, founded in 1732 by a group of young Grand Tourists. They were mostly aristocrats, but also scholars and artists, and their main achievement lay in the Society-sponsored publications that encouraged a shift in interest towards Greek art. The Dilettanti's *Antiquities of Athens* (1764) was judged by Sir John Summerson to be one of the three most influential architectural books of the 18th century. As one scholar wrote of the Dilettanti Society: 'First it was Roman. Then it was Greek. Then it was Graeco-Roman.'[1] The Dilettanti dinners were bibulous affairs at which the members toasted 'Viva la Virtù', 'Seria Ludo' and 'Grecian Taste and Roman Spirit'. Its membership reads like a roll-call of the great collectors of the next 100 years: Rockingham, Lansdowne, Townley, Weddell, Hamilton, Payne

Knight and Worsley, to name only a few. If the initial impulse at home was literary and social, the discovery of Herculaneum in 1738 and of Pompeii a decade later stimulated this cult of antiquity. Equally important was the creation of the public museums of ancient art in Rome, the Museo Capitolino in 1734 and the Museo Pio-Clementino in 1771.

The election of Pope Pius VI, whose long reign stretched from 1775 to 1799, opened the golden years for 'digging and dealing'. The Pope's election had been engineered by that most elevated of *marchands amateurs*, Cardinal Albani, and together they looked forward to filling the Museo Pio-Clementino largely through the fruits of British excavations which were shared out by prior agreement. The 80 excavations carried out during the Pope's reign, which constituted a virtual British monopoly (the French and Germans trailing far behind), were motivated by Pius's need for British naval support in the Mediterranean and, later, his anxiety over revolutionary France.[2] The end of the Jacobite cause had lowered tensions between London and Rome, and aristocrats from Britain and Italy formed partnerships with the dealers who became the central figures in this story.

A group of learned agents and dealers operated a professional network consisting of excavators, restorers and shippers, and they had the necessary

158 The Museum Room at Wentworth Woodhouse

159 Lansdowne House, apse at end of sculpture gallery showing Meleager, Marcus Aurelius and Hercules

contacts with the Roman authorities. The major figures were Matthew Brettingham, who acted for Lord Leicester, the painters Robert Fagan and Gavin Hamilton, and above all Thomas Jenkins (1723–1798). Like so many of the agents Jenkins was originally an artist but became the leading British dealer and banker in Rome. A man of considerable culture and a ruthless operator, he was, usefully, a friend of Popes Clement XIV and Pius VI as well as of Johann Winckelmann, the historian of ancient art. Although distrusted by his numerous rivals, like many an unscrupulous dealer before and since he delivered the goods. He produced regular catalogues of items available for sale – many heavily restored – which were not always legally exported. Jenkins wrote that he supplied 'the taste of English *virtuosi* who had no value for statues without heads', and to this end he maintained a network of local restorers, some of them successful sculptors in their own right to provide the missing parts. The most famous was Bartolommeo Cavaceppi, a sculptor and dealer whose large workshop was situated in the Via del Babuino, and who restored statues for Cardinal Albani. Cavaceppi also carved copies of original statues for British visitors to Rome, including the Duke of Northumberland, Lord Rockingham, Lord Palmerston and Henry Blundell.

Between 1761 and 1796 Jenkins excavated a few sites but Gavin Hamilton undertook the lion's share, including the unearthing of part of Hadrian's Villa at Tivoli beyond the Ponte Lucano, called the Pantanello, at Tor Colombaro on the Via Appia, at Albano, south of Castel Gandolfo and at Ostia. Jonathan Scott memorably observed that Hamilton had a nose for the remains like 'a Texan oilman who can smell oil under the desert sand'.[3] Before the results of British excavations became available from the 1760s, collectors in a hurry resorted to casts or copies. Charles Wentworth-Watson, 2nd Marquess of Rockingham (1732–1782), travelling on his Grand Tour (as Lord Malton) between 1747 and 1750, was asked by his father to find marble tables and statues 'about 6 feet high' to furnish the enormous edifice he was enlarging, Wentworth Woodhouse in Yorkshire (fig. 158). Malton sensibly responded, 'As I hear it will be impossible to have antique Statues, and as the Models made from them in plaster are so easily broke and at best have but a mean look... I intend trying to

get Copies done in marble of the best antique statues.'[4] He commissioned eight copies, four from Roman sculptors including *The Capitoline Antinous* from Bartolommeo Cavaceppi, and four from British sculptors working in Rome including *The Medici Venus* from Joseph Wilton. He also acquired the large marble group of *Samson Slaying the Philistines*, by Vincenzo Foggini, completed in Florence in 1749 (V&A). Rockingham was a member of the Dilettanti Society and co-sponsored the Athenian voyages of James Stuart, who largely inspired the shift in taste towards Greek art among British collectors over the rest of the century. Rockingham served as Prime Minister but is probably better known today for commissioning *Whistlejacket*, the monumental horse portrait by George Stubbs (NG London). He also bought a significant cabinet of coins from the Abbé Visconti, president of the Society of Antiquaries in Rome, and collected ancient Greek vases.

The man who succeeded Rockingham as Prime Minister in 1782 was William Petty, Lord Shelburne, later 1st Marquess of Lansdowne (1737–1805). He illustrates the huge increase in supply that emerged once the excavations promoted by Hamilton and Jenkins had got under way. Shelburne went to Italy in 1771, perhaps as a solace after the death of his first wife, and conceived the idea of a sculpture gallery for his London home, the future Lansdowne House (fig. 159). Although Shelburne prevaricated over his choice of architect, and his plans for a gallery were never completed in his lifetime, he formed one of London's two finest private collections of antiquities.

To Hamilton and Jenkins, Shelburne's wealth made him a tempting prospect. In 1771 Hamilton invoiced him for 1063 crowns for 55 antiquities and put forward a proposal for '16 fine antique statues, 12 antique busts, 12 antique basso-relievos etc... that will make Shelburne House famous not only in England but all over Europe'. From the excavation of Hadrian's Villa at Tivoli Hamilton sent a *Cincinnatus* (Copenhagen) which the Pope had turned down at £500 but Shelburne acquired for £450. Hamilton later claimed that he had to smuggle it out of Rome. Similarly, from the excavation at Tor Colombaro in Rome, Hamilton supplied the *Antinous/Meleager* and the *Wounded Amazon* (both now Metropolitan), but it was Jenkins who supplied Shelburne's most

famous piece, the *Lansdowne Hercules* (Getty) for £500, discovered near Hadrian's Villa. Shelburne's interests, however, changed and instead of a sculpture gallery he planned a grand library for his important collection of books and manuscripts. It was left to the 3rd Marquess to complete the sculpture gallery to the designs of Smirke between 1816 and 1819. Interestingly, Hamilton also supplied Lord Shelburne with a number of Italian paintings, including the London version of Leonardo's *Virgin of the Rocks* (NG London).

In contrast to Shelburne, Charles Townley (1737–1805) of Towneley Hall, Lancashire instead arranged his collection in his terraced house in Park Street, Westminster (now Queen Anne's Gate). In contrast to Shelburne, who was in Italy for only six months, Townley made three lengthy visits (in 1767–68, 1771–74 and 1777) and added to his collections throughout his life. Rather than a Whig aristocrat distracted by high office, Townley was a Catholic country gentleman who devoted his life to connoisseurship and collecting antiques. Although he was never an active scholar, nor wrote books, his informed knowledge helped him assemble the most important collection of antiquities in 18th-century England. His taste was antiquarian and went beyond the decorative requirements of most collectors; he avoided restored pieces, his vast correspondence revealing his testiness when he was not offered items first and in an unrestored condition.

Townley's papers provide a complete picture of the growth of the collection. Initially he bought from the competing dealers Gavin Hamilton, James Byres and Thomas Jenkins. The latter sold him, for £400, the most expensive of his early purchases, the fragmentary *Boys Fighting over the Game of Knuckle-bones*, formerly in the Palazzo Barberini. Townley corresponded with Jenkins for 30 years and the dealer provided him with long credit to enable his collecting when back home in London. On his second Grand Tour, which lasted three years, Townley established himself as a serious collector. He acquired the celebrated bust of *Clytie* (fig. 160), which became his personal favourite, from Prince Laurenzano in Naples, and the statue of *Atalanta* (or *Diana*), unearthed by Jenkins in Rome in 1772. During the same decade Hamilton was excavating at Monte Cagnolo, south of Lake Nemi, and from this source Townley bought the *Townley Vase* which cost £250, and *Victory Sacrificing a Bull* and *Two Dogs*. It was at Ostia in 1775 that Hamilton found the *Townley Venus*, which sold for the huge sum of £600, and which Canova described as the most beautiful female nude in England. Townley's lavish expenditure also benefited Jenkins, who in 1773 sold him a *Head of a Homeric Hero* for £200, a statue of *Diana* for £250 and a *Faun Ravishing a Nymph* for £350. By 1781, such was the growth of his collection that Townley, who bought strictly out of income, needed more time to pay off his loans. As he wrote to Jenkins: 'You must be sensible that I have always bled freely in your hands and that my finances must be a little shaken in the service of *virtù*.'[5]

Townley displayed his collections in rooms on the ground and first floors of his house at Park Street. Periodically he produced catalogues for the use of visitors, which reveal frequent rearrangements to accommodate new acquisitions. His last important acquisition, *The Discus Thrower*, came from Hadrian's Villa, where it was found in 1791, and was bought from Jenkins for £400. It appears in the famous Zoffany portrait of *Charles Townley and his Friends in the Towneley Gallery*, which shows the collector surrounded by his finest sculptures in an imaginary and rather overcrowded arrangement (fig. 161). Townley became a Trustee of the British Museum in 1791, and in 1805, after his death, the museum bought the collection for £20,000.

160 Marble bust of *Clytie*
Charles Townley; now British Museum

161 Johann Zoffany, *Charles Townley and his Friends in the Towneley Gallery, 33 Park Street, Westminster*
Towneley Hall Art Gallery and Museum, Burnley, Lancashire

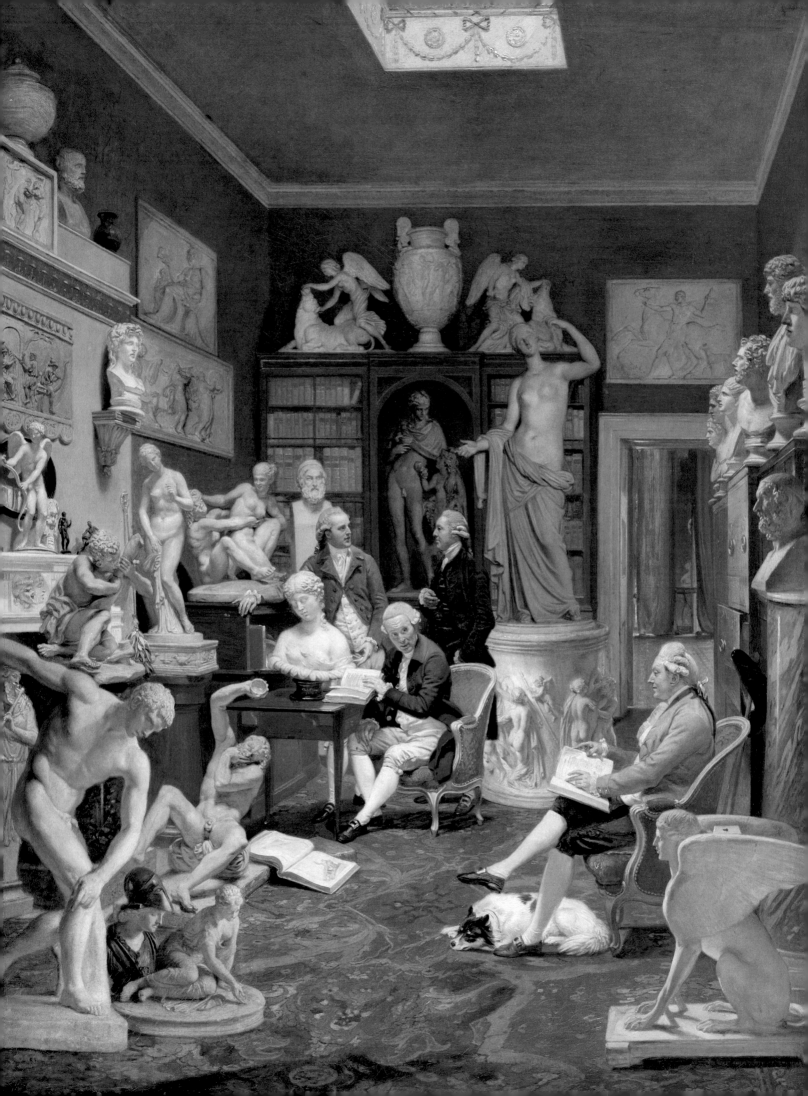

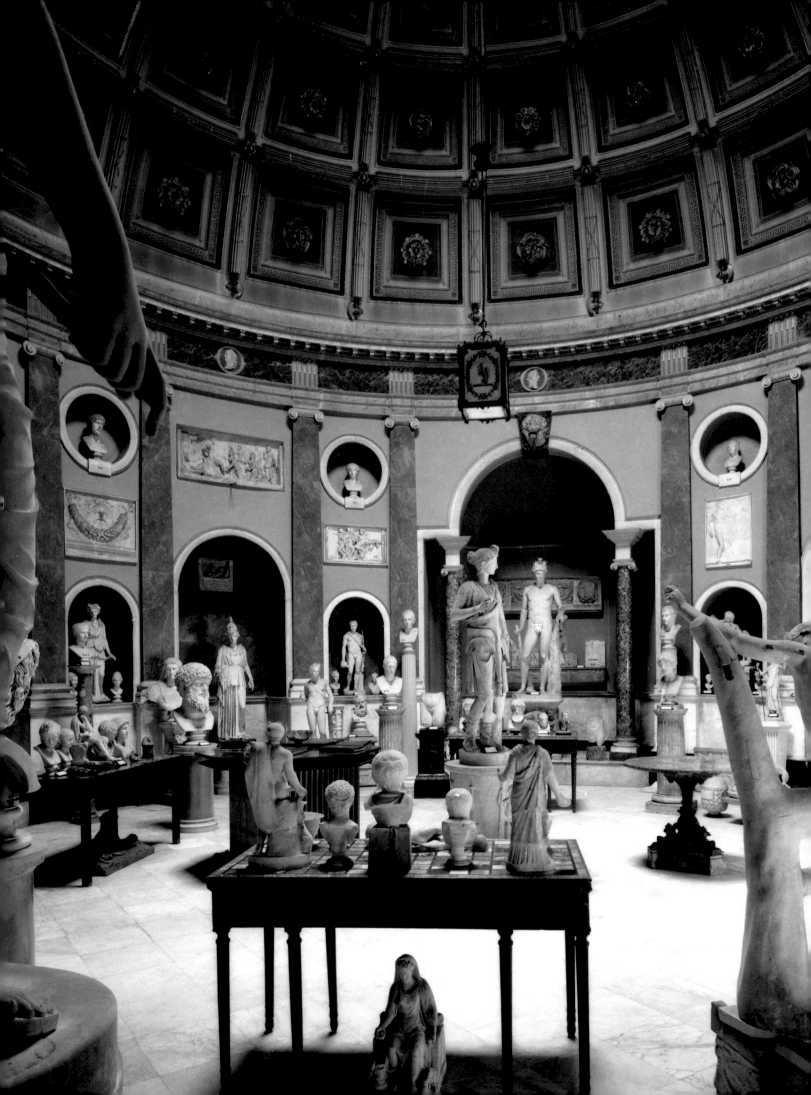

162 The interior of the
Pantheon at Ince Blundell
Hall

163 Ince Blundell, with the
Pantheon at right, connected
to the house

Townley's neighbour, Henry Blundell (1724–1810) of Ince Blundell Hall, Liverpool, was also a Roman Catholic and thereby prevented from taking part in political life. His estates in Lancashire occupied his attention and provided his income, and he did not visit Italy until 1777 when he was a widower and aged over 50. With encouragement from Townley, Blundell began to collect antiquities, joining Townley in Rome in 1777. He was to visit Italy on three subsequent occasions, in 1782–83, 1786 and 1790. Unlike Townley, Blundell was not particularly knowledgeable, and he bought in bulk and delighted in bargains. However, Blundell remains significant as the creator of a vast, idiosyncratic collection of almost 600 sculptures that, he declared, 'give me pleasure and suit me,' and for the outstanding setting he created for them, a dramatic Pantheon connected to the main house and modelled on the Pantheon in Rome, as well as a separate Garden Temple (figs 162–163).

Through Townley, Blundell met Thomas Jenkins, who sold him the residual collection of 80 marbles from the Villa Mattei. Others were acquired from the Villa d'Este at Tivoli, the Villas Altieri and Borioni and the Palazzi Negroni and Capponi. He also bought pieces in the London auction rooms, at the sales of the collections of Lord Cawdor (1800), Lord Bessborough (1801) and Lord Mendip (1802). The resulting assemblage included statues, bust portraits of Roman emperors and other portrait heads, mosaics, bas-reliefs, cinerary urns and other ancient marbles, but the chief beauty of his collection was the overall effect of the ensemble through the skilful

placing of the objects in a neo-classical setting. The display survived until 1959, when Joseph Weld-Blundell generously presented the sculpture collection to the Liverpool Museum and the Hall to the Augustinian Sisters as a nursing home for elderly Catholic residents, but it is tragic that the collection has been exiled from the splendid neo-classical setting which Blundell created for it.

Townley and Blundell hailed from ancient families, but William Weddell (1736–1792) of Newby Hall was the son of a York grocer who inherited a stock market fortune from an uncle. He was a protégé and eventual brother-in-law of Lord Rockingham and quickly assimilated into the landed classes. Aged 28, Weddell set off on his Grand Tour in 1764, stopping in Paris where he commissioned a set of Gobelins tapestries for a tapestry room at Newby. He had already planned a sculpture gallery designed by John Carr of York, and while in Rome set about filling it with Jenkins's help. Being in a hurry pushed up the prices Weddell paid but he bought a wide range of items, realising, however, that he needed to secure at least one masterpiece. Weddell's most celebrated purchase was the so-called Jenkins or Barberini *Venus* (fig. 164). The story of its acquisition and restoration perfectly illustrates the kind of speculation and deals undertaken by Hamilton and Jenkins in Rome at that time.

The *Venus* was sold to Jenkins by the Princess Barberini, and according to the version of the story that Joseph Nollekens told the diarist Farrington, 'the Trunk of the figure, and one of the thighs and part of the leg is antique. The Head, Arms, and the other thigh and leg are modern.' Jenkins was unhappy with the head 'and finding a Head of Agrippina with a veil falling from the Hair, He had the Veil chiselled away and the Head trimmed and set on the body of the figure.'[6] Jenkins then sold the work to Weddell on the basis that it was in perfect condition, but for export purposes he emphasised the extent of the restorations and submitted documents with the price he had paid to Princess Barberini.[7] He claimed that the statue was for the King, to ease its export, and suggested that it was unsuitable for the Papal collection since 'it was a naked female'. Weddell, with his enormous fortune, paid Jenkins a huge sum for the *Venus*, estimated at between £1,000 and £4,000. Weddell also granted Jenkins an annuity until his death,

which explains the wide range in the estimated cost. The saga amounted to a coup for Jenkins and earned him what was probably the highest price paid for an antiquity by a British collector in the 18th century. The *Venus* was sold at Christie's in 2002 for £8 million and its place is occupied today by a cast.

Weddell bought other antiquities from Piranesi, Cavaceppi, Jenkins and Hamilton, including statues, busts, heads, sarcophagi and tripods. In all nineteen chests of marbles were shipped back to Newby, as well as paintings, among them Weddell's spectacular portrait by Batoni. On returning home Weddell sacked Carr of York and commissioned Robert Adam to design a series of brilliant rooms to house the new collection, its climax being the most attractive of all country house sculpture galleries (fig. 165). Townley criticised the gallery for its overly rich ornament, but it remains neverthe-less one of the most perfect creations of the 18th century in terms of its scale, proportion, design and contents.

All the collectors discussed in this chapter so far were travellers who made Rome their principal destination. Sir William Hamilton (1731–1803), a born collector with an enquiring mind, forms the exception in many ways. Appointed His British Majesty's Envoy Extraordinary to the Kingdom of the Two Sicilies in 1764, he lived in Naples for 35 years, only returning to live in England in 1800. Every Grand Tourist who went to Naples visited his home and museum in the Palazzo Sessa, and Hamilton happily combined his twin passions, collecting vases and vulcanology. The excavations at Herculaneum and Pompeii stimulated his collecting. Goethe remarked of Pompeii, 'Many disasters have befallen the world, but few have brought posterity so much joy,' and Hamilton would have agreed.

Although Hamilton collected sculpture, bronzes, gold jewellery and carved gemstones, he focused his interest on Greek vases, which he could acquire soon after their recovery from the volcanic ash. His first collection of them was catalogued by Pierre Hugues D'Hancarville in four sumptu-ously illustrated volumes in 1766–67. Among the most beautiful is an Athenian red-figured hydria (water-jar) of *c*.420–400 BC, attributed to the Meidias Painter, depicting the *Rape of the Daughters of Leucippus and Hercules in the Garden*

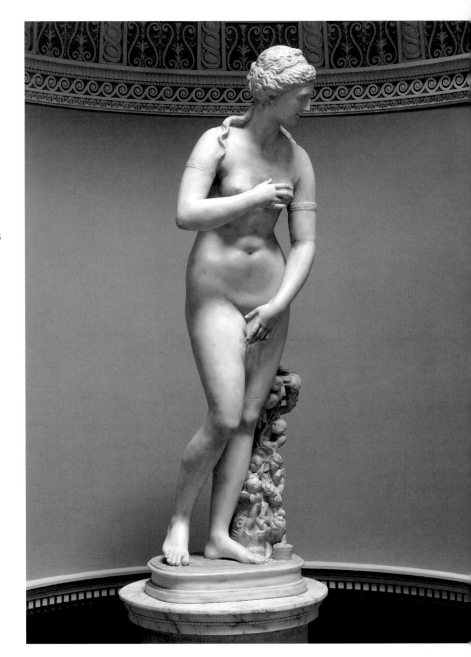

of the Hesperides. In 1772, needing to reduce his overdraft, Hamilton sold his vases, bronzes, terracottas and gold ornaments to the young British Museum for £8,400, where they formed the nucleus of the Department of Greek and Roman Antiquities. But unable to resist the urge to collect, he formed a second collection of vases, cameos, intaglios, Egyptian scarabs and an important group of bronze artefacts. Several vases from this

famous vases, the Warwick and the Portland. The colossal marble Warwick Vase, dating from the 2nd century AD, was discovered by Gavin Hamilton near Hadrian's Villa during excavations in 1769–70. Much restored, it was bought by Hamilton and etched by Piranesi. Having tried in vain to persuade the British Museum to buy it, Hamilton sold it to his nephew, Lord Warwick and it remained at Warwick Castle until 1978 (Burrell

164 The Jenkins or Barberini Venus, formerly at Newby Hall

165 The sculpture gallery at Newby Hall, Yorkshire

166 Pietro Fabris, *Kenneth Mackenzie, 1st Earl of Seaforth, at Home in Naples: Concert Party*. This is one of a pair of pictures which depict vases and bronze objects, probably excavated from Pompeii. The two keyboard players have been identified as the fourteen-year-old Wolfgang Amadeus Mozart and his father, Leopold, who visited Naples in 1770.
Scottish National Portrait Gallery

collection were lost with the sinking of the *Colossus* on its return journey to England in 1778. Others were sold by Hamilton to the wealthy banker and collector Thomas Hope (see chapter 13). The publication and display of Hamilton's vases had a considerable effect on English taste, notably influencing the architecture of Robert Adam, the Etruscan rooms of Wyatt and the pottery of Josiah Wedgwood. The Neapolitan artist Pietro Fabris, much patronised by Hamilton, painted two interior views of the house in Naples taken by the 1st Earl of Seaforth (Scottish NPG; fig. 166). They vividly depict red figure and black figure amphorae and bronze artefacts recently excavated from Pompeii, together with his pictures, prints and books.

Sir William owned two of the world's most

Collection). The Portland Vase is considered the most important glass object to survive from antiquity. A blue glass vase from the 1st century AD, it depicts a mythological subject of love and marriage, executed in the cameo technique by carving through two layers of white and blue glass. Long in the possession of the Barberini family, it was sold in 1780 to pay off gambling debts to James Byres, who sold it on to Sir William Hamilton for £1,000. Four years later he in turn passed it to the Duchess of Portland for 1,800 guineas. Sir William was elected a member of the Society of Dilettanti in 1777, an event immortalised in two well-known group portraits painted by Reynolds. In one of them Hamilton is depicted seated at a table with the folio D'Hancarville catalogue opened to reveal

the image of one particular vase, the original of which is displayed (fig. 167).

If Hamilton popularised the collecting of vases, numismatics had appealed to British collectors since the time of Lord Arundel, embracing engraved gems (intaglios and cameos) as well as coins and medals. The gems collected by the 3rd and 4th Dukes of Devonshire were published in 1730, drawn by M. Gosmond and engraved by Claude du Bosc, in the earliest engraved catalogue of a British collection of gems. Another landmark publication was by Lorenz or Laurent Natter, who spent seventeen years in Great Britain, where he published *A Treatise on the Ancient Method of Engraving on precious Stones, compared with the Modern* in 1754, intended to extend the knowledge of connoisseurs in classical gems. The book is embellished with 37 engraved plates of gems from the collections of the Duke of Devonshire, Lord Bessborough (when Lord Duncannon), Lord Carlisle, Dr Mead and others. In 1761, Natter catalogued the Bessborough gems which, like those of Arundel, were bought by the Duke of Marlborough, whose collection was only surpassed by the Duke of Devonshire's. The Marlborough gems were recorded in a two-volume folio catalogue that appeared between *c.*1780 and 1791, and in 1785 John Spilsbury engraved 50 prints of antique gems from the collections of Earl Percy, Charles Greville and Thomas Moore Slade.

In comparison with Italy, the collecting of Greek antiquities lagged far behind. Under Turkish rule since the years following the fall of Constantinople in 1453, Greece itself and the sites of Hellenic civilisation in Thrace, Macedonia, Asia Minor and the Archipelago had become practically inaccessible. The scholarly arbiter of taste who first promoted Greek above Roman art was the German art historian and archaeologist, Johann Joachim Winckelmann (1717–1768). Winckelmann moved to Rome in 1755, entering the employment of Cardinal Albani, who was then forming his magnificent collection of antiquities. Winckelmann's belief that 'liberty alone was the reason for the power and majesty that Athens achieved' sounded the trumpet for the long dispute known as the Graeco-Roman controversy, with Winckelmann in one corner, declaring that good taste was born under Greek skies, and Piranesi in the other, defending Roman art and architecture.

Winckelmann opened people's eyes to Greek art, in the same way that Piranesi had to the glory of ancient Rome – through the imagination. In 1755 Winckelmann published his *Reflections on the Imitation of Greek Works in Painting and Sculpture*, outlining the new Hellenism which spread rapidly to England.

Practical steps to foster knowledge of all things Greek were undertaken by the Society of Dilettanti. In the 1750s it began to finance a sequence of expeditions to excavate, collect, measure and draw classical antiquities in Greece, thereby laying the foundations of Greek archaeology. The results of its expeditions were published in a series of folio works, beginning with *The Antiquities of Athens Measured and Delineated by James Stuart and Nicholas Revett, Painters and Architects*, which appeared in four volumes in 1762, 1787, 1794 and

1816. Volume One, which was immediately hailed as a masterpiece, provided the first accurate survey of ancient Greek architecture. James 'Athenian' Stuart, an artist, archaeologist and architect, made all the topographical drawings, and Nicholas Revett, an architect, supplied the measurements that gave the book its authority. But it was Stuart who garnered the chief credit and with it the nickname 'Athenian'. The book played a significant role in promoting neo-classicism during the early Greek Revival.

Although agents for Buckingham, Arundel and Charles I brought antiquities back from Greece in the 17th century, the leading such collector in the 18th century was Sir Richard Worsley (1751–1805), who was elected to the Society of Dilettanti in 1778 and for whom collecting and travel provided a distraction from a scandalous divorce. He spent five years between 1783 and 1788 travelling through Greece, Turkey, Egypt and the Crimea, acquiring bas-reliefs, stelae and gems. Some marbles came into his possession from excavations in Athens, Eleusis and Megara. Sir Richard was novel in his pursuit of Greek originals and his preference for unrestored pieces. He displayed his collection in a series of Athenian rooms at his country house,

Appuldurcombe, on the Isle of Wight, where he was visited by Charles Townley. He engaged Ennio Quirino Visconti to help catalogue his collection, and the resulting publication, the *Museum Worsleyanum; or a collection of antique basso-relievos, bustos, statues and gems...*, was a lavish folio work, privately printed in 1794 in a limited edition of 250 copies.[8] It was divided into six classes. The first three covered the marbles, the fourth covered the antique gems and intaglios, the fifth covered the bas-reliefs and the final class a selection of 'Views and Ruins in the Levant'. Perhaps the finest marble, a great rarity in England at the time, was a 5th-century Greek stele carved in low relief of a *Girl with Two Doves*.[9] Worsley left his collections to his niece, who married the 1st Lord Yarborough, and the latter moved the collection to Brocklesby in Lincolnshire, where much of it remains.

Perhaps the most unfortunate collector in British history – with the possible exception of the Earl-Bishop of Bristol – is Thomas Bruce, 7th Earl of Elgin (1766–1841). Pilloried by Byron, imprisoned by Napoleon, denigrated by members of the Dilettanti Society, and almost bankrupted by an ungrateful government, Lord Elgin died a broken man. His achievement in securing the Acropolis marbles (fig. 168) has been overshadowed ever since by controversy.

Elgin set out as ambassador to the Sublime Porte at Constantinople in 1799 with the intention of bringing back antiquities, casts and drawings for 'the progress of the taste in England'. En route he visited Sir William Hamilton at Naples who introduced him to the artist Giovanni Battista Lusieri, whom Elgin employed to lead a team to record the ancient monuments in Athens, above all on the Acropolis. The city was under Turkish rule, and after a long period of uncertainty Elgin was favoured with a *firmān* (permit). Its conditions were vague and the change from the measuring and drawing of the ruins to their partial removal was envisaged in principle. This was nothing new. Ten years earlier the French had attempted to remove sculptures from the Parthenon and many had already been lost, stolen or offered for sale locally. Elgin sincerely believed that he was saving the marbles and diligently recorded all his finds. When he found the marbles they were discoloured and disfigured.

For Elgin, the real trouble began when the

marbles went on show in London for the first time in 1807. While many, led by Byron, deplored the vandalism to the Parthenon, the initial controversy surrounded whether the sculptures were sublime originals, as the artists Canova, Lawrence, Haydon, Westmacott and Nollekens maintained, or Roman marbles from the time of Hadrian, as was believed by the *arbiter elegantiarum*, Richard Payne Knight. In 1811 Elgin offered the collection to the government for £62,000, a sum which barely covered his costs. The offer was refused and the matter was slogged out at a Select Committee of Parliament until 1816, when Elgin was obliged – in order to ward off bankruptcy – to accept £35,000.

Whereas Payne Knight was not insensitive to the early Greek style, his inability to appreciate the high quality of the Elgin marbles is revealing. As J. Mordaunt Crook perceptively wrote of English connoisseurs: 'Trained in the appreciation of the Ideal Forms, they rejected the naturalism of the Parthenon marbles; collectors of Roman and Greco-Roman figures, they spurned the simplified architectural sculptures of the Greeks. They preferred the Apollo Belvedere to the Theseus, grace to grandeur.'[10] A similar problem may have attended the failure of the British – despite the efforts of some – to secure the pedimental sculptures from the sanctuary of Aphaia at Aegina discovered in 1811, which embody the transition from the Archaic to the Classical style. They went to King Ludwig I of Bavaria. English connoisseurs were slow to see the merits of Archaic art, the *Kouros* bought by Lord Strangford (1780–1855) and now in the British Museum (fig. 157) constituting an exceptional purchase at the time.

Richard Payne Knight (1750–1824), who so misjudged the Elgin Marbles, was a collector, pundit, polemicist, garden designer and a major benefactor to the British Museum of which he was a trustee. Unlike Elgin, whose heroic figure sculptures he failed to appreciate, Payne Knight preferred bronze and portable small-scale pieces, including coins and engraved gems. This was partly fuelled by his interest in cult objects. An original thinker and writer on beauty and the Picturesque, whose own house, Downton Castle, was built on an asymmetrical ground-plan, Payne Knight was elected a member of the Dilettanti Society in 1781. His collection of ancient art included a Greek 5th-century-BC mirror stand (from Sir William

Hamilton's collection), a silver statuette of Psyche and a Roman bronze Jupiter (fig. 169). His bequest of over 1,100 Old Master drawings to the British Museum transformed the Print Room, adding significant examples by Mantegna and Rembrandt and a group by Claude equalled only by his *Liber Veritatis* from the Devonshire collection. Knight's paintings, which like his estates he left to his brother, formed an unorthodox medley of works by artists as varied as Mantegna, Claude, Bernard Van Orley, Elsheimer, Michiel Sweerts, Rembrandt, Ruisdael, Turner and Wilkie.

The Napoleonic Wars brought a temporary halt to Continental travel and an end to British excavations in Italy. When John Russell, 6th Duke of Bedford (1766–1839) arrived in Rome in 1815 he found little available on the market, but he managed to buy sarcophagi from both the Villa Aldobrandini and the painter and dealer Pietro Camuccini. By this date the preference of British connoisseurs for free-standing statues was more easily satisfied by contemporary sculptors. Bedford became a major patron of both Bertel Thorvaldsen and Antonio Canova, commissioning a version of Canova's iconic *Three Graces* for which he paid an eye-catching £3,000 (jointly V&A and NG Edinburgh; fig. 170). It represents one of the most important European commissions of the century by a British patron. The Duke created an attractive sculpture gallery out of a conservatory at Woburn House, with a *tempietto* at one end designed to hold Canova's group. Similarly, William Cavendish, 6th Duke of Devonshire (1790–1858) bought antiquities in a desultory way, but his passion was for contemporary sculpture. 'My Gallery was intended for modern sculpture,' he wrote in his Chatsworth guidebook, and filled it with the works by Thorvaldsen, Bartolini and above all Canova (fig. 171). The Duke, however, did purchase one major antique, the 5th-century-BC Greek bronze *Apollo* (British Museum) known as the 'Chatsworth Head', which he acquired in Smyrna (now known as Izmir) while on a cruise in 1839.

169 Roman bronze figure of Jupiter
Payne Knight bequest to British Museum

170 Antonio Canova, *The Three Graces*
Commissioned by the 6th Duke of Bedford; now Victoria & Albert Museum, London

By the mid-19th century the sources of antique art were drying up and English collectors turned to patronising living sculptors. The archaeologists no longer served individual collectors but universities and public collections and museums. Tastes were also changing. In his *Sketches of the History of Christian Art* (1847), Lord Lindsay wrote of the great classical statues that 'none of these completely satisfy us. The highest element of truth and beauty, the spiritual, was beyond the soar of Phidias and Praxiteles.'[11] The transmission of classical culture was to pass to museums. In future, private collectors were either specialists like Sir John Beazley, who formed a scholarly assemblage of vases, or William Waldorf Astor, who bought ornamental garden statuary for his garden at Hever Castle. As the collecting of antiquities declined, curiously, the prestige of casts rose. They became particularly important for the training of young artists and formed a significant component of European museums as can still be appreciated at the Victoria and Albert Museum and the Ashmolean Museum. In 1882 Adolf Michaelis published his *Ancient Marbles in Great Britain*, simultaneously a celebration of and a lament for the activities of British collectors in the field of antiquities. Henceforth the story among private collections was one of sales and dispersals.

171 The Sculpture Gallery at Chatsworth House

Part Three

PLUTOCRACY

Metropolitan Apogée

Chapter 12

THE ORLÉANS COLLECTION AND NAPOLEON'S BONANZA

'Flocks of agents, dealers, unsuccessful artists and adventurers of all kinds descended like vultures on Italy to take their pickings … For more than a decade it seemed as if the whole of Europe from dukes and generals to monks and common thieves was involved in a single vast campaign of speculative art dealing.'[1] Thus Francis Haskell characterised the most formative moment in British art collecting since the days of the Earl of Arundel and King Charles I. The consequences of the French Revolution and the ensuing wars and occupations in Italy and Spain prised art treasures that had seemed locked up forever from monasteries, palaces and cathedrals. Suddenly available for sale, the majority came to England, and George III wryly observed that 'all his noblemen were now picture dealers'. The flow of paintings that began at the end of the 18th century continued for at least 25 years. But if Italy offered most of the opportunities, France provided the greatest single collection of masterpieces to come on the market since the Gonzaga purchase in the 1620s: the Orléans collection.

No two accounts of the complex story of the arrival of the Orléans collection in London entirely tally. Louis-Philippe-Joseph, Duc d'Orléans, known as Philippe Egalité, was a colourful and anglophile member of the French royal family with ambitions to serve his country in place of Louis XVI. He had inherited the finest private art collection in the world, formed by his great-grandfather Philippe II, Duc d'Orléans, and it included portions of the collection of Queen Christina of Sweden and of three cardinals: Richelieu, Mazarin and Dubois. Philippe Egalité's need for cash to support his political ambitions obliged him to sell his cabinet

3rd Duke of Bridgewater

2nd Marquess of Stafford

5th Earl of Carlisle

7th Viscount Fitzwilliam of Merrion

William Buchanan

The Taste for Titian

Noel Joseph Desenfans

Philip John Miles

172 Orazio Gentileschi, detail from
The Finding of Moses
Orléans collection to Earl of Carlisle; now Private Collection, on loan to National Gallery, London

of engraved stones to Catherine the Great in 1787.

The following year Philippe Egalité approached the British, and several eminent figures were involved in negotiations that failed, including the Prince of Wales and the auctioneer James Christie. But in 1791, the Duke was declared bankrupt, paving the way for a British consortium led by Thomas Moore Slade, a rich speculator, with Lord Kinnaird, Thomas Hammersley and William Morland to secure whatever parts of his collection that were available. The Italian and French pictures were already sold by the time Slade appeared. Negotiations went backwards and forwards with Slade heroically pleading his case in Paris to suspicious French creditors. He was rewarded with the Dutch and Flemish pictures which arrived in London in 1793, the year of the Terror when the Duke went to the guillotine. Rembrandt's *The Mill* was sold to William Smith, MP, while Rubens's *Judgement of Paris* was selected by Lord Kinnaird himself but ended up with the Yarmouth collector, Thomas Penrice.

The fate of the Italian and French pictures from the Orléans collection was more convoluted. They had been bought first by a Brussels banker,

Edouard Walckiers, who then sold them to his cousin, Francois-Louis-Joseph de Laborde-Méréville with the help of a mortgage from the banker Jeremiah Harman. Méréville was eventually obliged to sell the entire collection to Harman, who in turn sold it to a consortium organised by the art dealer, Michael Bryan. He successfully assembled a syndicate of three aristocratic collectors and speculators to back the deal. Foremost was Francis Egerton, 3rd Duke of Bridgewater, supported by his nephew, Earl Gower, and the 5th Earl of Carlisle who was Gower's brother-in-law.

The Duke of Bridgewater was one of the great and eccentric success stories of English history. Like that other ducal oddity, the 5th Duke of Portland, he was rejected in love and remained a bachelor. Bridgewater had one big idea: to construct a canal from Manchester to Liverpool to transport coal from his mines. He sank £220,000 into this project and when it faltered reduced his household expenditure to £400 a year. But when the canal was completed his income rocketed to £80,000 a year, so he could afford almost anything. Bridgewater's interest in art arose late in life and it is difficult to consider his motives as anything

173 Title page of the first exhibition catalogue of the Orléans collection held at Michael Bryan's Gallery, London, 1798

174 Title page of the second Orléans collection catalogue, for the exhibition held at the Lyceum, London

but a clever speculative venture. Nevertheless, he retained some of the best pictures, including Raphael's *Bridgewater Madonna*, Titian's *Diana and Actaeon* and its pendant, *Diana and Callisto*, Poussin's second series of the *Seven Sacraments* and Titian's *Three Ages of Man*. They all hang in Edinburgh today, on loan from the Duke of Sutherland, save that *Diana and Actaeon* and *Diana and Callisto* are now jointly owned by the National Galleries of London and Edinburgh.

The Bridgewater syndicate achieved one of the greatest coups in the history of collecting. Advised by Michael Bryan, they bought all the Italian and French works for £43,000 but then employed Bryan to value each picture separately, who raised the total value to £72,000. Reserving 94 pictures (valued at 39,000 guineas) for themselves, Bridgewater, Gower and Carlisle put the entire collection of 295 pictures on exhibition. Of these, 135 were sold immediately and a further 66 by auction in 1799. The proceeds, together with the admission fees (one shilling) reached nearly 41,000 guineas. In this way the three peers secured their 94 capital pictures at virtually no cost.[2] Five-eighths of these paintings went to Bridgewater, a quarter to Lord Gower and the remainder to Lord Carlisle.

So extensive was the Orléans collection of Italian and French pictures that no single space in London could accommodate the whole of it and it had therefore to be exhibited in two groups (figs 173–174). The first 138 pictures were shown at Bryan's Gallery at 88 Pall Mall. These included works by Raphael, Titian and Poussin's *Seven Sacraments*. The remaining 157 were displayed at the Lyceum in the Strand, among them pictures by Tintoretto, Veronese, and both Annibale and Ludovico Carracci. The exhibitions opened to potential purchasers 'for sale by private contract' on Wednesday 26 December 1798. On the first day, John Julius Angerstein paid the 3,500 guineas asking price for the huge *Raising of Lazarus*, by Sebastiano del Piombo, later to become No. 1 in the inventory of the National Gallery, London.

The exhibition of the Orléans pictures in 1798–99 preceded the foundation of the National Gallery by a quarter of a century. Nothing of even remotely comparable quality and quantity had been seen in England since the dispersal of Charles I's pictures a century and a half earlier. In a letter dated 5 March 1799, Mary Berry noted that the pictures were 'by far the finest – indeed the only real display of the excellency of Italian schools of painting that I ever remember in this country'.[3] William Hazlitt was similarly dazzled: 'My first initiation into the mysteries of the art was at the Orléans gallery: it was there that I formed my taste... I was staggered when I saw the works there collected and looked at them with wondering and with longing eyes.'[4] After the exhibition, the pictures were distributed to great London and country houses and some years later began to appear in bequests to museums.

The second member of the Bridgewater syndicate, the Earl Gower (1758–1833), was the Duke's nephew and heir. He had reserved several paintings including Titian's *Noli me Tangere*, but didn't keep it for long. Gower married the Countess of Sutherland and thus complicated the matrix of families, titles and houses from which the art collections passed to the Dukes of Sutherland. His fortune, joined with that of his uncle and wife, was such that Charles Greville described him as 'the Leviathan of wealth' and 'the richest man who ever died'. On his father's death in 1803, he succeeded as the 2nd Marquess of Stafford; in 1833, the year of his own death, he would be created 1st Duke of Sutherland. On his uncle's death, also in 1803, he inherited his London home, Cleveland House, its collections and all the Bridgewater estates. From 1806 he opened its Gallery to the public on Wednesday afternoons in the summer. The Bridgewater Gallery at Cleveland House (which became known as the Stafford Gallery) therefore served the function of the National Gallery eighteen years before it was established in 1824.

On the death of the 1st Duke of Sutherland in 1833, his eldest son, the 2nd Duke of Sutherland, inherited Stafford House, near to Green Park, and its contents (later renamed Lancaster House, which it remains today). However, under the terms of the Duke of Bridgewater's will, the Bridgewater estates, Cleveland House and its collections passed to the younger son, Lord Francis Egerton (1800–1857), created 1st Earl of Ellesmere. In 1841 Lord Francis demolished Cleveland House and commissioned Charles Barry to build on its site the grandest Italianate palazzo in London, Bridgewater House, where the collection survived intact until the Second World War (fig. 178). Among the major pictures on view

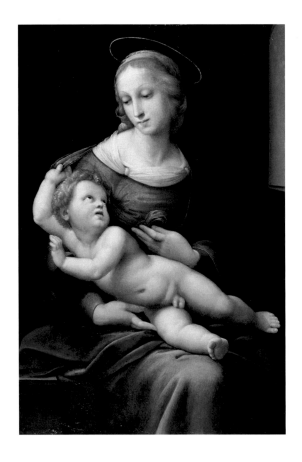

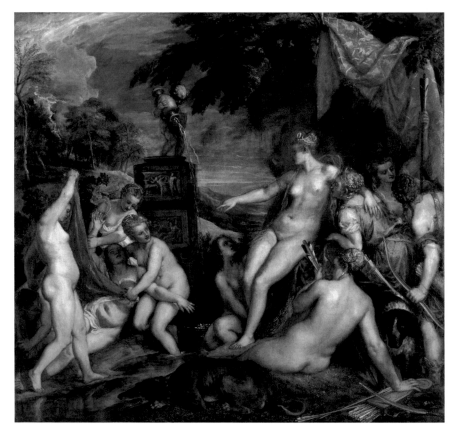

there (figs 175–177) were Guercino's huge *David and Abigail*; Lorenzo Lotto's *Virgin and Child with ss Peter, Jerome, Clare (?) and Francis*; two works by Tintoretto (*The Deposition of Christ* and a *Portrait of a Venetian*); three by Raphael (*The Holy Family with a Palm Tree, The Bridgewater Madonna* and the *Madonna del Passeggio*); five by Titian (*The Holy Family with St John the Baptist, The Three Ages of Man, Venus Anadyomene, Diana and Actaeon* and *Diana and Callisto*); and Nicolas Poussin's *The Seven Sacraments*.

The junior partner in the syndicate was the 5th Earl of Carlisle (1748–1825) of Castle Howard, Yorkshire, an avid collector who began buying pictures well before the Orléans sale. On his Grand Tour between 1768 and 1769, he travelled for part of the time with Charles James Fox. In Parma, he wrote that the 'pictures would have furnished my new wing [at Castle Howard] very well', and in Bologna he found 'the best pictures in the world' although it was on his return to London that he acquired at auction for 500 guineas Guercino's *Erminia Finding the Wounded Tancred* (1651), now in the Scottish National Gallery. He was a patron of Reynolds and owned at least ten of his paintings; apart from family portraits, he acquired the full-length *Portrait of Omai*, the Tahitian who

had been brought to England, which was exhibited at the Royal Academy in 1776.

Carlisle's purchases in the Orléans syndicate included *The Circumcision* from the workshop of Giovanni Bellini and *The Dead Christ Mourned* by Annibale Carracci (both later bequeathed to NG London) and *The Finding of Moses*, then believed to be by Velázquez, but in fact a fine work of the early 1630s by Orazio Gentileschi (fig. 172). Carlisle was considerably ahead of his time in his purchase, by 1796, of *The Adoration of the Kings*, an early Flemish altarpiece by Jan Gossaert, called Mabuse, (c.1510–15) from the Lady Chapel at St Adrian's Grammont, near Brussels (purchased by the National Gallery, London in 1911).

As we observed with the Duke of Bridgewater, connoisseurship was not strictly required of those wishing to purchase pictures, but money was. So plentiful was the supply that anyone with sufficient funds and tolerable advice could buy a well-known masterpiece. In 1798 the apparatus of art history remained embryonic and wholly inadequate to distinguish an original painting from a copy or the work of a celebrated artist from that of a minor follower. Yet it is a remarkable testament to the judgement of the principal purchasers at the Orléans exhibition that they selected pictures which are

175 Raphael,
*The Virgin and Child
(The Bridgewater Madonna)*
Orléans collection; Duke of Bridgewater; now Scottish National Gallery, Edinburgh

176 Titian,
Diana and Callisto
Orléans collection; Duke of Bridgewater; now Scottish National Gallery, Edinburgh

177 Raphael,
*The Holy Family Meeting the Infant St John the Baptist
(The Madonna del Passeggio)*
Orléans collection; Duke of Bridgewater; now Scottish National Gallery, Edinburgh

178 The Picture Gallery at Bridgewater House, photographed in the early 20th century

179 Palma Vecchio,
Venus and Cupid in a Landscape
Orléans collection; Viscount Fitzwilliam; now Fitzwilliam Museum, Cambridge

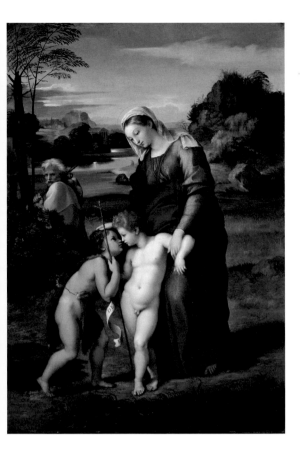

mostly still attributed to the same painters as in 1798. The Orléans collection contained twelve pictures attributed to Raphael, of which eight have retained this status, although of 28 pictures given to Titian, only eleven are currently accepted as autograph. Because of its scale, the collection contained some pictures attributed to the wrong artists and many copies. Its most celebrated 'Giorgione', *The Adoration of the Shepherds*, has long been recognised at the Fitzwilliam Museum as the work of Sebastiano del Piombo. The Castle Howard Gentileschi was not the only picture by this artist

attributed to Velázquez; *Lot and his Daughters* (NG Ottawa) has undergone the same reattribution.

After Bridgewater and Gower, the collector who benefited most from the sale of the Orléans pictures was the 7th Viscount Fitzwilliam of Merrion (1745–1816), whose paintings still remain in his eponymous museum in Cambridge. He inherited great estates in Ireland as well as a collection of Dutch pictures from his maternal grandfather, Sir Matthew Decker, Bt. Contrary to his rather cerebral character, Fitzwilliam had a taste for grand theatrical Venetian pictures which he collected beside a judicious group of Rembrandt etchings, and illuminated as well as musical manuscripts. Among his Orléans purchases were Titian's *Venus and a Lute-player*; Veronese's *Hermes, Herse and Aglauros*; Palma Vecchio's *Venus and Cupid* (fig. 179); the above-mentioned Sebastiano del Piombo *Adoration of the Shepherds*; *St Roch and the Angel* by Annibale Carracci; *Christ appearing to the Virgin Mary*, now attributed to Ludovico Carracci; and *The Campo Vaccino, Rome* by Herman van Swanevelt. In 1816 he bequeathed his collection to the University of Cambridge to found a museum, and his Orléans pictures went on public display in Cambridge eight years before the foundation of the National Gallery.

The era of the Grand Tour, no longer the main conduit of art to Britain, was succeeded by the age of the dealer. The chief among them was William Buchanan, who operated with his partner Arthur Champernowne. Other dealer-speculators included Alexander Day (an artist and dealer active in Rome from *c.*1794), William Young Ottley (see chapter 17) and Andrew Wilson (who bought several Old Masters in Genoa between 1803 and 1806). They offered their services to the great Italian families afflicted by the enormous fines and taxes imposed by the occupying French armies. In Rome, Florence and Genoa the ancient families of Aldobrandini, Barberini, Borghese, Colonna, Corsini, Falconieri, Giustiniani, Balbi, Cambiasi, Cataneo, Doria, Durazzo and Spinola resorted to selling celebrated pictures from their collections which were, in their turn, to add lustre to new collectors such as Lords Berwick, Darnley, Garvagh, Northwick and Radstock.

As William Young Ottley wrote in the introduction to the catalogue of his 1801 commercial exhibition of paintings recently acquired in Rome: 'some few years past, no price could have tempted the Constable Colonna or the Prince Borghese to have permitted any one great work of a great master to be removed from their galleries... It is to the era of fatal revolution in Italy; to the fallen grandeur of the Nobles and Princes of Rome; to their extreme need and distress that is to be attributed finally their parting with what they so long possessed and so highly valued.'[5] Ottley was able to offer ten pictures from the Borghese collection including works attributed to Raphael, Annibale Carracci, Guido Reni and Titian, twelve from the Palazzo Corsini, and fourteen from the Palazzo Colonna which included five Salvator Rosas and three Claudes – among the latter his *Landscape with Ascanius Shooting the Stag of Sylvia* (1682), the artist's last and – to many – his most lyrical work, now in the Ashmolean (fig. 180). It is interesting to observe that Ottley retained his collection of *Trecento* and *Quattrocento* pictures, as he knew he could never sell them in London at that time. They were sold after his death by auction in 1837 (including Botticelli's *Nativity*) and in 1850 (see chapter 17).

The sudden need for money was combined with

180 Claude Lorrain, *Landscape with Ascanius Shooting the Stag of Sylvia*

Procured by William Young Ottley from the Palazzo Colonna, Rome; now Ashmolean Museum, Oxford

181 Raphael,
*The Madonna and Child
with the Infant Baptist
(The Garvagh Madonna)*
Sold by Prince Aldobrandini. *c.*1800;
now National Gallery, London

William Buchanan (1777–1864), a Scottish lawyer turned art dealer, was to benefit most from the turmoil caused by the Napoleonic Wars, although he started too late to participate in the Orléans sales. He employed mainly James Irvine of Drum, Aberdeenshire, in Italy and George Augustus Wallis in Spain and Portugal as agents to scour the cities for available works of art and ship them back to London. Describing the risk and danger to which his agents were subject, Buchanan noted that 'in troubled waters we catch the best fish'.[6] His *Memoirs of Painting, with a Chronological History of the Importation of Pictures by the Great Masters into England since the French Revolution* (1824) provides much information about the period and has been described as 'by far the frankest [book] ever written by any dealer anywhere, and by printing many of the original documents and letters that passed between him and his agents Buchanan conveys much of the profitable excitement of the pursuit'.[7] Buchanan thought 'that vanity prompts the English to buy' and his contempt for his customers was astonishing. He offered Lord Wemyss a *Venus* by Van Dyck and later referred to him as 'the lecherous Old Dog'. Buchanan never visited Italy and his knowledge has sometimes been questioned, 'which enabled him to turn a deaf ear and blind eye to any criticism of his wares'.[8] His strategy was simple: offer inducements to the agents and artists advising the collectors.

There is no doubt that English collectors of this period were in thrall to works by Titian, a taste that echoed their predecessors from the 17th-century Whitehall circle. The Orléans collection amply satisfied this demand. In Italy, James Irvine of Drum was 'repeating on a smaller scale what had been so profitably done by the purchasers of the Orléans Collection' and managed to supply Titian's *Bacchus and Adriadne* to Lord Kinnaird. In 1829 the first English monograph on Titian appeared, written by the collector Sir Abraham Hume, MP. He had come under Titian's spell at the Orléans sale, where he acquired one of the Venetian's great late works, *The Death of Actaeon* (fig. 182). Hume's *Notices of the Life and Works of Titian* appeared anonymously and contained a catalogue of the engravings after works by Titian in a 94-page appendix.

Not all the Orléans Titians went to Bridgewater House or Lord Fitzwilliam. The 2nd Lord

the collapse of the temporal power of the Papacy, so that the export laws ceased to operate effectively. Old families as well as churches and monasteries took advantage of the situation. The most sought-after artist was Raphael whose genuine works had until now been so rare in England. Ottley sold the artist's *Aldobrandini* or *Garvagh Madonna* (fig. 181) for 1,500 guineas, a sum considerably exceeded by the *St Catherine* which fetched £2,500. Annibale Carracci's *Christ and St Peter* sold for 2,000 guineas, while *Christ Disputing with the Doctors*, a picture then attributed to Leonardo da Vinci, but actually by Luini, changed hands for 3,000 guineas. Although prices were rising, the market was patchy. The war had caused an economic recession and the appearance of so many paintings from Italy and France coincided with home sales, such as that of Sir Joshua Reynolds deceased (1795), causing a glut. Two of the main factors which transformed the situation were the dealings of William Buchanan and the arrival of the Orléans collection in England.

Berwick (1770–1832) acquired Titian's *Rape of Europa* (fig. 183) – from the same suite as *Diana and Actaeon* and *Diana and Callisto* – for his picture gallery at Attingham Park in Shropshire where it hung alongside Van Dyck's *The Balbi Children* (NG London) and, surprisingly, Vittore Carpaccio's *Holy Family with Donors*, painted *c*.1505 (Gulbenkian). When Berwick over-reached himself with building projects and collecting he was forced to hold sales in 1827 and 1829. Lord Darnley purchased *The Rape of Europa* and took it to Cobham Hall in Kent to join his other Titian, the *Portrait of a Man with a Quilted Sleeve*

(NG London). Darnley already owned five other excellent Venetian pictures from the Orléans collection including examples by Tintoretto (fig. 184) and Veronese.

One dealer-collector who particularly benefited from the exodus of paintings from France was Noel Desenfans (1745–1807), a Frenchman who arrived in London in 1796 to make his fortune. He began to dabble in picture dealing but presented himself as a gentleman amateur which he thought – probably correctly – would make him more acceptable to English society. He became a collector by default. In 1790 Prince Michael

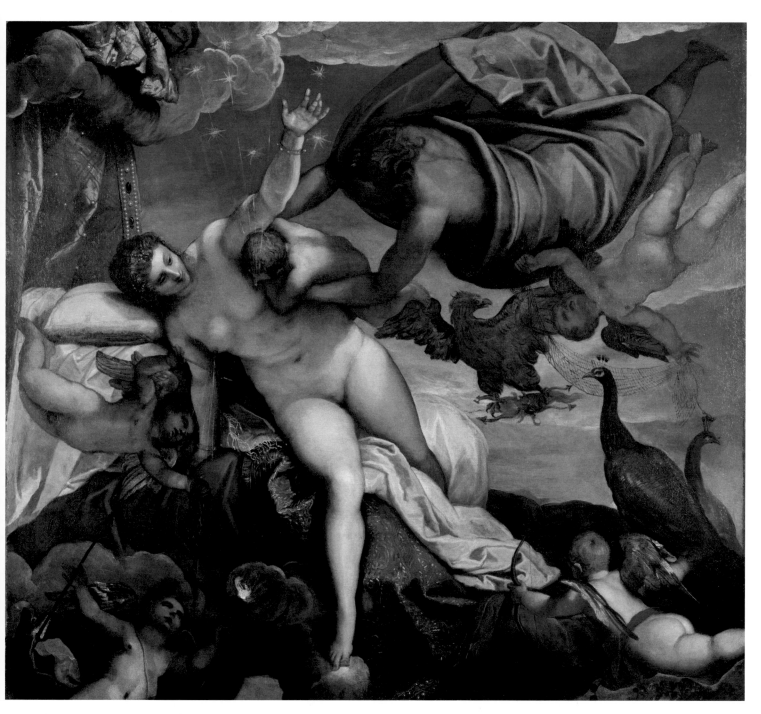

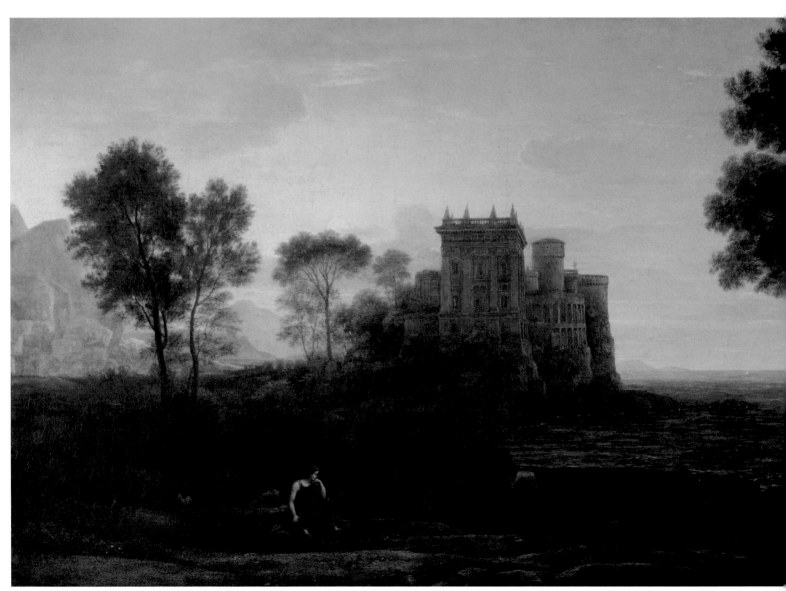

Poniatowski, brother of the King of Poland, on a visit to London, suggested to Desenfans that he should assemble Old Master paintings for a Polish national collection. He bought extensively from the distinguished collection of Charles Alexandre, Vicomte de Calonne (1734–1802), a fascinating instance of a French collection sold in its entirety in London: in March 1795, his 359 paintings were sold in four days at Skinner and Dyke's Great Rooms in Spring Gardens. Desenfans bought *The Flower Girl* by Murillo; *The Triumph of David* by Nicholas Poussin; *A Bridge in an Italian Landscape* by Pynacker; *The Portrait of Titus* by Rembrandt; *A Sow and her Litter* by David Teniers II and *An Italian Landscape* by Claude-Joseph Vernet. However, in 1795 his plans misfired when Poland was partitioned. The King lost his throne but Poland's loss proved England's gain. After an abortive attempt to resell the pictures by auction when prices were depressed by the French wars, on his death in 1807 Desenfans bequeathed the collection to Sir Francis Bourgeois, who had the inspired and public-spirited idea of giving the collection to Dulwich College as a picture gallery. It is ironic that the only English collection of paintings – apart from Lord Fitzwilliam's – to survive intact from this time was originally formed by a Frenchman for Poland.

The enthusiasm for Old Master paintings was not confined to London aristocrats. The collector Philip John Miles (1774–1845) typifies the new class of merchant, having made his money financing the building of railways and of the Avonmouth docks. Miles bought Leigh Court, near Bristol, for which he assembled an extraordinary collection of works attributed to Leonardo da Vinci, Correggio, the Carracci, Guercino, Van Dyck and a Giorgione now in the National Gallery, London (fig. 185), but his fame rests on his purchase of the Altieri Claudes from the Beckford collection. The pictures were later ruined by inept cleaning and by the time the American oil tycoon Lord Fairhaven bought them for Anglesey Abbey in 1947, they were only shadows of the pictures that had caused such a stir when Beckford brought them to England. The English taste for Claude remained undimmed, and while an earlier generation had collected them on the Grand Tour, many of the artist's finest works only became available from Roman or French

aristocratic collections at this time. Perhaps the most beautiful of Calonne's French pictures was Claude's *Landscape with Psyche* (1664), better known as *The Enchanted Castle*, which had all the poetic qualities that beguiled English connoisseurs of this artist (fig. 186).

The remarkable opportunities available to British collectors between 1790 and 1815 were unprecedented and probably even greater than those experienced by American collectors between 1880 and 1930. Riches from land ownership at a time when the Industrial Revolution was creating wealth from mining, canals and railways, combined with turmoil on the continent, created the perfect conditions for the acquisition of art. The long-term winners turned out to be British public collections. The National Gallery was founded in 1824 with many important Orléans paintings at its core. Dulwich Picture Gallery and the Fitzwilliam Museum were created from paintings imported during this period, while Edinburgh retains on long-term loan the dazzling residue of the Bridgewater syndicate.

185 Giorgione,
The Adoration of the Kings
Philip John Miles; now National
Gallery, London

186 Claude Lorrain,
*Landscape with Psyche outside
the Palace of Cupid*
(*The Enchanted Castle*)
Sold by de Calonne in London in
1795; later acquired by William Wells
and Lord Overstone; now National
Gallery, London

TASTEMAKERS

William Beckford and Thomas Hope were aesthetes and tastemakers interested in every aspect of art and design. They thought deeply about the relationship between architecture and art, and how works of art should be displayed. Both bought and commissioned art in equal measure and knew what they wanted. Their tastes converged at certain points but generally had a different emphasis. Beckford's was a private passion, the occupation of a misanthropic perfectionist, while Hope had a didactic plan to influence a rich – and in his view debased – London society. Both were outsiders, Francophiles who had a *de haut en bas* view of the fox hunting English world. Although they were capable of acts of kindness and showed occasional loyalty, to the world at large they demonstrated what Dr Johnson called 'the impertinence of riches'. They were bibliophiles drawn to the exotic in religion and art. Both saw themselves as figures wounded by the English establishment, with which they had a love-hate relationship – longing for its approbation and sulkily turning away when cold-shouldered. But above all they were both men of extraordinary discrimination, whose lives were devoted to the pursuit of art and the creation of dramatic settings. Beckford (fig. 188) is the more important of the two men and in his lonely compulsion he is the most interesting collector in England during the two centuries he spans.

William Beckford (1760–1844) was the child of a City of London magnate, Alderman William Beckford, and a clever, domineering mother ('the Begum'). His father died when he was nine and Beckford grew up in his Palladian mansion in Wiltshire, Fonthill Splendens, which he was eventually to replace with the colossal neo-Gothic

William Beckford

Thomas Hope

187 Francis Danby, detail from *Fonthill Abbey*
Private Collection

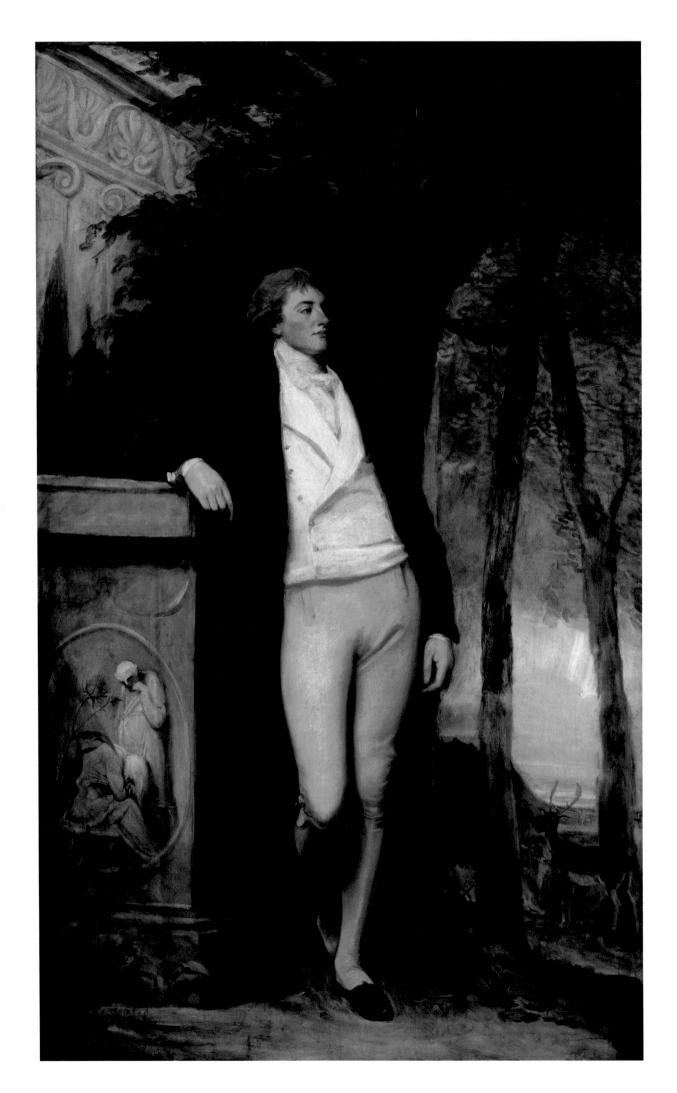

abbey. His fortune derived mainly from sugar plantations in Jamaica. Sensitive and intelligent, Beckford declined a political career. His mind swirled with Ossianic spirits and Gothic sentiments, and his mother sent the sixteen-year-old William to Calvinist Switzerland where he was enchanted by the abbey at the Grande Chartreuse. Back home he adopted aesthetic and literary pursuits and caused a scandal over his liaison with young Lord Courtenay ('Kitty'). This precipitated an extended period of travel which lasted from 1780 until 1798, especially in Italy, Portugal and France, where he gained a thorough education in European art and languages.

While abroad he wrote his novella, *Vathek*, a life manifesto and harbinger of the Gothic dreams of Fonthill. In 1783 his mother forced him into a marriage with Lady Margaret Gordon, which produced two daughters and proved surprisingly happy until her early death in 1786. In the following year Beckford visited Portugal for the first time and was delighted with this toy kingdom. Setting himself up at Monserrate near Sintra, he lived there on and off until 1795 with long forays back to London and Paris. The central task of his life was the construction of Fonthill Abbey (fig. 187) and

the arrangement of his collection in that dramatic setting. It began in the spirit of a convent in the woods and ended as a fallen legend, more written about and portrayed than any other house in England. James Wyatt designed and re-designed it for his impatient client. Beckford loved and hated his 'sublime abode'. He appreciated the drama of its profile across the park but was appalled by its dampness and cold. Hazlitt called it 'a Cathedral turned into a toy shop'.[1] For most it was a palace of dreams, what John Constable called 'quite fairy land'.

Beckford was obsessed with placement. 'Everything depends on the way objects are placed, and where' he wrote. The Grand Drawing room of Fonthill was the repository of some of his most important treasures and represents many of Beckford's interests: a Gothic overmantel, neo-classical chairs showing Thomas Hope's influence, an Aubusson carpet woven for St Cloud, but the most impressive object was the Riesener roll-top bureau made for the Comte d'Orsay (*c*.1760), now in the Wallace Collection. To complete the ensemble were a pair of Boulle neo-classical cabinets, and an 'Egyptian marble' table on dolphin supports supposedly from Malmaison. What the furniture reveals is that Beckford's taste looked forwards and backwards. Contemporary French taste was usually his point of departure: Boulle and Boulle revival, anything with pietre dure, and above all lacquer. Added to this was an English antiquarian taste which prompted Beckford's 'Holbein cabinet'. By the end of his life, Beckford had settled on a rather ponderous northern Renaissance classical style.

Beckford had something of an obsessive passion for Boulle and lacquer furniture – nineteen items of Boulle appeared in his 1822 sale at Christie's. Perhaps his most magnificent was the Boulle *Armoire*, which according to Beckford came from the Duc d'Aumont's collection; it is now in the Louvre. Pietra dura furniture was a continuous theme – a taste probably developed in Paris where ebonists were enjoying a vogue for cabinets with hard stone and mosaic panels. While Beckford owned many rich French pieces with plaques, his most famous piece of pietre dure was an enormous Italian 16th-century tabletop from the Borghese Palace which stood in King Edward III's Gallery at Fonthill and is today at Charlecote Park in Warwickshire with many other Beckford items (fig. 189). It is with Japanese lacquer that Beckford

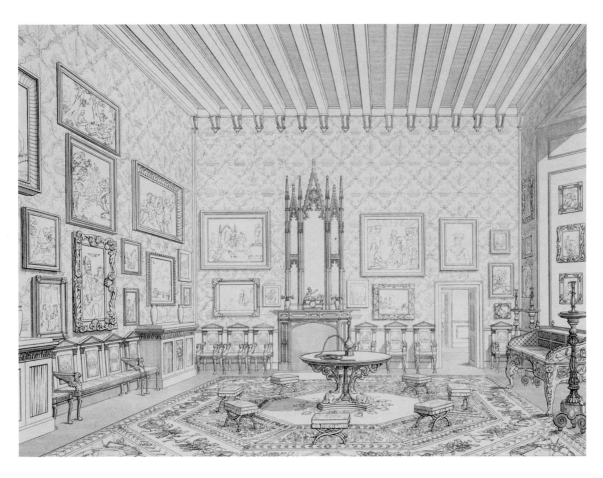

is especially associated – another taste developed in France, 'owning at one time or another most of the finest pieces on record'.[2] Two pieces seem to epitomise Beckford's taste; the van Diemen box (V&A) that had belonged to Madame de Pompadour, and the Chiddingstone Casket – whose Beckford provenance is less certain – in which Japanese lacquer is mounted on a late Renaissance-style casket. Sometimes Beckford himself would have lacquer boxes reassembled on specially made cabinets. He had only one collecting rival in this area, his son-in-law the Duke of Hamilton.

Another unusual continental taste of Beckford's was for *Kunst und Wunderkammer* material in which he anticipated the Rothschild collections. His love of bejewelled ewers and cups was such that there are engravings of this material in John Rutter's celebrated *Delineations of Fonthill and its Abbey* (1823; fig. 190). There was the Fonthill Ewer of smoky crystal made in Prague c.1680 (Metropolitan), the 4th-century agate Rubens Vase (Walters; fig. 191), and the Lapis Lazuli Cup with mounts by John Harris. Beckford loved metalwork and collected medieval and Renaissance enamelwares; a Limoges *chasse*, German cups, and so on – but it was his contemporary commissions

of historicist pieces that most markedly anticipated 19th-century taste. He had a passion for remounting objects, whether an Indian agate cup or a piece of Chinese porcelain. His forays into Eastern collecting reveal his innate love of workmanship and the exotic, a Syrian Glass enamel *Ewer* (13th century) of prodigious quality, Mughal jades and 18th-century Chinese vases.

Beckford had a great many agents in London and Paris and they were well briefed on his requirements. He bought porcelain and furniture from Robert Fogg and E.H. Baldock. The most consistent agent was his companion, Gregorio Franchi, a musician Beckford met on his early travels in Portugal. Franchi had one of the happiest and longest associations of Beckford's life but it didn't save him from receiving missives such as 'what rage for trash governs you? How is it possible for you to tolerate this monstrosity?' The architect James Wyatt supplied much of the Fonthill furniture and the cabinet-maker, Robert Hume, supplied hardstone cabinets and paintings to both Beckford and his son-in-law the 10th Duke of Hamilton, whose Francophile collection is considered in chapter 15.

When it came to paintings, Beckford's Old Master collection was outstanding – there are over twenty of his paintings in the National Gallery in London. His father had owned Hogarth's *Rake's Progress* series which Beckford sold in order to help pay for Fonthill Abbey. His first travelling companion to Italy was the watercolourist John Robert Cozens and Beckford was later to patronise Turner. He had a preference for Italian pictures, and was a pioneer collector of 'primitives'. Important Italian paintings which he owned include Giovanni Bellini's *Agony in the Garden* (fig. 192) and his famous *Portrait of Doge Leonardo Loredan*, Raphael's *St Catherine* (fig. 193) as well as works by Gentile Bellini and Bronzino, and

Titian's *Portrait of Vincenzo Capello*. Beckford's most celebrated purchase by far was the Altieri Claudes: *The Father of Psyche Sacrificing at the Temple of Apollo* (1663) and its pendant, *The Landing of Aenas at Pallanteum* (1675). The pair had been bought from the Altieri Palace in Rome for £500 by two painter-dealers, Robert Fagan and Charles Grignion. Lord Nelson organised their transport on the *Tigre* to Falmouth. Beckford was in Portugal at the time and used another painter-dealer, Henry Tresham in London, to arrange the purchase. Owing to the excitement generated by the Orléans sale, Beckford was obliged to pay the huge sum of 7,000 guineas for the pair (plus some minor pictures) in 1799. Nine years later he resold them for 10,000 guineas.

In the same year that he bought the Claudes, Beckford purchased six paintings by Dughet, Raphael and Rosa from William Young Ottley. His most important Raphael came a year later when he acquired for £3,000 the *St Catherine* (NG London) recently imported from Rome by the dealer Alexander Day. Beckford's northern paintings were fewer but no less distinguished: four works by Gerrit Dou, most notably *A Poulterer's Shop* (NG London), Memling's *Young Man at Prayer* (Thyssen), works by Jan Brueghel, Rembrandt and de Hooch, and an excellent group of Italianate landscapes.

By 1822 the Jamaican sugar plantations were no longer delivering the necessary cash and Beckford was forced to sell Fonthill and many of its contents

192 Giovanni Bellini, *The Agony in the Garden* William Beckford; now National Gallery, London

193 Raphael, *Saint Catherine of Alexandria* William Beckford; Borghese; now National Gallery, London

to John Farquhar. A big auction sale was planned by Christie's which brought thousands of curious auction visitors but the £300,000 offered by Farquhar for the whole was too tempting to refuse and the sale was postponed twice and then cancelled. Beckford moved to Lansdown Crescent in Bath where he allowed himself a little fantasy by building a tower on the hill above his house and creating a mile-long private corridor linking the two. Lansdown Tower, as it was generally known, was a repository of art with a greater aesthetic unity than Fonthill. Beckford worked closely with Robert Hume, Edmund English and the architect Henry Goodridge to achieve a series of personal interiors, which now seem proto-Victorian in character. In 1823 the contents of the Abbey were finally sold by order of John Farquhar: the sale by the auctioneer Henry Philips extended over 37 days and was composed of 3,960 lots. Just two years later, the central tower of Fonthill collapsed and today only a tantalising fragment of the Abbey remains.

There was a final string to Beckford's bow: books. He was an important bibliophile, versed in the major European languages. His main interests were travel, 'demonology', novels, divinity, exotica, Baroque book illustrations and above all bindings. These last were the finest in England. Five rooms at Fonthill contained books and they were removed after his death by his daughter to Hamilton Palace where they were kept separately from the Duke's library. Beckford wasn't interested in fine printing but showed his discrimination in the choice of copy: clean, large paper, good provenance and beautiful bindings.

Thomas Hope (1769–1831) came from a rich Dutch banking family of Scottish extraction. Several members of the family collected art which they lent to Thomas for display. He set himself the task of raising English taste through design and collecting. Hope coined the term 'interior decoration'. Though he shared Beckford's passionate engagement and brilliance in choosing objects, his collection was smaller but his achievements were just as broad and encompassed everything from architecture to knives and forks.

Between 1787 and 1795 Thomas Hope and his cousin Henry Hope made an extended Grand Tour of Europe and the Near East. In Rome Thomas gave commissions to the neo-classical sculptor, John Flaxman and bought antiquities

from Vincenzo Pacetti, including two important recently discovered Greek marbles, the *Hygeia* and *Athene* (fig. 195). The French invasion of Italy brought the Hope cousins home in time to take part in the sale of the Orléans collection. In 1799 Thomas Hope bought an Adam house in Duchess Street off Portland Place and created the most original and advanced neo-classical setting for an art collection in London (fig. 194). Its picture gallery was in the form of a Greek temple with baseless Doric columns. There was a statue gallery, an Egyptian room, an Indian room, a Flaxman room, a Flemish picture gallery and a sequence of vase rooms. These display rooms were opened to the public in a pioneering move in 1804. The Dutch and Flemish paintings were for the most part the collection of Thomas's cousin, Henry. London society was impressed by these

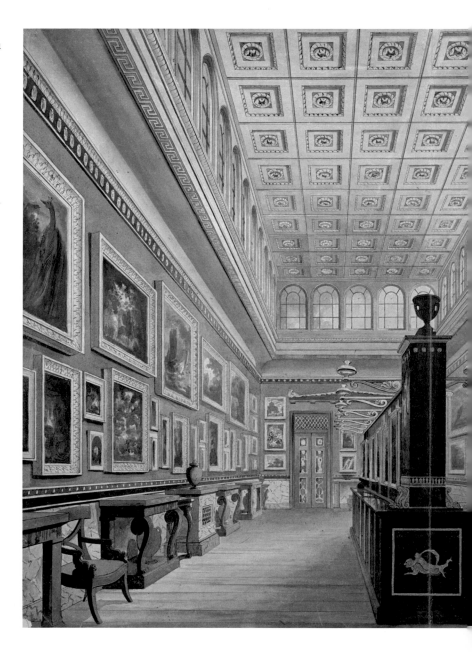

fastidious interiors and their contents. Although Thomas Hope was to become the high priest of neo-classical design in England, his best Old Master paintings were Baroque: Rubens's *Death of Adonis* (Jerusalem), Guercino's *Betrayal of Christ* (Fitzwilliam) and *Doubting Thomas* (NG London) and Poussin's *The Inspiration of the Epic Poet* (Louvre) from the Mazarin collection.

Today the name of Hope is mostly associated with furniture. He was impressed by contemporary French furniture and frustrated by what he believed to be the poor design and low standard of execution in England. He therefore designed it himself, with inspiration from ancient Egypt, Greece, Rome and two modern French designers: Percier, a friend of his, and Fontaine. These eclectic but inventive pieces were matched by decorative bronzes and domestic silver. They all came together in his book *Household Furniture and Interior Decoration* (1807), illustrated with precise linear outline engravings by Aitkin and Dawe (fig. 196). Apart from furniture and sculpture, antique vases were the most striking element of these interiors. In 1801 Hope acquired much of Sir William Hamilton's second collection of Greek vases which was to have an influence on his furniture and decorative style (fig. 198). He was eventually to own over 1,500 vases, many of which later re-appeared in the collections of Samuel Rogers and the 5th Earl of Carlisle. Michaelis listed 46 items of sculpture in the collection.[3] Perhaps the most unusual antiquities section was the Egyptian, and although Hope was interested more in the general effect of his Egyptian room, there were some important

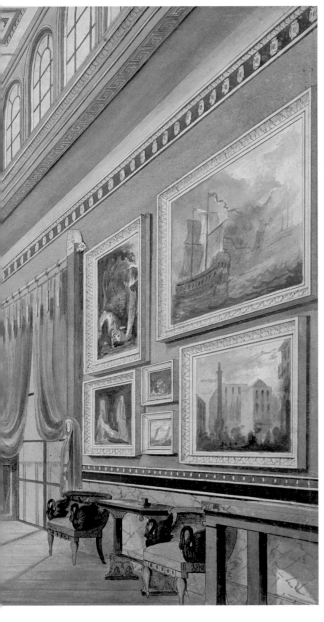

pieces. His love of exotica dispelled any sense of frigidity at Duchess Street; he enjoyed Hindu and Moorish furnishings and even had himself painted by Beechey wearing Ottoman dress.

One of the most successful aspects of Hope's patronage was his contemporary sculpture. He patronised Flaxman, Canova and above all Bertel Thorvaldsen. In Rome in 1803 he met this Danish sculptor, who was about to return home owing to a lack of patronage. Hope bought his unfinished *Jason* (fig. 199) but he did not receive it in London until 1828, something of a record. When it came to contemporary painting, Hope's choices look curious to modern eyes; history pictures by Richard Westall (fig. 197), Benjamin Robert Haydon and Benjamin West. Where he comes closest to modern taste is his admiration for the architectural watercolours by Joseph Michael Gandy. As an avowed Francophile, Hope bought

196 Thomas Hope, illustration from *Household Furniture*, 1807

197 Richard Westall, *The Sword of Damocles*
Thomas Hope; now Ackland Art Museum, North Carolina

198 Vase of patinated copper with ormolu mounts, designed by Thomas Hope
Victoria & Albert Museum, London

199 Bertel Thorvaldsen, *Jason with the Golden Fleece*
Thomas Hope; now Thorvaldsens Museum, Copenhagen

paintings by Jacques-Louis David's follower, Louis Gauffier, but is remembered for a drama concerning the portrait of his wife commissioned from Antoine Dubost. Hope had bought the artist's *Damocles* for 800 guineas and annoyed him by eradicating the artist's signature and slicing a section off the top. Dubost's portrait of Mrs Hope was generally regarded as poor and Hope refused to pay. The artist retaliated with a picture of Thomas Hope depicted as a monster offering his wife jewels which he exhibited under the title *Beauty and the Beast*. London society enjoyed the dispute and flocked to see the portrait.

If Duchess Street was best known for its interiors, from 1818 onwards Hope created, with the help of the architect William Atkinson, a novel, picturesque country house, The Deepdene in Surrey, blending architecture and nature in an asymmetrical grouping of sculpture galleries and conservatories. Its Italianate, loggia-topped tower anticipated those of Victorian buildings such as Osborne House on the Isle of Wight. The Deepdene was completely rebuilt by Hope's son and pulled down in 1969, sadly before the architectural conservation movement had got into its stride: like Fonthill, the house lives on in watercolours and folklore.

Thomas Hope and William Beckford lived for art. Their influence on taste and collecting endures to this day. Between them they anticipate many aspects of Victorian tastes; Beckford with his Italian primitives, French *ancien regime* furniture and medievalism, and both collectors in their historical revivalism. In the 20th century their influence was if anything even stronger, and many aesthetes still create 'Hope' interiors and collect 'Beckford' objects. Beckford and Hope remain giants of early 19th-century taste.

Chapter 14

CHAMPIONS OF THE BRITISH SCHOOL

'An Academy in which the Polite Arts may be regularly cultivated, is at last opened among us by the Royal Munificence. This must appear an event in the highest degree interesting, not only to the Artists, but to the whole nation,' begins the first *Discourse* of Sir Joshua Reynolds. The foundation of the Royal Academy in 1768 marked a turning point in the way collectors viewed British art. Since the days of Holbein, the story of patronage at home was dominated by artists – usually foreign – painting portraits. 'You surely would not have me hang up a modern English picture in my house, unless it were a portrait?' Northcote recalls a collector exclaiming in the 1760s.[1] There had been several attempts from the beginning of the 18th century to alter the situation. The first problem was one of education. Where could British artists learn their trade and exhibit their work, and how could they persuade native collectors to patronise them? The Royal Academy provided a curriculum and a showroom. The foundation (Angerstein) collection of the National Gallery was predominantly composed of famous Old Masters, but did include pictures by Hogarth and Wilkie. In the 19th century the initiative moved from the artists to patriotic collectors who started to campaign for a national gallery of British art. This was achieved with the foundation of the Tate Gallery in 1897.

The Royal Academy was not the first art school in London. In 1711, while collectors were in thrall to the Grand Tour, Kneller founded an academy, and Vanderbank and Cheron started another at St Martin's Lane in 1720. The latter introduced life drawing and taught that history painting was the highest form of art. It was from this school that William Hogarth emerged. Hogarth, the champion

The Foundation of the Royal Academy

Sir John Soane

1st Lord de Tabley

Walter Fawkes of Farnley

3rd Earl of Egremont

Hugh Andrew Johnstone Munro of Novar

William Wells

Thomas Lister Parker

Northern Industrialist Collectors

Robert Vernon

John Sheepshanks

Sir Henry Tate

200 William Frederick Witherington, detail from *A Modern Picture Gallery*. Exhibited at the Royal Academy in 1824, it is an imaginary grouping: a contemporary reviewer wrote that it was 'filled with beautiful copies of many of the leading pictures of the English school and is a perfect gallery in itself'.
Wimpole Hall, Cambridgeshire (National Trust)

bulldog of British art, tore up the rule book and reinvented British painting. He formed his own group who met at Old Slaughter's Coffee House. Patriotic, angry, energetic and with a genius for self-promotion, Hogarth hooked himself onto the newly established Foundling Hospital and persuaded his fellow artists to donate work to what was effectively the first showcase of British art. They responded magnificently: the sculptor Rysbrack, and the painters Hayman, Highmore, Hudson, Pine, Ramsay, Scott and Wilson all donated works. In 1749 Hogarth portrayed the founder of the Hospital, Thomas Coram, in the benevolent masterpiece that is the first great middle-class state portrait, an icon of the British school (fig. 202). Hogarth's popularity was primarily based on his extraordinary success in publishing prints after his rumbustious paintings of contemporary life.

The accession in 1760 of George III, who 'gloried in the very name of England', marks the start of the classical age of British painting. The King gave his assent to the foundation of the Royal Academy and was one of its leading patrons. Encouraged by his tutor, Lord Bute, he was the most artistically inclined monarch since William of Orange. When the King bought Old Masters he tended to rely on his librarian, Richard Dalton, who negotiated the purchase of the Consul Smith collection in 1762, but when it came to British art he expressed strong preferences for the portraits of Ramsay, the conversation pieces of Zoffany, and the history paintings of Benjamin West. He paid an annual pension of £1,000 in exchange for West's *Burghers of Calais*. Although the King's judgement was not infallible – he disliked Reynolds – his support did much to bolster the confidence of, and competition between, English artists.

The Royal Academy provided artists with professional status, training and an annual exhibition. Its first president, Sir Joshua Reynolds

201 Sir Joshua Reynolds,
Self-Portrait
Royal Academy, London

202 William Hogarth,
Portrait of Captain Coram
Foundling Museum, London

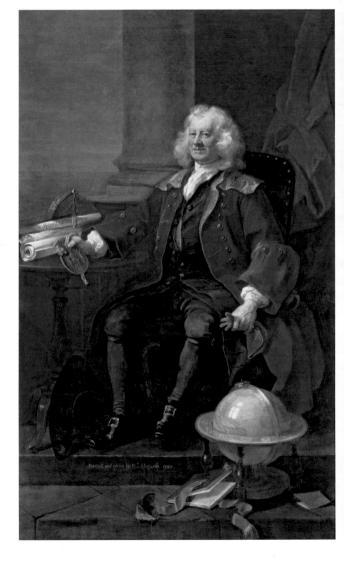

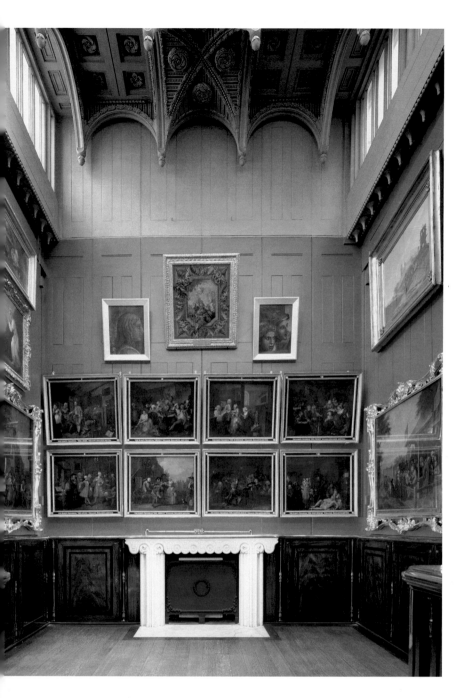

One surviving collection formed from exhibits at the Royal Academy in the early 19th century is that of the architect, Sir John Soane (1753–1837), himself an academician, at his astonishing house-cum-museum in Lincoln's Inn Fields. This creation was designed as an expression of the inter-relationship of the arts: 'architecture Queen of the Arts... Painting and Sculpture are her handmaids'. At the core of the house, under the dome, is Soane's collection of antique fragments and statues which included the Egyptian *Sarcophagus of Seti 1*. The greater part of the painting collection is by his Royal Academy colleagues, Reynolds, Edward Bird, William Hamilton, A.W. Callcott, Francis Bourgeois and George Jones, but his most important painting purchases were two celebrated series by Hogarth (fig. 203): *A Rake's Progress* (eight pictures) acquired in 1802, and *An Election* (four pictures). Some of the greatest treasures of Soane's museum lie hidden, an enormous group of architectural drawings mostly by British architects, including 9,000 drawings from the office of Robert and James Adam.

It was not long before rival groups formed alternative exhibition centres opened to compete with the Royal Academy. In London, the Society of Painters in Watercolour opened in 1804, and the British Institution for Promoting the Fine Arts in the United Kingdom the following year with the King as Patron and the Prince of Wales as President. The British Institution actively encouraged the imitation of Old Master paintings by contemporary British artists and the integration of the latter into the collections of the former by giving prizes for pendants. It was funded with subscriptions from many celebrated collectors: Lord Northwick, Sir George Beaumont, John Julius Angerstein and Thomas Hope among others. Local art societies were springing up all over England at the turn of the 19th century, including Norwich (1803), Edinburgh (1808) and Liverpool (1810). Several now esteemed artists, including John Constable, were comparatively neglected by collectors until the 1820s. Their neglect contrasted markedly with the enormous early success of J.M.W. Turner.

Alderman John Boydell hoped to stimulate masterpieces by embarking on a project in 1786 to publish prints by England's best artists illustrating her greatest playwright, Shakespeare.

(fig. 201), helped enormously to make English art acceptable during the age of the Grand Tour with his heroic portraits that hung serenely beside works by Claude and Guercino. Gainsborough was a founding member of the Academy and, although never short of patronage, he never achieved the social success of Reynolds. The landscape painter Richard Wilson had difficulty finding patrons but when Lord Pembroke commissioned five views of Wilton (*c*.1758), he rose to the challenge. The Academy initially excluded sporting artists which did not make much difference to George Stubbs since he was already receiving steady patronage from the Marquess of Rockingham, the Duke of Richmond and Earl Grosvenor.

He commissioned over 300 paintings from artists such as Hamilton, Smirke, Westall, Fuseli (fig. 204), Northcote, Opie, Stothard and West, many of which lie forgotten in museum storerooms today. Boydell opened a gallery in 1789 whose initial success was halted by the outbreak of the French wars. The wars' effect on British collecting is described in chapter 12; while initially unsettling, they also provided a stimulus to the patronage of native art. They produced a wave of patriotism which deemed British culture vastly superior. Lack of access to the Continent made artists and patrons look more closely at the picturesque qualities of their own country. War also forced the pace of the Industrial Revolution and with it came a new type of collector, not landed but with an industrial or commercial background.

One of the founders of the British Institution was Sir John Fleming Leicester (1762–1827), created Lord de Tabley in 1826, who unusually brought nothing home from his Grand Tour. From 1800 onwards, Leicester was the first collector to set about forming a collection exclusively of modern British paintings, although he admitted recently deceased artists such as Reynolds and Wilson, and owned Gainsborough's *Cottage Door* (Huntington). The collection was displayed at Tabley House in Cheshire (fig. 12), and at 24 Hill Street in London, which was open to the public from 1818. Leicester patronised Beechey, Collins, Fuseli, Hilton, Hoppner, Lawrence, de Loutherbourg, Thomson and Ward. He was an astute early collector of Turner, acquiring *Kilgerran Castle* (Wordsworth House) *c.*1804–08, and was to purchase eight more paintings of Turner by 1818, including *Tabley Lake and Tower* (Petworth; fig. 206) and *Pope's Villa*. In 1823 Leicester offered his collection in a significant gesture as the foundation of a national gallery of British art, but the offer was turned down by the Prime Minister, Lord Liverpool. At the posthumous sale of the collection the following year, Turner bought back two of his own pictures.

Turner's genius was quickly recognised and he found patronage from both landed gentry and self-made men. The Earl of Essex bought three paintings in 1797–99 and the elderly Duke of Bridgewater commissioned *The Bridgewater Sea Piece* in 1801. Turner was never an easy man and he disliked high society but he became friendly with three patrons, Walter Fawkes, Lord Egremont and Hugh Andrew Johnstone Munro of Novar.

Walter Fawkes of Farnley Hall, Yorkshire was probably the closest to him. The artist first visited Farnley in 1808 and returned almost every year until his host's death. Fawkes spent £3,500 on nine paintings and 200 watercolours; the largest group of Turner watercolours ever assembled by an individual. The centrepiece of his collection was the large oil, *View of the Dort* (Mellon Collection), painted about 1817, which Constable described as 'the most complete work of genius I ever saw' (fig. 205). Ruskin thought Turner 'did all his best work' for Farnley. On one occasion while Turner was staying there, a storm blew up and he started sketching on the back of an envelope. Finally he turned to Fawkes's son saying, 'There Hawkey, in two years you will see this again and

call it Hannibal Crossing the Alps.'[2] The finished painting was one of the large number that the artist wouldn't sell and it formed part of his bequest to the nation.

One of the most attractive stories of patronage in the 19th century is that of Turner and George Wyndham, 3rd Earl of Egremont (1751–1837). The Earl, whose motto was 'live and let live', created an open house for artists and sculptors at Petworth in Sussex. He filled his Gallery with a collection of recent British paintings by Beechey, Phillips, the Daniels, Copley Fielding, Fuseli, C.R. Leslie,

204 Henri Fuseli,
Lear Banishing Cordelia
Alderman John Boydell; now Art Gallery of Ontario, Toronto

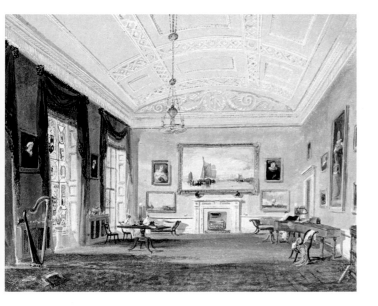

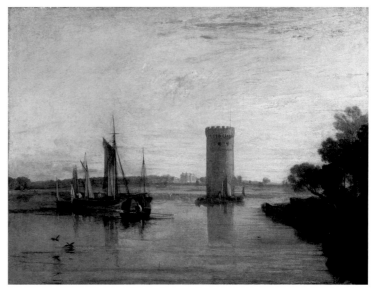

205 Joseph Mallord William Turner, *Farnley Hall Drawing Room showing Turner's View of the Dort*

Walter Fawkes; Private Collection

206 Joseph Mallord William Turner, *Tabley, Cheshire, the Seat of Sir J.F. Leicester, Bart.: Calm Morning*

Sir John Fleming Leicester; 3rd Earl of Egremont; now Petworth House, West Sussex (Tate Britain and the National Trust)

207 Joseph Mallord William Turner, *Petworth Park with Tillington Church in the Distance*

Tate (Turner Bequest)

Romney, Smirke and Wilkie, nearly all of which can be seen there today. He also commissioned very expensive marbles from Flaxman and Westmacott. But it was Turner who was to have a special place at Petworth and his atmospheric studio is still there. The artist's affinity with the house, its park, and art collection are palpable. Benjamin Robert Haydon wrote that 'the very flies at Petworth seem to know there is room for their existence'.[3] Turner's work at Petworth falls into two main periods. Many of the earlier paintings from 1804–12 are Claudian in spirit but the 1827–29 works have a freedom and rapturous sense of place, particularly *The Lake, Petworth* (c.1829) and *Petworth Park with Tillington Church in the Distance* (1827–28; fig. 207). Perhaps the greatest of all, *Interior at Petworth*, Lord Egremont never owned (Turner bequest of 1851, now Tate Britain). It was painted around 1837, the year of

his death, and is convincingly thought to be a homage to Turner's friend and patron.[4] Egremont was a patron who gave Turner the freedom and conditions to create masterpieces. The Earl supplemented his collection by buying Turner oil paintings at the Tabley sale of 1827.

Hugh Andrew Johnstone Munro of Novar (1797–1864), a Scottish landowner and amateur artist, was 22 years younger than Turner, which made their close friendship all the more remarkable given the artist's curmudgeonliness. Munro devoted the greater part of his life to collecting pictures but his friendship and ardent support of Turner was central to his patronage. Acquainted with Turner by 1826, Munro acquired his first oil painting in 1830 and bought many of the most important pictures the artist exhibited at the Royal Academy between 1836 and 1844. It was Munro's diffident manner and unaffected love of art that

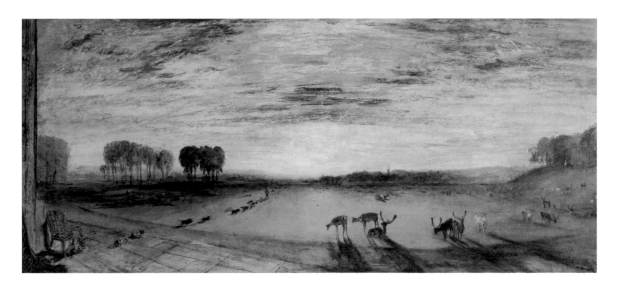

appealed to the painter. In 1836 Munro acquired *Rome from Mount Aventine* and *Juliet and her Nurse*, both from the Royal Academy. Two years later he bought *Modern Italy* and *Ancient Italy* there. Munro eventually owned fifteen oils and 129 watercolours but it was the big romantic Italian Turners that defined his taste. He acted as executor on the artist's death in 1851.

Munro was friendly with several other artists but with none of them did he have the same level of intimacy as he did with Turner. He knew John Constable and owned six of his paintings. Landseer stayed at Novar and painted the *Deer Forest* there. Munro's posthumous sale at Christie's in 1878 revealed the extent of his patronage: 56 paintings by Etty, 27 by Stothard, 19 by Wilson and 12 by Bonington. However, it was his enormous Old Master collection that was most admired by contemporaries for his works by Watteau, Rubens, Rembrandt, Titian's *Rest on the Flight* (Longleat), G.B. Tiepolo's *Martyrdom of St Agatha* (Berlin) and the then most celebrated picture, the *Madonna dei Candelabri* at that time attributed to Raphael (now in the Walters Art Gallery, as Giulio Romano).

William Wells (1768–1847) was another collector of Old Master paintings who befriended artists. He owned Claude's *Enchanted Castle* (NG London) and Van Dyck's *Triple Portrait of King Charles* (acquired by George IV in 1822) but he also owned works by Collins, Landseer, Stanfield and Wilkie. Wells was a shipbuilder and harbour owner who became a trustee of the National Gallery and lived at Redleaf in Kent. Landseer was his favourite artist and he owned, among many other paintings by him, *The Sanctuary* (Royal Collection). Wells had an unfortunate tendency to lecture artists, to the fury of John Constable who was enraged by the 'self satisfaction in his opinions' and thought 'all this comes of the vanity of connoisseurship'.[5]

It is striking how many collectors traded in their Old Masters for works by contemporary British artists in the early 19th century. The 6th Duke of Bedford sent 44 paintings by Flemish and Dutch Old Masters to Christie's for sale in 1827 to make way for works by Sir William Allan, Bonington, Sir Charles Eastlake, Hayter and Ward and others. Thomas Lister Parker (1779–1858), a landowner of Browsholme Hall, Lancashire, was another who changed around. An early northern

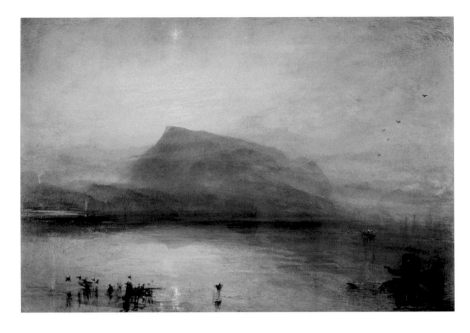

patron of Turner, his first interest was in Old Masters: at Sir William Hamilton's sale in 1801 he bought the *Portrait of Juan de Pareja* by Velázquez (Metropolitan). By 1807, the Gallery at Browsholme contained over 50 paintings, chiefly Dutch and Italian, and his catalogue compiled in that year records just four paintings by British artists, by Gainsborough, Wilson, Callcott and Turner (his *View off Sheerness*). Parker lived extravagantly and became besotted with the acting prodigy, Master Betty, 'the Juvenile Roscius', whose performances he followed around the country. Financial pressures forced him to sell his Old Masters in 1808 and thereafter he concentrated on British artists. Parker was an enthusiastic patron of Northcote and commissioned or bought works from Gilpin, Havell, Morland, Opie, Reinagle, Turner of Oxford and Ward. He had patronised J.M.W. Turner since 1798 and may have introduced the painter to his first cousin, Sir John Leicester, and to Walter Fawkes. When Parker sold Turner's *Sheerness*, he commissioned a copy from Callcott.

Occasionally the movement went the other way. James Morrison (1789–1857) was a collector who started with British paintings and gradually turned into a very distinguished collector of Old Master paintings. His fortune came from several sources (haberdashery, railways and America) which enabled him to acquire several important houses including Beckford's old estate at Fonthill and Basildon Park which features later in the book. Morrison acquired John Constable's *The Lock* (Thyssen) in 1824 for 150 guineas from the Royal

Academy. He supplemented this with works by Collins, Wilkie and above all Turner, including the latter's *The Thames at Pope's Villa* and *Thomson's Aeolian Harp*. He bought his first Old Master painting in 1831, Claude's *The Rape of Europa*, and rapidly expanded with important works by Rembrandt – *Portrait of Hendrickje Stoffels* (NG London) – Hobbema, Cuyp, Rubens, Nicolas Poussin and Parmigianino.

The Great Reform Act of 1832 offered confident men with newly made money the opportunity to enter the world of politics and art. Patronage was passing from the landed gentry to the merchants and manufacturers of London, Liverpool, Birmingham, Manchester and Newcastle. For the emerging Victorian middle-class, the fashion of collecting pictures was rapidly changing from Continental Old Masters to contemporary British art commissioned directly from artists. Elhanan Bicknell (1788–1861), a successful sperm whale oil merchant, did not 'give a damn'[6] for the work of Old Masters. He liked landscapes and gave commissions to Callcott, Eastlake, Etty, Frost, Roberts, Turner and Stanfield. His paintings, which included Turner's watercolour *The Blue Rigi: Lake Lucerne-Sunrise*, hung in his house at Herne Hill, south London, where he liked to entertain the artists (fig. 208). The collection was sold in 1863,

realising £58,600; as *The Star* of 28 April 1863 reported proudly, 'English money was being spent on English art'.

It was not for nothing that the greatest show of the age, the *Art Treasures of the United Kingdom* exhibition, was held in Manchester in 1857, an alliance of northern businessmen and the great aristocratic collectors. The artist who had the most exhibits was Turner with a hundred works. London no longer had a monopoly of dealers either. Winstanley in Liverpool and Agnew in Manchester were addressing the new breed of provincial collector. Typical was Joseph Gillott, a mass producer of steel pen nibs in Birmingham who patronised Turner, Etty, Linnell, Müller, William Hunt and David Cox. He liked 17th-century Dutch genre scenes and looked for contemporary equivalents to fill the three galleries at his Edgbaston house. His sale in 1873 was the first great auction sale of Turner's work (except for a small sale by Ruskin in 1869), which included 24 works in oils and watercolour and attracted enormous interest. The most expensive of Turner's oil paintings, *Schloss Rosenau* (Liverpool), sold for £1,942 10s, whereas no less than £3,307 10s was paid by Lord Dudley for the artist's large watercolour of Bamborough Castle. In Newcastle, Sir William Armstrong (hydraulic engineer and armaments manufacturer)

filled his country house, Cragside, with pictures by Wilkie, Albert Moore, Rossetti, Linnell and Lord Leighton.

Mention of Rossetti brings the Pre-Raphaelite Movement into the story. It had a strong following with the new northern money. James Leathart, a Newcastle lead manufacturer, sold his first collection of Cox and Varley to buy Ford Madox Brown (who painted Leathart), Burne-Jones (fig. 210), Arthur Hughes (fig. 209) and Rossetti (who painted a portrait of Leathart's wife). John Miller of Everton (tobacco merchant), George Rae of Birkenhead (banker) and George Holt of Liverpool (shipping) were typical Pre-Raphaelite collectors. Two of Rossetti's patrons deserve special mention, William Graham (1817–1885) and Frederick Leyland (1831–1892), who both, notably, collected early Italian paintings as well. Graham owned Rossetti's *Girlhood of the Virgin Mary* (Tate) and *Dante's Dream* (Liverpool; fig. 211) and was also a major patron of Burne-Jones. Leyland, a Liverpool shipping magnate, collected on the advice of Rossetti, owned many of his works, and later commissioned Whistler to create the Peacock Room.[7]

The offer of Sir John Leicester in 1823 to present his paintings for a national gallery of British art was the germ of an idea that eventually led to the foundation of the Tate Gallery. Robert Vernon (1774–1849), who made a fortune as a hackneyman and stable owner, marked a milestone in this process. He bought British school paintings from auction sales and exhibitions, particularly at the British Institution. In 1841 the wealthy sculptor Sir Francis Chantrey died and directed that his fortune should be spent on the purchase of British art for the nation. This inspired Vernon to take action; from 1843 he exhibited his enormous collection of Mulready, Bonington, Constable and Turner at his Pall Mall house. Four years later, the National Gallery accepted 164 of Vernon's paintings, thus transforming its holdings of modern British paintings. Vernon's aim was actually the establishment of a separate gallery of British Art. His paintings were later transferred to Marlborough House, then the South Kensington Museum, and displayed at the National Gallery before most were transferred to the Tate in 1897 (fig. 212). Vernon's were not the only paintings to follow this path. The Turner Bequest of 1851 which consisted of 300 oil paintings and over 20,000 drawings and watercolours, about 60 per cent of the artist's output, stipulated that his work should be displayed in a specially constructed 'Turner Gallery'. This was ignored and selections from the collection were shown at Marlborough House, and later at South Kensington before arriving at the Tate in 1897.

The Leeds clothing manufacturer John Sheepshanks (1787–1863) was another public-spirited collector who in 1856 gave his collection of 233 oil paintings and 93 watercolours and drawings to the South Kensington Museum for the same

211 Dante Gabriel Rossetti, *Dante's Dream*
William Graham; now Walker Art Gallery, Liverpool

212 Sir Charles Lock Eastlake, *The Escape of Francesco Novello di Carrara, with his Wife, from the Duke of Milan*
Robert Vernon; now Tate Britain, London

With Sir Henry Tate (1819–1899) the dream of a British Gallery was finally realised, but not without pain. Tate, whose fortune derived from sugar refining in Liverpool, bought pictures at the Royal Academy exhibitions and from Agnew's. In 1890, he offered his paintings to the nation, but insisted that the collection should go to the National Gallery. In a somewhat ungracious response, the Chancellor of the Exchequer (Sir William Harcourt) countered that his gift should join the Vernon collection at South Kensington. Eventually Harcourt made available the site of the former Millbank Prison. Tate generously gave 65 of his pictures and offered to pay for the new building (fig. 213). His foundation gift brought to the infant Tate Gallery well-known works such as Lady Butler's *The Remnants of an Army*, Landseer's *Scene at Abbotsford* and works by Alma-Tadema, Thomas Faed, Sir Luke Fildes, Albert Moore, Orchardson, Briton Rivière, John William Waterhouse and no fewer than seven pictures by Millais, including *Ophelia* (fig. 214), *The Boyhood of Raleigh* and *The Order of Release*. While it seemed that John Bull had triumphed at last, the victory was short-lived, as from 1916 the British pictures were obliged to share their accommodation with the national collection of modern foreign art.

213 The Tate Gallery on Milbank, London (now Tate Britain), photographed in *c.*1900

214 Sir John Everett Millais, *Ophelia*
Sir Henry Tate; now Tate Britain, London

purpose as Vernon, to form the elusive national gallery of British art. He wanted it 'to be in an airy and quiet place, to assist pupils in the Schools of Art, and hoped that it would open in the evenings and on Sundays for the benefit of working people'.[8] In addition to providing education, Sheepshanks wished to demonstrate the superiority of recent British genre and landscape painters over earlier Dutch and Flemish models, and to that end he collected works by Mulready, C.P. Leslie, Wilkie, Constable, Turner, Collins and Landseer.

LE GOÛT FRANÇAIS

As early as the 12th century, Abbot Suger of
St Denis believed that 'the English are destined
by moral and natural law to be subjected to the
French and not contrawise'.[1] In terms of culture
this remained substantially the case until Voltaire's
visit to England in 1726–29. French influence
in the visual arts, strong in England since the
Norman Conquest, was personified at the end of
the 17th century by Ralph, 1st Duke of Montagu,
and during the 18th century by Dr Richard
Mead, Frederick, Prince of Wales, and at its close
by William Beckford and Thomas Hope. The
revocation of the Edict of Nantes in 1685 brought
a flood of skilled refugee craftsmen to England:
silk-weavers, silversmiths and iron-workers.
Montagu was their patron, along with the 2nd Earl
of Warrington, whose patronage of silversmiths
remains one of the glories of Dunham Massey.
Warrington's preference was for sober plain silver,
at the opposite end of the scale from the French
Rococo style. The latter never permeated English
architecture – it was so at odds with Palladianism
– but its influence strongly informs almost
everything else, from Chelsea porcelain, Langlois
furniture, the engravings of Gravelot and Paul de
Lamerie silver to the paintings of Francis Hayman.

As we have seen (in chapters 6 and 7), the
taste for Poussin and Claude, which began in the
mid-17th century, became well established in the
18th century and formed the basis of the strong
collection of both artists' work now in the National
Gallery. English connoisseurs regarded them as
Italian or Roman as much as or more than French,
and fourteen paintings by Poussin were already in
England in 1716–1744.[2] Watteau's story remains
more elusive, despite his friendship with Dr Mead

The 18th Century

King George IV

The Marquesses of Hertford

Sir Richard Wallace

10th Duke of Hamilton

Ralph Bernal

John Jones

The Rothschilds

Lord Hillingdon

John Bowes

215 Jean-Henri Riesener, *Jewel Cabinet*
Royal Collection

and the claim of Count Rothenburg, in a letter to Frederick the Great in 1744, that nearly all his paintings were in England. Perhaps the most thinly represented major 18th-century French artist in Britain was Chardin, whose works were bought by William Fauquier, the 2nd Earl Harcourt and William Hunter (see chapter 18) but ignored by most collectors including, later, the 4th Marquess of Hertford. Numerous other French artists came to England in the 18th century to paint portraits of English sitters, most notably Jean-Baptiste Van Loo and Philip Mercier who as a dealer and engraver promoted Watteau. As Alexander Pope famously wrote 'We conquer'd France, but felt our captive's charms; Her arts victorious triumph'd o'er our arms'.[3]

By the end of the 18th century English curiosity about France, although strained by colonial wars

in America and India, remained high. The French Revolution brought refugees to London and another war, until the Treaty of Amiens in 1801 provided a brief opportunity to visit Napoleonic France. Despite over a decade of conflict between then and the battle of Waterloo (1815), French craftsmen continued to supply affluent English patrons with luxury goods. The enthusiasm for all things French received a notable check when France invaded Spain in 1808, tarnishing her reputation as a mainstay of Liberty. How the transfer of paintings as a result of the French Revolution benefited Britain has already been noted in chapter 12. Noel Desenfans, the French dealer, was supplied from Paris by Jean-Baptiste-Pierre Lebrun, husband of the painter Elisabeth Vigée, acquiring Poussin's masterpiece, the *Triumph of David*, and Watteau's *Les Plaisirs du Bal*, the artist's most

216 Jean-Antoine Watteau, *Les Plaisirs du Bal*

Noel Joseph Desenfans; Sir Francis Bourgeois bequest to Dulwich College, 1811; now Dulwich Picture Gallery, London

beautiful painting in England (fig. 216). Both are today at Dulwich Picture Gallery.

The decorative arts, above all, defined British Francophile collecting, and were given a huge impetus by the enthusiasm of George IV. Direct patronage of French craftsmen in the second half of the 18th century, though unusual, was by no means unknown in England. The fashion for creating Gobelins tapestry rooms with centrepieces after Boucher with elaborate floral borders is exemplified by Osterley Park and Newby Hall. More unusual was the commission by the 3rd Duke of Richmond for the Sèvres blue and green bird service, since virtually every other British collector around the time of the Revolution bought their porcelain from dealers.

George IV was the most acquisitive British monarch since Charles I and became almost as unpopular. By nature flamboyant and extravagant, it seems natural that he should look towards France where the arts were at a higher state of sophistication. He spoke French and made a minor cult of the Bourbons, but above all he bought their decorative arts and followed their architectural fashions. In 1784, as Prince of Wales, he took up residence at Carlton House, his palace that stood on the site of Waterloo Place. He chose England's most Francophile architect, Henry Holland, and engaged Guillaume Gaubert, Dominique Daguerre and Louis-André Delabrière to decorate the house. From the start, the Prince of Wales ardently collected French but also English furniture. Daguerre, also a leading Paris dealer, opened a London branch in 1786 and supplied French decorative arts not only to the Prince but also to Henry Holland's clients at Althorp, Woburn and Broadlands.

Carlton House was the greatest expression of English Francophilia before the formation of the Wallace Collection. The furniture was simultaneously advanced and conservative. The Prince bought up-to-the-minute pieces like the great Boulle revival *Secretaire* by Etienne Levasseur and Weisweiler's pietra dura cabinet, but also, astonishingly, was presented by Louis XVIII with the *Table des Grands Capitaines* (1812) with cameos painted by L.B. Parant, ordered by Napoleon but never delivered. Later in life when, as King, he was rebuilding and furnishing both Buckingham Palace and Windsor Castle he bought enormous Boulle *armoires* and in 1825 the great Riesener Jewel Cabinet (*c.*1787; fig. 215) which Napoleon had rejected as too old-fashioned. George IV's interests extended to everything artistic and his silver, porcelain, bronzes, paintings and arms reveal the same preoccupation with elegance, quality and, occasionally, novelty. His Sèvres collection remains the finest in the world and between 1810 and 1813 he acquired from Robert Fogg the swan song of soft-paste Sèvres, the Louis XVI service which took nine years to make between 1783 and 1793 (fig. 217).

The Prince primarily collected the decorative

217 The Sèvres Louis XVI Service
Royal Collection

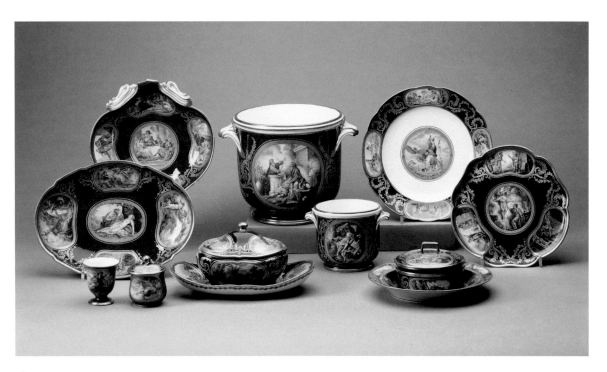

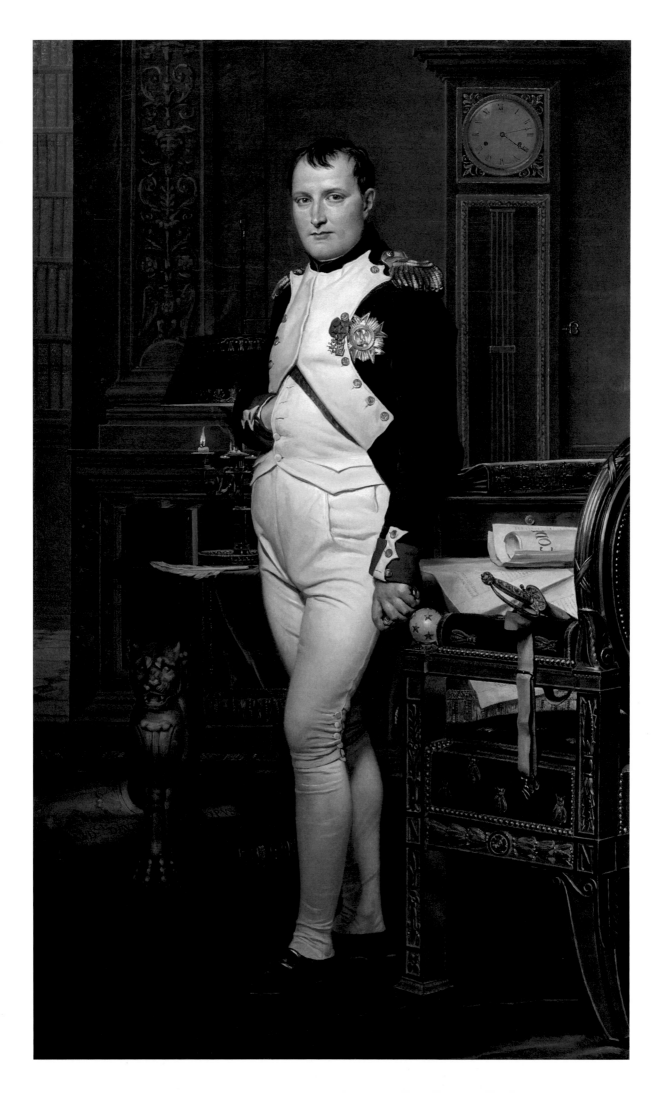

arts but his taste in paintings veered mainly towards the Dutch and Flemish schools. In 1814 he completed his most important purchase, acquiring 86 mostly Dutch paintings from Sir Francis Baring, including Cuyp's *Evening Landscape*. But his two most spectacular pictures were Rubens's *Landscape with St George*, secured in exchange for Baring paintings with the dealer William Harris, and Rembrandt's *Shipbuilder and his Wife*, which the 3rd Lord Hertford purchased on his behalf. He bought a few works by Greuze and Pater but was seldom attracted by contemporary French paintings.

The Prince was also an important patron of British art and owned eighteen paintings by Stubbs. He commissioned pictures from Reynolds, Beechey, Gainsborough, Wilkie, and above all Sir Thomas Lawrence, who provided the glamorous and theatrical series of portraits of the allied victors for the Waterloo Chamber at Windsor Castle.

But George IV's interests were not confined to the winning side. A curious taste which he shared with several Whig aristocrats was for Napoleonic art. He bought Isabey's *The Review at the Tuileries* but was trumped by the 10th Duke of Hamilton, who commissioned Jacques-Louis David in 1811 to paint *Napoleon in his Study at the Tuileries* (NG Washington; fig. 218). Arguably the most startling manifestation of this taste occurred in 1816 with the purchase by the British Government for under £3,000 of the colossal nude statue of Napoleon by Antonio Canova. It was presented to the Duke of Wellington and still adorns Apsley House. Several noblemen shared this enthusiasm for Napoleonic art including the 2nd Marquess of Lansdowne. Sir John Soane collected Napoleonic bindings. In other examples from later in the century, the 5th Lord Rosebery owned a collection of portraits of the Emperor and his family (including the portrait by David, sold from Hamilton Palace in 1882) and other memorabilia.[4] John Bowes hung portraits of Napoleonic marshals on the staircase of his museum at Barnard Castle.

Lord Hertford's connection with George IV proved particularly fruitful. The 3rd Marquess, though dubbed 'the devil's worst rake' and generally regarded as a monster, was nevertheless also a man of taste. He advised the Prince Regent on paintings while the Prince introduced him to French decorative arts. As a result Hertford bought Boulle marquetry furniture, thereby laying the foundations of the Wallace Collection, the greatest monument to British Francophilia. It was the creation of three generations, the 3rd and 4th Marquesses of Hertford and Sir Richard Wallace. The 3rd Marquess (1777–1842), whose deleterious glamour was captured by Thackeray's 'Lord Steyne' in *Vanity Fair* and Balzac's 'Lord Dudley', was chiefly interested in 17th-century Dutch painting but also bought Titian's *Perseus and Andromeda* which Richard Wallace, ignorant of its importance, later hung above his bath.

The wife of the 3rd Marquess, known as Mie-Mie, was an heiress who fled to Paris to escape her cynical husband. With her she took her eldest son, Richard, the 4th Marquess (1800–1870), the main collector of the family. Despite owning several houses and great estates in England and Ireland, he was to spend the rest of his life in Paris. Neurotic, a hypochondriac and increasingly reclusive, he lived for collecting, and this is vividly revealed by his letters to his London agent, Samuel Mawson. Hertford lived next door to his mother at 2 Rue Lafitte, and at the Château de Bagatelle, the small pleasure pavilion built by the Comte d'Artois on the edge of the Bois de Boulogne. He never married but kept mistresses and produced an illegitimate son, Richard Wallace. When his father died in 1842 the family wealth was estimated at above £2,000,000; Lord Hertford could afford anything.

The 4th Marquess followed his father's taste for Old Master paintings but was altogether exceptional in his passion for the French *ancien régime*. His love of pretty things played to his strengths and weaknesses as a collector, and today only half of his furniture collection – which was overwhelmingly French 18th-century in origin – remains in the collection at Hertford House. It however serves to demonstrate his taste for the finest pieces: the rococo commode attributed to Gadreaus and Caffièri, the roll-top desk made by Riesener for the Comte d'Orsay (fig. 220), which Beckford had owned, and three pieces made for Marie-Antoinette at the Petit Trianon. Hertford considered a French royal provenance to be a guarantee of quality and when a piece he admired was unavailable, such as the *Bureau de Roi* or the Riesener Jewel Cabinet, he simply had them copied, often at a greater cost than the originals.

The Boulle furniture, the snuff boxes, the clocks and above all the Sèvres, which is almost without peer, demonstrate Hertford's love of Rococo richness and high-quality craftsmanship.

Lord Hertford's taste in furniture was paralleled by that of the 2nd Duke of Buckingham, the 2nd Marquess of Abercorn and the 5th Duke of Buccleuch who, confusingly, completed the furnishing of Boughton in the style of Ralph, 1st Duke of Montagu. Mention should also be made of Hertford's compatriot in Paris, the 12th Earl of Pembroke, a reclusive figure of whom little is known apart from the 1862 sale of the contents of his apartment at 19 Place Vendôme. Earlier, when he tried to remove his property from Paris during the troubles of 1848, the mob set the carts on fire, a precedent which dissuaded Lord Hertford from attempting such a move.

When it came to paintings, there were three distinct branches to Lord Hertford's collecting: the French 18th century, European Old Masters and contemporary 19th-century works. His epicurean eye regarded Watteau, Boucher, Pater and Lancret with equal relish. In 1865 in Paris he bought Fragonard's *The Swing*, the epitome of *ancien régime* prettiness (fig. 219) but this aspect of his taste caused him to miss opportunities. Hertford loved Murillo but once wrote to his agent, Mawson: 'I have no doubt it is fine, as you say so. But I confess I do not much like the portrait of an old man, however fine it may be: it is not pleasing... I only like pleasing pictures'.[5] Hertford bought no fewer than 25 works by Greuze, mostly children, but his preference for polish and elaboration conditioned his response to contemporary art. The 4th Marquess enjoyed the Oriental paintings of Decamps and Vernet which became fashionable following the Duc d'Aumale's conquest of Algeria in 1830. Like many a conventional Salon visitor, his taste was for Diaz, Isabey, Meissonier and Dedreux, but he also bought Scheffer, Delaroche and Bonington. His most interesting French 19th-century purchase was Delacroix's the *Execution of Doge Marino Faliero*, but it remained an isolated case and most of his works of this period have long ceased to be fashionable.

The Hertford Old Master painting collection was largely formed through Mawson from London auctions. Although spectacular, it raises a question about its owner's motives. The Marquess owned

219 Jean-Honoré Fragonard,
The Swing
4th Marquess of Hertford; now
Wallace Collection, London

220 Jean-Henri Riesener,
Roll-top Desk (bureau à cylindre)
4th Marquess of Hertford; now
Wallace Collection, London

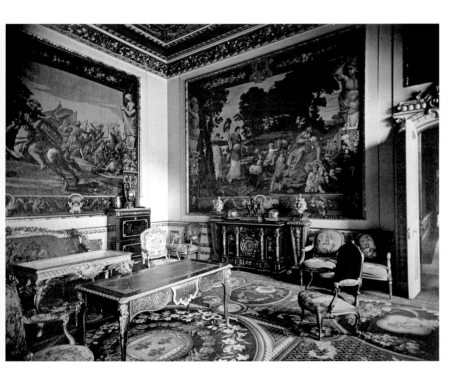

221 The Drawing Room at
Hamilton Palace, Lanarkshire,
photographed before 1882

more paintings than he could possibly hang and many were never displayed during his lifetime. Rather surprisingly, in 1857 the Marquess lent 44 paintings to the *Art Treasures* exhibition at Manchester (see chapter 20), and when it was suggested he might miss them he replied, 'Au fait, je ne suis pas fâché d'envoyer mes tableaux à Manchester; ce sera pour moi une occasion de les voir'.[6] It also seems that the Marquess, while craving anonymity, still needed to outbid all-comers. A case in point is the sale at Christie's in 1856 of the Rubens *Rainbow Landscape*, the pair to which was already in the National Gallery. After he had ruthlessly outbid the gallery at 4,550 guineas, the painting was delivered to Hertford House in London and the Marquess never saw it again. This need to win is most striking in the story of Frans Hals's *Laughing Cavalier*, its modern fame being largely due to the bidding battle that took place in Paris in 1871 with James de Rothschild, with Hertford finally paying six times the estimate. He bought great paintings by Rembrandt (a portrait of his son, Titus), Velázquez, Poussin, Claude and Champaigne and the Long Gallery at Hertford House remains a testament to his discrimination.

Richard Wallace (1818–1890), who was brought up in the household of the 4th Marquess but was unaware of his parentage until Hertford's death in 1870, rounded off the collection. His tastes were more eclectic: *Schatzkammer* items, Venetian glass, French ivories, Italian bronzes, German silver, Limoges and above all Italian maiolica. In his enthusiasm for oriental armour he emulated his father but it was Wallace who bought *en bloc* the two finest collections of armour then available, the Nieuwerkerke and Meyrick collections. The Franco-Prussian War caused Wallace, who had spent all his life in Paris, to bring a part of the collection to London for safety, and he lived at Hertford House in Manchester Square from 1875. While the house was being prepared between 1872 and 1875, Wallace exhibited the collection in the new Bethnal Green Museum in the heart of London's deprived East End, where an astonishing five million people are said to have viewed it. The collection was bequeathed to Lady Wallace, his French mistress of 30 years (and who spoke no English), to fulfil Wallace's intention to leave 'the great accumulation of works of art at Hertford House to the English nation'. The other half of the collection remained in Paris and eventually passed to Lady Sackville, who sold it in 1913 to the dealer Seligmann for $1 million.

Up in Scotland, one whale of a collection, indeed the grandest ever put together north of the border, was formed by the 10th Duke of Hamilton (1767–1852) with a distinctly Francophile flavour. Hamilton claimed the French Dukedom of Chatelherault and enjoyed collecting French art and furniture of the *ancien régime* as well as Napoleonic material. The aim of the latter was political, to give the impression that he was at the centre of events. He turned Hamilton Palace in Lanarkshire (fig. 221) into a gorgeous if gloomy repository where the decorative arts, books and manuscripts were paramount. He married Beckford's younger daughter, Susan Euphemia, and built a special wing to house the Beckford library. Paintings by Poussin and Rubens hung alongside the *Portrait of Napoleon* which he had commissioned from David, above some of the greatest commodes by Riesener and Cressent. He shared many of his father-in-law's tastes, not least for lacquer, agate and precious stones as well as manuscripts, although he never achieved Beckford's discrimination. The sale of the contents of Hamilton Palace by Christie's between 6 June and 21 July 1882 forms a watershed in the history of British collecting. Foreigners flocked to the sale and it signalled the end of the era of British domination of the art market.

If the 4th Marquess of Hertford was an epicurean collector whose collection exuded *ancien régime douceur de vivre*, Ralph Bernal (1786–1854) heralded a new era of specialist and discerning collecting that anticipated the Rothschild collections. Despite forming one of the greatest collections of Sèvres porcelain, Bernal was no ordinary Francophile collector. His heart lay in French medieval and Italian Renaissance objects. As Frank Herrmann wrote: 'to Ralph Bernal, a highly intelligent man trained as a barrister and a Member of Parliament for 30 years, more than to any single individual in the history of English collecting, we owe the shift of interest among collectors from the work of the artist to the product of the craftsman'.[7] Bernal's wealth, which was limited, was derived from the West Indies. A Jewish convert to Christianity, he sat as an MP for several constituencies and also became President of the British Archaeological Association.

All descriptions of the Bernal collection focus on the great sale at Christie's in 1855 after his death. The 4,244 lots occupied 32 days and produced £62,690. An attempt was made, supported by the Prince Consort, to buy the collection for the nation but in the event the Treasury granted the newly formed South Kensington Museum (then temporarily housed at Marlborough House) only £12,000

and the British Museum £4,000 to buy objects. The latter acquired the *Lothair* Crystal (*c.*865) made for Lothair II, King of the Franks, and 21 pieces of Italian maiolica. The South Kensington Museum, with its mission to improve design in Britain, bought Limoges enamels and some of the finest Sèvres and Meissen. The museum was not authorised by the Treasury to bid above the

222 The Becket Casket
English antiquaries, including William Stukeley; now Victoria & Albert Museum, London

223 The Drawing Room in John Jones's house at 95 Piccadilly, London, plate 10 from *Handbook of the Jones Collection in the South Kensington Museum*, 1883

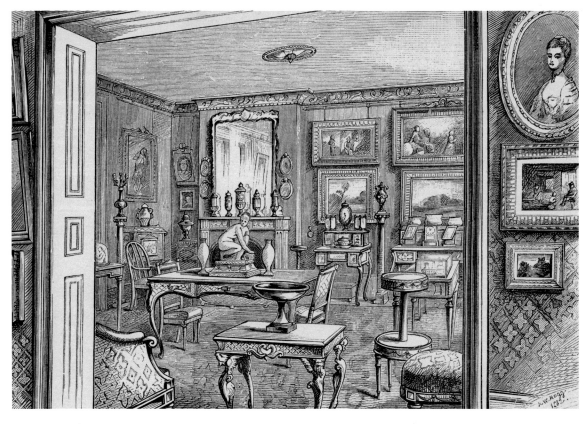

estimates and they consequently missed items, notably a St Thomas Becket casket similar to that formerly in the Stukeley collection, which eventually came to the V&A in 1996 (fig. 222). What the museums passed on, private collectors, notably the Rothschilds, snapped up. There was particularly stiff competition for Bernal's Sèvres between Lord Hertford, Baron Mayer de Rothschild, Sir Anthony de Rothschild, Lord Bath and Samuel Addington. A pair of Sèvres Rose Pompadour vases soared to nearly £2,000; Hertford secured all but one of the most expensive Sèvres pieces. The range was wide: armour, antique jewellery, crosses, Chinese porcelain, Faenza and Urbino wares, Grès de Flandres and German enamelled glass. The paintings were principally English and French historical portraits but included works by Cranach and El Greco. The consistently high quality amazed those who attended the sale.

French art traditionally appealed to the upper classes, but John Jones (1798/9–1882) fascinatingly exemplifies the self-made man. His fastidious collection of French decorative arts came to form the basis of the V&A's holdings in this area. A dapper bachelor with a monocle, Jones made a fortune as a regimental tailor and army clothier, based in Waterloo Place. Although he had less room for display and a far smaller fortune than Lord Hertford, a handbook of Jones's collection published in 1883 nevertheless lists an impressive 878 items, including 89 pieces of Sèvres and 135 of furniture (fig. 223). He took advantage of the sales of Strawberry Hill, Lady Auckland, Lord Pembroke, Henry Hope and Ralph Bernal. His crown jewels were excellent examples of Carlin's work (fig. 224), including two that belonged to Marie Antoinette, as well as pieces by Weisweiler, Dubois, Bernard van Risamburgh (BVRB),[8] miniatures by Jean Petitot, boxes by Blarenberghe and paintings by Boucher, Etty, Landseer and, surprisingly, Crivelli. The V&A had formerly been poorly provided with 18th-century French decorative arts and successfully courted Jones, whose bequest in 1882 remains fundamental to its collections. It was perhaps to impress Jones with their serious intentions that in 1869 the museum purchased for £2,100 the

224 Desk by Martin Carlin

John Jones; now Victoria & Albert Museum, London

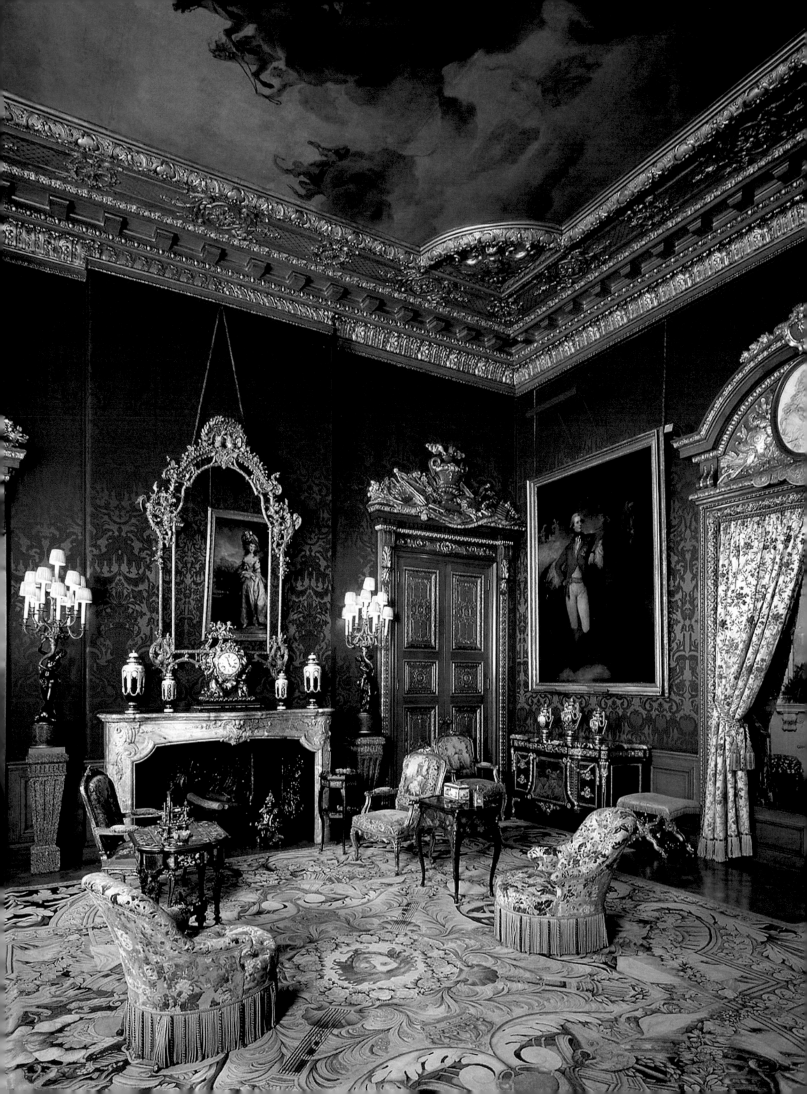

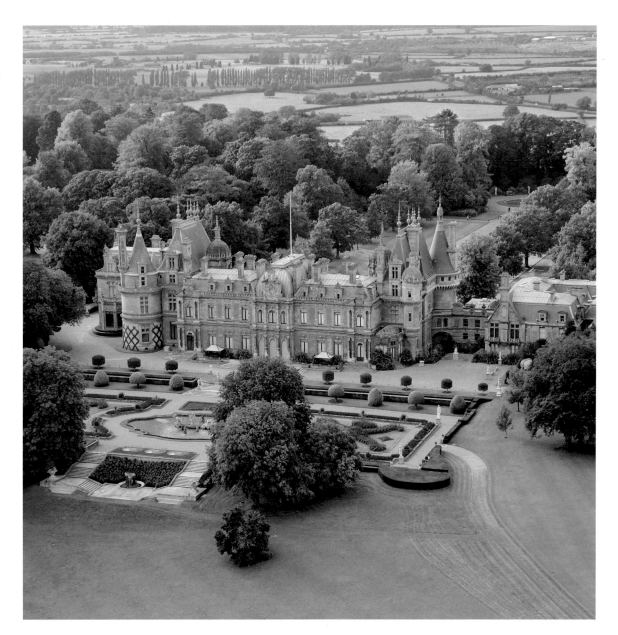

complete fittings of the boudoir of Mme Serilly, Lady-in-Waiting to Marie-Antoinette.

Francophile collecting was not confined to the metropolis. Several country houses, chief among them Hamilton Palace, contained important French decorative arts but the zenith was *le goût Rothschild* as expressed in the two great Rothschild houses in the vale of Aylesbury, Mentmore Towers and Waddesdon Manor. The Rothschilds are an exceptional family. Established internationally, they have for six generations reinvented themselves both as financiers and collectors. Baron Mayer Amschel de Rothschild (1818–1874), who hailed from the third generation of the Frankfurt bankers, built Mentmore, employing Joseph Paxton as his architect, and filled it with paintings by Fragonard, Boucher and Lancret, sculpture by Clodion and furniture by Cressent, Riesener and Carlin.

The opulence was matched by the high quality of the individual objects, and this was equally true of Waddesdon, built for Baron Ferdinand de Rothschild (1839–1898) by the architect Destailleur in the French Renaissance style (fig. 226).

Baron Ferdinand came from the main collecting branch of the family. His father Anselm collected German medieval and Renaissance goldsmith's work and he married his first cousin, Charlotte, whose father Nathan Rothschild had acquired objects for his Piccadilly house. At Waddesdon, Ferdinand pioneered the taste for grand English portraits and French decorative arts that was later to flourish in America (fig. 225). Gobelins and Beauvais tapestries were set against 18th-century *boiseries*, but strangely Baron Ferdinand did not buy French paintings. Portraits by Reynolds and

195 · THE BRITISH AS ART COLLECTORS

Gainsborough hung above French royal furniture by Riesener and, more unusually in England, Charles Cressent. The Baron bought avidly at the Hamilton Palace sale, where he acquired a Cressent Commode (fig. 227) among many other pieces. Among his Sèvres there were no fewer than three examples of the very rare potpourri vases in the shape of masted ships.

The Rothschilds hunted, entered Parliament and socialised with their neighbours; collecting art functioned not only as an expression of wealth but also marked their assimilation into the English elite. Just as Baron Ferdinand wrote of his works of art, 'their pedigrees are of unimpeachable authenticity', so a Rothschild provenance became a guarantee of quality, the name becoming synonymous not only with the style, but above all with high quality. Kenneth Clark memorably wrote that: 'Up to the last war the style of Sir Richard Wallace was still to be seen in private hands in the houses of the Rothschild family. Indeed, if all their collections could have been united they would I believe, have put the Wallace Collection in the shade. A visit to a Rothschild Collection was always a memorable experience. Hushed, inviolate, almost indistinguishable from one another, they were impressive not only by their size and splendour, but by a sense of solemnity of wealth which hung about them. In a Rothschild collection I always found myself whispering, as if I were in a church.'[9] But with the Rothschilds, the taste for the *ancien régime* reached its climax.

If Waddesdon and Mentmore represented the peak of the Francophile country house, Camelford House, Park Lane, holds the same position in London. It was the home of Charles Mills, a partner in Glyn Mills bank. A sumptuous catalogue privately printed in 1891 reveals a familiar combination of English 18th-century portraits by Romney, Reynolds and Gainsborough along with Sèvres porcelain and French furniture (fig. 228). Mills had a particular taste for furniture mounted with Sèvres plaques by Weisweiler and Carlin. In 1853 his only son married Louise Lascelles, daughter of the 3rd Earl of Harewood. Mrs Charles Mills told her husband she feared the Lascelles family marriage to a family with City connections would be a bitter pill to swallow. Mr Mills is reported to have replied dryly 'Then, my dear, we must gild it'.[10] The son was duly created

227 Commode by Charles
Cressent
10th Duke of Hamilton; Baron
Ferdinand de Rothschild;
now Waddesdon Manor,
Buckinghamshire

228 Commode and Sèvres
porcelain from Blue Drawing
Room at Camelford House,
from the *Catalogue of the
Furniture, Porcelain, Pictures,
&c. at Camelford House, Park
Lane, the town residence of
Lord Hillingdon*, 1891

229 Jean-Baptist-Camille
Corot, *Landscape with Cattle*
John Bowes; now Bowes Museum,
County Durham

Lord Hillingdon in 1886. Fifty years later Duveen bought the Hillingdon collection and sold much of it to the Kress Foundation which passed it to America.

The most improbable of the English Francophile collections is the Bowes Museum at Barnard Castle. It was the product of the childless marriage of John Bowes (1811–1885), a local landowner and illegitimate son of the 10th Earl of Strathmore, to a French actress, Josephine Coffin-Chevalier (1825–1874). After marrying in 1852 she abandoned the stage and took up painting, and together the couple formed a collection of decorative arts and the largest group of French paintings in Britain. This they housed in a vast Second Empire, French Renaissance-style museum designed by Jules Bellechet. The aim was didactic and educational; one specimen of each type or artist usually sufficed and the budget was limited to £10 per item, which occasionally stretched to £200. The result provides a microcosm of what

was available in Paris during the 1860s at the lower end of the market. Yet despite this, by 1866 they owned works by Corot (fig. 229), Courbet, Boudin, Fantin-Latour, Monticelli and Goya as well as Old Masters by El Greco, Sassetta (bought as a 'Fra Angelico') and many more. This quirky but entrancing museum opened to the public in 1892. Bowes lived into the era of Impressionism: the Belgian art dealer Ernest Gambart arrived in London in 1840 and soon started exhibiting continental prints and paintings, particularly the work of Rosa Bonheur. This departure ushered in a new phase of Francophilia in Britain, focused on modern paintings, and brought with it the mixed reception accorded to Impressionism.

Chapter 16

HISPANOPHILE COLLECTING

Hispanophile collecting stands as a paradigm of the arts in Britain, with a small band of enthusiasts producing important results, stimulated by literary works and military intervention, finally to be taken up by artists. Hilary McCartney has characterised the phenomenon: 'rather than the discovery of a school, the history of taste for Spanish art in Britain should perhaps be seen more as a series of epiphanies in which the genius of a handful of individual artists was each revealed in turn'.[1] Gustar Waagen asserted that it was only after the French invasion of Spain in 1807 that it became possible to buy works of art in Spain, their export having been subject to strict controls since 1779. It was then largely thanks to the energy of the dealer William Buchanan that so many Spanish paintings arrived in London.

The ground had been laid by many art-collecting contacts with Spain long before 1807 but they were sporadic. Charles I visited Spain in 1623 and sat to Velázquez for a now lost portrait. The King owned a group of Spanish still lifes presented by Sir Arthur Hopton, British ambassador to Madrid, but a more unexpected appearance is a version of El Greco's *Christ Driving the Moneylenders from the Temple* (now in Minneapolis; fig. 231) in the inventory of the 1st Duke of Buckingham's collection. Spain's almost impenetrable barriers of religion were compounded by the Pyrenees, rendering her literally, *ultra montes*. British relations were generally baleful until the French invasion united the Spanish to accept the British as allies during the ensuing Peninsular War.

Spanish paintings had trickled into Britain; the activities of British diplomats in Spain were important. Sir Benjamin Keene, born in King's

The Peninsular War

1st Duke of Wellington

The Rokeby Venus

William Bankes

Richard Ford

Sir William Stirling-Maxwell

John and Josephine Bowes

230 Domenikos Theotokópoulos (El Greco),
Lady in a Fur Wrap
Sir William Stirling-Maxwell; now Pollok House, Glasgow
(National Trust for Scotland)

Lynn, Sir Robert Walpole's constituency, served as ambassador to Madrid 1729–39 and 1748–57. Walpole had bought a Velázquez *Head of Pope Innocent X* (now thought to be a copy) for eleven guineas in 1725–26, but more importantly owned an outstanding group of Murillo paintings, at least one of which was a gift from Keene, who was probably instrumental in the acquisition of some or all of the others. While the Duke of Bedford and Lord Burlington owned versions of Velázquez paintings, the British instigated a minor cult of Murillo, probably because of his affinities with Italian art. 'Oh wonderful Spain. Think of this romantic land covered in Moorish ruins and full of Murillos,' exclaimed Disraeli in 1830.[2]

A century earlier the widow of Sir Daniel Arthur had imported several important Murillos into England and the artist's name appears in auction catalogues as early as 1693 at the sale of John Drummond, Lord Melfort (1649–1714), which included the *Three Boys* and *The Peasant Boys*, probably those now at Dulwich Picture Gallery (fig. 232). By 1729 Sir Daniel Arthur is thought to have acquired Murillo's *Self-Portrait* (NG London), which was to pass through a sequence of distinguished collections, namely Frederick, Prince of Wales, Sir Lawrence Dundas, the Lords Ashburnham and Earls Spencer. Later, pictures

by Murillo were also owned by the Blathwayts of Dyrham, the Cartwrights of Aynhoe, Sir Sampson Gideon at Belvedere House and the Dukes of Rutland at Belvoir.

Another British favourite was Ribera who lived in Naples and became known as Spagnoletto. His characteristic *Democritus* was owned by the 8th Earl of Pembroke and recorded at Wilton in 1731, but perhaps the most surprising arrival was the series of *Jacob and his Twelve Sons* by Zurbarán and his studio. Owned in 1726 by the Jewish merchant, James Mendez, they were acquired in 1756 by the Bishop of Durham who installed them

231 Domenikos Theotokópoulos (El Greco), *Christ Driving the Money Changers from the Temple*
1st Duke of Buckingham; now Minneapolis Institute of Arts

232 Bartolomé Esteban Murillo, *Three Boys*
Possibly John Drummond, 1st Earl of Melfort; Noel Joseph Desenfans; Sir Francis Bourgeois bequest to Dulwich College, 1811; now Dulwich Picture Gallery, London

at Bishop Auckland where they remained, virtually unnoticed until the 1930s (fig. 233).[3] At the end of the 18th century a number of publications made Spain more familiar: Edward Clarke's *Letters concerning the Spanish Nation written at Madrid during the years 1760 and 1761*, followed by *Travels through Portugal and Spain in 1772 and 1773* by Richard Twiss.[4]

Everything changed with the Peninsular War (1808–14), its principal artistic beneficiary being the British Commander, Arthur Wellesley (1769–1852), later 1st Duke of Wellington. After the Battle of Vitoria in 1813, paintings purloined by Napoleon's brother, Joseph, were captured. Wellington tried to return the loot to Ferdinand VII of Spain, who insisted that he kept them as a reward. Wellington was interested in painting and suitably grateful, though he preferred Italian and Dutch works. His haul included Velázquez's *Portrait of José Nieto* and the early *Waterseller of Seville* (fig. 234), as well as Correggio's exquisite *Agony in the Garden*, from which he was never

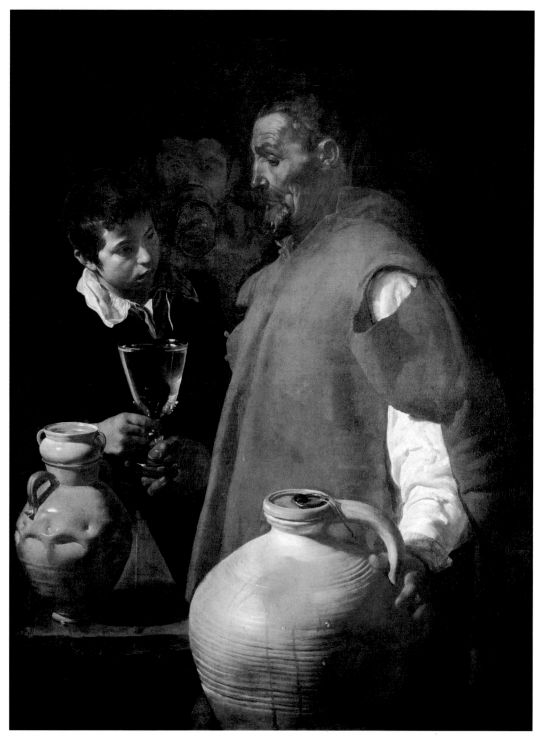

233 The Zurbarán Room at Auckland Castle, Bishop Auckland, County Durham
James Mendez; Bishops of Durham

234 Diego Velázquez, *The Waterseller of Seville*
1st Duke of Wellington; now Apsley House, London

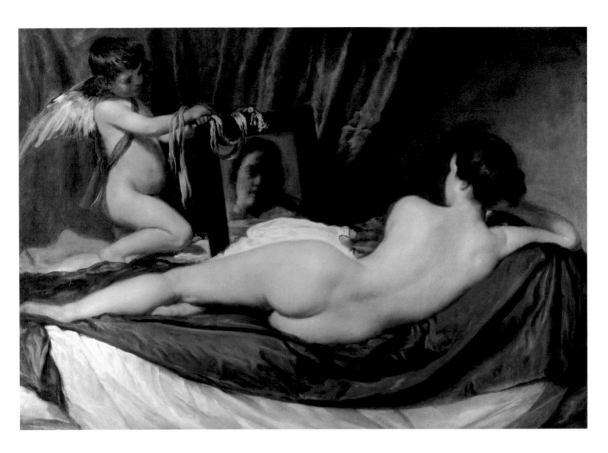

separated – his carriage contained a special hook on which to hang it. In 1816 Wellington bought Apsley House where he displayed his collection. His own acquisitions tended to be Dutch genre paintings and commemorative portraits of his allies and combatants, but he commissioned Wilkie's *Chelsea Pensioners Reading the Waterloo Despatch* and was presented by the government with Canova's colossal nude sculpture of Napoleon.

Into the confusion of the Peninsular War came Buchanan's agent George Augustus Wallis who visited Madrid between 1808 and 1813. Among other works he acquired Velázquez's *Toilet of Venus* ('The Rokeby Venus'), which Buchanan sold for £500 to John Morritt of Rokeby Hall (fig. 235). The delighted new owner wrote to Sir Walter Scott, 'I have been all morning pulling about my pictures and hanging them in new positions to make room for my fine picture of Venus's backside which I have at length exalted over my chimney piece in the library'.[5] In 1809–10 the British Minister Plenipotary to the Spanish government, Bartholomew Frere, bought two early Velázquez paintings in Seville, *St John the Evangelist* and *The Immaculate Conception*, both now in the National Gallery in London.

One of the first Englishmen to form a collection of Spanish art was the bohemian, William Bankes (1786–1855), described by Byron as his Cambridge 'collegiate pastor, master and patron... and father of all mischiefs'.[6] Bankes, the scion of a distinguished Dorset family, travelled to Portugal and Spain between 1812 and 1815 and shipped back a collection of Spanish paintings, 'more geese than swans',[7] which included examples by Alonso Cano, the studio of Zurbarán and a copy of *Las Meninas* which he believed to be Velázquez's original sketch. Bankes continued his travels up the Nile, acquiring an obelisk at Philae (see chapter 18), and explored Syria. His most distinguished purchases were secured in 1820 in Bologna with Titian's *Francesco Savorgnan della Torre*, the unfinished *Judgement of Solomon* thought to be by Giorgione but now attributed to Sebastiano del Piombo, and Velázquez's *Cardinal Camillo Massimi*. Between 1838 and 1855 as part of the remodelling of the family home, Kingston Lacy, Bankes created the Spanish Room, unique in England, with the paintings hung on walls lined with Spanish leather under a heavy Venetian ceiling (fig. 236). In 1841 he was prosecuted for a homosexual act with a guardsman and fled to Venice – never to return – from where he continued to direct the rebuilding of his

home and the hanging of new acquisitions until his death.

Spain attracted more than just rich gentlemen. An important pioneer in the appreciation of Spanish art was the artist, David Wilkie, who visited the Prado in 1827. He correctly divined the influence of Velázquez on Reynolds, Romney, Raeburn and Lawrence, and might have added that of Murillo on Gainsborough. Wilkie bought paintings for Sir Robert Peel, including the Velázquez *Portrait of Archbishop de Valdés* (now NG London)

and described the artistic riches of Spain as the 'wild, unpoached game-preserve of Europe'. As so often in England the agents and artists played a key role in collecting, supported by a literary campaign. A key literary figure in this regard was Richard Ford (1796–1858), who travelled to Spain in 1830. He made over 500 drawings of the country but it was his *Handbook for Travellers in Spain* (1845) that was to have such a profound effect on the British understanding of the country.

Ford collected Spanish paintings, including

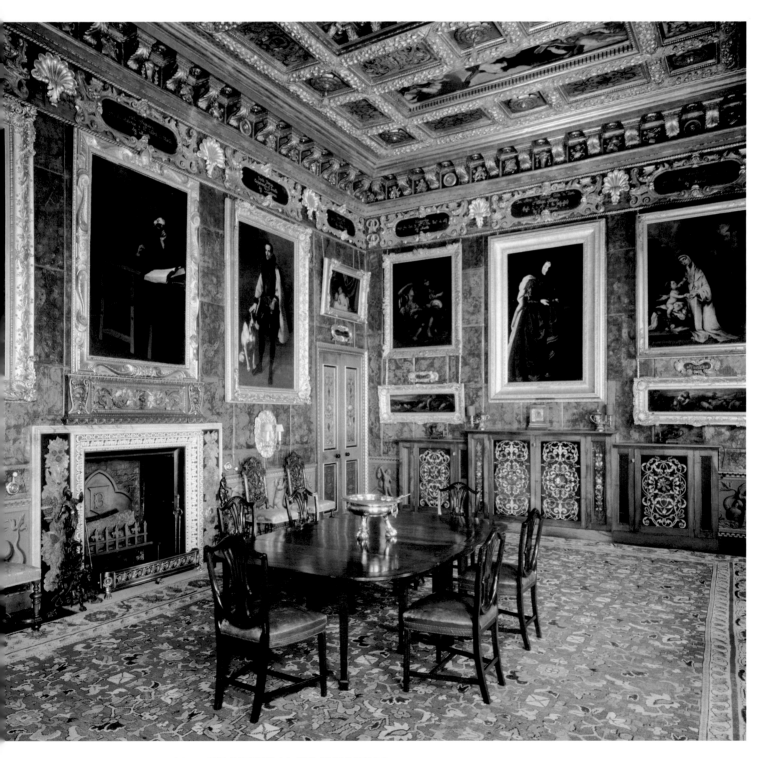

examples by Murillo, Ribalta and Zurbarán but he sold them in 1836 because 'they... give me no pleasure and much expense and trouble. The pleasure is in the *acquisition not in possession*'. Ford wrote a short life of Velázquez in the *Penny Encyclopaedia* (1843), followed by the first catalogue raisonné of the artist, published in Sir William Stirling's *Annals of the Artists in Spain* (1848). This formed a milestone in the appreciation of Spanish artists, including Goya; he compared him to Hogarth as a printmaker and satirist, but was dismissive of his paintings. One of the many merits of Stirling as an art historian (he became Stirling-Maxwell after 1865) was his interest in prints and he owned a set of Goya's *Caprichos* etchings. In 1855 he published *Velázquez and his Works*, which has the distinction of being the first work of art history illustrated with photographs (talbotypes), and in 1873 he privately printed (in an edition of 100 copies) a *Catalogue of Prints Engraved from the Works of Velazquez and Murillo*, founded on his own collection and the 'still larger collection of my friend Mr Charles Morse'. This catalogue extended to 137 pages, printed in small type.

In his *Annals* of 1848, Stirling declared that Britain 'could probably furnish forth a gallery of Spanish pictures second only to that of the Queen of Spain', which may simply reflect the dearth of Spanish art elsewhere. The greatest opportunity to acquire Spanish art in London came four years later in 1853 when the collection formed by Frank Hall Standish was sold at Christie's by the heirs of Louis-Philippe of France. Standish (1799–1840) had lived in Seville where he formed an enormous collection of Zurbarán, Murillo and Velázquez which he bequeathed along with his 340 incunables to the French king. He had offered the collection to the British nation in return for a baronetcy, but Peel turned him down. The paintings hung briefly in the Louvre as the Musée Standish but after 1848 Louis-Philippe successfully claimed them as his personal property and sent them to London for sale. Stirling availed himself of this opportunity and bought many paintings, including works by El Greco and Zubarán.

Nineteenth-century British ambassadors and consuls formed some notable collections of Spanish pictures, many of which subsequently came to England. General the Hon. John Meade

(1775–1849), consul-general in Madrid from 1816 to 1832, formed a large collection of Spanish paintings, from which 387 were sold at Christie's in March 1851; Richard Ford and William Stirling were among the purchasers. Sir William A'Court, later 1st Lord Heytesbury (1779–1860), who served as ambassador in 1822–24, owned Murillo's seductive portrait of *Two Women at a Balcony* or *Las Gallegas* (NG Washington). John Brackenbury (1778–1847), British consul in Cadiz from 1822 to 1842, owned Murillo's full-length *Portrait of Don Andrés de Andrade* (Metropolitan). Julian Williams (died 1866) lived in Seville from 1818, serving as honorary vice-consul until his

237 Francisco de Goya y Lucientes, *The Forge*
Henry Labouchère, 1st Lord Taunton; now Frick Collection, New York

promotion to consul in 1856, was partly a dealer, but no sale of his collection is known. He owned Murillo's drawing *The Adoration of the Magi* (NG Washington). It is likely that much of these two consular collections passed to King Louis-Philippe. George Villiers, 4th Earl of Clarendon (1800–1870), ambassador between 1833 and 1839, was among the first to acquire the work of Goya.

El Greco's name is missing from most lists of British collections of Spanish art. J.C. Robinson, the first superintendent of the V&A and Keeper of the Queen's Pictures, acquired an outstanding work in 1887, *Christ Driving the Moneylenders from the Temple*, which he gave to the National Gallery, the first El Greco to enter its collection. After the Duke of Buckingham's El Greco in the 1630s, virtually no other painting by this artist is recorded for 200 years. One of the few exceptions was *The Adoration of the Shepherds* (now at Boughton) bought by the 3rd Duke of Montagu in Paris in 1756, but he believed it to be by Tintoretto. According to Reitlinger, the name first appeared in the London saleroom in 1849.[8] The Louis-Philippe sale of 1853 contained several works by El Greco, including the *Lady in a Fur Wrap*, which was bought by William Stirling (Pollok House; fig. 230).

The oddest collection of Spanish art in Britain was undoubtedly that put together by John and Josephine Bowes for their museum at Barnard Castle. It consists of 78 Spanish paintings; most are by little-known artists, but it does contain an El Greco, *The Tears of St Peter*, and a Goya, the *Interior of a Prison*. Their agent Benjamin Gogué negotiated these from the Condé di Quinto collection and the Goya cost only £8. Apart from his prints, Goya was barely known in England in the 19th century. Lady Holland mentions him first in 1809 as 'the celebrated Goya', and three years later the artist painted Wellington in Madrid in the strangely haunted portrait that does little credit to either artist or sitter. Probably the finest Goya in Britain in the 19th century was *The Forge* (Frick; fig. 237), owned successively by William Coningham and Henry Labouchère, later 1st Lord Taunton.

By the end of the 19th century, interest in Spanish painting was rekindled by a new generation of artists such as Millais, Whistler and Sargent, and Spanish art joined mainstream art history and collecting. In 1900 the first monograph on Goya in English was published by William Rothenstein, too late to have much effect on British collecting but in time to make him fundamental to collectors of Spanish art in America during the 20th century. In 1904, Sir George Donaldson presented Goya's portrait of Don Andrés del Peral to the National Gallery. Tomás Harris (1908–1964), a collector, dealer and MI5 agent, formed a seminal collection of Goya's prints, one of the last important manifestations of hispanophile collecting in Britain. It was left to the nation in lieu of inheritance tax and is in the British Museum.

Chapter 17

THE LURE OF FLORENCE

The British fascination with Italian art did not diminish in the 19th century but shifted its centre of gravity. Aristocrats and Grand Tourists in Rome gave way to merchants, scholars and clergymen who developed a cult of Medieval and Renaissance Florentine art and history. Throughout the 18th century and despite the popularity of the Uffizi, Florence played second fiddle to Rome and Naples. The last Medici, the widowed Electress Palatine Anna Maria Luisa, died in 1743, bequeathing the Medici collections to Tuscany. The enthusiasm for Florentine art grew slowly, beginning in the mid-18th century and gathering pace under Napoleon. In 1799 the French invaded Tuscany and occupied Florence until 1814. These upheavals precipitated the closure of a number of religious institutions, speeding a process that had already begun in the 1770s, and released large numbers of paintings.

Early Italian pictures first attracted the notice of artists including Reynolds, Romney, Flaxman and above all Thomas Patch, who in the early 1770s published *The Lives of Giotto, Masaccio and Fra Bartolommeo*, illustrated with engravings by Patch himself after original frescoes and paintings. Reynolds had praised Masaccio in his 1784 *Discourse* and owned Giovanni Bellini's *Agony in the Garden*, yet in 1795 Horace Walpole could still write of the Italian 'primitives' that 'their works are only curious for their antiquity, not for their excellence and... not to be met within collections.'[1] Given the amount of art dislocated by these upheavals, Francis Haskell posed the rhetorical question: 'who wants a Masaccio or a Botticelli when a Guido Reni can be had for the asking?'[2] In fact perceptive artists, dealers, writers and

William Roscoe

William Young Ottley

Edward Solly

William Fox-Strangways

Clerical collectors

John Ruskin

William Drury-Lowe

Thomas Gambier-Parry

The Cult of Botticelli

Alexander Barker

Lord Lindsay (later 25th Earl of Crawford & Balcarres)

Prince Albert

William Graham

4th Duke of Northumberland and the Camuccini Collection

238 Duccio di Buoninsegna (school of), detail from *The Crucifixion*
Lord Lindsay; now Manchester Art Gallery

historians were taking a closer look at the earlier periods but a whole century would pass before the taste was fully established. By 1908 the new priorities were well encapsulated by Miss Lucy Honeychurch in E.M. Forster's *A Room With a View* when she chooses postcards: she starts with Botticelli's *Birth of Venus*, followed by Giorgione's *Tempesta*, Fra Angelico's *Crucifixion*, Giotto's *Ascension of St John*, some Della Robbia babies and finally 'some Guido Reni Madonnas'.

If anything the French stole a march on the British in their appreciation of the primitives, perhaps a consequence of their domination of Italy during the Napoleonic era. Séroux d'Agincourt wrote an influential history of art published in French in 1823 and employed William Young Ottley as a copyist. Influenced by d'Agincourt, Napoleon's uncle, Cardinal Fesch, assembled a vast collection, ranging from Giotto to Raphael – with many geese and swans – which would provide a generation of British dealers and collectors such as Samuel Woodburn and the Rev. Walter Davenport-Bromley with an important source. The change of taste was gradually exemplified by the cautious but ultimately successful activities of the National Gallery, founded in 1824, and its first and most acquisitive director, Sir Charles Eastlake, appointed in 1855.

The motivations for turning to early Italian art were various: for artists like Patch it was affordable; for dealers like Samuel Woodburn and William Spence, its sudden availability provided economic opportunities to be exploited. For a number of brilliant collectors like William Beckford, the Earl-Bishop of Bristol and Samuel Rogers, 'primitives' were underrated curiosities, whereas William Roscoe, Ottley and Prince Albert were motivated principally by historical and didactic concerns. William Graham and the great clergyman collectors, the Revs John Sanford and Walter Davenport-Bromley, were moved by a search for elevated Christian sentiments. All this was fuelled by a growing number of publications that revealed Italian art and history to the British public with an emphasis on the Florentine Renaissance: the translation of Giorgio Vasari's *Lives* between 1850 and 1885, John Murray's influential *Handbook for Travellers in North Italy* (1842) compiled by Francis Palgrave, Lord Lindsay's *Sketches of the History of Christian Art* (1847), which had

a profound influence on Ruskin, Mrs Anna Jameson's *Sacred and Legendary Art* (1848) and Crowe and Cavalcaselle's *New History of Paintings in Italy from the Second to the Sixteenth Century* (1864–66).

The 19th-century shift in interest from ancient Greece and Rome to Renaissance Florence was echoed in architecture, from the buildings of Klenze in Munich to Barry's Italianate Clubs on Pall Mall. The latter underline the identification of the London merchant princes with their Florentine predecessors. The Italian city republics represented a more acceptable model in Protestant England than Papal Rome. By the end of the 19th century Florence had become home to a considerable English colony and its art was being reproduced by the Arundel and Medici Societies. Its influence is most striking in the Pre-Raphaelite movement, one of the most direct examples of a change of taste – in part stimulated by art collecting – informing the creative process. Its members also enthused over the engravings by Carlo Lasinio in his *Pitture a fresco del Campo Santo di Pisa* (1828). Rossetti admired Mantegna and Fra Angelico and even owned a Botticelli that he reputedly touched up.

The buyers of early Italian art were a different breed from the Grand Tourists of previous generations. Merchants jostled with scholars and younger sons whose finances were not always secure. It is striking how many sales took place to feed the small pool of collectors, so that the same paintings passed from one to another. Equally striking is the undeveloped art-historical framework, so that attributions constantly changed. A case in point is the panel *Birth of St John* which was bought with its predella companion (Polesden Lacey) by the artist-agent, Henry Tresham, from the Casa Pucci in Florence on behalf of a gifted collector, the 1st Lord Cawdor. The latter owned Bellini's *Portrait of Doge Leonardo Loredan* before William Beckford, and had a sculpture gallery attached to his London house. Cawdor bought the Pucci panel as a Masaccio and sold it in 1800. It next appears in the collection of the intriguing military man, Colonel Matthew Smith, Governor of the Tower of London. The Colonel offered it in his sale in 1804, which included several 'Masaccios', a Giotto and a Cimabue. *Birth of St John* was bought with Simone Martini's *Christ Discovered in the Temple* by William Roscoe of Liverpool, who changed the

attribution to Fra Angelico. Today both hang in the Walker Art Gallery, Liverpool, the Pucci panel now ascribed to Perugino and the subject matter is considered to be the *Birth of the Virgin* (fig. 239).

The life of the collector William Roscoe (1753–1831) is inseparable from his home city of Liverpool which he regarded as the modern Florence. A lawyer, banker, poet, historian, philanthropist, slave abolitionist and MP, Roscoe was a larger-than-life, proto-Victorian figure, whose approach to collecting was didactic, historical and moral. A religious dissenter and Unitarian who

equally popular *Life of Pope Leo X*, and Roscoe's name became as internationally famous as that of Gibbon.[3] In 1804 Colonel Smith's sale provided his first significant paintings. His knowledge of art was derived from Vasari's *Lives* and he put himself in the hands of a Liverpool dealer, Thomas Winstanley, also taking sound advice from the dealer Samuel Woodburn, as well as William Young Ottley. His intention was to document the development and origins of European art. Works of art were therefore not judged primarily for their aesthetic appeal but by the way they illustrated

239 Perugino,
Birth of the Virgin

1st Lord Cawdor; Colonel Matthew Smith; William Roscoe; now Walker Art Gallery, Liverpool

was attracted to Catholic art, Roscoe helped to popularise the Italian Renaissance through his writings, without (like Winckelmann and Greece) ever setting foot in the country he wrote about so eloquently.

Roscoe was the self-educated son of a Liverpool innkeeper. He rose through the law and started collecting books and prints. In 1773 he and a group of friends founded the Society of Encouragement of the Arts, Painting and Design, which mounted the first exhibition of paintings ever held in a provincial city. It may have been his friendship with the artist Henry Fuseli, who had spent eight years in Rome, that stimulated Roscoe's growing passion for Italian history. In 1796 he published his hugely successful *Life of Lorenzo de Medici* and began to measure himself and Liverpool against Lorenzo and Florence. This was followed by the

history, particularly that of the great Italian merchant republics which he so admired. Roscoe acquired such masterpieces as Ercole de' Roberti's *Pietà* and *The Entombment* by the Master of the Virgo Inter Virgines.

Disaster struck in 1816 when, as a partner of a collapsed bank, Roscoe was forced to sell his house, Allerton Hall (where his father had once been butler), and its art collection, which he endured with stoic resignation. Roscoe forlornly hoped that the city would buy the entire collection, but a group of local merchants did at least purchase 35 paintings in the Liverpool auction which they presented to the Liverpool Royal Institution, and they remain in the Walker Art Gallery. Of the 43 paintings in the sale painted before 1500, 24 are still in Liverpool. Lord Leicester (the first Earl of the second creation), a major buyer in the sale,

acquired the *Virgin and Child*, then attributed to Ghirlandaio but actually by Amico Aspertini (now in Cardiff), and Leonardo's *Head of Christ*, as well as the pick of the books. Roscoe lavished care on the sale catalogue and as John Hale pointed out 'from Cimabue and Giotto onwards, scarcely an important name was missing from Angelico to Zuccarelli'.[4] Art collecting meant more to Roscoe than an absorbing recreation. It went hand in hand with his historical studies and his vision of Liverpool as a worthy successor to Florence.

Two of the most popular Italian paintings in the National Gallery, Botticelli's *Mystic Nativity* (fig. 240) and Raphael's *Vision of a Knight* or *Dream of Scipio*, came from the collection of William Young Ottley (1771–1836). The son of a captain in the Coldstream Guards, at different times he was a writer on art, collector and *marchand amateur*, and finally became Keeper of Prints and Drawings at the British Museum. Gustav Waagen, who visited Ottley in 1835, wrote that 'it would now be difficult, nay impossible to form in Italy a collection of this quality'. Ottley, whose fluctuating fortune came from land in St Vincent, was in Italy between 1791 and 1798 and most crucially during the French invasion of 1796, which displaced so much art. He was a systematic collector and an outstanding connoisseur who foraged for engravings and drawings as much as paintings and acted as a dealer to fund his growing collection. Ottley took every opportunity to buy pictures by or attributed to Raphael, the Carracci, Claude and Poussin, from the Colonna, Borghese and Corsini collections. These pictures appealed to an older taste but his greatest *coup* was to buy a group of Michelangelo and Raphael drawings.

240 Sandro Botticelli, *Mystic Nativity*
William Young Ottley; now National Gallery, London

241 Francesco Pesellino and Fra Filippo Lippi and workshop, *The Trinity*
William Young Ottley; Rev. Walter Davenport-Bromley; now National Gallery, London

242 Fra Filippo Lippi,
Adoration of the Christ Child
Edward Solly; now Gemäldegalerie,
Berlin

These came from the Florentine painter Antonio
Fedi, who had acquired them from the thieves who
had stolen them from the French superintendent
of depredations, Jean-Baptiste Wicar – a case of
looting the looters.

Most of Ottley's drawings were bought
by Sir Thomas Lawrence in 1823 for £8,000.
Like Lawrence and Mariette, Ottley adopted a
particular style of mount for his drawings, although
as a part-time dealer he seldom used his collector's
mark. His main publications included a *Descriptive
Catalogue of the Pictures in the National Gallery*
(1826), the earliest catalogue of that collection,
and a book of engravings of Florentine art from
the 15th to 17th centuries. His collection, like
Roscoe's, was scholarly and formed with aesthetic
and historical considerations equally in mind. But
it was gradually sold off after his death. His Gentile
da Fabriano, the *Quaratesi Madonna* of 1425, was
sold privately to the Royal Collection, and his
collections were auctioned in 1837, 1847 and 1850,
providing a major source for the next generation
of collectors of early Italian art. A 'Giotto' and the

Pesellino *Trinity* (now in the NG London; fig. 241)
went to Davenport-Bromley (see below), a Taddeo
Gaddi to Eastlake (see chapter 19) and an Agnolo
Gaddi later to Sir Francis Cook (see chapter 20).

If Cardinal Fesch had an English equivalent
it was Edward Solly (1776–1844), a rich timber
merchant who lived in Berlin and bought paintings
on an enormous scale. Solly started in around
1810 and within a decade owned 3,000 paintings,
many of which had been vetted by two commit-
tees of taste, one each in Venice and Milan. His
collection, which had benefited to an enormous
degree from the closure of religious institutions,
was dominated by the early Italians, with works by
Giotto, Daddi, Botticelli, Fra Filippo, Pollaiuolo,
Piero di Cosimo, Verrocchio, Mantegna, Raphael
and Titian, but it also included early German and
Flemish masters. It was Solly's friend, the architect
Karl Friedrich Schinkel, who first alerted him
to the availability of Holbein's *Portrait of Georg
Gisze*. The other masterpieces included part of
van Eyck's Ghent altarpiece, *The Adoration of
the Lamb*, Fra Filippo Lippi's *Adoration of the
Christ Child* (fig. 242) and Titian's *Self Portrait*
of *c*.1550. Solly collected in isolation from his
English peers and his activities reveal how much
dislocated art from Italian religious houses was to
reach Berlin as well as London. 'Who was Solly?'
The Times asked in a leading article in 1905, and
until recently he remained shadowy.[5] While the
Napoleonic Wars provided him with opportunities
to buy art, they also caused the downturn of his
timber business. When he was forced to sell, the
Prussian state stepped in and acquired much of
the collection, which became the solid basis of the
Berlin Gemäldegalerie and many other German
museums. Solly retired to London where he
formed a second collection and started to deal in
paintings. Christie's held several Solly sales after
his death in 1847.

If Roscoe and Ottley followed a didactic sense
of history, the Hon. William Fox-Strangways
(1795–1865), an aristocratic amateur, followed
his nose. Although he believed Raphael's *Sistine
Madonna* 'the finest picture I ever saw', his taste
was for Tuscan primitives and he donated impor-
tant groups to his old college, Christ Church,
Oxford, in 1834, and to the Ashmolean Museum
in 1850. He was a younger son who pursued a
diplomatic career to escape one in politics, but

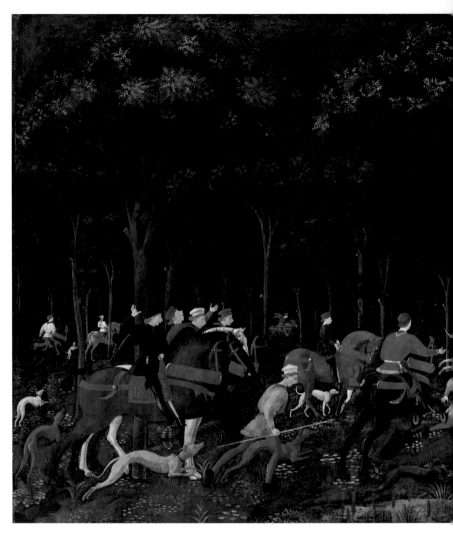

his main interest was horticulture. Posted to Italy, he discovered the Uffizi in 1825, enjoying 'the simplicity and severity of the Florentines.'[6] His correspondence reveals an approach that was much in the air in the 1820s, buying paintings with the creation of a gallery in mind. Perhaps it was the example of General Guise that led him to Christ Church with his first collection, which included paintings from the workshops of Duccio, Botticelli and a then rediscovered name, Piero della Francesca. By 1850 when he gave his second collection to the newly re-formed Ashmolean Museum he could provide, among other works, Bicci di Lorenzo's *St Nicholas of Bari Rebuking the Storm* and Barna da Siena's *Crucifixion* and most notably, Paolo Uccello's *The Hunt in the Forest* (fig. 244). In 1858 he succeeded his half-brother and became the 4th Earl of Ilchester.

Rather surprisingly, there was no compulsory connection between the Roman Catholic Revival and an admiration for early Italian painting. However, if English Papists revealed no

exceptional interest, a number of wealthy Anglican clergymen formed fine collections. The Rev. John Fuller Russell owned so many Sienese paintings that the German art historian Dr Gustav Waagen felt 'transported into a chapel in Siena or Florence'. The great *Virgin and Child* by Masaccio (now in the NG London; fig. 243), recorded by Vasari in the church of the Carmine in Pisa, was owned by the Rev. Frederick Heathcote Sutton, while the Rev. John Sanford, who lived in Florence in the early 1830s, acquired among many pictures Fra Filippo Lippi's *Annunciation*, which survives with much of his collection at Corsham Court, Wiltshire. The giant among the clerical collectors was the Rev. Walter Davenport-Bromley (1787–1862), a younger son, whose pictures eventually went to Capesthorne Hall in Cheshire (fig. 245). He bought a number of paintings at the Fesch Sale in Rome in 1845, including Giotto's *Death of the Virgin* (now in Berlin) and Foppa's *Adoration of the Kings* (NG London). When he died, Christie's held a 174-lot sale of his early Italian paintings.

243 Masaccio,
The Virgin and Child
Rev. Frederick Heathcote Sutton; now National Gallery, London

244 Paolo Uccello,
The Hunt in the Forest
William Fox-Strangways; now Ashmolean Museum, Oxford

245 Anonymous watercolour of *The Library at Wootton Hall, Staffordshire*, depicting Rev. Walter Davenport-Bromley, his wife and son
Capesthorne Hall, Cheshire

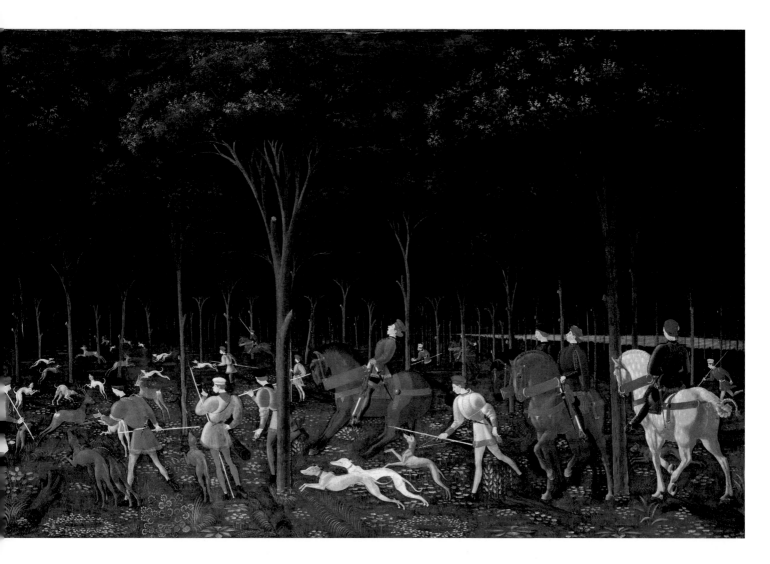

Eastlake acquired four for the National Gallery, including Bellini's *Agony in the Garden*. Waagen rated his paintings in this area as the best in England and recognised him as an 'ardent admirer of all such pictures... in which an unaffected and genuine feeling is expressed'.[7]

John Ruskin, the great art critic and social prophet, shared Waagen's sentiment, since he too sought spiritual understanding through art. He became interested in early Italian art during a trip to Italy in 1845 and had a revelation in front of Jacopo della Quercia's tomb of Ilaria del Carretto in Lucca. He acquired the Verrocchio workshop *Madonna and Child* (NG Edinburgh) and influenced many collectors, albeit most famously through his championing of Turner. In 1848 a group of collectors that included Ruskin, Lindsay, Layard and the ageing Samuel Rogers founded the influential Arundel Society, which published chromolithographs of early Italian art, notably by Fra Angelico, Giotto and Perugino, with a few of the descriptions supplied by Ruskin. They provided what Rossetti, writing to Layard, described as 'one's first real chance of forming a congruous idea of early art'. Ruskin's *Mornings in Florence* (1875–77), an idiosyncratic guide to the city and its art, sealed his association with the place.

A gentleman collector from Locko Park in Derbyshire, William Drury-Lowe (1802–1877), forms an early example of the inheritor of a country house buying 'primitives', in his case with an unusual emphasis on Sienese paintings. He travelled to Italy frequently between 1839 and 1864, buying pictures in Florence, Pisa and Rome. He owned Castagno's *David with a Sling* (NG Washington), Lorenzo Monaco's *Madonna and Child* (NG Edinburgh), Bernardo Daddi's *St Catherine of Alexandria*, Cosmo Tura's *Portrait of Duke Ercole of Ferrara* (Metropolitan) and two portraits by Domenico Ghirlandaio (Huntington). Having completed his collection, Drury-Lowe spent the last decade of his life altering Locko Park in an Italianate manner, adding a campanile and a picture gallery. The collection remained there intact until the early 20th century, when the most prized pictures were surreptitiously copied and sold without the knowledge of the Locko Park Trustees and went to America.

Thomas Gambier-Parry of Highnam Court (1816–1888) was a gentleman artist who contributed to the fresco revival in England by painting frescoes at Highnam Church. He was deeply interested in artistic techniques. He bought the Daddi *Crucifixion* and Lorenzo Monaco *Coronation of the Virgin* from the Davenport-Bromley sale and formed a desirable collection of paintings, including Pesellino's *Annunciation*, as well as ivories, glass, enamels, maiolica and Islamic

246 Interior of Highnam Court, Gloucestershire, with works from Thomas Gambier-Parry's collection including (centre) Lorenzo Monaco, *Coronation of the Virgin* Courtauld Gallery, London

247 Lorenzo Monaco, *Coronation of the Virgin* Thomas Gambier-Parry; now Courtauld Gallery, London

248 Sandro Botticelli,
Venus and Mars
Alexander Barker; now National
Gallery, London

metalwork (figs 246–247). He was more fortunate than Drury-Lowe because his collection has survived largely intact at the Courtauld Institute, thanks to the generosity of his grandson Mark Gambier-Parry.

The rediscovery of Botticelli forms a leitmotif of British 19th-century collecting of Italian art. Although the artist featured in Vasari's *Lives* and sporadic references to him appeared in Britain in the 18th century, British collectors initially failed to notice him. By 1858 a Botticelli revival was in full swing and Lady Eastlake wrote of 'Quattrocentro Florentine figures of whom Botticelli is first'.[8] Cardinal Fesch in Rome had owned some genuine Botticellis, Fox-Strangways owned others in the artist's style, but the first incontrovertibly genuine work to arrive in England was the artist's only signed work, *The Mystic Nativity*. This came from the Aldobrandini Collection and was bought by Ottley around 1799. Twelve years later he tried to sell it but failed to find a buyer until Fuller Maitland purchased it in 1828. Another early arrival was Botticelli's *Portrait of a Youth* (NG London) sold to Lord Northwick by that military collector, Colonel Matthew Smith, as a Masaccio.

Eastlake acquired the first Botticelli for the National Gallery in 1855, the studio *Virgin and Child* tondo, but it was bought as a Ghirlandaio. The great *Venus and Mars* (NG London; fig. 248) was purchased in Florence in the 1860s by Alexander Barker. By then the momentum of the

enthusiasm for Botticelli was gaining ground and in 1868 Swinburne published a fulsome appreciation of the artist's merits, which was followed by the poetic contributions of Pater and Ruskin. By the time the Aesthetic Movement was established, from the 1880s onwards, the artist had become a cult figure and a touchstone of taste, where the Pagan and Christian could co-exist with what John Addington Symonds called 'the echo of a beautiful lapsed mythology'. Between 1900 and 1920 more books were published on Botticelli than any other great painter.[9] At the centre of this cult stood the strange figure of Herbert Horne, who published his classic book on the artist in 1908.

Alexander Barker (*c*.1797–1873), an army contractor who owned Botticelli's *Mars and Venus*, possessed one of the most interesting and, today, least known collections in London. The son of a self-made boot-maker, he covered his house with rose bushes through which could be seen banks of maiolica, rich French furniture and the pick of early Italian paintings in London. Apart from the Botticelli he owned masterpieces such as Piero della Francesca's *Nativity* (fig. 249) and Filippo Lippi's *Adoration of the Magi* (NG Washington) and works by Fra Angelico, Bellini, Credi and Crivelli. Barker did not only collect Italian art: he had a strong taste for French 18th-century art and owned the eight canvases by Boucher depicting *The Arts and Sciences* (Frick) and much Sèvres. Barker was a member of the Burlington Fine Arts Club, established in 1856 as a club where collectors,

scholars and curators could meet, and from 1867 it
mounted a series of exhibitions using loans from
its members.

Victorian collectors also prized the work of Fra
Angelico, whose bright colours were to be echoed
in the paintings by Dante Gabriel Rossetti. At
the Fesch sale in 1846, Lord Dudley paid the vast
sum of £1,500 to buy the artist's *Last Judgement*,
a triptych depicting Paradise and hell on its outer
wings. In 1885, the triptych was bought by the
Berlin Museum for no less than £10,000. In 1883,
the National Gallery, London had paid £178 for
two panels by Duccio from the Maestà.

One of the most singular British 19th-century
collectors of early Italian art was Lord Lindsay
(1812–1880). The greatest book collector of the
age, he built Dunecht in Aberdeenshire to house

his vast library, which also required Balcarres
and Haigh Hall to contain it. He approached art
with a metaphysical mixture of scholarship and
emotion, exemplified by his *Sketches of the History
of Christian Art* (1847), which had a profound
influence on John Ruskin. Although systematic in
his approach, he sought in art 'a holy purity'. His
instincts as a collector reflected this: he wanted a
private museum that would 'assemble together the
wisest and most graceful thinkers of all countries,
ages and pursuits'. Lindsay therefore bought Guido
Reni and Annibale Carracci alongside Duccio and
Ghirlandaio, and he had a penchant for copies.
Better a good copy of an elevated original than a
work by a second-rate master, particularly when
the greatest art was in fresco. Perhaps as a result,
Lindsay missed many opportunities until the

dealer William Spence took him in hand. William Blundell Spence (1814–1860) became the main dealer in early Italian art. An artist by training, his clients included not only Lord Lindsay but also Alexander Barker, Lord Northesk and C.D.E. Fortnum. Lord Lindsay bought the Duccio *Crucifixion* (Manchester; fig. 238) in the Davenport-Bromley sale and many works from the Lombardi-Baldi collection in Florence, including Della Robbia sculpture. He collected art in the same spirit as books, seeking one of everything to illustrate progress and ethical ideas. The result included an important group of 14th- and 15th-century paintings with a wide range of Christian subject matter.

The collectors of early Italian art – with the possible exception of William Roscoe – were not public figures (nor for the most part especially rich), which makes the appearance of Prince Albert (1819–1861) all the more interesting. His approach to

art was primarily intellectual and art historical; Raphael was his God, but beyond his budget. After his marriage in 1840, Queen Victoria set aside the modest sum of £2,000 a year to be spent on works of art. If their contemporary patronage tended towards the high finish of Winterhalter and Landseer, they also collected some fine early Flemish, German and Italian paintings during the following decade. Schooled in the Nazarenes, Prince Albert admired Cranach, buying the artist's *Apollo and Diana.* Ludwig Gruner, his main adviser, bought him 27 early Italian works including part of Pesellino's *Pistoia Altarpiece* and a triptych by Duccio. Seven came from Ottley's collection, including Gozzoli's *Death of Simon Magus* and Gentile da Fabriano's *Quaratesi Madonna* (fig. 250).

The Prince's largest purchase came by accident in 1851. As collateral for a loan he accepted the collection of German, Flemish and Italian paintings belonging to Prince Louis of Öttingen Wallerstein. The security had to be called in,

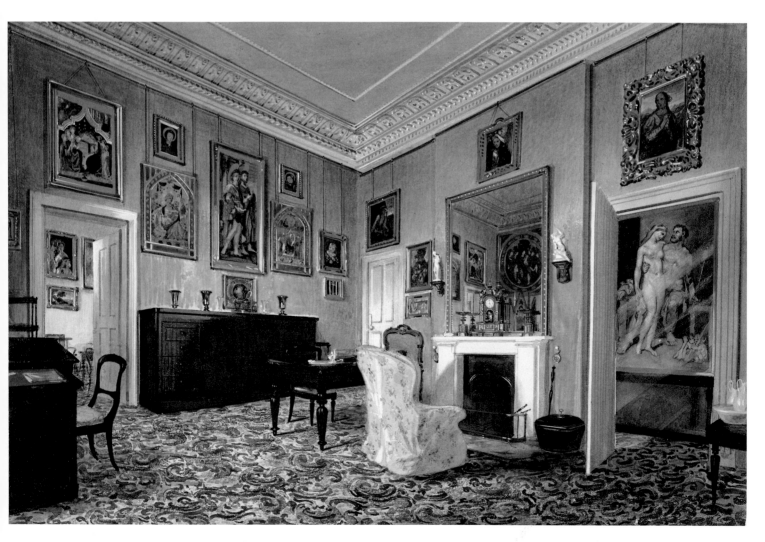

bringing Prince Albert a mixed bag of paintings that included Memling's *Virgin and Child*. Queen Victoria later presented 22 of them to the National Gallery. The Queen and her consort hung their early pictures mostly at Osborne House in the Isle of Wight (fig. 251), and after her death they were moved to the private apartments of Buckingham Palace. Perhaps Prince Albert's greatest role was not as a collector but as the re-organiser of the Royal Collection and catalyst for other initiatives. Apart from the Great Exhibition of 1851, the Prince helped bring to fruition the great exhibition *Art Treasures of the United Kingdom* held at Manchester in 1857, which gave an equal emphasis to early Italian and Northern Schools, and to which he and the Queen lent 82 'Ancient Masters'. Royal approval no doubt influenced taste.

The past and present came together in the collection of William Graham (1817–1885), whose vast collection of over 700 pictures contained at least 200 modern paintings, mostly of the Pre-Raphaelite School. Graham, a Scottish port merchant, started collecting and patronising artists in his forties. He particularly favoured two painters: Burne-Jones, who encouraged Graham's enthusiasm for Mantegna, and Rossetti, whom Graham urged to emulate Botticelli. Like Ruskin, Graham preferred works of the second half of the 15th century, owning examples by Santacroce and Pesellino as well as by Titian, Luini and Ghirlandaio's *Portrait of Francesco Sassetti and his son Teodoro* (Metropolitan). It was an attractive collection rather than a great one, with serried ranks of workshop paintings. Graham's touchstones were emotional and sentimental, and he sought a certain purity in art. He once kissed a panel by Burne-Jones as if it were an icon.

While Graham would happily disburse £1,000 to Rossetti or Burne-Jones for a painting, he rarely paid more than £100 for an Old Master. He bought the latter mostly in Italy in the 1860s and 1870s, and, as his daughter Frances Horner ruefully recalled, 'a dealer has only to murmur to him "*Virgine – intatta – sulla tavola*" to lure him any distance'.[10] His patronage of Rossetti – although stormy – resulted in *Dante's Dream* (Liverpool) and *La Ghirlandata* (Guildhall), and that of Burne-Jones elicited such personal works as *The Orpheus Piano* for his daughter, Frances (fig. 252). Graham's chief rival for Pre-Raphaelites was the

252 Sir Edward Burne-Jones, *The Orpheus Piano*
William Graham; now Earl of Oxford

Liverpool shipping tycoon, F.R. Leyland, whose London house, for which Whistler painted the Peacock Room, was transformed by Norman Shaw. In addition to a clutch of the best works by Rossetti and Burne-Jones, Leyland owned six Botticellis.

Sculpture is the missing element from this chapter and its hero, Sir John Charles Robinson, collected Old Master drawings in his private life. But he displayed something close to genius in assembling Italian Renaissance sculpture for the Museum of Ornamental Art at Marlborough House, the forerunner to the V&A. His efforts created the finest collection in the world outside Italy, with excellent examples by Donatello, Rossellino and Andrea della Robbia. The story forms a striking and early example of the State providing for a deficiency in private collecting.

The taste for the Italian Baroque and schools of painting other than the Florentine was sustained in the 19th century by aristocrats such as the 4th Duke of Northumberland. He admired the Venetian Renaissance and remodelled Alnwick Castle from 1854 onwards using Italian decorators. His acquisition in 1856 of the collection of Vincenzo Camuccini and his brother Pietro was the last major purchase of a group of Italian Baroque paintings in Britain until Sir Denis Mahon revived the taste some 80 years later. The Camuccini pictures contained Guido Reni's *Crucifixion*, but

the most important painting chimed with the Duke's Venetian tastes, Bellini's *Feast of the Gods* (NG Washington). The Italianate rooms at Alnwick were matched by those created for the Marquess of Bath at Longleat, who called in J.D. Crace to create rich Venetian interiors. For the Drawing Room (fig. 253), which is still remarkably intact, he bought Titian's *Rest on the Flight into Egypt* (which had formerly belonged to Munro of Novar, described in chapter 14) along with a group of early Italian paintings.

Nowhere can we understand the progress of this new aesthetic more clearly than at the National Gallery. When the Gallery bought Reni's *Susannah and the Elders* at auction in 1844 for £2,000, John Ruskin led an outcry. As early as 1844, the dealer Samuel Woodburn had offered his services to the Gallery as a travelling agent in Italy for paintings, but it was not until the appointment of Sir Charles Eastlake as director in 1855 that works of the early Italian school were acquired in depth. Even Eastlake was cautious about the 'rage for very early works of art', a fashion he thought would pass, but nevertheless he believed that acquisitions 'should be undertaken with discretion and discrimination'. He appointed Otto Mündler as his agent in Italy and took advice from two brilliant art historians, Giovanni Morelli, the pioneer of scientific connoisseurship, and Giovanni Battista Cavalcaselle, author – with Crowe – of the very influential history of early Italian art. Thus the National Gallery gradually built up one of the finest collections of primitives in the world, a process continued by Eastlake's later successor, Sir Frederick Burton. Eastlake made frequent visits to Italy with his clever wife, who became a partner in his activities, and they themselves owned Piero della Francesca's *St Michael*, which passed to the National Gallery in 1867. By the time Wilhelm von Bode, later to be appointed director of the Berlin Museum, arrived in Italy in 1872, he recognised that London had secured many of the best prizes. Five years later Bode visited England, finding it much easier to acquire great treasures from British private collections, thereby starting the reversal of 200 years of British art importing.

253 The Drawing Room at Longleat, Wiltshire, showing the Italianate style chosen by the 4th Marquess of Bath

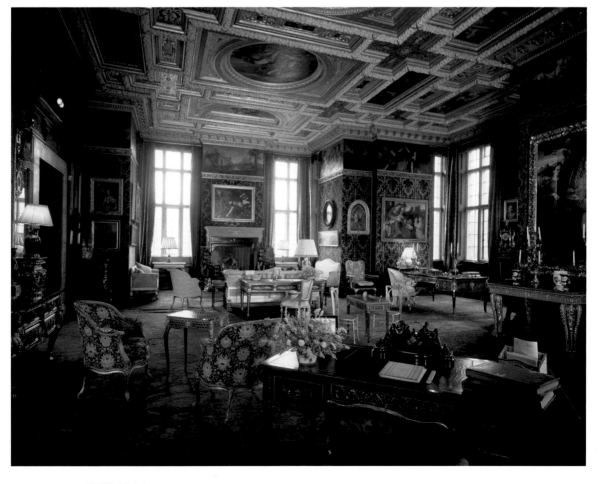

Part Four

DEMOC

Collecting
Museum A

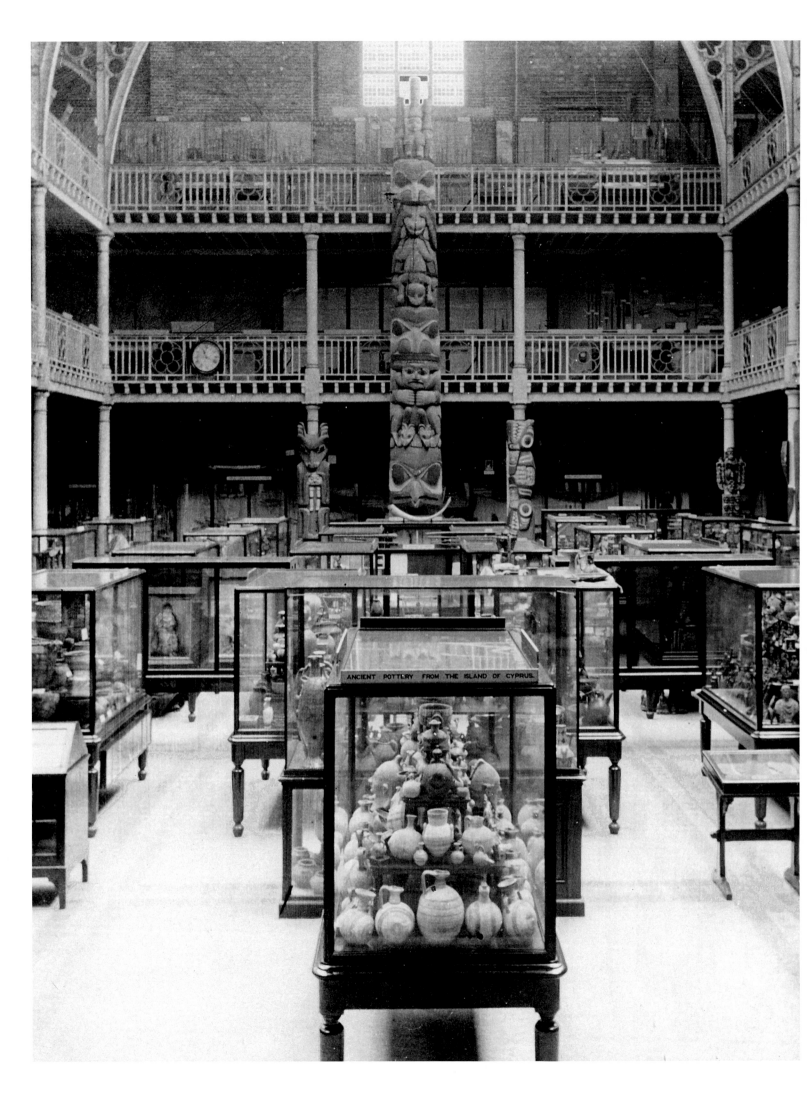

ANCIENT POTTERY FROM THE ISLAND OF CYPRUS.

Chapter 18

A WORLD BEYOND EUROPE

Soldiers, merchants, explorers and above all plant collectors are the heroes of this chapter. John Tradescant's museum, described in chapter 2, set the tone with its curiosities and exotica from the world beyond the shores of the Mediterranean. But as Jacobean antiquarians gave way to Restoration merchants the scene changed. Artefacts poured into Britain from far away places throughout the late 17th and the 18th centuries and the English began to seek novelties from beyond Europe. From China and Japan they were entranced by luxury goods, particularly as receptacles for the newly fashionable beverages of tea and coffee. Egypt appealed to scholars, as did India, which also produced exquisite jewelled arms and miniatures. The tribal artefacts of North America and later Polynesia captivated the imagination and demonstrate changing attitudes to so-called primitive societies: what had previously been explorers' curiosities became Enlightenment utopia. More than anything else, this chapter reveals an advance in attitudes to what would now be characterised as ethnographical material.

In the background of all this activity was the British Museum (fig. 255). This was initially a sometimes reluctant repository and later became the driving force. Brought into being in 1753 against the Prime Minister's advice, the motivation of the museum was part patriotic, part educative and part Enlightenment. Although the original focus was the natural world, later augmented by antiquities from Greece and Rome, it was from the outset a world museum or what Joseph Addison called 'an emporium for the whole earth'. The statutes of 1753 declare that its contents were held in trust for all men, native and foreign. The

China and Japan

India

The Pacific

Cook's Voyages

Egypt

Africa

General Pitt-Rivers

254 The interior of Pitt Rivers Museum, Oxford, 1901

founding and development of the museum runs as a leitmotif through the story and the two key figures in its early history, Sir Hans Sloane and Sir Joseph Banks, are also the two central figures of Britain's first attempts to understand art beyond Europe before the overflow of imports in the imperial 19th century.

The importance of the small nucleus of ethnographical material owned by Sloane is that it created an alternative foundation to natural history and antiquities on which to build the British Museum. Without this, items such as those brought back by Captain Cook might never have come. Sloane owned as many as a thousand items, mostly weapons, clothing, baskets and utensils. The largest group were 'made by the Indian Esquemos in Hudsons Steights' but the range included India, Persia, China, Japan, Turkey and Russia. By 1753 his inventory contained 351 items, most of which are unidentifiable, that were probably lost or perished in the early days of the museum.

CHINA AND JAPAN

Knowledge of Japanese and Chinese porcelain came to England from the Spanish, Portuguese and Dutch merchants and it was often referred to as 'Indian'. In the 16th century items were so rare that we find them mentioned in wills and mounted in precious metals. Elizabeth I owned several examples of blue and white porcelain mounted in silver (fig. 256). Drake captured Spanish ships with cargoes of porcelain and it slowly entered grand English households as a luxury for display rather than use. The English initially believed that all porcelain came from China and all lacquer from Japan until they were able to distinguish between Chinese porcelain as blue and white and Japanese from the Arita kilns (called Imari after the port it was shipped from) as brilliantly enamelled. We know of shops in London – the China Shop in Leadenhall Street and the Golden Anchor in Bedford Street – that supplied porcelain; the presence of similar items at Burghley, Welbeck and Drayton has even led to speculation of an itinerant dealer operating up and down the Great North Road. English collectors at once recognised its luminous beauty and vast technical superiority over European ceramics.

The Portuguese supplied the first cargoes of porcelain until they were surpassed in Eastern

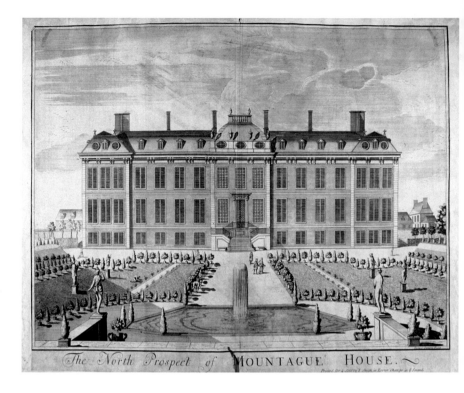

trading by the Dutch who were much more systematic in their freight westwards. By the 1670s the fashion for coffee, tea, cocoa and porcelain went hand in hand. 'For we women of quality never think we have china enough,' exclaims Wycherley's Lady Fidget in 1675. This china mania started in Europe in the 1640s and records show the first ship loads arriving from Japan in the 1650s and reaching a peak in the 1680s. The Countess of Arundel was a pioneer in the use of porcelain to cover walls for decorative effect at Tart Hall, an idea she picked up on her travels in the Netherlands.[1] Queen Mary,

255 Montagu House, London, first home of the British Museum

256 *The Walsingham bowl*: Chinese blue and white bowl, *c*.1580–1600, on European silver-gilt mounts, probably late 16th century.
Elizabeth I; now Burghley House, Lincolnshire

married to a Dutchman, was a voracious collector and 780 pieces were listed at Kensington Palace. By the end of the 17th century we have two important inventories, that of Burghley of 1688 and the Devonshire schedule of 1690. The Burghley inventory records 'China over ye chimney', and we can see from Marot engravings how porcelain was used decoratively in the home, usually a stepped effect of piled-up vases and plates, much as silver would be used on a sideboard for lavish display. And yet from the extraordinary collection that remains at Burghley, formed by John Cecil, 5th Earl of Exeter, the pieces have enough individuality to suggest that it was also put in display cabinets: wrestling figures of the Japanese Edo period and irregularly formed Arita ware dishes (fig. 257).

The fashion for buying ornamental pieces for display continued through the 18th century.

Sloane collected Chinese *famille verte* figures and he acquired Engelbert Kaempfer's pioneering collection of orientalia including Japanese and Chinese prints, paintings and lacquer. Horace Walpole at Strawberry Hill had a 'China Room' filled with what he called 'Japan China' and 'Saxon China'. The usual focus was tableware in blue and white. Richer households commissioned armorial services made entirely to Western taste, which were enormously popular in the 18th century. A few collectors emerge, notably Margaret, 2nd Duchess of Portland and William Beckford, who shared a passion for fine Japanese lacquer. Given the erratic availability of anything other than exportware and the lack of historical terms of reference, it is perhaps not surprising that serious collecting in this field in England did not develop until the end of the 19th century.

INDIA

India was another matter. Indian objects arrived in England in the 17th century as curiosities. Sir Thomas Roe made an embassy to the Mughal Court in 1615–18 and returned bearing gifts. An Indian bronze is listed in the 1638 catalogue of the Royal Collection, which may have come from the 'Indian chamber' at St James's Palace in Charles I's time, of which very little is known. India could mean anything from the Far East to the Americas, and it may not have held any actual Indian works of art. Arms, medals, manuscripts and miniatures began to trickle home but by the mid-18th century British power in India allowed for more settled appreciation of the country's language and art. Richard Johnson (1753–1807) was a British East India Company servant who arrived in Calcutta in 1770 and immersed himself in Sanskrit and Persian literature. A decade later, he was posted to Lucknow where he befriended the French collectors Claude Martin and Antoine Polier (whose manuscript collection was later bought by William Beckford). Johnson's final posting in 1784 was as Resident at Hyderabad where he completed his scholarly collection 'contributing to the clearer understanding of the history and religion of that important country.'[2] His 714 manuscripts and 64 paintings form the backbone of the India Office Library collection. One or two similar collections formed with scholarly intent have survived: Thomas Alexander Cobbe's from Newbridge, and John Baillie's now in Edinburgh University Library. The most celebrated Indian collections were those of the nabobs, Warren Hastings and Clive of India. Hastings commissioned S.P. Cockerell in 1788 to build Daylesford House in Gloucestershire with Indian motifs to house his collection of ivory furniture, arms, armour and miniatures, which was crowned with a group of Indian views by Hodges and the Daniells. If Hastings only dabbled with the Indian styles, the same architect was to go even further by building Sezincote in the Indian style: it represents a high point of English Indophilia.

By far the best known of the nabobs was Clive

of India, Robert 1st Lord Clive, the victor of Plassey, whose accumulations of Indian objects formed part of a broad collection of art which contained paintings by Claude, Poussin and Veronese held in his many homes, which included Claremont in Surrey, Oakly Park in Shropshire and 45 Berkeley Square. The Indian elements consisted of a collection of Mughal decorative arts, textiles and miniature paintings, some of which survive at Powis Castle, including jewelled daggers (fig. 258), armour and even some sculpture. The last probably came from the 2nd Lord Clive and one of the fascinating questions is why it took so long for collectors to understand this area. As late as 1836 Major Rhode Hawkins was able to complain of the lack of Indian art and in particular sculpture in Britain. It was heavy and awkward to remove, was often still in religious use, and its sexual imagery may have been disconcerting. Charles Townley owned a few pieces but the principal sculpture collection was formed by Colonel 'Hindoo' Stuart who served in India between 1777 and 1828. His heirs shipped the collection to England for sale at Christie's in 1830 where it was mostly acquired by John Bridge, whose heirs in turn gave it to the British Museum in 1872. By that stage the museum had a figure of international stature who made the museum a pioneering force in international collecting. Sir Augustus Wollaston Franks was probably the most persuasive and influential of all its keepers.

THE PACIFIC

If Hans Sloane acquired his American or Indian items as an afterthought, matters had not much improved by the end of the 18th century. Sir Joseph Banks (fig. 259) may be the most important figure in the history of plant collecting, but his role as a collector of art is more ambivalent, especially given the opportunities he had and the power he wielded. Banks was a fixer, entrepreneur, catalyst and arbiter. Britain was greatly enriched by the arrival of artefacts from North America and the South Seas through his patronage, but these always took second place to his plants. In 1776 he sailed to Newfoundland and Labrador but he is best known for his passage on Captain Cook's first voyage through the South Seas in 1768–71 to New Zealand and Australia. This voyage had an enormous impact on the European imagination.

If collecting of works from Egypt, China and Japan was at a remove from their creators, in Africa and Polynesia experience of art was sharpened by direct encounters with the society and individuals

258 Mughal Indian dagger with goats-head pommel of white nephrite jade and jewelled handle
Clive Museum, Powis Castle, Wales (National Trust)

259 Benjamin West, *Sir Joseph Banks*
Usher Gallery, Lincoln

260 Male figure carved from hard wood, collected on James Cook's third expedition
James Cook; Sir Ashton Lever; Harry Beasley; now National Museum of Scotland

261 Late 18th century headrest, Tonga, from Cook's third expedition
Probably James Cook; now The Hunterian, University of Glasgow

262 William Hodges, *Tahiti Revisited* (based on Captain Cook's second voyage to the Pacific 1772–75)
National Maritime Museum, Greenwich

who made the objects. Revelations about the way of life of the South Sea Islanders fuelled the fashionable notion propagated by Rousseau of the 'noble savage'; whose idyllic existence apparently lacked any social rules or law and whose sexual licence conflicted with Christian notions of good and evil. These notions didn't cut much ice with Captain Cook. However something of this paradise was captured in the Tahiti paintings of William Hodges, who accompanied Cook on his second expedition of 1772–75 on HMS Resolution (fig. 262). They lent a keen interest to the artefacts brought home, and fostered a liberal attitude towards the societies and their beliefs that contrasts with that of the 19th century.

Cook's first voyages had a dual purpose, astronomical and exploratory: to observe the transit of Venus and to locate the much postulated great southern continent. The acquisitions Banks brought home were not catalogued. They were distributed to friends and institutions including a group to Christ Church, Oxford – today at the Pitt Rivers Museum. Banks's attitude to the eventual home of the material was never consistent, unlike George III who gave a fine group to the University of Göttingen 'where the most coherent ethnographical collection from Cook's voyages survives'.[3] The main artistic legacy of Banks from the first Cook voyage were the watercolour painters he took with him and the high standard of scientific accuracy he demanded in botanical and zoological depictions.

It was Cook's second voyage of 1772–75 that provided much of the Göttingen group, and it was on the third voyage in 1776–80 that Cook lost his life under enigmatic circumstances on a beach in the Hawaiian Islands. Cook described the people he encountered in a detached and scientific manner, but the material he and Banks brought home was never properly recorded or classified. Cook distributed the items from his first voyage to his patron Lord Sandwich, George III, and the British Museum. These included fishing equipment, wooden bowls, fly whisks, and neck-rests of classical beauty which have tended to condition the view among later collectors that anything classically pure must have a Cook provenance (fig. 261).

Although much of the Cook material survives, it often cannot be identified. One of Joseph Banks's assistants, Johann Fabricius, noted, 'A case in point are the objects which Banks had acquired from Cook's last voyage, dresses, weapons, instruments and which, according to his noble thinking, he had sent to the Museum in order that the museum could choose from them what they thought best. There they remained for about two years, without anybody taking any notice about them, until finally

Sir Joseph – not uninfluenced by our arguments – gave permission for me and two other friends to bring everything back from the Museum to his house and divide it amongst ourselves.'⁴ Much of Cook's personal collection went to the Leverian Museum (fig. 260) where better care was taken of it than in the British Museum.

There was a touch of the circus about Sir Ashton Lever (1729–1788) who first opened a museum in 1771 at his country seat at Alkrington Hall, Lancashire. He moved it in 1775 to Leicester House in London (fig. 264) where it achieved a success with the public never achieved by Sloane, whose collection remained largely locked up. It constituted antiquities, natural history (the largest component) and ethnographical material from Captain Cook's second and third voyages, which proved a great draw. Lever also possessed Indian bronzes and stone sculpture, North American material, unidentifiable Asian artefacts and even African items. The museum was a hit with the public before the collections in the British

Museum were fully accessible. The documentation of the Leverian by drawings and catalogues give the museum permanent historical importance. The relationship of the Lever Collection to the British Museum has echoes in the 1980s of the Saatchi collection vis-à-vis the Tate Gallery. When Lever ran out of money he offered the collection to the British Museum for £20,000 but the offer was refused on the advice of Joseph Banks. The Empress of Russia also declined to buy it. The collection was put up for auction in 1806, and most of the collection was bought up by the Imperial Museum of Vienna. Other major purchasers included the Earl of Derby and William Bullock, who had his own large private collection.

Commercially run private museums in the tradition of Tradescant abounded in 18th-century London. Apart from Lever, there was the Donovani Museum and Institute of Natural History, and – commercially the most successful of all – Bullock's Museum at the Egyptian House, Piccadilly. Richard Greene, a surgeon and apothecary in Lichfield, created a museum of curiosities, his Lichfield Museum, the 1786 catalogue of which extended to 84 pages. Likewise in Yarmouth, Daniel Boulter set up the *Museum Boulterianum* consisting of a 'curious and valuable collection of Natural and Artificial Curiosities': his catalogue (undated but from the mid-1790s) included prints and Boulter's library, but required 165 pages to list the entire collection.

One of the few survivors and among the most interesting of these museums was that of the Scottish society physician William Hunter (1718–1783) in London's Great Windmill Street. It began as an anatomical museum but included his paintings collection. He bought from the sale of Richard Mead and was an early collector of Chardin. Hunter had a penchant for portraits of scientists that hung alongside his

collections of geology, anatomy, ethnography and zoology. Perhaps it was natural that he would commission Stubbs to paint exotic animals. They, along with the rest of the collection, were bequeathed to the University of Glasgow where it remains today.

By the 1820s we observe a new type of 'trophy' collection put together by Christian missionaries whose aim was, for the most part, to expose the idolatry of the items confiscated as evidence of evangelical success. Ironically, their self-righteous zeal, particularly that of the London Missionary Society, preserved a great many important pieces of Polynesian art. The Society's Museum was established in London (fig. 263) and a catalogue was produced in 1826. George Bennet made a world tour inspecting their Missions between 1821 and 1829 and became an assiduous collector. In 1816 the Tahitian chief Pomare gave a group of items to the Society along with a statement which may have been written for him: 'If you think proper, you may burn them all in the fire, or if you like, send them to your country, for the inspection of the people of Europe, that they may satisfy their curiosity, and know Tahiti's foolish gods!'[5]

Perhaps the most interesting missionary collector was the Reverend John Williams, author of *Missionary Enterprises* (1837). It was Williams who took possession of the extraordinary figure of A'a from the natives of Rurutu (fig. 265). From the hollow back of this idol he removed 24 smaller gods and displayed them before his Polynesian congregation at Ra'iatea. This and other idols were later sent to the Missionary Museum 'as trophies of the Redeemer's victories over superstition and idolatry and presage of that glorious time when the idols everywhere shall be utterly abolished!'[6] The A'a figure in particular caught the public imagination when it later passed to the British Museum. It was to inspire both Henry Moore and William Empson's poem *Homage to the British Museum* which begins:

There is a Supreme God in the ethnological section;
A hollow toad shape, faced
With a blank shield
He needs his belly to
Include the Pantheon...

EGYPT

Egypt, so close to Europe and yet historically so remote, land of the Old Testament, exercised

a strong appeal to early collectors of curiosities. The pyramids were the only survivors of the seven wonders of the world and the hieroglyphic script, although instantly recognisable, offered a tantalising puzzle, even if most visitors were unimpressed by the artistic skills of the Egyptians. The French dominated Egyptology throughout the 17th and 18th centuries but one of the earliest collectors, albeit on a very small scale, was George Sandys (1578–1644). He visited Egypt in 1611 and brought back several items which he gave to John Tradescant, who entered them in his catalogue as: 'The Idol *Osiris*, *Anubis*, the Sheep, the Beetle, the Dog which the Ægyptians worshipped'.[7] During the 18th century the more adventurous Grand Tourists reached Cairo and some like Edward Wortley Montagu organised excavations, the results of which formed a nucleus (along with a few Sloane pieces) of the British Museum's first Egyptian display.

One of the earliest books with plans and draw-ings about ancient Egyptian temples was published in London in 1743–45.[8] Despite this and other books, collectors were few. Sir Hans Sloane owned about 250 bronze and terracotta figures, ushabtis, scarabs and small pieces of sculpture. *Specimens of Antient Sculpture, Aegyptian, Etruscan, Greek and Roman* was published by the Society of Dilettanti in 1809, with a second volume in 1835. Volume 1 included a seated figure of *Ammon* and a standing figure of *Osiris* (both Payne Knight) and a head of *Osiris* in green basalt (Townley), but these pieces appear to have been seen more as curiosities than works of art: the basalt *Osiris* in particular suffering unjustly adverse criticism from the unequal comparison with the spectacular statue of *Laocoön and his Sons*, unearthed in 1506 in Rome near Nero's *Domus Aurea* (Vatican).

It was Napoleon's strategic interest in Egypt that was to make such an enormous difference to its archaeology and, by extension, collecting. The 175 savants he took with him between 1798 and 1801, explored and studied the Nile valley, making major discoveries, of which the most celebrated is the Rosetta Stone. The greatest achievement was Vivant Denon's *Voyage dans la basse et le haute Egypte* published in two volumes in 1802. It was the failure of Napoleon's military campaign that opened the way for collectors to mount ambitious expeditions for the removal of antiquities and the

266 *Fowling in the Marshes*:
fragment of wall painting
from the tomb of Nebamun in
Thebes, Egypt, around 1350BC
Henry Salt, with the help of
Giovanni Belzoni; now British
Museum, London

267 Egyptian *Stela of the
Scribe of the Army of the Lord
of the Two Lands Kenro*
Roger Pratt of Ryston Hall, Norfolk;
now British Museum, London

so-called 'War of the Consuls' as different national agents competed for objects. The protagonists were Bernardino Drovetti, the French consul-general, and his British counterpart, Henry Salt (1780–1827) who was appointed in 1815. Salt was encouraged by Joseph Banks to acquire objects for the British Museum. Few collectors have worked harder for and been treated so badly by that institution. He received permission to remove a colossal head of Ramesses 11 and called upon the service of Giovanni Belzoni, the most colourful figure in the history of Egyptology. Belzoni had been a circus strongman and was a brilliant, if improbable, engineer who could winkle things out of impossible places.

Salt formed three collections; the first was assembled with Belzoni's help, and he tried to sell it to the British Museum for £8,000 but received only £2,000, which was less than the cost of excavation. It included the spectacular wall paintings from the tomb-chapel of Nebamun (fig. 266). One of the main treasures, the alabaster sarcophagus of Seti 1, he sold to Sir John Soane for £2,000 for his museum where it forms the bedrock of his gallery of antiquities. Salt fell out with Belzoni, owing to the latter's extravagance, and formed his second collection with the help of Giovanni D'Athanasi, a Greek excavator, who later wrote an account of the story largely to blacken Belzoni's name. Salt had more success with this collection which he sold to King Charles X of France for £10,000 on Champollion's recommendation. Salt kept a third collection which was dispersed after his death at Sotheby's in 1835 in over 1000 lots for just over £3,000. The most sought-after items were the rolls of papyrus, the furniture from the tombs at Thebes and sculptural tables from Abydos. However it was the mummy case of 'a Royal personage' that made the highest price of £330.

Salt was not the only English collector of Egyptology. He encouraged William Bankes of Kingston Lacy, who with Belzoni's help removed the obelisk from Philaie to Dorset where it remains to this day. Less well known is Sir John Gardner Wilkinson, a hieroglyphic scholar who worked somewhat in parallel to his French rival, Champollion. He gave many smaller items to the British Museum illustrating daily life and left a collection to Harrow School. Some travellers to Egypt brought back antiquities, such as Edward

Roger Pratt of Ryston Hall, Norfolk, who during a visit to Egypt in 1833–34 acquired a finely carved limestone *Stele of the army scribe Kenro* of *c*.1220BC (British Museum; fig. 267). Joseph Bonomi catalogued the Egyptian Antiquities at Hartwell House in the collection of John Lee (privately printed in 1858) and those belonging to the late Robert Hay of Linplum (privately printed in 1869).

One extraordinary collector of Egyptian artefacts was Joseph Mayer of Liverpool (1803–1886). He was a successful jeweller who put together an important group of Assyrian, Babylonian, Etruscan, Greek, Roman and Anglo-Saxon antiquities, but Egypt was his central interest and in 1852 he opened the 'Egyptian Museum' in Liverpool. He was also a collector of European and Oriental manuscripts. His philanthropy to his home town included a public park, a lending library and the contents of his museum.

AFRICA

European contact with Africa dated back to the 15th-century voyages of discovery but it was not until 1638 that the Royal Africa Company was recognised by Charles 1. The Portuguese had a virtual monopoly of African trade at this time. Hans Sloane owned a few West African tribal pieces but lack of knowledge, the vast and impenetrable nature of the continent and the high mortality rate of European visitors meant that Africa remained *terra incognita*. Eighteenth-century plant collectors, notably Sir Joseph Banks, showed interest, but this was overtaken by an obsession with the sources of the two great rivers, the Niger and the Nile. It was not until 1817, when Thomas Bowdich, a low-ranking member of the Royal Africa Company, was sent on a diplomatic mission to the West African kingdom of Ashanti, that one can observe anything approaching systematic collecting. He published *Mission from Cape Coast to Ashantee* (1819), full of vivid detail, which was the best description to date of an African kingdom. Bowdich also brought back artefacts, of which two dozen survive, to form the backbone of the British Museum collection, mostly demonstrating practical skills and indigenous technologies. Thus the collecting of African tribal arts in Britain began with an ethnographical emphasis which it was never entirely to lose.

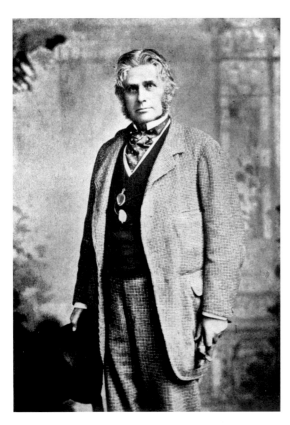

268 Augustus Henry
Lane Fox, Lieutenant-General
Pitt Rivers

269 Augustus Wollaston
Franks

The first major private collector of African art was Augustus Henry Lane Fox (1827–1900), latterly known as Lieutenant-General Pitt Rivers (fig. 268). In 1880, he inherited the Rivers estate in Dorset amounting to 27,000 acres and in consequence could afford anything he wanted. Soldier, educationalist, pioneering archaeologist, the General was the learned Victorian worthy *par excellence*. It may have been the 1851 Great Exhibition that stimulated Pitt Rivers as a collector because the following year he started acquiring a bewilderingly wide range of objects. As a soldier his first interest was in the development of firearms and he extended this to tribal societies. E.B. Taylor described how 'he collected weapons until they lined the walls of his London home from cellar to attic'.[9] The General attempted to find in tribal weaponry the same evidence for technological progress that would apply to European models. Part of his motivation was to unveil the laws of cultural evolution, Darwinism applied to art. It was a collection put together 'solely with a view to instruction... typical specimens... are arranged in sequence with a view to show, in so far as the very limited extent of the collection renders such demonstration practicable, the successive ideas by which the minds of men in a primitive condition of culture have progressed in the development of

their arts from simple to complex'.[10] The range of his interests was startling: Chinese porcelain, coins, armour, furniture, jewellery, Indian bronzes and glass, as well as the more famous archaeological and ethnographical collections.

Eccentric, solitary and energetic, Pitt Rivers stands as a pivotal figure between the magpie age of the adventurers and explorers and the age of the specialist collector of ethnographical material. In 1884 he gave over 16,000 items to Oxford (fig. 254), which remain his enduring legacy, and many thousands more to the 'second' Pitt Rivers Museum at Farnham in Dorset. The display at Farnham was designed to entertain as well as educate and 40,000 visitors a year came. He acquired items on his travels but mostly from dealers and occasionally as gifts. His greatest purchase was the 420 or so artefacts from Benin City from the Punitive Expedition of 1897 (fig. 270). The expedition and the remarkable sale catalogue produced in 1899 by W.D. Webster represented a turning point in the appreciation of African art around 1900. The General published a catalogue of his Benin works of art in the year of his death in which he erroneously attributed their 'advanced stage' to European influence, probably Portuguese. There was general disbelief that such high-quality bronze iron and ivory artefacts could have been made by Africans.

Pitt Rivers saw himself as fundamentally different from other collectors by virtue of the systematic formation of groups of objects of like form or function to display differences and development.

In 1845 the British Museum opened a gallery of ethnographical items, four years after Queen Victoria had given a group 'of curious objects from the South Sea islands'. But it was the arrival of Augustus Wollaston Franks (fig. 269) in the Antiquities Dept in 1851 that was to transform the museum's holdings. Signalling a new era of professional curators and scholarly interest in ethnography, Franks is sometimes described as the second founder of the British Museum. It was by his energy, scholarship and taste which ran to items across the Far East that he attracted princely bequests: Meyrick, Slade, Octavius Morgan, Willett and above all Henry Christy's collection of prehistoric and ethnographical material which, at one stroke, raised the status of this area. With the removal of the Natural History Museum to South Kensington in 1881, he seized the chance and extended his department. When he arrived at the museum there were roughly 3,700 ethnographical artefacts and by the time he retired this figure had risen to 38,000, of which he had donated 9,000. Franks was a passionate collector himself, often buying for the museum on his own account. His own collecting ranged from bookplates (30,000 of them), Asian and American material, and oriental ceramics, to early drinking vessels. He ushers in a new age of scholarship and specialist collecting.

270 Head of an Oba, from Benin, Nigeria, early 16th century, collected on the Punitive Expedition of 1897
Lieutenant-General Pitt Rivers; Robert and Lisa Sainsbury; now Sainsbury Centre for Visual Arts

Chapter 19

THE FOUNDING OF
THE NATIONAL GALLERY

'We are about to lay the foundation of a National Gallery by the purchase of Mr Angerstein's Pictures – you know that Sir Geo Beaumont has announced his intention of leaving his Pictures to the Public and I am persuaded that when a Gallery is established there will be many bequests'; so Lord Liverpool, the Prime Minister, informed the Duchess of Devonshire in September 1823.[1] The roots of the Gallery went back a long way. The sale of Charles I's collection in 1649 ensured that Britain's national picture gallery would not be a royal collection, like continental examples. The British Royal Collection was to remain a large private collection, suitable to a constitutional monarchy that nobody sought to overthrow. Neither George IV nor Queen Victoria offered to follow George III's precedent of giving the royal library to the British Museum, by offering the royal collection of paintings to the nation. European public galleries had opened throughout the 18th and early 19th centuries: the Uffizi in 1737 when the collection of the last of the Medici passed to the State of Tuscany; Vienna in 1782; the French royal collections were nationalised in 1792; Amsterdam followed in 1808; and in Berlin the Giustinani collection had been bought in 1815 and the Solly collections in 1821 for the intended public gallery. It could only be a matter of time before London followed suit.

The British Museum had been unique at the time of its foundation in being established by Parliament solely for the edification of its citizens; but it didn't include paintings. It was the sale of the Houghton Hall pictures to Russia that provoked the first call by John Wilkes in Parliament in 1777 to save the collection for display in an annexe

British Institution

Sir George Beaumont

John Julius Angerstein

Sir Thomas Lawrence

Rev. William Holwell Carr

Sir Charles Eastlake

Samuel Rogers

William Coningham

Sir Robert Peel

271 Gerrit Dou, *A Poulterer's Shop*
Sir Robert Peel; now National Gallery, London

to the British Museum. Wilkes's pleas fell on
deaf ears; perhaps if the suggestion had come
from a less radical MP, the result might have
been different. This first 'heritage crisis' created
the template for all future examples of the
phenomenon: alarm at the export of important
art, a plea to national pride and justification
through education – which in those days was
provided by and for artists. The last in fact played
a very ambivalent role in the story. It was the
Irish painter James Barry who coined the term
'National Gallery' and suggested buying the
collection of Sir Joshua Reynolds at his death
in 1792, and to add the Italian paintings from
the Orléans collection. Barry saw the Royal
Academy as the natural home of such a collection
and Wilkes had already stated how much it
would benefit the native school. Unfortunately
Barry was a tactless hothead and the Academy
instead used its resources to create a pension
fund for artists. A surprising feature of this
story is the artists' opposition to the proposal.
Some Academicians thought that a national
gallery should exclude foreign works, while
others, chiefly John Constable, fervently believed
that artists should take inspiration from nature
instead. There was also fear of competition.

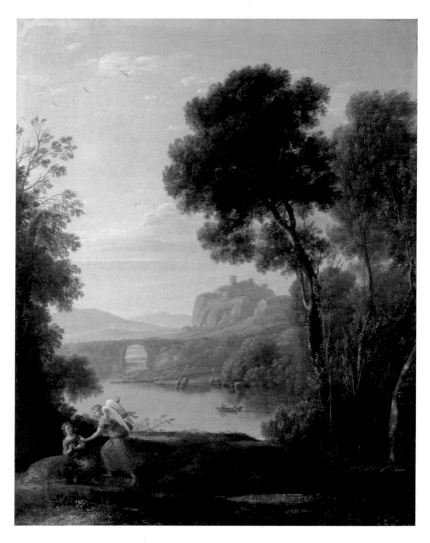

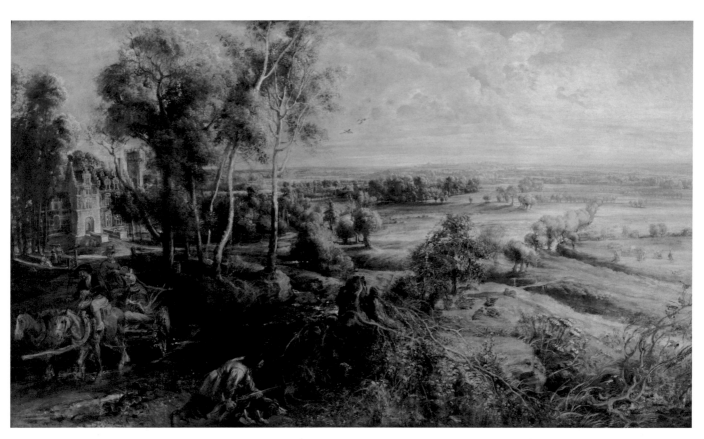

The establishment in 1805 of the *British Institution for Promoting the Fine Arts in the United Kingdom* sought to resolve these conflicting interests (see chapter 14). The King agreed to become Patron and the Prince of Wales its President, but it was created by a group of private collectors and not by government. Its governors included the most distinguished collectors of the day, who lent their pictures to exhibitions which alternated between the works of living British artists and Old Master paintings. Joseph Farington recorded in his diary on 23 April 1805 that Benjamin West invited him to a meeting to discuss the plan of Sir Thomas Bernard, 3rd Bt, for 'establishing a National Gallery of painting & for encouraging historical painting' and that West invited Sir George Beaumont, William Smith and Richard Payne Knight and intended to ask Lawrence and Smirke. The metamorphosis of the British Institution into a National Gallery was frustrated by the artists themselves for nearly 20 years.

Artists were particularly suspicious of Sir George Beaumont (1753–1827), 7th Bt of Coleorton Hall in Leicestershire, who exercised enormous influence. The painter Thomas Hearne described him as the 'supreme dictator of taste'.

Beaumont was an 18th-century man of taste whose preferences had been formed on his Grand Tour in 1783. He was out of sympathy with young artists, calling Turner and others 'white painters', who had caused 'an influenza in art'. He staunchly upheld the established canon of the Old Masters and raised a memorial to Reynolds in his park, the subject of a painting by Constable. Beaumont was an able artist in oils and watercolour and he befriended the older generation of painters: Reynolds, Wilson, Thomas Jones, West, Girtin and Constable (although he never bought from the last). Beaumont was also a friend of Wordsworth and Coleridge. In 1785 he bought Claude's *Hagar and the Angel* (fig. 272), for which he had a travelling case made so that this favourite painting could accompany him wherever he went.

Although Beaumont was wealthy, his income was exceeded by that of many; nevertheless he formed a collection of exceptional appeal and added a picture gallery to his house in 1792. He owned four paintings by Claude and one of the most desirable of Rubens's landscapes, *View of Het Steen in the Early Morning* (fig. 273). His other pictures included Canaletto's eternally popular *Stonemason's Yard*, Poussin's *Landscape with a Man Washing his Feet at a Fountain* and Rembrandt's *Lamentation over the Dead Christ*. In 1821 Beaumont returned to Italy where he met Antonio Canova through whom he bought *The Virgin and Child with the Infant St John*, carved by Michelangelo *c.*1504–05, known as the *Taddei Tondo* (fig. 274). Beaumont bequeathed it to the Royal Academy and it remains the only marble sculpture by Michelangelo in Great Britain. Sight of the public museums in Rome convinced him of the need for a national gallery in London. On his return Beaumont offered his own collection if such a gallery were to be formed. The talisman which converted this offer into a gift was the collection of John Julius Angerstein (1735–1823), whose pictures were more important than Beaumont's.

Angerstein, born in St Petersburg, came to England in about 1749 and built up a large fortune based on estates in Grenada and a career as an underwriter at Lloyd's. His policies quickly acquired a great authority and became known as 'Julians'. Through his influence, the old Lloyd's Coffee House was abandoned and by the time Angerstein retired he was regarded as the founder

of the modern Lloyd's. We know a lot about him and his activities in the art world thanks to the diarist Joseph Farington. Angerstein befriended the young Thomas Lawrence, who painted sympathetic portraits of him and his family (fig. 275) and is sometimes given credit as the architect of his art collection. This was conventional but of a very high quality. An early purchase was Rubens's vigorous *The Rape of the Sabine Women*. Other northern pictures included Cuyp's large *Hilly Landscape with Figures*, an important work of Cuyp's maturity, bought in 1794 at the sale of Sir Lawrence Dundas (see chapter 9), and Rembrandt's *Woman Taken in Adultery*, acquired in 1807 for 4,000 guineas. Like Beaumont, Angerstein esteemed Claude, who provided the heart of his collection with five paintings, including the pair from the Duc de Bouillon's collection *The Marriage of Isaac and Rebecca* and *Seaport with the Embarkation of the Queen of Sheba*.

Angerstein's collection was dominated by Sebastiano del Piombo's huge *Raising of Lazarus*, which he bought on the advice of Lawrence (fig. 276). It had been painted in Rome *c.*1517–19

for Cardinal Giulio de'Medici (later Pope Clement VII) and was subsequently sent to Narbonne Cathedral where it remained until about 1720. The picture arrived in London with the Orléans collection in 1798. Angerstein paid 3,500 guineas for this picture, which was to be inventoried as number 1 in the National Gallery's collection. He also bought Raphael's *Portrait of Pope Julius 11*, which came from the Palazzo Borghese. Angerstein admired the work of Hogarth and acquired his *Self-Portrait with a Pug* (Tate) and his *Marriage à la Mode*, a heavily moralistic series of six pictures charting the downfall of a young aristocratic spendthrift.

Angerstein's adviser, the brilliant portrait painter Sir Thomas Lawrence (1769–1830), assembled one of the finest drawings collections of all time, comprising some 4,300 single sheets and seven albums including the two containing over 500 drawings by Fra Bartolommeo (Rotterdam). He took advantage of the unusual opportunities offered by the Napoleonic Wars and through the agency of William Young Ottley and Samuel Woodburn assembled important sheets by Raphael, Michelangelo, Leonardo da

275 Sir Thomas Lawrence, *John Julius Angerstein, aged about 55*
National Gallery, London

276 Sebastiano del Piombo, *The Raising of Lazarus*
John Julius Angerstein; now National Gallery, London

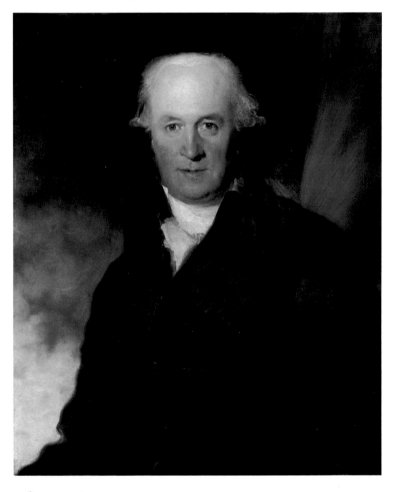

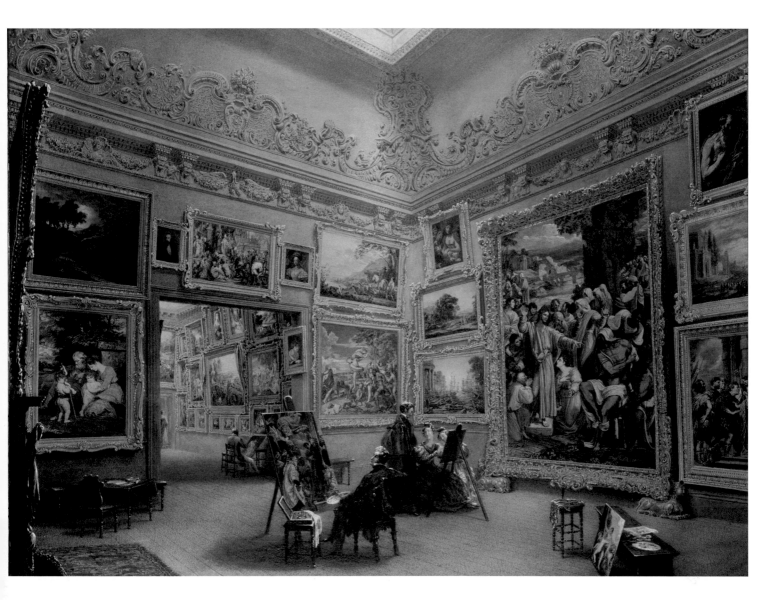

277 The gallery at John Julius
Angerstein's house at 100 Pall
Mall, watercolour by Frederick
Mackenzie, c.1834
Victoria & Albert Museum, London

Vinci, Andrea del Sarto, Giulio Romano, the
Carracci, Van Dyck, Rubens, Rembrandt, Claude
and Poussin. Although the collection had cost
Lawrence £40,000, his will stipulated that it
should be offered to the nation for £18,000. His
patriotic offer was refused but a body of supporters
managed to save a fine group of Michelangelo and
Raphael drawings for the Ashmolean Museum.

John Julius Angerstein's death in April 1823
aroused fears that his pictures would be sold
abroad. On 1 July 1823 Agar Ellis announced to
the House of Commons that he would propose
that the collection should be acquired for the
nation. At the same time Beaumont wrote a letter
confirming his gift of sixteen pictures 'whenever
the gallery about to be erected is ready to receive
them'.[2] By September, the Prime Minister Lord
Liverpool was persuaded that a National Gallery
should be established and in December agreement
was reached with Angerstein's executors over

the acquisition of 38 pictures for £57,000. The
timing was fortunate because the unexpected
repayment of an Austrian war loan covered the
sum. The purchase was completed in 1824 but
the pictures remained at Angerstein's house in
Pall Mall (fig. 277), which served as premises for
the National Gallery until 1838, when William
Wilkins's building was completed on the site of
the old Royal Mews on the north side of what
was later to become known as Trafalgar Square
(fig. 278).

The young National Gallery quickly expanded
through purchases, bequests and gifts. Among
the early donors was the Rev. William Holwell
Carr (1758–1830), an absentee vicar and Fellow
of Exeter College, Oxford, who bequeathed 35
pictures in 1830, including Titian's *The Holy
Family with a Shepherd*, Rembrandt's *A Woman
Bathing in a Stream* (fig. 279) and works by
Tintoretto, Domenichino, Reni and Claude. One

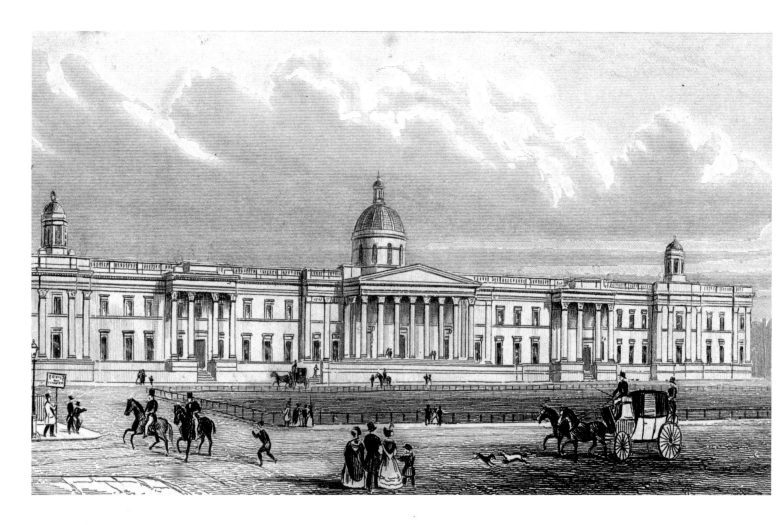

remarkable early gift was Caravaggio's *Supper at Emmaus* (fig. 281): it was donated by the Hon. George Vernon in 1839 after he had failed to sell it at Christie's in 1831. Vernon owned some fine Dutch pictures including Rembrandt's *Bathsheba* but nothing is known about the circumstances of his buying the Caravaggio. Pictures by this artist had been very rare in England ever since the days of the Duke of Buckingham. The 5th Lord Aston of Forfar bought his *St John the Baptist* (Nelson-Atkins) 'on Malta in the 18th century'.[3] Caravaggio's *Boy Bitten by a Lizard* (NG London) had been in the Chandos Collection since at least the 18th century. References to the artist in British literature and sales are however rare until the end of the 19th century.

Charles Eastlake (1793–1865) transformed the National Gallery's collection and was appointed its Keeper in 1843. He was a painter who had spent 14 years in Italy, where he acquired a deep knowledge of the history of art. After an interlude between 1847 and 1855, following a row over the Gallery's cleaning policy, Eastlake returned as its first director. An historian of the Gallery writes

that until then 'Trustee acquisition policy was in keeping with Beaumont's legacy'.[4] Lord Aberdeen and others thought that 'hitherto it had been merely like the collection of a private gentleman'.[5] Sir Robert Peel had prevented Eastlake as Keeper from adopting a didactically structured method in which acquisitions told a 'visible history of art' but instead insisted that the Gallery 'give preference to works of sterling merit... rather than purchase curiosities'.[6] Eastlake's approach, conditioned by the thinking of professional German art historians such as Passavant and Waagen, was to prevail and was shared by other systematic collectors such as Lord Lindsay (later 25th Earl of Crawford). Eastlake shrewdly concentrated on adding to the Italian collections, where his knowledge and contacts were especially valuable. His acquisitions included works fundamental to the Gallery's collection by artists such as Margarito d'Arezzo, Duccio, Botticelli, Antonio and Piero del Pollaiuolo, Piero della Francesca, Giovanni Bellini, Mantegna and Veronese, to name only a few.

In 1855, the year when Eastlake became director, Samuel Rogers (1763–1855) bequeathed three

278 Engraving of the newly built National Gallery, London, *c*.1840

279 Rembrandt van Rijn, *A Woman Bathing in a Stream (Hendrickje Stoffels?)*
Rev. William Holwell Carr now National Gallery, London

280 Titian, *Noli Me Tangere*
Samuel Rogers; now National Gallery, London

281 Michelangelo Merisi da Caravaggio, *The Supper at Emmaus*
The Hon. George Vernon, later 5th Lord Vernon; now National Gallery, London

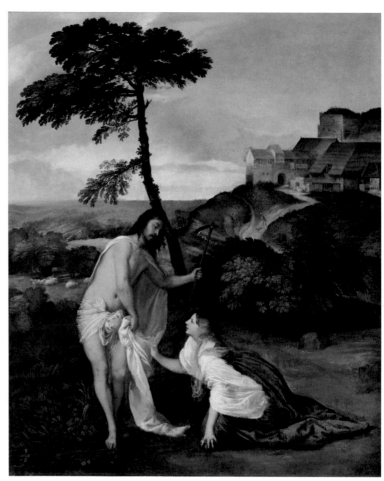

pictures to the Gallery, of which the most important was Titian's *Noli me Tangere* (fig. 280). Rogers, the banker bard of 22 St James's Place, was a friend to poets and artists: Byron, Sheridan, Walter Scott, Flaxman, Opie, Archer Shee and Fuseli, as well as Charles James Fox. He ran a literary salon and his

Table Talk[7] was later described by Cyril Connolly as an 'authentic glimpse of a golden age', the transition from high 18th-century *douceur de vivre* to the early Victorian period. Echoing Peel's objections to Eastlake, Rogers wrote to his agent in Paris in 1819, 'my wish is always for the beautiful rather than the curious', but his tastes were broader than this suggests.[8] Rogers collected illuminated manuscripts, literary manuscripts, Egyptian antiquities, drawings (including the works of Turner) and above all paintings, 150 of them. As Byron wrote in his diary, 'if you enter his house... say not this is the dwelling of a common mind. There is not a gem, a coin, a book thrown aside on his chimney-piece, his sofa, his table, that does not bespeak an almost fastidious elegance in the possessor.'[9]

Samuel Rogers acquired most of his paintings at auction and it was therefore fitting that apart from a few bequests his own collection was auctioned by Christie and Manson on 28 April 1856 and 18 following days. Lord Hertford bought Velázquez's *Don Baltasar Carlos in the Riding School* for 1,210 guineas, Reynolds's *The Strawberry Girl* for an astonishing £2,205 and two other pictures.

Rubens's *Landscape by Moonlight* was bought by Lord Ward (Courtauld) and Raphael's exquisite predella panel *The Agony in the Garden*, from the Orléans collection, was bought by Baroness Burdett Coutts (Metropolitan). Eastlake bought four pictures for the National Gallery, including Jacopo Bassano's *The Good Samaritan* and Rubens's *Roman Triumph*.

Not all collectors were wholehearted supporters of the National Gallery. Despite many of his pictures ending up there, William Coningham (1815–1884) was one of its most severe critics. A highly strung and quixotic man, Coningham was Liberal MP for Brighton and a friend of Carlyle and Monckton Milnes, later Lord Houghton. He despised contemporary art and its 'chalky absurdities' and fiercely attacked the Gallery's administration for its acquisition policy, its cleaning policy – in which he was not alone – and he campaigned for Sunday opening. But he was a remarkable collector. His interest was stimulated by a series of visits to France and Italy between 1843 and 1846. During the following six years he gathered a collection of astonishing quality which he then inexplicably at the age of 34 sold at Christie's on 9 June 1849. Before the sale, in 1848, he had presented to the National Gallery the two large panels of *Adoring Saints*, the left and right portions of the San Benedetto Altarpiece by Lorenzo Monaco. Among the outstanding pictures in his short-lived collection, many have since passed to the National Gallery including Antonello da Messina's *St Jerome*, Mantegna's *Agony in the Garden*, Antonio Pollaiuolo's *Apollo and Daphne* and Sebastiano del Piombo's *Holy Family*. His Titian, *Tarquin and Lucretia*, is in the Fitzwilliam Museum, Cambridge. Not all his paintings were Italian and he owned El Greco's signed *Portrait of Vincenzo Anastagi* (Frick) and Rembrandt's *Portrait of Martin Looten* (LACMA).

The earlier bequests to the Gallery were predominantly of Italian pictures and Eastlake concentrated on building up this part of the collection. The counter-balance was provided in 1871 through the purchase for £75,000 of 77 Flemish and Dutch paintings from the collection of Sir Robert Peel, 2nd Bt (1788–1850), sometime Prime Minister. For many years Peel was associated with the Royal Academy and he had played a leading role in the acquisition of the Angerstein collection for the

National Gallery. He was a sympathetic voice for the arts in Parliament and on its committees. Peel's London house at 4 Whitehall Gardens was visited in 1838 by Dr Gustav Waagen,[10] who praised the 'tasteful choice of his collection, which consists of a series of faultless pearls of the Flemish and Dutch schools'. Waagen noted Rubens's celebrated *Portrait of Susanna Lunden* (fig. 282), known at the time as the *Chapeau de Paille*, which Peel had acquired in 1824 for £2,725 from John Smith, one of the most remarkable art dealers in London. Smith, who also numbered the Duke of Wellington among his clientele, was a specialist in Dutch and Flemish painting. He was the author of one of the

282 Peter Paul Rubens, *Portrait of Susanna Lunden* ('*Le Chapeau de Paille*')
Sir Robert Peel; now National Gallery, London

landmarks of art history, the *Catalogue Raisonné of the Works of the Most Eminent Dutch, Flemish and French Painters* (1829–39), which listed all the then known works by 37 painters of the Dutch and Flemish schools, with Claude, Poussin and Greuze lifting the number of artists surveyed to 40.

Peel bought two other paintings by Rubens from Smith: *The Lion Hunt* in 1826 for 100 guineas and *The Drunken Silenus supported by Satyrs* in 1827 for £1,100. Although admired by Wilkie at the time, the *Silenus* is now considered a work of Rubens's studio. In addition he owned *The Poulterer's Shop* by Gerrit Dou (fig. 271), bought on commission by Smith at the Fonthill sale in 1823 for 1,270 guineas; and also acquired works by Rembrandt and Ter Borch, Metsu, Frans van Mieris, Slingelandt, Jan Steen, Pieter de Hooch, Adriaen van Ostade, Karel du Jardin; two pictures by Jacob van Ruisdael; three by Cuyp; and six by Wouwermans. William Buchanan in his *Memoirs* of 1824 states that until the arrival of the Orléans collection in England the prevailing taste and fashion had been for Flemish and Dutch pictures. While this statement has been questioned, Buchanan later noted the rise in the prices of works from these schools around 1840 with the activities of Peel and Robert Holford (see chapter 20) who had 'within these last two years given prices for a few Dutch pictures, which Dutch pictures were never sold at before'.[11]

At the core of the Peel collection was Meindert Hobbema. Waagen considered that 'no collection in the world, perhaps, can compare with that of Sir Robert Peel in masterpieces of this rare and great landscape painter, the only one who can compare with Ruysdael'. Peel owned four paintings by him, of which *The Avenue at Middelharnis* (fig. 283) cost £800 and *The Ruins of Brederode Castle* (bought from Nieuwenhuys) £1,400, and in 1829 he paid Nieuwenhuys a further 1,205 guineas for Paulus Potter's *Landscape with Cows, Sheep and Horses by a Barn*. Peel patronised living artists, notably Wilkie, Stanfield and Collins, but his most striking acquisitions or commissions of British works comprised a portrait gallery of contemporary great men, mostly political but also leading figures from the world of literature and science.

The National Gallery was well into its stride by the time of the Peel purchase in 1871. Frank Herrmann described its foundation as 'the most important event in the whole history of English collecting.'[12] While this statement ignores the full richness of British collecting of decorative arts, it is essentially true. The motivation behind the creation of the National Gallery combined Enlightenment ideas 'to provide public instruction, through institutions of fine art' and 19th-century nationalism.[13] With the sheer quantity of works of art that spilled into London during the preceding 40 years, it is unlikely that its foundation could have been postponed for much longer, given the desire of so many collectors to find a permanent home for their art collections. The Gallery has remained until the present time the focal point of art collectors motivated to donate, sell or bequeath art and to serve as trustees on the Board. What is perhaps striking is the extent to which the Gallery's purchasing since its foundation has been conditioned by a conception of the national heritage, as defined by acquisitions from British private collections. The National Gallery was not only an outlet for collectors but also a conduit for masterpieces that cumulatively comprise a history of British collecting.

283 Meindert Hobbema,
The Avenue at Middelharnis
Sir Robert Peel; now National
Gallery, London

Chapter 20

THE VICTORIAN RICH

The Victorian reign impinges on at least six chapters of this book. No single chapter could capture the variety and richness of an era that passionately believed in its native artists, made a cult of Florence, brought back tribal artefacts, created baronial halls, admired French decorative arts and wanted the best of everything. Together with contemporary British paintings, the 19th-century rich – particularly City of London merchants and bankers – most wanted Old Master paintings, and they formed mighty collections. This chapter examines some of these collectors and a single ground-breaking female collector of ceramics, Lady Charlotte Schreiber. If the Orléans generation were talented opportunists who scooped up what was available, Victorian collectors of Old Master paintings were admirably discerning and open to a much wider canon of art. Early Italian and Flemish pictures, German and medieval art could be found alongside Rembrandt and Reynolds. The Victorian collectors paraded their achievements at the great Manchester Exhibition of 1857 which coincided with the high water mark of British collecting. It was the last time that British collectors dominated the art market. The Hamilton Palace sale of 1882, followed by that of the Blenheim pictures in 1886, signalled the change with the arrival of German and American collectors.

The collector who bridges the era of the Grand Tour and the Victorian age was John Rushout, 2nd Lord Northwick (1769–1859), of Northwick Park. He was a dilettante collector in the spirit of the 18th century, a bachelor who devoted his life to collecting paintings which he shared with the public. Sent to school in Hackney and then to Neuchâtel, Northwick's eyes were opened during the eight

2nd Lord Northwick

The Baring Family

1st Lord Overstone

Robert Stayner Holford

The Manchester Exhibition

Robert Benson

Lady Charlotte Schreiber

Sir Francis Cook

Lord Iveagh and the Cult of the Masterpiece

284 Johannes Vermeer, detail from *The Guitar Player*
2nd Viscount Palmerston; 1st Earl of Iveagh; now Kenwood House, Iveagh Bequest (English Heritage)

years between 1792 and 1800, which he spent in Rome, a city he profoundly venerated. He returned home on the death of his father in 1800 and started collecting. Northwick particularly enjoyed 15th- and 16th-century Italian paintings, owning Botticelli's *Portrait of a Young Man* (NG London) and his *Virgin Adoring the Sleeping Christ Child* (NG Edinburgh; fig. 285), Beccafumi's *Tanaquil* and *Marcia* (NG London) and Fra Angelico's *Miracle of Saints Cosmas and Damian* (Kunsthaus, Zurich). While other collectors in the first decades of the 19th century were also discovering the delights of the so-called Italian 'primitives', the catholicity of Northwick's taste is striking – he also owned more traditional works by Titian, Guercino and Salvator Rosa, as well as portraits by Reynolds and Gainsborough and works by many contemporary artists.

Northwick added a picture gallery to his house in 1832 but this was rapidly filled and he purchased Thirlestane House in Cheltenham for more space. Its 1846 guidebook lists over 500 paintings, and when he died Northwick's sale catalogue listed 1,400 pictures as well as a large collection of other works of art. His geniality and generosity in opening his houses to visitors raised hopes in Cheltenham that his collection would be bequeathed to the public. All hopes were dashed in 1859 when it was discovered that he had died intestate. The consequent auction attracted the greatest collectors of the day, including the Dukes of Hamilton and Buccleuch, Lord Hertford and Baron James de Rothschild. The National Gallery bought at the sale as did Northwick's nephew, the 3rd Baron, whose considerable purchases were returned to Northwick Park.

Northwick died in the middle of the Victorian reign, but his vast accumulation of paintings recalls an earlier age. The family that characterises the development of refined Old Master taste in the 19th century is the great banking dynasty of Baring and its three generations of collectors. Hailing originally from Bremen and of Lutheran stock, the Barings enjoyed such an unassailable financial position in the City of London that they were described in 1818 as 'the Sixth Great Power of Europe'. Sir Francis Baring (1740–1810) founded the family fortune, acquired a country estate, Stratton Park in Hampshire, and commissioned George Dance to remodel the house in

an up-to-the-minute neo-classical style. He filled it with excellent Dutch paintings, typically Jan Steen's *Twelfth Night Feast*, Ter Borch's *The Letter* and Hobbema's *The Watermill*. He also commissioned Thomas Lawrence to paint him with his associates in what is probably the finest of all corporate portraits (fig. 286).

Sir Francis's two elder sons were also collectors. The eldest, Sir Thomas (1772–1848), 2nd Bt, inherited most of his father's collection, to which he added many Dutch pictures before selling them in 1814 to the Prince Regent for Carlton House.

285 Sandro Botticelli,
*The Virgin Adoring the
Sleeping Christ Child*
2nd Lord Northwick; 10th Earl of
Wemyss; now Scottish National
Gallery, Edinburgh

In 1819 he sold Raphael's *Madonna della Tenda* to the Crown Prince of Bavaria, shortly after its purchase, suggesting a speculation. Thomas had a taste for Italian and Spanish paintings and owned fine examples including Antonello da Messina's *St Jerome in his Study* (NG London; fig. 289), which he believed to be by Dürer, Sebastiano del Piombo's *Madonna and Child with Saints and a Donor* (NG London), five paintings by Murillo and Ribera's *Holy Family with Saints Anne and Catherine of Alexandria* (Metropolitan). Thomas's younger brother, Alexander (1774–1848), created Lord Ashburton in 1835, lived nearby at the Grange, a neo-classical house by Wilkins. He inherited the family penchant for Dutch pictures and acquired a group from the dealer William Buchanan that had come from the Talleyrand collection, including Backhuysen's *View of the Sea Coast* (700 guineas), a Cuyp *Landscape and Figures* (1,100 guineas), an Isaac van Ostade *Country Inn with Numerous Figures* (700 guineas)

and a Wouwermans *La Ferme au Colombier* (1,200 guineas). Baring also bought pictures through the dealer John Smith, acquiring Rubens's *The Wolf Hunt* and Rembrandt's *Portrait of a Man Holding Gloves* (both now in the Metropolitan).

The most important collector in the Baring family belonged to its third generation, Sir Thomas's son, also called Thomas (1799–1873). A bachelor, devout churchman and a Tory MP of no political ambition, his main interest after the family bank was his art collection. He purchased his father's Italian, French and Spanish paintings from the executors but more clearly revealed his taste and discrimination in his own choices. He acquired Mantegna's *Agony in the Garden* (NG London; fig. 287), and unusually, had an eye for early Flemish pictures of which he had excellent examples: *The Portrait of a Young Man* by Petrus Christus (NG London; fig. 288), *Saint Giles and the Hind* by the Master of Saint Giles (NG London) and *The Virgin and Child Enthroned*

286 Sir Thomas Lawrence,
Sir Francis Baring, 1st Bt.,
John Baring and Charles Wall
Private Collection

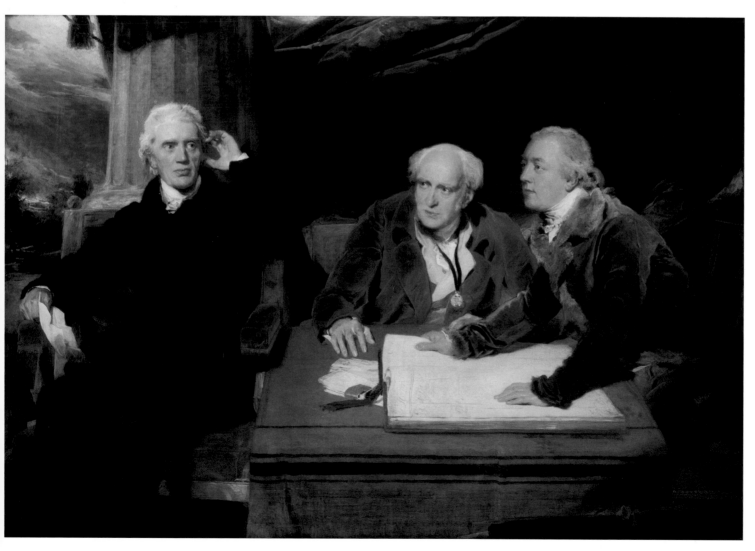

by Jan Gossaert called Mabuse (Waddesdon). His breadth of taste also extended to Spanish portraits by Murillo and Coello, and a Watteau *Pierrot* (Waddesdon) that appealed to Waagen. When the German expert viewed the collection in 1851 he thought it particularly impressive in its scope and quality. Baring also owned some recent British paintings by Bonington, Wilkie and Etty. He made a single bulk purchase in 1846 when he and two other collectors divided between them the renowned collection of Dutch paintings formed by Baron Verstolk van Soelen of The Hague. Baring acquired 43 of the 100 paintings for £12,472, including works by Cuyp and Steen.

The second partner in this deal, Samuel Jones-Loyd (1796–1883), later Lord Overstone, lived at 2 Carlton Gardens. Like Baring, he was a distinguished banker, whose recommendations to Peel resulted in the Bank Charter Act of 1844. He collected pictures from the 1830s, showing conservative taste and a Dutch bias: paintings by Carlo Dolci and Domenichino, as well as Jan van de Capelle, Koninck and Wouwermans. His share of the Verstolk van Soelen collection brought major works by Hobbema, Hackaert, Pynacker, Rembrandt, Steen and others. In 1851 he acquired his most celebrated painting, Claude's *The Enchanted Castle* (NG London), but his most original purchases were two large panels by Lucas Cranach the Elder, *Saints Geneviève and Apollonia*

and *Saints Christina and Ottilia* (NG London; fig. 290), which had formed the reverses of the wings of the *St Catherine Altarpiece* in Dresden. Lord Overstone's only surviving child, Harriet, illustrates how interconnected Victorian collectors were. She married General Robert Lindsay VC (later Lord Wantage) whose elder brother, Sir Coutts Lindsay, founded the Grosvenor Gallery. His two sisters married two of the greatest collectors of the age, Lord Lindsay (see chapter 17) and Robert Holford (see below).

The sociability of so many Victorian collectors encouraged the formation in 1856 of the Fine Arts Club, an association of gentlemen who viewed one another's collections so that 'a school of criticism is formed, and a material influence imperceptibly exercised on taste'.[1] By 1866 the club occupied premises in Piccadilly opposite the Royal Academy, which led to its adoption of the name Burlington Fine Arts Club. At various times, Frederic Leighton, J.C. Robinson, Ruskin, W.E. Gladstone, Sir Richard Wallace, Dr Bode, George Salting, Roger Fry and Sir Herbert Cook were all members. The club mounted important exhibitions and provided a stimulating and competitive milieu for its members, whose numbers reached several hundred.

Robert Stayner Holford (1808–1892) was a founder-member of the Fine Arts Club in 1856 and a central figure of the Victorian arts establishment. Having inherited £1 million at the age of 30 from a

287 Andrea Mantegna, *The Agony in the Garden*
Thomas Baring (1799–1873); now National Gallery, London

288 Petrus Christus, *Portrait of a Young Man*
Thomas Baring (1799–1873); now National Gallery, London

289 Antonello da Messina, *Saint Jerome in his Study*
Sir Thomas Baring, 2nd Bt.; now National Gallery, London

290 Lucas Cranach the Elder, *Saints Geneviève and Apollonia* (left) and *Saints Christina and Ottilia* (right)
Lord Overstone; now National Gallery, London

bachelor uncle and another fortune the following year from his father, he commissioned Lewis Vulliamy to build Dorchester House on Park Lane. Designed to emulate Barry's Bridgewater House, it was the finest house of its time in London. He commissioned much of the interior decoration from Alfred Stevens, most notably the dining room. The house was designed to receive and display Holford's princely collection of Old Master paintings, prints, sculpture, Della Robbia ware, bronzes, maiolica, porcelain, Renaissance gold and silver, and superb illuminated manuscripts and printed books. Before Sir Richard Wallace and the Randlords, Dorchester House presented one of the richest private spectacles in London (figs 291–292). Holford also commissioned Vulliamy to remodel his country house, Westonbirt, in Gloucestershire, in a neo-Elizabethan style to display the rest of his collection.

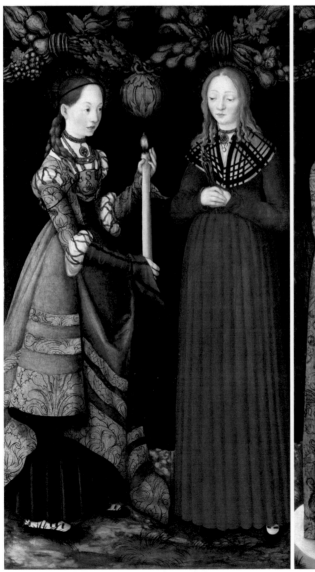

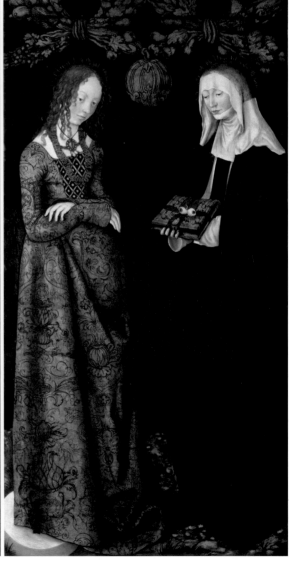

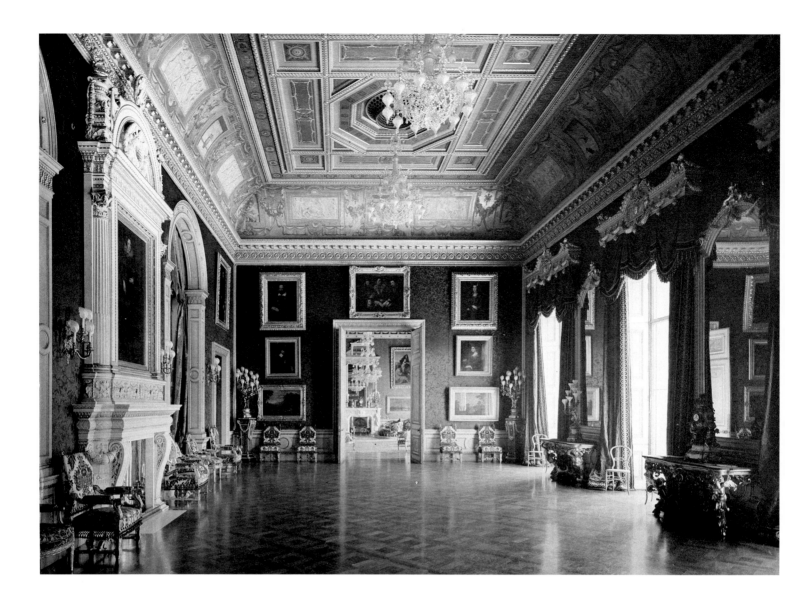

Holford started collecting paintings as soon as he inherited. In 1840 he paid the then elderly William Beckford 4,500 guineas for seven pictures: five landscapes, by Claude, Berchem, Gaspar Poussin, Jan Both and Wouwermans, and two interior scenes, by Jan Steen and Adriaen van Ostade. Four years later he acquired Lord Methuen's large Claude, *Landscape with a Temple of Bacchus* (NG Ottawa). Holford's taste in paintings may not have been advanced but he was discriminating despite a rather dismissive notice by Waagen. The latter was impressed with the acquisitiveness and youth of the proprietor when he visited Dorchester House but also reflected that 'this collection proves how much more difficult it is to secure genuine and fine specimens of the Italian school... for although there are many remarkable... yet there are many also which... do not do justice to their great names'.[2]

Holford showed little interest in the craze of his brother-in-law, Lord Lindsay, for early Italian

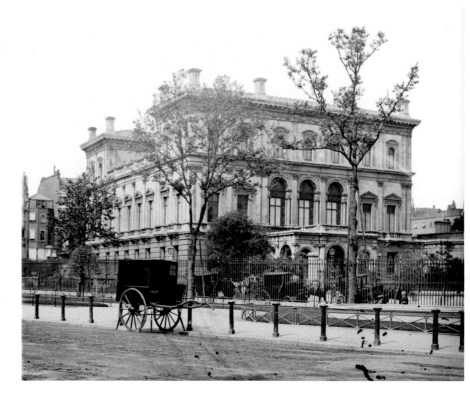

291 The Grand Gallery at Dorchester House, from an album of photographs by Bedford Lemere taken *c*.1910. Rembrandt's *Portrait of Marten Looten* (fig. 293) hangs to the left of the doorway.

292 Dorchester House on Park Lane, London, in the late 19th century

293 Rembrandt van Rijn, *Portrait of Marten Looten*

Robert Stayner Holford; now Los Angeles County Museum of Art

294 Sir Anthony van Dyck, *Portrait of the Abbé Scaglia*

Robert Stayner Holford; now National Gallery, London

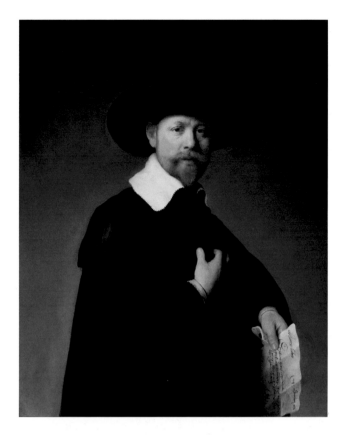

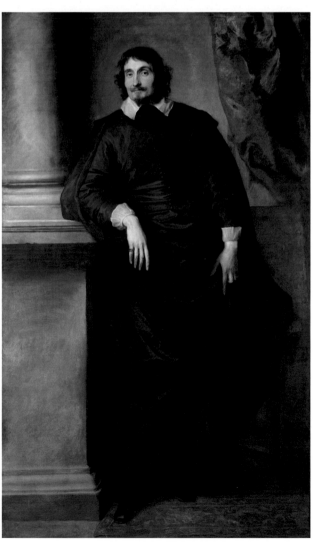

paintings although he did acquire works by Bellini and Pesellino. His son-in-law Robert Benson later said that Holford preferred 'the fullness of the summer of Art to its colder springtime'.[3] Holford purchased Lotto's *Lady as Lucretia* (NG London) as well as pictures by Bartolomeo Veneto, Garofalo, Gaudenzio Ferrari, Tintoretto, Perugino and Veronese. His connoisseur's eye ensured that he acquired Dutch and Flemish paintings of a high standard, including Cuyp's *Dordrecht on the Maas* (Ascott) and Van Dyck's *Portrait of Cesare Alessandro Scaglia* (NG London; fig. 294). Remarkably, Dorchester House contained two full-length portraits by Velázquez: *Philip IV of Spain* (Ringling) and *Gaspar de Guzman, Conde-Duque de Olivares* (Hispanic Society). After the death of Holford's childless son, the entire collection was sold in 1927 and 1928. Dorchester House was demolished to make way for the hotel of that name, while Westonbirt survives as a school for girls.

Holford particularly admired Rembrandt, and owned a choice group of his etchings and drawings as well as five paintings, all portraits, including *Marten Looten* (LACMA; fig. 293). It is pertinent to ask where Rembrandt stood with Victorian connoisseurs. Reitlinger believed that after a boom during the Regency, when the Prince Regent paid 5,000 guineas for *The Shipbuilder and his Wife*, the artist became less fashionable until the 1860s, when prices rose dramatically.[4] Large Rembrandts with many figures made high prices, but the Victorians were nervous of works ascribed to the artist, being aware of the attributional problems posed by his school and followers. This was particularly the case after the National Gallery paid £7,000 in 1866 for *Christ Blessing the Children*, which turned out to be a school painting.[5] It was not until the 1880s that German interest, followed a decade later by strong American interest in Rembrandt, confirmed the artist's pre-eminence. When the 1898 Rembrandt retrospective took place in Holland, British collections were by far the largest overseas lenders with 40 works.

In 1857 occurred the great benediction

295 Louis Haghe,
*Sir Thomas Fairbairn handing
over the address to the Prince
Consort in the Art Treasures
Exhibition at Manchester in
May 1857*
Manchester Art Gallery

of Victorian art collecting, the *Art Treasures*
exhibition in Manchester (fig. 295), a civic gesture
to match London's Great Exhibition of 1851. It was
Prince Albert who suggested an exhibition of art
rather than industry for Manchester. The result was
'the mother of all blockbusters', held on the old
cricket ground at Old Trafford. A special railway
line and station were constructed to transport visi-
tors to the doors of the exhibition, and the Bank
of England underwrote the exhibition.[6] It revealed
the astonishing riches amassed by British collec-
tors. Queen Victoria and Prince Albert headed the
list of lenders who constituted a veritable *Who's
Who* of British collecting, including the Dukes
of Buccleuch, Newcastle, Northumberland and
Richmond, Lords Carlisle, Cowper, Ellesmere,
Northwick, Overstone, Pembroke, Spencer, Ward,
Westminster and Yarborough, Alexander Barker,
Thomas Baring, Angela Burdett-Coutts, the Rev.
Walter Davenport-Bromley, Robert Holford
and William Stirling. The catalogue listed 1,079
Old Master pictures (including 28 supposed
Rembrandts), with a further 44 lent by Lord
Hertford, 689 by British artists, almost a thousand
watercolours and a vast array of the decorative arts.

The French critic Théophile Thoré thought that
the exhibition was the equal of the Louvre.[7]

Italian art received the greatest prominence
at the Manchester Exhibition, but perhaps the
long-term winner was British art which received
equal billing with the Old Masters, a status
unthinkable in the previous century. Generally the
exhibition impressed visitors with the economic
power, wealth, artistic taste and discrimination
of Victorian Britain. Even a cursory study of the
later history of works lent to Manchester shows
that a substantial majority has since entered public
ownership around the world. Never again was such
an immense display of privately owned works of art
to occur, and within a quarter of a century the tide
of art would start to retreat from Britain.

For a while this change was imperceptible.
The generation of collectors after Robert
Holford shared his enthusiasm for Italian art.
His daughter, Evelyn, married Robert 'Robin'
Benson (1850–1929), and together they formed an
important specialist collection. The senior partner
of his eponymous bank, Benson was a member
of the Burlington Fine Arts Club, a trustee of
the National Gallery, and the editor of a number

of catalogues of paintings, including that of his father-in-law's collection. The Bensons' taste was *à la mode*. They owned 114 early Italian paintings which reveal a comprehensiveness that would have done credit to a professional curator, as well as pictures by Gainsborough and Burne-Jones. Their first acquisition, Marco Basaiti's *Portrait of a Collector*, came from Colnaghi in 1884 and the following year they bought seven more pictures including *The Marriage of the Virgin* attributed to Agnolo Gaddi. Frank Herrmann pointed out the close friendship between the Bensons and three other great collectors of the day, William Graham, Charles Butler and George Salting, commenting that 'they learned from them, imitated them and bought extensively from their collections when they were dispersed'.[8]

In fact, Benson bought 15 paintings at Graham's sale, including works by Ghirlandaio, Piero di Cosimo, Cosimo Tura, Lorenzo Costa, Dosso Dossi, Carlo Crivelli and Giovanni Bellini. To these he added four panels detached from Duccio's celebrated *Maestà* from Siena Cathedral and in 1894 he acquired a rare Giorgione, *The Virgin and Child with St Joseph*, once possibly in the collection of James II (NG Washington). Benson catalogued his collection in 1914, with the pictures arranged in scholarly order by schools: Sienese

(twelve), Florentine (27), Umbrian (fifteen), Ferrarese and Bolognese (seven), Milanese (seven), Venetian (42) and Veronese (four). Despite the publication of his catalogue, Benson's collection is not well known today, probably because it was never the subject of a spectacular auction sale. Duveen bought the entire collection in 1927 and sold most of it to his American customers, including the banker, Jules S. Bache, who was to bequeath his pictures to the Metropolitan Museum in New York: today Benson's pictures are dispersed across many leading museums in North America.

A collector in startling contrast with these Victorian bankers is Lady Charlotte Schreiber (1812–1895). Her life reads like a novel. She was an exceptionally intelligent and unconventional aristocrat who broke the mould of Victorian collecting and became the greatest collector of English ceramics of all time. She was the daughter of the 9th Earl of Lindsey who died when she was six, with the result that she endured a miserable childhood under an odious stepfather. A natural linguist who spoke seven languages, she became a close friend of Tennyson and Disraeli. She married the widowed Welsh ironmaster, Sir John Guest, who was twice her age, and bore him ten children in what was a very happy marriage. Unusually for the time, she became directly involved in her husband's business, both before and after his death in 1852. Three years later she married her children's tutor, Charles Schreiber, who was aged 29, to the horror of both her family and society. It was not until she was in her fifties that she succumbed to 'China Mania'.

There was nothing whimsical about Lady Charlotte's new passion. She systematically formed a comprehensive collection of English pottery and porcelain from the factories of Wedgwood, Bow, Chelsea, Worcester, Plymouth, Derby and others (fig. 296). Her assiduity is recorded in her lively *Journals*, one of the most complete and honest accounts of what she described as the collector's *chasse*.[9] She gave the English part of her collection to the V&A in 1884 and it remains the cornerstone of the national collection of English ceramics. Her scholarship and thoroughness were legendary; she pored over old account books and even took part in the excavations of kiln sites. Lady Charlotte collected continental wares with an almost equal passion, and her *Journals* offer vivid accounts of visits

296 Lady Charlotte Schreiber

to Italy, for instance trying to persuade a reluctant chemist to part with old blue and white drug vases that had been used in his family for generations. She recorded every price in her *Journals* and certainly never paid a shilling more than she thought was correct. This indefatigable lady 'hunted and high and low, through England and abroad; France, Holland, Germany, Spain, Italy, Turkey, all were ransacked; she left no stone unturned, no difficulty, discomfort, fatigue or hardship of travel daunted her' as her son Montague Guest records.[10]

When Charlotte Schreiber died in 1895 she left the continental wares to her family and fellow collectors such as Augustus Wollaston Franks. Not content with being a giant among ceramic collectors, she also acquired fans. She wrote two books on the subject and gave her own collection to the British Museum in 1891, to which she additionally gave her scholarly collection of playing cards. This extraordinary woman, who lived at Canford Manor in Dorset and Portland Place in London, also assembled a fine group of Old Master paintings, mostly of the Ferrarese school.

From the middle of the 19th century the phenomenon of the 'masterpiece' collection becomes increasingly apparent: broad collections spanning several schools, characterised by the search for top paintings. Two outstanding examples were formed in the second half of the 19th century, the Cook and Iveagh collections. Sir Francis Cook (1817–1901), 1st Bt, though primarily remembered for his Old Master paintings, also assembled the last great collection of Greek and Roman marbles in Britain and possessed excellent decorative arts: enamels, jewels, ivories, amber, bronzes and miniatures. His money derived from his father's linen retailing business, which he expanded into a vast wholesaling empire. Cook lived at Doughty House on Richmond Hill and also owned Beckford's old house, Monserrate, in Sintra, which he remodelled in the style of an oriental palace. But it was above all his paintings which enthralled visitors to Richmond.

Italian paintings predominated. One of the most admired was *The Adoration of the Magi* by Fra Angelico and Fra Filippo Lippi, a tondo painted in Florence between 1440 and 1460 which Cook acquired at the sale in 1874 of Alexander Barker

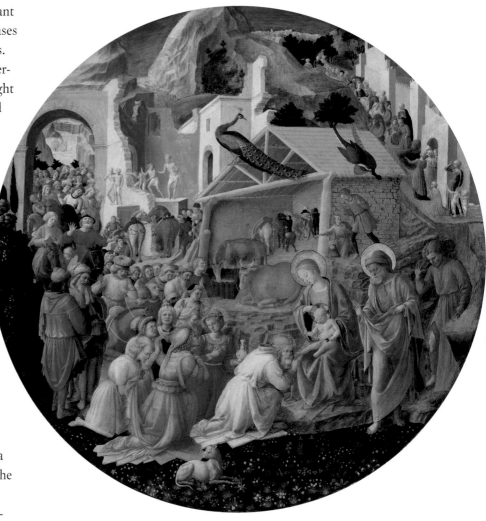

(NG Washington; fig. 297). His other Italian pictures included major works by Antonello da Messina, Giovanni Bellini, Carlo Crivelli, Titian and Raphael.

Cook's most admired northern masterpiece was a work rare in any private collection, a panel attributed to the brothers Jan and Hubert van Eyck of *The Three Marys at the Sepulchre* (Rotterdam; fig. 298). Cook also acquired works by Rubens, Van Dyck, Rembrandt, Claude, Poussin, Chardin, Greuze and Lancret, and François Clouet's *A Lady in her Bath*, which Cook believed to depict Diane de Poitiers (NG Washington), as well as Spanish pictures including Velázquez's *Old Woman Cooking Eggs* (NG Edinburgh) and El Greco's *Christ Cleansing the Temple* (NG Washington). His collection therefore resembled a smaller private version of the National Gallery, London. Astonishingly, his grandson, Sir Herbert Cook (1868–1939), was able to add works of similar quality, notably Titian's *Portrait of a Lady 'La Schiavona'* (NG London) and Rembrandt's *Portrait of Titus* (Norton Simon).

297 Fra Angelico and Fra Filippo Lippi, *The Adoration of the Magi*
Alexander Barker; Sir Francis Cook; now National Gallery of Art, Washington

298 Jan van Eyck and Hubert van Eyck, *The Three Marys at the Sepulchre*
Sir Francis Cook; now Museum Boijmans van Beuningen, Rotterdam

299 Rembrandt van Rijn, *Self Portrait*
3rd Marquess of Lansdowne; 1st Earl of Iveagh; now Kenwood House, Iveagh Bequest (English Heritage)

The dispersal of the Cook collection began after Sir Herbert's death and many of the paintings were acquired by Samuel H. Kress and are now consequently in Washington.

A comparable 'masterpiece' collection was that of Sir Edward Guinness (1847–1927), later 1st Earl of Iveagh. In 1874 he bought his first major painting, Rembrandt's *Judas Returning the Thirty Pieces of Silver* (Private Collection) formerly in the Charlemont collection, but it was the flotation of the family's Dublin brewery on the Stock Exchange in 1886 that gave him ample funds to buy art. Between 1887 and 1891 he acquired nearly 250 pictures, almost exclusively from Agnew's, at a cost of about £550,000. Iveagh's taste was unadventurous and he indulged in the characteristic millionaire's preference for grand 18th-century English portraits. He surrounded himself with 36 by Reynolds, 22 by Romney, and 16 by Gainsborough, competing with the Rothschilds and the Randlords, and anticipating the American boom in English ancestor portraits fuelled by Duveen. In 1888 he paid the then enormous sum of £26,400 for a pair of portraits by Reynolds, *Mrs Tollemache as Miranda* and *Lady Louise Manners*. But his two unquestioned stars were Rembrandt's *Self Portrait* (fig. 299), which cost £27,500 with two other pictures by Bol and Cuyp, and Vermeer's *Guitar Player* (fig. 284), for which he paid £1,050.

The rediscovery of Vermeer was in full spate by the end of the century, with several publications following Théophile Thoré's pioneering study of 1866. George Salting and Alfred Beit also managed each to acquire a Vermeer, but it was a taste that would particularly appeal to American collectors, who were to acquire most of his few available works. Lord Iveagh was one of a handful of British collectors who could compete with the Americans, and like them he wanted his collection to become a public asset. Just before his death in 1927 he bought Kenwood House on Hampstead Heath, a magnificent house by Robert Adam, which opened two years later as the Iveagh Bequest. It was a fitting climax to the great tale of Victorian collecting of Old Master paintings. By the time of Iveagh's death, Old Master collecting on that scale was over in Britain. Samuel Courtauld had already acquired his first Cézanne, and a new era of collecting had dawned that was more specialist in its focus and addressed modernism.

Chapter 21

ECLECTICS AND AESTHETES 1870–1914

Few periods offer as many contradictions as the years between 1870 and 1914. The zenith of the British Empire was ornamented by the *Yellow Book*, the Aesthetic Movement and the Café Royal. It was a period of intensive interchange between literature and visual art which nurtured Walter Pater, Oscar Wilde and Matthew Arnold. London, shrouded in *fin de siècle* mists, supported a colony of wealthy artists whose studios were centres of fashion. The sinuous lines of Japanese art were all the rage, the Arts and Crafts movement flourished against the backdrop of Victorian imperial bombast and Edwardian philistinism.

The Empire confidently threw a girdle of progress and trade around the world: although cracks were already beginning to show, at home the superiority of the British model of empire was seldom doubted. Elgar put it to music, Sargent painted it and Kipling wrote about it. The contradictions of the age are accurately mirrored in its art collecting: the plutocratic excess, the delicacy, the paternalistic philanthropy, the scholarship and the jingoism. Under the surface the tectonic plates of culture were beginning to shift and modernism was seeping through, with – as one cultural historian has put it – 'the consequence that virtually every art form by the turn of the century was to have its obverse and reverse, the world of the establishment and that of the forces setting out to challenge and transform it'.[1] Museums were founded in the great cities and a democratised art became part of the educational curriculum. Art collecting became increasingly linked with public benefaction. Fairfax Murray and Salting left their collections to various established museums, while Lord Leverhulme and Sir William Burrell sought the monument of

The Aesthetic Movement

Frederick Leyland

The Ionides Family

Collectors of Tribal Arts

Sir A. W. Franks and his Collectors

Ricketts and Shannon

George Salting

Ludwig Mond

1st Viscount Leverhulme

The Randlords

Sir William Burrell

300 Kitagawa Utamaro, detail from woodblock print of *Ebiya Oi* (from Seiro Rokassen series) Ricketts and Shannon; now British Museum

a stand-alone museum. If Leverhulme's taste was primarily for British art, Burrell's was Continental art and they shared a fashionable interest in Chinese ceramics.

The lights of Mayfair may have burned more brilliantly than ever but the seeds of aristocratic decline were already sown. The exodus of art to America had begun. Dynastic collecting in the manner of the 18th-century Whigs was finished. Only the South African 'Randlords' attempted it. The Rothschilds had been among the first to buy grand 18th-century English portraits and this remained the taste of the rich. Sargent perpetuated this tradition (fig. 301). Osbert Sitwell observed that the Edwardians knew they were rich but didn't know how rich until they saw how Sargent painted them. Certain French contemporary artists were popular in Britain, where there was a market for Puvis de Chavannes, Bastien-Lepage, Eugene Carrière, Corot and the Barbizon school, but the Paris of *Trilby* and *La Bohème* was considered morally corrupting. The 1862 International Exhibition in London had introduced the public to Japan, a country with an unbroken tradition of craftsmanship. The exhibition fuelled the enthusiasm for a generalised orientalism in which artists took up the Japanesque, while blue and white China Mania preoccupied the middle classes by the turn of the century (fig. 302).

It was a great age of book illustration when Phil May, Dulac, Rackham and Beardsley were all popular. When he was in London Van Gogh particularly admired Leech. What would strike the visitor most about British collections between 1870 and 1914 was their size and variety. Oliver Brown recalled: 'when I walked home through Kensington at the end of the day I used to see through the windows of the tall houses, pictures hung in three or four rows almost to the ceiling'.[2] An extreme example was the collection of James Staats Forbes, the General Manager of the London, Chatham and Dover Railway Company. Staats Forbes had a passion for pictures and assembled over 4,000. He liked landscapes of the Barbizon school by Rousseau, Daubigny, Millet and Corot and the Modern Dutch School represented by Mattijs Maris and Jozef Israels, which he combined with John Constable and the Norwich School. After Forbes's death the Leicester Galleries dispersed his collection in a series of exhibitions extracted from

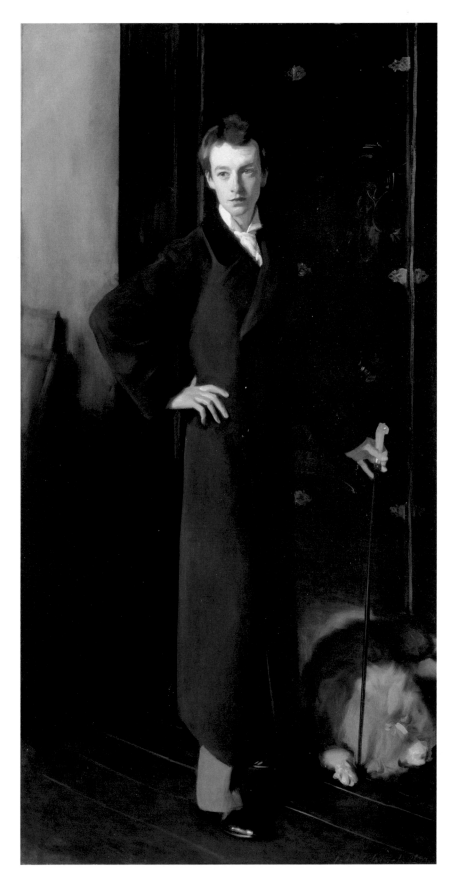

the stacks stored under the roof at Victoria Station.

The grip of the Royal Academy and its exhibitions so doggedly patronised by the trustees of the Chantrey Bequests and the Establishment was challenged by the Aesthetic Movement. Walter

Pater's *The Renaissance* (1873) preached the gospel of art for art's sake and in 1877 the Grosvenor Gallery was founded by Sir Coutts Lindsay and the opening put it into practice. Graham Robertson, the artist and author, commented, 'The opening of the Grosvenor Gallery was to be an epoch-making event, said rumour, and for once rumour was right.'[3] It exhibited Burne-Jones, Walter Crane and Whistler and was lampooned by Gilbert and Sullivan in *Patience*: 'a pallid and thin young man, a haggard and lank young man, a greenery yallery Grosvenor Gallery, foot in the grave, young man'. Whistler had introduced oriental porcelain and Japanese prints into his paintings and set the

tone for collectors such as the Ionides family and William Cleverly Alexander (1840–1916). The latter was the wealthy head of a bill-broking and banking business in Lombard Street, a member of the Burlington Fine Arts Club, of whom Roger Fry said he 'was able to save England from the disgrace of leaving Whistler unrecognised'.[4] The artist painted portraits of his three daughters (fig. 304). Alexander, who lived at Aubrey House in Kensington, also collected fine pictures by Cuyp, Hals, Hogarth and G.B. Tiepolo as well as Chinese Qing porcelain, a popular taste of the time, but more unusually he bought Song period pieces.

Whistler's most famous patron, introduced to him by D.G. Rossetti in 1864, was the Liverpool shipping magnate, Frederick Richards Leyland (1832–1892). Leyland collected Renaissance art, patronised the Pre-Raphaelites and in 1876 commissioned Whistler to decorate his London dining-room at 49 Princes Gate. This metamorphosed into the Peacock Room (Freer; fig. 303) whose primary purpose was to showcase his Chinese blue and white porcelain. Artist and patron fell out over the commission which, despite bringing bad luck to all parties, remains the finest achievement of the Aesthetic Movement. The movement's pervasive influence was ridiculed by the poet Swinburne: 'the fairyland of fans, the paradise of pipkins, the limbo of blue china, screens, pots, jars, joss-houses and all the fortuitous frippery of Fusiyama [*sic*]'.[5]

At the centre of the blue and white porcelain craze was the dealer Murray Marks who operated from a shop in Oxford Street. Norman Shaw redesigned the building in the 'Queen Anne' style, while his business card was 'the combined works of Rossetti, William Morris and Whistler. Rossetti designed the Chinese ginger jar and peacock feathers, Morris the lettering, and Whistler, the background.'[6] Marks, who supplied the blue and white porcelain for the 'Peacock Room', commented that Leyland was not a true collector because he only bought pieces when they were needed to decorate a particular location.[7]

The Aesthetic Movement threw up several serious collectors, notably the Ionides family. Of Greek origins, with a Manchester textile fortune, they settled in the grand London artists' *quartier* around Melbury Road. Alexander (1810–1890) patronised Whistler and discovered that most fallen of late Victorian enthusiasms, G.F. Watts.

His son Constantine (1833–1900) combined an interest in early Renaissance and Pre-Raphaelite paintings with an enthusiasm for modern French art: Delacroix, Daumier, Millet, Courbet, Degas and Rodin and some significant Old Master paintings including Le Nain's *Landscape with Figures*. He bequeathed his collection of over a thousand paintings, drawings and prints to the

V&A. Constantine's brother Aleco (1840–1898) brought together the Aesthetic Movement with the Arts and Crafts Movement in his remodelling of his father's London house at 1 Holland Park. His collection of pottery and antiquities was displayed with paintings by Rossetti, Burne-Jones, Whistler and Simeon Solomon, set in interiors designed by Philip Webb, Thomas Jekyll and William

303 The Peacock Room
Commissioned by F.R. Leyland for the dining room of his London house at 49 Princes Gate; now at Freer Gallery of Art, Washington, DC

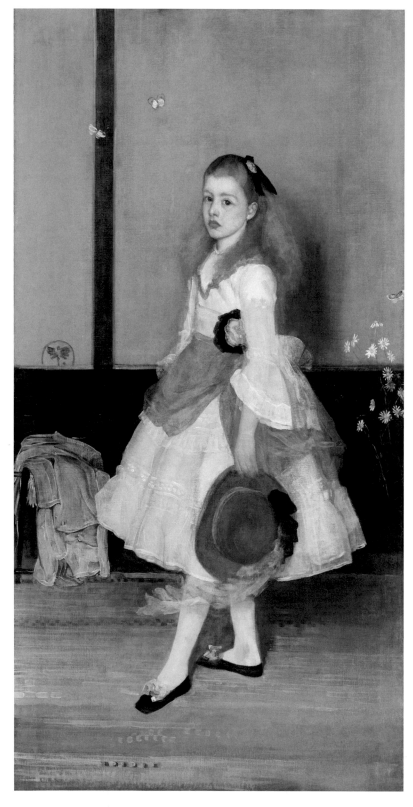

304 James Abbott
McNeill Whistler,
*Harmony in Grey and Green:
Miss Cicely Alexander*
William Cleverly Alexander;
now Tate Britain, London

Morris. The cultured aristocratic coterie known
as the 'Souls' even took the style to the country
house. Percy and Madeline Wyndham engaged
Philip Webb to design Clouds in Wiltshire, and
William Morris to decorate it, as a 'glorified Kate
Greenaway affair, all blue and white inside, and all
red and green outside.'[8]

 If China and Japan had been colonised by the

Aesthetic Movement, the tribal artefacts of Africa
and the Pacific remained the province of special-
ists. In 1890 Sir Charles Hercules Read wrote of
the British Museum acquisition of the London
Missionary Society 'idols' that 'the series illustrates
in a very complete manner the degradation of
an ornamental group of human figures to a mere
conventional symbol'.[9] Explorers, missionaries and

soldiers brought back a vast quantity of artefacts at the height of the empire. Those which did not go directly to museums were acquired by a small group of dedicated collector/dealers. Typical was W.D. Webster who issued the first illustrated sale catalogues of ethnographical artefacts and 'was the last dealer not to depend on the break up of museum collections as a major source for his stock'.[10] Webster's interests were broad and included African, American and Pacific material. James Edge-Partington (1854–1930) of the British Museum was unusual in being a collector who travelled to find material and spent a lengthy sojourn in Fiji. His fine Pacific collection was split between the British Museum and the Auckland Museum in New Zealand. A younger collector who knew Edge-Partington through the Royal Anthropological Institute and was mentored by Webster was William Oldman (1879–1949) of Brixton Hill who issued his first catalogue in 1902. He was a classic dealer-collector who built up the finest Polynesian group ever assembled by one man. He exerted a huge influence on his contemporaries and his collection was purchased by the New Zealand government for £44,000 in 1948.

The late 19th century and early 20th century was a period of outstanding museum curators who guided collectors and persuaded them to leave their treasures to the public. Most of these collections were fairly wide-ranging in character and well suited to museums developing a range of departments. Sir Augustus Wollaston Franks at the British Museum effectively created several of its specialist departments, attracting Henry Christy's collection of ethnographical and prehistoric material in 1865, Felix Slade's collection of glass in 1868, John Henderson's collection of Oriental material in 1878, and, after Franks's death, Ferdinand de Rothschild's bequest in 1898 of illuminated manuscripts and *Schatzkammer* treasures including the Reliquary of the Holy Thorn. The Ashmolean Museum in Oxford was fortunate in its benefactor, C.D.E. Fortnum (1820–1899), who not only caused the reorganisation of its collections but also gave his extraordinary collection of maiolica, bronzes, classical antiquities, rings and gems (fig. 305).

The Fitzwilliam Museum at Cambridge attracted a number of gifts from artist-collectors. Charles Fairfax Murray gave his Titian *Tarquin and Lucretia* and a part of his important

305 Maiolica dish with Hercules and the Hydra, probably by Maestro Giorgio Andreoli

C. D. E. Fortnum; now Ashmolean Museum, Oxford

Pre-Raphaelite collection. In 1908 the museum appointed a young and acquisitive director, Sydney Cockerell. This larger-than-life personality had caught the tail of the Arts and Crafts and the Pre-Raphaelite movements, and been on close terms with John Ruskin and William Morris. He proved a magnet for collectors, attracting princely bequests such as that of the artists Charles Ricketts (1866–1931) and Charles Shannon (1863–1937), two apostles of art whose 'flat was filled with exquisite things, Persian miniatures, Tanagra figures, Egyptian antiques, jewels and medals, which millionaires had overlooked'.[11] Both apprenticed as wood-engravers, they had met in the 1880s and lived in Bohemian Chelsea where they set up The Vale Press. Ricketts later became an important theatre designer. By the time of Shannon's death in 1937 their collection comprised over a thousand items, most of which went to Cambridge. They collected early antiquities, particularly Egyptian, Attic red-figure pottery, Japanese prints, and drawings. The Japanese prints, mostly by Utamaro (fig. 300) and Hokusai, they left to the British Museum, where they had been friendly with the Print Room curator Laurence Binyon. Drawings were the most

numerous part of their collection including sheets by Tiepolo, Rembrandt, Goya, Watteau (fig. 306), Delacroix, Bayre, Puvis de Chavannes and Rodin, as well as their English near-contemporaries: Burne-Jones, Ernest Cole and Alfred Stevens. In January 1920, they bought at auction Van Dyck's *Portrait of Archbishop Laud* (Fitzwilliam). Ricketts wrote afterwards of their 'great stroke of luck having bought at Christie's (all London having seen it) for the price of a good frame, Van Dyck's missing portrait of Laud'.[12]

The largest museum bequest of the time was that of George Salting (1835–1909). Of Danish descent, brought up in Australia and educated at Eton, Salting was a bachelor who inherited an enormous fortune from sheep stations. Thrifty in his own habits – living in a two-roomed flat in St James's – he spent his fortune on art. 'The greatest English art collector of his age, perhaps of any age,' *The Times* wrote on his death with excusable hyperbole. Salting's range and discrimination were impressive: 2,500 Renaissance bronzes (fig. 307), ivories, Limoges, enamels, Barbizon school paintings, drawings by Clouet, Rembrandt, Turner, and an Old Master painting collection that included

Vermeer's *Young Woman Seated at a Virginal* (NG London). His Chinese ceramics collection mirrored that of A.W. Franks (whose breadth of interests was shared by Salting), and was above all distinguished by 18th-century examples of brilliant virtuosity. These were divided between the British Museum and the V&A, while 93 paintings went to the National Gallery in 1909.

The National Gallery received another valuable bequest in the same year, the Italian paintings of the German industrialist, Ludwig Mond (1839–1909) which reflects the cult of the masterpiece, so evident in the Iveagh collection. Mond settled in England in the 1860s and specialised in chemically producing soda and ammonia and other practical applications of science. Such a careful and serious man wanted the best advice and he consulted the German art historian, Jean Paul Richter, an early instance of the independent adviser, neither museum curator nor dealer. Mond wanted paintings fit for a public gallery and the quality of his acquisitions was prodigious: Botticelli's *Scenes from the Life of St Zenobius*, Raphael's enchanting *Crucified Christ with the Virgin Mary, Saints and Angels* (fig. 308)

and Bellini's *Pietà* (all NG London), as well as works by Correggio, Mantegna, Titian and Guardi. Mond had a special fondness for Venetian art and left over 40 paintings (half of his collection) to the National Gallery with a troublesome clause that they should be displayed together.

If most collectors were content to leave their collections to established museums – albeit with conditions – William Hesketh Lever, later 1st Viscount Leverhulme (1851–1925), was one of the last British general collectors to found his own museum. Art collecting began as a commercial adjunct to his successful soap-making business,[13] and then became a means of furnishing his country house, Thornton Manor, Cheshire. Around 1896, Lever met the artist, collector and dealer, James Orrock, who steered him towards creating a collection of British art which was the basis of the Lady Lever Art Gallery at Port Sunlight. Lever followed many earlier northern industrialists in buying Victorian pictures (fig. 309), particularly those of Frederic Leighton. Orrock may have encouraged him to collect the grand-manner portraits of Reynolds and his contemporaries which exemplified tycoon taste of the time. In 1913 he bought heavily at the sale of George McCulloch including paintings by Millais, Leighton, Rossetti and Holman Hunt.

At about the same time Lever conceived the Port Sunlight Museum, a monument that is both educative and paternalistic. Its handsome Beaux Arts building (fig. 310) occupies the centre of a model village of workers' houses in the Arts and Crafts style. As a piece of social engineering, it creates an odd, self-conscious impression, but is filled with fascinating works which reveal the tension between 18th- and 19th-century British art. The furniture reflects an earlier taste and includes the best group of English commodes anywhere. Lever was not immune to fashionable orientalism and collected blue and white porcelain[14] as well as *famille vert* and *famille noir*. He bought Lord Tweedmouth's collection of Wedgwood pottery and had a penchant for the nude paintings of William Etty.

If there was one group of collectors who demonstrate the conspicuous consumption and plutocratic excess of the Edwardian era it was the Randlords, whose fortunes derived from the goldfields and diamond mines of South Africa. Sir Joseph Robinson took a lease on Dudley House in

Park Lane and filled it with expensive Old Master paintings, particularly French 18th-century works by Boucher, but also by Gainsborough, Frans Hals and Murillo. Among contemporaries he favoured Millais but in his later manner. Alfred Beit (1853–1906) was a more ambitious collector who consulted two excellent advisers, Rodolphe Kann and the celebrated German curator and scholar Wilhelm von Bode, who in return received donations to the Kaiser Friedrich Museum in Berlin. Beit favoured Dutch 17th-century paintings and owned many wonderful examples: Rembrandt's

308 Raphael,
The Crucified Christ with the Virgin Mary, Saints and Angels (The Mond Crucifixion)
1st Earl of Dudley; Ludwig Mond; now National Gallery, London

309 Sir Edward Burne-Jones,
The Beguiling of Merlin
Lord Leverhulme; now Lady Lever Art Gallery, Port Sunlight

310 The Lady Lever Art Gallery, Port Sunlight

Portrait of a Man (Melbourne), Vermeer's *A Lady Writing a Letter*, Ruisdael's *Castle at Bentheim* and a series of six canvases depicting the *Parable of the Prodigal Son* by Murillo. His wealth enabled him to afford anything. Lady Dorothy Nevill remarked that the plutocratic collectors of the time surrounded themselves 'with the beautiful 18th century portraits of the class they have conquered'.[15] A bachelor, on his death Alfred bequeathed his collection to his brother, Sir Otto Beit (1865–1930), who hung important works by Raeburn, Reynolds, and Gainsborough as well as Goya's *Portrait of Doña Antonia Zárate* in his Belgrave Square dining room. Bode failed to interest Beit in Italian Renaissance painting but he formed instead a fine collection of bronzes and maiolica. Sir Otto's son, Sir Alfred, removed the greater part of the collection to Russborough, Co Wicklow, and bequeathed seventeen of the greatest paintings to the National Gallery of Ireland (including works by Velázquez, Goya, Vermeer, Metsu, Ruisdael, Murillo, Gainsborough and Raeburn) and the remainder of the collection and the house to the Alfred Beit Foundation.

Sir Julius Wernher (1850–1912) was the most enigmatic of the Randlords. Born in Darmstadt with a Lutheran background, he was the first Randlord to return to Europe, and although he chose to live in London his tastes remained continental. He was never principally a buyer of paintings like Beit, although three of his pictures today hang in the National Gallery: Watteau's *The Scale of Love* (bequeathed by Wernher), Altdorfer's *Christ Taking Leave of his Mother* (fig. 313) and *St Michael* by Bartolomé Bermejo. He bought the obligatory 18th-century portraits but his main passion was for the decorative arts: medieval ivories, tapestries, bronzes, Limoges enamels, Renaissance jewellery, maiolica and Hispano-Moresque ceramics. Photographs of his London home, Bath House, show this astonishing hoard, the most singular of the Randlord collections (figs 311–312). Wernher took advice from Bode, but fell out with him – partly for not being generous enough to the Berlin museum – and was to a large extent his own man. The Altdorfer, which he bought from the scholarly dealer Langton Douglas, was a startlingly original purchase for a London-based collector at that time. Wernher's country house was Luton Hoo in Bedfordshire which he altered in the French manner using the

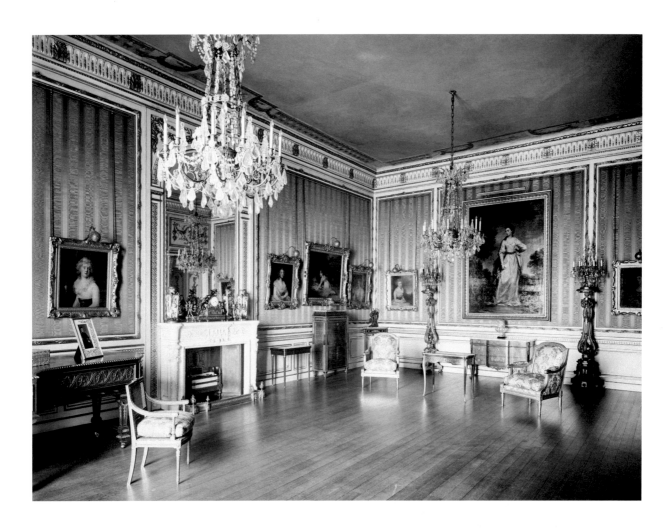

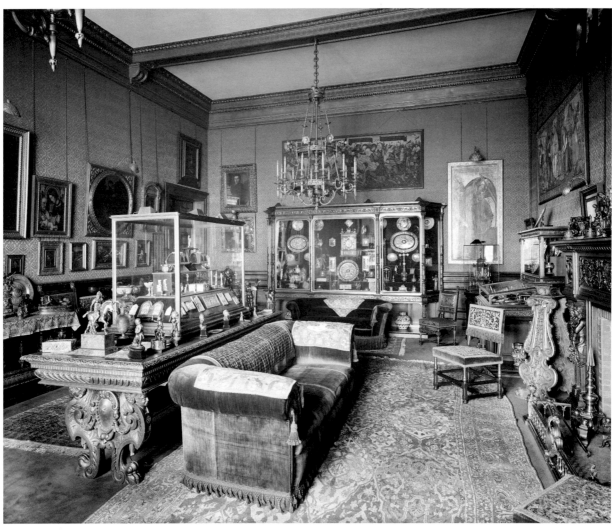

architects of the Ritz, Mewès and Davis.

It is fitting to end this chapter with Sir William Burrell (1861–1958) because he represents so many of the tastes of the period and sustained them until after the Second World War. Burrell was a Glasgow ship-owner who started collecting under the influence of the great Glasgow dealer, Alexander Reid, and the Scottish industrialist collectors, Alexander Young, Arthur Kay and W.A. Coats. From the 1880s until the 1940s Burrell collected relentlessly, haggling with dealers over works of art. He was a conservative in his taste for paintings, enjoying Boudin, Géricault, Daumier, Monticelli and Whistler, assembling over twenty works by Degas, including *The Rehearsal*. His

Old Masters included a Rembrandt *Self Portrait* (from the Orléans collection) but Burrell's greatest enthusiasm was his vast collection of medieval works of art and sculpture. He was proudest of his 150 tapestries from the 15th and 16th centuries, representing all the main centres of production. A major group of Chinese ceramics and bronzes rounded off the last collection of its kind to be formed in Britain. It took many years to reach its present home. Burrell gave 6,000 pieces to the city of Glasgow in 1944 but it was not until 1983 that the museum which bears his name opened, with an additional 2,000 items. Its contents bridge the divide between the taste of the 19th century and that of the 20th century.

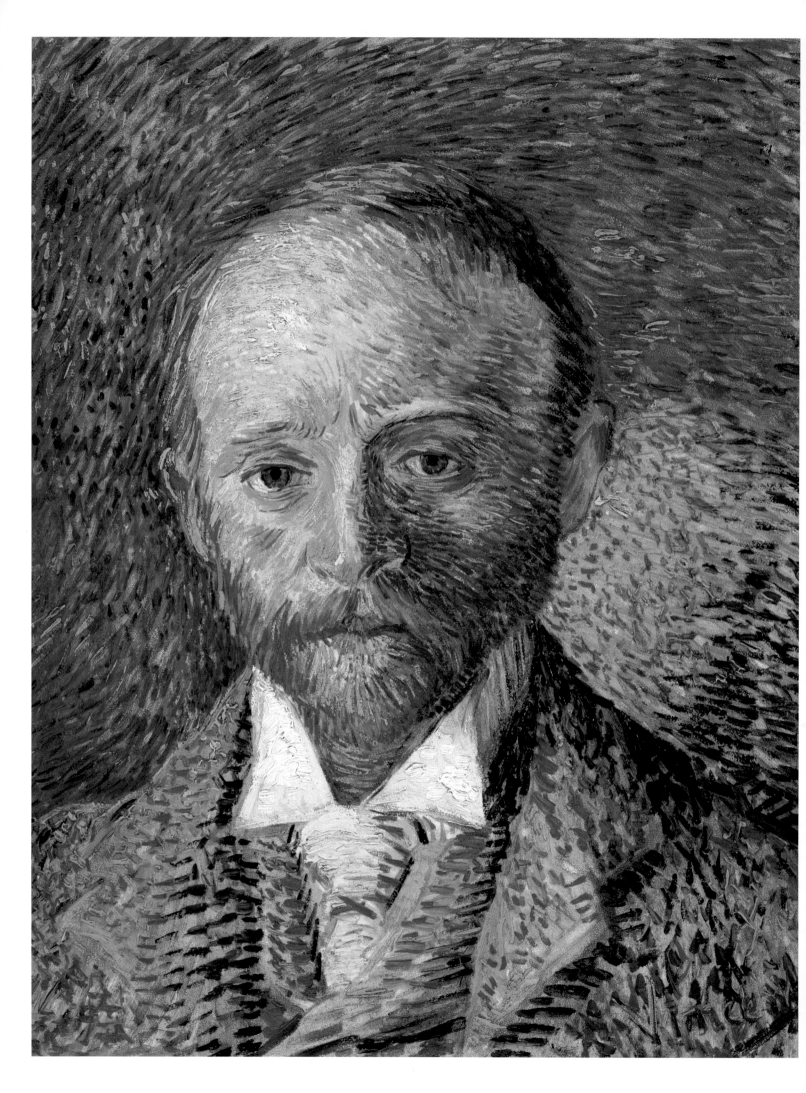

Chapter 22

CATCHING UP:
MODERNISM 1880–1945

In his review of the 1845 Paris Salon Baudelaire wrote, 'It is true that the great tradition is lost and that the new one is as yet unformed'.[1] The world did not have to wait long. In 1863 Manet exhibited *Le Déjeuner sur l'herbe* and nine years later Monet painted the eponymous *Impression-Sunrise* that was to give the new movement its name. A British audience, fed on the anecdotal subject matter of Frith served up with the polished detail of Landseer, had difficulty understanding the new French Impressionist School. They collected Corot's dreamy landscapes in large numbers, while the sculptor Jules Dalou, who spent eight years in England between 1871 and 1879, altered the course of British sculpture. The great Parisian dealer Durand-Ruel opened a gallery in London in 1870 to sell French artists, particularly the Barbizon school, but it closed a mere five years later. Lord Salisbury's dictum of British foreign policy as 'splendid isolation' was much truer of the arts. A mixture of imperial triumphalism and cultural provincialism meant that London cast an arrogant and sceptical eye on newer artistic arrivals from Paris. The main early collectors of Impressionist paintings were German and American. When a small band of British collectors finally discovered modern French art, they showed a public-spirited zeal to change attitudes and many of them bequeathed their collections for public enjoyment. The notion of leaving art to the nation was well established during the 19th century but it is striking how this became the motivating force for so many early 20th-century collectors. The National Art Collections Fund was founded in 1903 and collectors were now both competing with, and often collecting for, the State.

Captain Henry Hill

Sir Hugh Lane

Gwendoline and Margaret Davies

Leicester Galleries

Alex Reid and Scottish Collectors

Samuel Courtauld

Michael Sadler

Sir Edward Marsh

Bloomsbury Group

Sir Herbert Read

Edward James

Douglas Cooper

Roland Penrose

314 Vincent van Gogh, *Portrait of Alexander Reid*
Alexander Reid; now Kelvingrove Art Gallery, Glasgow

The first real foothold for advanced French painting in London was the 1910 exhibition of Manet and the Post-Impressionists, the brainchild of the brilliant critic Roger Fry, which showed the works of Manet, Cézanne, Van Gogh, Gauguin, Picasso and Matisse. This was followed up two years later with another exhibition which besides the French included Russian and English artists. The art critic Clive Bell wrote, 'The battle is won… we have ceased to ask, 'What does this picture represent?' and ask instead "What does it make us feel?"' In reality the battle was far from won. The British public and the national museums were extraordinarily slow to appreciate Impressionism and its successors. It was left to a small number of critics and collectors to achieve the surgical operation of getting Manet, Monet and Cézanne into public collections. The story of the reception of Continental Modernism from the 1880s up until the 1930s was one of catching up. By then Britain had produced a talented group of critics and collectors who were fully in touch with developments of European art and were even a part of them. The story has four overlapping categories of collector: [1] the first generation of Impressionist collectors exemplified by the Davies sisters with one foot still in traditional 19th-century art; [2] the generation of Post-Impressionist collectors such as Michael Sadler and Maynard Keynes, who also picked up the new generation of British artists influenced by them; [3] those who collected only young British artists, like Edward Marsh; and [4] the brilliant 1930s trio of Edward James, Roland Penrose and Douglas Cooper, collecting surrealism and cubism. Towering over them all is Samuel Courtauld who bought only the finest Impressionist and Post-Impressionist paintings, quite late but still available at a price.

The honours for holding the first Impressionist paintings in Britain are usually awarded to Captain Henry Hill (1812–1892), variously described as a tailor and a retired soldier. He lived on Marine Parade in Brighton where he was a town councillor. It was during the brief life of the London Durand-Ruel Gallery that Hill purchased a number of paintings by Degas. By 1876 he owned seven works by the artist including *L'Absinthe* (fig. 315) and *Classe de Danse* (Louvre) as part of an enormous collection of 400 paintings including a Whistler and a Monet. His collection was destined for Brighton Art Gallery, which he had helped to found, but because of a dispute with the Corporation, it was sold in two auctions at Christie's in 1889 and (in a posthumous sale)

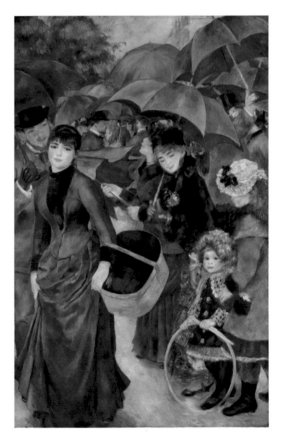

315 Edgar Degas, *L'Absinthe*
Captain Henry Hill, Brighton; now Musée d'Orsay, Paris

316 Pierre-Auguste Renoir, *Les Parapluies*
Sir Hugh Lane; now National Gallery, London

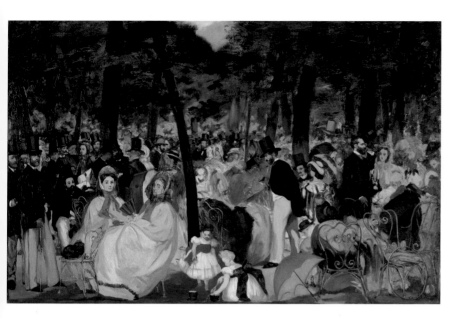

317 Edouard Manet,
Le Concert aux Tuileries
Sir Hugh Lane;
now National Gallery, London

1892. This was the first time Impressionist paintings were sold at a London auction. Sickert bought Degas's *Repetition d'un Ballet sur la Scène* (Metropolitan), owned by Henry Hill between 1876 and 1889, while *L'Absinthe* (which was hissed at when presented) was bought by an unusual Scottish dealer, Alex Reid, who had once shared an apartment with Van Gogh and his brother Theo.

Despite the hissing, Degas, the most classical of the Impressionists, was relatively easy to swallow and it is unsurprising that the first Impressionist to enter a British public collection was Degas's *Ballet Scene from Robert Le Diable* which slipped in – like the Vermeer into the Royal Collection – barely registered amid the huge Ionides bequest in 1901 to the Victoria and Albert Museum. Mr and Mrs Fisher Unwin owned a group of Degas paintings and, more unusually, a painting of *Flowers* by Van Gogh, acquired in the 1890s. In Scotland the first Impressionist collector was a Greenock sugar refiner, James Duncan, who bought Renoir's late *The Bay of Naples* (Metropolitan) from Durand-Ruel in Paris in 1883. Interestingly, Duncan also owned by far the most important Delacroix to come to Britain, *The Death of Sardanapalus* (Louvre) which he was forced to sell when his finances collapsed.

The first thing that strikes the student of Impressionist collecting in Britain is that the main characters are at one remove from the London establishment: Nonconformists, Scotsmen, Welsh ladies or. in the case of Hugh Lane, an Irishman. Lane was a charming, but highly strung

Anglo-Irish dealer, the son of a clergyman and a mother from Galway gentry stock. An unstable childhood followed a parental separation. Lane lacked a formal education (his mother taught him French) and he was apprenticed at the age of seventeen to the art dealer, Martin Colnaghi. He soon branched out on his own and was an enterprising and energetic dealer in Old Master paintings. While he made his money in London, his aunt, Lady Gregory, introduced him to the Dublin intelligentsia, including W.B. Yeats. No doubt inspired by the Irish cultural renaissance, a mission formed in Lane's mind to promote modern art to the Irish people, and to a lesser extent to the English. He was impressed by the Staats Forbes collection, and in 1904 Lane went to Paris with the painter William Orpen to buy paintings. What is remarkable is the confidence with which Lane bought two masterpieces from Durand-Ruel: Manet's *Portrait d'Eva Gonzales* and Renoir's *Les Parapluies* (fig. 316). The same year he organised a successful exhibition at the Royal Hibernian Academy of Modern Art, comprised of loans, largely from the executors of Staats Forbes, which triggered Lane's desire for a permanent modern collection in Dublin.

By 1908 Lane had drawn up a list for 'a conditional gift of continental pictures' which included works by Boudin, Puvis de Chavannes, Corot, Courbet, Daubigny, Daumier, Degas, Ingres, Mancini, Manet, Monet, Monticelli, Pissarro and Vuillard. The London National Gallery was used as a lever to persuade the City of Dublin to come up with a permanent home and the architect Lutyens even prepared a design. However, Lane's intentions and will went backwards and forwards between the two. In 1915 he drowned on the *Lusitania* and although his intention at that time was to leave everything to Dublin, an unwitnessed codicil meant that London had possession of 39 French paintings, which caused a dispute that took years to resolve by a sharing arrangement. The majority of his paintings are today in Dublin and include a number of distinguished Old Masters by Titian, El Greco and Rembrandt which hung in Lane's London home, Lindsey House, on Cheyne Walk. Lane was at heart a classicist who disliked Picasso and the avant-garde. His early purchases of Manet's *Le Concert aux Tuileries* (fig. 317), Renoir's *Les Parapluies* and Degas's *Sur la Plage*, however,

give him an imperishable position in the story of British collecting.

Gwendoline (1887–1951) and Margaret (1884–1963) Davies were two remarkable sisters who formed one of the three great surviving national assemblages of Impressionists (figs 319–320). From a Nonconformist, Methodist background, they inherited a coal and railway fortune of around £1 million from their father in 1907. It was Hugh Blaker, the brother of their governess, who introduced the sisters to art collecting and he remained their guide. The sisters, who never married, started collecting in 1908 with a pair of late Turner oils from Colnaghi. Millet, Corot, Raeburn and Meissonier followed, but in January 1912 Gwendoline bought a view of Venice by the artist whom many regarded as the English Impressionist, James McNeill Whistler. Venice was to remain a favourite subject for the sisters. In August Hugh Blaker wrote from Paris, 'I will certainly keep my eyes open in Paris for anything good, and am delighted that you think of getting some examples of the Impressionists of 1870. Very few English collectors except Hugh Lane have bought them at all, although much of their best work is in America.'[2] In October Margaret bought Monet's *Grand Canal, Venice*, a Boudin and a Manet sketch from Bernheim-Jeune in Paris. Not to be outdone, Gwendoline followed suit with two Monets of San Giorgio Maggiore from the same source. In 1912 the Davies sisters spent £19,000 on art purchases which included works by Millet, Rodin and Daumier, who became a favourite.

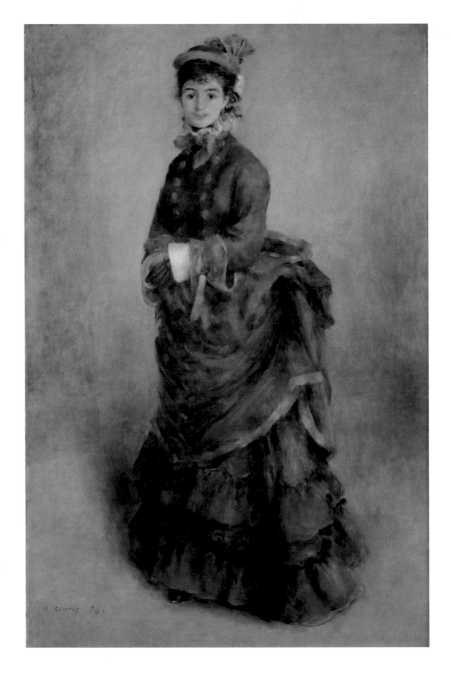

318 Pierre-Auguste Renoir, *La Parisienne*

The Davies sisters; now National Museum of Wales

319 Margaret Davies

320 Gwendoline Davies

321 Claude Monet,
Nymphéas
The Davies sisters; now National
Museum of Wales

In December 1912, perhaps inspired by Hugh Lane's loan to Dublin, the Davies sisters agreed to exhibit their collection anonymously in Cardiff City Hall. The sisters who were philanthropically minded, no doubt wanted to share their good fortune and they even paid the costs of mounting the show. The exhibition, inevitably controversial at so early a date, was in Blaker's words 'a milestone in Welsh artistic development'. The years 1913–14 saw the consolidation of Monet as the central figure in the collection with three *Nymphéas* (fig. 321) as well as London and Venetian views. The sisters spent £6,280 on five good Monets but this must be set against £5,250 for a single painting by Matthijs Maris, *He is Coming*. They bought eight works by Daumier during the same period. Gwendoline

spent £5,000 at the Grosvenor Gallery on Renoir's great *La Parisienne* (fig. 318), a striking purchase since the sisters, with their Calvinist roots, usually avoided metropolitan Paris. They preferred Venetian views, landscapes and peasant subjects over fashionable scenes. A daring purchase by Gwendoline was a bronze cast of Rodin's *The Kiss*. The sisters also bought bronze casts of wax models by Degas, but never a painting by him.

The 1914 war interrupted the collecting and the sisters directed their financial resources to helping Belgian refugees. In 1916 they were the main buyers at Augustus John's exhibition at the Chenil Gallery. The following year Gwendoline was back on form buying from Bernheim in Paris, Monet's *Rouen Cathedral: Setting Sun*, and the first major

Cézannes in Britain, *Mountains at L'Estaque* (fig. 322) and *Provençal Landscape – The Copse*.[3] In 1920 this was followed by another Cézanne, *Still Life with Teapot* (£2,000), and Van Gogh's *Rain, Auvers* (£2,020), as well as, surprisingly, Margaret spending £9,000 on a portrait attributed to Frans Hals. Their talent undoubtedly lay with the new art but by 1921 Gwendoline was expressing doubts about art collecting in the face of so much human misery in the world. The art collecting did continue but their main focus from the 1920s onwards was Gregynog Hall and the artistic and musical activities they initiated, particularly the Gregynog Press. On the death of the two sisters, in line with their idealism, their collection went to the National Museum of Wales. The collection Cardiff received was astounding by any standards. About half of it represented progressive taste including many British artists: Walter Sickert, Harold Gilman, Ivon Hitchens and John Piper.

Artists were among the first to appreciate Impressionism, and in 1886 a group that included John Singer Sargent, Wilson Steer, Walter Sickert and William Rothenstein formed the New English Art Club which was heavily Francophile and set itself up against the traditionalist Royal Academy. Over the next three decades other groups were to follow: the Camden Town Group, the London Group and the Euston Road School, all of whom modified and anglicised Continental painting and subject matter. Collectors rarely remained loyal to any one group, and nor for that matter did the artists. The arrival of the Ballets Russes in London from 1910 onwards had an enormous influence on metropolitan taste but it was the role of dealers that was to be pivotal. The acceptance of Impressionism and later developments in Europe was largely due to the persistence of a group of remarkable dealers, Vollard and Durand-Ruel in Paris, Cassirer in Berlin and Alex Reid in Glasgow.

322 Paul Cézanne, *Mountains at L'Estaque*
The Davies sisters; now National Museum of Wales

In London the role of the creative dealer was played by the Leicester Galleries which virtually invented the one-man show in Britain long before it was adopted by museums. The Phillips brothers and later Oliver Brown at the Leicester Gallery were responsible for the first one-man shows in London of Boudin (1906), Matisse (1919, at which Michael Sadler, Maynard Keynes and George Eumorfopoulos bought works), Picasso (1921), Degas (1922), Van Gogh (1923), Gauguin (1925), Cézanne and Renoir (both in 1926). The gallery not only influenced collectors but also a generation of young English artists whom they picked up and exhibited including Walter Sickert, Wilson Steer, Wyndham Lewis, Barbara Hepworth, Stanley Spencer and Ben Nicholson. The history of avant-garde English collecting between 1900 and 1930 is virtually the history of the Leicester Galleries.[4] In Scotland that position was held by Alex Reid, the son of a Glasgow carver, gilder and dealer, who went to Paris in 1887–89 to learn the trade. He was apprenticed to Theo Van Gogh, who introduced him to his brother Vincent. The artist painted two portraits of Reid in 1887 – a head and shoulders now at Glasgow (fig. 314), and a sketchier seated portrait at the University Museum at Oklahoma – but the relationship was strained by the canny dealer's refusal to buy Van Gogh's work outright, only selling it on commission.

Reid returned to Scotland in 1889 and established his influential gallery in Glasgow, La Société des Beaux-Arts, the forerunner to the Lefevre Gallery. In 1891–92 he exhibited Monet's *Vétheuil* as well as works by Corot, Monticelli, Courbet, Puvis de Chavannes and above all Degas, in Glasgow and at Arthur Collie's Gallery in London. It was largely through Reid that William Burrell became so hooked on the paintings of Degas, eventually owning 23. The 1920s were the heyday for Scottish Impressionist collections, with the Glasgow shipbuilder William McInnes buying Monet and Sisley, Sir John Richmond (engineer) buying Pissarro, and Leonard Gow (ship owner) buying Manet. Whistler was especially popular in Scotland but it was Manet who was to have the most influence on the next generation of Scottish painters: Cadell, Peploe and Fergusson. Alex Reid's son, McNeill Reid, soon began to promote them alongside the foreign artists. In 1921 William McInnes bought Van Gogh's *Le Moulin*

de Blúte-fin and hung it alongside his Scottish colourists. William Boyd, a Dundee jam manufacturer, bought his first Van Gogh in 1922, *Field with Ploughman*, to join his collection of paintings by Monet, Sisley and Peploe.

One of the earliest Scottish female Post-Impressionist collectors, Elizabeth Workman, brought the first Gauguin to Scotland in 1923, *Martinique Landscape*, and later owned his *Self Portrait* (NG Washington) as well as three Van Goghs including *The Hospital at Arles* (Reinhart). David and William Cargill, who had the Burmah Oil fortune behind them, bought works by Degas, Monet, Manet, Toulouse-Lautrec, Cézanne and Gauguin as well as Scottish colourists. The extraordinary run of Scottish Impressionist collections comes to an end with Sir Alexander Maitland, QC, mainly collecting in the 1930s, who gave 21 paintings of extraordinary quality to the Scottish National Gallery including Cézanne's *Mont Sainte-Victoire*, Van Gogh's *Orchard in Blossom*, Sisley's *Molesey Weir, Hampton Court* and Monet's *Haystacks*. Many of the collectors – an exception being the Cargills – left their paintings to the Scottish nation, but none were as splendid as those of Maitland, which at one stroke gave the National Gallery a major international collection in this field.

That one collector can inspire another is amply illustrated by the example of Samuel Courtauld (1876–1947), the giant of all British Impressionist collectors, who was inspired by seeing paintings belonging to Hugh Lane and the Davies sisters. Douglas Cooper wrote that 'the formation of Samuel Courtauld's collection was a cardinal event in the history of artistic taste in England'.[5] He assembled one of the finest Impressionist and Post-Impressionist collections in existence and it has a very attractive character. A successful and hard-working textile manufacturer from a Unitarian background, with a strong sense of liberal idealism, he is an austere figure until you consider the art he purchased. His interest in art was first awakened on a trip to France and Italy with his wife in 1901. Courtauld began to appreciate how dead English art had become and recognised that the Old Master tradition was most alive in the modern French school. In his own words, 'My second real "eye-opener" was the Hugh Lane collection which was exhibited at the Tate Gallery in 1917.

There I remember especially Renoir's *Parapluies*, Manet's *Musique des Tuileries* and Degas's *Plage à Trouville...* I knew nothing of Cézanne.'[6] This was remedied by seeing *Provençal Landcape*, belonging to Gwendoline Davies, in 1922 at the Burlington Fine Arts Club and 'at that moment I felt the magic and I have felt it in Cézanne's work ever since'.[7]

In 1921 Samuel became chairman of Courtaulds, which gave him the financial freedom that enabled him over the next decade to form his collection. In purchasing, Courtauld appears to have been his own man, though he sought advice from the dealer Percy Moore Turner and was deeply influenced by the views of the critic Roger Fry. It was never a large collection but the quality is staggering and he quickly got into his stride. In 1924 he bought Monet's *Autumn Effects at Argenteuil* and works by Manet, Renoir and Cézanne, and the following year two masterpieces: Cézanne's *Mont*

Sainte-Victoire and Renoir's *La Loge*. In 1926 came Gauguin's *Nevermore*, two Seurats including *Young Woman Powdering Herself* (fig. 324) and the collection's greatest work, Manet's *A Bar at the Folies-Bergère* (fig. 323), acquired through Percy Moore Turner for $110,000 from the Thannhauser gallery in Lucerne.[8] Prices were beginning to rise and one senses Courtauld's desire not to miss any opportunity. The masterpieces came thick and fast: Van Gogh's *The Crau at Arles* in 1927, the *Self Portrait with Bandaged Ear* in 1928, Gauguin's *Te Rerioa* in 1929. Cézanne and Seurat were his favourites, and Courtauld owned ten works by the former and eleven by the latter. Courtauld's spending reached around £40,000 a year between 1926 and 1928, rising to a peak in 1929 of £54,000. In 1931 his wife died and he established in her memory the Institute for teaching Art History under the wing of London University. It was

323 Edouard Manet, *A Bar at the Folies-Bergère*
Samuel Courtauld; now Courtauld Gallery, London

324 Georges Seurat, *Young Woman Powdering Herself*
Samuel Courtauld; now Courtauld Gallery, London

to this rather than the National Gallery that he bequeathed the collection. As early as 1923 he had given £50,000 to the National Gallery to build up, while it was still possible, the modern French collection, which was then housed at Millbank. With this fund the first paintings by Bonnard, Cézanne, Seurat, Sisley, Utrillo and Van Gogh were acquired by any museum in England, including Seurat's masterpiece of 1884, *Bathers at Asnières*. As for Courtauld's own collection, which he hung in his Adam house in Portman Square (fig. 325), it is the sheer brilliance of Courtauld's eye and discrimination which strikes us today. Collecting in the second wave made it harder financially but easier intellectually since Courtauld had the confidence to go straight for the winners and not get bogged down in the thickets of the Barbizon school or be distracted by Monticelli.

If Degas was usually the Impressionist painter most popular with British collectors, Cézanne shared the honour with Gauguin among the Post-Impressionists. Marjorie Strachey (sister of Lytton) bought Gauguin's *Tahitian Study* at Roger Fry's 1910 exhibition and the following year Michael Sadler (1861–1943) bought four works by the artist in Paris, including *L'Esprit Veille* and *Vision of the Sermon* (NG Edinburgh; fig. 326). Sadler was an advanced educationalist who became Vice-Chancellor of Leeds University and later Master of University College, Oxford. He found buying paintings a palliative for depression. Sadler started conventionally enough with Monticelli and Fantin-Latour but by 1911 he was not only buying Gauguin but had also acquired the first Cézanne in Britain, *Maison Abandonnée*, and woodcuts by Kandinsky. He visited the latter at Murnau the

325 Interior of Home House, Samuel Courtauld's house at 20 Portman Square, London

326 Paul Gauguin, *Vision of the Sermon (Jacob Wrestling with the Angel)*
Michael Sadler; now Scottish National Gallery, Edinburgh

327 Vassily Kandinsky, *Fragment 2 for Composition VII*
Michael Sadler; Douglas Cooper; now Albright-Knox Art Gallery, Buffalo

following year and tried to persuade the artist to come to England. Sadler's Kandinsky collection, which included the important *Fragment 2 for Composition VII* (1913; fig. 327), was probably the first in England. Sadler later became an important patron of contemporary English artists: Stanley Spencer, C.R. Nevinson and Duncan Grant. He bought at the first exhibition of Henry Moore. Visitors to the Master's Lodge recall paintings by all of the above and in addition by Matisse, Rouault, John Constable and Cotman, as well as African and Pacific masks.

Sir Edward Marsh (1872–1953) represents a middle ground in English collecting. He was almost exclusively a collector of young British artists and unusual in coming from the bosom of the Establishment. He was, for over 25 years from 1905, the Private Secretary to Winston Churchill, and a friend of Rupert Brooke, Bertrand Russell, George Moore and Maurice Baring. He started collecting early British watercolourists until in 1911 he went to an exhibition of the Camden Town Group and bought Duncan Grant's *Parrot Tulips* for £15. From that moment onwards he was a voracious buyer and patron of young artists: Paul Nash, Stanley Spencer and Mark Gertler, Eric Gill, Mervyn Peake, David Bomberg and Eric Ravilious. He befriended many artists, buying Spencer's *The Apple Gatherers* after a visit to Cookham in 1913,

and was famously generous to Gertler (fig. 329). Marsh liked representational art, particularly landscapes (he was Ivon Hitchens's first patron, buying *The Miller's Cottage* in 1925), and had little sympathy for abstraction. As Richard Shone has written, 'he must have breathed a huge sigh of relief, as did so many, at the emergence of the Euston Road School (1938) of which there were choice examples in his collection'.[9]

If most collectors, like Marsh, rolled with the changing seasons of British art, one who focused on a specific group was artist and collector, Edward Le Bas (1904–1966). It was Harold Gilman's rejection by the New English Art Club that brought into being the Camden Town Group of seventeen artists who included Charles Ginner, Spencer Gore, Robert Bevan, Henry Lamb, Wyndham Lewis and Walter Sickert. Le Bas was a rich, talented painter whose enormous collection of 340 British and French artists reflected his own tastes and practice as a painter. He concentrated on the Camden Town Group and especially Charles Ginner, Harold Gilman (fig. 328) and Walter Sickert. In 1963 the Royal Academy exhibited the collection under the title *A Painter's Collection*.

The influence of the Bloomsbury Group on the acceptance of French art was crucial, thanks to Roger Fry and Clive Bell. Roger Fry's exposition of Poussin was reassuring to an audience hostile

328 Harold Gilman, *Interior with Mrs Mounter*
Edward Le Bas; now Ashmolean Museum, Oxford

329 Mark Gertler, *Jewish Family*
Sir Edward Marsh; now Tate Britain, London

330 Herbert Read at No. 3 The Mall, Parkhill Road, Hampstead, London, 1934

towards modernism. Lady Ottoline Morrell (1873–1938) was a bird of brilliant plumage who hovered on the edge of the group and supported young artists. One of her lovers, Augustus John, called her 'a most noble and generous soul', while other people, like Virginia Woolf, thought she was 'a garish strumpet'. Morrell was buying Henry Lamb and Jacob Epstein as early as 1908, when the latter was under attack. In 1910 she was a founder member of the Modern Art Association which became the Contemporary Art Society, formed to support young artists and 'for the acquisition of works of modern art for loan or gift to public galleries'. Her country house, Garsington Manor, a watering hole for writers and artists, contained works by Augustus John, Charles Conder, Duncan Grant, Henry Lamb, Gilbert and Stanley Spencer and James Pryde, most of whom painted her portrait. She also owned a group of drawings by Picasso.

By far the most important collector in Bloomsbury was the economist Maynard Keynes (1883–1946), who it was said was 'forming a collection that Duncan Grant would have made if he had the money'. He bequeathed 150 works to his old Cambridge college, King's, which included the Seurat sketch for *La Grande Jatte*, two Picassos including *Still Life* (1924), a Cubist Braque (1911), four Cézannes including *L'Enlèvement* and *Pommes*, as well as works by Matisse, Modigliani and Derain, and inevitably many paintings by Duncan Grant. Keynes collected many other young British artists: William Roberts, Ivon Hitchens, Henry Moore's *Shelter* drawings, Matthew Smith, Spencer Gore and Frederick Etchells as well as several artists who have sunk almost without trace. It was a collection of friends, rather Cambridge in its austerity, and it is fitting that it remains there, with many works on loan to the Fitzwilliam Museum.

If Roger Fry explained modern continental art to the pre-1914 generation, it was Herbert Read (1893–1968) who held that position for the next generation. A scholar and poet, Read published *Art Now: An Introduction to the Theory of Modern Painting and Sculpture* in 1933, and in it discussed continental movements such as Abstraction, Surrealism and Expressionism but also illustrated the young English artists: Henry Moore, Ben Nicholson, Barbara Hepworth and Francis Bacon. Read, a Yorkshireman, lived in Leeds close to

Michael Sadler until 1933 when he moved to the 'modernist fortress' of Hampstead, next door to Henry Moore and close to Jim Ede, Geoffrey Grigson and Roland Penrose. The house at No. 3 The Mall became a modernist manifesto with paintings by Ben Nicholson, Alfred Wallis, sculpture by Hepworth and furniture by Aalto and Mies (fig. 330). Many grateful artists presented Read with their works including Burra, Nash and Miró, and he added works by Klee, Moore, Magritte, Gabo and Heron, and Papua and New Guinea masks. Read's prolific writings are seldom read today but conditioned a generation to continental modernism. One of his many achievements was the early recognition of his fellow Yorkshireman Henry Moore, and his 1934 monograph on the artist. Read believed that sculpture was reborn in Moore. With considerable foresight, Leeds City Art Gallery bought Moore's early masterpiece *Reclining Figure* (1929).

By the 1930s a small group of British collectors, for the first time since the 19th century, were patronising major European contemporary artists. One of the oddest and most engaging was Edward James (1907–1984), a creator of fantastic dwellings that housed works by artists such as Magritte and Dalí, who created many of the decorations. To a capricious, rich, spoilt, sexually confused boy of philistine Edwardian parents, Surrealism offered a licence to derangement. Edward James would never have defined himself as a collector but rather as a poet and creator. He acquired a collection, the equal of the Parisian poets, André Breton and Paul Eluard, which was based on collaborative relationships with the artists.[10] James realised his fantasies through the creation of extraordinary interiors at 35 Wimpole Street in London, Monkton House in Sussex and finally his jungle exotica at Xilitla in Mexico.

Norman Parkinson's photograph of Edward

331 Edward James and Igor Markevitch at 35 Wimpole Street, London (photograph by Norman Parkinson)

332 Salvador Dalí and
Edward James, *Lobster
Telephone*
Tate Modern, London

James and Igor Markevitch in the Tent Room at
35 Wimpole Street shows Dalí's *White Calm* and
Picasso's *Femme Assise Au Chapeau* (fig. 331).
Dalí was a frequent visitor and created with James
the Lobster Telephone for the house (fig. 332).
James built up probably the finest private
collection of Dalí in the world including *Suburbs
of a Paranoiac-Critical Town, Metamorphosis
of Narcissus* (Tate) and *Sleep*. In 1938 Dalí and
James created together *The Mae West Lips Sofa*
for the dining room at Monckton. In addition
to Dalí, James owned important groups of work
by Delvaux, Derain, De Chirico, Fini, Magritte
and especially Pavel Tchelitchew and Leonora
Carrington. Edward James's final refuge was
the Caliban kingdom he created at Xilitla from
1949 onwards with petrified, fantastic and weird
architectural sculpture. Poetry, painting and
architecture were one and the same to James.
Educated at Eton and Oxford, art was the vehicle
through which he was able to surrealise his life.

Considerable elements of the collection survive at
Brighton Art Gallery.

British collectors' enthusiasm for Matisse and
Picasso has been shown to be greater than was
previously thought.[11] The Leicester Galleries
Matisse exhibition of 1919 was a particular success
with multiple purchases by Michael Sadler and
the South African, Brandon Davis, while Maynard
Keynes and George Eumorfopoulos bought one
each. As for Picasso, Clive Bell acquired the artist's
first painting in a British collection, *Pots et Citron*
(1907), in 1911, and in the same year Lady Ottoline
Morrell's half-brother, Lord Henry Bentinck, lent
a Picasso to a Manchester exhibition. It appears
that all the early Picasso collectors were connected
with the Bloomsbury Group except Frank Stoop
who owned a couple of Picassos by 1912 including
the Blue Period *Girl in a Chemise* (Tate; fig. 333).
It has been shown that around 130 paintings by
Picasso were acquired by British collectors before
1940.[12] Sixty-five collectors owned his paintings

between 1910 and 1940. By the end of the 1930s there were three Englishmen who could claim friendship with the artist: Clive Bell, Douglas Cooper and Roland Penrose. The last two formed seminal collections of the artist's work. Penrose first saw a Cubist Braque in the rooms of Maynard Keynes while up at Cambridge. He came from a wealthy Quaker family and went to Paris in 1922 to join the Surrealist movement as a painter, although his fame was later determined by what he achieved as a writer and collector.

Penrose was first introduced to Picasso in 1935 by Paul Eluard and bought *Woman Lying in the Sun*, but it was the purchase of the René Gaffé collection the following year that turned him into a major collector, with twelve Cubist Picassos. This was supplemented in 1938 by Penrose buying Eluard's important collection of six De Chiricos, ten Picassos, 40 Ernsts, four Magrittes and three Dalí paintings. Penrose called his collection 'the collection that collected itself' although his rival Douglas Cooper sneeringly described it as 'ready-made'. The most important work in the collection came as a result of a visit to Picasso with Eluard in 1937. There on the easel was the greatest of all the artist's portrayals of Dora Maar, the *Weeping Woman* (1937), which was still wet. 'Oh, may I buy that from you?' 'And why not?' came the unusually straightforward reply from Picasso. No doubt the artist saw the point of pleasing Penrose who was to become his first major English-language biographer (fig. 334).

During the war Penrose returned to England with his collection, which, with the removal of the Cooper collection to France in 1949, was the most important group of Picassos in England. He was always the biggest single lender to Tate exhibitions of the artist from 1939 onwards. He became a trustee of the Tate and founder of the Institute of Contemporary Art (ICA) which, in addition to his writings, made him, along with Herbert Read, the main standard bearer in England for the School of Paris. In the post-war era Penrose became a major collector of young British artists acquiring early works by Henry Moore, Francis Bacon, Richard Hamilton, Kenneth Armitage and William Turnbull. Most of his collection was later acquired by the Scottish National Gallery

Douglas Cooper (1911–1984) was Picasso's other English friend, and the artist took mischievous

pleasure in playing the two of them off against each other. Outrageous, extrovert, touchy and utterly confident in his views, Cooper was a focused art historian and collector who had a well-developed gift for making enemies. At the age of 21 Cooper came into a £300,000 fortune (made by his forbears in Australia) and he decided to spend a third of it on the early phase of Cubism, which he strictly defined as 1906–14. He became a world authority on Cubism and his collection was correspondingly important (fig. 335). It was largely amassed in six years between 1933 and 1939 from a shadowy German collector living in Switzerland called G.F. Reber, who had lost his money in the 1929 crash. Cooper concentrated on four artists, Picasso, Braque, Léger and Gris, but he also had works by Klee and Miró. The collection was housed in Egerton Terrace in London until 1949 when Cooper and his companion, John Richardson, removed themselves to the Château de Castille in

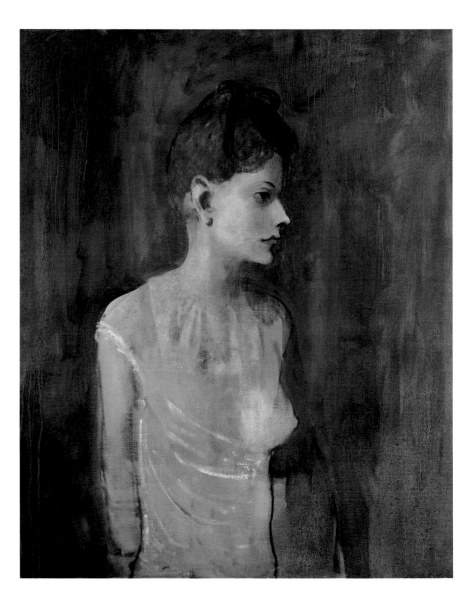

333 Pablo Picasso,
Girl in a Chemise

Frank Stoop; bequeathed to the Tate Gallery, 1933; now Tate Modern, London

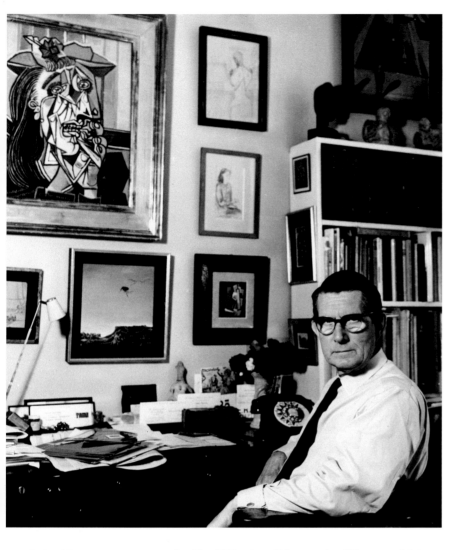

334 Roland Penrose in 1966; above his desk hangs Picasso's *Weeping Woman* (see fig. 9)

335 Douglas Cooper with Pablo Picasso at La Californie, Picasso's villa at Cannes, 1961, alongside the artist's sculpture *Femme au Chapeau* (1961)

the Gard District of the south of France, which *L'Oeil* dubbed 'Le Château des Cubistes'. His most important Picasso, *Nudes in the Forest* (1907), was to end up in the Musée Picasso in Paris due to a sleight of hand by the French Minister of Culture. The Cooper collection attained classic status and set the standard for all subsequent Picasso collections. From France, Cooper enjoyed waging war on the British art establishment, and in particular the Tate Gallery which had lost its focus in the 1930s.

It is curious that Britain produced such talented collectors and patrons of the School of Paris in the 1930s, a situation that was not repeated after 1945. Picasso became the main collecting focus of European and American collectors in the post-War era but there were never again to be Picasso collections in Britain of the same quality as those of Penrose and Cooper. The first half of the 20th century is perhaps comparable to the 17th century in terms of British collectors catching up with the Continent. By 1939 this was largely achieved but the Second World War was to change

the landscape dramatically. In 1945 Britain was bankrupt, and when collecting was reborn after the war initially the most brilliant collectors were classicists rather than modernists. In the post-war era, the artistic innovations had moved across the Atlantic and it took another generation before British collectors caught up with them.

Chapter 23

SPECIALISTS AND SCHOLARS 1918–45

While avant-garde modernism gradually penetrated the robust armour of British self-satisfaction, traditional art collecting began to move fiom the general to the particular. Specialist collecting was nothing new: coins, drawings, books and ceramics had found their champions in the past, but general collecting on the scale of Salting and Burrell was declining in Britain and moving to America. This was partly for economic reasons: Britain's financial position, already weakening before the First World War, fell into a sharper decline. In addition, the confident country house world had sung its swan song in Edwardian England. The American collector Paul Mellon later recalled, 'England had a stillness and deep serenity in those last few years before the First World War. It is impossible to describe the atmosphere and the feeling of that long-lost summer of 1913... to me it had the colour and feeling of childhood itself.'[1]

The world after 1918 was irrevocably changed. With ten million dead, four empires destroyed and the rise of Bolshevism, it was a world in dissolution, followed in Britain in the 1930s by industrial turmoil and class confrontation. By the time of the 1929 crash, the certainties of Edwardian England had been shattered and with this came a concomitant fragmentation of the nation's cultural life. The classical culture of the public schools reigned supreme on the surface but traditional Hellenism was challenged, not only by modernism, but also by the wider cultures embracing Japanese, Chinese and African art. Although European art remained the dominant field of collecting, the most interesting collectors broke away. The fragmentation of culture led to increased specialisation, backed by a trend towards smaller homes and also

Old Master Collectors

Country Houses

Sir Philip Sassoon

Drawings Collectors

Oriental Ceramic Society

George Eumorfopoulos

Sir Percival David

Tribal Art

Sir Jacob Epstein

336 The David Vases
(two large porcelain temple-vases), Yuan dynasty, 1351
Sir Percival David; now British Museum

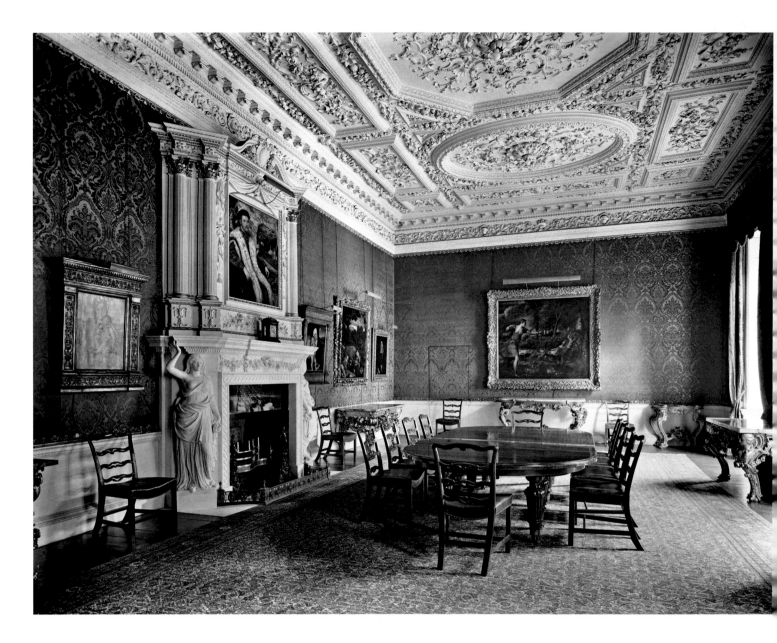

by American competition. Furthermore, the growth of specialist museum departments at the end of the 19th century, particularly under A.W. Franks at the British Museum, and the rise of art-historical publications created the critical framework that made specialist collecting both possible and attractive. With changes in standards of knowledge and in taste there coincided a greater availability. The contents of many great country houses were sold up during the period, but foreign postings in the imperial heyday and the greater ease of steamship travel also brought new kinds of material to the market.

The most dazzling of the old-style paintings collections from the early part of the century was that formed by Henry, Viscount Lascelles, later 6th Earl of Harewood. He inherited a fortune in 1916 from the Marquess of Clanricarde and enquired

at the Burlington Fine Arts Club about an adviser to help him form a collection of Old Master paintings. Tancred Borenius, the ubiquitous Finnish art historian, was recommended and even while Lascelles served in the trenches during the First World War their correspondence continued. The collection, which initially hung at Chesterfield House in London (fig. 337), was marked by a strongly Venetian flavour with works by Tintoretto, Bellini, Veronese, Cima and El Greco. The lion of the group was Titian's *Death of Actaeon* (NG London), once owned by Sir Abraham Hume, which moved with the rest of the collection to Harewood House on the succession of Lascelles to the Earldom in 1929.

If Lascelles represented old money, Walter Samuel, 2nd Viscount Bearsted (1882–1948) represented the new. He was a philanthropic

337 The Dining Room at Chesterfield House, London in 1931, when it belonged to the 6th Earl of Harewood, with Titian's *Death of Actaeon* visible on the far wall

financier with a Shell Petroleum fortune. In 1922 he bought his country house, Upton in Warwickshire, which he filled with treasures before finally bequeathing it to the National Trust. The taste is toned-down Rothschild with Dutch paintings, English 18th-century portraits, sporting art and European 18th-century porcelain (fig. 338). The furniture was sober English but the choice of painters is revealing: Bosch, Memling, Brueghel and El Greco alongside Hogarth, Romney and Ben Marshall. The activities of the art dealer Joseph Duveen rendered grand English 18th-century portraits fashionable in America but the rich at home were not immune to this taste. Lord Lee of Fareham bought several outstanding examples along with more thoughtful works such as Hans Eworth's allegorical *Portrait of Sir John Luttrell*. Lee, who gave Chequers to the nation as a country

residence for the Prime Minister, was among the joint instigators of the Courtauld Institute and left his Old Masters to join Courtauld's Impressionists, perhaps realising that his collection would not stand up alone. However, the Lee collection, which like Harewood's was catalogued by Tancred Borenius, did contain several significant master-pieces including Rubens's sketch for his Antwerp *Descent from the Cross* and Botticelli's *Trinity and Saints*. Lee also formed a comprehensive collection of British and German silver, including chalices, patens, drinking horns, coconut cups, mazers, tankards, goblets, jugs and standing cups, which he gave to the University of Toronto.

As country houses were sold, new owners moved in and filled them with new collections. In 1922, Clive Pearson, younger son of the 1st Viscount Cowdray, bought Parham in Sussex at a time when

the cult of the castle and manor house was at its height. He furnished it in a historicist style with the best Elizabethan and Jacobean portraits picked up at the sales of Rufford Abbey, East Knoyle and Surrenden Dering (fig. 339). While Pearson wanted historical portraits, James Buchanan, 1st Lord Woolavington, chased sporting art. His fortune came from Black and White whisky and his purchase of Lavington Park in 1903 to form a stud stimulated him to become one of the greatest collectors of English sporting art. Lord Woolavington won the Derby twice, patronised Munnings, and formed a collection of Stubbs, Ferneley, Ben Marshall and Landseer that hangs today at Cottesbrooke Hall in Northamptonshire. Every country house in England contained some sporting art but it was not until Sir Walter Gilbey (1831–1914) that anyone thought it worthy of collecting exclusively. Gilbey, who had made a fortune importing wine and making gin, wrote monographs on Morland and Stubbs and avidly collected books, prints and paintings on equine subjects.

Country house collecting was not restricted to new money. In 1912, Captain George Spencer-Churchill inherited Northwick Park (fig. 340), a hallowed name in English collecting (see chapter 20), and proceeded to add 200 paintings to the 400 he had inherited. He haunted the auction rooms for bargains, or what he called the 'Northwick Rescues', his description of the pictures, of all schools, which he bought and 'rescued from dirt, overpainting and oblivion'.[2] More unusually, he collected early antiquities, especially Egyptian, and had a disconcerting way of greeting visitors with 'are you BC or AD? I'm a BC man.'

Occasionally modernism invaded the country house world, especially at Garsington Manor in Oxfordshire, the home of Lady Ottoline Morrell, and Renishaw Hall in Derbyshire, the ancestral home of Osbert Sitwell and his brother, Sacheverell. The Sitwells made a great deal of modernist noise and patronised the Vorticists. They were founder-members of the Magnasco Society, dedicated to Italian, particularly Neapolitan, Baroque art, paving the way for the revival of scholarly collecting in this field after the Second World War, led by Sir Denis Mahon. Their Carlyle Square house contained a curious mixture of baroque furniture and paintings by Wyndham Lewis, Rex

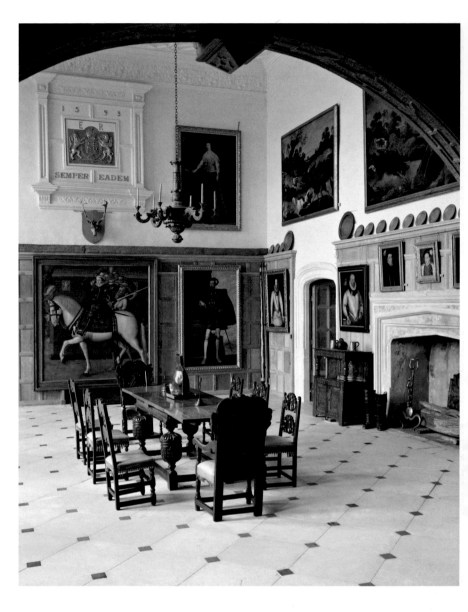

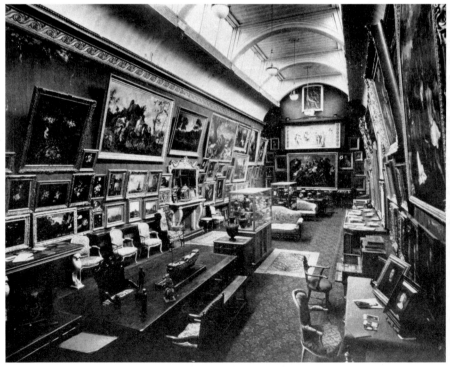

Whistler, Paul Nash and C.R. Nevinson. In 1947 Sir Osbert bought Salvator Rosa's great *Belisarius* for the Ballroom at Renishaw. Until then it had hung at Raynham Hall, Norfolk, one of the tiny elite of paintings that gave its name to a room.

The prevailing Georgian taste of the time was epitomised by King George V's consort, Queen Mary. She was a woman of taste with an aversion to Victoriana. She bought Fabergé, jade, gold boxes, 18th-century furniture, bibelots and anything historically or sentimentally attached to the royal family, whether Jacobite or Hanoverian. This family piety overrode her accepted rules of taste, but Queen Mary's Dolls' House, designed by Sir Edwin Lutyens and presented to her in 1924, illustrates her Georgian preferences.

The consummate man of taste was Sir Philip Sassoon (1888–1939) whose various houses became a centre of fashion and political gossip. Ronald Fleming described Sassoon's London house in Park Lane as having 'the atmosphere of the palace of a wealthy pasha combined with the meticulous taste and connoisseurship of an artistic

aristocrat'.[3] He combined French decorative arts and 18th-century English paintings, particularly conversation-pieces, the popularity of which he did much to promote. At Port Lympne in Kent he wallowed in the modish retro-modernism of Glyn Philpot, Sargent and Rex Whistler (fig. 341). Between 1923 and 1928, Sassoon mounted an annual exhibition at his Park Lane house which exerted a marked influence on taste. In this he was assisted by his sister, Hannah Gubbay, whose collection of English furniture and English, Continental and Oriental porcelain, furniture, textiles and carpets is preserved at Clandon Park, Surrey. The exhibitions began with *Early English Needlework and Furniture*, followed by *Old English Plate* (1929) and the *Age of Walnut* (1932). By far the most important display was devoted to *English Conversation Pieces* (1930), which brought into focus Hogarth, the early works of Thomas Gainsborough, Arthur Devis, George Stubbs and above all Johann Zoffany. Sassoon lent six of his own paintings, including works by Gainsborough (fig. 342) and Zoffany. Queen Mary's visit to the

exhibition set the seal on its acceptance as the epitome of well-informed good taste – 'Sassoon à son goût', as Osbert Sitwell quipped.

Collecting in London was greatly stimulated by the almost daily auction sales at Sotheby's and Christie's. The auction houses were national only in those days, with offices exclusively in London, and the international art market lay in the hands of a number of dealers based in Paris, London and New York, such as Duveen, Knoedler and Wildenstein. The business of the auction house was, in general, to handle sales from the estates of deceased collectors. One of the most spectacular was that of Henry Oppenheimer of 9 Kensington Palace Gardens, the greatest drawings collector in inter-war London. Born in Washington, he was educated in Frankfurt and settled in London, where he joined the Burlington Fine Arts Club. Oppenheimer owned important Italian drawings by Leonardo, Michelangelo, Carpaccio, Canaletto and an important group of Rembrandts. These he combined with medieval and Renaissance works of art, ivories and maiolica – the classic mixed scholarly collection of late 19th-century character. His posthumous sales at Christie's in 1936 created a benchmark, and it was here that Brinsley Ford bought his celebrated Michelangelo drawing of *The Risen Christ* (fig. 343).

For English collectors with native tastes, and lacking the means of an Oppenheimer, this was a golden era for acquiring English watercolours. As Kenneth Clark observed, 'they were still plentiful, but emerged unpredictably in albums and piles of prints; they were still cheap, but there were a few rival collectors, keen, fastidious and not too rich, to make the running'.[4] Typical was the scholarly civil servant, Paul Oppé (1878–1957), who was especially interested in the work of Alexander Cozens and Francis Towne. His numerous publications demolished many an agreeable legend and he brought a high level of accuracy to his collecting. Oppé may have been a meticulous scholar, and as Kenneth Clark wrote, 'beauty stirred him deeply'. His contemporary, Sir Robert Witt, formed a reference collection of 3,500 drawings which he bequeathed to the Courtauld Institute to document artists 'who while interesting or charming, were slightly below the highest rank'. This taste for 18th- and 19th-century British watercolours remained a favourite among gentleman 'amateurs' until the 1970s, when

they disappeared from the scene. An outstanding collector of prints was Campbell Dodgson (1867–1948), Keeper of the Department of Prints and Drawings at the British Museum, who left his collection to that institution. As well as Old Masters, his collection's strength lay in the modern period, which the museum ignored at the time.

The taste for collecting Chinese ceramics had been established for at least 200 years, but in the inter-war period British collectors dramatically changed in intensity and discrimination and led the world in this field of collecting. The displacement of many native collections during the decade after the collapse of the Qing dynasty (1644–1911) offered excellent opportunities for Westerners. The landmark formation of the Oriental Ceramic Society in England in 1921 brought about a remarkable combination of museum curators and rich collectors. It was one of the most beneficial of such unions in the history of British collecting to the great enrichment of the national collections.

343 Michelangelo Buonarroti, *The Risen Christ*
Henry Oppenheimer; Sir Brinsley Ford; now Private Collection

The British Museum was the focus and the fine collections which gravitated there included those of H.B. Harris and Oscar Raphael (split with the Fitzwilliam). R.L. Hobson of the British Museum was a key figure who seemed ubiquitous during the period and was the collectors' preferred cataloguer. The influence of the Oriental Ceramic Society was enormous and created a more scholarly approach to Chinese porcelain. It moved the taste of British collectors away from the colourful Fa Hua preferred by Robert Benson, or the K'ang Hsi vases decorated with peach blossoms collected by Leonard Gow, towards the monochrome simplicity of the Song period. Hobson's own taste matured from the decorated later wares he had championed in 1906[5] towards the 'simple strength of the Song masterpiece and the restful tints of their monochrome glazes'.[6]

The first president of the Oriental Ceramic Society was George Eumorfopoulos (1863–1939), a collector of Greek origins who worked for the trading company Ralli Brothers. He had been seconded for membership to the Burlington Fine Arts Club by another Greek collector of an earlier generation, Constantine Ionides, who also turned

to oriental ceramics in his later years. 'Eumo', as Eumorfopoulos was known, put together an encyclopaedic reference collection of mostly Chinese, but also Korean and Japanese art. It was kept in a large house on Chelsea Embankment, a veritable temple to Chinese ceramics, bronzes and paintings (fig. 344). The arrangement resembled a museum, with 2,400 pieces in upright glass cabinets, but in the Dining Room Chinese paintings were combined with 18th-century English furniture. The house was visited by experts, dealers, potters and collectors of all ages. Robert Sainsbury recalled that on his first visit, when he handled the porcelain nervously, the collector barked, 'Stop this nonsense!' Eumo intended to leave his collection to the British Museum, or a projected Oriental Museum which never materialised, but was forced to change his plans after suffering losses in the Great Depression of 1929. Instead, he offered his collection to the British Museum for £100,000, a fraction of its value. Eventually, the British Museum and the V&A joined forces to save the collection.

The success of the Oriental Ceramic Society can be judged by the 1935 International Exhibition of

344 A museum room in George Eumorfopoulos's house at 7 Chelsea Embankment, London

345 Ru ware bowl,
Northern Song, 12th century
Sir Percival David; now
British Museum

346 Delftware cistern
Lee Glaisher; now Fitzwilliam
Museum, Cambridge

Chinese Art in London. Its three main organisers
were Hobson, Eumorfopoulos and Sir Percival
David (1892–1964). Although David, who was a
cousin of the Sassoons, was not a founder member
of the Oriental Ceramic Society because he was
actually in China at the time, he was the main
lender to the exhibition. The giant among British
collectors of Chinese ceramics (figs 336 and 345),
David formed a scholarly collection of flawless
Imperial quality Song ceramics from the 10th
to 12th centuries. The monochrome perfection
of Songwares became the classic taste among
serious collectors of the time, but David was also
a pioneer of blue and white Ming, so popular
with American collectors of the next generation.
A businessman educated in Bombay and London,
David spoke fluent Chinese. He started collecting
at the age of 21 and continued relentlessly until
his death, putting together a collection of some
1,200 pieces. David preferred marked and inscribed
pieces which provided evidence about dating and
manufacture. At a time when most collectors were
still looking for decorative pieces, David sought

out perfect pieces of historical importance. He collected works similar to those found in the Imperial Chinese Collection, which provided the lodestar of his taste. Indeed, many of his treasures may have originally come from the Imperial Collection, but provenance was rarely recorded in those days. In 1931 he established a chair of Chinese Art and Archaeology at the University of London, to which he gave his collection in 1950. It was housed in Gordon Square until its transfer to the British Museum in 2009.

The collecting of English ceramics received a boost from the foundation of the English Ceramic Circle in 1927. This made collectors more discerning and probably encouraged the drift in taste to earlier forms of English porcelain and pottery. Millionaires like Lord Bearsted at Upton continued to favour the 'gold anchor' wares. He formed a large collection of the Chelsea, Bow, Derby and Worcester factories. But the influence of arts and crafts studio pottery created a fashion for simpler ceramics. In 1924 Herbert Read and Bernard Rackham published *English Pottery*, which

directed collectors to gravitate towards English Delftware and slipware. This taste may be seen in the collection of Lee Glaisher, the Astronomer Royal, who bequeathed his early English pottery to the Fitzwilliam Museum (fig. 346).

The world of inter-war British ethnographical collectors resembles that of Chinese ceramics, with a dedicated group of enthusiasts, museum curators, dealers and collectors united by a missionary zeal to rescue material and knowledge for the future. The dealer James Keggie likened them to 'a lot of school boys, chasing and swapping objects like so many marbles'. During the heyday of the Empire a bias towards British territories was fuelled by an abundance of weekly sales.[7] The collectors of this generation did not need to travel but formed their collections at home. High-quality material was abundant, often thrown out as junk or sold for a pittance by the descendants of explorers, missionaries, whalers, soldiers or colonial civil-servants. Following the tradition of General Pitt Rivers and A.W. Franks, British collecting tended towards an

347 James Hooper in the Totems Museum, Arundel, *c*.1958, holding a South American Shuar (Jivaro) shrunken head and surrounded by mostly African artefacts

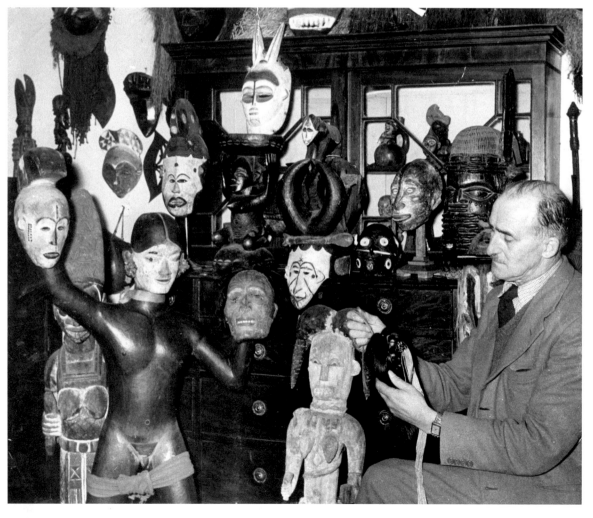

ethnographical approach whereas in France it was the artists – not least Gauguin, Vlaminck and Picasso – who transformed the view of tribal artefacts.

Harry Beasley (1881–1939) created the Cranmore Ethnographical Museum at his home in Chislehurst, Kent, of mostly Pacific, but also North American, Asian and African material. Many of the pieces that had poured into Britain at the end of the 19th century languished, poorly catalogued, in local museums. Beasley wrote to curators and often successfully persuaded them to transfer their specimens to his museum.

Captain Walter Fuller (1882–1961) was the son of a clergyman, and lived in Sydenham Hill. Predominately a collector of Pacific artefacts, he considered the study of anthropology provided an essential background to tribal art collecting. Although of high integrity, he believed that 'all's fair in love and war and collecting'. Like Beasley, he attended sales zealously and procured works sold by museums. Dr Roland Force described a visit to Fuller thus: 'he had crammed more than 16 tons of Pacific artefacts into his unpretentious residence in a London suburb. A maze of aisles wove among stacks of spears and war clubs and between cabinets and shelves...'[8] Fuller had a horror of trading, or being taken for a dealer, but like most collectors he had little choice but to swap and trade items.

James Hooper (1897–1971) spent his life working for Thames Conservancy and supplemented his modest income to satisfy his enormous appetite for forming a tribal collection, with sections devoted to Africa, New Zealand, North and South America, the Pacific Islands and, particularly, Polynesian sections (fig. 347). Hooper understood that 'with the advent of modern civilisation the whole way of life of many primitive peoples had changed and this was bringing about the disappearance of their weapons, ornaments, dress, gods, masks and other objects... I could see that no time should be lost if such objects were to be preserved.'

The fate of these three tribal art collections varied. Beasley's was dispersed but significant parts survive in the British Museum; Fuller sold his collection to the Field Museum in Chicago to pay for the upkeep of an invalid daughter; while Hooper's was auctioned at Christie's in several sales between 1976 and 1980.

Jacob Epstein (1880–1959) was a collector entirely different from Beasley, Fuller and Hooper; an artist with an eye for a masterpiece. He told Arnold Haskell in 1931 that African art had hitherto been regarded mainly as an element of ethnographical studies providing 'a running commentary on folk-lore',[9]

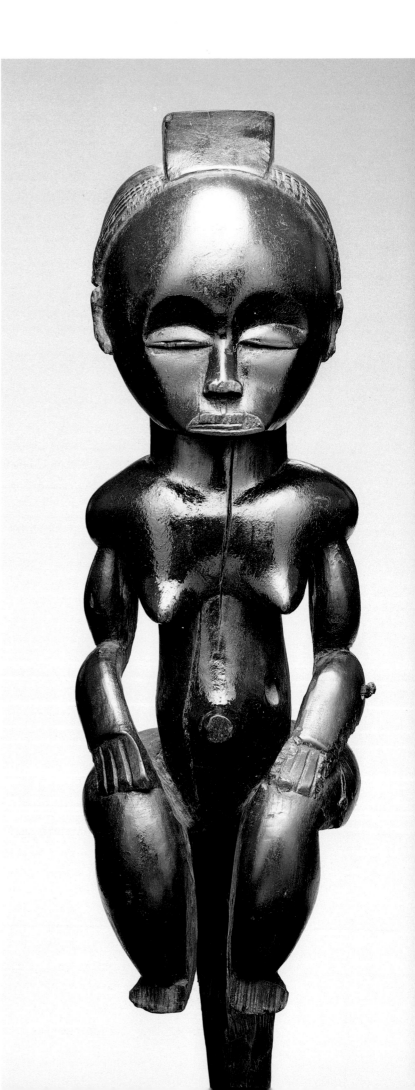

348 Figure from a Reliquary
Ensemble: Seated Female
(The Pahouin or Black Venus),
Fang peoples, Betsi group;
Gabon, 19th century
Jacob Epstein; now Musée Dapper,
Paris

349 The collection of
Jacob Epstein

whereas he was interested in it as art. Epstein viewed tribal art as pure and uncluttered by the baggage of artistic personalities: 'the work is either good or bad'. The son of Jewish immigrants from central Europe, his outlook on art was conditioned by three years spent in Paris from 1902, before he settled in London. Epstein claimed that he collected 'negro sculpture' – as it was then routinely called – ahead of Picasso, Vlaminck and Matisse. 'It was the only sculpture I could afford', he wrote in his autobiography. The Epstein collection was mainly figurative, dominated by African (424 pieces), then by Pacific (236), with smaller groups of Pre-Colombian, Egyptian and Cycladic art. Epstein bought many of his finest pieces in Paris in 1930: the Fang figure from the Breton and Eluard collection (fig. 348) and, later that year, superb items at the George de Miré sale: a Fang male, a seated Fang female, the Dan mask and the Dogon hermaphrodite.[10]

The character of the Epstein collection (fig. 349) was captured by William Fagg: 'the muddle in his first-floor room might have repelled the conventional art-lover, if they had ever had the chance of seeing it, but in a sense it expressed the true artist better than the most careful arrangement would have done. From that repository he would bring down a few pieces of an evening and spend hours in silent contemplation or animated discussion of them.'[11] Although as a sculptor Epstein

broke with the classical canon of beauty, he always warned that this should not make one turn away from the art of Greece and Egypt.

One collector who kept the flame of Hellenism alive was Sir John Beazley (1885–1970). The world authority on Athenian painted vases, which tell us so much about Greek life, art and taste, his collection acted as a study tool, and his life's work was to document 50,000 vases, which he attributed to 1,000 different artists. He presented his collection of over 600, mostly Attic red-figure, but also Etruscan black-figure vases, to the Ashmolean Museum. For the most part, the collecting of antiquities had become a branch of archaeology and the transmission of classical culture had become the preserve of museums. Dynamic private collecting was in the field of Asiatic and ethnographical art. Museums were still acquiring Asiatic art while selling tribal artefacts but in both cases it was the cooperation between private collectors and museum staff that raised them to stand as the most influential and rewarding collectors in England of their time. Epstein, who collected independently, is the odd one out. His collection was a source of artistic creativity, making a direct link with the modernist collectors of chapter 22.

350 Mark Rothko, *White Cloud*
Ted Power; now Private Collection

Chapter 24

FROM POST-WAR TO SWINGING SIXTIES 1949–79

The first decade of post-war Britain was an austere time when the country was dismantling an empire and attempting to build a utopian socialist future. In America the abstract expressionists arrived on the scene in the late 1940s to announce a brave new world, and several important artists emerged in Britain, notably Francis Bacon and Lucian Freud. The St Ives School in Cornwall flourished with new blood and the first post-war decade of collectors focused mostly on British art. The great pre-war trio of international modernist collectors, Douglas Cooper, Roland Penrose and Edward James were stopped in their tracks by the war. Cooper took his collection to France and almost never returned, while Edward James went to America and Mexico. But Roland Penrose remained a beacon of modernist collecting, re-inventing himself with enormous influence through the Tate and the Institute of Contemporary Arts. In 1951 the Festival of Britain seemed to symbolise the country's cultural resurgence, yet the division between modernist and traditionalist collectors remained as wide as ever.

There is a case to be argued that British art collecting between 1945 and 1979 dissolved into ownership of small groups of objects while the State and its various arms, the Arts Council, the Tate, and charities like the Contemporary Arts Society took the place of traditional private collectors. The weakened financial position of Britain and rises in taxation made it harder for individuals to compete, and yet important collections were still formed. Specialist collecting continued, but in a lower key. Gerald Reitlinger pursued Chinese porcelain, Geoffrey Keynes collected the drawings and prints of William Blake, James Hooper

The Art Historians

Sir Denis Mahon

Institute of Contemporary Arts

Contemporary Arts Society

St Ives Collectors

Jim Ede

Sandy Wilson

Ted Power

Alastair McAlpine

Robert and Lisa Sainsbury

opened his Totems Museum of tribal artefacts at Arundel in 1957, and in every field from porcelain to watercolours collectors were busy, but few were important by pre-war standards. Whether traditionalist or modernist, there was a pronounced shift towards collecting with a view to public display or benefaction. Many of the traditionalists were also scholars whose motivation was similar to that of the modernists, to open people's eyes to the art they were collecting.

London had many advantages for traditional collectors, including superb museums and regular exhibitions, and it was the home to several distinguished organisations connected with the arts: the Warburg and Courtauld Institutes, *Apollo*, *The Burlington Magazine*, *The Connoisseur* and, perhaps above all, Sotheby's and Christie's. The war marked a watershed in the fortunes of the stately homes of England, and from the 1940s to the 1970s, the contents of a great many were sold, culminating in the sale of Mentmore Towers in 1977. Vast numbers of sales in every category were offered by the principal auction houses during the 1960s and '70s. Phillips, Bonhams, Knight Frank and Rutley, Henry Spencer and many provincial auctioneers added to the scale of dispersal. Well-established Old Master painting dealers, such as Agnew's and Colnaghi's, were further sources of supply.

One of the first major post-war exhibitions was *The King's Pictures* at the Royal Academy in 1947. Buckingham Palace had been bombed and needed redecorating. Queen Elizabeth, Consort of George VI, seized her chance to brighten the private rooms with modern paintings. In 1938 she had bought Augustus John's *Portrait of Bernard Shaw*. During the war, encouraged by Kenneth Clark, she had commissioned the John Piper Windsor Castle series and bought works by Sickert, Paul Nash and Matthew Smith from the Tooth Gallery. At the end of the war she attended private views and made purchases of Duncan Grant, Norma Bull and others, in her own words, to 'get things going again'.

The most interesting category of collectors in England after the war was a group of art historians who used their knowledge to form great collections. The most famous was Sir Kenneth Clark, the most formidable Sir John Pope-Hennessy, and the group included Sir Brinsley Ford, John Gere,

351 Sir Denis Mahon at the National Gallery in 1996, standing in front of some of his paintings lent to the Gallery, including Guercino's *The Cumaean Sibyl with a Putto*

352 Guercino, *Elijah Fed by the Ravens*
Sir Denis Mahon; now National Gallery, London

Francis Haskell, Philip Pouncey and Sir Denis Mahon (fig. 351). The last was without question a central figure and a fascinating example of the conjunction of scholarship and collecting having a profound influence on taste. It was the German expatriate scholar Nikolaus Pevsner who first led Mahon to the 17th-century Italian paintings which he made his life's quest to study, collect, publish and exhibit; notably those of the Bolognese Giovanni Francesco Barbieri, called Guercino (1591–1666). Mahon was fortunate in his share in the family bank Guinness Mahon, and in his timing. Italian 17th-century, or *Seicento*, painting

353 Joseph Mallord William Turner, *Seascape, Folkestone*
Kenneth Clark; Thomson; now Private Collection

had fallen low in critical acclaim and the last great purchase in England had been as long ago as 1853 when the Duke of Northumberland bought the Camuccini collection in Rome.

In 1936 Mahon acquired Guercino's early masterpiece, *Elijah Fed by the Ravens* directly from Prince Barberini in Rome for £200 (fig. 352). His main hunting ground was the London salerooms between 1934 and 1960, by which date prices were beginning to rise. Apart from ten paintings by Guercino (and 46 of his drawings), Mahon acquired four by Domenichino, four by Reni, and eleven by Giordano, as well as works by Crespi, Annibale and Ludovico Carracci. In 1997, 79 of Mahon's paintings were exhibited at the National Gallery and the brilliance of his collection became evident. They were never returned to his house

in Cadogan Square but were distributed on loan to museums in London, Dublin, Birmingham, Liverpool, Oxford and Cambridge, where they remained, on condition that the trustees maintain free access to museums. Sir Denis (1910–2011) was a ferocious watchdog of legislation concerning the preservation of cultural heritage. His achievements as collector and scholar were impressive but not unique, once far-sighted dealers like Jim Byam Shaw at Colnaghi's began to promote *Seicento* paintings, albeit to a small clientele.

Very different from Denis Mahon's tightly focused collection was Kenneth Clark's magpie group of favourite artists and objects. Clark (1903–1983), later Lord Clark of Saltwood, director of the National Gallery between 1934 and 1945, was almost unique among the art historian-collectors, not only in his engagement with the artists of his own generation, but also in his considerable personal wealth. He bought from Henry Moore's first exhibition in 1928 and was also a patron of Sutherland, Piper, Nolan, David Jones and Victor Pasmore. To their work he added watercolours by Cézanne, paintings by Degas, Renoir, Matisse and Tintoretto, and Turner's late *Seascape, Folkestone*, purchased from Agnew's in 1951 (fig. 353). Clark sometimes illustrated his books with art from his own collection. His landmark television series *Civilisation* made him a media celebrity and through it he did more to open the eyes of the general public to visual art than anyone since John Ruskin. Sotheby's sold part of his collection in 1983 with Japanese, Chinese and African works, important medieval works of art and illuminated leaves, as well as Renaissance medals and maiolica. The Clark collection resembled an updated version of those fin-de-siècle assemblages of Fairfax Murray and Ricketts and Shannon. Somewhere between Mahon and Clark in his interests was the scholar-collector, Brinsley Ford. The inheritor of Richard Ford's collection,[1] he purchased Michelangelo's drawing of *The Risen Christ* from the Oppenheimer sale (1936), *Seicento* and *Settecento* paintings and sculpture, Ingres drawings and modern works by Toulouse-Lautrec, Henry Moore, Christopher Wood and Augustus John. His scholarly legacy was his archive of British visitors to Italy in the 18th century.[2]

Sir John Pope-Hennessy, a sometime director of the V&A and, later, the British Museum,

bought three paintings from the Bridgewater House sale of Bolognese paintings in 1946, including Domenichino's *Christ Carrying the Cross* for which he paid £43 and sold towards the end of his life to the J. Paul Getty Museum for £750,000. This sale enabled him to buy Sienese paintings that were too expensive in his youth. Count Antoine Seilern (1901–1978) was a scholar-collector who moved from Vienna in 1939 to 56 Prince's Gate in London. He had started collecting under the guidance of Johannes Wilde, formerly on the staff of the Kunsthistorisches Museum. He acquired 32 paintings and 23 drawings by Rubens, 40 works by Tiepolo, six drawings by Michelangelo and 30 by Rembrandt in a collection which stretched from Bernardo Daddi to Kokoschka. Wilde also moved to London where he became deputy director of the Courtauld Institute, to which the Count bequeathed his collection in one of the greatest benefactions ever made to a British gallery.

An unusual country-house rescue was that of Basildon Park, Berkshire by Lord and Lady Iliffe. Their first purchases were small pre-Impressionist paintings by Daubigny and others which were overwhelmed by their setting: the scale and palette needed to be stronger. They sought the advice of Jim Byam Shaw at Colnaghi's who sold them Baroque religious pictures by Batoni, Pittoni and La Fosse, a constellation impossible to imagine but for the revival of the taste for such works initiated by Denis Mahon. Since part of his fortune came from the *Coventry Evening Telegraph*, Lord Iliffe also bought Graham Sutherland's sketches for his huge tapestry reredos for the newly built Coventry Cathedral. In 1978 the Iliffes gave their house to the National Trust.

Traditional Old Master painting collecting continued. Harold Samuel, later Lord Samuel of Wych Cross, a property developer, formed an important collection of 17th-century Dutch paintings which he bequeathed to the Corporation of London. The revival of the collecting of historic British art was primarily effected by an American, Paul Mellon. Pre-war collectors of British art were transfixed by grand 18th-century portraits but Mellon's interest lay in the provincial byways of sleepy country houses, fox-hunting squires and family music groups. In 1936 he bought his first Stubbs and was to form a comprehensive

collection of British painting and drawings from the reign of Elizabeth I to the mid-19th century. His collection revitalised English art as an academic subject, particularly sporting art. In 1966 Paul Mellon established the Yale Center for British Art and in 1977 opened his museum, which remains the greatest collection of British painting ever formed by an individual.

Post-war modernism began with the founding of the Institute of Contemporary Arts in 1947 by E.C. Gregory, Peter Watson and Roland Penrose, as a laboratory of contemporary art. It had been conceived by Herbert Read who was, with Penrose, the main standard bearer in England of the School of Paris. The ICA inaugural show was called *40 Years of Modern Art* with loans from all its founders. The memory of Picasso's *Guernica* exhibited at the Whitechapel Art Gallery in 1939 remained powerful, but over the next decade British artists redirected their attention from Paris to New York. The Tate under John Rothenstein organised shows of American art in 1956 and 1959, but perhaps more important was the dazzling series of exhibitions put on by Bryan Robertson at the Whitechapel Art Gallery (fig. 354): Turner (1953), Mondrian (1955), Pollock (1958), Malevich (1959), Rothko (1961), Rauschenberg (1964) and Johns (1964).

The Contemporary Arts Society, founded in 1909 to promote and purchase British art, continued to flourish and had talented buyers after

354 The Whitechapel Art Gallery, London

355 Stanley Spencer, *Sunflower and Dog Worship* Wilfred Evill; now Private Collection

the Second World War who made telling acquisitions on its behalf: Sir Colin Anderson, chairman of P&O and an important patron in his own right, chose Francis Bacon's *Figure Study II* in 1946, and Wilfrid Evill, a solicitor with a special interest in employment law, followed this with Bacon's *Pope I* in 1952, while E.C. Gregory, who left his collection to the Tate, chose *Homage to Beethoven* by Ceri Richards in 1953. These works were distributed to museums around the country: Leicester, Leeds and Aberdeen and so on. The tiny band of London contemporary art dealers who offered the supply were crucial to this development: Freddy Mayor, Peter Cochrane of Tooth's, Lillian Browse and Erica Brausen, who was Bacon's first dealer before he – like so many other big fish – swam into the Marlborough Gallery net. One of Bacon's earliest patrons was Eric Hall, who became his lover and gave two major paintings to the Tate.

Many of the collectors who sat on the influential exhibition committees in the post-war years had made their best acquisitions in the 1930s but some enthusiastically embraced the new generation of artists. The ubiquitous Roland Penrose bought Farley Farm on the Sussex Downs in 1949 and started a new collection of younger artists: Richard Hamilton, Kenneth Armitage, William Turnbull and Heinz Henghes. Penrose wrote the introduction to Bacon's 1957 Paris exhibition and owned *The Poet* (1960). In 1965 he managed to secure Picasso's *The Three Dancers* for the Tate (of which he was a trustee), something of a coup since many curators around the world had their eye on it.

Wilfrid Evill was a London solicitor who collected living British artists between 1930 and 1963. At the core of his collection was Stanley Spencer, whose legal adviser Evill became. He assembled the most important private collection of Spencer's work, including *Sunflower and Dog Worship* (fig. 355). To these he added Roberts, Burra and Bevan and, after the war, Graham Sutherland and Ivon Hitchens. Evill gave equal prominence to sculpture and acquired works by Gaudier-Brzeska, Epstein, Underwood, Moore, Frink and Chadwick. The only area in which he looked backwards was his Regency furniture, in Thomas Hope taste,

which gave the ensemble great panache. In June 2011 Sotheby's held a sale of the collection (on the death of his ward Honor Frost) which set new records for the artists he collected.

The St Ives School in Cornwall, already associated with Ben Nicholson, Barbara Hepworth and Christopher Wood, was refreshed by a new generation of artists, especially Peter Lanyon, Roger Hilton, Patrick Heron, and Terry Frost. One collector of the earlier St Ives period with enormous influence was H.S. (Jim) Ede (1895–1990) whose house can still be visited in Cambridge today. Ede had worked at the Tate Gallery and befriended artists in the 1920s. In 1957 he and his wife Helen converted a row of Cambridge artisan cottages due for demolition into an extraordinary modernist manifesto (fig. 356). Works by Ben Nicholson, Christopher Wood, Brancusi, Miró, David Jones,

Alfred Wallis and, above all Henri Gaudier-Brzeska were set against white walls, simple furniture, stones and pebbles to create an outpost of St Ives in the Fens. Light was all-important and in these austere surroundings the art took on a talismanic quality. Kettle's Yard remains a beacon of 1930s modernism, homely by continental standards, but a classic of its time.

Margaret Gardiner was a collector from a distinguished academic family who had studied at Cambridge and acquired both generations of St Ives artists. She keenly supported St Ives artists in the 1930s and 1940s and became a close friend of Barbara Hepworth (fig. 357). After the war she was a patron of Naum Gabo, Peter Lanyon, Patrick Heron, Terry Frost, Margaret Mellis and John Wells. In the 1950s she discovered Orkney, which perhaps reminded her of St Ives in earlier

356 Kettle's Yard, Cambridge. The house extension, downstairs, showing the Buddha from the Prang Sam Yot Temple, Lopburi, Thailand (13th or 14th century) and works by Mario Sironi, Henri Gaudier-Brzeska and Ben Nicholson

357 Margaret Gardiner with Barbara Hepworth's *Curved Form (Trevalgan)*, at the Pier Arts Centre on Orkney

358 Richard Hamilton, *Interior Study*
Colin St John Wilson; now Pallant House, Chichester

days. She gave her collection to the island and in 1979 opened the Pier Arts Centre in Stromness to display it.

The generational change from the 1940s to the 1960s is well expressed by the collections of the Rev. Walter Hussey (1903–1980) and Colin St John (Sandy) Wilson (1922–2007) who both left their art to Pallant House Gallery in Chichester. The former had begun an astonishing career of patronage as vicar of St Matthew's in Northampton, commissioning musical compositions from Britten and Tippett, and art for the church from Moore (*Madonna and Child*, 1944) and Sutherland. Hussey no doubt influenced the decision to fill the new Coventry Cathedral with works of art. In 1955 he was appointed Dean of Chichester where he continued his patronage of musicians such as Bernstein and Walton, and of artists including Ceri Richards and Piper, and commissioned a Chagall stained glass window. The grateful artists gave Hussey their sketches and allowed him to buy other works cheaply, so that he was able to assemble fine examples by Sutherland, Piper, Richards, William Scott, Minton and Moore.

Sandy Wilson planned to be a painter but became an architect, reaching his apogee with the new British Library. If any collector personifies the idealism of New Jerusalem it is Wilson. 'We all wanted to help rebuild Britain – help create

a new utopia,' he later told an interviewer.[3] At the ICA he met Richard Hamilton and Eduardo Paolozzi. He bought well: Nigel Henderson's *Screen* (1963), some of the best work of Hamilton (fig. 358) and Paolozzi, as well as Blake, Kitaj, Tilson and Hodgkin. Wilson was associated with the Independent Group (1952–55) and much influenced by the Whitechapel exhibitions, *This is Tomorrow* (1956) and the *New Generation* exhibitions of the 1960s. His collection focused on figurative and abstract art, and includes one of the best groups of English Pop art ever formed. It was created on what he called 'sacrificial victims' by always trading up. The collection found a permanent home at Pallant House in a gallery designed by his wife, M.J. Long.

Another collector of Paolozzi was Gabrielle Keiller, the 'marmalade Queen', who united eighteen of his works with a distinguished collection of Dada and Surrealist art. She also owned one of the few Duchamps in Britain (fig. 359) and had her dachshund painted by Andy Warhol. On her death in 1996 she bequeathed her collection of 136 paintings, sculptures, prints and drawings, as well as manuscripts and books, to the Scottish National Gallery of Modern Art.

Ted Power (1899–1993) was the most impressive collector of international contemporary art in the 1950s and 1960s. He was an Irishman whose fortune came from Murphy Radio Ltd which was

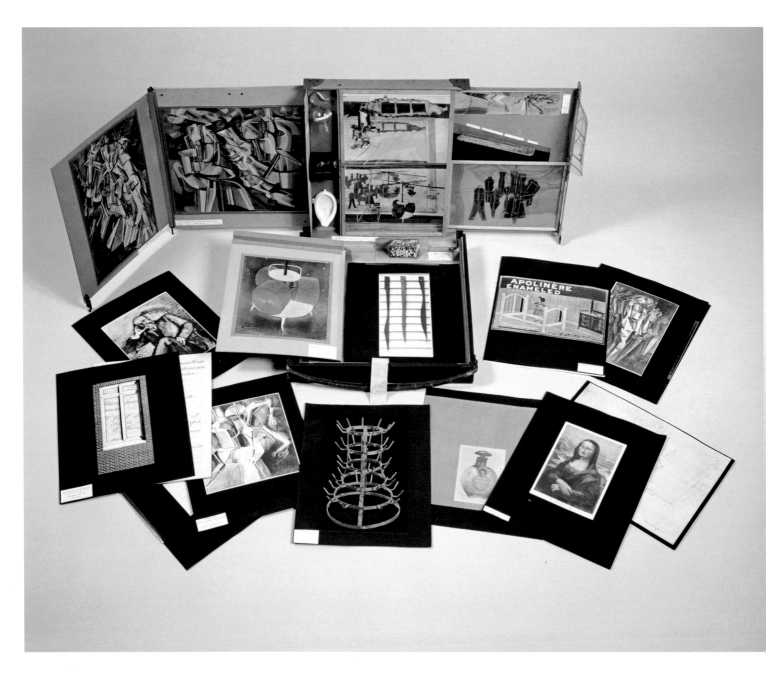

floated on the stock market in 1949 and provided him with the capital to collect. Power started with Jack Yeats and Matthew Smith and then extended his interests to Paris with nine works by Nicolas de Staël. His favoured dealers were Peter Cochrane at Tooth Gallery (from whom he made over 50 purchases in 1954) and later Leslie Waddington. Power liked to buy artists in depth and by the end of the decade he had an impressive group of Jorn, Picabia, Dubuffet, Ernst and Soulages. While the ICA and Whitechapel mounted the exhibitions, it was generally agreed that the finest permanent avant-garde display in London was at Power's flat in Grosvenor Square. He exhibited his collection at the Arts Council in 1956–57, and a year later at the ICA. The 1956 exhibition of American

painting at the Tate with a final room devoted to Abstract Expressionism proved a revelation, and in the same year he bought his first Rothko and followed it up with a group of Pollocks, Clyfford Still, De Kooning, Kline, Newman, Lichtenstein and Rosenquist. If he wasn't the first to buy the new American artists, Power embraced them more comprehensively than anyone else (fig. 350). In 1958 he discovered Ellsworth Kelly and bought eight works, including *Broadway* (1958), which he later gave to the Tate.

New York and Paris did not blind Power to the interesting developments at home, and he was among the first to spot the early stirrings of London's emergence as a capital of contemporary art. In the early 1960s he bought Kitaj, Allen Jones,

359 Marcel Duchamp, *La Boîte-en-Valise*

Gabrielle Keiller; now Scottish National Gallery of Modern Art, Edinburgh

Peter Blake and had the largest collection of the most innovative of them all, Richard Hamilton. In 1968 Power became a trustee of the Tate where he encouraged an adventurous policy. When the trustees wouldn't buy *Fat Battery* (1963; fig. 360) by Joseph Beuys, largely because of the conservation difficulties of mixed fat and cardboard, Power bought it himself and later gave it to the Tate. The gallery honoured him with a retrospective exhibition of his achievements as a collector in 1997.

The 1960s saw the explosion of pop culture in Britain across the fields of music, photography and design. This was the era of David Bailey, The Beatles and Swinging London. By 1965 John Russell was able to ask the question 'just what has turned London into one of the world's three capitals of art?'[4] He thought that the two factors that gave London its pre-eminence were the auction houses and the aeroplane. In 1958 Peter Wilson of Sotheby's masterminded the sale of seven paintings from the estate of an American banker, Jacob Goldschmidt. The sale was the birth of the international auction market and for the next two decades London held a monopoly of important international sales. The capital also had plentiful art schools and committed dealers

to nurture young talent, but surprisingly few important collections were formed in the 1960s and '70s. John Kasmin promoted David Hockney. who was instantly recognised as a star. Kasmin's partner, Sheridan Dufferin. bought *A Bigger Splash*. The Marlborough Gallery had a dazzling array of British artists but largely sold them to foreign collectors. Between 1945 and 1979 the State dominated art collecting. Lawrence Gowing, Alan Bowness and David Sylvester replaced Kenneth Clark and Roland Penrose as the most influential arts committee figures of the time. Bowness was to become director of the Tate between 1980 and 1988.

One collector who had an eye on America was Peter Palumbo. It was a visit to modernist architect Philip Johnson at The Glass House in Connecticut that inspired him to become a collector. Palumbo acquired works by Jim Dine, Oldenburg, Rosenquist, Barnett Newman's *Uriel* from Alan Power, Ted's son, and from the seminal Scull sale at Sotheby's in 1973 he bought Jasper Johns's *Target* (fig. 362). He combined contemporary art with antiquities (influenced by David Sylvester) and Guercino drawings (Jim Byam Shaw). Palumbo's contemporary interests were nurtured by the London dealers Leslie Waddington, who allowed

360 Joseph Beuys,
Fat Battery
Ted Power; now Tate Modern,
London

him long credit, and Robert Fraser. Perhaps his most remarkable acquisitions were a group of modernist houses by Frank Lloyd Wright, Le Corbusier and Mies van der Rohe's Farnsworth House at Plano, Illinois.

Peter Cochrane of Tooth exemplifies the most impressive group of international acquisitors of the time, the dealer-collectors, who flourished especially in America and Switzerland. Cochrane's walls were covered with small-scale works by Dubuffet, Jorn, Klein, Twombly, Hockney and Hodgkin, competing for space with his Carltonware and market stall purchases from Portobello Road. Eric Estorick was another pioneering dealer-collector, who opened the Grosvenor Gallery in London in 1961. He dealt mainly in Italian modern art but did not like to part with paintings. He kept back Boccioni's *Modern Idol*, Modigliani's *Dr Francois Brabander* as well as works by de Chirico, Russolo, Balla and Severini which are all displayed today in the eponymous house-cum-museum dedicated to Italian 20th-century art at Canonbury Square, North London.

A collector who caught the mood of the 1960s was Alastair McAlpine, later ennobled in 1983 by Margaret Thatcher as Lord McAlpine of West Green. He is a rare example of a collector who became a dealer. Born into the Scots building dynasty which benefited from the London property boom of the 1960s, McAlpine began collecting the paintings of Alfred Wallis and the sculptor David Wynne. He discovered abstraction in 1964 and bought paintings by Rothko, Ellsworth Kelly and Morris Louis. The 1965 Whitechapel exhibition *The New Generation* introduced him to the young British sculptors he was to champion. Rejecting carvers like Moore, he patronised the 'construction' sculptors of geometric and abstract work, such as David Annesley, Michael Bolus, Phillip King, William Tucker and Isaac Witkin. At first McAlpine displayed the sculpture in his garden at Fawley House, near Henley, but after finding that it got dirty, he built a gallery for the collection of 60 works, which he gave to the Tate in 1971. McAlpine went on to form over 40 separate collections, ranging from Aboriginal art to natural history books. In 1962 he opened an antique shop in Sloane Street and in 1980 an antiquities and curiosities shop, Erasmus, in an attic in Cork Street. Possession is the least important part of

collecting for him: 'I collect I suppose to learn, for I have never collected to possess. When a collection passes from my hands it goes in total – nothing remains.' He has given away or sold almost everything and today retains little except books and textiles.

In the mid-1970s, while lamenting the general decline of British collecting, Denys Sutton, editor of *Apollo* magazine, was able to point to one shining exception, Robert and Lisa Sainsbury. Robert (1906–2000), always known as Bob, had the family grocery fortune behind him although his collection was begun with modest sums of money. Lisa Sainsbury came from a Dutch Jewish background and was brought up in Geneva and Paris. Perhaps on her account, their collection represents the continental fusion of ancient artefacts and modern masters that André Breton had pioneered in Paris. Bob started collecting Epstein drawings, and in 1933 he bought Moore's *Mother and Child* (1932; (fig. 364), which remains

361 Yoruba janiform head
(right side view)
Robert and Lisa Sainsbury; now
Sainsbury Centre for Visual Arts

362 Jasper Johns,
Target, 1961
Peter Palumbo; now Stefan T. Edlis
Collection

363 Francis Bacon,
*Study (Imaginary Portrait of
Pope Pius XII)*
Robert and Lisa Sainsbury; now
Sainsbury Centre for Visual Arts

364 Henry Moore,
Mother and Child
Robert and Lisa Sainsbury; now
Sainsbury Centre for Visual Arts

the centrepiece of the museum they founded, the
Sainsbury Centre at the University of East Anglia
near Norwich.

Freddy Mayor directed the Sainsburys' taste in
modern art while John Hewett had considerable
influence in shaping their taste for tribal art and
ancient civilisations. Hewett sold them three New
Guinea pieces from the Pierre Loeb Collection.
The Sainsburys bought Yoruba figures (fig. 361),
Benin bronzes, Egyptian and Cycladic work, and
Cook Island figures all set against Picasso drawings
and Henry Moore sculpture. Picasso, Moore and
Giacometti were the dominant artists in the col-
lection until 1953 when the Sainsburys met Francis
Bacon through Erica Brausen. Their immediate
and unstinting support for the artist was their
greatest achievement as patrons (fig. 363). They
acquired at least a dozen works before Bacon
was a celebrity and he became a close friend. Bob
guaranteed his overdraft and it was said that the
only time the artist ever behaved properly was
when he was with the Sainsburys.

By the mid-1960s parts of the collection
had been on exhibition to New York and the
Netherlands and the Sainsburys decided that
they wanted to give their art to the public. They
identified the young Norman Foster of the Olson
building at Millwall as their architect at the
University of East Anglia, which was the benefi-
ciary. The result is a cool, restful, light grey hangar.
The Bacons dominate: *Pius XII* (1955), *Van Gogh*
(1957), *Portrait of P.L., No. 2* and *Two Figures
in a Room* (1959) and the huge space provides
a surprisingly intimate setting for small-scale
figurative works from around the world. It was
the most ambitious post-war example of creating
a collection as the foundation of a museum. The
next generation of the Sainsbury family, Robert's
nephews, were to provide a new wing for the
National Gallery.

Chapter 25

LONDON: INTERNATIONAL ART CITY 1979–2000

In 1979 Margaret Thatcher became Prime Minister and Britain was to change profoundly over the next decade. The 1980s were a period of strife in which the New Jerusalem welfare consensus of the 1950s was trumped in favour of a robust free market economy. For art collecting there were several consequences. The period brought liquidity into the market and caused a surge of confidence among collectors. The relatively benign fiscal conditions in relation to international capital in the UK encouraged a number of foreign art collectors to make London their home. Some British expatriates who had made fortunes abroad brought their art home. It is mainly a London story; an unexpected feature of the period was the way in which the capital transformed itself from the international centre of the market in Old Masters paintings to a city of contemporary art. The stepping stones had been laid earlier at Whitechapel and the ICA, but the period is defined by the success of Charles Saatchi and the crowning appearance of Tate Modern. The latter was largely the achievement of its first director, Sir Nicholas Serota, who had established his credentials at Whitechapel.

Momentum for contemporary art was rapidly established. The Royal Academy played its part by organising a series of important exhibitions curated by Norman Rosenthal, beginning with *Post-Impressionism* in 1978 and *A New Spirit in Painting* in 1981. The following year the Tate Patrons of New Art were founded, uniting the new high society with contemporary art. In 1984 the Turner Prize was instigated, and the Saatchi Gallery in Boundary Road opened in 1985, serving the growing public appetite for new art. The launch of Tate Modern in 2000 established London's

Charles Saatchi

Janet and Gilbert De Botton

Collecting outside London

Andrew Lloyd Webber

International Collectors in London

David Khalili

Dealer-Collectors

Frank Cohen

365 Gilbert and George, *Red Morning Trouble*
Janet Wolfson de Botton; now Tate Britain, London

position as a leading contemporary art city (fig. 366). David Sylvester was the most influential British art critic and his hand was everywhere. The dominating presence was that of the artists and in particular the YBAS (young British artists) of the 'Brit pack' who became the best internationally marketed generation of British artists ever, with Charles Saatchi playing the role of ringmaster (fig. 368).

Charles and his brother Maurice founded their advertising agency Saatchi & Saatchi in 1970; by the end of the decade it was the largest in Britain and promoted the campaign that saw the Conservative Party elected to power in 1979. As a child Charles Saatchi had collected Superman comics and juke boxes. His first wife, Doris Lockhart, whom he married in 1973, came from Memphis, USA and together they started buying minimalist art from the Lisson Gallery: Carl Andre, Donald Judd and Sol LeWitt. The focus was initially on America, and Saatchi early established a pattern of making multiple purchases. Typical was the visit of Charles and Doris to Julian Schnabel's studio in New York in 1978; the Tate's Schnabel exhibition of 1982 included nine works lent by Saatchi out of eleven. Shortly after he resigned from the Patrons of New Art at the Tate and as a trustee of Whitechapel to become an independent force with his own gallery.

Saatchi has always maintained that 'I primarily buy art to show it off' and his acquisition of gallery space at Boundary Road served precisely this purpose. In 1983 he bought a warehouse in St John's Wood, a wealthy, rather sleepy residential area of North London where fashionable artists had lived at the end of the 19th century. London had seen nothing like it before: a large, neutral space dedicated entirely to contemporary art, it became the focus of the London *avant garde*. In the period before Tate Modern it was the most cutting-edge venue in the capital and initially charged no entrance fee. Saatchi's astonishing programme of exhibitions have changed the face of British art. Their sheer pace and turnover is striking, but it was Saatchi's instinct to mount seminal shows that gave Boundary Road its place in history.

He opened in 1985 with American art: Donald Judd, Brice Marden, Cy Twombly and Andy Warhol (fig. 367). This was followed the next year with Carl Andre, Sol LeWitt, Robert Ryman, Frank Stella and Dan Flavin. The third year showed no let-up with the German artist, Anselm Kiefer, and Serra, followed by an exhibition of New York Art Now, including Koons and Gober. The American artists he chose were mostly already well known in New York, but the young British artists who saw these exhibitions went on to feed the next generation of Saatchi exhibitions and elevate his collection to international status. Collectors are usually credited for their choice of art works but Charles Saatchi is one of only a handful who influenced a generation of artists.

In 1989–90 Saatchi turned away from America and mounted two exhibitions of well-established British artists, mostly figurative: Leon Kossoff, Frank Auerbach, Lucian Freud, Richard Deacon and Bill Woodrow. The so-called School of London had been discovered in America and was already energetically promoted by London dealers. Two years later in 1992 Saatchi mounted the first YBA show that was to define the next generation, and included Damien Hirst, Sarah Lucas, Jenny Saville and Rachel Whiteread. The central figure was undoubtedly Hirst, clever, articulate and quick to spot other people's talent. As a student at Goldsmiths College in 1988 he had curated an exhibition of student work in Docklands which achieved almost mythical status: *Freeze*. Saatchi attended this show, and Hirst drove Norman Rosenthal, the exhibitions secretary of the Royal Academy, to see it in his rickety old car, a move which bore fruit some years later.

The extraordinary pace of Saatchi's collecting was driven by the needs of his next show. Much was bought from the artists directly but two notable dealers were also involved, Jay Jopling of White Cube and the eponymous Karsten Schubert who sold him works by Gary Hume, Glenn Brown, Michael Landy and most notably Rachel Whiteread. By 1997 Saatchi owned 875 works by the younger generation of British artists. If there was one critic Saatchi listened to it was David Sylvester.

A chance conversation led to the most electrifying moment in the history of the collection. Norman Rosenthal had a gap in the Royal Academy exhibition diary and Saatchi suggested lending the young British artists. In the autumn of 1997 they mounted the aptly named show *Sensation*, with 100 works by 42 artists, 18 of them former Goldsmiths students (fig. 383). The show had its intended shock effect, causing the resignation of four venerable Academicians and acres of print both for and against the exhibits. Marcus Harvey's *Myra* (1995), a grainy painted police mug-shot of the Moors Murderer, caused most offence, but two other works caught the public's imagination. Damien Hirst's shark (1991), with the cumbersome title *The Physical Impossibility of Death in the Mind of Someone Living*, could not have been created without Saatchi's support (fig. 369). It began as a drawing and Hirst's dealer

Jay Jopling took the project to Saatchi, who agreed to fund it to the tune of £50,000. This barely covered the costs of the hunter, taxidermist, freezer and other specialist apparatus, so it is doubtful whether the artist received more than a fifth of this sum. Saatchi later sold the work to Steve Cohen for $12 million.

The other work that caught the public imagination in England was Tracey Emin's *Everyone I Have Ever Slept With 1963–1995*, a mattress and tent with names appliquéd on the sides. The exhibition established the Britpack (as it became known) as an international force and its interest in body fluids and the seamier side of life confirmed the rather uncouth direction of British art. Nearly 300,000 people visited the exhibition and Rosenthal claimed that London had for the first time become the world's art capital. In October 1989 Saatchi had sold up to a hundred works through the New York dealer Larry Gagosian, causing howls of anguish from some of the artists involved. Shortly after *Sensation* he constructed a public test of the market's faith in his artists. In 1998 Christie's held a major auction sale of Saatchi's collection in their short-lived warehouse in Clerkenwell. The dealers had huge misgivings. The collector's faith was justified, and the sale was an enormous success, firmly establishing many artists like Jenny Saville with no previous auction form. Nevertheless, Saatchi was criticised for the effect his dispersals had on one or two artists' prices, giving rise to the mantra that he was more dealer than collector.

By 2001 Tate Modern had overtaken Saatchi's Boundary Road Gallery as London's principal contemporary art venue and he realised it was time for a change, but his choice took everybody by surprise: County Hall, London's Edwardian municipal palace opposite the Houses of Parliament. Its ponderous architectural style was inevitably at war with the contents of his exhibitions, and it proved a very different story from Boundary Road, a commercially run exhibition venue. The new gallery opened in 2003 with Damien Hirst and many of his Britpack contemporaries – including the Chapmans, Emin, Hume, Lucas, Rego and Saville – accompanied by the catalogue: *100: The Work that Changed British Art*. Saatchi had acquired several seminal pieces by other young artists: Richard Wilson's *Oil Room*, Rachel Whiteread's *Ghost* (1990) and Emin's *My Bed* (1998), for which he paid £150,000 in 1999, but he continued to buy the work of an older generation, such as Patrick Caulfield (his entire Waddington exhibition in 1998) and John Bratby. One feature of the younger artists that never seemed to trouble Saatchi was the scale and complexity of their work. Perhaps he is partly responsible for the gigantism that overtook British art for a decade.

In 2005 Saatchi moved his gallery to Chelsea. If it is not too early to arrive at a definitive conclusion, he occupies a central role in the history of British art in the 1980s and '90s. Saatchi wielded such power because he lacked serious competition,

but did much to promote British art globally.

One contemporary collector who started in the 1970s was Janet Wolfson de Botton. Charles and Doris Saatchi were close friends but otherwise she was inspired by the foreign collectors: Si Newhouse in New York, Susan and Lewis Manilow in Chicago and Giuseppe Panza in Milan. She started with a John Hoyland abstract and the intention of furnishing a home. Janet Wolfson hired a private tutor in art history and visited exhibitions at the Whitechapel and ICA galleries. She preferred new works, sometimes buying directly from the artist's studio as in the case of Grenville Davey. She also used several dealers in London and New York including Larry Gagosian, Mary Boone, Leo Castelli, Leslie Waddington and Anthony d'Offay, but has a fiercely independent mind and strong opinions. De Botton's collection is divided between figurative and abstract work with a preference for stillness. In 1996, she gave Nicholas Serota, director of the Tate, a free choice from her collection, which significantly extended the museum's holdings. Serota selected works by Carl André, Richard Artschwager, Grenville Davey, Gilbert and George (fig. 365), Richard Long, Sean Scully and Cindy Sherman. Several of the artists were a first for the Tate, including Roni Horn, Gary Hume, Reinhard Mucha, Lucas Samaras and Nancy Spero.

In 1998 Janet married another art collector,

Gilbert de Botton (1935–2000), who has the unique distinction of having been painted by both Francis Bacon and Lucian Freud. Gilbert was a financial genius who nurtured a passion for Montaigne and late Picasso. A sephardi born in Alexandria, he eventually held Spanish nationality. He made his first fortune in Switzerland and in 1983 moved to London where he set up Global Asset Management. With a natural academic mind, he listed reading Seneca as one of his hobbies. Gilbert de Botton had a particular fondness for the geometric simplicities of the American sculptor, Scott Burton, and formed a collection of his furniture. Acquiring late works by Picasso can be a lottery but he chose unerringly, forming probably the most important collection in England. Gilbert made generous financial gifts to the Tate and Serota acknowledged him as a crucial figure in the establishment of Tate Modern.

While London seemed captivated by the present, there remained collectors of the art of the past who typically preferred to place their collections in the country. One of the most interesting regional developments was the opening of the museum-cum-country house, Compton Verney, by the football pools heir, Sir Peter Moores (fig. 370). His Foundation restored this Adam house and then filled it with a mixture of art that combines several traditional themes of British collecting: Grand Tour view paintings, 18th-century British

370 Compton Verney, Warwickshire, opened as a museum by Sir Peter Moores

371 Allen Jones's *Carefree Man* at Chatsworth House, viewed from below with the Great Stair behind

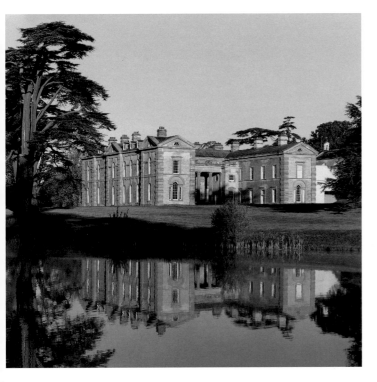

portraiture and Chinese art. Moores differs from previous collectors in his emphasis on Chinese bronzes rather than ceramics. More unusually, he has formed a collection of German Renaissance sculpture, very rare in British private collections. He acquired the only major Riemenschneider sculpture in Britain since the time of the Randlords. It cannot be said that this eclectic group of collections sits comfortably together, but future acquisitions may bridge the aesthetic divides which separate them.

One of the few dynastic collections to be refreshed in recent years is that of the Devonshire family at Chatsworth – who have the longest unbroken collecting tradition of any family in Britain – where both the late Duke and the present one have added a strong contemporary element (fig. 371) to their inherited Rembrandts and Van Dycks. Lord Rothschild also made significant additions to his family home, Waddesdon, in Buckinghamshire, above all of traditional 18th-century paintings and silver. Perhaps the most discreet collector was Simon Sainsbury (1930–2006), one of the trio of brothers who donated a wing to the National Gallery in 1991. Characteristically, he had no entry in *Who's Who*. Sainsbury formed a general collection – in itself quite rare at the time – to furnish his Georgian country house: paintings by Monet, Gauguin, Douanier Rousseau, Degas, combined with Freud, Bacon, Balthus, Pasmore, Gainsborough and Zoffany. It was an Epicurean

group from which he left the plums to the National Gallery and the Tate.

If Sainsbury was at heart a Georgian, Andrew Lloyd Webber was vehemently a Victorian. Enthralled at an early age by the London churches of Butterfield and Pearson, he allowed this richer spirit of Victoriana to nourish his imagination. The success of his musical *Jesus Christ Superstar* in 1971 at the age of 23 enabled him to start collecting Victorian paintings and decorative art at a time when they were still at the nadir of fashion. It was the Pre-Raphaelites, the most ornate and self-consciously artistic products of their age, that formed the bedrock of his collection, in particular Burne-Jones. At its centre are 40 works in all media by the artist, including such major works as *The Mirror of Venus*. All the Pre-Raphaelites are present in depth: Rossetti, Millais, Waterhouse, Stanhope, Holman, Hunt and Hughes. The market for Victorian paintings rose with Lloyd Webber's success and he was its dominant force for a generation. An unexpected hole in the Royal Academy's exhibition schedule in 2003 provided a window for his collection (fig. 372). He was revealed as the greatest collector of Victorian paintings since the 19th century with startling masterpieces such as Richard Dadd's *Contradiction: Oberon and Titania* and John Brett's *The Val d'Aosta*. Like Denis Mahon in an earlier generation, Lloyd Webber showed that a collector can resuscitate a period and influence taste.

London in the 1980s became a magnet for a new breed of global collector who moved themselves and their art around the world. Stanley Seeger, an American, arrived in 1979 and the following year bought Sutton Place, the Getty mansion in Surrey (fig. 373). Picasso was the main ingredient of its décor: 123 works in all media representing the whole of the artist's career. While Picasso held the central position in international collecting during the second half of the 20th century, there had been no major collector of his works in Britain since the days of Roland Penrose and Douglas Cooper. Stanley Seeger's partner, Christopher Cone, had studied at Cambridge, where he was impressed by Kettle's Yard, and he brought Christopher Wood, Sutherland and Ben Nicholson into the collection.

Ken Thomson, 2nd Lord Thomson of Fleet (1923–2006), the Canadian newspaper tycoon whose family once owned *The Times*, formed an important collection of medieval works of art, an unfashionable field at the time, and had a penchant for the works of Cornelius Krieghoff, a Dutch-born artist who emigrated to North America where he painted Canadian landscapes. In 2002 he donated his collection to the Art Gallery of Ontario including Rubens's *Massacre of the Innocents* which had been on loan for a time to the National Gallery, London. If Thomson's collection was formed out of the London trade but destined for Canada, Arthur Gilbert's came in the opposite direction. Gilbert had emigrated as a young man to California, made a fortune in the property business, and started collecting gold boxes and classic English silver. Towards the end of his life he negotiated for his entire collection to be displayed at Somerset House, an arrangement that survived for a decade before it was put on long-term loan at the v&a. The closure of the Gilbert collection the same year as the Percival David Foundation, revealed the vulnerability of smaller specialist museums as well as the growing preference for contemporary art with the London public.

One collector who moved to London in the late 1970s, after marrying an English wife, was David Khalili. He is of Iranian Jewish descent and has formed one of the finest private collections of Islamic art in the world. It is the cornerstone of his activities: he writes, lectures, publishes and exhibits. His interests are wide; in addition to Islamic art, he has also formed definitive collections of Japanese

19th-century Meiji art, Swedish textiles and Spanish damascened metalwork. These collections have been exhibited in 35 museums around the world but looming above them all are the staggering 32 folio volumes (expected to rise to 52) of the catalogue of the Khalili collections. These constitute the closest examination of any private collection yet undertaken.

Khalili was born in 1945 in Isfahan and brought up in Tehran where his family were art dealers. After military service he went in 1967 to America, where he studied computer science and dealt in art. A decade later Khalili married and moved to London, where he demonstrated his unusual ability to create wealth, while continuing his education with a PhD on Persian lacquer at London University's School of Oriental and African Studies. He differs from most previous western collectors of Islamic art in his respect for the written word. Khalili has important Safavid manuscripts and ten

374 *Farnak, the mother of Faridun, sends him gifts from her treasury*, folio 38b from the *Shahnamah* of Shah Tahmasp ('Houghton' *Shahnamah*); Iran, Tabriz, 1520s

Nasser D. Khalili Collection of Islamic Art

leaves of the celebrated Houghton *Shahnamah* (fig. 374), as well as numerous Mughal gold boxes and rare copies of the Qur'an. Whether expressing luxury or utility, Khalili has them all, and today his Islamic collection is the most extensive in private hands. In 2009 it was exhibited in Abu Dhabi, but it has remained in search of a permanent display venue ever since.

In the previous chapter, mention was made of the international growth of dealer collections and several came of age during the 1980s in London. Andrew Ciechanowiecki, a Polish émigré who ran the Heim Gallery, brought cosmopolitan tastes and museum cataloguing standards to his commercial exhibitions. He collected decorative arts with an 18th-century Polish-French emphasis with a view to donating his collection to his home country. Danny Katz, like Ciechanowiecki primarily a sculpture dealer, has formed a remarkable collection redolent of several artistic eras: Edwardian England, Italian Mannerism and Rudolph II in Prague. More recently he has been concentrating on his British art that extends from Turner's *Whitstable* to Lucian Freud's *Portrait of Peter Watson* (fig. 375),

375 Lucian Freud,
Portrait of Peter Watson
Collection of Danny Katz

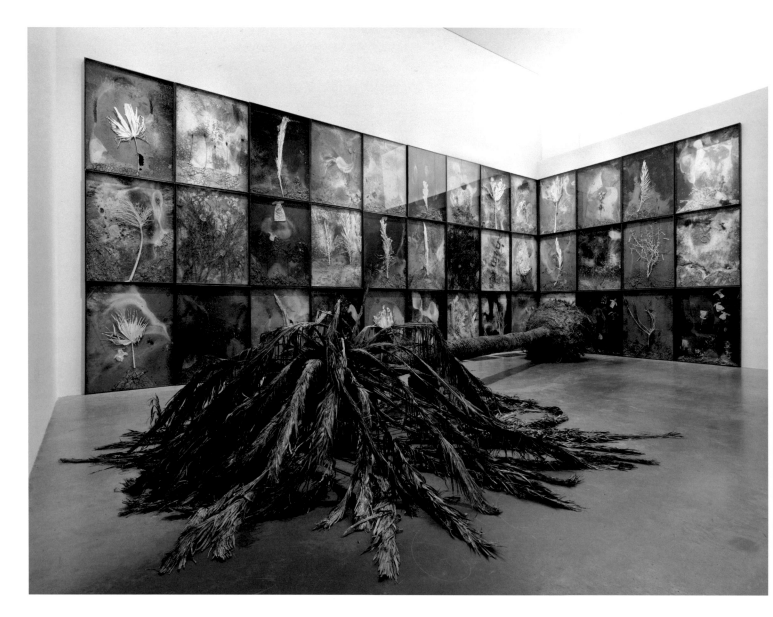

with an emphasis from Sickert to Auerbach. This brings up to date a collection of European paintings that speaks of Renaissance Italy and its Northern visitors.

The great modernist dealer collection of this period was formed by Anthony d'Offay. 'I was never a collector,' he says; 'I had the idea of putting together rooms with the purpose of inspiring young people.' His dream of being a curator was realised when he transferred 725 works by 32 artists to the joint ownership of the National Galleries of Scotland and the Tate in 2008.[1] D'Offay had held a singular position initially in the gallery world since he opened his Dering Street premises in 1969. His interests were focused on the early 20th century with gallery exhibitions including Vorticism, Bloomsbury, Epstein, Spencer, Lewis and Gill. In 1980 he would enter the contemporary fold following his marriage to Anne Seymour, formerly an assistant to David Sylvester and curator at the Tate. The museum transfer was of post-war art, which d'Offay entitled *Artist Rooms*, which includes works by Beuys, Ian Hamilton Finlay, Gilbert and George, Damien Hirst, Jeff Koons, Anselm Kiefer (fig. 376), Warhol and Richter, a roll-call of artists validated by later consensus. This speaks volumes about the ability of talented dealers to be in advance of the museum establishment. His collection filled many gaps in the two museum inventories and he was invited to become an ex-officio curator for five years.

A northern collector who has attracted much attention is Frank Cohen, usually dubbed 'the Saatchi of the North'. A Mancunian with a Wolverhampton gallery space named *Initial Access, Unit 2*, Cohen has created a powerful momentum with shows of British, American, German and Japanese contemporary art (fig. 377). One of

376 Anselm Kiefer,
Palm Sunday
Anthony d'Offay; National Galleries of Scotland and Tate Modern, London

the most important international developments since the 1990s is the collector's Kunsthalle where collectors of contemporary art rotate their collections. Saatchi pioneered this in England and foreign examples include Eli Broad in Los Angeles and Francois Pinault in Venice. They represent the collector as impresario. The sheer scale of such collections both in terms of the size of individual items and the quantity of works inevitably moved collecting contemporary art out of the home. Paradoxically, the taxonomy of much international collecting is more nationally based than ever, with growth in areas such as Chinese, Iranian and Russian art.

Collecting with a public purpose remained prevalent throughout the 20th century but was even stronger by the turn of the 21st century. For most collectors since the Second World War, public exhibition has been the main motivation. Nearly all the collections in this chapter were created from scratch and have a public dimension. Some have remained private but their owners have often given generously to museums, and served on their boards. Sir Joseph Hotung at the British Museum and Sir Paul Ruddock at the V&A are two prominent examples. British collectors have never been more public-spirited or more international. Indeed the term *British* collector is almost meaningless today. They could, in most cases, be more accurately referred to as a London or global collector.

Where will collecting in Britain go from here? Nobody can tell, but from the evidence of this book, the story will continue to develop in an unexpected and dynamic manner.

377 Installation at Initial Access, Frank Cohen's warehouse gallery in Wolverhampton, featuring (left to right) Bharti Kher's *Invisible People* (five panels), and *The Skin Speaks a Language Not Its Own*, and Ravinder Reddy's *Blue Painted Head*, *Red Painted Head* and *Gilded Head*
Frank Cohen Collection

Appendix

PRIVATE COLLECTION CATALOGUES

Private collection catalogues have been indispensable in writing this book. They tell us of the successive formation and dispersal of collections of pictures, drawings and other works of art by providing firm evidence of ownership at a fixed date. A study of such catalogues is in effect a study of the history of collecting. In nearly four centuries, the best of their kind have metamorphosed from a simple inventory or hand-list into informative and well illustrated works of scholarship, frequently handsomely printed at a private press. The 18th-century practice of visiting country houses, which created the need for portable guidebooks, stimulated the process. This appendix provides a sketch of their history. [1]

Printed catalogues differ from manuscript inventories in that their inherent purpose is to convey information to a wider readership, whereas manuscript inventories tend to be compiled for the use of the owner, his family or advisers, often being produced following a marriage or death. Hence manuscript catalogues can be viewed as a discrete subject in themselves: apart from a few early exceptions, they lie outside the scope of this appendix.

Abraham van der Doort, appointed Keeper of the King's Pictures in 1625, compiled the first manuscript inventory of the Royal Collection. Sir Oliver Millar described the entries in van der Doort's catalogue as 'written in greater detail and providing more information on provenance, size, condition and frames than can be found in any known inventory of the royal collection before the great inventory, begun at Prince Albert's instigation, by Richard Redgrave'. [2] Over 125 years later, van der Doort's manuscript was edited by George Vertue and prepared for publication by Horace Walpole: the book was published in 1757. [3]

In the light of the more exacting standards of the 20th century, the inaccuracies and omissions of the 1757 edition became more evident, so a definitive edition of the original van der Doort catalogue was prepared in 1960 by Oliver Millar. [4] He wrote in the foreword that the original catalogue was 'perhaps the finest inventory of its kind ever compiled in England. It is certainly the most important single source for our knowledge of the growth, arrangement and quality of a collection unrivalled in the history of English taste. The care and restraint with which it is drawn up bear witness to the connoisseurship in Charles I's circle and parts of the catalogue are presented in such detail that they help us to envisage the appearance of some of the royal apartments in the age of Inigo Jones.'

As mentioned in chapter 4, the Duke of Buckingham's collection was kept in York House, a palace on the Thames. Two manuscript inventories of Buckingham's collection were made, in 1635 (listing 330 pictures) and 1648 (200 pictures only). [5] The earliest printed inventory of a British collection is Selden's *Marmora Arundelliana*, published in 1628 with a second edition in 1629. The title page was printed in red and black and the text of this sophisticated and handsome work is mostly in Latin and Greek, with some Hebrew.

It was not until the early 18th century that the next printed catalogue of a private collection was published. Although not a full catalogue, reference should be made to the undated sequence of 20 plates, engraved by Hamlet Winstanley, reproducing Italian and Dutch pictures collected by James Stanley, 10th Earl of Derby (1664–1736). [6] This folio work was begun in 1727 and may have been published c.1730. [7]

The first proper catalogues were compiled on the orders of Thomas Herbert, 8th Earl of Pembroke (*c*.1656–1733, see chapter 8). The third son of the 5th Earl, he succeeded his brother in 1683, holding the earldom for 50 years until his death. Serious minded, learned and industrious, he held many offices of state, including that of Lord High Admiral in 1702. He made good the family fortunes and was a collector on a large scale, adding pictures, coins and medals and sculpture from the Mazarin, Arundel and Giustiniani collections.

Towards the end of his life, this methodical man decided to commission catalogues of his collections. He chose Count Carlo Gambarini to compile that of the pictures. The book, *A Description of the Earl of Pembroke's Pictures, now Published by C. Gambarini of Lucca*, was published in 1731 and it has the distinction of being the earliest printed catalogue of a British collection of pictures. Pembroke's coins and medals were catalogued by Nicola Francesco Haym: his catalogue *The Earl of Pembroke's Medals in V. Parts* is undated but must have been written before March 1729. For his sculpture, Lord Pembroke chose one Cary

Creed, an engraver completely unknown save for this one work. The title page, like that of Haym's work, was engraved in a cursive script: *The Marble Antiquities, the Right Honble the Earl of Pembroke's at Wilton*. Although Creed's attributions are optimistic, the images are attractive: the work exists in four states between *c*.1729 and 1731.

The sequence of 18th-century catalogues of Wilton stands with Stowe as the most remarkable continuous record of any British collection. After Gambarini's work of 1731, the second catalogue was written by Richard Cowdry: *Description of the Pictures, Statues, Busto's, Basso-relievo's and other Curiosities at Wilton House*, which appeared in two octavo editions of 1751 and 1752. Six years later, in 1758, James Kennedy issued his *New Description of the Pictures, Statues, Busto's, Basso-relievo's and other Curiosities at Wilton House*. As the collection of pictures and works of art was gradually expanded and visitor numbers grew, a regular demand arose for updated versions: Kennedy's *Description* extended to nine octavo editions between 1758 and 1779. In 1769, Kennedy published his guidebook in a new quarto format:

Description of the Antiquities and Curiosities at Wilton House (fig. 379). Two subsequent editions were published, in 1781 and 1786. This was arranged as guidebook, but on a grander scale to keep on the shelf at home rather than in the pocket while touring the house. George Richardson commenced a rival sequence of octavo Wilton guidebooks in 1774 in competition with Kennedy. His *Aedes Pembrochianae* ran to thirteen editions between 1774 and 1798, ultimately outlasting Kennedy's final octavo edition of 1779.

The sequence of guidebooks to Stowe was the longest of any house in Great Britain. Whereas the span of Wilton guidebooks was approximately 70 years, those of Stowe exceeded a century. The earliest book, on the gardens only, was published in 1732. The latest, a description of both the house and the gardens, appeared as late as 1838. During these 106 years, no fewer than 38 descriptions were published, an astonishing rate of one new version every 33 months. This frequency is largely explained by the number of visitors to the celebrated gardens. The information given about the pictures is somewhat sparse and its style resembles a handlist rather than a catalogue.

As with Wilton, there was competition between rival authors. Benton Seeley (1716–1795) produced the earliest guidebook in 1744, *A Description of the Gardens of the Lord Viscount Cobham at Stow in Buckinghamshire*. The book was well received and further editions were produced to keep pace with the expansion of the gardens. George Bickham the younger (1706?–1771) published a rival octavo guidebook *The Beauties of Stow* in 1750, which ran to three editions. However, the Seeley family comprehensively saw off Bickham: between 1744 and 1832, they published no fewer than 26 editions of their Stowe guidebook.

Horace Walpole catalogued the famous collection of pictures at Houghton formed by his father, Sir Robert Walpole, who in 1742 was created 1st Earl of Orford (see chapter 8). This work, *Aedes Walpolianae*, was his first published art criticism.[8] In the introduction, Horace Walpole wrote that his account was meant as a *Catalogue* rather than a *Description* of the pictures, adding that 'the Mention of Cabinets in which they have formerly been, with the Addition of Measures will contribute to ascertain their Originality, and be a kind of Pedigree to them'. Horace Walpole made

plain his deep affection for the house his father had built and the collection which embellished it: 'There are not a great many Collections left in Italy more worth seeing than this at Houghton: In the Preservation of the Pictures, it certainly excells most of them.'

Over twenty years later, Horace Walpole turned his attention to his own house at Strawberry Hill (see chapter 10). In 1774 he printed *The Description of the Villa* in an edition of 100 octavo copies with six on large paper. The work began with a brief history of the houses on the site preceding Strawberry Hill and quickly moved on to a description of the individual rooms and their contents. The book continued thus for 116 pages, by which time Horace Walpole was afflicted by the problem faced by all collectors who try to compile catalogues: additions soon make the work incomplete. This resulted in an appendix, adding another 25 pages. The appendix was followed by a *List of the Books Printed at Strawberry Hill*, which interestingly refers to books printed as late as 1781. Further purchases necessitated a further section (of four pages) entitled '*Additions since the Appendix*', the first of which was the well-known portrait by Reynolds of his three Waldegrave nieces (NG Edinburgh), to be followed by yet another section (of six pages) entitled '*More Additions*', on the final page of which Walpole referred to an event which took place in 1784.

The 1774 *Description* had taken ten years to evolve and in 1784 Horace Walpole decided to reprint the entire book again, this time in quarto with the information re-arranged to show the objects in the rooms where they were then placed. It constitutes as detailed an inventory as one could wish for, but as Wyndham Ketton-Cremer implied, it seems peculiar that equal attention appears to be given to a Sèvres cup and saucer as to the Reynolds portrait of his nieces.[9] Whereas the 1774 edition was unillustrated, the 1784 edition contained many images, of which the evocative views of the Library, Tribune and Gallery at Strawberry Hill are familiar examples.

By the turn of the century, the great aristocratic collections became the subject of catalogues, particularly as the houses were open to recommended visitors on certain days in the season. Cleveland House in St James's, which then belonged to Lord Stafford (1758–1833, see chapter 12), was open

CATALOGUE

OF THE

BRIDGEWATER COLLECTION

OF

PICTURES,

BELONGING TO

THE EARL OF ELLESMERE,

AT

BRIDGEWATER HOUSE, CLEVELAND SQUARE,

ST. JAMES'S.

PRINTED FOR J. M. AND S. M. SMITH,
137, NEW BOND STREET,
(BY PERMISSION.)

———

1851.

A CATALOGUE

OF

THE PICTURES

AT

CANFORD MANOR

IN THE POSSESSION OF

LORD WIMBORNE

PRIVATELY PRINTED
1888

every Wednesday for four months, starting in May 1806. Stafford's second son, later 1st Earl of Ellesmere, rebuilt Cleveland House as Bridgewater House. In 1808 John Britton published his *Catalogue Raisonné of the Pictures belonging to the Most Honourable the Marquis of Stafford in the Gallery at Cleveland House*. The splendour and renown of the collection led to the appearance of several catalogues, but the finest of them was produced in 1818 by William Young Ottley and Peltro William Tomkins.[10] It was produced as a heavy folio of letterpress and plates in four parts, but a limited number of exceptional coloured copies were produced and offered for sale for the enormous sum of £171 4s. One remarkable feature

of the publication is the series of plates depicting the hanging arrangements of the pictures in every room. The Regency furniture is also depicted, and the windows looking through to Green Park. Each picture is described *in extenso*, all with dimensions and provenance information, wherever possible.

John Young was Engraver in Mezzotinto to the King, and Keeper of the British Institution. In 1820 he compiled the catalogue of the pictures at Grosvenor House belonging to Robert Grosvenor, 2nd Earl Grosvenor, who was created 1st Marquess of Westminster in 1831.[11] Young's style was to provide a description of each picture, its measurements, provenance and an engraved image. These pictures remained *in situ* until 1924,

when Grosvenor House was given up and many pictures sold. John Young also catalogued the collections of Philip John Miles[12] (see chapter 12), John Julius Angerstein[13] (chapter 19), Sir John Fleming Leicester[14] (chapter 14) and Lord Stafford[15] (chapter 12). Leicester's pictures were also catalogued by William Carey in 1819.[16]

Understandably the standard of provincial cataloguing and printing in the early 19th century did not match that of the capital. Lord Bagot's pictures at Blithfield in Staffordshire were the subject of a catalogue, privately printed in Uttoxeter in 1801.[17] It is a simple handlist, detailing only the title of the picture and the name of the artist to whom it was attributed. No attempt was made to describe the pictures, or to give measurements or provenance. The 1814 Marbury Hall catalogue is also no more than a handlist.[18] This was a significant collection formed by John Smith Barry, later Lord Barrymore. Such scant detail appears parsimonious to today's students of provenance. Thomas Lister Parker of Browsholme Hall (1779–1858, see chapter 14) catalogued his own collection of pictures in both 1807 and 1808.[19] More than a handlist, Lister also gave intermittent information on provenance.[20]

Sir George Scharf (1820–1895) was the inspired choice as the first director of the National Portrait Gallery, which he served with brilliant success from 1857 to 1895. He was commissioned by three aristocratic owners to catalogue their collections of pictures: all three owned fine sequences of historical portraits, which played to Scharf's strength. First, in 1860 came the catalogue of the pictures in Blenheim Palace (see chapter 8).[21] He brought a high degree of professionalism to the task of describing the pictures, but it strikes one as odd that such a methodical author should not also have provided the dimensions and provenance of the pictures, as was occasionally provided as early as the 1731 Wilton catalogue: perhaps this category of information interested him less than the images of the sitter. For Lord Derby Scharf compiled a catalogue of pictures at Knowsley, published in 1875,[22] and in about 1877 he began work on the extensive collections belonging to the Duke of Bedford. The Bedford project was a protracted one: volumes were privately printed in draft form at irregular intervals between 1877 and 1890, when the definitive works were printed,

divided into three parts.[23] The first, devoted to portraits at Woburn Abbey, and the second, which covers 'imaginary subjects, landscapes, drawings and tapestries' at Woburn Abbey, are usually bound together. The third part, which covered the Duke's London collection at 81 Eaton Square, was privately printed in a separate volume.

One of the most attractive catalogues of the early 19th century was printed in 1817 at the private press at Lee Priory,[24] which belonged to Thomas Brydges Barrett. The design was briefly to list the pictures on the left hand side and to set out on the facing page biographical notes about the artists. Although perfectly produced, its use as a catalogue is limited, with no description of the pictures, dimensions or information on provenance.

An entirely different privately printed catalogue, *The Handbook of Raby Castle, 1870*, was written by the Duchess of Cleveland, the wife of the 4th and last Duke of that title. The Duchess included remarkably complete details of the pictures, chiefly Dutch and Flemish, bought by her husband Duke Henry, and her book was modelled on the Bachelor 6th Duke of Devonshire's *Handbook of Chatsworth and Hardwick*, privately printed in 1844 in a very limited edition, which could be as small as 25 copies.

Although not catalogues commissioned by the collector, two invaluable guides to British private collections in the 19th century were provided by a pair of German scholars. The importance of Dr Gustav Waagen cannot be overestimated. As well as covering well-catalogued collections, such as those of Holkham and Wilton, the value of his *Treasures of Art in Great Britain* is that it covered many collections not otherwise separately catalogued. It appeared in three volumes in 1854 with a supplement in 1857,[25] amplifying a briefer earlier edition of 1838.[26] Together, they cover collections as diverse as those of Edward Cheney at 4 Audley Square, London (Tiepolo and Longhi); Lord Heytesbury in Wiltshire (Veronese, Velazquez and Murillo); Smith Barry at Marbury Hall (classical sculpture, Lievens and Honthorst); and Lord Murray of Great Stuart Street, Edinburgh (Greuze, Watteau and Pater). Professor Adolf Michaelis wrote *Ancient Marbles in Great Britain*: a heavy quarto of over 830 pages, it was published in 1882 and covered every collection of note in the United Kingdom.

The first Superintendent of the South Kensington Museum, which was to evolve into the V&A, was Sir John Charles Robinson (1824–1913). He bought a vast number of works in marble, bronze, maiolica and terracotta and used his connoisseurship to benefit the young museum by buying at the low prices then available. He also advised some private collectors and catalogued their collections, including Matthew Uzielli, a railway millionaire;[27] John Malcolm of Poltalloch (fig. 382), whose superb collection of drawings was bought by the British Museum;[28] Sir Francis Cook (see chapter 20); and Robert Napier, a pioneering Clydeside shipbuilder. In 1865 Robinson prepared a privately printed catalogue of Napier's vast collections of pictures, sculpture and works of art of all kinds,[29] which he displayed at his house, West Shandon in Dumbartonshire. Christie's made much use of Robinson's catalogue whan Napier's collection was sold by auction in 1877.

The earliest known catalogue of a private collection illustrated by photography appeared in 1858 and was devoted to the collection of drawings formed by Henry Reveley at Brynygwyn, North Wales.[30] The folio volume contained 60 large photographs, mounted on stiff cards, of drawings attributed to artists as varied as Leonardo da Vinci, Raphael, Titian, Guercino, Dürer, Van Dyck, Rembrandt, Canaletto and Rowlandson. Six years later, Christie's used photography for the first time in an auction sale catalogue: the vendor was John Watkins Brett deceased of Hanover Square, and his extensive collection was sold on 5 April 1864 and the nine following days.

As described in chapter 20, Sir Francis Cook (1817–1901), who vastly increased the scale of the textile trading business started by his father, lived at Doughty House in Richmond and at Monserrate, near Sintra in Portugal. An *Abridged Catalogue of the Pictures at Doughty House* was printed in 1907 and designed for visitors to the galleries, but the considerable acquisitions by Sir Francis's grandson, Herbert Cook, made the abridged catalogue incomplete.

Sir Herbert Cook, a distinguished *amateur d'art* himself, edited the folio three-volume catalogue of his family's collection[31] which was privately printed between 1913 and 1915. The first volume (1913) was written by Tancred Borenius and was

devoted to the Italian pictures. The second (1914) by J. O. Kronig catalogued the Cooks' Dutch and Flemish pictures. The final volume (1915) by Maurice Brockwell covered the English, French, early Flemish, German and Spanish pictures. The title page of each volume, printed in red and black, was an impressive indicator of the quality of the catalogue, which was a model of its kind. The entry for each picture was scholarly and professional, with brief notes on the artist, a description of the picture, its dimensions, provenance and then location. All the pictures were illustrated. The book was finely printed with rubricated text and initial letters. This was a monumental achievement as a private collection catalogue, which was printed in a generous edition of 500 numbered and signed copies. Tragically during the First World War, a zeppelin fell on the warehouse where the undistributed copies of the recently produced catalogue were stored: the inevitable firestorm destroyed everything inside. The catalogue remains of legendary rarity: no one knows how many copies had been distributed before the fire.

A number of collections formed in the 19th

383 The jacket for the
Royal Academy's *Sensation*
exhibition catalogue, 1997

century were catalogued in the 20th. The *Catalogue of the Petworth Collection of Pictures in the possession of Lord Leconfield* was written by C. H. Collins Baker in 1920. That the number of paintings in the Petworth collection was (and is) so great may explain the relative brevity of the entries, but the essential information is all present. Robert Benson, a collector in his own right, compiled the catalogues of the collection of his father-in-law, Robert Stayner Holford (1808–1893), at Westonbirt[32] and Dorchester House[33] (see chapter 20 for both Holford and Benson).

What is the future of the private collection catalogue? The general change in ownership from private collections to public museums might have undermined their need, but perhaps surprisingly catalogues have continued, albeit in a different form.

Occasionally, a public-spirited collector will wish his collection to undergo the critical process stimulated by a catalogue. The late Sir Brinsley Ford (1908–1999, see chapter 24), who inherited his family's pictures by Richard Wilson and vastly enriched the collection, arranged for the Walpole Society to publish a double-volume catalogue of his collection.[34]

The transition of a private collection into public hands is also likely to stimulate the publication of a catalogue. In 1997 Sir Denis Mahon, scholar and collector (see chapter 24), in effect promised his outstanding collection of Italian Baroque paintings partly to the National Gallery in London, in part to a small but fortunate group of museums in Britain and Ireland, and partly to the Bologna Gallery. An exhibition was held of the complete collection, for which a scholarly catalogue was prepared.[35] Likewise a loan exhibition can bring into existence a scholarly catalogue, as was the case with the collection of Andrew Lloyd Webber, which was shown at the Royal Academy, London in 2003,[36] or a substantial gift to a museum, such as those to the Tate Gallery by Lord McAlpine and Janet Wolfson de Botton.[37] Some collectors primarily collect in order to exhibit art, such as Charles Saatchi (fig. 383) and Frank Cohen, for whom the catalogue is perhaps the only record of past glories. Possibly the most surprising, if not astonishing, of all recent published catalogues is that of Nasser Khalili's collection, mainly of the arts of Islam, which has reached 32 volumes and is still rising.[38] Websites may play a bigger role in the future,[39] as they have done for the collections of certain museums.

What has kept the private collection catalogue alive is the public dimension which is attached to most of today's art collecting. Collectors feel a responsibility when owning works of art to make them available for exhibitions and scholarship: this has increasingly become an end in itself.

YOUNG BRITISH ARTISTS FROM THE SAATCHI COLLECTION

SENSATION

ACKNOWLEDGEMENTS

A great many people have helped us with this book. We were given particular help with the Tudors and Jacobeans by Mark Girouard, Dr Elizabeth Goldring and Sir Roy Strong; with the Restoration by Dr Richard Luckett; with Archaeology and Antiquity by Professor Sir John Boardman and Jonathan Scott; with Sir Robert Walpole and with the Duke of Chandos by Dr Susan Jenkins; with Beckford and Hope by Professor David Watkin; with Champions of the British School by Simon Swynfen Jervis; with Le Goût Français by Jonathan Marsden; with Hispanophiles by Ian Robertson; with Egypt by Tom Hardman and Dr Nick Reeves; with Africa and the Pacific by Julian and Barbara Harding; and with the 20th-century chapters by Richard Calvocoressi, John Kasmin, Norman Rosenthal, Sir Nicholas Serota, Richard Shone and Leslie Waddington.

Other friends and scholars who gave us help were Adriano Aymonino, Roger Bevan, Stephen Calloway, the Marquess of Cholmondeley, John Culverhouse, Professor Peter Davidson, Peter Foden, Professor Steven Hooper, Tim Knox, John Mallett, Dr Christopher Ridgway, Sarah Rutter, Desmond Seward and, the doyen of British collecting studies, Frank Herrmann.

A number of scholars were kind enough to read the entire book at different stages of its production. We are profoundly grateful to Dr Tessa Murdoch who waved the flag for the decorative arts, Professor Edward Chaney, Dr John Martin Robinson, Dr Arthur Macgregor and Dr Bill Zachs.

The full manuscript was read by Professor Brian Allen, Dr Hugh Brigstocke, Professor David Ekserdjian, Dr Nicholas Penny and Dr Giles Waterfield, all of whom have made numerous improvements. Especial thanks are owing to Martin Royalton Kisch and Dr Mark Evans, both of whom did an extraordinary amount of work on our behalf with excellent suggestions to improve the book. Various assistants grappled with the manuscript, including Gemma Rankine and above all Devon Cox.

We are particularly grateful to those who have sponsored the large number of illustrations in order to keep the cover price of the book to its present level: Ivor Braka, Mark Glatman, Danny Katz, the Paul Mellon Centre for Studies in British Art, the Marquess of Salisbury, and above all John Murray whose Trust has made up the greater part of the shortfall.

Our final thanks are to our publisher, David Campbell, our editor at Scala, Oliver Craske, and our designer, Robert Dalrymple, who has created a beautiful book.

JS & CS-M

SELECTED BIBLIOGRAPHY

GENERAL WORKS IN ALL CHAPTERS

ANON (THOMAS MARTYN), *The English Connoisseur, containing an account of whatever is curious in Painting, Sculpture, &c. in the Palaces and Seats of the Nobility and principal Gentry of England...*, 2 vols (London, 1766)

BAUDRILLARD, Jean, 'The System of Collecting' in John Elsner and Roger Cardinal (eds), *The Cultures of Collecting* (London, 1994)

BEDDINGTON, Charles, *Canaletto in England*, exh. cat. Dulwich Picture Gallery and Yale Center for British Art (New Haven, 2006)

BRIGSTOCKE, Hugh, *William Buchanan and the 19th Century Art Trade*, privately published by the Paul Mellon Centre for Studies in British Art (London, 1982)

BRIGSTOCKE, Hugh and Somerville, John, *Italian Paintings from Burghley House*, exh. cat. American Museums and Edinburgh (Alexandra, VA, 1995)

BROWN, Oliver, *Exhibition: The Memoirs of Oliver Brown* (London, 1968)

CABANNE, Pierre, *The Great Collectors* (London, 1963)

CHANEY, Edward, *The Evolution of the Grand Tour* (London, 1998)

COOPER, Douglas (ed.), *Great Family Collections* (London, 1965)

COOPER, Douglas (ed.), *Great Private Collections*, with an Introduction by Kenneth Clark (London, 1963)

CROOKSHANK, Anne and the Knight of Glin, *Ireland's Painters, 1600–1940* (2nd edition: New Haven, 2002)

EVELYN, John, *The Diary of John Evelyn*, ed. E. S. de Beer (London, 2006)

FORD, Brinsley, 'William Constable, an enlightened patron'; 'Thomas Jenkins, Banker Dealer and Unofficial English Agent'; 'The Earl-Bishop, an Eccentric and Capricious Patron of the Arts'; 'James Byres, Principal Antiquarian for the English Visitors to Rome'; and other articles, *Apollo* (June 1974)

GARLICK, Kenneth, *A Catalogue of Pictures at Althorp*, Walpole Society, vol. 45 (London, 1976)

GERE, Charlotte and Vaisey, Marina (eds), *Great Women Collectors* (London, 1999)

HALE, John, *England and the Italian Renaissance* (Oxford, 2005)

HASKELL, Francis, *Rediscoveries in Art* (London, 1976)

HERRMANN, Frank, *The English as Collectors: A Documentary Sourcebook* (1st edition: London, 1972)

HONOUR, Hugh, *Neo-Classicism* (London, 1968)

INGAMELLS, John, *A Dictionary of British and Irish Travellers in Italy 1701–1800, compiled from the Brinsley Ford Archive* (New Haven, 1997)

JACKSON-STOPS, Gervase (ed.), *The Treasure Houses of Britain*, exh. cat. National Gallery of Art Washington (Washington, 1985)

MACGREGOR, Arthur, *Curiosity and Enlightenment* (New Haven, 2007)

MACGREGOR, Arthur (ed.), *The Late King's Goods: Collections, Possessions and Patronage of Charles I in the Light of the Commonwealth Inventories* (Oxford, 1989)

MUENSTERBERGER, Werner, *Collecting, An Unruly Passion: Psychological Perspectives* (Princeton, 1994)

NORTH, Michael and David Ormrod (eds), *Art Markets in Europe 1400–1800* (Aldershot, 1998)

PEARCE, Susan, *On Collecting: An Investigation into Collecting in the European Tradition* (London, 1995)

REITLINGER, Gerald, *The Economics of Taste*, 3 vols (London, 1961, 1963 and 1970)

ROYALTON-KISCH, Martin, *Les artistes collectionneurs de dessins en Angleterre: une étude*, Société du Salon du Dessin, from a symposium 21–22 March 2007

SCOTT, Jonathan, *The Pleasures of Antiquity* (London, 2003)

SMITH, John, *A Catalogue Raisonné of the works of the most eminent Dutch, Flemish, and French Painters...*, 9 vols (London, 1829–42)

SPALDING, Frances, *The Tate Gallery: A History* (London, 1998)

STRONG, Roy, *The Spirit of Britain* (London, 1999)

SUTTON, Denys, Special issue on *Aspects of British Collecting, Part I*: 'Early Patrons and Collectors'; 'London as an Art Centre'; 'Augustan Virtuosi'; 'The Age of Sir Robert Walpole', *Apollo* (November 1981)

SUTTON, Denys, Special issue on *Aspects of British Collecting, Part II*: 'New Trends'; 'Cross-Currents in Taste'; 'From Florence to Naples'; 'From Rome to Naples', *Apollo* (December 1982)

SUTTON, Denys, Special issue on *Aspects of British Collecting, Part III*: 'The Lure of the Antique'; 'Amateurs and scholars'; 'Paris-Londres'; 'A Wealth of Pictures'; 'The Orleans Collection', *Apollo* (May 1984)

SUTTON, Denys, Special issue on *Aspects of British Collecting, Part IV*: 'From Ottley to Eastlake'; 'The Age of Robert Browning'; 'Crowe and Cavalcaselle'; 'Discoveries', *Apollo* (August 1985)

SUTTON, Denys (ed.), Special issue on *Patrons and Patriots I: The Rise of a National School, Apollo* (September 1985)

SUTTON, Denys (ed.), Special issue on *Patrons and Patriots II: The Triumph of British Art, Apollo* (October 1985)

TAYLOR, Francis Henry, *The Taste of Angels: A History of Art Collecting from Rameses to Napoleon* (London, 1948)

TURNER, Jane (ed.), *The Dictionary of Art*, 34 vols (London, 1996)

VERTUE, George, *The Vertue Note Books, Volume 1*, Walpole Society, vol. 18 (Oxford, 1930)

VON HOLST, Niels, *Creators, Collectors and Connoisseurs* (London, 1967)

WAAGEN, Dr Gustav, *Galleries and Cabinets of Art in Great Britain: being an account of more than 49 collections of Paintings, Drawings, Sculptures, MSS., &c.* (London, 1857)

WAAGEN, Dr Gustav, *Treasures of Art in Great Britain: being an account of the Chief Collections of Paintings, Drawings, Sculptures, Illuminated MSS., &c.*, 3 vols (London, 1854)

WAAGEN, Dr Gustav, *Works of Art and Artists in England* (London, 1838)

WALPOLE, Horace, *Anecdotes of Painting in England* (London, 1872)

WALPOLE, Horace, *Yale Edition of Horace Walpole's Correspondence* (New Haven, 1937–83)

WATERFIELD, Hermione and King, Jonathan, *Provenance: Twelve Collectors of Ethnographic Art in England 1760–1990* (Geneva, 2006)

WATERHOUSE, Sir Ellis, *Painting in Britain, 1530–1790* (Harmondsworth, 1962)

WENDORF, Richard, *The Literature of Collecting* (Boston, 2008)

WHITLEY, William T., *Art in England 1800–1820; 1821–1837*, 2 vols (Cambridge, 1928 and 1930)

WHITLEY, William T., *Artists and their Friends in England 1700–1799*, 2 vols (London, 1928)

WILSON, David, *The British Museum* (London, 2002)

ROYAL COLLECTION

CAMPBELL, Lorne, *The Early Flemish Pictures in the Collection of Her Majesty the Queen* (Cambridge, 1985)

LEVEY, Michael, *The Later Italian Pictures in the Collection of Her Majesty the Queen* (Cambridge, 1991)

MILLAR, Oliver, *The Later Georgian Pictures in the Collection of Her Majesty the Queen* (London, 1969)

MILLAR, Oliver, *The Queen's Pictures* (London, 1977)

MILLAR, Oliver, *The Tudor, Stuart and Early Georgian Pictures in the Collection of Her Majesty the Queen* (London, 1963)

MILLAR, Oliver, *The Victorian Pictures in the Collection of Her Majesty the Queen*, 2 vols (London, 1992)

SHEARMAN, John, *The Early Italian Pictures in the Collection of Her Majesty the Queen* (Cambridge, 1983)

WHINNEY, Margaret, *Sculpture in Britain 1530–1830* (Middlesex, 1964)

WHITE, Christopher, *The Dutch Pictures in the Collection of Her Majesty the Queen* (Cambridge, 1982)

CHAPTER 1 · PRECURSORS: COLLECTING AND PATRONAGE IN THE TUDOR AGE

BOYNTON, Lindsay (ed.), 'The Hardwick Hall Inventory of 1601', *Furniture History*, vol. VII, 1971

CAMPBELL, Thomas P., *Henry VIII and the Art of Majesty, Tapestries at Hampton Court* (New Haven, 2007)

CHANEY, Edward (ed.), *The Evolution of English Collecting* (New Haven, 2003)

FOISTER, Susan, *Holbein in England*, exh. cat. Tate Britain (London, 2006)

DEVONSHIRE, 6th Duke, *Handbook of Chatsworth and Hardwick* (London, privately printed, 1844)

GIROUARD, Mark, *Elizabethan Architecture* (New Haven, 2009)

GIROUARD, Mark, *Life in the English Country House* (New Haven, 1978)

GOLDRING, Elizabeth, 'The Earl of Leicester and portraits of the duc d'Alençon', *The Burlington Magazine*, vol. 146, no. 1211 (February 2004)

GOLDRING, Elizabeth, 'An Important Early Picture Collection: The Earl of Pembroke's 1561/2 Inventory and the Provenance of Holbein's *Christina of Denmark*', *The Burlington Magazine*, vol. 144, no. 1188 (March 2002)

GOLDRING, Elizabeth, 'Portraits of Queen Elizabeth I and the Earl of Leicester for Kenilworth Castle', *The Burlington Magazine*, vol. 147, no. 1231 (October 2005)

HOWARD, Maurice, *Inventories, Surveys and the History of Great Houses, 1480–1640*, in *Architectural History*, vol. 41 (1998)

SMUTS, R. Malcolm, *Culture and Power in England 1585–1685* (New York, 1999)

STARKEY, David (ed.), *Henry VIII: A European Court in England* (London, 1991)

STRING, Tatiana C., *Art and Communication in the Reign of Henry VIII* (Aldershot, 2008)

STRONG, Roy, *The English Icon* (London, 1969)

CHAPTER 2 · JACOBEAN ANTIQUARIANS

ADAMSON, John, *The Princely Courts of Europe* (London, 1999)

EVANS, Mark (ed.), *The Lumley Inventory and Pedigree, Art Collecting and Lineage in the Elizabethan Age* (The Roxburghe Club, 2010)

GOOCH, Leo, *John Lord Lumley* (Sunderland, 2009)

HOWARTH, David, *Images of Rule* (London, 1997)

PARRY, Graham, *The Trophies of Time* (Oxford, 1995)

STRONG, Roy, *Henry Prince of Wales* (London, 1986)

TITE, Colin G.C., *The Early Records of Sir Robert Cotton's Library* (London, 2003)

WATERHOUSE, Ellis, *Painting in Britain 1530–1790* (Harmondsworth, 1962)

WILKS, Timothy, 'Art Collecting at the English Court from the Death of Henry Prince of Wales to the Death of Anne of Denmark', in *Journal of the History of Collections*, vol. 9, no. 1 (1997)

WILKS, Timothy (ed.), *Prince Henry Revived*, London 2007

CHAPTER 3 · THE EARL AND COUNTESS OF ARUNDEL

ANGELICOUSSIS, Elizabeth, 'The collection of classical sculptures of the Earl of Arundel, "Father of Vertu in England"', *Journal of the History of Collections*, vol. 16 (2) (2004), pp. 143–59

CHANEY, Edward, *Inigo Jones's 'Roman Sketchbook'* (The Roxburghe Club, 2006)

CHEW, Elizabeth V, 'The Countess of Arundel at Tart Hall' in Edward Chaney (ed.), *The Evolution of English Collecting* (New Haven, 2003)

HERVEY, Mary, *The Life, Correspondence and Collections of Thomas Howard, Earl of Arundel* (Cambridge, 1921)

HOWARTH, David, *Lord Arundel and His Circle* (New Haven, 1985)

HOWARTH, David, 'The Patronage and Collecting of Aletheia, Countess of Arundel 1606–54', *Journal of the History of Collections*, no. 10 (2) (1998)

CHAPTER 4: CHARLES I AND THE WHITEHALL CIRCLE

BETCHERMAN, Lita-Rose, 'The York House Collection and its Keeper', *Apollo*, 92 (October 1970)

BROWN, Jonathan, *Kings and Connoisseurs: Collecting Art in Seventeenth Century Europe* (London, 1995)

DAVIES, Randall, 'An Inventory of the Duke of Buckingham's Pictures, etc., at York House in 1635', *The Burlington Magazine*, vol. 10, no. 48 (March 1907)

FAIRFAX, Brian, *A Catalogue of the Curious Collection of Pictures of George Villiers, Duke of Buckingham* (London, 1758)

HASKELL, Francis, unpublished lectures on Stuart collecting (Library of the National Gallery, London)

HEARN, Karen, *Van Dyck and Britain*, exh. cat. Tate Britain (London, 2009)

LUZIO, Alessandro, *La Galleria dei Gonzaga venduta all'Inghilterra nel 1627–28* (Milan, 1913)

MILLAR, Oliver, *The Age of Charles I*, exh. cat. Tate Gallery (London, 1972)

MILLAR, Oliver (ed.), *Van Dyck in England*, exh. cat. National Portrait Gallery (London, 1982)

MILLAR, Oliver, 'Van Dyck in England', Part IV of *Van Dyck: A Complete Catalogue of the Paintings* (New Haven, 2004)

CHAPTER 5 · DISPERSAL AND
COMMONWEALTH

BROTTON, Jerry, *The Sale of the Late King's Goods: Charles I and His Art Collection* (London, 2007)

HASKELL, Francis, unpublished lectures on Stuart collecting (library of the National Gallery, London)

MILLAR, Oliver, *The Inventories and Valuations of the King's Goods 1649–51*, Walpole Society, vol. 43 (London, 1972)

CHAPTER 6 · THE RESTORATION
1660–88

BARCLAY, Andrew, 'The inventories of the English Royal Collection, temp. James II', *Journal of the History of Collections*, vol. 22 (1) (2010), pp. 1–13

GIBSON, Robin, *Catalogue of Portraits in the Collection of the Earl of Clarendon* (London, 1977)

KEAY, Anna, *The Magnificent Monarch: Charles II and the Ceremonies of Power* (London, 2008)

LATHAM AND MATTHEWS, *The Diary of Samuel Pepys* (London, 1983), 10 vols (especially Volume X, the companion)

[LELY, Sir Peter], 'Sir Peter Lely's Collection', Editorial in *The Burlington Magazine*, vol. 83, no. 485 (August 1943), pp. 185–91

MAHON, Denis, 'Notes on the "Dutch Gift" to Charles II', *The Burlington Magazine*, vol. 91, no. 560 (November 1949) and vol. 92, no. 562 (1950)

MILLAR, Oliver (ed.) *The Age of Charles II*, exh. cat. Royal Academy (London, 1960)

MURDOCH, Tessa, *Boughton House* (London, 1992)

NORTH, Roger, *Autobiography*, ed. Augustus Jessopp (London, 1887)

OGDEN, Henry and Margaret, *English Taste in Landscape in the Seventeenth Century* (Ann Arbor, 1955)

ROWELL, Christopher, *Elizabeth Murray (1626–1698) as a Patron and Collector* (London, 2008)

WATERHOUSE, Ellis, 'A Note on British Collecting of Italian Pictures in the Later Seventeenth Century', *The Burlington Magazine*, vol. 102, no. 682 (February 1960), pp. 54–58

WHITNEY, Margaret and Millar, Oliver, *English Art 1625–1714* (Oxford, 1957)

CHAPTER 7 · THE GRAND TOUR: THE
FIRST PHASE

ANON., *A Descriptive Catalogue of the Pictures at Castle-Howard* (Malton, 1805)

DAWSON, John, *The Stranger's Guide to Holkham...* (Burnham, 1817)

FORD, Brinsley, 'Sir Andrew Fountaine: One of the Keenest Virtuosi of his Age', *Apollo* (November 1985), pp. 352–63.

HIBBERT, Christopher, *The Grand Tour* (London, 1987)

IMPEY, Oliver, *Four Centuries of Decorative Arts from Burghley House*, exh. cat. American Museums (Alexandra, VA, 1998)

ISHAM, Gyles, *A Catalogue of Pictures at Lamport Hall* (privately printed, no date but *c*.1936)

ISHAM, Gyles and Burdon, Gerald, *Sir Thomas Isham: An English Collector in Rome, 1677–8*, exh. cat. Northampton Art Gallery (Northampton, 1969)

KNOX, Tim, *West Wycombe Park*, National Trust Guidebook (2001)

LEES-MILNE, James, *Earls of Creation* (London, 1962)

MCCARTHY, Michael (ed.), *Lord Charlemont and his Circle* (Dublin, 2001)

MOWL, Timothy, *William Kent* (London, 2007)

SAXL, Fritz and Wittkower, Rudolf, *British Art and the Mediterranean* (Oxford, 1948)

SCHMIDT, Leo and others, *Holkham* (Munich, 2005)

SCOTT, Jonathan, *Piranesi* (London, 1975)

SICCA, Cinzia Maria (ed.), *John Talman, An Early Eighteenth Century Connoisseur* (New Haven, 2008)

STIRLING, Anna M. W., *Coke of Norfolk and His Friends* (2nd edition, 1912)

WILTON, Andrew and Bignamini, Ilaria (eds), *The Grand Tour: The Lure of Italy in the Eighteenth Century*, exh. cat. Tate Gallery (London, 1996)

WOODBRIDGE, Kenneth, *Stourhead*, National Trust Guidebook (1975)

CHAPTER 8 · TOWN AND COUNTRY IN
THE EARLY 18TH CENTURY

GAMBARINI, Carlo, *A Description of the Earl of Pembroke's Pictures* (London, 1731)

GIBSON-WOOD, Carol, 'Classification and Value in a 17th century museum: William Courten's collection', in *Journal of the History of Collections*, vol. 9, no. 1 (1997), pp. 61–78.

JENKINS, Susan, *Portrait of a Patron, the Patronage and Collecting of James Brydges, 1st Duke of Chandos* (Aldershot, 2007)

LIVERSIDGE, Michael and Farrington, Jane (eds), *Canaletto in England* (London and Birmingham, 1994)

[MEAD, Dr Richard], *A Catalogue of the Genuine and Capital Collection of Pictures by the Most Celebrated Masters of that Great and Learned Physician, Dr Richard Mead, Deceased, which... will be sold by auction by Mr Langford at his House in the Great Piazza, Covent-Garden on 20th, 21st and 22nd March 1754*

MILLER, Edward, *That Noble Cabinet: A History of the British Museum* (London, 1973)

RUSSELL, Francis, 'A Collection Transformed, The 8th Earl of Pembroke's Pictures', *Apollo* (July/August 2009)

RUSSELL, Francis, *The Derby Collection 1721–35*, Walpole Society, vol. 53 (1987)

SCHARF, George, *Catalogue Raisonné; or A List of the Pictures in Blenheim Palace* (London, 1862)

WALPOLE, Horace, *Aedes Walpolianae: or A Description of the collection of pictures at Houghton-Hall in Norfolk, the Seat of the Right Honorable Sir Robert Walpole...* (London, 1st edition 1747, 2nd edition 1752 and 3rd edition 1767)

CHAPTER 9 · THE GRAND TOUR:
HIGH SUMMER

ANDREW, Patricia, *Jacob More and the Earl Bishop of Derry* in *Apollo* (August 1986)

BLUNT, Anthony, *The Paintings of Nicolas Poussin* (London, 1966)

ELLER, Irvin, *The history of Belvoir Castle... accompanied by a description... and notices of paintings, tapestry, statuary, &c....* (London, 1841)

FORD, Brinsley, 'The Earl-Bishop: An Eccentric and Capricious Patron of the Arts', *Apollo* (June 1974)

FRIEDMAN, Joseph, *Spencer House: Chronicle of a Great London Mansion*, London 1993

GARNETT, Oliver, *Kedleston Hall*, National Trust Guidebook (1999)

MILLAR, Oliver, *Zoffany and his Tribuna* (London, 1966)

PARKER, James, *The Tapestry Room from Croome Court* in *Decorative Art from the Samuel H. Kress Collection at the Metropolitan Museum of Art* (London, 1964)

ROYALTON-KISCH, Martin, 'Reynolds's Collection', in *Gainsborough and Reynolds in the British Museum*, exh. cat. British Museum (London, 1978), pp. 61–92

RUSSELL, Francis, *John, 3rd Earl of Bute: Patron and Collector* (London, 2004)

WATERHOUSE, Ellis, *Reynolds* (London, 1973)

CHAPTER 10 · HORACE WALPOLE AND
ANTIQUARIAN TASTE

BARKER, Nicolas, (ed.), *Horace Walpole's Description of The Villa at Strawberry-Hill* (The Roxburghe Club, 2010)

HALL, Ivan, *Burton Constable Hall* (Beverley, 1991)

KETTON-CREMER, Wyndham, *Horace Walpole* (London, 1940)

LEWIS, Wilmarth Sheldon, *Horace Walpole* (London, 1961)

MULCAHY, Geraldine, *Burton Constable Hall*, guidebook (2008)

[NATIONAL TRUST], *Charlecote Park, Warwickshire*, guidebook (1996)

SNODIN, Michael (ed.), *Horace Walpole's Strawberry Hill*, exh. cat., (New Haven and London, 2009)

STARKEY, David and David Gaimster and Bernard Nurse, *Making History: Antiquaries in Britain 1707–2007*, exh. cat. Royal Academy (London, 2007)

WAINWRIGHT, Clive, *The Romantic Interior* (New Haven, 1989)

WALPOLE, Horace, *A description of the villa of Horace Walpole ... at Strawberry Hill, near Twickenham, with an inventory of the furniture, pictures, curiosities* (Strawberry Hill, 1784)

[WALPOLE, Horace], *Horace Walpole and Strawberry Hill*, exh. cat. Orleans House (Twickenham, 1980)

CHAPTER 11 · ARCHAEOLOGY AND ANTIQUITY

ALEXANDER, Jonathan and others, *The Towneley Lectionary, Illuminated for Cardinal Alessandro Farnese by Giulio Clovio* (The Roxburghe Club, 1997)

BELLINGHAM, David, 'The Jenkins Venus', in Tony Godfrey (ed.), *Understanding Art Objects* (London, 2009)

BIGNAMINI, Iliaria and Hornsby, Clare, *Digging and Dealing in Eighteenth-Century Rome* (New Haven and London, 2010)

BLUNDELL, Henry, *Engravings and etchings of the principal statues, busts, bass-reliefs, sepulchral monuments, cinerary urns, &c. In the collection of Henry Blundell, ... at Ince* (s.l.,1809)

BRYANT, Jacob and Cole, William, *Gemmarum Antiquarum Delectus... [The Marlborough Gems]*, 2 vols, (n.p., no date but *c.*1780–91)

CLARKE, Michael and Penny, Nicholas, *The Arrogant Connoisseur: Richard Payne Knight 1751–1824*, exh. cat. Whitworth Art Gallery (Manchester, 1982)

COOK, Brian Francis, *The Townley Marbles* (London, 1985)

CROOK, Professor Joseph Mordaunt, *The Greek Revival* (London, 1972)

CUST, Lionel (ed. by Sidney Colvin), *A History of the Society of Dilettanti*, 2nd edition (London, 1914)

GORDON, Pryse Lockhart, *Personal Memoirs; or Reminiscences of Men and Manners at Home and Abroad during the last half century...* (London, 1830)

HASKELL, Francis and Penny, Nicholas, *Taste and the Antique* (New Haven, 1981)

HUSSEY, Christopher, 'Ince Blundell Hall, Lancashire – II', *Country Life* (17 April 1958)

JAFFE, Michael, *Treasures from the Fitzwilliam* (Cambridge, 1989)

JENKINS, Ian and Sloan, Kim, *Vases and Volcanoes: Sir William Hamilton and His Collection*, exh. cat. British Museum (London, 1996)

MICHAELIS, Adolf, *Ancient Marbles in Great Britain* (Cambridge, 1882)

MILLER, Edward, *That Noble Cabinet: A History of the British Museum* (London, 1973)

NATTER, Laurent, *A Treatise on the Ancient Method of Engraving on Precious Stones, Compared with the Modern* (London, 1754)

SMITH, Arthur Hamilton, *A Catalogue of the Ancient Marbles at Lansdowne House, based on the work of Adolf Michaelis, with an Appendix containing Original Documents relating to the Collection* (London, privately printed, 1889)

SPILSBURY, John, *A collection of fifty prints from antique gems in the collections of the Right Honourable Earl Percy, the Honourable C.F. Greville and T.M. Slade, Esquire* (London, 1785)

STUART, James and Revett, Nicholas, *The Antiquities of Athens Measured and Delineated by James Stuart and Nicholas Revett, Painters and Architects* (London, 1762)

SUTTON, Denys, 'The Lure of the Antique', *Apollo* (May 1984)

VISCONTI, Ennio Quirino, *Museum Worsleyanum; or a collection of antique basso-relievos, bustos, statues and gems...* (privately printed, 1794)

CHAPTER 12 · THE ORLÉANS COLLECTION AND NAPOLEON'S BONANZA

BUCHANAN, William, *Memoirs of Painting, with a Chronological History of the Importation of Pictures by the Great Masters into England since the French Revolution* (London, 1824)

GERSON, Horst, Goodison, Jack and Robertson, Giles, *Fitzwilliam Museum Cambridge, Catalogue of Paintings, Volume I, Dutch and Flemish... Schools*, Cambridge 1960 and *Volume II, Italian Schools*, Cambridge 1967

HAZLITT, William, *On the Pleasures of Painting* in *Works*, vol. VIII, from the *Complete Works*, edited by P. P. Howe, 21 vols (London 1930–34)

[HUME, Sir Abraham] Anonymous, *Notices of the Life and Works of Titian* (London, 1829)

LEWIS, Lady Theresa (ed.), *Extracts of the Journals and Correspondence of Miss Berry from the year 1783 to 1852* (London, 1865)

[ORLÉANS COLLECTION], *A Catalogue of the Orleans Italian Pictures, which will be exhibited for sale by Private Contract on Wednesday the 26th of December 1798 and following days at Mr. Bryan's Gallery, No. 88, Pall Mall*, [pictures 1–138], with *A Catalogue of the Orleans Italian Pictures, which will be exhibited for sale by Private Contract on Wednesday the 26th of December 1798 and following days at The Lyceum in the Strand*, [pictures 139–295] (London, 1798)

OTTLEY, William Young, *A Catalogue of Pictures from the Colonna, Borghese and Corsini Palaces &c., Purchased in Rome in the Years 1799 and 1800. Now on Exhibition and Sale by Private Contract, at No. 118, Pall-Mall* (London, 1801)

STRYIENSKI, Casimir, *La Galerie de Régent Philippe, duc d'Orléans* (Paris, 1913)

YOUNG, John, *A Catalogue of the Pictures at Leigh Court, near Bristol; the Seat of Philip John Miles, Esq. M.P. with etchings from the whole collection... and accompanied with Historical and Biographical Notices* (London, 1822)

CHAPTER 13 · TASTEMAKERS

[BECKFORD, William], *A Catalogue of the Magnificent, Rare and Valuable Library... the Books of Prints, Galleries of Art, Curious Missals and Manuscripts, the Persian and Chinese Drawings, &c., which will be sold by Mr. Phillips at the Abbey...* (1823)

[BECKFORD, William], *Magnificent Effects at Fonthill Abbey, Wilts., to be sold by Mr. Christie on the Premises...* (1822)

FOTHERGILL, Brian, *Beckford of Fonthill* (London, 1979)

HOBSON, Anthony, 'William Beckford's Library', *The Connoisseur*, vol. 191, no. 770 (26 March 1976)

HOPE, Thomas, *Household Furniture and Interior Decoration, executed from designs by Thomas Hope* (London, 1807)

LEES-MILNE, James, *William Beckford* (Tilbury, 1976)

MICHAELIS, Adolf, *Ancient Marbles in Great Britain* (Cambridge, 1882)

OSTERGARD, Derek E. (ed.), Hewat-Jaboor, Philip and McLeod, Bet, *William Beckford 1760–1844: An Eye for the Magnificent*, exh. cat. (New Haven, 2001)

RUTTER, John, *Delineations of Fonthill and its Abbey* (Shaftesbury and London, 1823)

WATKIN, David, *Thomas Hope (1769–1831) and the Neo-Classical Idea* (London, 1968)

WATKIN, David and Hewat-Jaboor, Philip (eds), *Thomas Hope: Regency Designer*, exh. cat. (New Haven, 2008)

CHAPTER 14 · CHAMPIONS OF THE BRITISH SCHOOL

AGNEW, Geoffrey, *Agnew's 1817–1967* (London, 1967)

BECKETT, R.B. (ed.), *John Constable's Correspondence* (Ipswich, 1962–68)

[BICKNELL, Elhanan], *Catalogue of the Renowned Collection of English Pictures and Sculpture of that Distinguished Patron of Art, Elhanan Bicknell, deceased... will be sold by auction by Messrs Christie, Manson & Woods... April 25th 1863*

PETER BICKNELL, 'Elhanan Bicknell', entry in *Dictionary of Art*, vol. 4 (London, 1996)

BOYDELL, John, *A Catalogue of the Pictures &c. in the Shakespeare Gallery, Pall-Mall* (London, 1789)

BRITISH INSTITUTION FOR PROMOTING THE FINE ARTS IN THE UNITED KINGDOM, (founded 4 June 1805; opened 18 January 1806): successive annual exhibition catalogues

BUTLIN, Martin and others, *Turner at Petworth*, exh. cat. Tate Gallery (London, 1989)

CAREY, William, *A Descriptive Catalogue of a Collection of Paintings by British Artists, in the Possession of Sir John Fleming Leicester, Bart.*, (London, 1819)

DAKERS, Caroline, *A Genius for Money: Business, Art and the Morrisons* (New Haven and London, 2011)

FINBERG, Alex, *Turner's Water-Colours at Farnley Hall* (London, no date [1912])

FROST, William and Reeve, Henry, *Catalogue of the Paintings, Water-Colour Drawings and Prints in the Collection of the late Hugh Andrew Johnstone Munro, Esq., of Novar*, no date [before 1867]

[GILLOTT, Joseph], *Catalogue of the Renowned Collection of Ancient and Modern Pictures of that Well-known Patron of Art, Joseph Gillott, deceased... with the sale prices and names of the*

*Purchasers, sold by Messrs Christie, Manson &
Woods... April 19th, April 26th and May 3rd 1872*

HAYES, John, 'British Patrons and Landscape
Painting', *Apollo* (November 1967), pp. 358–65

KNOX, Tim, *Sir John Soane's Museum* (London,
2008)

MACLEOD, Dianne Sachko, *Art and the Victorian
Middle Class* (Cambridge, 1996)

[PARKER, Thomas Lister], *Catalogue of the
Paintings in the Gallery at Browsholme, the Seat
of Thomas Lister Parker, Esq.* (Lancaster, 1807 and
1808)

REYNOLDS, Graham, 'John Sheepshanks', entry in
Dictionary of Art, vol. 28 (London, 1996)

SANTANIELLO, A. E., *The Boydell Shakespeare
Prints* (New York, 1979)

WATERHOUSE, Ellis, *Three Decades of British Art
1740–1770* (Philadelphia, 1965)

WATKIN, David, *The Architect King, George III
and the Culture of the Enlightenment* (London,
2004)

YOUNG, John, *A Catalogue of Pictures by British
Artists in the Possession of Sir John Fleming
Leicester, Bart., with etchings from the whole
collection including pictures in his gallery at Tabley
House, Cheshire, executed by permission of the
proprietor and accompanied with historical and
biographical notices...* (London, 1825)

CHAPTER 15 · LE GOÛT FRANÇAIS

ANON, *Carlton House: The Past Glories of
George IV's Palace*, exh. cat. The Queen's Gallery,
Buckingham Palace (London, 1991)

ANON, *George IV and the Arts of France*, exh.
cat. The Queen's Gallery, Buckingham Palace
(London, 1966)

ANON, *Catalogue of Furniture, Porcelain, Pictures
etc at Camelford House* (London, 1891)

ANON, *Handbook of the Jones Collection* in the
South Kensington Museum (1883)

BOHN, Henry G., *A Guide... and illustrated
catalogue of the Bernal Collection of works of art*
(London, 1857)

DEJARDIN, Ian and others, *Rembrandt to
Gainsborough: Masterpieces from Dulwich Picture
Gallery*, exh. cat. (London, 1999)

EIDELBERG, Martin, 'Watteau Paintings in
England in the Early Eighteenth Century', *The
Burlington Magazine*, vol. 117, no. 870 (September
1975), pp. 576–82

FULFORD, Roger, *Glyn's 1753–1953: Six
Generations in Lombard Street* (London, 1953)

HALL, Michael, *Waddesdon Manor: Heritage of a
Rothschild House* (Waddesdon, 2002)

HUGHES, Peter, *The Wallace Collection: Catalogue
of Furniture*, 3 vols (London, 1996)

INGAMELLS, John, *The Wallace Collection:
Catalogue of Pictures*, 4 vols (London, 1985–92)

LOMAX, James and Rothwell, James, *Country
House Silver from Dunham Massey* (London,
2006)

MALLETT, Donald, *The Greatest Collector, Lord
Hertford and the Founding of the Wallace Collection*
(London, 1979)

MORRIS, Edward, *French Art in 19th Century
Britain* (New Haven, 2005)

[DE ROTHSCHILD, James], *The James A.
Rothschild Collection at Waddesdon Manor*, multi-
volume series of catalogues (1967–2006)

SAVILL, Rosalind, *The Wallace Collection,
Catalogue of Sèvres Porcelain*, 3 vols (London,
1988)

SNODIN, Michael (ed.), *Rococo Art and Design
in Hogarth's England*, exh. cat. Victoria & Albert
Museum (London, 1984)

SUTTON, Denys, 'A Born Virtuoso' [John Jones],
Editorial in *Apollo* (March 1972), pp. 162–75

THORNTON, Peter, 'John Jones: Collector of French
Furniture', *Apollo* (March 1972), pp. 156–61

VINE, Humphrey, *The Seventeenth Century French
Paintings*, National Gallery cat. (London, 2001)

CHAPTER 16 · HISPANOPHILE COLLECTING

BRAHAM, Allan, *El Greco to Goya*, exh. cat.
National Gallery (London, 1981)

CARR, Dawson, Bray, Xavier and others, *Velázquez*,
exh. cat. National Gallery (London, 2006)

FORD, Richard, *A Hand-Book for Travellers in
Spain* (1845; reprinted 1966 by the Centaur Press,
Fontwell)

GLENDINNING, Nigel and McCartney, Hilary,
*Spanish Art in Britain and Ireland, 1750–1920,
Studies in Memory of Enriquetta Harris Frankfort*
(Woodbridge, 2011)

HOWARTH, David and others (eds), *The Discovery
of Spain*, exh. cat. National Gallery of Scotland
(Edinburgh, 2009)

[NATIONAL TRUST], Kingston Lacy National
Trust Guide Book (1988)

ROBERTSON, Ian, *Richard Ford: Hispanophile,
Connoisseur and Critic* (London, 2004)

STIRLING-MAXWELL, Sir William, *Annals of the
Artists of Spain* (London, 1847, and subsequent
editions)

WATERHOUSE, Ellis, 'Murillo and Eighteenth
Century Painting Outside Spain', in *Murillo*, exh.
cat. Royal Academy (London, 1982)

CHAPTER 17 · THE LURE OF FLORENCE

BARKER, Nicolas, *Bibliotheca Lindesiana: The
Lives and Collections of Alexander William 25th
Earl of Crawford etc* (London, 1978)

BARKER, Nicolas, Brigstocke, Hugh and Clifford,
Timothy, *'A Poet in Paradise': Lord Lindsay
and Christian Art*, exh. cat. National Gallery of
Scotland (Edinburgh, 2000)

BLUNT, Anthony, 'The History of Thomas
Gambier Parry's Collection', and 'Seventeenth and
Eighteenth Century Pictures in the Gambier Parry
Collection', *The Burlington Magazine*, vol. 109, no.
768 (March 1967), pp. 112–16 and p. 177

CALVOCORESSI, Richard, 'Locko Park: An
Important Family Collection', *Connoisseur*, vol. 192,
no. 772 (June 1976), pp. 141–45

CHANDLER, George, *William Roscoe of Liverpool*
(London, 1953)

DUVAL, Susan, 'F. R. Leyland: A Maecenas from
Liverpool', *Apollo* (August 1986)

GARNETT, Oliver, *The Letters and Collection
of William Graham*, Walpole Society vol. 62
(London, 2000)

HASKELL, Francis, 'William Coningham and
His Collection of Old Masters', *The Burlington
Magazine*, vol. 133, no. 1063 (October 1991)

HORNER, Frances, *Time Remembered* (London,
1933)

LEVEY, Michael, 'Botticelli and Nineteenth
Century England', *Journal of the Warburg
and Courtauld Institutes*, vol. 23 no. 3/4 (July–
December 1960), pp. 291–306

LLOYD, Christopher, *A Catalogue of the Earlier
Italian Paintings in the Ashmolean Museum*
(Oxford, 1977)

LYGON, Dorothy and Russell, Francis, 'Tuscan
Primitives in London Sales: 1801–1837', *The
Burlington Magazine*, vol. 122, no. 923 (February
1980), pp. 112–17

MARSDEN, Jonathan (ed.), *Victoria and Albert:
Art and Love*, exh. cat. The Queen's Gallery,
Buckingham Palace (London, 2010)

RUSSELL, Francis, 'Early Italian Pictures and Some
English Collectors', *The Burlington Magazine*, vol.
136, no. 1091 (February 1994), pp. 85–90

SEBAG-MONTEFIORE, Charles, Introduction to
the sale catalogue *Old Master Paintings from the
Drury Lowe Collection at Locko Park*, Sotheby's
6th December 1995

SUTTON, Denys, 'From Ottley to Eastlake', *Apollo*
(1985), p. 84–110.

WATERHOUSE, Ellis, *Some Notes on William
Young Ottley's Collection of Italian Primitives* in
Italian Studies Presented to E.R. Vincent, ed. by
C. P. Brand and others (Cambridge, 1962)

CHAPTER 18 · A WORLD BEYOND EUROPE

ARCHER, Mildred, Rowell, Christopher and
Skelton, Robert, *Treasures from India; the Clive
Collection at Powis Castle* (London, 1987)

BRAUNHOLTZ, Herman, the late (ed. William
Fagg), *Sir Hans Sloane and Ethnography* (London,
1970)

BOWDEN, Mark, *Pitt Rivers: The Life and
Archaeological Work of Lieutenant-General
Augustus Henry Lane Fox Pitt Rivers* (Cambridge,
1991)

BROOKS, Eric St John, *Sir Hans Sloane: The Great
Collector and his Circle* (London, 1954)

HARDING, Julian, 'A Polynesian God and the
Missionaries', *Tribal Arts*, no. 4 (Winter 1994),
pp. 27–32

HOOPER, Steven, *Pacific Encounters: Art and
Divinity in Polynesia 1760–1860*, exh. cat. Sainsbury
Centre for Visual Arts (Norwich, 2006)

IMPEY, Oliver and McGregor, Arthur (eds) *The Origins of Museums* (Oxford, 1985)

MCGREGOR, Arthur (ed.), *Sir Hans Sloane: Collector, Scientist, Antiquary; Founding Father of the British Museum* (London, 1994)

MCLEOD, Malcolm, 'T. E. Bowditch: An Early Collector in West Africa' in *Collectors and Collections*, British Museum Yearbook no. 2 (London, 1977)

MITCHELL, T.C. (ed.), 'Captain Cook and the South Pacific', *British Museum Yearbook no. 3* (London, 1979)

PETCH, Alison, 'General Pitt Rivers' Collections', *Journal of the History of Collections*, vol. 10 no. 1 (1998)

PITT RIVERS, Augustus Henry, *Antique Works of Art from Benin Collected By Lieutenant-General Pitt Rivers* (privately printed, 1900)

[PITT RIVERS, Augustus Henry], *Manuscript catalogue of Pitt Rivers collection at the University Library, Cambridge, with water colour illustrations by G.F.W. Johnson*

SLOANE, Kim (ed.), *Enlightenment*, exh. cat. British Museum (London, 2003)

CHAPTER 19 · THE FOUNDING OF THE NATIONAL GALLERY

BATES, William, *The Maclise Portrait Gallery of Illustrious Literary Characters...* (London, 1898)

BISHOP, Morchard (ed.), *Recollections of the Table Talk of Samuel Rogers* (London, 1952)

CONLIN, Jonathan, *The Nation's Mantelpiece* (London, 2006)

CROOK, Professor Joseph Mordaunt, 'Peel as a Patron of the Arts', *History Today* (January 1966)

FARINGTON, Joseph, *Diary 1793–1821*, ed. Kathryn Cave, Kenneth Garlick & others, 17 vols (New Haven, 1978–88)

HENDY, Sir Philip, *The National Gallery, London* (London, 1958)

HERRMANN, Frank, 'Peel and Solly', *Journal of the History of Collections*, vol. 3 no. 1 (1991), pp. 89–96

NATIONAL GALLERY LONDON WEBSITE, complete list of paintings by each artist in the collection: www.nationalgallery.org.uk

OWEN, Felicity and Brown, David Blayney, *Collector of Genius: A Life of Sir George Beaumont* (New Haven, 1988)

[ROGERS, Samuel], *Catalogue of the Very Celebrated Collection of Works of Art, the property of Samuel Rogers, Esq., Deceased... which will be sold by Messrs Christie and Manson... April 28th 1856 and 18 following days*

SAUMAREZ SMITH, Charles, *The National Gallery: A Short History* (London, 2009)

YOUNG, John, *A Catalogue of the Celebrated Collection of Pictures of the late John Julius Angerstein Esq., containing a finished etching of every picture and accompanied with historical and biographical notices...* (London, 1823). Text in English and French.

CHAPTER 20 · THE VICTORIAN RICH

ANON, *A Catalogue of the Pictures at Canford Manor in the possession of Lord Wimborne* (privately printed, 1888)

BENSON, Robert, *Catalogue of Italian Pictures at 16, South Street, Park Lane and Buckhurst in Sussex collected by Robert and Evelyn Benson* (privately printed, London, 1914)

BENSON, Robert (ed.), *The Holford Collection illustrated with 101 plates selected from twelve manuscripts at Dorchester House and 107 pictures at Westonbirt in Gloucestershire, privately printed for Sir George Holford and members of the Burlington Fine Arts Club...* (London, 1924)

BENSON, Robert (ed.), *The Holford Collection, Dorchester House, with 200 illustrations from the twelfth to the end of the nineteenth century*, 2 vols (Oxford, 1927)

BORENIUS, Tancred and others, *A Catalogue of the paintings at Doughty House and elsewhere in the collection of Sir Frederick Cook, Bt*, ed. Herbert Cook, 3 vols (London, 1913–15)

BRYANT, Julius, *Kenwood: Paintings in the Iveagh Bequest* (New Haven, 2003)

[DAVIES, Henry], *Hours in the Picture Gallery of Thirlestane House, Cheltenham, being a Catalogue of the... Paintings in Lord Northwick's Collection* (Cheltenham, 1846)

[LORD NORTHWICK], *Catalogue of the late Lord Northwick's Extensive and Magnificent Collection of Ancient and Modern Pictures, Cabinet of Miniatures and Enamels, and other choice Works of Art...*, Auction sale catalogue by H. Phillips, 26th July 1859 and 21 subsequent days

RUSSELL, Francis, *The Loyd Collection of Paintings, Drawings and Sculpture* (privately printed, 1991)

SCHREIBER, Lady Charlotte, *Confidences of a Collector of Ceramics and Antiques throughout Britain, France, Holland, Belgium, Spain, Portugal, Turkey, Austria and Germany from the year 1869–1885*, ed. Montague J. Guest, with annotations by Egan Mew (London, 1911)

SEBAG-MONTEFIORE, Charles, 'Robert Stayner Holford' and 'Lord Northwick', *Dictionary of National Biography*, first published in *Missing Persons* (Oxford, 1993)

STRONG, Eugénie, 'Antiques in the Collection of Sir Frederick Cook Bart., at Doughty House, Richmond', *Journal of Hellenic Studies*, vol. 28 (1908)

TEMPLE, Alfred George and Benson, Robert, *Catalogue of the Pictures forming the Collection of Lord and Lady Wantage at 2, Carlton Gardens, London, Lockinge House, Berks and Overstone Park and Ardington House* (London, 1902)

WEALE, W. H. James and Richter, Jean Paul, *A Descriptive Catalogue of the Collection of Pictures belonging to the Earl of Northbrook* (London, privately printed 1889)

WHITE, Christopher, *The Dutch Pictures in the Collection of her Majesty the Queen* (Cambridge, 1982)

ZIEGLER, Philip, *The Sixth Great Power: Barings 1762–1929* (London, 1988)

CHAPTER 21 · ECLECTICS AND AESTHETES 1870–1914

ANON, *The Lady Lever Art Gallery*, Museum Guide (Port Sunlight, 1996)

BLANCHE, Jacques-Emile, *Portraits of a Lifetime* (London, 1937)

BRYANT, Julius and Ekserdjian, David (eds), *Decorative Arts from the Wernher Collection*, magazine off-print from *Apollo* (2002)

CHERRY, John and Caygill, Marjorie (eds), *A.W. Franks, Nineteenth-Century Collecting and the British Museum* (London, 1997)

DARRACOTT, Joseph (ed.), *All For Art: The Ricketts and Shannon Collection*, exh. cat. Fitzwilliam Museum (Cambridge, 1979)

GERE, Charlotte, *The House Beautiful* (London, 2000)

HILLIER, Bevis, *Pottery and Porcelain 1700–1914* (London, 1968)

MORRIS, Edward (ed.), *Art and Business in Edwardian England: The Making of the Lady Lever Art Gallery*, special edition of *Journal of the History of Collections*, vol. 4, no. 2 (1999)

NORWICH, John Julius and others, *The Burrell Collection*, Museum Guide (1983)

PIERSON, Stacey, *Collectors, Collections and Museums: The Field of Chinese Ceramics in Britain 1560–1960* (Berne, 2007)

ROBERTSON, W. Graham, *Time Was* (London, 1931)

STEVENSON, Michael, *Art and Aspirations: The Randlords of South Africa and Their Collections* (South Africa, 2002)

THOMAS, Ben and Wilson, Timothy (eds), *C.D.E. Fortnum and the Collecting and Study of the Applied Arts and Sculpture in Victorian England*, special issue of the *Journal of the History of Collections*, vol. 11, no. 2 (1999)

CHAPTER 22 · CATCHING UP: MODERNISM 1880–1945

ADES, Dawn, 'Edward James and Surrealism', in Nicola Coleby (ed.), *A Surrealist Life: Edward James*, exh. cat. Brighton Museum & Art Gallery (Brighton, 1998)

ANON, *An Honest Patron: A Tribute to Sir Edward Marsh*, exh. cat. Bluecoat Gallery (Liverpool, 1976)

BAILEY, Martin (with an essay by Frances Fowle), *Van Gogh and Britain*, exh. cat. National Gallery of Scotland (Edinburgh, 2006)

LE BAS, Edward, *A Painter's Collection*, exh. cat. Royal Academy (London, 1963)

LE BAS, Edward, *Paintings and Drawings by Harold Gilman and Charles Ginner in the Collection of Edward Le Bas* (London, 1965)

BAXANDALL, David, *The Maitland Gift*, exh. cat. National Gallery of Scotland (Edinburgh, 1963)

BEECHEY, James, and Stephens, Chris, *Picasso and Modern British Art*, exh. cat. Tate Britain (London, 2012)

BODKIN, Thomas, *Hugh Lane and his Pictures* (Dublin and London, 1934)

COOPER, Douglas, *Alex Reid & Lefevre 1926–1976* (London, 1976)

COOPER, Douglas, *The Courtauld Collection* (London, 1953)

DUNLOP, Ian, *The Shock of the New*, New York 1972

EDE, Jim, *Kettle's Yard House Guide*, foreword by Jim Ede (Cambridge, 2002)

EVANS, Mark, 'The Davies Sisters of Llandinam and Impressionism for Wales, 1908–1923', in *Journal of the History of Collections*, vol. 16, no. 2 (2004)

FOWLE, Frances and others, *Impressionism and Scotland*, exh. cat. (Edinburgh, 2008)

HOOK, Philip, *The Ultimate Trophy* (Munich, Berlin, London and New York, 2009)

HOUSE, John, and others, *Impressionism for England: Samuel Courtauld as Patron and Collector* (London, 1994)

INGAMELLS, John, *The Davies Collection of French Art* (Cardiff, 1967)

KORN, Madeleine, 'Collecting Paintings by Matisse and by Picasso in Britain before the Second World War' in *Journal of the History of Collections*, vol. 16, no. 1 (2004)

PICKVANCE, Ronald, *A Man of Influence: Alex Reid (1854–1928)*, exh. cat. Scottish Arts Council (1967)

READ, Benedict and Thistlewood, David (eds), *Herbert Read: A British Vision of World Art*, exh. cat. (Leeds, 1993)

SADLER, Michael, *Michael Ernest Sadler* (London, 1949)

SEYMOUR, Miranda, *Ottoline Morrell* (London, 1992)

CHAPTER 23 · SPECIALISTS AND SCHOLARS 1918–45

ARTS OF ASIA, Special Issue on Percival David Collection, vol. 39, no. 3 (2009)

BASSANI, Ezio and McLeod, Malcolm D., *Jacob Epstein: Collector* (Milan, 1989)

SIR JOHN AND LADY BEAZLEY, exh. cat. Ashmolean Museum (Oxford, 1967)

FAGG, William, *The Epstein Collection of Tribal and Exotic Sculpture*, exh. cat. The Arts Council of Great Britain (London, 1960)

GARNETT, Oliver, *Upton House*, National Trust Guidebook (2003)

GREEN, Judith, '"A New Orientation of Ideas": Collecting and the Taste for Early Chinese Ceramics in England: 1921–36' in Stacey Pierson (ed.), *Collecting Chinese Art: Interpretation and Display*, Colloquies on Art and Archaeology in Asia no. 20, Percival David Foundation of Chinese Art (London, 2000)

HOBSON, Robert Lockhart, *A Catalogue of Chinese Pottery and Porcelain in the Collection of Sir Percival David* (London, 1934)

LINDSAY, Patrick, *Essay on Captain Spencer Churchill* in Douglas Cooper (ed.), *Great Private Collections* (London, 1963)

THE PAUL OPPÉ COLLECTION, exh. cat. Royal Academy (London, 1958)

[OPPENHEIMER, Henry], sale catalogue of Old Master Drawings, 10, 13 & 14 July 1936

[OPPENHEIMER, Henry], sale catalogue of Medieval and Renaissance Works of Art, Christie's, 15–17 July 1936

POPE HENNESSY, James, *Queen Mary* (London, 1959)

SPENCER-CHURCHILL, Edward George, *The Northwick Rescues 1912–1961* (privately printed, 1961)

STANSKY, Peter, *Sassoon* (New Haven, 2003), p.185

WATERFIELD, Hermione and King, J.C.H, *Provenance: Twelve Collectors of Ethnographic art in England 1760–1990* (Geneva and Paris, 2006)

CHAPTER 24 · FROM POST-WAR TO SWINGING SIXTIES 1949–79

BOWNESS, Alan and others, *British Contemporary Art 1910–1990: Eighty Years of Collecting by the Contemporary Art Society* (London, 1991)

BRAHAM, Helen, *The Princes Gate Collection*, exh. cat. of the Seilern Collection, Courtauld Institute (London, 1981)

ESTORICK COLLECTION OF MODERN ITALIAN ART, (Turin/London, 1997)

FINALDI, Gabriele and Kitson, Michael (eds), *Discovering the Italian Baroque: The Denis Mahon Collection*, exh. cat. National Gallery, London (London, 1997)

HOOPER, Steven, and others, *The Robert and Lisa Sainsbury Collection*, 3 vols (New Haven, 1997)

MCALPINE, Alistair, *Journal of a Collector* (London, 1994)

ROBERTSON, Bryan, Russell, John and Lord Snowdon, *Private View* (London, 1965)

PENROSE, Sir Roland and Cowling, Elizabeth, *Visiting Picasso: The Notebooks and letters of Roland Penrose* (London, 2006)

PHELPS, Steven, *Art and Artefacts of the Pacific, Africa and the Americas: The James Hooper Collection* (London, 1976)

SEILERN, Count Antoine, Catalogues of Pictures and Drawings at 56 Princes Gate, 7 vols (London, 1955–71)

SKIPWITH, Peyton, 'How to Cultivate the Art of Friendship: Interview with Colin St John Wilson', *Apollo* (January 2007), pp. 27–33

CHAPTER 25 · LONDON: INTERNATIONAL ART CITY 1979–2000

ADAMS, Brooks, Ortiz, George, Rosenthal, Norman and others, *Sensation: Young British Artists from the Saatchi Collection*, exh. cat. Royal Academy (London, 1997)

BEUDERT, Monique, Rainbird, Sean and Serota, Nicholas (eds), *The Janet Wolfson de Botton Gift*, exh. cat. Tate Gallery (London, 1998).

EARLE, Joe, *Splendors of Imperial Japan: Arts of the Meiji Period from the Khalili Collection* (London, 2002)

HATTON, Rita and Walker, John (eds), *Supercollector: A Critique of Charles Saatchi* (London, 2003)

HILLIER, Bevis, Unpublished profile of Arthur Gilbert, 1987 (copy at Gilbert Collection, London)

KELLEHER, Patrick J. (ed.), *The Stanley J. Seeger Jnr collection*, exh. cat. The Art Museum, Princeton University (1961)

[KHALILI], *The Khalili Collection*, multi-volume catalogues of the Islamic Art, Japanese and other collections, London (1992 and still appearing)

[LLOYD WEBBER], *Pre-Raphaelite and Other Masters: The Andrew Lloyd Webber Collection*, exh. cat. Royal Academy (London, 2003)

MCCULLY, Marilyn, *Picasso: A private collection (The Stanley J. Seeger Collection)* (1993)

ROGERS, J. Michael, *Empire of the Sultans: Ottoman Art from the Collection of Nasser D. Khalili* (London, 1995)

SCHRODER, Timothy (ed.), *Heritage Regained: Silver from the Gilbert Collection*, exh. cat. Christie's (London and other locations, 1998)

STOURTON, James, *Great Collectors of our Time: Art Collecting Since 1945* (London, 2007)

ABBREVIATIONS

Where the location of works of art is provided in brackets, the following short forms are used in this book.

ALNWICK Alnwick Castle, Northumberland

ALTHORP Althorp House, Northamptonshire

ANGLESEY Anglesey Abbey (National Trust)

ANTWERP Koninklijk Museum voor Schone Kunsten, Antwerp

ASCOTT Ascott House, Buckinghamshire (National Trust)

BERLIN Gemäldegalerie, Berlin

BIRMINGHAM Birmingham Museums and Art Gallery

BOSTON Museum of Fine Arts, Boston

BOUGHTON Boughton House, Northamptonshire

BRITISH LIBRARY British Library, London

BRITISH MUSEUM British Museum, London

BURGHLEY HOUSE Burghley House, Lincolnshire

BURRELL COLLECTION Burrell Collection, Glasgow

CARDIFF National Museum Wales, Cardiff

COPENHAGEN Ny Carlsberg Glyptothek, Copenhagen

COURTAULD Courtauld Institute, London

DRESDEN Gemäldegalerie Alte Meister, Dresden

FIRLE PLACE Firle Place, East Sussex

FITZWILLIAM Fitzwilliam Museum, Cambridge

FOUNDLING MUSEUM Foundling Museum, London

FREER Freer Gallery of Art, Washington

FRICK The Frick Collection, New York

GETTY Getty Museum, Los Angeles

GUILDHALL Guildhall Art Gallery, London

GULBENKIAN Gulbenkian Collection, Lisbon

HISPANIC SOCIETY Hispanic Society of America, New York

HUNTINGTON Huntington Art Gallery, San Marino, California

JERUSALEM Israel Museum, Jerusalem

KROMERIZ Archbishop's Palace Museum, Kromeriz

KUNSTHAUS ZURICH Kunsthaus Zurich, Switzerland

LACMA Los Angeles County Museum of Art

LIVERPOOL Walker Art Gallery, Liverpool

LONGLEAT Longleat House, Wiltshire

LOUVRE Musée du Louvre, Paris

MANCHESTER Manchester Art Gallery

MELBOURNE National Gallery of Victoria, Melbourne

MELLON COLLECTION Mellon Collection, Yale Center for British Art, New Haven, CT

METROPOLITAN Metropolitan Museum of Art, New York

MINNEAPOLIS Minneapolis Institute of Arts

MONTREAL Montreal Museum of Fine Arts

MUNICH Alte Pinakothek, Munich

NELSON-ATKINS Nelson-Atkins Museum, Kansas City

NG EDINBURGH Scottish National Gallery, Edinburgh

NG LONDON National Gallery, London

NG OTTAWA National Gallery of Canada, Ottawa

NG WASHINGTON National Gallery of Art, Washington

NORTH CAROLINA North Carolina Museum of Art, Raleigh, NC

NORTON SIMON Norton Simon Museum of Art, Pasadena, California

PETWORTH Petworth House, West Sussex

POLESDEN LACEY Polesden Lacey, Surrey (National Trust)

POLLOK HOUSE Pollok House, Glasgow

PRADO Museo del Prado, Madrid

REINHART Reinhart Collection, Winterthur, Switzerland

RINGLING John and Mable Ringling Museum of Art, Sarasota, Florida

ROTTERDAM Boymans van Beuningen Museum, Rotterdam

ROYAL COLLECTION Royal Collection (HM Queen Elizabeth II)

RUTLAND Duke of Rutland's collection, Belvoir Castle, Leicestershire

SCOTTISH NPG Scottish National Portrait Gallery, Edinburgh

STOURHEAD Stourhead, Wiltshire (National Trust)

SUTHERLAND COLLECTION Duke of Sutherland's collection, on loan to Scottish National Gallery

TATE Tate Britain or Tate Modern, London

THYSSEN Thyssen-Bornemisza Collection, Palacio de Villahermosa, Madrid

V&A Victoria & Albert Museum, London

VATICAN Vatican Museums

VIENNA Kunsthistorisches Museum, Vienna

WADDESDON Waddesdon Manor, Buckinghamshire (National Trust)

WALLACE Wallace Collection, London

WALTERS Walters Art Gallery, Baltimore

WESTMINSTER Duke of Westminster's collection, Eaton Hall, Cheshire

WORDSWORTH HOUSE Wordsworth House, Cockermouth (National Trust)

NOTES AND REFERENCES

INTRODUCTION · PAGES 6–27

1. Anne Robins (ed.), *Cézanne in Britain*, exh. cat. National Gallery (London, 2006–07), p. 17.

2. William Buchanan, *Memoirs of Painting...* (London, 1824), vol. II, p. 204.

3. 17th century

4. His *Notices Illustrative of the Drawings and Sketches of some of the Most Distinguished Masters in all the Principal Schools of Design* was published posthumously in 1820 and was intended as a manual for collectors.

5. See Mark Girouard's essay in Gervase Jackson-Stops (ed.), *The Treasure Houses of Britain: 500 Years of Private Patronage and Art Collecting*, exh. cat. National Gallery of Art, Washington (Washington, 1985), pp. 22–39.

6. Michael Jaffé, 'The Dukes of Devonshire' in Douglas Cooper (ed.), *Great Family Collections* (London, 1965), p. 145.

7. There is an excellent account of Irish collecting in *Ireland's Painters 1600–1940* by Anne Crookshank and the Knight of Glin (New Haven, 2002).

8. See Hugh Brigstocke (ed.), *Masterpieces from Yorkshire Houses*, exh. cat. York City Art Gallery (York, 1994).

9. The story of Norfolk collecting is exceptionally well told in three exhibitions held at the Norwich Castle Museum, all organised by its Keeper of Fine Art, Andrew W. Moore: *Norfolk and The Grand Tour* (1985), *Dutch and Flemish Painting in Norfolk* (1988) and *Family and Friends* (1992).

10. This side of the Alps, as opposed to the 'Ultramontane' with its corresponding desire for a grander liturgy and more control from Rome.

11. Kenneth Clark, *Another Part of the Wood* (London, 1974), pp. 193–94.

12. Quatremère de Quincy, *Lettres sur le préjudice qu'occasionneraient aux Arts...* (Paris, 1796), p. 48.

13. Théophile Thoré-Bürger, *Trésors d'Art en Angleterre* (1860), p. 1.

14. See Giles Waterfield, 'The Public Role of Country House Collections', in *The Art of the Country House*, exh. cat. Tate Gallery (London, 1998–99), p. 15.

15. 'Sed durante Musaeo Ashmoleano, nunquam moriturus.'

16. Carl Meyer's *Letters*, Vol IV: 1906–1914 (Private Collection).

17. Bernard Berenson, 19 July 1896. From Rollin von N. Hadleg (ed.), *The Letters of Bernard Berenson and Isabella Stewart Gardner, 1887–1924* (Boston, 1987), p. 45.

18. Interview with author, December 2010.

19. Dr Gustav Waagen, *Works of Art and Artists in England* (London, 1838).

20. Frank Herrmann, *The English as Collectors* (London, 1972), p. 427.

21. For a brilliant discussion on the psychology of creativity, see Antony Storr, *The Dynamics of Creation* (London, 1972).

CHAPTER 1 · PAGES 30–39

1. Horace Walpole (ed.), *Anecdotes of Painting in England*, collected by George Vertue (Strawberry Hill, 1762), vol. I, p. 117.

2. Roy Strong, *The English Icon* (London, 1969), p. 45.

3. Strong, *The English Icon*, p. 44.

4. See Elizabeth Goldring, 'Portraits of Queen Elizabeth I and the Earl of Leicester for Kenilworth Castle,' *The Burlington Magazine*, vol. 147, no. 1231 (October 2005), pp. 654–60.

5. See Elizabeth Goldring, 'The Earl of Leicester and portraits of the Duc d'Alençon,' *The Burlington Magazine*, vol. 146, no. 1211 (February 2004), pp. 108–11 (especially n.29).

6. For the identification of 'Hubbard', see Josua Bruyn, 'Hubert (Huybrecht) Beuckelaer, an Antwerp portrait painter, and his English patron, the Earl of Leicester,' in Juliette Roding et al (eds), *Leids Kunsthistorisch Jaarboek: Dutch and Flemish Artists in Britain, 1550–1800* (Leiden: Primavera Press, 2003), pp. 85–112.

7. The evidence for the presence of the Veronese portrait at Leicester House will be discussed by Elizabeth Goldring in her article, 'A Portrait of Sir Philip Sidney by Veronese at Leicester House, London, 1582–c.1590,' forthcoming in *The Burlington Magazine*.

8. See Elizabeth Goldring, 'An Important Early Picture Collection: The Earl of Pembroke's 1561/2 Inventory and the Provenance of Holbein's *Christina of Denmark*', *The Burlington Magazine*, vol. 144, no. 1188 (March 2002), pp. 157–60.

9. Letter to the author from Mark Girouard, 6th March 2011.

10. 6th Duke of Devonshire's *Handbook of Chatsworth and Hardwick* (London, privately printed, 1844), pp. 192–93.

CHAPTER 2 · PAGES 40–47

1. Though it was not published until 1595, Sidney wrote the *Defence* in c.1580, and copies of it circulated in manuscript at court from that date onwards.

2. The inventory is among the Arundel papers in the Wiltshire Record Office at Chippenham.

3. See Bruno Ryves, *Mercurius Rusticus* (Oxford, 1646).

CHAPTER 3 · PAGES 48–55

1. David Howarth, *Lord Arundel and His Circle* (New Haven, 1985), p.53.

2. As early as 1565 there was a 'galarye of stone' at Arundel House that went through the London customs so it is possible that Jones only redecorated an existing building.

3. Mary Hervey, *The Life, Correspondence and Collections of Thomas Howard, Earl of Arundel* (Cambridge, 1921), p.256.

4. Howarth, *Lord Arundel and His Circle*, p.89.

5. Howarth, *Lord Arundel and His Circle*, p.120.

6. Hervey, *The Life, Correspondence and Collections of Thomas Howard*, p.473.

7. Hervey, *The Life, Correspondence and Collections of Thomas Howard*, p.394.

8. Elizabeth V. Chew, 'The Countess of Arundel at Tart Hall' in Edward Chaney (ed.), *The Evolution of English Collecting* (New Haven, 2003), p.287.

9. Chew, 'The Countess of Arundel at Tart Hall', p.305.

CHAPTER 4 · PAGES 56–65

1. Oliver Millar, *The Queen's Pictures* (London, 1977), p.32.

2. Quoted by Oliver Millar in *The Age of Charles I*, exh. cat. Tate Gallery (London, 1972), pp.17–18.

3. Randall Davies, 'An Inventory of the Duke of Buckingham's Pictures, etc., at York House in 1635', *The Burlington Magazine*, vol.10, no.48 (March 1907), pp.376–82. See also Lita-Rose Betcherman, 'The York House Collection and its Keeper', *Apollo*, 92 (October 1970), pp.250–59, especially p.258.

4. Brian Fairfax, *A Catalogue of the Curious Collection of Pictures of George Villiers, Duke of Buckingham* (London, 1758), pp.1–23.

5. Quoted from *The Age of Charles I*, p.38.

6. John Aubrey, *Aubrey's Brief Lives*, ed. Oliver Lawson Dick (London, 1960), p.146.

CHAPTER 5 · PAGES 66–71

1. Francis Haskell, unpublished lectures on Stuart collecting (Library of the National Gallery, London).

CHAPTER 6 · PAGES 72–81

1. Horace Walpole (ed.), *Anecdotes of Painting in England*, collected by George Vertue (Strawberry Hill, 1762), vol.3, p.2.

2. Oliver Millar, *Sir Peter Lely*, exh. cat. National Portrait Gallery (London, 1978), p.25.

3. Roger North, *Autobiography*, ed. Augustus Jessopp (1887), from the original MS in the British Library Add. MSS. 32,506.

4. See H. & M. Ogden, *English Taste in Landscape in the Seventeenth Century* (Ann Arbor, 1955), p.88.

5. John Evelyn, *The Diary of John Evelyn*, ed. E. S. de Beer (London, 2006), p.476 (12 December 1668).

6. Christopher Rowell, *Elizabeth Murray (1626–1698) as a Patron and Collector* (London, 2008).

7. The diary of Samuel Pepys, 26 January 1663.

CHAPTER 7 · PAGES 84–99

1. James Boswell, *Life of Samuel Johnson LL.D* (5th edn, edited by Edmund Malone, 1807), p.325

2. Andrew W. Moore, *Norfolk and the Grand Tour* (Norwich, 1985), p.31.

3. Moore, *Norfolk and the Grand Tour*, p.34.

4. Anna M.W. Stirling, *Coke of Norfolk and His Friends* (2nd edn, 1912), p.38.

5. Jane Clark, *Lord Burlington is Here*, in Toby Barnard and Jane Clark (eds), *Lord Burlington: Architecture, Art and Life* (London, Hambledon Press, 1995), pp.251–310; Ricky Pound, 'The Master Mason Slain: The Hiramic Legend in the Red Velvet Room at Chiswick House' in Richard Hewlings (ed.), *English Heritage Historical Review* (Bristol, 2009), pp.154–163; Barry Martin, 'The "G" Spot: An Explanation of its Function and Location within the context of Chiswick House and Grounds', in Edward Corp (ed.), *Lord Burlington: The Man and his Politics – Questions of Loyalty* (Lampeter: Edwin Mellen Press, 1998), pp.71–90.

6. *Julia as Diana* (British Museum).

7. John Ingamells, *A Dictionary of British and Irish Travellers in Italy 1701–1800, compiled from the Brinsley Ford Archive* (New Haven, 1997), p.67.

8. Andrew Wilton and Ilaria Bignamini (eds), *The Grand Tour: The Lure of Italy in the Eighteenth Century*, exh. cat. Tate Gallery (London, 1996), p.12.

CHAPTER 8 · PAGES 100–113

1. Evelyn, *The Diary of John Evelyn*, p.827 (16 April 1691).

2. Carol Gibson-Wood, 'Classification and Value in a 17th century museum: William Courten's collection', in *Journal of the History of Collections*, vol.9, no.1 (1997), pp.61–78.

3. Although not a full catalogue, reference should be made to the undated sequence of 20 plates, engraved by Hamlet Winstanley, reproducing Italian and Dutch pictures collected by James Stanley, 10th Earl of Derby (1664–1736). This folio work was begun in 1727 and may have been published circa 1730. Lord Derby sent Winstanley, who was born near Knowsley Hall, to Rome to look out for pictures: he was abroad between 1723 and 1725. Many of Winstanley's letters to Derby survive, giving a degree of detail unusual for the period on the acquisition of pictures and sculpture for Knowsley. These were published by Francis Russell, *The Derby Collection 1721–35*, Walpole Society, vol.53 (1987), pp.143–80.

4. Francis Russell, 'A Collection Transformed: The 8th Earl of Pembroke's Pictures', *Apollo* (July/August 2009), pp.48–55.

5. Susan Jenkins, *Portrait of a Patron: The Patronage and Collecting of James Brydges, 1st Duke of Chandos* (Aldershot, 2007), p.120.

6. Anon (Thomas Martyn), *The English Connoisseur*, vol.1 (London, 1766), pp.117–143.

7. Anon, *The English Connoisseur*, vol.1, pp.41–50.

8. Anon, *The English Connoisseur*, vol.1, pp.41–50.

9. Ellis Waterhouse, *Painting in Britain 1530–1790* (Harmondsworth, 1962), p.157.

10. Jenkins, *Portrait of a Patron*, p.19.

11. Jenkins, *Portrait of a Patron*, pp.58–60.

12. Jenkins, *Portrait of a Patron*, pp.127–28.

13. Jenkins, *Portrait of a Patron*, Appendix 1, pp.183–93.

14. George Vertue, *The Vertue Note Books, Volume 1*, Walpole Society, vol.18 (Oxford, 1930), pp.8 and 14.

CHAPTER 9 · PAGES 114–125

1. Walpole (ed.), *Anecdotes of Painting in England*, collected by George Vertue, Vol.1, p.xii (Preface).

2. Horace Walpole to Richard West, 28 September 1739: *Yale Edition of Horace Walpole's Correspondence* (Yale, 3rd printing 1970), vol.13, p.181.

3. Ingamells, *Dictionary of British and Irish Travellers in Italy 1701–1800*, pp.343–44.

4. There is some doubt as to whether it was Lord Robert Spencer or John, 1st Earl Spencer who acquired this painting in Italy.

5. Quoted by Brinsley Ford in an article in *Apollo* (June 1974), 'The Earl-Bishop: An Eccentric and Capricious Patron of the Arts', pp.426–34, especially p.430.

6. Also quoted by Brinsley Ford in 'The Earl-Bishop', on p.432.

7. Adriano Aymonino, *Patronage, Collecting and Society in Eighteenth-Century Britain: The Grand Design of the 1st Duke and Duchess of Northumberland*, forthcoming.

8. Quoted in Ingamells, *A Dictionary of British and Irish Travellers in Italy 1701–1800*, p.883.

9. Anthony Blunt, *The Paintings of Nicolas Poussin* (London, 1966), pp.73–76.

10. See Francis Russell, *John 3rd Earl of Bute, Patron and Collector* (London, 2004).

CHAPTER 10 · PAGES 126–133

1. *Horace Walpole and Strawberry Hill*, exh. cat. Orleans House (Twickenham, 1980), p.14.

2. Michael Snodin (ed.), *Horace Walpole's Strawberry Hill*, exh. cat., (New Haven and London, 2009), p.20.

3. Thomas Babington, Lord Macaulay, *Critical and Historical Essays*, vol.2 [1832]: *Letters of Horace Walpole, Earl of Orford, to Sir Horace Mann, British Envoy at the Court of Tuscany. Now first published from the Originals in the Possession of the Earl of Waldegrave*. Edited by Lord Dover. 2 vols. 8vo (London, 1833).

4. Clive Wainwright, *The Romantic Interior* (New Haven, 1989), p.33.

5. The second edition, privately printed in 1784 in 4to, expanded the first edition into a much more complete record of the contents of Strawberry Hill.

6. Walter Scott, *Chronicles of the Canongate*, Magnum Opus edition (1832), vol. 41, p. 81.

CHAPTER 11 · PAGES 134–149

1. Professor J. Mordaunt Crook, *The Greek Revival* (London, 1972), p. 7.

2. See Ilaria Bignamini and Clare Hornsby, *Digging and Dealing in Eighteenth-Century Rome* (New Haven and London, 2010)

3. Jonathan Scott, *The Pleasures of Antiquity* (London, 2003), p. 198.

4. Scott, *The Pleasures of Antiquity*, p. 117.

5. Scott, *The Pleasures of Antiquity*, p. 197.

6. Quoted by David Bellingham, 'The Jenkins Venus', in Tony Godfrey (ed.), *Understanding Art Objects* (London, 2009), pp. 123–24.

7. Reported to be 300 Scudi.

8. According to Adolf Michaelis, *Ancient Marbles in Great Britain* (Cambridge, 1882), p. 116, the publication cost 'not less than £3,000'.

9. Sold to the Metropolitan Museum, New York in 1927.

10. Quoted by Crook, *The Greek Revival*, p. 39.

11. Quoted by Francis Haskell and Nicholas Penny, *Taste and the Antique* (New Haven, 1981), p. 121.

CHAPTER 12 · PAGES 152–163

1. Francis Haskell, *Rediscoveries in Art* (London, 1976), p. 44.

2. Information on internal valuation and sales proceeds from Buchanan, *Memoirs* (1824), vol. 1, p. 19.

3. Lady Theresa Lewis (ed.), *Extracts of the Journals and Correspondence of Miss Berry from the year 1783 to 1852*, vol. 11 (London, 1865), p. 87.

4. William Hazlitt, *On the Pleasures of Painting* in *Works*, vol. VIII, p. 14 from the *Complete Works*, edited by P.P. Howe, 21 volumes (London, 1930–34).

5. William Young Ottley, *A Catalogue of Pictures from the Colonna, Borghese and Corsini Palaces Purchased in Rome in the Years 1799 and 1800* (London, 1801), p. 3.

6. Buchanan, *Memoirs of Painting*, vol. 11, p. 204.

7. Haskell, *Rediscoveries in Art*, p. 27.

8. Hugh Brigstocke, *William Buchanan and the 19th Century Art Trade*, privately published by the Paul Mellon Centre for Studies in British Art (London, 1982), p. 11.

CHAPTER 13 · PAGES 164–173

1. Derek E. Ostergard (ed.), *William Beckford 1760–1844: An Eye for the Magnificent*, exh. cat. (New Haven, 2001), p. 172.

2. *William Beckford 1760–1844*, p. 225.

3. Michaelis, *Ancient Marbles in Great Britain*, pp. 279–293.

CHAPTER 14 · PAGES 174–183

1. Ellis Waterhouse, *The Dictionary of British 18th Century Painters in Oils and Crayons* (Woodbridge, 1981), p. 14.

2. Martin Butlin and Evelyn Joll, *The Paintings of J.M.W. Turner* (London and New Haven, 1984), Text Volume, no. 126, p. 89.

3. Martin Butlin and others, *Turner at Petworth*, exh. cat. Tate Gallery (London, 1989), p. 20.

4. Butlin, *Turner at Petworth*, p. 93.

5. R.B. Beckett (ed.), *John Constable's Correspondence* (Ipswich, 1962–68), vol. III, pp. 97–98.

6. Peter Bicknell, 'Elhanan Bicknell', entry in *Dictionary of Art*, vol. 4 (London, 1996), p. 35.

7. See Chapter 21.

8. See Graham Reynolds, 'John Sheepshanks', entry in *Dictionary of Art*, vol. 28 (London, 1996), pp. 575–76.

CHAPTER 15 · PAGES 184–197

1. Erwin Panofsky, 'Abbot Suger of St-Denis', in his *Meaning in the Visual Arts* (London, 1970), p. 174.

2. Ellis Waterhouse, *Poussin et l'Angleterre jusqu'en 1744*, in A. Chastel (ed.), *Nicolas Poussin*, vol. I, CNRS, Colloques Internationaux (Paris, 1960), pp. 283–95.

3. Alexander Pope, *Imitations of Horace – Epistle: to Augustus* (London, 1737).

4. See John Sainsbury's *A Catalogue of a Collection of Cameos, Marble Busts, Statues... Drawings, Manuscripts, Prints and Books Relating to the Emperor Napoleon and his Family*, no date but privately printed in London (?) in 1835–40. The author's copy belonged to and carries the bookplate of Lord Rosebery.

5. Lord Hertford to Mawson, 12 May 1853. See John Ingamells (ed.), *The Hertford Mawson Letters: The 4th Marquess of Hertford to his agent Samuel Mawson* (London, 1981), letter 23, p. 38.

6. 'In fact, I am not at all annoyed to send my pictures to Manchester; it will be a chance for me to view them', quoted in Wallace Collection, *Catalogue of Paintings* (1968), p. xiv.

7. Herrmann, *The English as Collectors*, p. 293.

8. Now recognised to be Bernard II van Risamburgh.

9. Douglas Cooper (ed.), *Great Private Collections*, Introduction by Kenneth Clark (London, 1963), p. 15.

10. Roger Fulford, *Glyn's 1753–1953: Six Generations in Lombard Street* (London, 1953), p. 87.

CHAPTER 16 · PAGES 198–205

1. David Howarth and others (eds), *The Discovery of Spain*, exh. cat. National Gallery of Scotland (Edinburgh, 2009), p. 85.

2. *Home Letters Written by the Late Earl or Beaconsfield* (London, 1885), Letter VI, p. 44.

3. One of the original series, Benjamin, is at Grimsthorpe Castle, Lincolnshire. In 2011 the series was acquired permanently for a charitable trust to hold and manage the Castle at Bishop Auckland in place of the Church Commissioners.

4. See also: Joseph Baretti's *A Journey from London to Genoa* (1770), Henry Swinburne's *Travels through Spain in 1775 and 1776* (1779), and Joseph Townsend's *Journey through Spain in the years 1786 and 1787* (1791).

5. Dawson Carr, Xavier Bray and others, *Velázquez*, exh. cat. National Gallery (London, 2006), p. 99.

6. Kingston Lacy National Trust Guide Book, 1988, p. 50.

7. Kingston Lacy National Trust Guide Book, p. 31.

8. Gerald Reitlinger, *The Economics of Taste* (London, 1961), vol. 1, p. 135.

CHAPTER 17 · PAGES 206–219

1. John Hale, *England and the Italian Renaissance* (Oxford, 2005), p. 80.

2. Haskell, *Rediscoveries in Art*, p. 35.

3. Hale, *England and the Italian Renaissance*, p. 61.

4. Hale, *England and the Italian Renaissance*, p. 81.

5. Frank Herrmann wrote a major study of Solly and the formation, eventual sale and dispersal of his collections, 'Who was Solly?', which was published in a sequence of five articles in *The Connoisseur* in 1967 and 1968, namely April 1967 (vol. 164, no. 662); May 1967 (vol. 165, no. 663); July 1967 (vol. 165, no. 665); September 1967 (vol. 166, no. 667); and September 1968 (vol. 169, no. 679).

6. Christopher Lloyd, *A Catalogue of the Earlier Italian Paintings in the Ashmolean Museum* (Oxford, 1977), p. xviii.

7. Dr Gustav Waagen, *Treasures of Art in Great Britain* (London, 1854), vol. III, p. 371.

8. Michael Levey, 'Botticelli and Nineteenth Century England', *Journal of the Warburg and Courtauld Institutes*, vol. 23 no. 3/4 (1960), p. 295.

9. Levey, 'Botticelli and Nineteenth Century England', p. 291.

10. Frances Horner, *Time Remembered* (London, 1933), p. 6; and Oliver Garnett, *The Letters and Collection of William Graham*, Walpole Society vol. 62 (London, 2000), p. 150.

CHAPTER 18 · PAGES 222–233

1. Juliet Claxton, 'The Countess of Arundel's Dutch Pranketing Room', *Journal of the History of Collections* (2009), pp. 1–10.

2. Mildred Archer, 'The British as Collectors and Patrons in India, 1760–1830', in Mildred Archer, Christopher Rowell and Robert Skelton, *Treasures from India: The Clive Collection at Powis Castle* (London, 1987), p. 11.

3. David M. Wilson, *The British Museum* (London, 2002), p. 44.

4. Wilson, *The British Museum*, p. 44.

5. Quoted in Steven Hooper, *Pacific Encounters: Art and Divinity in Polynesia 1760–1860* (Norwich, 2006), p. 65.

6. Julian Harding, 'A Polynesian God and the Missionaries', *Tribal Arts*, no. 4 (Winter 1994), p. 28.

7. John Tradescant [the younger], *Musæum Tradescantianum, or, a Collection of Rarities Preserved at South Lambeth neer London* (London, 1656), p. 42.

8. Richard Pococke, *A Description of the East and Some Other Countries...* (London, 1743–45), 2 volumes.

9. See Alison Petch, 'General Pitt Rivers' Collections', *Journal of the History of Collections*, vol. 10 no. 1 (1998), p. 77.

10. Colonel Lane Fox, *Catalogue of the Anthropological Collection. Parts I and II* (London, 1874), p. xi.

CHAPTER 19 · PAGES 234–243

1. Charles Saumarez Smith, *The National Gallery: A Short History* (London, 2009), p. 22. In 1823, Lord Liverpool rejected Lord de Tabley's offer of his collection to form the basis of a gallery for British art (see chapter 14).

2. Quoted in Saumarez Smith, *The National Gallery*, p. 22.

3. Ellen R. Goheen, *The Collection of the Nelson-Atkins Museum of Art* (New York, 1988), p. 53.

4. Jonathan Conlin, *The Nation's Mantelpiece* (London, 2006), p. 69.

5. Conlin, *The Nation's Mantelpiece*, p. 69.

6. Saumarez Smith, *The National Gallery*, p. 57.

7. Morchard Bishop (ed.), *Recollections of the Table Talk of Samuel Rogers* (London, 1952).

8. Samuel Rogers, signed autograph letter to a Mr Sutton, dated 1 November 1819. Author's collection.

9. Quoted in William Bates, *The Maclise Portrait Gallery of Illustrious Literary Characters...* (London, 1898), p. 15.

10. Waagen, *Works of Art and Artists in England*, vol. II, pp. 1–27.

11. Frank Herrmann, 'Peel and Solly', *Journal of the History of Collections*, vol. 3, no. 1 (1991), pp. 89–96 (91).

12. Herrmann, *The English as Collectors*, p. 263.

13. Saumarez Smith, *The National Gallery*, p. 12.

CHAPTER 20 · PAGES 244–255

1. Editorial, *The Burlington Magazine*, vol. XCIV (April 1952), pp. 97–99.

2. Waagen, *Treasures of Art in Great Britain*, Vol II, p. 194.

3. Robert Benson, *The Holford Collection* (Westonbirt, privately printed, 1924), p. 24.

4. Reitlinger, *The Economics of Taste*, Vol I, pp. 15, 137.

5. The National Gallery's catalogue states that this 'is now generally agreed to be an early work by Nicholaes Maes, dating from the early 1650s, not long after his training with Rembrandt.'

6. See Simon Schama, *Scribble, Scribble, Scribble* (London, 2010), pp. 230–33.

7. W. Burger, *Trésors d'Art exposés à Manchester en 1857* (Paris, 1857), page (v).

8. Herrmann, *The English as Collectors*, p. 394.

9. Lady Charlotte Schreiber, *Confidences of a Collector of Ceramics and Antiques throughout Britain, France, Holland, Belgium, Spain, Portugal, Turkey, Austria and Germany from the year 1869–1885*, ed. Montague J. Guest, with annotations by Egan Mew (London, 1911).

10. Herrmann, *The English as Collectors*, p. 334.

CHAPTER 21 · PAGES 256–267

1. Roy Strong, *The Spirit of Britain* (London, 1999), p. 564.

2. Oliver Brown, *Exhibition: The Memoirs of Oliver Brown* (London, 1968), p. 37.

3. W. Graham Robertson, *Time Was* (London, 1931), p. 46.

4. Roger Fry, *The Burlington Magazine* (May 1916), and quoted in Florence Gladstone, *Aubrey House, Kensington 1698–1920* (London, 1922), p. 53.

5. Bevis Hillier, *Pottery and Porcelain 1700–1914* (London, 1968), p. 292.

6. Hillier, *Pottery and Porcelain 1700–1914*, p. 211.

7. Charlotte Gere, *The House Beautiful* (London, 2000), p. 32.

8. Gere, *The House Beautiful*, p. 47.

9. Hermione Waterfield and J.C.H. King, *Provenance: Twelve Collectors of Ethnographic Art in England 1760–1990* (Geneva and Paris, 2006), p. 7.

10. Waterfield and King, *Provenance*, p. 59.

11. Quoted in Joseph Darracott (ed.), *All for Art: The Ricketts and Shannon Collection*, exh. cat. Fitzwilliam Museum (Cambridge, 1979), Foreword, p. ix.

12. *All For Art, The Ricketts and Shannon Collection*, exh. cat. Fitzwilliam Museum (Cambridge, 1979), p. 55.

13. The most famous example was Lever's use of Millais's *Bubbles* in an advertisement which caused him to fall out with the artist.

14. In this Lever was probably encouraged by Orrock who was such an avid collector of porcelain that he was called 'Admiral of the Blue'.

15. Lady Dorothy Nevill, *Reminiscences* (London, 1906), p. 105, and Michael Stevenson, *Art and Aspirations: The Randlords of South Africa and their Collections* (South Africa, 2002), p. 140.

CHAPTER 22 · PAGES 268–285

1. Quoted Charles-Pierre Baudelaire (trans. P.E. Charvet), *Selected Writings on Art and Artists* (Harmondsworth, 1972), pp. 104–07.

2. Mark Evans, 'The Davies Sisters of Llandinam and Impressionism for Wales, 1908–1923', in *Journal of the History of Collections*, vol. 16, no. 2 (2004), pp. 219–253.

3. The first Cézanne to be acquired by a British collector was that belonging to Sir Michael Sadler.

4. See Brown, *Exhibition*.

5. Douglas Cooper, *The Courtauld Collection* (London, 1953), p. 76.

6. Quoted in Cooper, *The Courtauld Collection*, p. 3.

7. Quoted in Cooper, *The Courtauld Collection*, pp. 3–4.

8. According to John House in *Impressionism for England: Samuel Courtauld as Patron and Collector* (London, 1994), in 1926 this was equivalent to approximately £22,600, to which commission of £1,500 had to be added.

9. *An Honest Patron: A Tribute to Sir Edward Marsh*, exh. cat. Bluecoat Gallery (Liverpool, 1976), p. 14.

10. Dawn Ades, 'Edward James and Surrealism', in Nicola Coleby (ed.), *A Surrealist Life: Edward James*, exh. cat. Brighton Museum & Art Gallery (Brighton, 1998), p. 75.

11. See Madelaine Korn, 'Collecting Paintings by Matisse and by Picasso in Britain before the Second World War' in *Journal of the History of Collections*, vol. 16, no. 1 (2004), pp. 111–129.

12. Korn, 'Collecting Paintings by Matisse...', p. 112.

CHAPTER 23 · PAGES 286–297

1. Paul Mellon and John Baskett, *Reflections in a Silver Spoon* (New York, 1992), p. 72.

2. Edward George Spencer-Churchill, *The Northwick Rescues 1912–1961* (privately printed, 1961).

3. Quoted in Peter Stansky, *Sassoon* (New Haven, 2003), p. 185.

4. *The Paul Oppé Collection*, exh. cat. Royal Academy (London, 1958), Introduction by Kenneth Clark, p. iv.

5. See Judith Green, '"A New Orientation of Ideas": Collecting and the Taste for Early Chinese Ceramics in England: 1921–36,' in Stacey Pierson (ed.), *Collecting Chinese Art: Interpretation and Display* (London, 2000), p. 43.

6. Green, '"A New Orientation of Ideas": Collecting...', p. 44.

7. Waterfield and King, *Provenance*, p. 13.

8. Waterfield and King, *Provenance*, p. 102.

9. Ezio Bassani and Malcolm D. McLeod, *Jacob Epstein: Collector* (Milan, 1989), p. 13.

10. Bassani and McLeod, *Jacob Epstein: Collector*, p. 41.

11. *The Epstein Collection of Tribal and Exotic Sculpture*, exh. cat. The Arts Council of Great Britain (London, 1960), Introduction by William Fagg.

CHAPTER 24 · PAGES 298–309

1. See chapter 16.

2. Ingamells, *A Dictionary of British and Irish Travellers in Italy 1701–1800.* (London, 1997).

3. Interview with Peyton Skipwith in *Apollo* (January 2007), pp. 26–33.

4. Bryan Robertson, John Russell and Lord Snowdon, *Private View* (London, 1965).

CHAPTER 25 · PAGES 310–321

1. Although money changed hands it was at a fraction of the value of the collection.

APPENDIX · PAGES 322–329

1. This Appendix is a revised version of an essay which appeared in *Publishing the Fine and Applied Arts 1500–2000*, edited by Robin Myers, Michael Harris and Giles Mandelbrote (London and New Castle, DE, 2012)

2. Millar, *The Queen's Pictures*, p. 46.

3. George Vertue and Horace Walpole (eds), *Catalogue and Description of King Charles the First's Capital Collection of Pictures, Limnings, Statues, Bronzes, Medals and Other Curiosities* (London, 1757).

4. Oliver Millar, *Abraham van der Doort's Catalogue of the Collections of Charles 1*, Walpole Society, vol. 37 (1960).

5. Davies, 'An Inventory of the Duke of Buckingham's Pictures', pp. 376–82; Brian Fairfax, *A Catalogue of the Curious Collection of Pictures of George Villiers, Duke of Buckingham...* (London, 1758), pp. 1–23.

6. No title page issued. The engraved dedication by Hamlet Winstanley begins 'Praenobili Iacobo Comiti Derby...'

7. See Russell, *The Derby Collection 1721–35*, pp. 143–80.

8. Horace Walpole, *Aedes Walpolianae: or A Description of the collection of pictures at Houghton Hall in Norfolk, the Seat of the Right Honorable Sir Robert Walpole...* (1st edition 1747, 2nd edition 1752 and 3rd edition 1767).

9. Wyndham Ketton-Cremer, *Horace Walpole: A Biography* (London: Faber and Faber, 1946), p. 276.

10. William Young Ottley and Peltro William Tomkins, *Engravings of the Most Noble, the Marquess of Stafford's collection of pictures in London: arranged according to schools and in chronological order / with remarks on each picture by William Young Ottley, the executive part under the management of Peltro William Tomkins* (London, 1818).

11. John Young, *A Catalogue of the Pictures at Grosvenor House, with etchings from the whole collection... accompanied by historical notices of the principal works...* (London, 1820; and later edition, 1821).

12. John Young, *A Catalogue of the Pictures at Leigh Court, near Bristol,... with etchings from the whole collection... accompanied by historical notices of the principal works...* (London, 1822).

13. John Young, *A Catalogue of the Celebrated Collection of Pictures of the late John Julius Angerstein Esq., containing a finished etching of every picture and accompanied with historical and biographical notices...* (London, 1823). Text in English and French.

14. John Young, *A Catalogue of Pictures by British Artists in the possession of Sir John Fleming Leicester, Bart., with etchings from the whole collection including pictures in his gallery at Tabley House, Cheshire, executed by permission of the proprietor and accompanied with historical and biographical notices...* (London, 1825).

15. John Young, *A Catalogue of the Collection of Pictures of the Most Noble the Marquess of Stafford, with an etching of every picture and accompanied by historical and biographical notices...*, 2 vols (London, 1825).

16. William Carey, *A Descriptive Catalogue of a Collection of Paintings by British Artists in the possession of Sir John Fleming Leicester, Bart.*, (London, 1819).

17. Anon., *Catalogue of the Pictures in the Possession of Lord Bagot at Blithfield* (Uttoxeter; R. Richards, 1801). Large 8vo, 10 pages, printed on rectos only.

18. Anon., *A Catalogue of Paintings, Statues, Busts, etc. at Marbury Hall, the Seat of John Smith Barry, Esq. in the County of Chester* (London, 1814).

19. Parker, Thomas Lister, *Catalogue of the Paintings in the Gallery, at Browsholme, the Seat of Thomas Lister Parker, Esq.* (Lancaster, 1807 and 1808). The 1807 edition has 7 pages and lists the pictures unnumbered. The text was reset for the 1808 edition, which has 8 pages and numbers the pictures consecutively 1 to 59.

20. A later account of Browsholme and its collections was printed in 1815: *Description of Browsholme Hall: in the West Riding of the County of York, and of the parish of Waddington, in the same county: also, a collection of letters, from original manuscripts, in the reigns of Charles 1 and 11 and James 11 / in the possession of Thomas Lister Parker, of Browsholme Hall, Esq.* (London, 1815).

21. George Scharf, *Catalogue Raisonné; or a List of the Pictures in Blenheim Palace* (London, 1860 (8vo); 1861 (8vo and as an expanded 4to) and 1862 (8vo and 4to)).

22. George Scharf, *A Descriptive and Historical Catalogue of the Collection of Pictures at Knowsley Hall...* (London, 1875). Edition limited to 300 copies.

23. George Scharf, *A Descriptive and Historical Catalogue of the Collection of Pictures at Woburn Abbey...* Part 1 – Portraits; Part 11 – Imaginary Subjects, Landscapes, Drawings and Tapestries, London, 1890 and *Third Portion of a catalogue of Pictures, Miniatures and Enamels, at the residence of His Grace the Duke of Bedford, 81 Eaton Square, London* (1877–90).

24. Thomas Brydges Barrett, *List of Pictures at the Seat of T. B. Brydges Barrett, Esq. at Lee Priory in the County of Kent* (Printed at the private press at Lee Priory by John Warwick, 1817). The edition was limited to 60 copies.

25. Dr Gustav Waagen, *Galleries and Cabinets of Art in Great Britain*, 1 volume (London, 1857).

26. Waagen, *Works of Art and Artists in England*.

27. J. C. Robinson, *Catalogue of the Various Works of Art forming the Collection of Matthew Uzielli, Esq of Hanover Lodge, Regent's Park, London* (Privately printed, London, 1860).

28. J. C. Robinson, *Descriptive Catalogue of Drawings by the Old Masters, forming the Collection of John Malcolm of Poltalloch, Esq.* (Privately printed at the Chiswick Press, London, 1869). A second edition was printed in 1876.

29. J. C. Robinson, *Catalogue of the Works of Art forming the Collection of Robert Napier of West Shandon, Dumbartonshire, mainly compiled by J. C. Robinson, F.S.A.* (London, privately printed by the Chiswick Press, 1865).

30. Henry Reveley, *The Reveley Collection of Drawings at Brynygwyn, North Wales. Photographed by Philip H. Delamotte, F.S.A Professor of Drawing, and T. Frederick Hardwich, Lecturer in Photography in King's College, London* (London 1858), folio. Reveley's *Notices illustrative of the drawings and sketches of some of the most distinguished masters in all the schools of design*, was published posthumously by his son Hugh Reveley in 1820.

31. Herbert Cook (ed.), *A Catalogue of the Paintings in the Collection of Sir Frederick Cook Bt, Visconde de Monserrate*, 3 volumes (London, 1913–15). Folio.

32. Robert Benson (ed.), *The Holford Collection illustrated with 101 plates selected from twelve manuscripts at Dorchester House and 107 pictures at Westonbirt in Gloucestershire*, privately printed for Sir George Holford and members of the Burlington Fine Arts Club... (London, 1924).

33. Robert Benson (ed.), *The Holford Collection, Dorchester House, with 200 illustrations from the twelfth to the end of the nineteenth century*, 2 vols (London, 1927).

34. *The Ford Collection*, 2 vols, Walpole Society vol. 60 (1998).

35. Gabriele Finaldi and Michael Kitson, *Discovering the Italian Baroque: the Denis Mahon Collection*, exh.cat. National Gallery (London, 1997).

36. *Pre-Raphaelite and other Masters: The Andrew Lloyd Webber Collection*, exh. cat. Royal Academy (London, 2003).

37. Monique Beudert, Sean Rainbird and Nicholas Serota (eds), *The Janet Wolfson de Botton Gift*, exh. cat. Tate Gallery (London, 1998).

38. *The Khalili Collection*, multi-volume catalogues of the Islamic Art, Japanese and other collections, London (1992 and still appearing).

39. For example www.khalili.org

ILLUSTRATION CREDITS

All references are to figure numbers.

The Abbotsford Trust: 156

Roma, Accademia Nazionale di San Luca. Photograph: Mauro Coen, Roma: 7

Ackland Art Museum, University of North Carolina at Chapel Hill. Ackland Fund: 197

© 2012. Albright Knox Art Gallery/ Art Resource, NY/Scala, Florence; © ADAGP, Paris and DACS, London 2012: 327

From the Collection at Althorp: 93

Photo: Joerg P. Anders © 2011. Photo Scala, Florence/BPK, Bildagentur fluer Kunst, Kultur und Geschichte, Berlin: 242

Apsley House, London. © English Heritage Photo Library: 234

Ascott, The Anthony de Rothschild Collection (National Trust), © NTPL/ John Hammond: 6

Ashmolean Museum, University of Oxford: 24, 53, 60, 180, 244, 305, 328

Paul Barker: 94, 171

Gift of Sir Alec Martin, The Beaverbrook Art Gallery, Fredericton, NB, Canada: 117

Reproduced by kind permission of His Grace the Duke of Bedford and the Trustees of the Bedford Estates: 5

© Belvoir Castle, Leicestershire, UK/The Bridgeman Art Library: 145

Bibliothèque des Arts Decoratifs, Paris, France/ Archives Charmet/ The Bridgeman Art Library: 111

© Birmingham Museums and Art Gallery: 22

© Peter Blake. All rights reserved, DACS 2012: 26

Photo by Keith Blundy / Aegies Associates: 233

The Bowes Museum: 229

Bristol Museums and Art Gallery/ Corsham Court, UK/ The Bridgeman Art Library: 125

© The Trustees of the British Museum: 55, 95, 157, 160, 168–9, 264–7, 269, 300

With permission of Lady Bromley-Davenport: 245

Browsholme Hall, Forest of Bowland, Lancashire, Home of the Parker Family since 1507: 11

Buccleuch Collection. Photography: Todd-Whyte: 96

The Burghley House Collection: 99, 100, 138–9, 256–7

© Burton Constable Foundation: 20, 154

Chatsworth House, Derbyshire, UK/ © Devonshire Collection, Chatsworth/ Reproduced by permission of Chatsworth Settlement Trustees/ The Bridgeman Art Library: 88, 126–30

Chatsworth House, Derbyshire, UK/The Bridgeman Art Library: 107

Photograph by Peter Mallet; courtesy of the Frank Cohen Collection: 377

Courtesy of Richard Compton: 165

Photograph by John Kippin © Compton Verney: 370

© Country Life: 77, 110, 158, 159, 162, 164, 253, 325, 337, 339, 341

Photographic Survey, The Courtauld Institute of Art, London. Private collection: 167

Photographic Survey, The Courtauld Institute of Art, London. Private collection; © University of Manchester (Tabley House Collection): 12

The Samuel Courtauld Trust, The Courtauld Gallery, London: 30, 246–7, 323–4

© Salvador Dali, Fundació Gala-Salvador Dalí, DACS, 2012. Photo credit: © Tate, London 2011: 332

Musée Dapper, Paris, Inv. No. 2891, © Archives Musée Dapper – Photo Hughes Dubois: Museum Boijmans Van Beuningen, Rotterdam. Photographer: Studio Goedewaagen, Rotterdam: 298

Sir Edward Dashwood; photo by Jonathan Hilder: 115

Sir Percival David Collection / © The Trustees of the British Museum: 336, 345

By Permission of the Trustees of Dulwich Picture Gallery: 216, 232

Dunham Massey, The Stamford Collection (National Trust). © NTPL/ Derrick E. Witty: 112

Dyrham Park, The Blathwayt Collection (acquired through the National Land Fund and transferred to the National Trust in 1961). © NTPL/Derrick E. Witty: 92

© Tracey Emin. All rights reserved, DACS 2012: 29

© English Heritage Photo Library: 284

© English Heritage.NMR: 292

Painting purchased in 2007 with support from National Heritage Memorial Fund (NHMF), The London Historic House Museums Trust, The Art Fund, Friends of Chiswick House and private individuals. © English Heritage Photo Library: 108

Photographed by H Bedford Lemere in March 1911. © English Heritage. NMR: 311–2

Mary Evans Picture Library: 16

Reproduced by permission of the Trustees of the Feversham Settled Estates: 21

© The Fitzwilliam Museum, Cambridge: 25, 179, 306, 346

© Coram in the care of the Foundling Museum, London/ The Bridgeman Art Library: 202

Freer Gallery of Art, Smithsonian Institution, Washington DC: Gift of Charles Lang Freer, F1904.6: 303

© The Frick Collection: 237

© Isabella Stewart Gardner Museum, Boston, MA, USA/ The Bridgeman Art Library: 183

© Getty Images: 28, 213, 255, 278

© Culture and Sport Glasgow (Museums): 230, 314

The Worshipful Company of Goldsmiths: 40

By permission of the trustees of the Goodwood Collection: 131

Guildhall Library, City of London: 190

Hardwick Hall, The Devonshire Collection (acquired through the National Land Fund and transferred to the National Trust in 1959). © NTPL/ John Bethell: 44

Eric Hardy: 54

© Jason Hawkes/CORBIS: 121

The State Hermitage Museum, St. Petersburg: 122

© Damien Hirst and Science Ltd. All rights reserved, DACS 2012: 369

Holkham Estate: 104

Holkham Hall, Norfolk, UK / Photo © Neil Holmes / The Bridgeman Art Library: 98

© Collection of the Earl of Leicester, Holkham Hall, Norfolk/ The Bridgeman Art Library: 4, 103, 105

Photo courtesy Steven Hooper: 347

With kind permission of Houghton Hall: 123

The Hunterian, University of Glasgow: 261

Ickworth, The Bristol Collection, (Acquired by the National Trust with the aid of the National Art-Collections Fund.) © NTPL/Christopher Hurst: 141

Edward James Trust: 27

Xavier de Jauréguiberry: 70

© Jasper Johns / VAGA, New York / DACS, London 2012: 362

Carefree Man by Allen Jones copyright: Allen Jones RA. Photo © Chatsworth House Trust: 371

Courtesy of Daniel Katz; © The Lucian Freud Archive: 374

Kenwood House, The Iveagh Bequest, London; © English Heritage Photo Library: 299

Kettle's Yard, University of Cambridge. Photo Paul Allitt: 356

Nasser D. Khalili Collection of Islamic Art. Copyright Nour Foundation. Courtesy of the Khalili Family Trust: 375

Kimbell Art Museum, Fort Worth, Texas /Art Resource, NY/Scala, Florence: 68

Kunsthistorisches Museum, Vienna: 66

Laing Art Gallery / Tyne & Wear Archives & Museums: 209

Lane Bequest, 1913; Dublin City Gallery, The Hugh Lane Collection: 18

Sammlungen des Fürsten von und zu Liechtenstein, Vaduz – Wien: 113

Lincolnshire County Council, Usher Gallery, Lincoln, UK/ The Bridgeman Art Library: 259

Collection Andrew Lloyd Webber: 373

Los Angeles County Museum of Art www.lacma.org: 293

© Manchester City Galleries: 295

© Manchester City Galleries. Manchester Art Gallery, UK/ The Bridgeman Art Library: 238

Andrew W. Mellon Collection Image courtesy of the National Gallery of Art, Washington: 3, 76, 134

© The Metropolitan Museum of Art/Art Resource/Scala, Florence: 197

© 2012. Image copyright The Metropolitan Museum of Art/Art Resource/Scala, Florence: 142, 120

The Minneapolis Institute of Arts, The William Hood Dunwoody Fund: 231

Reproduced by permission of The Henry Moore Foundation; Robert and Lisa Sainsbury Collection, University of East Anglia © James Austin (photographer): 364

Image copyright Stephen Mulligan, 2012. Used under license from Shutterstock. com: 35

Munich, Alte Pinakothek Muenchen, Bayerische Staatsgemaeldesammlungen. © 2012. Photo Scala, Florence/BPK, Bildagentur fuer Kunst, Kultur und Geschichte, Berlin: 64

© The National Gallery, London, Accepted by H M Government in lieu of Inheritance Tax and allocated to the National Gallery, 1999: 294

© National Gallery, London. Acquired under the Acceptance-in-lieu scheme at the wish of Sybil, Marchioness of Cholmondeley, in memory of her brother, Sir Philip Sassoon, 1994: 342

© The National Gallery, London, Bequeathed by Miss May Rowley, a descendant of the sitter's daughter, 1965: 275

© The National Gallery, London, Bequeathed by Samuel Rogers, 1856: 280

© The National Gallery, London, Bought with a contribution from the National Art Collections Fund, 1916: 243

© The National Gallery, London, Bought with a special grant and contributions from Samuel Courtauld, Sir Joseph Duveen, the National Art Collections Fund and the Phillips Fund, 1929: 80

INDEX

Chimneyside of the Closet

1	2	3	4	5	
Dutchefs of Suffolk ꟼꟼꟼ	ꟼꟼꟼ a Lady	S.ʳ Hen. Guldeford K.ᵗ ꟼꟼꟼ	The Lady Henegham ꟼꟼꟼ	The Lady Audley ꟼꟼꟼ	S.ʳ L.ᵈ

12	13	14	15	16	
ꟼꟼꟼ a Lady	The Earl of Surrey ꟼꟼꟼ	Pr. Edward ꟼꟼꟼ	M.ʳˢ Zouch ꟼꟼꟼ	S.ʳ William Sharington K.ᵗ ꟼꟼꟼ	The

23	24	25	26
S.ʳ I Gage ꟼꟼꟼ	Cephalus & Procris Going a Hunting	The Lady Barkley ꟼꟼꟼ	Nine Pic

30	31	32	33
Nine Pictures	S.ʳ Rich.ᵈ South- K.ᵗ well ꟼꟼꟼ	Nine small Pictures	Earl Orm E

A
55

37
Queen of Sheba, before Solomon ꟼꟼꟼ

B
56

C
57

38
a Drawing
a

D
58

39
12 small Heads

E
59

40
red Chalk Draw ing

F
60

41
12 small Heads

46
a Head

47
a Lady

48
a Head

49
a Boy

50
Venus on a Couch
6